The Avant-Gardists

SJENG SCHEIJEN

The Avant-Gardists

Artists in Revolt
in the Russian Empire
and the Soviet Union
1917-1935

For Wendel and Coosje

Frontispiece: Kazimir Malevich, *Female Torso*, 1928–29 (detail). Oil on plywood, 58 × 48 cm (22 ⅞ × 19 in). State Russian Museum, St Petersburg.

First published in the Netherlands in Dutch in 2019 by
Uitgeverij Prometheus, Herengracht 48, 1015 BN Amsterdam

First published in the United Kingdom in 2024 by
Thames & Hudson Ltd, 181A High Holborn, London WC1V 7QX

First published in the United States of America in 2024 by
Thames & Hudson Inc., 500 Fifth Avenue, New York, New York 10110

*The Avant-Gardists: Artists in Revolt in the Russian Empire
and the Soviet Union 1917–1935*
© 2024 Thames & Hudson Ltd, London

Text © 2019 Sjeng Scheijen
Translated by Brent Annable
Copy-edited by Carolyn Jones
Cover design by Jack Smyth
Designed by P D Burgess

The publisher gratefully acknowledges the support of the Dutch Foundation for Literature.

N **ederlands**
letterenfonds
dutch foundation
for literature

British Library Cataloguing-in-Publication Data
A catalogue record for this book is available from the British Library

Library of Congress Control Number 2023946508

ISBN 978-0-500-02455-3

Printed and bound in India by Replika Press Pvt. Ltd

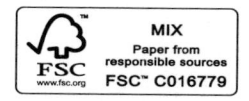

Be the first to know about our new releases, exclusive content and author events by visiting
thamesandhudson.com
thamesandhudsonusa.com
thamesandhudson.com.au

Contents

Как мы все погибли? Поймут ли это когда-нибудь...

The cause of our downfall? Someday they will understand...

NIKOLAI PUNIN

Я не верю в чудо, оттого я и не художник.

I do not believe in miracles; that is why I am not an artist.

VIKTOR SHKLOVSKI

Introduction:
Why We Paint Ourselves

Moscow, 14 September 1913. At around four in the afternoon, three men step out of a taxi at the corner of Kuznetsky Most and the Neglinnaya, two busy streets in the old town. The men, who had painted their faces with motifs in red and blue, walk approximately 400 metres (less than a quarter mile) down Kuznetsky Most, almost to Lubyanka Street. There they make an about-face, walk back the way they came, and step into the very same taxi, which then deposits them at one of the Philippov tearooms several hundred metres further on, where they enjoy a cup of coffee.

This event was attended by a number of young bystanders, some of whom were admirers of the three men, and several newspaper reporters.[1]

The leader of the trio, an artist named Mikhail Larionov, had announced the spectacle two days beforehand in a newspaper interview, saying that he would walk the length of Kuznetsky Most with a painted face. He also said that he planned to hand out copies of a pamphlet, a 'Manifesto for Man', that would proclaim a revolution in men's fashion. 'Men should weave ribbons of gold and silk into their hair, with the free ends dangling on their foreheads or beside their necks. Their feet should be bare, in light sandals, and tattooed or painted.' Men wishing to wear a beard should shave half of it off; a half-moustache was also permissible. Larionov also promised a future 'Manifesto for Women', stipulating that women should appear in public with bare breasts, extravagantly painted or tattooed.[2]

The observers who had flocked to the scene were rather disappointed, most likely owing to the lack of half-beards and exposed female bodies. Over the ensuing months, the painted men (and later also women) appeared with regularity in Moscow's commercial streets and coffee houses. They had to beat a hasty retreat now and again, when affronted members of the bourgeoisie tried – violently – to remove their make-up. Journalists devoted dozens of columns to the phenomenon, expressing a mixture of outright indignation and detached condescension. The painted men even made a short film, *Drama in the Futurists' Cabaret no. 13*, which screened in Moscow and Petrograd (now St Petersburg) and

finally showed – to everyone's relief – some exposed women's breasts. That, too, sparked the desired outrage.

The artists gave interviews in which they issued predictions and unsolicited recommendations. These pertained not only to fashion, but also to 'the culinary arts' which, in their view, were in drastic need of reassessment. Larionov believed that the menu of the future should contain far less meat (obtained mostly from cats, dogs, bats and rats), and consist primarily of vegetables and fruit. He wished to publish a series of recipes in a promised periodical to be titled *The Brick*. The journal – like so many of these artists' promised undertakings – never came about, but that was of concern to nobody.[3]

Shortly after their first piece of 'performance art', they published a manifesto titled 'Why We Paint Ourselves'. Among other things, it stated: 'We have connected art with life. After the artists' long-standing estrangement we have summoned life, and life has invaded art; now it is time for art to invade life. Face-painting is the beginning of the invasion. That is why our hearts are pounding'.[4]

These events mark the arrival of the avant-garde in Russia, a movement encompassing a whole spectrum of artists who all had at least one thing in common: the desire to unite art and life. According to them, artistry should find expression not only in paintings, poems or sculptures, but also in the most quotidian of activities. This longed-for unification remained the key element of their joint platform until the very end. Even in 1928 – when the avant-gardists had already been largely excised from the public sphere – Kazimir Malevich wrote in one of his final works on art history: 'Life should not dictate the content of art; rather, the substance of life must become art, for only then can life be truly beautiful.'[5]

To be clear: it was not their intention for all of life to be aestheticized, or for the world's external trappings (products, buildings, public spaces) to be cast in an avant-garde mould. No: first and foremost they wished for an artistic mindset, an artistic spirit, to constitute the essence of human existence, and for creativity – rather than rationality or emotion – to be pre-eminent among human values. This was the grand utopian mission they hoped to realize. And they saw the revolutionary events of 1917 as a rallying cry, a sign that their time had come.

The avant-garde is neither school nor style, nor is it (in my view) a theory. The avant-garde is a mentality, a modus operandi expressed by the participating artists through the entirety of their being: their conduct,

their convictions and their creative output. The avant-garde was radical. It was the outright rejection of an existing order, which had crammed artistic expression inside the cavity of an oppressive, academic carcass. Rather than fighting against this oppressive restriction with bombs or projectiles, they combatted it with provocative campaigns, performances and the shock factor, always attempting to ridicule what was considered 'good taste'.

Interestingly, the terms 'avant-garde' and 'avant-gardist' were used sparingly at the time. The more radical artists were generally referred to as 'futurists', like the Italian artists' group of the same name, though the similarities between the two groups were superficial at best. They did share a belief that the future would bring salvation, but the glorification of industry and technology so typical of the Italians garnered only a limited following in Russia, and the enthusiastic endorsement of war and violence embraced by the Italian futurists was likewise received coolly by their northern cousins. Most Russian futurists were keener on pacifism.

In the months following their first pieces of public performance art, the avant-gardists would bring an unprecedented amount of radical creativity to bear. Three months later Kazimir Malevich presented a futuristic opera, *Victory over the Sun*, with a cacophonous score by Mikhail Matyushin that made the daring wildness and conceptual framework of the Dada performances at Cabaret Voltaire seem pale by comparison. The following year, Vladimir Tatlin produced his first abstract installations made of scrap materials; these were first displayed on walls, but soon thereafter began to inhabit spaces, definitively blurring the distinction between painting and sculpture. Several months later, a futurist presented a conceptual artwork at an exhibition: a live mouse in a cage. Another displayed a painting that incorporated a working fan.

This was in early 1915. The avant-gardists continued to organize public performances, some with painted faces, others without. Some Russian artists had already begun experimenting with abstraction as early as 1911 (chief among them, of course, being Wassily Kandinsky). In 1915, however, spurred on by the unfettered rivalry between Kazimir Malevich and Vladimir Tatlin, a whole cavalcade of brilliant artists began to explore the possibilities of abstraction, including Lyubov Popova, Ivan Klyun, Ivan Puni, Alexandra Ekster and later on Alexander Rodchenko, El Lissitzky and many others. Within the span of a few years, their influence led to the production of hundreds of abstract works, of astounding variety and quality.

In essence, therefore, it took the Russian avant-gardists only a few years to develop and trial the most significant twentieth-century advances in artistic expression: performances, installations, conceptual art and abstraction. The fact that they were pioneers, and the first (or nearly the first) to conceive of such new forms, is a testament to their radical and rapid development. Yet, in a certain sense, the new forms were only a side-effect, one of the many products of their seemingly magical creativity, which naturally led to them leaving no conventional notions unchallenged, and rejecting all existing norms without a second thought.

The avant-gardists did not pop into existence out of nowhere. Almost all of their ideas were interpretations of notions that had essentially already been developed by the preceding generation of artists, and which were, therefore, part of a general cultural efflorescence whose roots could be traced back to around 1895. But that is another story.

A fascination for the avant-gardists' work cannot exist independently of their dramatic life stories, or the historical events taking place at the time – the series of dramatic political and social developments referred to collectively as 'The Russian Revolution'. The confrontation and connection between the avant-gardists and the revolution, and the doom and enchantment that sprang forth as a result, comprise the subject of this book.

That history begins as follows. Around five months after Lenin seized power, Marc Chagall, Wassily Kandinsky, Kazimir Malevich, Vladimir Tatlin, Alexander Rodchenko and Lyubov Popova (and in their wake, many other radical artists, writers and directors) were appointed to positions of high office in the new administration of the revolutionary state. This was a historically unique phenomenon; never before (and never again since) had such exceptional artists held such prominent positions of high authority in a country's government. They were responsible for the lion's share of cultural policy and education, and were in a position radically to redesign public spaces. Their circumstances raised them to new heights and they suddenly gained a global reputation. Their sudden rise to fame is all the more shocking when one considers that, before the revolution, they were little more than peripheral figures in the Russian cultural landscape: rambunctious, hardly taken seriously and impoverished, a kind of underground with barely any opportunity to participate in the 'serious' world of art.

Their time in office was short, lasting not more than a year, although they did enjoy a brief Indian summer and continued to play a minor but influential role in art education for many years.

In Europe, and among European artists especially, the presence of these figures in the administration of the revolutionary state gave rise to an expectation that, at any given moment, Russia could become the birthplace of a truly utopian society. Visionaries would rise to power! Had Saint-Simon, the founding father of socialism, not prophesied that the ideal socialist state would be led by scholars, engineers and artists?

The association – or confrontation – between avant-gardists and communists can be attributed to several causes, some of which comprise nothing more than a series of unconnected events.

It goes without saying that the avant-gardists rejected the Tsarist autocracy utterly and unconditionally. Various testimonies exist of their unadulterated aversion to the Tsar's policy and personality. Mikhail Matyushin, certainly one of the most mild-mannered of the avant-gardists, described his personal assessment of the Tsar when he was still a violinist in the court orchestra in St Petersburg, many years before the revolution:

> Because I played in the court orchestra, I was often in the presence of the royal Romanovs. You might say they were supposed to be viewed as paragons of humanity. But all I saw was mediocre, morally stunted people, with the clear malevolence and stupidity of mangy street-dwellers. The longer I thought about it, the more I perceived the personal bankruptcy of the Tsar, his utter lifelessness, snobbery and idiocy. It was with despair that I realized it would probably be a long time before society would reawaken and scrape off this detritus, like an old scab.[6]

Another typical excerpt is the following letter from Vsevolod Meyerhold, the greatest theatre director of his time. In 1901, when he still worked primarily as an actor, he wrote the following to his idol, Anton Chekhov:

> I am openly outraged at the abuse of power by the police that I witnessed in St Petersburg on 4 March. I cannot calmly engage in creative work while my blood boils, and everything calls me to fight. I want to be ablaze with the *Zeitgeist*! I want all those in the theatre to become aware of their great mission. I am concerned for my comrades, who have no desire to rise above the petty interests of their caste, which are so alien to the greater good.
>
> Yes, the theatre could play a vital role in the reformation of all that exists![7]

11

Though the avant-gardists were hardly a homogeneous group, much of Meyerhold's summation applied to them almost universally. They all shared both a deep aversion to the Tsar's repressive politics, and the conviction that their art could play a part in the formation of a new and better society.

Although these political musings would certainly explain much, things were certainly not that simple. Earlier in the same letter, Meyerhold voices another thought to Chekhov that contradicts the very sense of social engagement that he so espouses later on: 'I am of an irritable, captious, suspicious nature, and all see me as an unpleasant person. I suffer, and contemplate suicide. Very well; let them despise me. I honour Nietsche's covenant "*Werde, der du bist*" [Become who you are]. I openly say what I think. I hate lies not from the point of view of generally accepted morality (which is itself based on a lie), but as a person striving to purify his own personality.'[8]

So! Here we are privy to the firm convictions of a confessed individualist, a man who sees his personal sovereignty as the greatest good and pays no heed to society's judgment. And not only that, but a man who rejects established morality and acknowledges no higher ideal than 'becoming who you are' and 'purifying one's own personality'. Splendid. But how is it possible that immediately afterwards Meyerhold sings the praises of social engagement and the social responsibility of artists? Does he not see the inherent contradiction between striving for communal engagement and striving for individuality?

It would be easy to accuse Meyerhold of simply setting down two popular opinions side-by-side, without cognition of their apparent irreconcilability. That is not the whole picture, however, for this same ambivalence is evident among a great many (if not all) of the avant-gardists. What *can* be said of all avant-gardists is that they cherished a morality and ethos that encouraged social engagement, while on the other hand simultaneously prizing eccentricity, individualism and independence above all else.

They upheld this contradiction (or better: ambivalence) in a certain sense until the end of their active careers, and it is inherent to the utopian character of the avant-gardist mentality. Like American superheroes, they wished to unite absolute social responsibility with absolute individualism. They made no effort to resolve this ambivalence, regardless of how harshly they were criticized for it. Nor was this the only ambivalence characterizing their lives and work: they simultaneously embraced seriousness and frivolity; they upheld a highly intellectual culture yet

claimed to represent the masses; and they rejected rationality while simultaneously embracing science and technology.

I do not see the sense in trying to unravel these dichotomies, nor to dilute their significance through convoluted reasoning. I believe that the artists returned to this ambivalence time and again because it was one of the drivers of their creativity. The impossibility or absurdity of their positions fuelled their search for new artistic concepts and forced them to reinvent themselves again and again. In this way, they demonstrated that they embraced not a single idea, tradition, concept or ideology, but rather all of humanity. And it is precisely this – their inflated, magnified, distorted, terrifying humanity – that makes their work so provocative, and at the same time so astounding, compelling and moving.

Their willingness to accept humanity as one, with all its contradictions and ambivalence, lies at the foundation of their utopian dream. Which brings us to yet another characteristic trait of the avant-gardists: their utopian thought and feeling.

In principle, the avant-gardist brand of utopia, as it developed in Russia, had little to do with politics. The radical artists were not systematic dreamers who developed new models for society, or even supplied the impulse for others to do so. Their utopia consisted in amplifying the ecstatic moment of creativity so that it might penetrate all aspects of life. It hardly needs saying that they rejected the existing Tsarist order outright, yet they did not exhibit any serious interest in the many political alternatives that were the subject of fervent discussion at the time. None of the aforementioned artists belonged to a political party, or even regularly attended political meetings or gatherings.

The avant-gardists were revolutionaries, true. And yes, almost all of them were closely involved with the revolution. That, however, was more the result of their mission to unite life and art, to leave their studios and take to the streets, rather than a calling that stemmed from any specific political platform. At the same time, the term 'revolutionary' has done much damage to the reputation of the avant-garde, as it suggests that the complex relationship between art and the political revolution was inevitable, as though the two were deeply and inextricably linked. In fact, nothing could be further from the truth, and this view has pigeon-holed the avant-garde, limiting the understanding of its products, and ignoring far more than it elucidates.

Even 'revolutionary' as a generic term – in the sense of 'totally innovative' or as representing a 'turning point' – is of limited applicability to

the avant-garde. It is highly questionable whether the avant-garde even strove to be 'innovative'. They were provocative, certainly, and rejected existing notions regarding the nature, form and function of art. Yet the driving force behind these provocations and innovations was their own eccentricity, not any revolutionary sentiments.

This same eccentricity is, of course, also a typical characteristic of the romantic artist's mentality. The artist as a bohemian, as a detached commentator on a semi-hostile society, is an image familiar to us all through the likes of Baudelaire, Wagner or Van Gogh. In pre-revolutionary Russia, though, this eccentric position was stretched, as it were, to its very limits.

Tsarist society experienced drastic changes in the twenty years leading up to the revolution. Capitalism, economic liberalism, increased literacy, industrialization and urbanization in Russian cities led to the swift rise of a middle class that in many ways resembled their counterparts in Berlin and Paris. This in turn led to the rapid and far-reaching emancipation of many population groups, as evidenced by the rise of women in higher education and the arts (among other areas). At the same time, certain foundations of Tsarist society – the preservation of various centuries-old privileges, the impenetrability of the administrative elite and mandatory settlement areas for some population groups (such as the Jews) – went unchallenged. The avant-gardists were nearly all products of this social emancipation, but suffered under a patent inability to break through these conservative structures. They were not bohemians solely because they had chosen an artist's life; their participation in society as fully fledged citizens was made difficult (or impossible) by their cultural, social, sexual and ethnic identities.

I suspect that this situation was what caused them to internalize and radicalize their eccentricity. They could identify with the social role of the 'fool', which led them to develop a high degree of tolerance – and even respectful admiration – for anyone who dared to step off the beaten track. All manner of exceptional figures, misfits, fringe-dwellers and lunatics, who in other societies (or under more 'normal' circumstances) would only ever have been partially accepted or tolerated, were adored by this group of artists. They were smothered with affection, applauded, decorated, put in the spotlight, and became the privileged bedfellows of the most desirable men and women of the day. It seems self-evident, in my view, that such an atmosphere would be highly conducive to an extraordinary flourishing of the arts.

I do not believe for a moment that all good artists are misfits; I do, however, believe that when misfits are gifted with exceptional creative talent, and if their eccentricity is not only tolerated but also encouraged and supported by their environment, incredible things can happen. This nurturing of eccentricity is also a testament to a warm-blooded humanity, a joyful acceptance of the diversity and whimsy of human expression, which I find simply irresistible.

As mentioned above, the avant-gardists felt no sense of belonging in their fossilized yet slowly crumbling Tsarist society. The alternative that gradually materialized during that time, the prospect of a middle-class society based on a European model, held equally little appeal. Most of these artists regularly visited Berlin and Paris, and even lived there for some time (as quasi-vagrants, true, but that was of little consequence). They had a reasonable notion of how middle-class society worked and of its various pros and cons. They were also well aware that their Parisian counterparts fared little better. They saw how artists were forced to bend to the whim of some bourgeois hack or other: mediocre figures who, because they had stumbled into some decent earnings, felt entitled to strut through galleries dressed to the nines, turning up their noses and passing judgment on other people's art. And whenever a Parisian artist acquiesced to some boorish churl and toiled away to decorate their bland five-bedroom apartment, their reward at the end of the day was to sit outside at a café beside exactly this kind of character, with their legs crossed, sipping on cheap wine and keeping their shoes facing the ground to hide the worn-out soles. Hardly an attractive prospect.

Still, fools these artists were not, and they saw that the middle-class European societies did offer some advantages over their own circumstances. They valued the freedoms and relative wealth of the middle class. It was undoubtedly an improvement on Tsarist society, though not excessively so, and it did not seem misguided (and was possibly even their duty) to dream of an alternative that was better – far better – than any model in Europe.

In addition to the minor indignities that were an unavoidable part of the artist's life in bourgeois society, they also had several other, more fundamental objections to the middle-class capitalist system. These pertained to the compartmentalization and segregation of emotions from personality, which in turn led to alienation, melancholy and nervousness (to use a few fashionable terms of the day).

The bourgeois notion that one's being should be separated into a professional and a personal life was anathema to the avant-gardists: they rejected the idea that we should behave differently in public and in private, dividing our emotional and social existence between romance, sex, marriage, friendships, family and business dealings, each with a separate code of conduct and moral framework. No – they wanted to be whole, undivided people, not go through life as a collection of splintered fragments. They wanted to live *and* work *and* be with the people they loved, with their romantic and sexual partners, friends and family members. They did not wish to doff their creative mantle when closing the studio door behind them, and to shuffle about in comfortable slippers when they got home. No, an artist was an artist, in every respect and under any conceivable circumstance. Their creativity was the binding catalyst in all of their lives: work, love, friendships, family and social activism.

It was this twofold rejection of both Tsarist structures, with their centuries-old privileges, and the bourgeois alternative that paved the way for their association with radical political groups, including the Bolsheviks. And so it was that this set of brilliant, talented crackpots, libertines and hard-working gadabouts ended up in the stifling morass of Stalinism. It was there that they would learn the real meaning of homogenization, the power of exclusion and oppression, and drink from the bitter cup of conformity. That chapter is a dramatic story in itself. Yet it is their coalition with the Bolsheviks, and the brief administrative role they played in the government of their future oppressors, that made their slow but steady descent into the quagmire of the totalitarian system a tale of almost unbearable woe.

It would be unfair, and a gross mischaracterization, to paint the avant-gardists exclusively as innocent victims. Contrary to what one might expect from the above, the avant-gardists proved to be not entirely immune to the temptations of the totalitarian regime. They despised moderation in all its forms, including compromise and anything lacklustre. It was their wish to carry all ideas through to their logical conclusion, to develop and realize them ruthlessly and unapologetically. To some extent, they shared this 'maximalist' principle with the Bolsheviks. During one of Le Corbusier's visits to Moscow, a Bolshevik tried to explain this concept to the architect: 'Bolshevism means doing everything on the grandest possible scale. To the limit. Getting to the bottom of every question, plumbing the greatest depths and considering every possible

angle. Completely and utterly.' 'Until that moment,' Le Corbusier admitted, 'I had understood from our newspapers that a Bolshevik was a man with a red beard and a knife between his teeth.'[9]

The avant-gardists were also no strangers to intolerance, in certain ways. Their wholehearted acceptance of social non-conformity was matched only by their intransigence in discussions and negotiations. They cherished their own quirkiness and eccentricity, so much so that they never learned how to engage in open debate, to admit to being wrong, or to reach a compromise. More than that, they believed that real battles were won by staying the course and remaining true to one's principles. 'Watering the wine', or 'meeting in the middle', was seen as a contemptible and dishonourable humiliation.

This attitude created few problems, so long as the avant-gardists remained peripheral figures. Before the revolution, the internal conflicts resulting from their intransigence had no major consequences and were mitigated by other qualities: their sense of community, their love of joy and folly, and their ability to enjoy one another's creativity under the most adverse of circumstances.

That changed, however, once they were appointed to public office, and their views came to influence the regulation of public spaces, art education and, in part, their own material well-being. They were simply not programmed to consider that progress is always a product of negotiation, achieved through a series of incremental steps. They denied the value of pluralism and failed utterly to realize that they first needed to form a consensus among themselves before engaging with groups whose outlook on reality was completely different.

If one overall conclusion emerges from this book, it is the fact that although the avant-gardists certainly had powerful and vindictive enemies, they were also perfectly capable of self-destruction through their own irreconcilable vendettas. We cannot deny, therefore, that to some extent, the avant-gardists had a hand in the orchestration of their own demise.

Lazy critics who claim that the avant-gardists were themselves essentially totalitarian, owing to their maximalism and relative intolerance, have closed their eyes to the most fundamental aspects of their mentality: their open-mindedness, their intrinsic ambivalence, their emphasis on the inner self, on contemplation, on dreaming, love and celebration.

Describing such a history, juggling the various contradictions and navigating the artists' inscrutable inconsistencies, is a complex endeavour.

The political and administrative aspects of the interplay between the avant-garde and the revolution can be considered and outlined using conventional sources. The motivations of the avant-gardists, however, along with their responses to the historical storm that swept them away and the impact it had on the avant-gardist mentality, cannot. These aspects of their personal histories remain shrouded in darkness, despite the fact that they are ultimately far more interesting and relevant, since they pertain directly to the artists themselves.

Much of this book is based on diaries, private correspondence and memoirs. Only in this way was it possible to elucidate not only the historical events, but also how they were experienced and processed by the people involved. Anyone wanting to understand how such gifted and free-thinking artists became 'slaves to an impossible freedom'[10] (in the words of Alexander Blok) cannot subsist on verifiable facts alone, but must inevitably turn to personal testimonies.

In the end, it was perhaps the author Yevgeny Zamyatin who described the avant-gardists most accurately. This may seem paradoxical, for Zamyatin was anything but a staunch supporter of the avant-garde. In one 1920 article, he gave them a severe dressing-down for their attempt to become 'national artists' (despite admitting, even then, that the attempt had been an utter failure). He also made a classic and oft-cited comment about the role of literature in the world, and one that I believe both honours and confronts the avant-garde. 'True literature,' Zamyatin wrote, 'can only exist where it is not created by duty-bound public servants who are loyal to the authority, but instead by lunatics, hermits, heretics, dreamers, rebels and sceptics'.[11]

Granted, scepticism was not the avant-gardists' greatest virtue. But they did personify all of the other characteristics listed by Zamyatin – cheerful lunacy, non-conformity, heresy, unbridled fantasy and rebellion – like no other twentieth-century artistic community before or since.

I have one final observation about the avant-gardists, one that is all too often eclipsed by the media circuses they organized, the impassioned nature of their theoretical discussions and the drama and tension of the surrounding historical events. It is the fact that the best among them were possessed of a grand and noble artistry, one that had nothing to do with bravura, and everything to do with concentration, dedication, independent taste and a sense of proportion, balance and form possessed only by the very greatest artists.

1

Kazimir Malevich in the Kremlin

November 1917

On 15 November 1917, *Izvestia* (a daily newspaper) announced that Kazimir Malevich had been appointed to the position of 'Interim Commissar for the Preservation of Valuables in the Kremlin' in Moscow.[1] As such, he became responsible for the management and maintenance of Russia's most sacred piece of property, the epicentre of its oft-ravaged but ever-expanding geographical and political body, the magnificent sanctuary where monarchs were crowned and religious leaders beatified; in short, the most highly venerated 24 hectares (60 acres) of land in the largest country in the world. His primary mandate was to protect the cultural treasure of the Kremlin itself, which included the centuries-old cathedrals and a multitude of precious artworks that had been amassed there over the centuries. Its defensive walls also enclosed valuables of a more particular nature. In 1914, at the start of the First World War, many chests full of imperial jewels from the Winter Palace in St Petersburg were stored there for fear of the advancing German troops. The jewels' relocation marked the simultaneous disappearance of their city's name – for propaganda reasons, St Petersburg was redubbed 'Petrograd' in order to sound less German. Then, in August 1917, in absolute secrecy, an endless convoy arrived from the Hermitage, transporting most of the Tsarist museum collection: the archaeological relics, sculptures, coins, prints and paintings, including Rembrandts, Titians and Raphaels. In total, there were 755 chests containing some of the world's most prized artistic treasures. They were temporarily stored in the Kremlin, as were large sections of the Russian art collection from the Russian Museum of His Imperial Majesty Alexander III (the modern-day State Russian Museum).[2] If ever a single person had been in a position to obliterate the very essence of Russia's cultural history in one fell swoop, then it was Kazimir Malevich in the third week of November 1917.

In this particular case, the notion that some infidel may have wanted to erase Russia's cultural history is not so far-fetched. Malevich was well known as a futurist, an artist who agitated for history to be forgotten and advocated 'burning the road behind us', since 'all that has been made, was made for the crematorium'.[3] He proclaimed that when carving *David*, Michelangelo had 'brutalized the marble, mutilating a magnificent piece of stone'.[4] It was also he who wrote: 'Do away with love, with aesthetics, with coffers full of wisdom, for in the new culture your wisdom will be ridiculous and insignificant.'[5]

The fearsome futurists were revolutionaries, who promised to 'Jettison Pushkin, Dostoevsky, Tolstoy, etc. etc. from the steamship of modernity',[6] and cried: 'Today we spit out the past that was stuck between our teeth!'[7] Or, as one of their most prominent theoreticians summarized not long afterwards: 'We are diametrically opposed to the entire old world. We have not come to renew it; we have come to destroy it.'[8] This message was proclaimed militantly, and their manifestos and poems were presented as part of wild public 'happenings' that included circus acts, staged fights, nudity and debates. Newspapers reported on them with grateful indignation.

Of course, those in the know understood that these catchphrases and performances were partly just fun and games. 'To hell with decency, look at us being all cheeky and sexy!' But just how far would the game go? That was a question that nobody ever asked the futurists.

Many observers responded to the initial public performances with detached amusement. The snobs from the capital regarded the futurists with open condemnation and secret fascination. According to them, the aura of provocation was nothing more than a transparent, but ingenious and successful, marketing trick.[9] The futurists were given a certain leeway because they were on the social, economic and political periphery – eccentric clowns, social fringe-dwellers who presented no tangible threat to the status quo. The futurists even went so far as to cultivate this image themselves, and much of their verbal ferocity was intentionally tongue-in-cheek, bordering on self-mockery. In a 1914 interview, two of them explained:

> — Are you futurists? — Yes, we are. — Do you reject
> futurism? — Absolutely we reject futurism.
> May it vanish from the face of the earth![10]

Three futurists, from left to right: artist and composer Mikhail Matyushin, poet Alexei Kruchyonykh (lying down), and Kazimir Malevich, 1913.

As the futurists' cultural visibility gradually increased and they came more into the public eye, however, the aversion towards them rose accordingly. Critics became less willing to interpret their futuristic flirtation with violence as a comedy act. When Ilya Repin's mammoth painting *Ivan the Terrible and his Son Ivan* was slashed with a knife by a certified madman, the finger of blame was summarily pointed at the futurists: Repin, the most respected artist from the old regime, suggested that they had hired the madman for the job, and that the attack was the 'opening gambit of a general artistic pogrom'.[11]

The futurists' glorification of progress and their belief in transformation through destruction took on a more sinister aura as the threat of a world war drew closer. As the destructive reality of modern industrial warfare began to dawn, opposition to these amoral vandal-worshippers became more serious.

That was the situation in 1917, when the Bolsheviks appointed precisely this kind of futurist – Malevich – as the administrator and protector of Russia's cultural heritage. The wolf had been set to watch the lambs, indeed. Little is known about the process leading up to his appointment or his brief period of service, but however it happened, it was an event laden with revolutionary symbolism.

Malevich, the Revolutionary

After the revolutionary conflict in the capital of Petrograd had been decided in October 1917, the violence shifted to Moscow, where the Bolshevik and Tsarist forces fought fiercely. The Kremlin was the last bastion of the ruling powers and was severely damaged in the battle. Shortly afterwards, the Bolsheviks appointed Malevich as Commissar of the Kremlin, though his activities there had already commenced far earlier.

Malevich had been sent to the front in 1916, and in mid-1917 he joined the 56th reserve infantry regiment. This regiment guarded the Kremlin, where he was almost always to be found from that moment on.[12] Most soldiers and officers in his division were Bolsheviks, and through them Malevich became involved with the Moscow Soviet of Soldiers' Deputies, a revolutionary soldiers' council dominated by Bolsheviks. He joined the Fine Arts branch, whose mandate was to take charge of the soldiers' cultural 'enlightenment' as part of their revolutionary emancipation. To this end, they organized lectures, theatre performances and tours through Moscow's museums – no mean feat, since most soldiers were illiterate and had probably never set eyes on a painting or non-religious artwork in their lives.[13] In August, Malevich was elected chairman of the Fine Arts section. Even then he already had an office in the Kremlin: in the building of the cavalry corps, where his growing reputation was confirmed through the allocation of an instrument worthy of a great innovator: a telephone. His telephone number was 3-25.[14]

One of his first official acts was to print and distribute a pamphlet, in which he called on all Moscow-based painters, artists and writers to join the revolutionary cause and fight together for a new order in the world and the arts.[15] At the same time, he commenced plans for a radical reform of art education in Russia.[16]

On 27 October, Lenin effected the coup d'état in Petrograd that led to the October revolution. The next day, troops loyal to the government (known as 'Junkers') responded by storming the Kremlin, and Malevich and his Fine Arts section were forced to flee for their lives. Over the next few days, Bolsheviks attempted to retake the hallowed grounds. The ensconced Junkers thought it inconceivable that Bolsheviks would ever fire on the Kremlin. They were not the only ones – the vast majority of the revolutionary fighters regarded a potential bombardment of the Kremlin as an unforgiveably sacrilegious act. The last time the Kremlin

had suffered an attack was in 1812 during the Napoleonic occupation. That had been committed by blasphemous, heathen foreigners; surely Russians – true Russians – would never open fire on the historic and religious heart of their nation, especially now that their museums' most valuable collections were stored there.

Alas, they were mistaken. The Bolshevik officers in Moscow resolved to bombard the Kremlin with heavy artillery fire for several days and retook it on the morning of 3 November. They later justified the artillery bombardment by saying that retaking the Kremlin by storming the grounds would have been impossible.[17] This position remains debatable; the Junkers were poorly armed, and their supply routes were cut off. One historian made the pointed observation that, when taking over the Moscow telephone exchange, the Bolsheviks deliberately avoided the use of artillery 'in order to protect the utilitarian equipment from grave damage'.[18]

The public was generally shocked at the Bolsheviks' willingness to desecrate such sacred ground. Official Soviet history either veiled or denied the bombardment of the Kremlin, characterizing it as the brainchild of 'reactionary forces aiming to generate fear of the revolution'.[19] Although post-Soviet historians have since corrected this error, the long period of denial means that this aspect of the bombardment often goes unmentioned.

On the afternoon of 2 November – one day before the Bolsheviks retook the Kremlin – a ceasefire was signed between the officers loyal to the government and the Bolshevik leaders. The Junkers vacated the Kremlin that very evening, and from seven o'clock the area was completely empty. Later that night, however, the Kremlin was once again fiercely attacked by the Bolsheviks. Various newspaper reports and eyewitness accounts tell of an interminable cannonade that persisted until dawn.[20]

The night-time bombardment of the empty Kremlin was an act of vandalism that is difficult to characterize as anything but an authentic and ecstatic form of iconoclasm: a violent reformation, born of a spontaneous urge to destroy not only the enemy, but also the sacred objects symbolizing the hostile power. This iconoclastic fervour continued through the Bolshevik soldiers' ensuing occupation. Once inside, eyewitnesses reported how they treated the imperial accommodations, offices and even the Kremlin archive. Portraits of the Tsar's family were 'so butchered, they became unrecognizable', furniture was smashed to

pieces, and foul words were smeared on the walls using fingers dipped in ink.[21] By miraculous contrast, the large Hermitage and State Russian Museum collections remained untouched.

Though iconoclasm is a part of every revolution, to many intellectuals the fact that the Kremlin could ever be the target for such a deliberate act of destruction came as a shock. Celebrated artist Mikhail Nesterov, a religious conservative, said that the Kremlin had been wilfully mutilated. Socialist artist Mstislav Dobuzhinsky, who was resolutely opposed to the old regime but not a Bolshevik, wrote two weeks later: 'It would be hypocrisy to console ourselves by saying that the destruction could have been worse; what is more, it would be bourgeois pettiness to express the damage in merely financial terms, and breathe a satisfied sigh of relief. No, it is not about the extent of the damage or the scope of the destruction – it is the moral symbolism of the fact itself.'[22]

Apollon, one of the most prestigious cultural journals in Petrograd, dedicated a whole series of furious articles to the attack on the Kremlin, drawing an explicit link with the futurists: '...destructive tendencies...of futurism have penetrated the masses..., where pillaging is legitimized through a hooliganistic contempt for the past'.[23]

Not all artists shared this view, however. In the Poets' Café, the go-to meeting place of the day for radical poets and artists, the self-proclaimed 'father of Russian futurism' David Burlyuk proclaimed: 'I welcome the Bolsheviks' bombardment of the Kremlin's sacred cathedrals with open arms!'[24] 'Why mourn for a burning junkheap? Do you not desire anything new?'[25] Of course, Burlyuk's provocative remarks were milked extensively by the papers.

Vladimir Mayakovsky, undoubtedly the most famous of the futurist poets, also applauded the bombardment. Shortly after the event he wrote the poem 'Ode to the Revolution', which he recited publicly for the first time the following December. The ode is in praise of the 6-inch shells (nicknamed 'hogs' in Russian) that fell upon the Kremlin and issues a personal warning to St Basil's Cathedral of the impending fireworks:

And tomorrow
O Blessèd one
With thy sacred turrets
Lifted in vain, begging for mercy,
Blunt-nosed hogs
Will eviscerate the millennia of the Kremlin.[26]

The ravaged Kremlin: sacristy of the Patriarch's Palace.
Moscow, November 1917.

The ravaged Kremlin. Moscow, November 1917.

The attack on the Kremlin was weaponized in the propaganda war between the Bolsheviks and the non-Bolsheviks, a conflict in which the futurists also played a prominent role. People flocked to the walls of the Kremlin in their thousands to view the damage. Crowds of the blind sat before the Kremlin gates (in all probability summoned there by the clergy) and sang religious songs.[27] Most of the mileage in the religious propaganda campaign came from the damage to Dormition Cathedral, the most important and hallowed church in the Kremlin. The religious press claimed that the Kremlin had been subjected to a 'pogrom of cannons'.[28] On the day following the bombardment, the Menshevik newspaper *Novaya Zhizn* (New Life) wrote: 'Cannons thunder, grenades fly through the air and innocent blood flows inside the Kremlin. If but a single historic monument falls into the hands of the vandals, they will never be forgiven: neither by us, nor by those who come after us.' When the unfounded rumour circulated that the sixteenth-century St Basil's Cathedral – Moscow's most iconic Red Square church – had been demolished, shocked responses flowed in from all sides. The newly appointed 'People's Commissar for the Enlightenment' (a kind of Minister for Education and Culture), Anatoly Lunacharsky, flew into absolute panic.[29] Rather than a veteran terrorist like Lenin, Lunacharsky was an author and an intellectual, the type who was wont to mention Michelangelo and Victor Hugo in the same breath. He was a man who leaned publicly on his status as a lover of cultural heritage, and he considered the fine arts to be of the utmost importance in the development of the working classes. When he heard of the destruction of the Kremlin, his outrage was so great that he promptly resigned. In his declaration he stated: 'St Basil's Cathedral and the Dormition have been destroyed. The Kremlin, which currently houses the greatest artistic treasures from Moscow and Petrograd, is being bombarded....I cannot bear it. This is the final straw. I am powerless to stop this terror. It is impossible to work under the yoke of these maddening thoughts. I therefore step down from my position as commissar on the People's Council.'[30] When it became apparent two days later that St Basil's had not, in fact, been demolished, he reversed his decision (under considerable pressure from Lenin). In a sense, Lunacharsky had become a victim of the propaganda war, for although the damage to the Kremlin was certainly extensive, it was not irreparable. The details only became clear over the ensuing weeks: many churches had suffered heavy damage, and some frescoes and iconostases had been destroyed. The external walls and towers had

borne the brunt of the attack, while the museum collections, as previously mentioned, had emerged remarkably unscathed.

Whether Malevich had a hand in the overnight bombardment is unknown; however, it would seem likely that his regiment did participate in reclaiming the Kremlin. In any case, the violence of that period resonates (sometimes literally) in the texts he produced over the ensuing year, and he makes direct reference to it now and again. A little over a year later, he wrote a text describing the bombardment of the empty Kremlin as a piece of futuristic performance art:

> The thundering of the October cannons moved the revolutionaries to rise up, rip off the old leeches and hang up the new banner of modernity. We now face the task of tearing down the monstrous sarcophagus marking the boundary between the old and the new, of grinding the figures of authority into nothingness, pulling down their buttresses and chasing away the tatterdemalions....
>
> In our performances, we foreshadowed the overthrow of all academic nonsense, and spat upon their sacred altar.
>
> The same was done by the other avant-gardes of our revolutionary comrades in life.[31]

When the Bolshevik troops returned to their posts in the Kremlin, by all accounts Malevich acted quickly to call his regiment together and resume his work in the undamaged portions of the complex. Meanwhile, in Petrograd, Lenin and Lunacharsky scrambled to gain control of the troops in Moscow and restore order. The attack was potentially also a PR disaster for the Bolsheviks. In their propaganda, they made it very clear that they were firmly against any further pillaging of the Kremlin. But the clear propagation of this message from far-distant Petrograd would prove difficult, as we will see. For at around the same time, a futurist – Malevich, the merciless iconoclast – was appointed 'Commissar for the Preservation of Valuables in the Kremlin'. It seems inconceivable, therefore, that Lunacharsky had been informed of Malevich's new post.

His appointment may have been a stopgap measure taken under chaotic circumstances, due to the lack of any other available revolutionaries with sufficient knowledge of art and cultural history. However, this theory is at odds with the brash publication of his appointment by *Izvestia*, since plenty of other appointments (including those of Malevich's successors) did *not* make the papers. The heated debates surrounding the bombardment of the Kremlin, the accusations of

iconoclasm and the stance adopted by the futurists in these discussions allow for only one conclusion: that Malevich's appointment was an act of provocation, a futuristic publicity stunt. It was also perceived as such by prominent members of the cultural establishment, who unabashedly made reference to a 'futuristic power grab' in the Kremlin.[32]

The precise length of Malevich's tenure is unclear. According to one source, the position was made redundant after only three days, owing to an appointment by a committee with a superior mandate.[33] One month later, another source continues to refer to Malevich as the Kremlin commissar.[34] There are also some indications that Malevich remained active in the Kremlin until at least February 1918, though probably not in the same capacity for the entire time.[35]

In any case, it is certain that Malevich was directly involved in the revolutionary battle in 1917, though he was not a member of the Bolshevik party and never referred to himself – either during the battle or subsequently – as a Bolshevik.

One other provocative aspect of Malevich's appointment as commissioner of the Kremlin is worth mentioning. Malevich was Polish and baptized as a Roman Catholic, and therefore belonged to a religious minority that suffered institutionalized discrimination throughout the Russian empire. His given name alone – Kazimir – was enough to identify him as Polish. Malevich did little to hide his Polish origins, retaining his Polish accent and never learning to speak grammatically correct Russian.[36] According to one friend and one enemy respectively, he looked like a Catholic prelate or a Catholic village priest.[37] Appointing somebody who was neither Russian nor Orthodox as the protector of Orthodox Russia's most holy sanctuary must have come across as quite the snub to Russia's conservative and religious communities.

The Russian distrust of Polish Roman Catholics was deep-rooted. The Polish region of Tsarist Russia had a long history of rebellion against Russian rule. Polish fighters made up a significant portion of the terrorist groups that began flooding into Russia in the 1860s. Tsar Alexander II's murderer was a Polish terrorist, and the imperial establishment's attempts to 'Russify' the Poles were never regarded as either successful or complete. Catholicism was viewed as a dangerous heresy whose aim was to undermine Orthodoxy, the very foundation of Russian civilization. Though legislation pertaining to religious and ethnic minorities in the Russian empire was subject to frequent change, the Catholic and Orthodox communities were never on equal footing, and as a rule

conversion to Catholicism was never permitted. Greater religious freedoms did emerge in Russia from 1905 onwards; however, integration into the elite was still far from a reality in Malevich's time.

So how did this Polish futurist, who grew up far from the empire's political and cultural centres, end up in such a lofty position?

A Youth in the Ukrainian Countryside

Malevich was born on 11 February 1879 in Kyiv, and grew up in the northwest of modern-day Ukraine, in the area surrounding Chernihiv (in Russian: Chernigov), in the villages of Avdiivka and Koryukivka.[38]

His parents spoke Polish to each other and to the children, and could sing Ukrainian songs. Even later in life, Malevich continued to speak Polish to his mother.[39] Russian was the language used at school. Malevich's father was of noble descent, but the family no longer had any estates, and owned little or no property. Severin Malevich was an agriculturalist and specialist in the cultivation of sugar beets and worked for other farms as an external consultant. The large family included twelve children – eight of whom reached adulthood – and was constantly on the move from one village to the next, staying for several years at a time. This was why the family spent time in the administrative divisions of Podolsk (near the border of modern-day Moldova) and Kharkiv, the smaller cities of Konotop and Bilopillia, and eventually wound up in the Russian city of Kursk. Though Severin Malevich's ongoing and itinerant quest for well-paid work was not such an uncommon story in the Russian empire, it does serve to illustrate his perseverence and work ethic, character traits that he passed down to his son. None of Kazimir's contemporaries ever neglected to mention his boundless energy, self-discipline and dedication to his work, even amid the most bleak and adverse of circumstances.[40] He later told his students: 'The most valuable thing in life is time.'[41]

At the age of eleven, Malevich contracted smallpox. Though he survived the deadly disease, his face remained forever scarred by the pockmarks and sores. The large family lived in impoverished circumstances and, as the eldest son, Kazimir was duty bound to work and contribute to the family's income. From the age of seventeen, he worked every day. There were no musical instruments in the home, very few books, and the family's constant movement through provincial backwaters meant that he could not even complete basic secondary school. This fact explains

both his lack of general education and his irrepressible urge to continue learning as an adult. Malevich had all the typical traits of a self-made intellectual: he was a font of originality – in his case, shockingly so – but he was unaccustomed to having his ideas tested, or to taking a firm stance in an intellectual debate, and had odd gaps in his knowledge. Despite his many intellectual gifts, Malevich retained a conspicuous naivety in matters of politics and economics. These aspects were compensated for by his enthusiasm, his neverending thirst for knowledge, and a constant need to describe his own thoughts and set out his intellectual process on paper. He is one of the great author-artists in world history, and his theoretical legacy is substantial – far greater than those left behind by Wassily Kandinsky or Piet Mondrian, for example. In contrast to those two artists, who were educated as a lawyer and schoolteacher respectively, Malevich's lack of proper schooling meant that he always had great difficulty writing. Irina Vakar, one of the world's greatest experts on Malevich, notes that he never became a 'man of books', and that he could not express himself in a fully 'literary fashion'[42] – that is to say, in accordance with accepted stylistic conventions. While his relative lack of literacy is indeed striking, it is nonetheless a salient characteristic of his written works. His style is angular and crooked, which is precisely what makes it so original and incisive. His almost broken Russian was also a statement of sorts: it was the gnarled, self-aware language of the autodidact, of the cultural outsider who eschewed convention and who would rather sin against grammar than against the holy writ of originality. Still, Malevich did suffer somewhat from his limited literary ability. He once bemoaned the fact that he never enjoyed revising or correcting his work. 'Tedium! I will write something new instead. But my writing is poor, I cannot learn.'[43]

Once a year, Malevich went with his father to the annual fair in Kyiv, where he saw art for the first time. Or to be more precise, he saw 'the art shown in the window displays of stationery stores'. While his father was at the fair, Malevich 'ran from store to store, and spent a long time looking at the paintings'.[44] These were probably the mass-produced shop signs and information boards typical of large cities in imperial Russia, which were also an important means of communication in a largely illiterate society. They played a decisive role in the development of various avant-garde artists, as they were often the first secular, painted representations of anything they had ever seen. The directness and immediacy of these advertisements also possessed a quality that would later

prove very useful to the avant-gardists in their rebellion against the vagueness and complexity of the symbolists and impressionists, the art of the generation preceding their own.[45] These shop signs, religious icons and the decorative paintings on farmsteads and various utensils were the most important sources of folk art from which Malevich and many other avant-gardists would later derive inspiration. In 1912, David Burlyuk would claim that 'the Museum of Russian Street Signs would be a hundred times more interesting than the Hermitage'.[46]

Malevich's father was less taken with his son's interest in the arts. 'Artists lead a poor life,' he said, 'and spend most of it in prisons.'[47] His mother did support him in his calling, and bought him drawing supplies which she kept hidden from his father.

Later in life, Malevich wrote a number of short autobiographical texts, in which historical accuracy is clearly considered subordinate to a rich and florid personal mythology. Even if his youthful interest in street signs was invented or exaggerated, what is certain is that as a child he had hardly any exposure to 'normal' secular art. Ukraine had no public museums or art galleries, and only the rich could afford to hang paintings in their homes. His love of visual art – a love that would rapidly turn into an all-consuming life mission – came from a genuine passion for drawing, to which he devoted increasing amounts of time from the age of twelve onwards. Money for paint or coloured chalk was scarce, and Malevich tried to produce his own pigments, sharing ideas with his friends. The arrival of three painters who came to refurbish the icons in the local Orthodox church was, therefore, a pivotal moment in Malevich's childhood. In his autobiographical text, he describes how he could not sleep at the thought of living, breathing artists walking around town:

> That night I slept poorly, waiting for the next day so I could make it to the artists' hut in time. Early in the morning, when everyone was still asleep, I slipped out of the house and made straight for my hiding place, running as fast as possible. I arrived, and my friend was already there. Nobody came outside....The cows were led out, the sun rose, but no artists appeared. Finally a window opened, and an artist looked out. We stood to the side, pretending to look at a vegetable garden. One hour later the gate opened, and the artists stood there before our very eyes....The artists walked out of town, and we followed them. In the field there were windmills, rye, and oak trees in the distance. We walked through the rye, where we could not be seen, and crawled through the wheat. Having arrived

at the mill, the artists set themselves down, took out their boxes, opened their parasols and began to work.

At that point, Malevich made an astounding discovery. With his medieval eyes, he beheld for the first time a magical, modern invention: oil paint from a tube. 'Very quietly we crept closer, on our bellies, holding our breath. We managed to get very close, and we saw coloured tubes from which they squeezed paint....Our excitement knew no bounds.'[48]

He continued to draw and paint, and managed to sell his first painting, *Moonlit Night*, for 5 roubles. According to Malevich, this sum would allow one to 'eat sausage for a month'.[49] Malevich also claimed that he studied at the drawing school in Kyiv that was founded and run by famed Ukrainian painter Nikolai Murashko. However, there is neither a record of his enrolment nor any other written proof of his presence at that institution, even though the school's archives are very well preserved. If he ever did receive lessons from Murashko, it can only have been very briefly, and unofficially, as an observer.[50]

In 1896 the family moved to Kursk, where Kazimir commenced work as a draughtsman for the railways. It was in Kursk that he received his first serious art education and met artists his own age. At least one of them, the musician (and later composer) Nikolai Roslavets, was a man of considerable talent, and almost as much of a revolutionary as Malevich. They had already met one another in Konotop, but did not become friends until Kursk. The Roslavets family was even more impoverished than the Maleviches; the violin on which the young Nikolai taught himself to play was purchased for him by Malevich's mother. The boys developed a very close friendship, probably founded on similar experiences of poverty, grand artistic and intellectual ambitions and a lack of formal education. Roslavets worked for the railways in Kursk, just like Malevich. Because he was a musician, their friendship was not overshadowed by Malevich's dominant and competitive character, a trait that thwarted many of his later friendships.

Malevich also met other artists, some of whom had attended the Imperial Academy of Arts in either St Petersburg or Moscow. These encounters also allowed for a confrontation with a wide variety of new ideas, which he then embraced with obsessive zeal. His best friend Lev Kvachevsky, an artist who had been an observer at the Imperial Academy of Arts, was a follower of the then aged Leo Tolstoy. At that time, he preached a radical materialistic and utilitarian vision of the arts

and was incredibly popular. Few were in a position to disregard his ideas and Malevich was no exception, despite his utter rejection of Tolstoy's philosophy later in life. One of the first known photographs of Malevich in Kursk shows him posing in Tolstoyesque garb, wearing a long peasant shirt extending below the hips.

Between 1900 and 1905, Malevich's life changed almost completely. It was then that he met the Polish-German Kazimira Zgleyts, with whom he had a child in 1901, Anatoly. The fact that he did not marry Kazimira was undoubtedly considered scandalous in the Kursk Catholic community, and probably brought him into conflict with his father once again. When Kazimira fell pregnant a second time, the couple eventually did get married, on 2 January 1902, in the Catholic church in Kursk. On 5 June a second son, Georgy, was born, but he died shortly afterwards. Whether Kazimir and his wife had much in common beyond their first names is debatable; in any case, family life suffered from the outset due to his manic desire to paint. On his days off he would disappear into nature; during breaks at work he would place an easel before the window and paint the world outdoors. He even drew his friends into his passion: 'My friends' wives hated me, since I dragged their husbands away at every spare moment to go and sketch: they were never at home.'[51]

Malevich himself claims to have sought entry even then to the Moscow School of Painting, Sculpture and Architecture. Though less prestigious than the Imperial Academy of Arts in St Petersburg, it had a reputation as being more progressive. Well-travelled artists of a more European mindset taught there, including portraitist Valentin Serov and impressionist Konstantin Korovin. Various reports claim that the application forms sent by Malevich were intercepted and destroyed by his father.[52] Whether this anecdote is fabricated (and there is plenty of reason to suspect so) is immaterial, for when his subsequent applications *did* arrive, they were not accepted anyway.

His father died shortly after Kazimir's marriage, on 9 March 1902. Not long afterwards, Malevich painted a portrait of his father based on a photograph, which remains one of his earliest surviving paintings (Plate 1).[53] The relationship between father and son may have been a cool one, but the portrait is nevertheless a peaceful tribute to a man who was as kind-hearted as he was self-assured.

To Moscow and St Petersburg

Whatever Kazimir's feelings may have been, the death of his father meant he had one less obstacle to deal with on his path to becoming an artist. He realized that his prospects in Kursk were limited: 'Like a wolf to the forest, I was drawn to Moscow and St Petersburg, where the real art was. Without those cities, any potential artist was doomed to languish in the provinces. Thoughts of those cities had plagued me for some time.'[54] He started saving, and left for Moscow in 1904 (at the age of twenty-five) with the intention of dedicating himself to art. He had applied to the Moscow School that year, and had been invited to complete an entrance exam, which he failed. Still, he remained in Moscow. It is unclear what this meant for his wife and children, who had stayed behind in Kursk. Kazimira was probably already pregnant at the time with their third child (Galina, a daughter). Though Malevich doubtless left money behind, clearly he was not predestined for the role of paterfamilias. His devotion to art was absolute, even then: he was personally prepared to starve for it, and expected no less from his loved ones.

He retook the exam at the Moscow School in the summers of 1905, 1906 and 1907, and failed every time. It must have been incredibly frustrating, but his self-confidence remained intact, as did his artistic calling. To make the break with Kursk complete, he had his family and mother brought to Moscow; but instead of living with him, they rented an apartment elsewhere in the city. Malevich found it impossible to reconcile his family responsibilities with his artistic life. He gave the order to have all their possessions sold in Kursk, and when he briefly returned there to finalize his affairs, he burned all of his earlier paintings. Many years later, Malevich wrote that 'to make art, you must burn the road behind you'.[55] Few knew then just how literally he put that theory into practice.

The destruction of his past was a daring and reckless act. It was not only a farewell to the provinces, but also a demonstration that he did not define art as an instrument for personal development or individual expression. He did not see his paintings as the reflection of his personal history; they were not an implicit autobiography. That was not the kind of artist he wished to be. Such an artist's early works – however imperfect or trivial – would still always constitute evidence of personal artistic growth. But for Malevich, art was an objective source of wisdom that only deserved a place in human history if it did not follow that history,

but led it. Seen in this context, the works from his youth were superfluous, and would be ignored by history anyhow. Malevich did not want to be a part of history – he wanted to write it.

In Moscow he lived in an artists' commune where a revolutionary mentality was the norm. 'A true starving Bohemian', 'happy but hungry', he wrote. The members of the commune pooled money to purchase bones and offal fit for consumption 'by dogs or humans', which they used to make stock. 'Under these conditions I worked. I cannot say in peace and quiet, but work I did.'[56] The public unrest that led to the revolution of 1905 did not go unnoticed. His two brothers Anton and Mechislav (and his wife) were under police observation in Kursk owing to their revolutionary sympathies.[57] During that time, Malevich himself became friends with one Kiril Shutko, a dyed-in-the-wool party communist. Later he would describe in great detail the events that took place in the second week of December 1905, when Moscow saw fierce riots. He and his comrades set out to occupy key locations in the city; they were fired upon by soldiers, sought refuge on the rooftops and clambered back down via drainpipes. He carried a revolver, for which he was always searching for ammunition, and was in constant fear of being attacked by Black Hundreds: proto-fascist monarchist lynch mobs that roamed the streets in search of socialists and long-haired louts. In Kursk, Kazimira lost her job at the railways on suspicion of involvement in revolutionary activities.[58]

The revolutionary atmosphere is evident in Malevich's work, which took on a bold post-impressionist quality from 1906. Although the post-impressionist works of Gauguin, Van Gogh and Cézanne were not unknown in Russia, it is still unclear precisely where Malevich obtained his examples. The journal founded by Sergei Diaghilev, *Mir Iskusstva* (World of Art), did not feature post-impressionist works until 1904, and even then they were in black and white. The Shchukin collection, world-famous for its wealth of post-impressionist art, was not open to the public until 1909. There were other young artists who experimented with impressionist and post-impressionist forms, and it is likely that reproductions and illustrations of French art were in circulation among young artists in Moscow. It was also in 1906 that Diaghilev organized his Russian retrospective in Paris as part of the *Salon d'Automne*, the largest exhibition of contemporary artists in France. What is certain is that Diaghilev took Mikhail Larionov with him, who was then the unofficial leader of the Moscow avant-garde. The Salon displayed work by Cézanne, and there was also a (posthumous) retrospective of

work by Gauguin. The Russian artists and their followers who visited Paris in Diaghilev's wake will have undoubtedly taken reproductions home and discussed them, but it remains unclear whether Malevich was exposed to such materials. We know that he did not go to Paris, and that he was not personally acquainted with Larionov at the time. Knowing this, we see just how bold and unique were his few known works from 1906, with their thick layers of paint and pastel colours. Although at the time he was still a peripheral figure in the Moscow art world, he was far more daring and experimental than most in the way he eschewed figurative illusion, and assigned greater importance to the painter's more autonomous means: colour, composition and line.

Malevich's career between 1906 and 1916 has always received the greatest attention, for it was then that he grew to become the leader of the Russian avant-garde through his role in the development of symbolism, cubo-futurism (the Russian variety of cubism) and the shocking unveiling of suprematism in 1915.

From 1905 until 1910, Malevich studied at the private studio of Fyodor Rerberg. Rerberg was a mediocre artist but a good teacher, and one with a great interest in impressionism that he passed on to his students. Among the artists that Malevich met there was Ivan Klyun, who 'fell in love with his talent'[59] and was one of the few who would follow Malevich until the very end. Klyun also supported Malevich financially, and once even bought him a winter coat (a potentially life-saving act in Moscow). Even then, Klyun regarded him as somebody who was 'fanned by a kind of mysticism'. 'He did not believe in God, but nor did he harbour a hostile attitude towards God....He and God were on friendly terms, as if to say: "You are a creator, and I am a creator. We are both creators."'[60]

During his first few years with Rerberg, Malevich's artistic approach changed. He evolved from a post-impressionist into a symbolist, and his small paintings and drawings were suddenly full of clearly defined, figurative, dreamlike depictions with titles such as *The Triumph of the Skies*, *Nude with Hands Raised*, and *Assumption of a Saint* (Plate 2).[61] This transformation came about primarily owing to his attendance at the 'Blue Rose' exhibition, which was held in March and April of 1907 and represents the official beginning of symbolism in Russian visual art. In 1908 he also moved back in with his wife and children, though their estrangement only increased. As married Catholics, divorce was out of the question, but they did decide to put an end to their shared life together. Kazimira left Moscow, taking her children Anatoly and Galina with her. The few

testimonies of Malevich's early romantic and married life are vague and contradictory; what is certain is that in 1910 he met Sofia Rafalovich, and moved in with her shortly afterwards. Sofia was of a different sort to Kazimira. She was well-educated, intellectually curious and of higher social status than Malevich himself. Her entire family shared a love for the arts; Sofia's two sisters would also marry artists.

Full of bitterness, Kazimira tried to prevent her daughter Galina from corresponding with her father, and intercepted Malevich's letters to her from Moscow. When their son Anatoly contracted typhus, she did not inform Malevich. At the time, Kazimira was already overwrought and had typhus herself. Galina later described her memories of her brother's death, providing a glimpse into the harsh day-to-day reality of many families similar to Malevich's:

> Toly died fully conscious. My mother washed him herself, her hands swollen and covered in sores. She had a high fever. Nobody visited us anymore, for fear of contracting typhus. On the third night, the autumn wind howled and rattled the shutters. My mother thrashed in her bed, delirious with fever. On the table lay Anatoly [dead], his belly swollen and full of something that trickled and gurgled. And huddled in the corner was [me], a small ten-year-old girl. There was no more kerosene, and the last candle burnt out. I could bear it no longer, I ran outside into the night with a bitter cry. A passing secondary school student heard me and took me back to his house. His parents roused the community, and the school, doctors and Jews all collected money for the funeral.[62]

Even after these dramatic events, Kazimira refused to contact her ex-husband. Malevich would not hear of his son's death until years later.

Brimming with confidence (and possibly spurred on by the Rafaloviches, the family that he had recently moved in with), in around 1910 Malevich made yet another artistic about-face, again effected by the confrontation with other progressive artists. In the previous years, Moscow had become a breeding ground for contemporary art. In 1908 and 1909, the exhibitions organized by a group called Golubaya Roza (Blue Rose) had exhibited works by Matisse, Derain, Van Gogh (his famous *Night Café*), Braque (his *Large Nude*, which is now in the Pompidou Centre, still wet on the canvas), Gleizes, Van Dongen and De Vlaminck. There were also various wealthy collectors who purchased the groundbreaking works

Kazimir Malevich's pockmarked face, 1913.

being produced in France, to adorn their palaces in Moscow. Collector Ivan Morozov bought the *Night Café* (which was sold to the West at a bargain price by Stalinist barbarians in 1933, and now hangs in the Yale Art Gallery).[63] In 1909 Sergei Shchukin opened the doors of his palace, making his collection of ultra-modern art accessible to artists and art-lovers alike. It was already one of the most radical collections in the world, with not only a dazzling array of fauvists and post-impressionists, but an unparallelled assemblage of the newest works by Henri Matisse and Pablo Picasso. Rerberg's students were granted early access to the collection in 1908, while it was still in development. It was around that time that Shchukin started acquiring Primitivist Picassos (see Plate 3), most of which were produced in the period leading up to the ground-breaking *Les Demoiselles d'Avignon* (1907). Shchukin was hesitant about purchasing such progressive works, and initially only accepted them on

consignment.[64] They were a raging success, however, and gave rise to immediate artistic in-fighting, which motivated Shchukin not only to keep the existing paintings, but to expand his collection of Picassos and even reserve a special hall for them in his palace. That hall left a deep impression on Malevich, and Shchukin gave him permission to visit more frequently, even without the other students. From 1910 onwards, the influence of the Shchukin collection became evident in Malevich's own work.

He also met several leading figures in the emerging avant-garde, and his relationship with Mikhail Larionov – one of the most active and energetic leaders among the progressive artists – was of especial importance. At some point in 1911, Malevich and Larionov were sitting on a bench on Tver Boulevard, where Larionov – already famous, well-travelled and under Diaghilev's protection – made a covenant with the Polish and provincial Malevich, who had just stepped out of the shadows.

Larionov would remember their conversation that day for the rest of his life. According to him, Malevich said (among other things): 'A painting should be produced in such a way that the intent behind its creation lies in its form; that the subjects depicted on the canvas are not important – on the contrary, that only the manner of execution is of importance.' Larionov reports that Malevich 'wanted to solve colour problems on his own, without engaging with the subject at all'. He also remembered a comment by Malevich that very keenly expressed the notion of abstract art: that a painting was nothing more than 'a surface for the resolution of various pictographic problems'.[65]

Malevich embarked on a radical reinterpretation of the Parisian cubism he had seen in both the Shchukin collection and the reproductions disseminated by travelling artists. He exhibited at shows run by various societies, and was one of the most radical artists wherever he went. He painted a series of marvellously original works depicting peasant figures constructed from cylindrical forms, such as *The Sower* and *The Woodcutter* (Plate 4) and shortly thereafter a series of legendary cubo-futuristic works, including *The Knife Grinder* (Plate 5) and *An Englishman in Moscow*.[66] In 1914 he also started publishing texts, and his sizeable theoretical legacy began to take shape.

During the pre-war years, he shuttled back and forth continuously between Moscow and the capital of St Petersburg. The artist, theoretician and pedagogue Mikhail Matyushin lived and worked in St Petersburg, and he and Malevich became friends. While Matyushin

Mikhail Larionov, portrait drawing of Kazimir Malevich.

was much older than the other avant-gardists (he had already turned fifty in 1911), his seniority, extensive education and overall development were of great influence in the community of the generally less well-educated avant-gardists. Matyushin was originally a musician, and combined painting and music in his pedagogical practice. Another artist that Malevich met in Petrograd was Pavel Filonov, who occupied a unique position in the history of radical art in Russia. He was somewhat of a recluse, did not take part in 'happenings' or other wild stunts, was far less interested in the developments in Paris, and forged his own path in all that he undertook. He lost both parents at a young age and worked as a vaudeville dancer in his youth. Unlike the other avant-gardists, he would always continue to paint, and developed an individual technique that was nothing like that of his compatriots. He would construct

a painting in very small, sometimes minuscule, units using extremely thin, overlapping layers of paint. Using this technique, his paintings create an impression of kaleidoscopic fragmentation, but one in which the appearance of humankind remains central. He was an asceticist, refused to sell his work to private citizens, and lived in constant abject poverty. Although far from all historians view Filonov as an avant-gardist, he was never very far removed from them, and outsiders continued to make the association.

Away from the clamour of Moscow, the presence of artists like Matyushin and Filonov most likely made Petrograd a more hospitable environment for Malevich, especially during the pre-revolutionary years.

The Revelation of Suprematism

Most historians consider May 1915 to be the moment when Malevich began working on suprematism in the form of drawings, paintings and textile designs. In November 1915, he submitted some embroidered-textile suprematist designs to an applied art exhibition at Galerie Lemercier in Moscow. Malevich's debut as a suprematist via embroidery remained unknown until ten years ago, and shocked both general and art historians alike. The significance of this discovery should not be overestimated, however: it pertains to three small works in an exhibition otherwise dominated by decorative patterns. Malevich's willingness to show his suprematist work at that stage was probably the result of his acquaintance with Natalia Davydova, an artist and sponsor who would play a major role in Malevich's life and the history of the avant-garde, albeit for a very short time. But more about her later.

Even then, Malevich produced exhibits that he himself described as *bespredmetny*, which attempted to 'create an infinite space, deep within the canvas'.[67]

This word, *bespredmetny*, was of great significance to Malevich and would become a recurring mantra in many of his theoretical texts. It means both 'non-objective' (i.e. 'object-free', 'non-representative' or 'lacking a subject') and 'immaterial'. Malevich used the term in all these senses simultaneously, and in various contexts. Not only could a painting be *bespredmetny*, but so could language, and ultimately the world itself. Most experts and followers of Malevich agree that his worldview was not spiritual, at least not in the sense of the traditional spirituality practised by the major religions. Yet he was a positivist least of all. His

Installation of Kazimir Malevich's paintings at the 0.10 exhibition, 1915.
Black Square is hanging in the upper corner.

outlook was cosmic and fantastical; for him, reality was not limited to the knowable or perceptible. His perspective on reality was more transcendental than metaphysical.

On 19 December 1915 the presentation of his *bespredmetny* artworks continued in the 0.10 ('zero-ten') exhibition, of which he was the principal organizer, and where he introduced suprematism and exhibited his famous *Black Square*. The subtitle to the exhibition was a polemic one: 'The Last Futurist Exhibition of Painting'. Here, Malevich directly addressed his fellow avant-gardists, declaring that the role of futurism had been played out, and was now redundant. It was time for radical art to take on a new leading nomenclature.

According to his own cast-iron logic, artists who persisted with 'outdated' methods were destined for the incinerators of history. For this reason, shortly before the 0.10 exhibition, he had approached his fellow artists and proposed that they step forward together under a single new banner, that of suprematism. They refused, but Malevich still succeeded in naming the exhibition 'The Last Futurist Exhibition of Painting'. Although he was not the official organizer, the show overwhelmingly



bore his personal stamp.[68] In the spotlight was his most provocative and controversial work: *Black Square*.

Black Square triggered an unprecedented level of critical literature, of a scope that may well have been unique in the twentieth century. This quality – the ability to generate a seemingly inexhaustible supply of critical response – seems to have been recognized by Malevich almost immediately. Even the work's title sparked debate. The first title used by Malevich was 'Quadrangle', then later he often referred to his 'Quadrant'. The title that became immediately attached to the work, *Black Square*, rarely crossed his lips.

Whatever significance the work may have attained, it makes no sense whatsoever unless viewed principally as a provocation, and one that far surpassed the playful cabaret-style jibes of most futurists. To Malevitch, provocation was a necessary step in the process of visual and intellectual liberation with which he was attempting to imbue his art. The work's provocative nature lay not in the painting itself, but in the place where it was displayed: high up in one of the corners of the room. That location was typically reserved for the house icon, an object that served as the sacred portal to the divine in every Russian home: the telegraph wire between the material here-and-now and immaterial eternity. Of course, *Black Square* was seen as a metaphorical custard pie to the face of the intellectual and religious establishment. This interpretation alone, however, does not suffice; the Russian 'icon corner', with its typical fixed location, was first and foremost an object of personal devotion. Seen this way, *Black Square* is a reference to the intimate profession of faith by ordinary believers. Malevich's primary goal was not to rile up the ecclesiastical powers, but to push forward a new vision of eternity, one that veered away from the divine and towards the cosmic.

Malevich's thought process was that of the genius autodidact: extremely naive, and extremely original. He remained fascinated his whole life by the elementary questions that children grapple with. He owned a small telescope, and could look through it at the stars for hours. His friend, the great philosopher Mikhail Bakhtin, once summarized this trait in an interview as follows:

> To Malevich, suprematism was the pinnacle of the arts, the
> final stretch, the supreme goal, the most high. This is what
> separated him from the abstract painters....The all-encompassing,
> the macrocosm, the universe, that was what occupied him.
> He said that our [modern] art inhabits but a tiny corner, in

three-dimensional space. It is but a remote corner, a backwater, a latrine, and nothing more. And the grandeur of the universe cannot enter there, it is impossible....It will not fit, and if we remain in our tiny backwater, no understanding of the universe will be possible. And that, so to speak, is what he tried to unravel.[69]

To Malevich, *Black Square* represented the culmination of a long quest to explode the flat surface: a literal 'breakthrough', not only from the two-dimensional world of visual art but also from the three-dimensional world of sensory perception. The result was no 'object', but rather an entryway, a portal to another dimension of true immateriality. That was where Malevich saw the revolutionary truth of his work.

His own theoretical underpinnings and justifications for suprematism are comprehensive, and the critical and academic response thereto is exhaustive. Still, it would be misguided to see it merely as a cerebral exercise, as the result of a philosophical process – or worse, as illustrations of a philosophical concept. His suprematist paintings are also radical in an almost tangible way, and cannot tolerate the close proximity of any other visual representations. The radicality of suprematism was perhaps best summarized by Nikolai Punin, in terms that drew applause from Malevich himself: 'Suprematism is the focal point, the centre where all of the world's art converges to die.'[70] Malevich would later tell one of his students that he viewed his revelation of the *Black Square* as 'an event of such tremendous significance that he could not eat, drink or sleep for an entire week'.[71] This wild hyperbole is also a testament to Malevich's sense of humour, for despite his praise of the immaterial, he was certainly no ascetic. He immediately put on weight, for example, whenever his daily life was not utterly dominated by poverty.

The opponents of the avant-garde were vociferous after the opening of the exhibition, their most vocal proponent being without a doubt the artist, writer, critic and historian Alexandre Benois. Though only nine years older than Malevich, this unique figure in Russian art history came from a completely different segment of Russian society. He grew up on the periphery of the imperial court, in a family that had produced generation upon generation of artists, architects and composers. They were Russian patriots with German, Swiss, French and Italian ancestry. Alexandre Benois had been educated in the country's most reputable grammar school, and went on to study law – along with the likes of Sergei Diaghilev and Wassily Kandinsky – at St Petersburg Imperial University. In his vast autobiographical works, which enjoy a canonical

Alexandre Benois.

status among the rich Russian repertoire of memoirs and autobiographies, he describes a happy childhood full of intellectual stimulus and emotional validation. Loving care and attention was always paid to the children's emotional and intellectual development, and enthusiastic discussion was encouraged. It should come as no surprise that a man from such a background had a completely different outlook on life from Malevich. Benois cultivated an ironic view of European history that he himself dubbed *Passéizm* (the embracing or glorification of the 'passé'). However, he was not a pure traditionalist, owing to his lack of respect for the fossilized pretentions of academic art in Russia and Western Europe.

From 1900 onwards, Benois was closely involved in *Mir Iskusstva*, a journal and exhibition association founded by Sergei Diaghilev that led a rebellion against academic realism and the notion of social engagement in the arts, and fought for an individual, aesthetic, apolitical approach to visual art.

Benois' greatest success was probably as a theatre designer. Though this was not his original career path, his stage designs took wing under the auspices of Diaghilev. It was Diaghilev who commissioned Benois

to make the legendary designs for Stravinsky's *Petrushka*, among other productions. Yet Benois was also an art historian and critic, and it is here that his most important contribution to Russian culture may very well lie. In this respect, too, he was conservative, though not reactionary (in spite of everything). Nevertheless, his opposition to the avant-garde was fierce, and fuelled by a deep-seated sense of cultural pessimism.

Mir Iskusstva was shut down in 1905, but relaunched by Benois (and others) in 1910 as an exhibition society. By that time, it was no longer leading the charge against academia, but instead represented the artistic 'centre' and aimed to plot a moderately progressive course in the turbulent world of Russian art. Nevertheless, it was viewed as the great opponent of the radical art movement that was responsible for so much upheaval in the Russian capitals from 1913 onwards.

Unlike many other critics, Benois took the avant-garde extremely seriously, and his harsh criticisms were not marred by snobbery or arrogant trivialization. His commentary on the 0.10 exhibition contained what is now one of the classic texts on *Black Square*, rendering its provocative essence with unmistakeable clarity. Benois evidently understood the significance and implications of *Black Square*; he was simply vehemently opposed to it.

> Without a number, and placed high in the corner, just below the ceiling, in the devotional space, a 'work' by Mr Malevich was hung, depicting a black square inside a white frame. There can be no doubt that this is the 'icon' that the Futurist gentlemen wish to institute as a replacement for Madonnas and shameless images of Venus. It is also the 'domination over the forms of nature', the inevitable conclusion not only of futuristic art, with its hodgepodge of fragmentation and its sly, unfeeling, rationalized practices, but also of the entire 'new culture' with its means of destruction and even more terrifying means of mechanical reproduction, its machinery, its Americanism, and the kingdom of idiocy that is no longer imminent, but is already here. A black square in a white icon frame – it is no mere jest, no ordinary provocation, no episode of happenstance playing out in the house on the Field of Mars, no, it is an act of self-affirmation, a beginning that bears the horrible name of corruption and boasts of that which will lead to our *downfall*, through pride, arrogance and the crushing of all that is dear and tender. This is no longer the hoarse cry of the street-seller, but the grand spectacle in the circus of the latest culture.[72]

By then, Benois had already been waging war against the avant-garde for some time and had been the cause of some open polemic. All the same, he did not wish to become embroiled in an intergenerational conflict that he would be destined to lose. Previously, in 1912, he had cautiously praised Malevich, and even allowed himself to write that he found the new art by the avant-gardists 'necessary', and 'at times even more necessary than anything else'.[73] Quite the admission from an indefatigable *passéist*. Four years later, however, Malevich's art had changed, and so had Benois' political stance. The war had shocked him, and within a very short time he became an outspoken proponent of immediate peace. In addition to humanism, his pacifism was also informed significantly by a genuine panic that had taken hold of him upon witnessing the apparent destruction of Russia's cultural heritage. Malevich's art, with its unequivocal goal of declaring all previous art null and void, represented a cultural parallel to the violence and repudiation of human and cultural values that had become evident in the practice of modern warfare. To Benois, *Black Square* was nothing less than the emblem of modern 'antisocialism' and deserved to be exposed and defeated. However different Benois and Malevich may have been, one trait they did share was the dogged idealism with which they regarded art.

Benois continued to attack Malevich's work wherever possible. A year and a half after the 0.10 exhibition, he outlined his position once again, this time in an article for the popular journal *Letopis* (The Chronicle): 'When one of their number displayed a black square in a frame, I protested resolutely in the name of life, driven by my innate desire for life. I cannot accept that black emptiness.'[74] Of course, the fact that a powerful dinosaur such as Benois wasted so much energy on Malevich the 'obscurist' was first and foremost a testament to the latter's growing prestige in the art world. Malevich took the same view of the situation. From then on, he presented himself as the undeniable arch-rival of the 'high priest' Benois, and only ever invoked his name as a curse.[75]

Shortly after the closure of the 0.10 exhibition, Malevich was drafted into the army and left for the front. He shared this first-hand experience of war with a large number of other radical European artists: Fernand Léger, Georges Braque, Max Beckmann, Ernst Ludwig Kirchner, Max Ernst, Egon Schiele, Oskar Kokoschka and Umberto Boccioni, to name but a few. And, like Malevich, most of the Russian avant-gardists participated directly in acts of war, which would influence their development. Larionov returned with trauma and severe injuries. Wladislaw

Strzemiński, a radical artist and theoretician, lost a leg, an arm and an eye. Unlike Benois, Malevich knew precisely what war was like day to day, with its ever-present threat of death. 'I know not what awaits me, perhaps the iron storm will pass me by entirely,'[76] he wrote in November from the front. He composed new theoretical texts amid the 'crunching, roaring and din of the propellers', and continued to spur on his friends to great artistic ambitions with hyperbolic, philosophical and spiritual language. 'Oh, how I love art,' he wrote, 'and it sickens me that she is insulted. I would rather be nailed to the cross than see her thus slandered.'[77] Most of all, in his eyes the war was an unavoidable historic phenomenon, a monstrous reality that was necessary for the creation of a more perfect society. He saw himself in the same way: 'I have not yet reached my full potential. And that is why I am here, why I walk among the whistling shrapnel.' But he also saw a key role for himself in the post-war world: 'If I return alive, I shall take up and carry the new stone tablets of the law with a strong hand. For now, farewell.'[78]

February 1917 saw the year's first revolutionary upheaval, which resulted in the fall of the monarchy and the institution of a 'Provisional Government' made up of liberals and revolutionary socialists, led by Alexander Kerensky from June onwards. In Malevich's division, however, the revolutionary hunger was not yet stilled. The Bolsheviks, who were not a part of the new government, continued to gain influence among his fellow soldiers. When they were stationed in the Kremlin, the soldiers elected Malevich as the chairman of the Fine Arts branch of the Soviet of Soldiers' Deputies.

French-Russian Malevich specialist Andrei Nakov, in particular, has fought against what he called 'the myth of Malevich the communist', undoubtedly to save the artist from political appropriation by the left, and the subsequent and inevitable rejection by the right. And while it is certainly true that Malevich never explicitly called himself a communist, nor was he ever a party member, his unrelenting revolutionary engagement and extreme left political convictions are beyond doubt.

Malevich welcomed the overthrow of the Tsarist regime in the February revolution with open arms. The 'toppling of the monarchist throne that had shackled the creative will of the people' was a 'grand turning point'. 'And I rejoiced that our consciousnesses were illuminated by the light of a new day.' Malevich immediately tied the fate of the avant-garde to that of the revolution: 'In these momentous times, it is even more important for the artists of the revolution to be standard-bearers for their

Alexander Kerensky greets Russian troops, summer 1917.

movement. For while our lives are illuminated by the idea of socialism, the arts are still dominated by the rulers of academicism.'[79]

Few in Malevich's circle doubted his political leanings. This should come as no surprise, as a revolutionary ethos was the decisive and binding element within the entire avant-garde. 'The creative work of the Russian avant-gardists,' wrote one of their key historians, 'expressed with striking perseverance and consistency the overall scenario of a revolutionary reformation: the overthrow of the old, and the affirmation of the new. It resonated with the public, and enjoyed a triumphant success among young people.'[80]

It was a glorious time for Malevich. From the depths of provincial Ukraine, with its material and spiritual poverty, and from his position within a distrusted minority in imperial Russia, from the dirt and the fringes of society, he had transformed and forced himself upon the world, and was now the administrator of the spiritual and political heart of a country sailing completely uncharted waters. The revolution within himself occurred in tandem with the political revolution in Russia, and these types of parallels were important to Malevich. He saw art and society as communicating vessels; or rather, art was a predictor of movements in society: 'The artist utters the secret that is hidden from him

by the word – premonitions and systemic changes are revealed in colourful forms….It is therefore essential, necessary, to read paintings, to open them up, for they are keys to new doors; it is necessary so that once the door has been opened, our consciousness does not collide with the unexpected….A painting is a sign of what is to come.'[81] In the same vein, one and a half years later he wrote: 'Cubism and futurism were artistic revolutions that foreshadowed the economic and political revolution of 1917.'[82] Statements like this, of varying levels of succinctness, can be found scattered throughout his body of theoretical work.

Fantasy as Reality

The avant-gardists were always rooted firmly in the world of their own imagination, and their public appearances and artworks constituted part of the same fantastical game. Now, amid the fury of the revolution, the boundaries between fantasy and reality, between fact and fiction, seemed to blur even more. Their artistic playground came to life. It was in the spring of 1917 that the poet Velimir Khlebnikov, homeless and starving, conceived of a novel political stunt.

We will return to this curious figure extensively over the next few chapters, but for now, suffice it to say that he was the one regarded by the various artists and authors as having integrated the futurist mentality most fully. Interestingly, he never referred to himself as a 'futurist', but rather as a *budetlyanin*, a neologism of his own invention that meant something like 'a man of what is to come'.

Khlebnikov fumed at Kerensky's politics and his decision to push ahead with the war. Above all, he found the term 'Provisional Government' offensive, and unworthy of a revolutionary administration. Instead, he proposed the institution of a 'Presidency of Planet Earth', and proclaimed: 'We alone, who have rolled up your three-years' war into a trumpet of terror in a single motion, we sing and shout, sing and shout, intoxicated by that one impertinent truth, that the Presidency of Planet Earth already exists. It is us.'

He immediately set about appointing the other board members who would govern the Earth with him. All of the futurists responded enthusiastically to Khlebnikov's clever new stunt, and Malevich was included on the initial list of the 'Presidents of Planet Earth'.[83]

Shortly thereafter, Khlebnikov sent a letter to the Provisional Government.

Dear all, all all!

During its session held on 22 October, the Presidents of Planet Earth decided: 1. To declare the Provisional Government provisionally non-existent, and that the uber-arthropod Alexander Kerensky be placed under strict arrest.

Not long afterwards, he sent a letter of clarification to the Provisional Government.

Dear all, all, all,

What? You don't know that the Presidency of Planet Earth already exists?
No, you do not know that it already exists.
Signed, the Presidents of Planet Earth [signatures].

This was a glorious stunt and was of course joyfully received by the artists. But, wonder of wonders, it occurred precisely when the positions of high office were actually being handed out, and their eventual incumbents seemed to correspond more or less with Khlebnikov's fantasy.

In the autumn, Malevich was informed that he would become a commissar in the Kremlin. Perhaps not quite the same as 'President of Planet Earth', but certainly a step in the right direction.

Three days before his position was publicly announced, he wrote a letter to his friend, the artist Mikhail Matyushin, drawing a direct association between his new role at the Kremlin and Khlebnikov's fantastical Presidency: 'Just this last summer, I declared myself the President of Space. That has made things easier for me, it bears me up, and I breathe more freely. How lovely. It is the best possible result – truly, the best. And now I am to enter a national union of co-presidents who are alien to me. It is strange, but I also feel deliverance, feel loneliness, despite being surrounded by the foreign, dark presidents of the Earth.'[84] These 'foreign presidents' were the Bolshevik revolutionaries with whom he now had daily contact.[85]

Real life took on fantastical traits, and the comical self-aggrandizement of the futurists suddenly became an alien reality. 'Something is tugging at my soul,' Malevich wrote in the same letter, 'drawing me out of the abode of earthly vapours....But now, having departed, I float freely, tracing through space like a flash from my mind, blossoming in colour.... I considered my greatness in space, as I am alone there, after all.'[86]

Malevich's grotesque self-aggrandizement and unhinged egomania could easily be ridiculed or considered tasteless, and would be merely a

source of aggravation in any lesser artist. It must also be viewed, however, within the context of his life story. Malevich's life was an epic struggle to escape the darkness; nothing was handed to him on a platter. The struggle only became more intense toward the end of his life, when he had to fight to maintain a tiny oasis of independence, eccentricity and refuge in a world of ever-encroaching homogenization. Viewed in this light, his vigorous self-aggrandizement can be seen as an impressive (and even moving) display of vitality and fortitude. Benois had no interest in such displays, neither then nor as time passed, and it was this aversion that he expressed in his narrow-minded views.

Since revolutionary Russia was largely devoid of objective reporting, news of the takeover at the Kremlin spread only gradually. Alexandre Benois heard the rumour of a futurist coup in the Kremlin ('a senseless carnival of devils!') and searched for information everywhere he could. Although he doubted the veracity of the reports, still he could not put his mind at ease: 'On the other hand, anything is possible in the current climate, even the ritual expulsion and incineration (*auto-da-fé*) of all Rembrandts and religious paintings.'[87] Three days later he telephoned a friend in Moscow, with hopes of gleaning some information on 'how the futurists were keeping house in the Kremlin'. The friend could only say that 'Malevich and [Peter] Malinowsky had indeed "evicted the company" [i.e. the prior administration] and are now running things with absolute authority!'[88] To Benois, this news must have seemed positively apocalyptic.

The reality, however, was that Malevich left all the historic artworks under his care completely untouched. The notion of personally destroying items of cultural heritage never even occurred to him. The old art forms no longer held sway and would vanish of their own accord.

Malevich was poised to play a major role in the construction of a new society and was brimming with ideas on the potentially decisive role to be played therein by the art world. Over the next few years, he would be involved in the revolution not only as an artist, but also in his position as an administrator. Very quickly he was forced to contend with a superior whom he knew very well, a figure who was first his friend, then his rival, and perhaps later even his enemy. A man with a character as revolutionary, and an artistic talent as radical, as Malevich himself, but with a strikingly different psychology. That man was Vladimir Tatlin.

2

Tatlin, 'Pittoresk'

June 1917 – May 1918

Without the intervention of an immensely wealthy pastry chef by the name of Nikolai Filippov, the history of the avant-gardists would have been very different. Filippov was a patron of the arts who had made his fortune running a chain of patisseries and several large hotels, including Hotel Lyuks ('Luxury') on Moscow's grandest avenue, Tver Boulevard.

To the avant-gardists, benefactors like Filippov were of vital importance. Prior to 1917, the visual art economy in Russia was dominated not by the commercial art market, but by the patronage of wealthy art-lovers. The wide variety of artistic media and styles that is so characteristic of Russia in the early twentieth century is a direct legacy of this colourful and diverse group of cultural philanthropists. The avant-gardists were even more dependent on them than traditional artists, because they virtually never sold any artworks. Filippov was a great lover of poetry, who composed his own works in secret and supported a vast array of poets, most commonly by providing them with free accommodation in his hotels. Though his taste was extremely progressive, he was also a successful businessman who knew how to run a club or café effectively, and he decided to combine his professional expertise and interests with his private passion. The cultural bars and clubs that he opened in Moscow would come to play a major role in the expansion of the avant-garde in Russia: not only were they meeting places for artists of various disciplines, but they also gave the avant-gardists a public platform, allowing them to reach a far greater audience.

In early 1917, Filippov opened the Poets' Café (*Kafe Poëtov*). It was run by Vladimir Mayakovsky (among others), and became a bustling venue where the most progressive poets and artists met and performed their works. Filippov's ambitions did not stop there, however. In late June 1917, he announced a contest for the interior design of a far larger

cultural platform in the heart of old Moscow, at number 5 Kuznetsky Most. Its name was Café Pittoresk, and the winner of the contest was Georgy Yakulov. Director Vsevolod Meyerhold was charged with organizing the theatre programme.[1]

They had grand plans: Café Pittoresk was to become an 'international station for the arts, with a large drum (an arena) to sound the military commands for the masters of the new era'. It was from this 'station' that Yakulov wished to 'send out the express trains of new artistic achievements'.[2] Several months after the opening in January 1918, he wrote: 'The second half of the nineteenth century changed the face of the cities, through the bounty of electric light, motorized transport, industry and the growth of the cities themselves. All of this has increased the emotional scope of creativity, and has brought painting to the streets.' Café Pittoresk was intended to draw attention to the challenge of designing public spaces in the modern city, and to lay the foundations for a new style not only in painting, but 'in all artistic disciplines'.[3] It shared this multidisciplinary character, of course, with a previous generation of artists who were also in search of a synthesis of the arts – an all-encompassing experience that would titillate the senses and transport one's entire spirit. But that 'all-encompassing experience' was a distinctive prerequisite of the avant-garde: any truly revolutionary experience should go beyond the merely visual, after all, and exert a more profound effect on the observer's heart and mind. The purpose of the avant-garde, just like that of religious art, was the transformation, not the mere representation, of reality. This same objective also meant that the project should be a test of collaboration among artists, a collective act of creation.

The winner of the design contest, Georgy Yakulov, was a colourful peripheral figure in the history of Russian revolutionary art. He was an Armenian subject of the Russian empire, born in Tbilisi, and his biography resembles that of many other avant-gardists: he was born into an ethnic minority, rejected from the Moscow School of Painting, Sculpture and Architecture, and then became a self-taught artist in various private studios. His reputation then grew quickly; in an article for the *Blue Horseman* almanac in 1912, David Burlyuk referred to him as one of the 'wildmen of Russia'.[4] One year later he spent some time in Paris, where he completed abstract colour studies. After his sojourn there, he published a polemic against European culture, which according to him had 'achieved nothing' and was 'in the midst of a crisis'. 'There is not, and

Vladimir Tatlin, 1914.

cannot be, any new art in Europe, for [art] arises from cosmic elements. All of Western art is territorial. The only country to have remained free of territorial art until now is Russia.'[5] The pamphlet caused a stir, and Guillaume Apollinaire even published a French translation of it in *Mercure de France*.[6] Yakulov served in the army during the war, during which time he was wounded, patched up and sent back to the front.

Yakulov did not dress like a revolutionary, but instead like a flamboyant dandy. He wore a *beshmet*, 'a grey jacket meant for Cossack officers accompanied by traditional light-blue riding breeches', and his appearance 'exuded an air of elegant correctness'. The fact that his breeches were made 'from an old curtain' was irrelevant. He wore 'clear brown gaiters, and on his colourful necktie a Parisian pin depicting the head of an African'.[7]

When Yakulov was awarded the commission from Filippov, almost immediately he invited other artists to collaborate. The first on his list was someone who in no way whatsoever resembled the flamboyant Armenian: a rough-hewn, simply dressed man by the name of Vladimir Tatlin, one of the most original and groundbreaking artists that Russia has ever produced.

Tatlin could sometimes exert a magical charisma, though it was due in no part to his appearance. 'Aside from his general unattractiveness,' wrote a female friend and admirer, 'he was completely yellow, with deep wrinkles, a large sort of nose that turned upwards, thin, with – albeit large – pale blue eyes that bulged out. Only his mouth was surprisingly small and dainty, with beautiful teeth. A tall build, very slender, awkward, red hands, and enormous feet.'[8] Tatlin engaged several other artists to aid him, including Alexander Rodchenko, Nadezhda Udaltsova and Sofia Dymshits-Tolstaya, who were among his acolytes at the time.[9] The agreement was that Yakulov would create the master plan, to be further fleshed out and executed by Tatlin and his followers.

At first glance, it might seem odd that Tatlin was prepared to work as Yakulov's 'underling'. The colourful Armenian's reputation was in no way comparable to his. Tatlin was regarded as one of the uncrowned leaders of the avant-garde, he was both worshipped and despised, and in truth was the only person who could compete with Malevich, especially after Larionov went to Paris for good in 1915. Although Tatlin of course knew Yakulov, the two men did not share any special bond, and Yakulov was not a regular visitor to Tatlin's studio. It would have been inconceivable for any independent, dominant figure such as Malevich or Kandinsky to agree to Yakulov's proposal – so why did Tatlin?

A few practical reasons present themselves. There was an economic need (Tatlin was always poor), as well as the opportunity to take part in an ambitious and very well-publicized project that would allow him to present his ideas in a new setting, outside of his familiar subculture. Tatlin also had a love of collaborative work. He was not a patriarchal leader (like Malevich), but a revered *primus inter pares*, or in his own words, 'the initiating unit within the creative collective'.[10] His love of collaboration was due in part to his personal psychology. Tatlin often needed others to free him from his inertia and suffered bouts of depression that wounded his self-confidence. The discipline of collaborative work helped him stay productive and in good spirits. At the same time, these partnerships were seldom unproblematic, as he was still far too

headstrong for his collaborators. One of his best friends once noted: '[Tatlin] was a man of revolutionary will, and incapable of any compromise whatsoever.'[11] In the summer of 1917, he worked on the artistic design of an ambitious film project to be directed by Meyerhold. The collaboration was a dismal failure, as Meyerhold demanded that Tatlin limit himself to the set design and leave the content decisions to him.

> Vsevolod asked me to make a grove of trees....But I made a single tree instead, for a grove has no integral identity. Vsevolod said that he was unhappy with my decision. I replied that I felt nothing for his grove, that this tree was a hundred times better than any grove. And he started yelling that I was undermining his concept. He told me he wanted nothing more to do with me, and I said I wanted nothing more to do with him. And that is how it ended.[12]

And so, when Yakulov's invitation arrived, Tatlin's calendar was empty.[13] In addition to these strategic, economic and psychological reasons for his acceptance, however, there was one other very concrete motivating factor. Café Pittoresk would become a platform for artistic performances in general, not just poetry recitations (as in the Poets' Café). Tatlin also wished to present himself as an artistic performer – in other words, as an actor, performance artist and musician – and the Pittoresk project offered a means of associating himself with the new venue. Perhaps most important, however, was the fact that the man with whom he intended to realize his theatrical ambitions, the poet Velimir Khlebnikov, was also part of the creative collective at Pittoresk.

Tatlin revered Khlebnikov, who was regarded both then and now as the most radical and exciting poet of the avant-garde. Their friendship and interest in each other's work had grown over the preceding years. Khlebnikov was also a protégé of Filippov and, like Yakulov, lived in his extravagant Hotel Lyuks.[14] He had promised to write Filippov a 'sketch' to be performed at the opening, where it was his intention to 'gather all the "Presidents of Planet Earth" at Pittoresk [Khlebnikov was still busy trying to appoint 365 'presidents', one for each day] in order to ultimately determine "the fate of the world"'.[15]

Tatlin ultimately joined the Pittoresk collective not because of Yakulov, but because of Khlebnikov. In mid-November, barely a week after the Bolsheviks had taken power in Moscow, he signed a written contract with Khlebnikov for the production of three performances. Khlebnikov supplied the text, and Tatlin would take care of the artistic direction.[16]

These performances were never to take place. The revolution threw everything into chaos, disrupting everybody's future plans and social arrangements. Khlebnikov left Moscow six months later, and Tatlin's collaboration with Yakulov ended in blazing conflict. Although there were various reasons for it, this sequence of events makes one thing clear: rather than becoming more harmonious, the relationships between artists during the revolutionary period instead became more militant.

The Conflict with Yakulov

Though Café Pittoresk was not due to open until 30 January 1918, most of the major renovations had probably already been completed by mid-December.[17] The few surviving blurry photographs of the interior reveal a zany decor, with abstract reliefs sprouting from the walls 'that seem to enlarge architectonic space', 'and magnificent sculptures hanging from the domed ceiling, with painted glass facets....Comparable sculptures also bordered the stage. Were they aeroplanes? Dynamos? Dreadnoughts?'[18] Everywhere there were capricious figures made of cardboard, plywood and fabric: lyres, wedges, circles, funnels, spiral shapes. Occasionally light bulbs were placed inside these solid bodies. 'All of these hung from the ceilings, leapt out from the corners and the walls, and astounded with their brazen, unusual nature.'[19] The glass ceiling was painted with abstract scenes. Even the furniture and the servers' uniforms were of the artists' design (Plate 7).[20]

The problem that sparked the conflict among the artists was rather banal in nature, and concerned payment. There was already some discontent surrounding the fact that Yakulov would be paid more than the other members, even while he was revelling in the attention he received at Filippov's Hotel Lyuks. In the period immediately following the revolution, there was great uncertainty regarding the stability of currencies and banks, and Yakulov suspended payments to the artists. An additional complicating factor was Yakulov's reputation for being irresponsible with money. 'No matter how much money he had of a morning,' one artist recalls, 'by evening he had managed to fritter it away, spending very little on himself. Then he would say, with incredulous eyes: "Where is it? The blazes!"...They say that money is like water, but that is a lie – money is like gunpowder: one spark, and – poof! – nothing.'[21]

The catalyst in the conflict between Tatlin and Yakulov was another artist, Alexander Rodchenko. At the time he was twenty-four, six years

Newspaper clipping with photograph of the interior of
Café Pittoresk.

younger than Tatlin, and had recently graduated. He had moved to
Moscow only one year before, and experienced a meteoric rise among
the radical artists. Rodchenko was one of the few avant-gardists even-
tually to garner worldwide fame, chiefly as a photographer. During the
Pittoresk affair he was still primarily a painter: he was brilliantly adept
with forms and influences, and – typical for the second generation of
avant-gardists – could not only incorporate and implement innova-
tions by others easily and at impressive speed, but could also perfect
and develop them to their logical conclusion. He was an activist, a quite
intolerant revolutionary, and a lover of intrigue, keen to sow dissent
among others (as we will see in the conflict with Yakulov). He had no
understanding whatsoever of people who did not fully exploit the new
revolutionary situation, and who still clung fast to the spoiled bour-
geois notions of law and order. Straight after the revolution, he wanted
to establish a large artists' colony by squatting in the Nirnzee, the
tallest apartment building in the city with a view of Tver Boulevard. He

believed it was a simple matter, since the complex had been inhabited by those known as *byvsyie* ('the former ones'), people who 'belonged to the exploiting class'. They had been chased out of their homes by those who had taken the law into their own hands. Years later he boasted in his memoirs:

> How I tried to convince the artists...to move into the nine-storey building, the former Nirnzee..., where we could have had a studio each, and a large communal studio on the roof. I had already discussed it with the Moscow Soviet and with the building's commandant....As a demonstration I moved in myself, into a marvellous studio with gas, a telephone, a small kitchen and bathroom, but no matter how I urged the others, they were timid. They were simply afraid that the Bolsheviks would leave again, and then...then I shall not repeat what was said next.[22]

The possibility that the artists were motivated not by fear, but instead by basic decency, was evidently inconceivable to Rodchenko.

When the payment conflict emerged between Yakulov and Tatlin, Tatlin knew not what to do. Rodchenko, on the other hand, was decisive, and convinced Tatlin to turn immediately to the Bolsheviks, who had hastily formed an impromptu tribunal to replace the existing courts system.

> 'The next day we went there together,' Tatlin recounted, 'and told a comrade in a leather jacket and carrying a Mauser that Yakulov wasn't paying for Tatlin's work.
> "– Show me your hands."
> We showed him our hands: they were calloused and covered in paint. He looked at them and said: "These are workers' hands," and immediately ordered the guard to go and bring Yakulov to the tribunal. We sat and waited. Yakulov was brought in, elegantly dressed, wearing a hat and yellow gaiters and reeking of perfume.
> "– Is this him?" We answered: "Yes."
> The man in the leather jacket stood up, adjusted the holster of his Mauser, and demanded to see Yakulov's hands.'[23]

Yakulov's smooth hands settled the matter, and he was ordered to pay up immediately in order to avoid arrest.

Whatever Yakulov may have done, having him dragged before a tribunal of trigger-happy Bolsheviks was a malicious act by Tatlin and Rodchenko, the outcome of which could have been far worse for Yakulov.

Rodchenko wrote phlegmatically, many years later, that the event 'haunted [Yakulov] for some time'.[24]

To Tatlin, the affair perhaps served as a lesson: the Bolsheviks were on his side, and his time seemed ripe. This summation was confirmed in the spring of 1918, when he was appointed to a major government post. Three months after the opening of Pittoresk, Tatlin was asked to be the head of the Moscow Art division in the brand-new People's Commissariat for Enlightenment. With this one appointment Tatlin thus became the most powerful cultural minister in Moscow and perhaps the entire country, albeit for only a short time. Although the instantaneous rise to power of the timid, gawky-looking Tatlin – who the previous January had been forced to show his calloused hands in order to get paid and avoid starvation – was just as radical a shift in the social hierarchy as Malevich's appointment as commissar of the Kremlin, it did not come entirely out of the blue.

Tatlin: Sailor, Artist, Bandurist

Vladimir Tatlin was in many respects a failed artist. He experienced periods of inertia, in which he produced hardly anything at all, which alternated with bouts of frenzied creative activity. He was emotionally unstable and vulnerable, with peaks and troughs in his self-confidence. This volatility of character may be the reason why he took such a careless approach to his artistic legacy, much of which (indeed, most of which) perished during his lifetime. Even if far more of Tatlin's work had been preserved, still his output would have been modest compared to that of Malevich or Picasso. He had few intellectual ambitions and seemed rather uncultivated in general. Nevertheless, Tatlin was an astounding figure, one whose conceptual boldness exceeded that of any other artist of his generation, as though his long periods of dormancy culminated in eruptions of creativity. His megalomaniacal design for the Monument to the Third International, which became an icon of the global avant-garde, is perhaps the most salient example of this phenomenon. Tatlin's artistry was rooted in radical powers of imagination, and the courage to reject without hesitation every ingrained habit and accepted idea. It is also often forgotten that his virtuosity in drawing and painting was consummate, and perhaps superior to all others of his generation. Everything he committed to paper or canvas was utterly convincing and combined a sketch-like lightness with the balance of a well-considered composition.

He enjoyed collaboration and was able to forge deep connections quickly, perhaps precisely owing to his vulnerability and intense emotional life. He lived frugally and had no apparent interest in material goods or comfort. If he did not work well during the day, he would refuse to eat. 'You should not feed me today,' he would say, 'for I have produced nothing good.'[25] Much of the reverence he received was based on this asceticism, while his thirst for rivalry and competition meant that he only felt at home in leadership roles.

Vladimir Tatlin was born on 16 December 1885 in Moscow, as the youngest of three children.[26] Little is known about his mother, except that she died young, probably four years after Tatlin's birth. His father was an engineer, and came from the impoverished nobility, though the family lived in better circumstances than the Maleviches. At the age of six, Tatlin was even registered as a member of the nobility in the city of Orlov, from where the family originally came. His father must have been a canny, hard-working and forthright man. He advanced his career quickly, travelled much, and in 1892 was sent to America by the Ministry of Transport to write a report on the development of the railways. Tatlin senior's 'Research Report on the Systems of Replacement Shunting and other Locomotives in the American Railways' was published twice, in 1893 and 1896. He shared with his son a penchant for the practical: the thrill of technological invention, and the will to master the technologies for himself.[27] In 1896 the family moved to Kharkiv, in modern-day Ukraine, where Tatlin senior became the manager of a small textiles factory. From the age of seven, Tatlin was gripped by a great urge to draw: 'At home I was always scratching away with pencil and paper, I enjoyed it immensely. I had no affinity with science then, which I now believe was due to the beatings my father always gave me for poor performance at school.'[28]

Although Tatlin did not move to Ukraine until the age of eleven, he learned to speak Ukrainian very well. The language was not taught in schools (the policy of the Tsarist regime was to Russify Ukraine), so he must have picked it up on the streets, little by little. His father's 'beatings' were probably related to his preference for roaming the streets, speaking the wrong language to the wrong people.

It was also during this period, however, that his great talent for drawing also manifested itself for the first time. The art teacher at his school in Kharkiv was an ageing figure who had studied at the Imperial Academy of Arts in St Petersburg, where he had received instruction from none other than Karl Bryullov, Russia's most venerated artist from

the first half of the nineteenth century and a contemporary and friend of Alexander Pushkin. This cannot but have influenced his artistic development, and Tatlin had 'the fondest memories of him'.[29] During this same period, Tatlin also developed his musical talents, probably without ever having taken music lessons. He learned to play the guitar and harmonium, but his main instrument was the *bandura*, a lute-like string instrument played by itinerant, often blind folk musicians in eastern Ukraine. It is likely that he learned this skill from travelling players on the street – it was not an 'official' instrument, in the sense that one could take lessons in it. And of course, it was unheard-of for the son of an engineer to be playing an instrument associated with beggars and vagrants. Tatlin's interest in the bandura was, therefore, also a provocation, a typical act of rebellion by a boy who wished to set himself apart from his middle-class milieu by aligning himself with the object of his parents' disapproval. He also sang as he played – in Ukrainian – and collected and copied songs from the same passing musicians.

Tatlin made his own banduras – a delicate and complicated procedure (the body of the instrument was made from a single, solid piece of wood) that he perfected through the years. Into his old age he always kept a few banduras at home, in various sizes and tunings. Even Tatlin's sceptics praised his moving playing and singing. Klyun, who was hardly partial to Tatlin, wrote that he 'had a brilliant baritone. It was not a grand voice, but we could listen to it forever – simple, unfeigned, and straight from the heart. We would listen to him perform a song that had been done to death as though hearing it for the first time, only then understanding its true merits.'[30]

Tatlin's family life was unhappy. His father remarried when Tatlin was eight, and – to put it mildly – his new stepmother did not see eye-to-eye with the children. From that point on, the surviving historical account becomes simultaneously more detailed and more dubious. For Tatlin was a brilliant fabulist and derived great enjoyment from dramatizing his past. He left few authentic autobiographical texts behind, but delighted greatly in talking about his life, not uncommonly inventing anecdotes and incidents on the spot. It is these stories that populate the memoirs of admirers and observers in great numbers.

At various times he described his family life as a kind of fairy tale, complete with an overbearing father and wicked stepmother.[31] Although many of these elements will have been exaggerations or fabrications, several facts are certain: Tatlin fled from home, probably aged around

fourteen, and his older brother committed suicide at a young age. The precise circumstances of this double family drama are unknown, but the lovelessness and violence often recalled by Tatlin are not likely to have been invented. 'Oftentimes we wouldn't see our father all day, except for when he would appear from his office, belt in hand, to whip us like prisoners.'[32] The legend says that once, when Tatlin showed a lack of respect for his stepmother, his father threw a fork at him that penetrated his eyeball, very nearly costing the boy his eyesight.[33]

After leaving home, Tatlin's life story took on a Dickensian flavour. The boy drifted through Russia and finally ended up in Moscow, where he worked in the ateliers of icon painters and in the scenery studios of the Solodovnikov Opera.[34] Occasionally he would appear as an extra, if ever a person of uncommon height was required. He told at least one person that he played the 'corpse' in the production of Rubenstein's *The Demon* (1903).[35] 'I lay there,' Tatlin recalled, 'and tried to appear lifeless. The director hissed at me from the wings: "Lie, don't pose, you dolt! You have no talent." I felt insulted, and went to work in construction.'[36] He lived in squalor, and regularly went without food. Later he recounted the following anecdote from his early days in Moscow:

> I lived in the slums, in my own damp, dark room. A student lived next door, and one day some guests arrived. Through the wall I could hear cheers of 'Hurrah!' and they brought in a pan full of hot potatoes. I had not eaten for two days. I lay weakly in bed, listening to their delight at the hot potatoes, and a desperate thought arose in my mind: what if I just went in there and took a potato? I decided to do it. Once in my neighbour's room, everyone fell silent. I grabbed the potatoes from the pan with both hands, and wordlessly left the room again. I could no longer hear any laughter through the wall. Soon afterwards, everybody left.[37]

This anecdote is a typical example of Tatlin's narrative style: concise, full of apparent contradictions and ending with a pregnant silence. First of all he sets the scene: dismal poverty. Next comes the contradictory storyline, which in a certain sense stresses the anecdote's authenticity: he plans to steal a single potato, but nonchalantly leaves the room with the entire contents of the pan. We finish with an implicit and mystifying twist: even as a group, these gutless students dared not stand up to Tatlin, an imposing hobo hardened by the school of life, and were left with no choice but to skulk away, leaving the potato-thief unpunished.

The clipper *Maria Nikolayevna*, on which Vladimir
Tatlin worked as a sailor.

Long before that episode, in the summer of 1899 or 1900, when Tatlin
was sailing the Black Sea on a boat as a *yunga* (cabin boy), he supposedly
received his first life lesson: 'The alarm sounded, and I was still asleep.
I didn't hear it. The bosun grabbed the chain that was attached to his
whistle, and smacked it into my back with all his might. I fell on the floor,
in pain. When I opened my eyes again, I was completely disoriented. The
bosun bent over me and said: "Tatlin, you must always get up on time."
Since then, I have always been on time for everything.'[38]

Doubtless because of his precarious situation, he remained in touch
with his father and stepmother. On 13 August 1902 he submitted a formal
request to complete the exam granting admission to the first year of
the general degree at the Moscow School of Painting, Sculpture and
Architecture, the same institution that would reject Malevich on four
occasions, several years later. Tatlin was fifteen years old at the time.
He was granted admission and moved in with his uncle Nikolai Tatlin
on Pantaleyev Alley, in a modest new development in the north of what
is now the centre of Moscow. He was expelled after a year due to 'poor
academic performance and inappropriate conduct'.[39] From Kharkiv,
Tatlin's father sent an official request for him to be allowed to advance to
the second year regardless, but without success.

In February 1904 his father died, and the wicked stepmother became
his legal guardian. Not long after the funeral, she remarried his father's
attending physician,[40] and arranged for Tatlin to be admitted to the

maritime college in Odessa (it is unclear whether this occurred at Tatlin's behest). He spent a year on a clipper called the *Maria Nikolayevna* as a trainee sailor and was awarded a certificate. Out at sea, he was required to scrub the deck on cold mornings. His feet were frostbitten as a result, and never healed completely.[41] In the summer of 1905 he was successfully admitted to the art academy in Penza, a city situated over 600 kilometres (370 miles) south-east of Moscow, on the road to Samara, where he would ultimately study for four years. Although the programme in Penza did not have the same prestige as the Moscow School (and certainly not the Imperial Academy in St Petersburg), it was a good school nonetheless, and Tatlin would continue to remember at least one of his teachers, Aleksei Afanasyev, as someone who exerted a decisive influence on his work.

Tatlin's Revolution

In 1905, Penza (and its art programme in particular) was a hotbed of revolutionary activity. Students took part in both demonstrations and acts of terrorism. In the summer of that year, one art student shot and injured a police officer with a pistol; fatal attacks on another police officer followed in 1906, and in 1907 on governor Sergei Alexandrovsky – an honorary board member of the very art programme attended by Tatlin.

At that time, all of Russia was in the throes of revolution. Dozens of attacks were carried out each year, primarily targeting the top tiers of public office and the military, though increasingly the lower levels as well. The year 1906 was especially violent, with many hundreds of deaths due to terrorism. Among them were four major-generals, five governors, an admiral and two public prosecutors. In a suicide bombing on 12 August targeting the conservative Prime Minister Stolypin, twenty-nine people lost their lives, including both of the bombers. Nine days beforehand, as part of a simultaneous, coordinated attack across nineteen (!) cities in Congress-Poland (part of imperial Russia), scores of victims died in what was, if only in terms of its logistics, probably the largest coordinated terrorist action in history. Terrorists burst into the homes of police commanders and murdered them at their dinner tables.[42]

Like so much of the progressive population, Tatlin did not denounce the bloodshed, as the following anecdote clearly illustrates. Seven students from the art academy had purchased a wreath to lay on the coffin of the murdered Alexandrovsky. The inscription read: 'from the students'.

When Tatlin heard of this, he made directly for the school rector's apartment to lodge a complaint. It seems that he applied so much pressure on the rector that he gave permission for Tatlin to visit the deceased governor's home, where Tatlin insisted that the inscription be altered to read: 'from seven students'.[43] It seemed that not even the smallest gesture of reconciliation from the student movement to the murdered governor's loved ones could be tolerated.

A student council was formed in Penza that named itself the *Soviet Starost* – the Council of Elders – and demanded the right to consultation on almost all aspects of student life other than the curriculum and examinations. Tatlin was a member. As such, he began to attract the attention of the police anti-terrorism division, which had him shadowed and assigned him the codename 'Diver' (or 'Little Ram').[44] He regularly travelled from Penza to Moscow, where he befriended the radical artists. The spies followed him, and he was not the only avant-garde artist being shadowed there: the reports by the investigator also refer to Mikhail Larionov, using the codename 'The Kremlinian'.

In Moscow Tatlin took lessons at various private studios, usually informal places where artists gathered together to paint. A model would be hired, or a scene created for a still life. The teachers were often only a few years older than the students, such as the 'Russian Matisse' Ilya Mashkov (four years older than Tatlin), Alexei Morgunov (one year older) and Mikhail Larionov (four years older). These studios were the fertile hotbeds that gave birth to the Russian avant-garde, the places where the social connections and conflicts that would shape the movement emerged. They housed a colourful troop of young men and women, most of whom had come from the distant corners of the Russian empire and were often uprooted, impoverished and poorly educated, but prepared to take full advantage of the opportunities offered them by the emancipating power of the urban environment. This 'studio life' fostered the unbridled exchange of ideas and visual discoveries, and facilitated the rapid incorporation, development and rejection of all manner of modernist trends that so typify this group from around 1908 to 1915.

In April 1910 Tatlin completed the art programme in Penza, and from then on would spend most of his time in Moscow. He earned money by working as a sailor in the summertime, and over the years visited the harbour cities of the Black Sea (Varna, Burgas, Odessa, Trabzon, Batumi) and large parts of the Mediterranean, including Beirut, Haifa, Jaffa, Tripoli and Istanbul.

Mikhail Larionov, portrait drawing
of Vladimir Tatlin.

Tatlin romanticized his life as a sailor, calling himself 'an old sea-wolf'
and making derisive references to 'landlubbers'. In 1911 he painted a
portrait titled *The Sailor*, with himself clearly recognizable as the subject
(Plate 6). The composition is dominated by ovoid shapes that lend it a
fleeting dynamism, highly unlike the static aplomb of Malevich's self-
portraits from the same period.

That Tatlin identified himself as a sailor was no coincidence. Sailors
were prime carriers of the revolutionary virus, many being young men of
low birth, rough and uneducated, runaways and refugees. They played
a crucial role in various revolutionary uprisings in 1905, first and fore-
most in the mutiny aboard the battleship *Potemkin*, an event widely cel-
ebrated in revolutionary history and artworks. Someone who was both
an artist and a sailor could, therefore, hardly avoid having revolutionary
blood flowing through their veins.

The Sailor also tells another story. The subject's cap bears the inscription (S)TEREGUSHCHIY, the name of a famous battleship that was torpedoed by the Japanese during the Russian–Japanese war of 1905. As the story goes, two brave sailors purposely flooded and sank the damaged ship to prevent it from falling into enemy hands. The Tsarist propaganda machine elevated these heroic sailors as an example of the virtuous self-sacrifice people were called on to make for Tsar and Fatherland, and erected a rather hideous monument to that effect in St Petersburg in 1911. This 'framing' of the sailors' heroism was, of course, also a subtle dig at the revolutionary soldiers aboard the *Potemkin*.

By depicting such a sailor (and, more to the point, himself) using his own revolutionary artistic idiom, Tatlin offered a commentary on the aforementioned monument, branding the sailors once again as revolutionaries, instead of self-sacrificing servants of the Tsar.[45]

Tatlin's self-identification as a sailor ran deep: for his entire life, he maintained the strict discipline that governed life at sea. This applied to the organizational rigour in his studios and his classrooms, and to his day-to-day life. He always lived frugally and was almost bereft of material possessions, as though he were always just passing through. Until his death, he would fold his clothes and wedge them underneath the mattress before bed, in the same manner that sailors do.[46]

During this period, he spent a lot of time with Mikhail Larionov, to whom he would later refer as one of his most important teachers. Larionov, in turn, understood Tatlin's great talent, and painted and sketched his portrait multiple times – an honour he rarely bestowed on anyone else.

In 1911 Tatlin was very active in the Tower, a communal atelier in St Petersburg that was also attended by many poets and theatre artists. There he befriended the poets Velimir Khlebnikov and Vladimir Mayakovsky, with whom he produced an artists' catalogue in 1912 and 1913.[47] Mayakovsky would go on to become the most famous poet of the revolution, but it was Tatlin's relationship with Khlebnikov that meant the most to him.

Khlebnikov was a timid, withdrawn figure. Neither money nor food interested him, and he rejected material comfort. Rodchenko once reported that Khlebnikov left the opulent bed in his two-room suite in Hotel Lyuks untouched, instead sleeping 'in a corner on the floor'.[48] That is, when he was even there – often he roamed the streets, or simply disappeared. He attached a note to the door of his room which said: 'visitors

Vladimir Mayakovsky, 1923. Velimir Khlebnikov, 1916.

from 11:30–12:30'. He developed an illogical and inconsistent system of numerology that he used to make all kinds of grandiose prognostications. Based on (frequently erroneous) historical data, he concocted a bizarre 'method' for predicting future catastrophes, including the following from 1912: 'From this we can expect the collapse of the state in 1917.'[49]

This combination of great poetic talent, propitious predictions and spartan non-conformity brought Khlebnikov a cult following that was instrumental in the development of the avant-gardist mentality. To many artists, and especially Tatlin, Khlebnikov came to be viewed as the benchmark and moral compass.

Though much has been written on the friendship between Tatlin and Khlebnikov, there is very little documented evidence of it – not even any correspondence. Almost all of the available information is second-hand. But despite the high degree of romanticization, it is undeniable that the two men felt an innate connection with one another.[50]

Formative Years

In the three years after meeting Khlebnikov, Tatlin experienced a period of rapid development that allowed him to rise up through the groups of avant-gardists. His success rested on a surprisingly limited artistic production: in 1911 he completed only eight paintings, and most likely

another eight in 1912. Of these sixteen paintings, only seven have survived – a pitiful number. Of the lost works that were listed in catalogues or exhibition critiques, the occasional vague reproduction in black and white has survived, but by and large only the titles of the works are known. These same catalogues also reveal that Tatlin usually exhibited fewer works than his direct colleagues and competitors. We can only guess at the precise reason for his limited output. Most of the surviving paintings were made on very cheap, flimsy canvas, and sometimes painted on both sides, which suggests a lack of available materials. Even the paper he sketched on was thin and inexpensive. These poor-quality materials testify to Tatlin's poverty, and also partly explain why so little of his work has been preserved. On the other hand, he was certainly not the only artist living in impoverished circumstances. Malevich was also poor, but far more prolific. Tatlin seemed far less capable of organizing his life in a practical sense, which is hardly surprising given his essentially bipolar behaviour and susceptibility to depression. All of these considerations remain speculative, however, for of all the other facets of his life – personal and business correspondence, and other archival materials – precious little has been retained.

Tatlin's disregard for his own past was also an artefact of his progressive mindset. More than any other Russian avant-garde artist, Tatlin believed that the conquest of the future was the only valid legitimization for the life of a great artist. Every innovation invalidated whatever had come before. In a certain sense, the mentality of 'after b, no longer a' underpinned the entire modern art movement from post-impressionism onwards, and demonstrated how closely the art world associated itself with the world of technology. Any technical innovation immediately rendered null and void whatever technology it surpassed, after all, and only nostalgic has-beens could possibly be interested in the obsolete.

In practice, however, most artists were primarily busy creating a body of work, even if they did value innovation above all else. Their artworks remained, to a greater or lesser degree, the reflection of their artistic life, the construction of a visual identity in the making. But not for Tatlin. More than anyone else, he was the embodiment of Ezra Pound's famous quote stating that the most important artist, the one at the top of the hierarchy, is the one who 'invents a new process, or whose extant work gives us the first known example of a process'.[51] In a sense, it is logical that such a person as Tatlin produced little work, since inventors only need to demonstrate a new process once in order to be the first.

The seven surviving paintings completed by Tatlin in 1911 and 1912 include the aforementioned *The Sailor (Self-Portrait)* and *The Fishmonger*.[52] They are both small but impressive works that are unquestionably among the greatest produced in Russia during that period – certainly no mean feat. In the subsequent year he completed two paintings that are larger than any of his other surviving work, and these were probably the most ambitious that he ever undertook. They are stylized nude portraits, and both build on two nudes completed earlier in 1911 and 1912. The first of the four nudes has been lost, but thankfully is still known due to a reproduction in a journal. As a series, the nudes trace Tatlin's artistic development, which can only be described as astounding. While the first still bears a close resemblance to the types of nudes being painted by the Matisse and Cézanne adepts around 1910, the second is already a typical Tatlin, and shows the influence on him of the Cézannes in the Shchukin collection. The second pair, from 1913, are mature, balanced, ambitious nudes that are admired the world over, and would be indispensable in any collection of pre-revolutionary Russian avant-garde art. The progression through the four portraits clearly demonstrates just how rapidly Tatlin could evolve as an artist, usually needing only several weeks to carry a new pictorial insight to its full conclusion, and doing so with the calm and authority of a seasoned veteran. During the same period, Tatlin made a long series of pencil sketches of nudes, both male and female, all of which use more or less the same technique to convert physical proportions into geometric relationships on the plane. These paintings and drawings also demonstrate Tatlin's aptitude for drawing and dynamically depicting the human figure. And this from a man who shortly thereafter decided never to paint again, since he believed that painting as an art form could never aspire to be a serious expression of the new age (Plate 8).

This conclusion can only have been preceded by a bitter internal struggle. Tatlin realized that his two nudes were also a swan song of sorts, as even upon their completion (which cannot have been any later than 3 April 1913), the paintings no longer reflected the latest trends. Wassily Kandinsky had already exhibited his abstract *Compositions* in Moscow in 1912, and Malevich's experiments in cubism were becoming increasingly radical. In this context, Tatlin's 1913 portraits and nudes – with their classical, academic choice of subject – came two years too late. In the summer of 1912, Tatlin suddenly broke contact with Larionov and openly turned against his former friend and teacher. According to pre-eminent Tatlin expert Anatoly Strigalev, Tatlin felt isolated, and fell into depression.[53]

Although little is known as to the precise cause, it would seem unmistakeable that his desire to extricate himself from Larionov's monolithic authority stemmed from his ambition to be a pioneer and a leader.

After breaking contact with Larionov, Tatlin moved into his own studio at 37 Ostozhenka Street, currently one of the most fashionable streets in Moscow. There he launched his own 'studio Tatlin', which would prove to be instrumental to the history of both the avant-garde and global modernism in general. All artists he invited to participate – probably half of whom were women – contributed to the rent. The space had no skylight but was otherwise very suitable. There was a second room with a wood-burning stove, where Tatlin slept. Every day, between ten-thirty and three, male and female nude models came to pose for paintings. Occasionally a still life would be constructed. The 'ascetic poverty' that dominated Tatlin's studio promoted concentration, and the studio quickly became one of the main hubs for the 'leftmost' artists.[54] The Vesnin brothers (who later became known principally for their architecture) worked there, as did Nadezhda Udaltsova and Lyubov Popova, both of whom had just returned from Paris.

Within the group, Popova stood out. She came from a very well-off family, and had even spent two years at a college for women at the university in Moscow. The fact that the most highly educated artist in the room was a woman says much about the social fabric of the group. Prejudices concerning heritage, educational background and gender seemed to be of no import whatsoever in the revolutionary milieu of the avant-gardists.

Tatlin asked his girlfriend at the time, the twenty-year-old artist Valentina Khodasevich, to move in with him, promising to 'scrub the floor, stoke the furnace and generally keep things tidy, as well as play the bandura. What say you?' Khodasevich agreed. 'With Tatlin, my soul felt calm,' she wrote, 'I believed in his sincere affection for me, in his beautiful works, and thought: how lucky I am!'[55]

The artists' community was small and close-knit. They were accustomed to criticizing one another's work openly, and did little to hide any dissatisfaction. When two female friends of Tatlin's, the sisters Anna and Sarra Darmolatova (a poet and sculptor respectively) expressed their utter dislike of his newest works, a deeply wounded Tatlin wrote to Anna: 'Sarra said decidedly, once and for all that my paintings are disgusting, and that she did crossword puzzles during the exhibition so as not to have to look at them. But you were kind, and said nothing.'[56]

The Rival

Now and then, the studio also welcomed another artist whose desire to dominate and lead was at least as great as Tatlin's: Kazimir Malevich. The two artists had already known each other for years and had shared exhibition space multiple times, but had never worked together in the same room before. Malevich undoubtedly made his presence felt, and most probably filled the space with his peerless and compelling rationales. Of course, the two men were interested in one another, and they were clearly on an equal footing. Perhaps they even spoke Ukrainian now and again, and the beginnings of a friendship emerged. If so, all traces of their budding amity were later carefully erased by both men. There are a few indications of their one-time friendship, however: Tatlin was one of the very few who called Kazimir by his nickname, 'Kazya'. And in the beginning, probably around 1913, he made a small pencil sketch of Malevich that, though caricaturesque in quality, nevertheless gives a solemn impression of Malevich's already palpable and dominant artistic personality.

Malevich later claimed that at the end of that year, or perhaps in early 1914, he gave Tatlin some lessons 'in cubism'.[57] This is a fabrication, despite Malevich's undeniable (and dogged) attempts to impress the value of cubism on Tatlin. Klyun recalled that 'Malevich and I explained in vain to Tatlin that it was time to embrace cubism. But he said no, saying that he had given the matter further consideration, but that he was right and his works were the greatest in the world'.[58] In other words, Malevich may have given him lessons, but they fell on deaf ears.

Truth be told, all of the artists present were constantly instructing one another, learning from each other and exchanging ideas. Popova and Udaltsova brought their experiences from Paris, and made cubist drawings in Tatlin's sketchbooks dating from that period.[59]

Exactly what transpired between Tatlin and Malevich at that time remains undocumented, but we know that those communal art sessions were when the initial resentment emerged between the Russian giant and the diminutive Pole – a resentment that would quickly grow into an irrepressible and often destructive competitiveness, and now and again flare up into blazing animosity. Was Malevich frustrated at Tatlin's intransigence, and his refusal to concede to what Malevich regarded as his undeniable truth? Did the Pole resent Tatlin's status as a natural born artistic talent, while he was the hard-working autodidact? Or did Tatlin feel threatened by Malevich's intellectual and discursive superiority?

Vladimir Tatlin, *Portrait of Kazimir Malevich*, 1913.

It is interesting to note that, during this period, Tatlin was still so poor that the Vesnin brothers frequently had to pay for his meals.[60] He therefore continued to search for ways to render his artistic activities financially viable without resorting to compromises.

In 1913, on his own initiative, he started work on the set for an opera, Mikhail Glinka's *Zhizn za Tsarya* (A Life for the Tsar). Working on set designs without a signed contract with a venue or theatre group was highly uncommon, but Tatlin seemed prepared to risk the investment. Working in the theatre was not only a long-time ambition of his, but also had the potential to provide a financial basis for his artistic practice.

Vladimir Tatlin, *Standing Nude*, 1912–14.

Many artists – including senior artists, and others with reputations far greater than his – relied on the theatre for their basic incomes (Plate 9).

Tatlin made open overtures to Mir Iskusstva and wrote an obsequious letter to Alexandre Benois, asking if he might honour his studio with a visit. As the only Russian artistic community, Mir Iskusstva had many direct connections to the theatre world, and Tatlin's participation in their 1913 exhibition can only be interpreted as an attempt to promote himself as a theatre designer. Benois was also a key adviser to Diaghilev, who at that time was taking Europe by storm with his ballet and opera productions. Tatlin was undoubtedly aware of his European triumphs.

The designs for *Zhizn za Tsarya* are astounding, and once again a testament to Tatlin's artistic gifts. But no theatres showed any interest. In that same year, Malevich did manage to score a coup with his Dadaist

Lyubov Popova, *Seated Figure*, 1914.

opera *Pobeda nad Solntsem* (Victory over the Sun). To make matters worse, Benois recommended not Tatlin, but Larionov's partner Natalia Goncharova to Diaghilev. She then received the commission for the opera-ballet *Le Coq d'or* (The Golden Cockerel), which represented the Russian avant-garde's debut on European stages in 1914. Tatlin had been overlooked on multiple fronts, and needed an innovation that would once again inspire those in his circle and reassert his position as leader.

His revelation came after a brief visit to the Paris atelier of Pablo Picasso in the spring of 1914. This meeting between Tatlin and Picasso later became the stuff of many myths and legends, but took place on a single afternoon, on either 24 or 25 March 1914.

Tatlin and Picasso

Despite his nautical history, Tatlin had never been to Germany or France, the two countries with which Russia maintained its strongest cultural ties. When he was invited to visit Berlin in 1913 and participate in an exhibition on traditional Russian folk art, he eagerly agreed, though under curious conditions: he was to present himself as an authentic Ukrainian bandura player. 'Life was very hard then,' he later explained, 'I heard... they were organizing an exhibition of applied Russian folk art, that was travelling to Berlin. They were looking for "live exhibits" and wanted a bandurist – preferably a blind one....I said: I can sing and be blind. They wanted to see, so I put on a show and they were satisfied. I sewed some Ukrainian knickerbockers, and practised my blind act. It was dreadful and I felt ill at ease, but I thought: with my eyes closed, I can get through it.'[61]

In the few surviving photographs of Tatlin's performance at the exhibition, his transformation seems utterly convincing. Tatlin's claims even seem plausible that the visitors 'tried to touch me and my embroidered shirt. A pair of well-to-do ladies democratically took my hand and thanked me. I said "Danke, Danke," kissed their smooth hands and peered at them through the slits in my eyes – some were quite pretty, though a little stodgy.'[62]

Tatlin's accounts of a supposed performance before Emperor Wilhelm II himself are generally viewed with greater scepticism.[63] In some versions of the story, the emperor appears only as a visitor to the exhibition, while in others he comes explicitly to hear Tatlin play. In Tatlin's most highly ornamented version, he was received personally at court, as a member of a large balalaika orchestra.[64] The facts, however, are these: Tatlin clearly negotiated the conditions of his performance, refusing to sing for five hours (as requested by the organizer) but agreeing to a maximum of three, and at fixed times.[65] That would have given him the opportunity to visit other artists and view the collections, which was of course the only reason he agreed to such a bizarre performance in the first place.

His main travel destination was not Berlin, however, but Paris, and specifically the studios of the artist who had become the sudden and sole focus of his monomaniacal attention: Pablo Picasso. Tatlin's sudden obsession with Picasso did not come out of the blue. Ever since the 1909–10 season, the movers and shakers in the art world had already pegged Picasso as the dominant model to be either emulated or rejected.

Vladimir Tatlin as a blind bandurist in Berlin, 1914.

Tatlin's studio-fellow Udaltsova described it as a 'Picasso epidemic',[66] the epicentre of which was, of course, Sergei Shchukin's Picasso collection that had so influenced Malevich. The hype spread far beyond the metropolises. Artist Kliment Redko recalled that in 1911 – when he was fourteen years old, and working at a Kyiv icon studio (hardly a location one would associate with a Parisian modernist) – Picasso's name was uttered with a kind of contemptuous respect.[67] Academic publications on Picasso also began to appear from 1913 onwards, and classes were given on his work. He was so in vogue in progressive circles, in fact, that Larionov, who believed that the Russian avant-garde too blindly followed the developments in Paris, said that 'we should no longer fight against Repin and Benois, but instead against Cézanne and Picasso'.[68] Conservative critics, on the other hand, described Picasso's art and

personality as 'a demonic and eschatological threat'.[69] This deliberate and fanatical rejection of Picasso by the 'right' only confirms how seriously he was regarded by the artists on the left.

Like Malevich, Tatlin had cultivated personal ties with Sergei Shchukin, who by 1914 would amass over fifty of Picasso's early cubist works. And though Tatlin regularly visited the collector's palace to study them, he was not directly motivated to meet Picasso or visit his studio. In November 1913, the journal *Les Soirées de Paris* published a long article on Picasso written by Guillaume Apollinaire. Tatlin's knowledge of the journal is almost certain: he was well acquainted with two of the five subscribers to the journal in Russia, Sergei Shchukin and the artist Alexandra Ekster.[70] The November 1913 issue did not publish any of Picasso's paintings, but rather reliefs known as *natures mortes*, constructed from wood scraps, cardboard and other materials. The article, and the accompanying illustrations especially, were what awakened Tatlin's resolute desire to seek a confrontation with these works and their creator.

After his performances at the folk art exhibition, Tatlin most likely left Berlin for Paris in late February 1914. This he did while still clad in his Ukrainian garb, and so he walked the streets in his embroidered shirt and home-made knickerbockers. According to artist Nadezhda Udaltsova, 'his primary aim was to meet Picasso, and the second, to find some proper clothes'.[71] His first guide in Paris would undoubtedly have come from the vast community of Russian artists: Alexander Arkhipenko, Sonia Delaunay, Marc Chagall, Jacques Lipchitz or perhaps Ossip Zadkine. Most lived and worked in the legendary artists' colony of La Ruche in Montparnasse. Picasso knew the Russian community in Paris very well, and was a frequent visitor to La Ruche. Most of the Russians would, therefore, have been in a position to arrange an introduction, and ultimately it was Lipchitz who presented Tatlin to Picasso.

Tatlin later concocted a colourful series of anecdotes surrounding his meeting with Picasso. In one version, he supposedly offered his services to Picasso as a servant. Yakulov was treated to a much more flamboyant version, in which Tatlin lingered outside the atelier as a blind bandurist, wearing dark glasses, in the hopes of being invited in by Picasso as a model. After inviting him in, Picasso briefly left the room, at which point 'Tatlin looked into the next room, where works were hanging from threads against various backgrounds, including a violin that had been sawn to pieces. Tatlin removed his glasses and started sketching furiously, but was caught in the act by Picasso, who madly chased him out of

the studio'.[72] Tatlin told this story to anybody who would listen, and his audiences took the 'comedy caper' as gospel.

In reality, the following occurred: Lipchitz took Tatlin to Picasso's studio and made introductions. An animated discussion ensued, Picasso gave Tatlin some tubes of paint as a gift, and the artists warmly took leave of one another. The entire visit probably lasted a couple of hours. The next morning Tatlin met Popova, who was also in Paris at the time and who relayed his account of the meeting on a postcard to Udaltsova that same day: 'Tatlin visited Picasso yesterday, and was in seventh heaven. He will be returning to Moscow very soon. Give him a call or pay him a visit, and he'll tell you everything. He liked Picasso very much, and Picasso took a great interest in him.'[73] That was all.

The First Reliefs

The culmination of this brief visit caused a great furore in the Russian art world. After returning home, Tatlin immediately began developing his new concepts. Forty days later, from 10–14 May, he opened his atelier on Ostozhenka Street every evening between six and eight o'clock for people to come and view the results of his intense productivity. He called his works 'synthesostatic compositions': small abstract artworks, reliefs constructed from wooden planks and waste materials. Every evening during this presentation, the futurist Sergei Podgaevsky would 'dynamically declaim his latest post-Zaumist records'.[74]

The studio exhibition was a great success, and during that same year, a cavalcade of artists including Lyubov Popova, Ivan Puni (who later became known as Jean Pougny in France), Yury Annenkov, Ivan Klyun and Olga Rozanova followed Tatlin's example, making reliefs that they displayed at various communal exhibitions. The fact that so many artists simultaneously broke out of the painted two-dimensional mould had far-reaching psychological ramifications. The traditional barrier between painting and sculpture had been torn down, and suddenly, any materials proved suitable for making art. Painting, which had occupied the topmost position in the hierarchy of fine arts since the Renaissance, thus tumbled from its pedestal.

While some artists followed Tatlin faithfully, others added their own personal touches. Annenkov applied collage techniques, and others added everyday items to their reliefs. Popova hung her reliefs in the corner of her studio, emphasizing their three-dimensional quality.

During that same period, Tatlin also started displaying his reliefs in corners instead of on flat walls (Plates 10, 11, 12).

In March 1915, at an exhibition he organized called 'Tramway V', Tatlin exhibited a number of new works that he now referred to as 'pictorial reliefs'. One of these probably contained kinetic elements.[75] The exhibition also featured cubist paintings by Malevich, but these now paled alongside Tatlin's radical constructions. Many others, including Malevich's faithful acolytes such as Klyun and Ivan Puni, now also made reliefs, signifying Tatlin's emergence as the new leader of the avant-garde. The term 'Tatlinism' was even bandied about with both admiration and horror, and there was a rumour that Sergei Shchukin had purchased one of Tatlin's pictorial reliefs for the astronomical sum of 3,000 roubles. Though untrue, it mattered little, as a number of furious newspaper articles were dedicated to the scandal – and that was what counted.[76] The ire in the press responses was directed exclusively at Tatlin, while Malevich's name was almost nowhere to be found.[77]

Tatlin's first reliefs were still very much indebted to those of Picasso, such as his *Guitar* (1912) or the *Mandolin and Clarinet* (1913). But unlike these Parisian antecedents, which were still cubist deconstructions, Tatlin's artworks were abstract, conceptual compositions, whose titles no longer referred to any visible reality.

It was clear to all that if Malevich (or anyone else) wished to lay claim to the leadership of this radical group of artists, then they would need to defeat Tatlin. And it was hard to imagine how anybody could conceive of anything more radical than his coarse, mysterious chunks of wood and metal that claimed to be high art.

Incidentally, Picasso's three-dimensional artworks were not the only source of inspiration for Tatlin's first reliefs. The painted planks he first exhibited were also a reference to traditional icons. The elementary materials – panels – along with their dimensions and colours allowed for simple associations with the religious works. This connection, too, contributed to the radical interpretation of these pieces.[78]

Although Tatlin was aware of the unique position he had adopted and of the value of his reliefs, still he retained a childlike vulnerability. Whenever he asked his friends for feedback on his work, their most minor criticism or the smallest suggestion of any imperfection would derail him completely. Then he would sit in a dismal silence in the corner of the room, refuse to drink tea, and become so consumed by self-loathing

Lyubov Popova's studio. Photograph by Alexander
Rodchenko, 1924. The relief in the corner is from 1915.

that he slept on the couch in the common room, since sleeping in the
same room with his reliefs had become impossible. When Vesnin's criti-
cism was once responsible for putting Tatlin into such a state, he 'very
nearly shed tears of pity'.[79]

One of his contemporaries summarized the group's fascination with
Tatlin as follows: 'We saw in Tatlin the shortest route to the autonomous
creation of quality, and quality of materials especially....We still had a
"graphic" approach to the material, in other words, our perception of it

was flawed. We needed Tatlin like we needed bread.'[80] Another historian wrote that Tatlin's followers 'idolized [him], and were prepared to fight for him'.[81]

The Lanky Leader

As Tatlin's reputation and creative abilities evolved, he simultaneously developed another character trait: paranoia, the unconquerable dread of being robbed of his creative ideas. All surviving memoirs about Tatlin are full of bizarre anecdotes involving his (ultimately quite destructive) distrustfulness. For the first few years, the situation was relatively manageable. According to Sofia Dymshits, Tatlin had 'screened off part of his atelier with a kind of tent...where he carried out his most groundbreaking work. His fellow artists were not allowed to look inside, and when he went out, he hid his works from potential thieves in another, secret tent.'[82] This dreaded, imaginary thief who was out to steal his ideas increasingly took on the form of a single man: Kazimir Malevich. During the day, Tatlin kept his curtains closed, just in case Malevich chanced to walk through Griboyedov Alley, where he was working at the time, and happened to look inside. The artist who documented this memory also noted that it would have been completely impossible for Malevich to glance through the window, because of the strip of garden separating the footpath and the building.[83]

Of course, Tatlin's fears were not completely unfounded. The art he was creating at that time was first and foremost conceptual, an idea, and ideas were far easier to steal than skills. Indeed, appropriation of ideas was a regular occurrence – Tatlin, after all, had created his reliefs by 'stealing' an idea from Picasso and developing it further. Even Picasso made no secret of the fact that he sourced his ideas from all sorts of places. Though, to be truthful, concepts such as 'stealing' and even 'adopting' are not applicable in this context. The artists were all grappling with the same artistic problems, asking comparable questions about the role of art in society and the evolution of visual expression. Independently of one another, sometimes even in full isolation, they developed extremely similar concepts in response to these questions. Their thoughts frequently moved in similar directions, and if they saw an original solution to a problem in the work of a fellow artist, they could simply take it as the starting point for their own ongoing development. This kind of cross-pollination was both ongoing and

Group photo: sitting with pipe, Vladimir Tatlin; immediately behind him, Ivan Klyun; beside him, in a white shirt and with a spoon hanging under his tie, Kazimir Malevich; beside Malevich, his wife Sofia Rafalovich. Extreme left, sitting, Natalia Katsman (née Rafalovich). The couple sitting to Tatlin's right are Maria and Yevgeny Rafalovich.

crucial to the success of the avant-garde. And while the artists of course understood this process, at the same time they wished to protect their ideas in order to preserve their image as innovators and leaders.

Malevich did indeed express a notable interest in Tatlin's work during this time, and there are some indications that he adopted certain aspects of Tatlin's newest reliefs. Malevich, too, kept his results hidden, except from a very small group of initiates. If ever he corresponded in confidence about his latest work, he would sign off with: 'Tear this letter apart.'[84]

That summer Tatlin was also invited to Malevich's in-laws' summer cottage, possibly on several occasions. He took his bandura along and would sing Ukrainian songs, sometimes joined by Malevich. It was on one such occasion that the only photograph that shows both artists was taken. They were in the company of Malevich's wife, his sister-in-law, several other family members and Ivan Klyun. The only copy of the photograph was in Tatlin's possession, but he kept its existence a secret, and

later denied with fierce outrage that it had ever been taken. He did admit that he had visited Malevich at the summer cottage, but claimed that he had dived fully clothed into the lake as soon as Malevich produced the camera to avoid having to appear in the same photograph as the dreadful Kazimir.[85] Nevertheless, he held on to the photograph as a cherished keepsake for the rest of his life, taking far greater care of it than of much of his own work.

What is certain is that at that time, the tensions between the two artists were already rising. Spurred on by Tatlin's success, Malevich was busy developing a new series of paintings and a new terminology: suprematism, the new leading 'label' intended to replace futurism. This new terminology was to be presented at the exhibition scheduled for late 1915: the 0.10 exhibition. The emergence of the term 'suprematism' cannot be viewed separately from the battle for leadership among the avant-garde. Malevich wrote quite unapologetically to a friend of his: 'I believe that "suprematism" is the most appropriate word, as it implies supremacy.'[86] In the summer of 1915, and perhaps earlier, Tatlin was also working to develop his reliefs even further and had already conceived of a name for them: *Kontr-relief* (counter-relief). His newest constructions were no longer hung vertically, but installed in corners, as though leaping out from the walls themselves. They were made of wood, metal, fabric, cardboard, paper, paint and other materials, and defied traditional means of classification. Because they were no longer confined to two-dimensional backgrounds, they were strictly speaking no longer 'reliefs', but nor were they sculptures, since they had to be viewed from a pre-determined perspective.[87] Their most salient feature was most probably the sense of dynamism they embodied, as though they were flying out from the walls, held in check merely by a few lengths of cord or steel wire.

Tatlin derived his final term, 'counter-relief' from the word *kontr-atak*, or 'counter-attack'. The works were, as described by his friend Sergei Isakov, 'expressions of tension and pressure. A "*kontr-atak*" must be greater in force than the regular attack to which it is a response; counter-reliefs are reliefs with a particularly pronounced tension.'[88]

Tatlin wanted to replace painting with an art form centred on the construction and physical perception of the material. It was not up to the artist to portray a world beyond visual reality – as Malevich strove to do – or to lay bare an 'immaterial' world. On the contrary, the purpose of art was to reacquaint modern society with the beauty and essence of

Vladimir Tatlin, photograph of a counter-relief (lost), 1915.

Reconstruction of Tatlin's counter-relief of 2015 by Dmitry Dimakov, 2006.

the material world, to allow for a renewed perception of reality and liberation from the isolation brought about by modernization and industrialization. 'Material, volume and construction,' he later wrote, 'became the basic principles. Distrusting the eye, we subject it to tactile verification'.[89] With this final phrase, as cryptic as it is explosive, Tatlin casts a fundamental doubt on the purely visual both as a means of expression and as the supposed culmination of the artist's being – a doubt that would plague the Russian avant-garde forever. Perhaps this was the most revolutionary aspect of Tatlin's new concept: the implicit rejection of painted art as the dominant artistic medium. His emphasis on the tactile sense also suggests that it was permitted to touch the reliefs – yet another reference to religious icons, which unlike secular artworks were routinely touched and even kissed by the faithful. Of these revolutionary counter-relief artworks, a single example survives. The others disappeared, or are known only from photographs, some of which were used to create reconstructions long after Tatlin's death.

Malevich was well aware of Tatlin's progress, and meticulously prepared his own *kontr-atak*. The exhibition's backers, married artist couple Ksenia Boguslavskaya and Ivan Puni, were patrons to Malevich, who was therefore able to exert significant influence over the organization of the 0.10 exhibition. Initially, he attempted to prevent Tatlin's participation entirely. One of the artists remembered that 'Tatlin was subjected to draconian conditions, and was forbidden from showing reliefs. When several artists...threatened to withdraw as a result, the organizers changed their minds, and Tatlin showed his reliefs after all.'[90]

Both Tatlin and Malevich prepared pamphlets in which they explained and promoted their respective contributions to the exhibition. Malevich's text, however, issued a not-so-subtle dig at Tatlin. He categorized Tatlin's reliefs as an extension of cubo-futurism, a movement that Malevich characterized as outdated and therefore obsolete. He also made use of the new terminology – counter-reliefs – before the term had even been introduced by Tatlin himself. By appropriating this new nomenclature and historicizing it immediately, Malevich effectively presented his own innovations as the bright, shining future, and Tatlin's latest work as the withered past. Several months earlier, perhaps even in the summer, Tatlin had evidently told Malevich about his counter-reliefs, and Malevich immediately made use of the information to issue a public attack. Tatlin's suspicions were thus not entirely unfounded.

Malevich may have also picked up other 'secrets'. Tatlin's counter-reliefs were installed in the corners of the room, in much the same manner as Russian house icons were hung. The reliefs were already perceived as modern icons, and their positioning in the corners strengthened this association. Was it therefore a coincidence that Malevich's most radical artwork, *Black Square*, was also installed in the corner, so clearly stylized as an 'icon'?

There is a second reason to suspect that Malevich applied Tatlin's innovations to his own work. When planning his *Black Square*, he went in search of black paint with a matte, velvet-like effect. Ordinary oil paint gave a glossy finish. Recent research into the chemical composition of the black paint used in Malevich's 'iconic' work has revealed that the desired result was ultimately achieved by mixing black oil paint with shellac or 'French polish', a substance used to varnish furniture. It was a curious choice, as French polish was not a staple of artists' studios. The only artist known to have made extensive use of French polish in his work was Tatlin.[91]

As previously mentioned, mutual inter-borrowing was part of the avant-gardists' day-to-day practice. Tatlin encouraged his followers to make use of his innovations. The adoption and ongoing development of ideas was simply a consequence of the transition to a conceptual approach to art, which was being brought to fruition by the Russian avant-garde. The difference here was that Malevich appropriated others' ideas without any acknowledgment – more than that, he even criticized and belittled Tatlin, contesting his position as leader of the avant-gardists, and as a result fuelled Tatlin's distrust and resentment. Ultimately it matters little, however, as no matter how much he 'borrowed' from others, nobody will ever dare to suggest that Malevich was anything other than a completely original artist.

The opening of the exhibition was dominated by the rivalry between the two artists and their supporters, who squabbled like children for territory in the exhibition space. The suprematists hid paintings away so that they could later surreptitiously hang them up among the works of Tatlin's followers. Tatlin then demanded that large screens should be interposed between the allocated spaces, to keep away intruders from the other side. He also delayed endlessly before hanging up his works, so that by five in the afternoon, he was still not finished. He did so intentionally, so that the installation of his most important reliefs became performance art: 'He arranged them while the public was

walking in, standing on a ladder, thus attracting their attention and interest.'[92]

Malevich's approach was more effective, however. He placed one of his comrades by the door to intercept the journalists, and funnel them toward the suprematist areas. Although the avant-gardists themselves saw the exhibition as a shared triumph by both Malevich and Tatlin, the press attention was more focused on Malevich, not only because of the unscrupulous manner in which he promoted his art, but also because he exhibited far more artworks: thirty-nine to be exact, nearly three times as many as Tatlin. Even though Tatlin had more follow-ers, this fact is what allowed Malevich and his group to dominate the exhibition. Moreover, the arrangement of his contributions – two walls of suprematist works, flanking the *Black Square* in the centre – was carefully considered and theoretically sound, unlike Tatlin's disjointed presentation of his reliefs. 'Malevich's great advantage,' wrote one historian, 'was his theoretical gift, his ability to provide conceptual justification for his methods, and to explain them in the form of lectures, polemic brochures and manifestos'.[93]

Though Malevich bore the brunt of most of the anger and vitriol in the press, Tatlin was not entirely spared. An anonymous critic from the conservative and anti-Semitic newspaper *Golos Rusi* (The Stem of the Rose) wrote the following about the space where the works of the Tatlin group had been hung: 'I fear the end that awaits them. These walls are lined with the extreme limits of human morality. Beyond them is where the road to theft, murder, pillaging, prison camps and hard labour begins.'[94] No bones about it.

At the dinner following the opening of the 0.10 exhibition, the two artists came to blows. Tatlin, who could not resist pointing out the slight difference in station between himself and Malevich, said: 'That boor insulted me,' and threatened to withdraw his works – and those of Udaltsova and Popova – from the exhibition. Udaltsova and Popova did not agree. However, the entire group of artists was divided into two camps, and to antagonize Malevich, Popova put up a sign in her section of the exhibition, reading: HALL OF PROFESSIONAL PAINTERS.[95]

Frictions arose once again one month later, when a symposium was held in Lev Bruni's apartment in Petrograd. Attendance was high, and the guests numbered not only artists, but also poets and authors (includ-ing Osip Mandelstam and Viktor Shklovsky), as well as a composer, Arthur Lourié. Malevich took the opportunity to present a boisterous

defence of suprematism. According to Punin, 'he convinced everybody with his astonishing, hypnotizing and compelling speech; he spoke with the sharpness of a rapier, his words incisive and his thoughts on the razor's edge'.[96] And so Tatlin, who could not be persuaded to speak before an audience, was drowned out once again. He had arranged for his entire posse to be there, so they could 'shout from their seats if Tatlin was maligned',[97] but when it came to representing themselves before Petrograd's artistic elite, Malevich was resplendent and Tatlin invisible. As though turning his silence into a manifesto, Tatlin even forbade Udaltsova and Popova from 'uttering a single word about their art in the presence of critics'.[98]

It was in this tense situation that he met Rodchenko, who eagerly accepted Tatlin as his leader. Rodchenko proposed organizing a new exhibition in Moscow, and after some token demurrals – 'I already have grey hair', 'I am acknowledged by no-one' – Tatlin accepted.[99] This time, however, he was in charge of the organization, and was better able to control the flow of events. With the exception of Malevich and Klyun, the list of artists consisted exclusively of himself and his followers, and of artists trying to maintain some kind of neutrality. Besides Tatlin, reliefs were also shown by Bruni and Sofia Dymshits-Tolstaya, who would soon become his new romantic partner.

During the opening, however, it was Malevich once again who provocatively sought attention. He had written '0.10' on his forehead, and beneath one of his paintings (and on his own back) he attached the text: 'I, the apostle of new concepts in art and the surgeon of reason, have taken my place on the throne of creative pride, and hereby declare academia to be the show ponies of the bourgeoisie.' Tatlin took the bait, and had Malevich removed from the exhibition because of his text and the 'propaganda of suprematism', whereupon Malevich and Klyun removed their paintings with great commotion. All of this showed that Tatlin was simply no match for Malevich's strategic propaganda.[100]

The Stern Singer of Propellers

In 1916 Tatlin continued to make counter-reliefs, but also produced abstract paintings on thick wooden boards. To Tatlin, the year was primarily one of reflection. Malevich may have surpassed him as the most boisterous and visible of the avant-garde artists, but among his immediate fellows and the few theoreticians of note, his position was

Nikolai Punin and Anna Akhmatova.

unchallenged. In that same year, Khlebnikov introduced Tatlin to the influential critic and theoretician Nikolai Punin,[101] who fell in love with Tatlin's works and regarded him as the most important artist of his generation. He started publishing articles about him, and quickly became his theoretical alter ego. This development was quite significant, as Tatlin had no aptitude for theory whatsoever, and theoretical discourse had become an important weapon in the battle for supremacy among the avant-garde. Punin thus dominated the historical perception of Tatlin – which was not always a good thing, as he was blind to certain aspects of Tatlin's artistic personality (such as his propensity for the theatrical and the absurd). His dedication to the artist, however, was unquestionable. Punin wrote:

Tatlin's giftedness clearly superseded that of almost all his contemporaries. He was possessed of a completely pure, individual and highly developed taste. Even today, I am still convinced that nobody could compete with his sense of quality. To us, every one of his judgments, every thought he expressed about art, paved the way to a new culture and into the future. We could do nothing other than listen to him, and adapt our individuality to this enormous machine that breathed energy, exploding the centuries-old layers of artistic tradition.[102]

It is important to note that Punin was no easily swayed newcomer, but himself an influential intellectual who wrote for the country's leading journals. He was friends with many artists and poets, including Osip Mandelstam, Velimir Khlebnikov and Anna Akhmatova, the celebrated poet with whom he had a romantic relationship for many years.

Immediately following the revolution, Punin started flirting with proto-fascist theories, and co-authored a brochure titled 'Against Civilisation' in which he outlined a system of utopian purism. In it, he described a desire for cultural homogenization that would later lead to the unification of culture and race. It was highly unpleasant. Thankfully, he never returned to most of these theories (and immediately abandoned his prattle about race); however, the embryonic vestiges of a fascist mindset can still be found here and there, such as when he ascribes 'a revolutionary will' to Tatlin, defining him as pure 'simplicity, completely untainted and organic'.[103]

Punin attempted to immortalize Tatlin's enigmatic narrative talent in his writings about the artist.

We spoke quickly, and I listened carefully to him. He painted with broad strokes, was ruthless with regard to the past, took no prisoners, and looked ahead with such a calm grandeur. When our conversation was over and I stood up and left, my footsteps no longer seemed my own, but those of some unfamiliar, heavy gait, and I seemed not to walk through space the way we normally do, remaining almost in place, no, I advanced, I was walking through time, from this moment into the future, and it seemed that the future surrounded me with a tranquil peace...[104]

He was convinced that Tatlin's latest work had opened the way to a new consciousness, to a new understanding of life's deepest truths. 'Only via Tatlin's reliefs,' Punin wrote that year, 'can we experience the true worthlessness of the worldly. Part creativity, part beauty, part truth....It is the

only way. Let the soul become Relief. The Relief is the only true and suitable state for a proper soul.'[105] Keep in mind, however, that Punin wrote these high-minded musings not in a manifesto or polemic brochure, but in his personal diary. These were intimate thoughts expressing his most personal insights.

Shortly beforehand, Khlebnikov had expressed his own vision of Tatlin and his counter-reliefs in a poem: a mini-excursion into Tatlin's universe. Khlebnikov combines references to his sailor's past (paddles, screws, rigging) with the reliefs (rigging, horseshoes, knots), and his disguise as a blind bandurist with his true calling as an artist:

> Tatlin, the oracle of blades
> And stern singer of propellors
> From the Suncatchers-squad.
> His dead hand tied a cobwebbed dale of gear
> with an iron horse-shoe
> Into oracle tongs.
> Dumb-struck blindmen
> Stare at what he showed.
> So unheard of are the things
> The tin things, handmade.[106]

From the February revolution onwards, Tatlin became politically more and more active. He led the leftist branch of the newly established union of artists, and played an important role in their many meetings. He never said much, but exerted his influence through his reputation and the dedication of his devotees. Like many others, he felt a natural connection between futurism and the revolution. 'In a conversation with Tatlin,' Punin wrote, 'I pointed out the socialist character of futurism, and I can happily say that he supported my view. The socialist nature of futurism does not, of course, lie in the fact that it is intended for every working-class person, but rather that the totality of aesthetic sensations developed by socialism is implied or expressed by futurist art.'[107] Here, Punin makes a very profound observation by identifying the objectively nonsensical but easily perceived affinity between avant-garde art and the socialist revolution. And he also quickly realized – far sooner than many others – that an affinity between this art and a popular revolt did not necessarily have to produce popular art.

When the revolution broke out, work on Pittoresk was put on hold and Tatlin mostly spent the days at home with his new girlfriend, Sofia

Vladimir Tatlin, portrait drawing of Velimir Khlebnikov.

Dymshits. During those October days, Tatlin and Khlebnikov saw one another on several occasions. Khlebnikov had lost his lodging, since Hotel Lyuks had been beset by the Bolsheviks, and so he roamed the deserted streets of the capital.[108] The poet described the curious atmosphere in the city thus: 'We rushed outside. The cannons had fallen silent. We ran through the city streets like children after the first snowfall, looking at the frosty stars of the bombarded windows and the ice-flowers surrounding the cracks of bullet holes; we wandered through the shards of glass littering the Tver, clear as ice. Ah, those first few hours. We collected bullets that had ricocheted from the walls, gnarled and twisted, like the bodies of scorched butterflies.'[109]

Though Khlebnikov and Tatlin often maintained silence in public, when they were together they could talk for hours. It was during these times that they decided to organize their performances. Dymshits described how on one such day, Khlebnikov 'came for a visit' in Tatlin's small apartment. 'It turned out that Khlebnikov wished to appoint "Presidents of the World" for all the artistic disciplines, and Tatlin had been chosen to represent the visual arts. So Khlebnikov, at one of the most decisive moments of the revolution, came to discuss the candidacy with Tatlin and ask for his approval. And so they sat upon the

Velimir Khlebnikov, portrait drawing of Vladimir Tatlin.

window-sill, with the orange afternoon light behind them, both lean and with long noses, two Don Quixotes absorbed in a discussion about matters of universal art.'[110]

Once the situation had normalized somewhat, work on Pittoresk was resumed. And though the work initially seemed menial and Tatlin was forced to work in Yakulov's shadow, the entire Pittoresk project did help Tatlin to realize two very important things: firstly, that the skills he had developed while making his reliefs could be applied to the design of objects and large spaces; and secondly, that he was not only an autonomous artist, but also an effective designer and foreman. His artistic gifts could be used for practical purposes, and he undoubtedly foresaw that the new age would be less tolerant of artists in ivory towers. His rejection of two-dimensional painted art opened up an entirely new paradigm of possibilities, which could only result in great excitement.

Given that Pittoresk was not yet finished – or at least not yet open – the artists needed a plan B for their New Year's festivities. At seven o'clock on 30 December, in the large auditorium of the Polytechnic Museum, a grand 'Futurists' Christmas Ball' was held, where everybody gathered: poets, artists and admirers alike. The announcement read: 'An evening extravaganza of the very best, unbridled poetic creativity. Chaired by the

celebrities David Burlyuk, Vladimir Goldschmidt, Vladimir Mayakovsky, etc. Bacchanalia. Speeches. Paradoxes. Discoveries. Opportunities. Oscillations. Predictions. An ambush of geniuses. Carnival. A flood of ideas. Laughter. Tears. Politics. Those wishing to come and adorn the futurists' Christmas tree are kindly requested not to bring children. Tickets sold daily.'[111]

Tatlin was also in attendance. Although all the tables were full when he arrived, one was made free for him. Some time later Mayakovsky, who recited poems from the stage, caught sight of Tatlin, and cried: 'We are visited today by the creator of the reinforced-concrete counter-reliefs, the genius artist and futurist, Vladimir Tatlin!' The audience applauded and Tatlin bowed. Mayakovsky threw signed copies of his poetry collection *A Cloud in Trousers* to the hysterical masses.[112] Outside it was freezing, but inside the packed auditorium it was 'hot, like the inside of a bathhouse'.[113]

Thus ended the revolutionary year of 1917.

Tatlin was now widely admired and revered. Many suspected, himself included, that a critical role had been set aside for him in the formation of the new Russia. 'We had been waiting for Tatlin,' Punin later wrote, 'as one awaits a phenomenon capable of meeting all expectations and pointing the way forward. We waited as one waits for a leader.'[114] It would be a little over three months before he was officially assigned that role, and eight months before it would force him into confrontation with a Vladimir of a very different kind: Lenin.

3

A White Revolution
November 1917 – March 1918

In the first few months following the October revolution, as the avant-gardists attempted to gauge their position within the fast-changing political landscape, they also continued to work on their artistic projects. Tatlin constructed his reliefs and pursued his theatre interests. Malevich completed a new series of artworks in which white geometric shapes were superimposed onto barely distinguishable white backgrounds. These 'white-on-white' paintings are quasi-ephemeral, benign works that contrast sharply not only with most of his mature works (which are about as subtle as a gong-strike), but also with the time in which they were produced: a period of chaos and suffering almost unprecedented even in Russia's turbulent history. The Bolsheviks' rise to power in Moscow and Petrograd was not the end of the Bolshevik revolution, after all, but merely the beginning, and would ultimately culminate in a devastating and bloody civil war.

On 27 October 1917, even before the Bolsheviks had taken Moscow, Lenin instigated a blanket censorship of the press – one of his first ever political measures. The Bolsheviks had already shut down the capital's ten largest newspapers the day before. The censorship brought a drastic end to the full freedom of the press that Russia had enjoyed since 1905. Between October 1917 and August 1918, the Bolsheviks closed down over 460 daily publications,[1] an act that was quite at odds with the complete press freedom they had been promising for years.

For the first few weeks, implementation of censorship was disorganized. Prohibited newspapers simply took on new names and continued as normal. When *The Day* was shut down, its owner re-registered it the following day as *Night*. It was closed again several days later and its back editions burned, after which the paper once again registered itself as *Midnight*. After the next prohibition it was re-registered as *In the Depths*

of the Night, and then once again as *Dawn*. It survived in this manner until the end of November, at which point its time was finally up.[2]

On 9 November, the Bolsheviks announced the formation of several People's Commissariats, or centralized executive government bodies. This act was at odds, yet again, with their key platform promises, namely to 'surrender all power to the soviets' and to disband the ministries. The soviets were small local administrative bodies (councils) and the Bolsheviks' political platform had advertised a decentralized model of self-government.

On 22 December, the Bolsheviks entered into peace talks with Germany, which would eventually culminate in the Treaty of Brest-Litovsk on 3 March 1918. On 19 January they dissolved the Constituent Assembly – which had been convoked as the highest democratic body in the revolutionary state – when it transpired that the Bolsheviks only obtained 25 per cent of the seats.

All of these measures, adopted during the first three months after seizing power, demonstrate both the Bolsheviks' radical resoluteness and their willingness to consolidate power at any cost, and via measures that were at odds with their most cherished principles if necessary. According to Karel van het Reve, Lenin's greatest quality as a politician was that he never 'fell victim to his own ideology'.[3] This may be true, but the purpose of Lenin's political opportunism was still to implement as many of the radical aspects of his agenda as possible. The day before the Decree on Press, on 26 October, the Bolsheviks announced the Decree on Land, which legalized the seizure of land by farmers and declared private ownership of land illegal. On 2 November, at roughly the time when the Kremlin finally fell into the hands of the Bolsheviks, Lenin published the Declaration of the Rights of the Peoples of Russia. It enshrined the right to self-determination, secession and the formation of a separate state for all peoples living in Russia.

On 16 December, the Decree on Divorce was issued, granting either partner the individual right to divorce regardless of sex or reason. Centuries of domestic patriarchy were thus undone with a single penstroke.[4] Banks and heavy industry were nationalized, the law of succession was abolished, and homosexuality was decriminalized.

Through these measures, the Bolsheviks demonstrated a great affinity with symbols of revolutionary change. On 1 February 1918, the young Soviet state leapt over thirteen days in a single bound, skipping straight to 14 February, when the Orthodox Julian calendar was replaced with the Gregorian calendar used throughout Europe.

Inaugural sitting of the revolutionary government, Petrograd, November 1917, with Lenin at the centre.

Almost immediately after the October revolution, chaos erupted throughout the country. Groups of uprooted farmers, returned soldiers, gangs of criminals and anarchists plundered estates, houses and palaces, and everywhere old scores were settled with rage and violence. Anti-Bolshevik powers, monarchists, republicans and liberals all started organizing and militarizing themselves. The Bolshevik militias, known as the Red Guard, tried to re-establish order; however, the situation remained unstable – at least in Petrograd and Moscow – throughout the winter of 1917–18.

While the anti-Bolsheviks were organizing themselves into an unbalanced and motley coalition of 'Whites', in January 1918 the Red Guard was reformed into the Red Army, and compulsory military service was introduced. Terrorism quickly escalated on both sides, leading to both 'White' and 'Red' atrocities. Even while the rumour spread that the family of the deposed Tsar Nicholas II had found a safe haven in Nagasaki, on 17 July 1918, in Yekaterinburg, the imperial family was executed with guns and bayonets.[5]

Acts of terror were carried out not only by the army and the All-Russian Extraordinary Commission (the Cheka), but also by groups of

rioters. These were tolerated and sometimes even encouraged by the Bolsheviks, and could even develop into lynch mobs. Lenin – after losing his temper at Zinovyev, whom he found to be too lenient as the party leader in Petrograd – demanded that the 'massality of terror' ought to be encouraged: 'Comrade Zinovyev! Only today did we hear in the Central Committee that the workers wished to respond...with mass terror, and that you...held them back. I most strongly protest! We thus compromise ourselves: even the resolutions of the workers' and soldiers' councils threaten terror, but when it comes down to it, we are weighing down the – completely justified – revolutionary momentum of the masses. It is im-pos-si-ble!...We must encourage the energy and the massality of terror....See you! Lenin.'[6]

One month later he gave the order to 'immediately initiate mass terror, execute and deport prostitutes, groups of soldiers, former officers, etc.' He also ordered 'mass house searches, and death by execution for possession of weapons. Mass deportation of Mensheviks and those who cannot be trusted.'[7] The resistance to the old regime thus quickly evolved into a war on any perceived opposition. Social life was completely politicized, contributing to general radicalization; the growing tolerance for violence and for disrespecting people's rights to privacy promoted demoralization and a general lowering of ethical standards.

The terror penetrated all layers of society, and the artists were not spared. A younger brother of David Burlyuk, Nikolai, himself a futuristic poet, was arrested and executed after a sorry excuse for a trial. Vadim Shershenevich, another futuristic poet, was arrested but later released.[8]

Another purpose of the hard-hitting, radical and violent acts of the Bolsheviks was to conceal their lack of any bureaucratic power base. Almost none of the leaders of the Bolshevik party had visited the Russian capitals in years. Lenin had spent the ten years prior to the revolution in Europe; Trotsky had done the same since 1911, and Stalin had lived in exile in Siberia from 1914. They were administrative amateurs, knew no highly placed officials or people of authority, and were unfamiliar with government procedures. Their only acquaintance with judges and prosecutors had been as defendants, and they had no trust whatever in the existing civil service channels. They had obtained power and a considerable public mandate, but when it came to national governance, they had no means of propping themselves up other than their iron-clad conviction, their bold sense of action and their willingness to resort to limitless violence.

The Avant-Garde and Bolshevism

Many avant-gardists felt a calling to play an active role in the administration of the new revolutionary state. This does not mean that they supported the measures taken by the Bolsheviks, or even the Bolsheviks themselves. The avant-gardists viewed the revolution first and foremost as a large-scale social (and in some cases even spiritual) upheaval, not as the victory of any one specific party. Many believed that the reign of the Bolsheviks would be but one more transient phenomenon; others rejected it categorically. Nadezhda Udaltsova described the initial days of the 'Bolshevik revolution' as follows: 'For three days now bullets have been zinging, machine-guns blasting, bombs exploding, it is like a city under siege, there are piles of dead and injured, and nobody knows why....There have been rumours of pogroms....The poor now want nothing more to do with the well-to-do. They will eventually start shooting at each other....People should have agreed not to start their riots in cities, but to go fight it out in a forest somewhere.'[9]

However, there was also public enthusiasm for the October revolution, and the 'joyous light of freedom' that it would bring (according to David Burlyuk).[10] Another futurist, the poet Vasily Kamensky, wrote that the first days of the revolution were 'terrifying, new and joyful'.[11] Burlyuk and Mayakovsky joined Kamensky to form the 'Flying Federation of Futurists', and released a single-issue newspaper: *The Futurists' Gazette*, which was handed out to passers-by during a wild performance on Kuznetsky Most (the same busy street that was home to Café Pittoresk). The paper was presented as 'pieces of young, raw art', that the public was invited to 'eagerly tear to shreds'. In it, Mayakovsky published an 'Open Letter to Workers', explaining why futurism was the direct artistic counterpart to the political revolution:

> In terms of its substance – socialist-anarchism – the revolution is unthinkable without a revolution in the form of futurism. ...
>
> Nobody can know what immeasurable suns will illuminate the future. Perhaps artists will transform the grey dust of the cities into rainbows of a hundred different colours; perhaps the thunderous music of the volcanoes, having transformed into flutes, will be audible from the mountain ranges; perhaps we will be able to convince the ocean waves to strum the networks of strings stretched between Europe and America. But one thing has become clear to us: the first page of the newest era of art history has been revealed.[12]

Of all the leading futurists, Mayakovsky certainly felt the greatest affinity with the Bolsheviks, although he never named them explicitly and referred to the October revolution as a socialist and anarchist event. Even to him, embracing the revolution was not synonymous with acknowledging or supporting the Bolsheviks. Whatever the avant-gardists thought of the Bolsheviks, the radical artists all shared the conviction that a revolution was inevitable, and that they had an important part to play in it.

This direct revolutionary engagement, the acknowledgment of the October revolution as a necessary and/or inevitable stepping stone on the road towards a genuinely new society, would seem a sufficient explanation as to why the artists started occupying high official posts in the cultural bureaucracy of the Soviet Republic from April 1918 onwards (see

Vladimir Lenin in Zakopane, August 1914, shortly after his release from a Ukrainian prison.

Chapter 4). Such logic is deceptive, however. The coalition between the avant-gardists and the Bolsheviks was anything but amicable – as we shall see – and in the winter of 1917–18, there seemed to be more driving them apart than bringing them together.

A general belief persists that, after the revolution, the Bolsheviks immediately embraced the avant-garde. This erroneous portrayal of events was first established in the 1960s, in art history books, documentary voiceovers and museum labels. Over the last twenty years, various studies have either thoroughly debunked or at least nuanced this view, yet it continues to raise its stubborn head, even in scholarly publications.[13] In 2009, a Tate catalogue referred to 'the Bolshevik ambition of modernising the country with the aesthetic of the avant-garde'.[14]

Neither the Bolsheviks nor the avant-garde were homogeneous, and any thorough analysis of relations between the two groups must be rich with nuance. But, as the following will reveal, the majority of Bolsheviks – in both upper and middle management – retained an explicit hostility toward futurism...if they even knew what it was.

By the end of the year, Kazimir Malevich had already lost his position as interim commissioner of the Kremlin. In a certain sense, this was typical of the chaotic circumstances that reigned during the initial months following the revolution. People applied voluntarily to the new rulers to offer their services, or simply took on public duties themselves. In such a situation, roles and staffing profiles alike quickly became fluid and blurred. Occasionally the situation was extremely chaotic: whoever turned up to a meeting could take decisions, and whether they would be carried out was utterly unclear. Committees had overlapping realms of authority, or even competed with one another for jurisdiction. Malevich's power base, the Moscow Soviet of Soldiers' Deputies, had already merged with the Soviet of Workers' Delegates and morphed into an administrative entity, and Malevich faded into the background.

A Futuristic Carnival

Most radical artists had few financial or other reserves to fall back on, and were immediately affected by the ensuing general shortages. There was a lack of food, fuel and all basic needs. Food was rationed by stamps valid for 'one-eighth of a pound of bread' (approximately 60 grams), which, according to one artist, 'was eaten in a single sitting, and not a

single crumb remained at home, no sugar, no tea. Sometimes, instead of bread, we got half a pound of oats.'[15] Artists shared tips for obtaining food; a recipe circulated for how to make coffee from roots. They shared information on how to recognize counterfeit currency, and tried to sell whatever art they could. The starvation began in the countryside, but slowly crept into the city via the suburbs. According to Nadezhda Udaltsova, whose diary is replete with fear of hunger, illness and violence, 'the hunger moved with gigantic strides…a genuine catastrophe awaits us'. And one month later: 'The hunger is getting closer and closer.' Peace had not yet returned to the streets, and riots and shootings were still regular occurrences.[16]

However dire their need, the avant-gardists continued to gather in the clubs and cafés, where they brought their own food (if there was any), held discussions and relaxed together. The café owners had either disappeared or been chased away. The magnanimous patisserie mogul Filippov fled to Brazil with his family, but Yakulov remained the artistic director of his Café Pittoresk, where Meyerhold continued to stage shows and produce performance art. Poets gave recitations, and anyone who was anyone had to be seen there. Although entry was now 'by invitation' and people could no longer just wander in, the new policy reinforced the notion of an exclusive 'club', and the halls were full every night.[17] According to Ilya Ehrenburg, it was 'a genuine, modern-day mecca, the only club that was the envy of all the artistic cesspools in the European capitals'.[18] Myriad artists' diaries and memoirs contain descriptions of the nights at Pittoresk:

> The hall was lively. Smoke, that drifted up to the ceiling, obscured the colourful murals and the painted glass roof. Huddled together, people debated one another dressed in felt boots, greatcoats, soldiers' boots with gaiters, tanned sheepskin jackets or simply in rags. The floor was littered with the wrappers of bread that people had brought with them, many ate their evening meal here. There were empty glasses of curdled milk and not a single crust of bread on the marble tables, only the glittering of the tin chandeliers – if the lights were on – or of candles in bottles. So glorious was the Parnassus of that time![19]

The nearby Poets' Café was where the 'life-futurist' and 'first Russian yogi' Vladimir Goldschmidt held his performances. He was a new face in Moscow, but became acquainted with Mayakovsky, Burlyuk and other

futurists in 1917. The Poets' Café had also been owned by Filippov, who made Goldschmidt his protégé and offered him permanent accommodation in Hotel Lyuks on the Tver Boulevard. Immediately following the October revolution, Filippov (evidently in a panic) is said to have sold the café to Goldschmidt for a pitiful sum.[20] This muscular giant, with unbuttoned shirt and a gold chain dangling on his chest, was known for giving yoga classes, splitting wooden boards in two on his forehead, showing his penis on stage, loudly declaiming his lines of futuristic poetry, and hypnotizing soldiers to make them sleepwalk. Some accounts say that he cross-dressed while doing so, 'powdered and with a woman's décolletage', or 'with his hair dyed gold'.[21] At the conclusion of such a performance, they would 'bring the life-futurist a large roasted potato on an enormous platter, which he would insert whole into his mouth and eat'. Then he would take the platter with both hands, hold it as far from himself as possible, then slam it into his forehead. 'The head of the first Russian yogi was unharmed, while the platter shattered into many pieces.'[22] He called these performances the Path to Beauty. Exactly how one came to tread this path, one sceptical contemporary wrote, remained 'Goldschmidt's secret'.[23] Others were more impressed, and believed that Goldschmidt had the power to hypnotize entire regiments.

There was a dancer who often performed alongside Goldschmidt, Yelena Buchinskaya. She appeared on stage (and often elsewhere) in a long, wide gown with bare arms and feet, her brown hair covered in grey ash. This 'bare-footed futurist' danced not only to music, but also to declamatory poetry. Sometimes she recited the poetry herself while kneeling, and accompanied her words with graceful arm movements. These she called 'word sculptures'. Later in the evening she would dance on the club tables with other female friends, occasionally even leaving her clothes on.[24] The surviving descriptions of her dancing paint a fairytale picture of carefree joy. 'Once, in the middle of the night, when most of the people had left and only our little circle remained, Buchinskaya danced naked on the table, where candles had been placed all around the long edges.' One of the women present 'took off her Egyptian silver scarf that was completely covered in small silver discs, so it looked like chainmail, and tied it around Yelena's waist. It suited the dance perfectly, and looked a little more decent besides.'[25]

Clearly, however much their stomachs growled, the artists' pre-revolutionary club life had certainly not suffered. On the contrary: poverty, hunger and violence reinforced the sense that they were experiencing

Vladimir Goldschmidt, 27 October, 1917.

'the night before the crack of doom', a final carnival at the threshold of the unknown. The club's clientele was more extensive than one might think. Buchinskaya's mother, the immensely popular columnist Teffi, was also a patron. Her fans numbered millions, and her most fervent admirers included – in his day – Nicholas II. Actors, musicians, stylists and snobs followed in Teffi's wake. The venue also became a hub for radical political figures, anarchists especially, who felt an affinity with Goldschmidt and his crowd.[26]

For a short time, the blend of circus, yoga, striptease and poetry made headlines in Moscow. Goldschmidt became a cult figure, but was soon forgotten. And yet eccentric figures such as himself and Buchinskaya were no mere irrelevant or decorative phenomenon in the history of the avant-garde. They embodied the playful, unsocial, nonsensical and hedonistic facets of radical art. In the joint projects carried out by these proto-hippies, creativity, eroticism and friendship were inextricably entwined, and the notion of laying claims on others or promulgating a dogmatic truth did not even occur to them. They were of limited ambition, naive, usually of mediocre talent, tolerant and sensual, but through their non-conformity and *joie de vivre* they created an emotional and even ethical space for the expansive egos of artists such as Tatlin and Malevich.

Vladimir Goldschmidt hypnotizes a chicken.

And speaking of Malevich: by this point, he had thrown himself back into a project that had been languishing for months owing to his commitments in the revolutionary government, but that now took on more urgency than ever before.

Malevich and the Supremus Society

Since 1916, Malevich had been trying to form a new artistic society founded on the theoretical underpinnings of his suprematism. This society, 'Supremus', was to be a new social and production platform for all of his activities. Now that the October revolution had come, he tried to present Supremus as the only relevant, and perhaps even the inevitable, platform for revolutionary art.

The core members were Malevich himself, Klyun, Nadezhda Udaltsova, Lyubov Popova, Vera Pestel, Olga Rozanova and Alexandra Ekster. This list shows the revolutionary nature not only of their theories and artworks, but also of the group itself: most of its members were women. Although the group's artistic course had been plotted by a man,

Malevich's female adherents were anything but obedient disciples, as he would soon learn. Most had been involved in the movement for at least as long as Malevich, and had independent funding sources and their own sales and publicity networks. Alexandra Ekster, for example, was a primarily Kyiv-based artist, with an international network that Malevich certainly lacked. She regularly visited Paris, was friend to Léger, the Delaunays and Marinetti, and before the war participated in prestigious exhibitions in Paris and Rome.

With the exception of Malevich, the most radical artist was Olga Rozanova. In 1917 she produced a series of astonishing suprematist paintings including *Green Stripe*: a bold, electric display that forms an indispensable element in any retrospective of abstract art (Plate 13).

The prominent female representation among the avant-garde artists, though noteworthy, was not a new phenomenon in Russia. Even around the turn of the century, artists such as Anna Ostroumova, Yelena Polenova and Maria Yakunchikova played a very visible and autonomous role in the Russian art world. From that time on, women also appeared as 'patrons' of the arts, and the financial support of these female patrons was crucial to the avant-garde. The 0.10 exhibition, for example, was largely financed by artist and poet Ksenia Boguslavskaya and her husband Ivan Puni. Lyubov Popova and Alexandra Ekster used their assets to promote the art of the avant-garde in general, and not just their own. The key benefactor for Malevich and Supremus was Natalia Davydova, who had met Malevich through Ekster in October or November of 1915. Davydova, born Gudim-Levkovits, came from a wealthy and aristocratic Ukrainian family. Her uncle was the governor of Ukraine, and her husband, Dmitry Davydov, was descended from a prominent and infamous Russian noble family, and even nephew to the composer Pyotr Ilyich Tchaikovsky.[27] The Davydov family played host to many intellectuals, including the philosophers Nikolai Berdyaev and Lev Shestov. Tchaikovsky was very attached to his Ukrainian family, and frequently stayed at their Verbovka estate. Later, the world-famous piano giant Arthur Rubinstein would visit, as well as the extremely young pianist Vladimir Horowitz (who had just turned seven).[28] Not far away was the estate of the Polish Szymanowski family. One of the family's sons, seven years younger than Natalia, was Karol Szymanowski, who would eventually become one of the greatest Polish composers of the twentieth century. Though Karol's romantic and sexual feelings generally focused on young men, he did

feel more than a friendly connection with Natalia (as would become evident in his correspondence and several of his works). Szymanowski's virtually omniscient and extremely meticulous biographer, Teresa Chylińska, claims that Natalia's youngest son Kika is almost certainly a child of Szymanowski.[29]

Natalia made a contribution to the artistic culture of Ukraine by researching, preserving and further developing Ukrainian folk art, and embroidery in particular. As part of her work, she set up a training and production studio in the village by her Verbovka estate, and in another neighbouring village. The work produced by these studios was distributed internationally and displayed in Roger Fry's Omega Workshops in London.[30] In 1912 she appointed Alexandra Ekster as manager of the studio, and the futurist and suprematist embroidery it produced soon made it a centre of early avant-garde culture.[31] It was also where she started to develop herself as an artist.

Malevich's association with a woman whose social background and general cultural development differed so from his own was no trivial matter, and is first and foremost a testament to Davydova's open-mindedness. It also proves, once again, how attractive Malevich could be to open and adventurous artists who were captivated by his visionary imagination. There are very few documents that shed light on the connection between Davydova and Malevich (their correspondence was not preserved), though there are some occasional remarks from unexpected sources. One such source is a letter by the intelligent but rather coarse-mouthed literature and art critic Ivan Aksenov, who had close ties with the futurists but nurtured a fierce disdain for Malevich. Malevich, who was equally outspoken and forthright, called him an 'insignificant parasite'.[32] Aksenov was a connoisseur of the French avant-garde and of Picasso in particular, was well-travelled, well-read and an outspoken pedant. Afraid of being exposed as mediocre, he was always prepared to single out the basest of intentions in other people's deeds and convictions. In any case, Aksenov's brief description of Malevich and Davydova in a letter dating from the summer of 1916 shows that after a mere six months of acquaintance, their relationship was already intense enough to be a wellspring of jealousy and slander:

> And now to Malevich. He is backed…by a certain Natalia Davydova (and everything in this letter from that name on must be kept in the strictest confidence), a very rich lady. Her wealth is surpassed by her greed, which is in turn dwarfed by her vanity and ambition.

She is over forty years old (by a long stretch). During the next season she will be taking painting lessons from Malevich, although I'm not sure if he's aware of that yet. The reason is not because the lady patroness believes in his artistic capacities (if they exist), and not because Malevich wishes to bed her (what is his background anyway? Not Jewish surely? Please let me know), that's not the point, her motivation is the desire to occupy a position of dominance in young art (as it always is with women, and of course with an erotic subtext, but that is not important here).[33]

It's fair to say that Aksenov had a keen eye for Davydova's wealth and the scope of her ambitions. His sexual insinuations are less well founded: Malevich never allowed his artistic goals to be eclipsed by romantic or erotic desires. He worked with women his whole life, but I know of no case where he allowed any romantic or sexual feelings to interfere with the higher purpose of his artistic collaboration with them. The letter illustrates something else: what a breath of fresh air it must have been for intellectual, curious women such as Davydova to spend time with a man who, unlike Aksenov, rarely showed signs of the resolute and insidious misogyny evident in this letter. Malevich could certainly be sexist, but ultimately, when it came to art, he was exclusively interested in ideas and artistic results. He and Davydova's shared Ukrainian heritage and knowledge of Polish may also have played a role. In any case, Malevich was delighted to have made her acquaintance, because it also opened pathways to international exhibitions. Neither of them could know in 1917 that things would turn out very differently. The dramatic events that would befall Davydova in 1920 would, therefore, have a grave and tragic impact on Malevich – but that page had not yet been written.

In the meantime, Davydova sponsored the publication of a journal that was to become the official outlet for the Supremus Society. The members were already busy collecting material, and Malevich was writing a series of articles. The first edition was scheduled for release shortly after the summer, and the second for 1 January 1918.[34] But the revolutionary chaos in the spring of 1917 had disrupted its organization, and by October the first edition had still not appeared. The circumstances were not at all conducive to a relaunch: the value of currency had dropped to practically nothing, there was a colossal paper shortage, and most of the participating artists were either simply trying to survive or making plans to leave Moscow. To Malevich, however, the formation of his society was of vital importance: the revolutionary upheaval that he had long seen

coming was now reaching a critical juncture, with which the presentation of Supremus ought to coincide. Moreover, in accordance with the spirit of the time, Malevich no longer wished to launch Supremus as a 'society' but as a 'party'. In December 1917 he therefore made one last-ditch attempt to breathe new life into Supremus and launch the journal. The brief history of this final attempt shows just how much the artists and their projects were thwarted by the stress of day-to-day events. It also illustrates how the formation of avant-garde factions had become even more pronounced since the split between Tatlin and Malevich in 1915. Malevich was perhaps the greatest aggressor in the ongoing battle among the 'leftist' artists, and was now forced to look on as his antagonism ruined even his most beloved project. Would he learn from the experience? No.

Alongside Malevich, Nadezhda Udaltsova had also emerged as a powerful leading figure among the group of Supremus artists. She had previously stood with Tatlin but strayed over to Malevich in 1916 in order to join his new platform-to-be. She was also a strong woman who had no interest in taking orders and had created her own group of followers within the platform. To ensure the success of Supremus, Malevich had decided that order – *his* order, to be clear – had to be restored. Udaltsova was prepared to negotiate with Malevich, although she wrote in her diary that he 'immediately adopted a tone that I couldn't bear'. 'That fool Malevich, really, why does he set himself against us? We can go on without him; what will he do without us? There is only him and Olga [Rozanova], the rest are complete imbeciles.' Two weeks later the desired negotiation did take place, which Udaltsova recalled as follows:

> Malevich: 'I wish to implement party discipline.'
> 'Well, with your people that should be easy,' Udaltsova replied, 'but not with mine. We have our own faction.'
> 'Then it is open warfare.'
> 'That is ridiculous, Kazimir Severinovich. I am asking how we can work together, what agreement we can reach, and you talk of war.'[35]

This conversation took place on 20 December, as the country descended into chaos and starvation. Supremus would never be born. The first edition of the journal, which had been conceived as an almanac, was not issued and the planned exhibitions never took place. Another potential unification of progressive artists thus met an early end.

Malevich's stubbornness was, of course, not the only reason for Supremus' failure. The circumstances were utterly unfavourable to artistic

collaboration. At around that same time, Udaltsova regularly bemoaned in her diary just how horribly difficult it was to earn any money from her art. At a small exhibition in December 1917, she sold a drawing for 20 roubles – a pitiful sum. 'I need money to survive, but what can I do?' she wrote in her diary just before New Year's Eve.[36] The impossibility of earning a living from making avant-garde art can only have exacerbated the existing frustrations on both sides. And it probably helped little that Lyubov Popova, one of the few artists in possession of a fortune, had invested 1,100 roubles in the Supremus journal that she most likely never saw back again.[37]

Amid all the social upheaval and suffering, Malevich was, therefore, also waging a personal battle to keep his ideas pure and his followers loyal. In the meantime, his research into the mechanisms of our perception and understanding of reality continued unabated. Whatever else can be said of Malevich's unprecedented intellectual and artistic legacy, it was certainly the result of an imperturbable tenacity. If ever he did go through periods of doubt, the most turbulent days of the October revolution and the civil war were no such time. After cutting ties between his art and the visible world in 1915 (or perhaps earlier) and striving to depict a pure, immaterial world, in 1917 he also began to avoid colour, which he regarded as a final reference to the tangible, object-oriented world. In several (largely unpublished) texts he offers a prelude to the 'new system of colourlessness':[38] 'The World, we predict, will be painted over in colourlessness' and 'I now see, among the innumerable corridors of the mind, under the pressure of seething forces, a new representation, beyond the world of colour.'[39]

In his drawings, instead of the sharply outlined geometric shapes that had so dominated his work from the previous years, he introduced blurred forms, sometimes floating in space, sometimes intersecting or passing over one another. This concept culminated in the cloud-like forms of works such as *Dynamic Suprematism* (drawing, 1917–18), or the paintings *Yellow Plane in Dissolution* (Plate 14),[40] and *Dissolution of a Plane* from 1917[41] – works that would absolutely be hailed as highlights of Malevich's *oeuvre* had they not been immediately succeeded by the aforementioned 'white-on-white' paintings, the immortalized, silent songs of bold, ecstatic angels. The most significant of these are the *White Planes in Dissolution*, 1917 and *Suprematist Composition: White on White*, 1917–18 (Plate 15). These 'white-on-white' works exerted a major influence on abstract post-war art in Europe and the United States, as nearly all of

them ended up in Western art collections: three in the Stedelijk Museum in Amsterdam, and one in the Museum of Modern Art in New York.

The most astonishing and even touching aspect (a characterization not readily associated with Malevich's works) is that this period of hunger, stress, desperation, dirt and exhaustion could still give rise to manifestations of such tranquillity and purity.

Whiteness persisted as a recurring theme in his writings, almost always in the representation of 'end times', evoking concepts such as 'salvation', 'sublimation', 'perfection' and 'resolution'. This quasi-cliché, trivial connection between 'whiteness' and 'salvation' surfaces again and again in all sorts of improvised variations, but perhaps never with greater clarity than in his brochure titled *The World as Non-Objectivity*. In it, he adds that his use of whiteness did not originate from a slow, evolutionary dawning of 'light', 'simplicity' or 'clarity', but rather from a radical enlargement of mystery, an expansion of the unknown, a homage to obscurity, and as a means of distancing oneself from all rationality and physicality – a dialectic dichotomy that ultimately led to the resolution provided by the white world. The explanatory text he produced is a shamanic incantation, one to be whispered or bellowed:

> I wish to create a clear path, free from the barricades of all tangible obstruction, from all boundaries, [free] from all attempts to clearly state the signs of wise wisdom, from the poet's words, the thoughts of others who attempt to hide the darkness and expose the sun; [free from] the sounds of music; I wish to purify language of its words, and purge the mind of mindless attempts at comprehension; [free] the body from the need to conquer or aspire to an unknown salvation. For the tongue is necessary for the discernment of flavours but not of words, and all else must heed the single rhythm of cosmic exhilaration. The surface of the Earth should be covered by the realm of eternal exhilaration as the rhythm of cosmic eternity of dynamic silence. To facilitate a distinction from the realms of all other secular rituals, I present the white world of Suprematist Non-Objectivity.[42]

To lend gravitas and momentum to his words, Malevich employs several uncommon stylistic techniques. Firstly, he builds stacks of synonyms (or near-synonyms), resulting in all kinds of pleonasms and tautologies ('barricades' of 'obstruction' or 'boundaries'; 'wise wisdom'; 'cosmic eternity', etc.) while simultaneously imposing express contradictions ('purge the mind of mindless attempts'; 'dynamic silence'; 'secular

rituals'). On the one hand, these juxtapositions lend the work a spasmodic, anti-aesthetic quality, while on the other, they provide an expert linguistic illustration of Malevich's internal dialectic ping-pong.

In later texts, too (until well into the 1920s), he continued to hark back to the significance of his white paintings, though he made attempts to exchange his former prophetic tone for a more analytical one, and to build up a more structured argument. Malevich expert Alexandra Shatskikh was right when she posited that Malevich's attempts at 'academic' and 'systemic' writing were primarily imitations – intuition and creative revelation remained the basis of his theoretical texts.[43] Malevich later admitted to a trusted student that he sometimes did not understand the meaning of his own texts. According to the student, his work was based on 'the unshakeable veracity of feeling and the central subconscious', and then cites Malevich himself, who supposedly said: 'Although it is unclear, we must understand it. There is much inside [the text], but everything was put there subconsciously, and can therefore only be the truth.'[44] Malevich's final word on the significance of white in his paintings is as follows:

> The philosophy of suprematism takes a sceptical view of all human thought and endeavour. It believes that nothing can be revealed in the world, since there was 'nothing' in it, and it cannot be there, for there was never anything. A counterweight to objectivity emerges – non-objectivity, 'nothing' is juxtaposed against 'something,' suprematism refuses to perceive anything through the lens of any culture or realm of knowledge. Of course suprematism developed via colour through to black and white, where we now come face-to-face with complete impersonality, formlessness, objectlessness, balance, indifference and non-temporal consciousness....the white square signifies that all is light-giving, that nothing in this disc will have a single spot or stain, it is invariable, and it will never produce anything in the form of an object.[45]

And to artist Antoine Pevsner, he said, 'I feel a desert around me. Lost in the jungle, I found only one way out. That is what you now see and admire: a white square on a white background. These are my last works, my ideal.'[46]

It goes without saying that an artist who so clearly defines his last work as an 'ideal' must necessarily enter a creative void, at least until a

Lyubov Popova in her studio, 1919.

new artistic objective can be defined. And that is precisely what happened. Malevich filled the void with writing, and from 1919 onwards increasingly with teaching. A quick tally of his collected writings reveals that over 95 per cent of them date from the spring of 1918 onwards, after his 'white' paintings. His key theoretical works were produced after most of his artistic exploration was behind him. They therefore constitute a reflection on his own works, rather than an exposition of his theoretical starting point.

His escape into writing was therefore also (and perhaps even primarily) the result of an impasse: his Supremus Society had been a failure, and his artistic development had reached a conclusion without any signs of a new beginning. It might also explain why his interest in cultural politics began to manifest itself in the spring of 1918.

Many radical artists encountered the same impasse, to a greater or lesser extent. Rozanova's newest abstract works, Lyubov Popova's 'painterly architectonics' (Plate 17) and a host of others all seemed to lead to an ever-greater reduction in complexity, towards the 'ground zero' of art, as Malevich put it. But how, from this new vantage point, could they realize their ideas on continuous innovation, revolution without end?

'And now? What now...?' wrote Popova at around that time. 'Revolution, always revolution. How difficult and tragic it is to bid farewell to the results one has worked so hard for. But once they are achieved, what else is to be done with them?'[47] The impasse, therefore, also prepared them for a new kind of ambition: to work for the revolutionary state as cultural officers and teachers.

Tatlin experienced a similar crisis. His collaboration with Khlebnikov had come to nothing; the poet left for Astrakhan in late 1917, as he had found himself unable to fulfil his obligations to patisserie mogul Filippov and therefore forfeited his accommodation at Hotel Lyuks. Tatlin made a few more reliefs during the winter, but it seemed as though his interest in the genre was already waning. He, too, became active in a variety of cultural administrative bodies in Moscow, and was ready to dedicate himself to work in governance and pedagogy.

Anatoly Lunacharsky

Shortly after the revolution, Lenin quickly appointed one of the original Bolsheviks – Anatoly Lunacharsky – as minister for education and culture.

Lunacharsky was an exceptionally gifted politician who played a major – and often misunderstood – part in the future of the avant-gardists. He described himself as an 'intellectual among Bolsheviks, and a Bolshevik among intellectuals'.[48] He had already joined a Marxist organization by the age of fifteen, and went to Zurich in 1894 to study philosophy for several years. Once back in Russia, he was frequently arrested and got to know various prisons from the inside. He was erudite, pedantic, warm-hearted and indefatigable. Lunacharsky was a zealous believer in the edifying and emancipatory power of the arts. His greatest passion was the theatre: he himself wrote several plays and knew the theatre world very well, partly through his second wife, who was an actress.[49] He was also relatively familiar with contemporary literature, but was least well-versed in the visual arts.

Much of his high standing was due to his exceptional oratorical skills. He was one of the most celebrated public speakers among the Bolsheviks, and regularly appeared before thousands at a time in factory halls and public squares. According to the artist Aristarkh Lentulov, who first heard Lunacharsky speak in 1918, 'his voice, his figurative manner of expression, can only be compared to the roaring of a lion. He made an absolutely

Anatoly Lunacharsky, People's Commissar
for Enlightenment.

astounding impression on everyone.'[50] Varlam Shalamov, author of the
chilling *Kolyma Tales*, heard Lunacharsky speak around thirty times.
'His speeches, given on the widest variety of occasions and topics, were
always dazzling, well-structured, paragons of oration.' Shalamov said of
a speech on a peace treaty that had just been signed: 'Everybody cried,
hardened diplomats wept, and I myself felt a tear run down my cheek.'[51]

Lunacharsky was also a marvellous debator, a connoisseur of the
sharp rebuttal and the theatre of sophisticated argument. He once
found himself in discussion with a prominent clergyman, Alexander
Vvedensky, on the divinity of creation. 'Vvedensky artfully said, "Fine,
then let us simply conclude that I was created by God, and that you, if
you must insist, descended from the apes!" Applause. Lunacharsky
calmly responded: "Very well. Compare me to a monkey, and all will say:
what a massive improvement! Compare you to God, and what will they
say? Such horrible degeneration!" *Ovation.*'[52]

Lenin was well aware of Lunacharsky's aptitude for propaganda, and
also valued his strict loyalty to the party. He had little patience, however,
for Lunacharsky's artistic predilections, and derived pleasure from
lambasting him occasionally or from instructing others to 'give him a
good going over'. Quite a number of historians have claimed that such
remarks were no more than friendly 'jibes'. That may be, but coming
from the mouth of such a violent man as Lenin, they inevitably also
carried the weight of a tangible threat.[53]

Lunacharsky's first and most notable task was to organize a new education system. In the first few months, cultural policy concentrated exclusively on the preservation of cultural monuments: the palaces, museums and other culturally significant pieces of real estate.

Lunacharsky was also tasked with the development of contemporary visual art policy. He operated cautiously, an approach largely explained by his limited knowledge of the art world and his lack of any major network in the sector. Lunacharsky had lived as an exile in Europe since 1907, and the artistic upheaval that had taken place in Russia had mostly passed him by. His artistic taste had hardly changed since 1907. According to Sergei Diaghilev, who met him several times in the twenties, he stayed true to the taste and judgments of a 'liberal intellectual from the pre-revolutionary period'.[54] He made no bones about his own position: 'Our primary visual arts regiment is the "centre," consisting of refined Europeans who have organized themselves around Mir Iskusstva. The linchpin of this group, as a theoretician, historian, aesthete and artist, is one of the finest and most civilized figures in Russia: Alexandre Benois.'[55] Benois, the principal opponent of the avant-gardists, thus became Lunacharsky's favourite.

Staying true to this position, Lunacharsky rejected futurism utterly. In his newspaper articles, he had never expressed anything but condescension for the futurists. He believed they created 'absurd miscarriages'; they were 'deranged idiots' who 'testified only to such an utter degeneration in taste and technique, we must not for a moment be surprised at the pessimism that has taken hold of so many genuine friends of the arts'. Cubism, according to Lunacharsky, was 'extraordinarily suspect, and reeks of charlatanism'.[56] The only Russian avant-gardist who had built up a reputation in Europe before the war, Wassily Kandinsky, received the following assessment from Lunacharsky: 'That man is clearly in the final stages of mental degeneration. He draws, drawing lines with the first colours that come to mind, then signs the work, the poor man, with "Moscow," "Winter," or indeed, why not "Saint George"? Why do we allow such work to be exhibited? Freedom, granted; but this is very clearly pathological, and therefore lacking in any significance, so much so that even [Le Douanier] Rousseau or a five-year-old child are masters compared to Kandinsky, who borders on the animalistic.'[57]

It hardly needs to be said that the avant-gardists invested little hope in such a politician. And it was no coincidence that the first artist to be personally commissioned and recommended to Lenin by Lunacharsky

Artist Isaak Brodsky before an enormous painting of Lenin.

was the hyperrealist Isaak Brodsky. He painted his first portrait of Lenin in 1918, and quickly became the go-to portraitist among the Bolshevik elite.[58] However, it is unclear whether the avant-gardists themselves had a clear idea of Lunacharsky's artistic views. His derogatory articles on the futurists had been written years earlier, when he still lived abroad, and published in a small newspaper in Kyiv.

During the first few months of his appointment, Lunacharsky had to amass adequate and reliable forces to implement his new policy. In light of the above, it is unsurprising that Lunacharsky turned to the establishment, and to the relatively conservative artists of his own generation.

Lunacharsky's approach also offered practical advantages. In order to operate effectively he needed professional, experienced people, most of whom were to be found in the established cultural networks. During

this initial period, however, he met with a wave of opposition that seemed to come from the entire art world, and which was supported by progressives and conservatives alike. To properly understand the predicament in which Lunacharsky found himself, we must first travel six months into the past.

Benois and the Bolsheviks

Artists had already become involved in the development of a new cultural policy half a year earlier, immediately after the February revolution. Many artists, both progressive and established, dreamt of a new organizational structure for the world of arts and culture. Exactly which form it should take was less clear, however. The artist who stepped up as the architect of the new cultural policy in March 1917 was Alexandre Benois.

Benois had formed a coalition with the immensely popular author Maxim Gorky, who was seen as the living link to the great nineteenth-century tradition of Russian realism. Benois' desire to collaborate with the very left-wing Gorky was partly opportunistic; in addition to his many connections with the various revolutionary parties, Gorky had a nigh-unassailable authority due to his millions of readers, his carefully constructed image as a 'man of the people' and his ceaseless efforts to aid Russia's poor. But opportunism was not the only motivator. Benois had also been affected by revolutionary events, and began to chart an ever more left-leaning course. This led to him writing for *Novaya Zhizn* (New Life) in April 1917, which was led by Gorky and the Mensheviks and supported a radical socialist agenda.

With the help and support of Alexander Kerensky (the new man in power after the February revolution), Gorky convened a committee made up primarily of painters, art historians and 'performing artists' (musicians and actors) who met for the first time at Gorky's home on Saturday 4 March 1917. The group consisted primarily of Gorky and Benois' contemporaries from St Petersburg, such as Mstislav Dobuzhinsky and Nicholas Roerich (the librettist of *Le Sacre du Printemps*). There was no representation from Moscow whatsoever, and certainly no futurist riff-raff. When Benois' plans started to become public, the conclusion was immediately drawn that he and his own clique wished to wield the power in the cultural world.

The idea was tabled to establish a Ministry of Fine Arts, in order to unite the disparate fields of cultural policy. If successful, it would have

been unique in history, for no other country in the world had a ministry dedicated exclusively to the arts at that time.

Under Benois' chairmanship, a list was drawn up of potential Ministers of Culture that, again, consisted almost entirely of Benois' old guard: his friend and rival Sergei Diaghilev, theatre artists such as Mstislav Dobuzhinsky and Nicholas Roerich, and even Walter Nouvel, Diaghilev's later secretary.[59] The committee quickly decided that Diaghilev should be appointed to the position of minister; it seemed that he was the ideal compromise, and the only member who had the respect of both his own and the younger generation. The press, however – who provided diligent coverage of the committee's public meetings – reported multiple times that Benois was himself a candidate.[60] Though ministership was not Benois' implicit goal, there are indications that he did not see it as inconceivable. Whatever can be said of Benois, almost all of his work in 1917 was characterized by an astonishing degree of social engagement. By far the greatest part of his time was invested into the immediate protection of valuable Russian cultural heritage. To report damage and prevent plundering, he personally began to take an inventory of abandoned palaces and their interiors, and even moved into the Winter Palace in order to work as efficiently as possible. The image of the lonely Benois conducting a stocktake in the all-but-deserted Winter Palace while a bloody history played out beyond its walls is poignant enough, but is also illustrative of the tragedy that seemed constantly to haunt this exceptional man.

Benois' problems did not diminish when Diaghilev declined the candidacy for the ministership. Without the unanimously preferred candidate, the ministry lacked a binding force, and the accusation of a power grab became more difficult to refute.[61]

A report quickly circulated that Benois was 'aiming to seize power' in the art world, and various newspapers published protests against attempts to favour a single faction of artists.[62] The general aversion to Benois' plans was directed not only at the various ministerial candidates, but also to the 'ministerialization' of the arts in general. Sparked by the revolutionary flame, a large portion of the artists called for decentralization, autonomy and an end to state patronage.[63]

The protests against a 'coup d'état' in the arts snowballed rapidly, and nearly every day artists from various disciplines gathered to try to form a counter-coalition.

On 12 March, the opponents of the Gorky committee organized a protest at the Mikhailovsky Theatre in Petrograd, 'against the formation

of a Ministry of Culture', and 'to combat the power grab by specific cultural groups'. Their slogan was: 'Fight with us for the right to self-determination and self-governance.'[64] The organizing committee was made up mostly of radical artists, including several prominent futurists such as Nathan Altman, Ksenia Boguslavskaya and Nikolai Punin.

To the surprise of many, no fewer than 1,403 cultural sector workers flocked to the Mikhailovsky Theatre. The gathering started at noon, and lasted until late in the evening. It was a unique revolutionary event that was reported on with great surprise by the papers and had a substantial impact on the participating artists. For the first time, artists were collectively involved in the revolution, and were attempting to take joint responsibility for the organization of cultural life. They called for the establishment of an 'artists' parliament' where cultural policy decisions would be made based on 'general, equal, direct, secret and proportional ballots, without discrimination on the basis of sex'.[65] The atmosphere in the crowded theatre was electric. Celebrities such as Mayakovsky and Meyerhold, who were closely involved in the organization, gave impassioned speeches in support of revolutionary art, and spoke out strongly against every form of 'ministerialization'.

A number of resolutions were adopted, including a motion to reject the Gorky Committee's plans outright. The key result, however, was the establishment of what became known as the Cultural Workers' Union, a centralized democratic body which was to represent artists' interests from that moment on. Artists of all creeds, conservatives and radicals alike, would be represented, to ensure that any 'resolutions' adopted could count on widespread support. Three factions were formed in order to streamline decision-making: a right-wing faction of academists and realists, a central faction of conservative modernists, and a left-wing faction dominated by the avant-gardists. Meyerhold and Mayakovsky were among the left-wing artists who stepped forward as leaders. This politicization of the arts, divided into three factions, would persist in the Russian art world for years. Although the factions were quite short-lived as actual organizations, their respective 'blood groups' would remain recognizable within the community of Russian artists for some time.

This radical democratization of the art world in Petrograd is now identified as a unique historical phenomenon. It carried the romantic ideal of the autonomous artist to its logical conclusion, namely the autonomy of the very arts themselves. The entire art world was to be liberated from

the forces of capital, state, media or any other non-creative power. The fact that the desired autonomy of the arts was just as unattainable as that of the artists themselves was, of course, perfectly understood by many. They also understood, however, that as a formulated ideal, it was potentially useful in the fight against utilitarianism, mercantilism and government pressure – the powers that, throughout the twentieth century, threatened the independent, competitive creativity to which contemporary art aspired.

The emergence of this Cultural Workers' Union meant first and foremost that Benois' plans were destined for the scrapheap. Nobody dared to resist such an expression of revolutionary ambition.

Poor Benois was bitterly disappointed. It might have been the first time that he became aware of the great disdain for him and his position of power. His anger knew no bounds. He described the meeting as a 'drunken shambles', 'pure vulgarity and absurdity'. 'Monstrous nonsense' was promulgated 'by the various Zdaneviches and Mayakovskies and other arch-geniuses of Russian futurism'. He was most disappointed by the fact that 'nobody dedicated even a single thought to peace – on the contrary, Mayakovsky and his companions voted for war'.[66] Even before the gathering was over, he quietly left the hall to return to his inventory manifests in the Winter Palace.

The Cultural Workers' Union aimed to be a pan-Russian organization, and so the members sought contact with artists in Moscow. The latter responded by setting up a similar union that established direct contact with the union in Petrograd. The Moscow organization was structured in the same manner, with right-wing, central, and left-wing 'blocs'.[67] Among the five permanent representatives of the leftist bloc, four names stand out: Vladimir Tatlin, Kazimir Malevich, Georgy Yakulov and Olga Rozanova. Their mandate, too, was to liberate the art world from 'any kind of pressure whatsoever from government bodies, institutions or agencies'.[68]

Artists lost themselves in a colourful storm of meetings and manifestos. Plans were made to organize exhibitions, set up journals and newspapers, propagandize Russian art abroad and protect artists' copyright. It was a turbulent game, brimming with genuine revolutionary energy, and played in deadly earnest.[69] Over the course of several months, it also became clear that a behemoth such as the Cultural Workers' Union, in which 1,500 artists were expected to take democratic decisions, would be hamstrung by its own weight. The avant-gardists also noted that

whenever a vote was taken, the right-wing and centrist blocs joined forces to derail the radical proposals from the left. The avant-gardists thus soon became disillusioned with the Union. According to Rozanova, the right and centrist blocs were always intent on 'violating the charter and interpreting it to their own advantage, and maligning the principle of autonomy for each bloc'.[70] Once again they felt marginalized, and excluded by the wider artistic community.[71]

Although they officially remained part of the Cultural Workers' Union, by the summer of 1917 the avant-gardists had, in fact, already started searching for other, more radical partners to help put their ideas into practice. They also remained staunchly opposed to the idea of a Ministry for Culture. From this perspective, they saw the October revolution as an opportunity to reshuffle the cultural deck.

The People's Commissariat for Enlightenment

The situation immediately following the October revolution can therefore be summarized as follows: the avant-gardists were searching for a new form of self-governance and autonomy. Their attitude to the cultural establishment had hit a nadir once again, and looking to the Bolsheviks for support seemed like a logical step. The Bolsheviks, after all, wished to force a break with the existing order, and promulgate a model for decentralized self-governance.

Alas, the first steps taken by the new Bolshevik government were not at all in line with the hopes of the avant-gardists. On 9 November, the Bolsheviks established the People's Commissariat for Enlightenment, which bore a suspicious resemblance to the Ministry for Education and Culture that had been the subject of so much protest. Initially, however, the Commissariat presented itself as a body aimed at 'providing connections and aid, as well as material, ideological and moral support' for local governing bodies and councils (*soviets*).[72] At first glance, therefore, it did not appear to have any aspiration to wield centralized government power in the art world.

The day before, Lunacharsky had written a long letter to his idol Alexandre Benois, inviting him to develop a policy brief for the establishment of a 'Department of Fine Arts' in the aforementioned Commissariat. He asked Benois explicitly to submit a proposal based on his existing plan. Lunacharsky and Benois saw each other regularly over the ensuing days, and a relationship of trust developed between the two men. This should

come as no surprise, as Lunacharsky and Benois, despite their disparate political views, had a lot in common in terms of their tastes and artistic temperament.

Benois was immediately enthusiastic about Lunacharsky, calling him a 'charmer' with a 'highly versatile education' and an 'excellent command of public speaking'. But Benois' sceptical side also showed itself, when he wrote that he had 'heard enough of his many spectacular, extremely sophisticated, but ultimately empty and meaningless orations'.[73]

Lunacharsky placed a great deal of trust in Benois, and shared with him the trials and tribulations of the day-to-day administrative chaos in which he found himself. He admitted to Benois that he, too, was a victim of the circumstances, and that he first heard about most of his own government's decrees in the papers. From this we can deduce that Lunacharsky was well aware of the endearing effect of taking an objective view of oneself. His technique was not lost on Benois: 'One of Lunacharsky's very effective methods of seduction is to pad out his utopian fantasies with pieces of scepticism (and even self-irony)..., which inspires great confidence.' Lunacharsky also visited Benois at home, and succeeded in charming his wife just as much.[74]

Lunacharsky offered Benois the position of 'Minister of Fine Arts' twice over, evidently with Lenin's explicit approval. If Benois were to accept, Lunacharsky would limit his own remit to education.[75] Benois resolutely declined, saying that he was, after all, 'not a socialist. So how could I ever take a seat in a government professing a communist creed?'[76]

Benois' refusal seems to have caused Lunacharsky to temper somewhat his aspirations with regard to a broad-ranging Fine Arts ministry, and he switched his main focus to other artistic disciplines. In December, the People's Commissariat (referred to universally as NARKOMPROS) saw the establishment of a state publishing house (Gosizdat) and a literary department (LITO), later followed by a theatre department (TEO). Truly, Russia had entered the age of abominable acronyms, leading to such monstrosities as OMACHRR, AGITPROP, the fearsome GLAVPOLIT-PROFOBR, and of course SSSR, the abbreviation for the new Soviet state itself. The sibilant pronunciation (Ses-ses-serrrr) so closely imitates the hissing of a snake that it comes across as a rare blunder on the part of the usually so marketing-savvy Bolsheviks.

The only progress made in the problematic Fine Arts portfolio was the establishment of a museum commission, in which Benois became a

compelling presence.[77] Igor Grabar, the director of the Tretyakov Gallery in Moscow, also joined and quickly became a force to be reckoned with. Grabar, a highly productive art historian and artist, was a loyal supporter of Benois and no friend to the avant-gardists.[78] Whenever Tatlin saw him, he would remark: 'Look, there goes the late Grabar.'[79] His involvement was a crucial victory for Lunacharsky, as Grabar was a universally respected professional with an extensive network of contacts in the Russian museum world. Grabar also proved willing to assist actively with the nationalization of private art collections, a responsibility that Benois had declined from the beginning. In his memoirs, Grabar described the negotiation process with Lunacharsky with surprising candour, and explains why he was prepared to ally himself so directly with the Bolsheviks and their political agenda.

> Anatoly noticed concern in my expression, and asked if anything was the matter. I said that they wanted to evict me and my family from the house, to accommodate workers who had arrived from Petrograd. – 'Wait a moment,' he said, 'we will put together a document.' And he left the office to dictate a letter to his secretary.
>
> But everyone had already gone home. Lunacharsky sat down at the typewriter himself, and quickly typed a letter to the local Soviet, asking them to leave me in peace. All we needed was the seal, which was locked in the desk drawer. He grabbed a thick bronze letter opener from the table and said: – 'Shall we break it open? It cannot possibly wait until morning, can it?'
>
> Together we broke into the desk. He took the seal, breathed on it and set it on the letter....Lunacharsky's letter had a magical effect on the district offices..., I was not bothered any further.[80]

The Bolsheviks' efficiency and their pragmatic approach to power thus began to have an impact. Cooperation with the Bolsheviks was rewarded with privileges, and few artists and intellectuals could afford the luxury of principles under such dire circumstances. The above, therefore, does not necessarily make Grabar a corrupt official. There was no doubting his sense of duty: he felt a genuine need to protect Russia's cultural heritage, and it was for this very reason that he was of use to Lunacharsky. The Bolsheviks also made it crystal clear that they would ensure that people such as Grabar could continue to carry out their work and feel a sense of protection. In this sense, the Bolsheviks had the upper hand: privileges are not rights, after all, and can be revoked as easily as they are granted.

By December 1917, therefore, Lunacharsky's organization was structured around several important specialists from the pre-revolutionary establishment who all had at least one thing in common: a fierce aversion to the avant-gardists. Lunacharsky also began to speak openly about the purpose behind his new cultural policy, formulating it unambiguously as 'preserving the greatest achievements of the old culture, and bringing them to the proletariat'.[81] No mention whatsoever of a break with the past, or of revolutionary artistic innovation.

When the avant-gardists became aware of the choices being made by Lunacharsky, they were shocked. Shortly after the October revolution, Mayakovsky independently sought contact with the new People's Commissariat. As the informal leader of the left-wing faction in the Cultural Workers' Union, he was of course received by Lunacharsky, but in the presence of Benois. Mayakovsky's companion, Osip Brik, looked on in mute amazement as 'Lunacharsky listened more attentively to Benois' recommendations on the organization of the galleries than to Mayakovsky's arch-revolutionary proposals'.[82] Afterwards, Brik was informed that he would need to 'submit any proposals to Alexandre Benois first for approval'.[83]

Lunacharsky could not distance himself from Mayakovsky and the futurists entirely. Benois and Grabar by themselves could not ensure sufficient legitimacy and effective governance – he needed the support of a far broader group of professionals within the cultural landscape.

This seemed impossible without the support of the new Cultural Workers' Union, which had just spoken out strongly *against* the establishment of a centralized cultural commission. Still, on 25 November he sent a proposal to the Union board, requesting that they place themselves under the authority of the new People's Commissariat. The Union board firmly refused, and three days later even foreswore 'any dealings with Lunacharsky whatsoever'.[84]

The only person in the Union who was prepared to cooperate with the Bolsheviks was Mayakovsky. This fact cannot have escaped Lunacharsky's attention.

Partly due to the Union's opposition, Lunacharsky now encountered resistance in all areas of the cultural bureaucracy. Public servants either did not turn up, or turned the heating off if they knew that Bolsheviks were coming for a meeting, so that it took place in the freezing cold. Concierges denied access to buildings, guards refused to provide security. The interim director of the Mariinsky Theatre, who refused to give

1 Kazimir Malevich, *Portrait of the Artist's Father*, c. 1902–3.
 Oil on canvas, 61 × 51.9 cm (24 ⅛ × 20 ½ in).

2 Kazimir Malevich, *Assumption of a Saint*, 1907–8.
 Paper and gouache on board, 26.3 × 26.4 cm (10 ⅜ × 10 ½ in).

3 Pablo Picasso, *Trois femmes* (Three Women), 1908.
Oil on canvas, 200 × 178 cm (78 ¾ × 70 ⅛ in).

4 Kazimir Malevich, *The Woodcutter*, 1912.
Oil on canvas, 99 × 76 cm (39 × 30 in).

5 Kazimir Malevich, *The Knife Grinder*, 1912–13.
Oil on canvas, 79.5 × 79.5 cm (31 ³⁄₈ × 31 ³⁄₈ in).

6 Vladimir Tatlin, *The Sailor (Self-Portrait)*, 1911.
Oil on canvas, 71.5 × 71.5 cm (28 ¼ × 28 ¼ in).

7 Georgy Yakulov, *Design Sketch for the Café Pittoresk*, Moscow, 1917.
 Graphite, brown ink and watercolour on paper, 17 × 34 cm (6 ¾ × 13 ½ in).

8 Vladimir Tatlin, *Model*, 1913.
Oil on canvas, 143 × 108 cm (56 ⅜ × 42 ⅝ in).

Lunacharsky's staff the keys to the imperial box, was imprisoned several days later.[85] Lunacharsky could not be too heavy-handed, however, lest the entire bureaucratic machine turn against him, and he could not mobilize enough manpower to replace every insurgent. He himself used the ominous term 'sabotage', which only several years later became a de facto synonym for 'high treason'.[86] Lunacharsky therefore needed to take the reins more firmly, and his experience with the rejection and animosity shown by the Cultural Workers' Union clearly prepared him psychologically both for a coalition with the avant-gardists, and along with it, a far more radical course for the People's Commissariat than he had originally envisaged.

At that time, however, he was not yet entertaining the notion of a collaboration with the avant-gardists; his aversion to their futurist artistic mentality was still too great.

His disdain aside, Lunacharsky had another problem: he knew too few radical visual artists. He was only vaguely acquainted with the Russian artists' enclave in Paris, whose work he had condemned in his newspaper articles. Before his return to Russia, he had perhaps never even heard of Tatlin or Malevich, or if so, had been exposed only to negative reports. And now, just after the October revolution, he still had little opportunity to get to know them, for the most radical artists were in Moscow and not in Petrograd. How was he to cultivate a relationship with them, to see whether they were trustworthy? One observant contemporary noted: 'Few knew or felt the loneliness that surrounded the Bolsheviks during those first few months.'[87] This loneliness understandably led to great insecurity. Lunacharsky continued to vacillate, and the avant-gardists had no patience.

The Avant-Garde and Anarchists

In the meantime, the Moscow artists had figured out that they had no useful ally in Lunacharsky. But the urgency of their desire to play a part in revolutionary Russia was as strong as ever, and their frustration mounted as a result. From the spring of 1918, the situation pushed some of the avant-gardists – in any case Malevich, Rodchenko, Rozanova, Udaltsova and Tatlin – towards a far more radical group of revolutionaries: the anarchists. An alliance with the anarchists also gave them the opportunity to publish in the journal *Anarkhia*, exposing their ideas to a far wider audience.

Their first few articles focused mainly on their plans to reform the art world. They issued a harsh polemic against Benois and other conservatives, and their dominant voice in the new administration. 'The social revolution,' Malevich wrote, 'that has broken the chains of capitalist slavery has not yet broken the old tablets of aesthetic values. And now...we must protect ourselves from the poison of bourgeois banality – a poison that is dispensed by the priests of bourgeois taste, the kings of criticism: Benois, Tugendhold and Ko.'[88] They also constantly reiterated their belief that social and political revolutions, by their very nature, should go hand-in-hand with a revolution in the arts. Malevich wrote: 'now that life is changing, attitudes to art should also change. It is time for art to stop being a side dish, an afterthought.'[89] Instead, a 'completely free "state" of artists' was necessary.[90] They further bolstered their revolutionary credibility by identifying as oppressed proletarians. 'We are the proletarians of the brush!' Rodchenko wrote, 'We are creators – martyrs! Oppressed artists! We, who bear the flaming torch of creativity, walk hungry and barefoot!'[91]

The affinity between the anarchists and futurists is not so surprising. The futurists' plea to destroy the past strongly resembled the well-known slogan by the father of Russian anarchism, Mikhail Bakunin: 'The passion for destruction is also a creative passion.' The futurists' outspoken disapproval of a government-run cultural framework and their preference to organize as a self-governing 'union' speaks immediately to an affinity with the principles of anarcho-syndicalism, an ideology developed by another Russian anarchist, Pyotr Kropotkin.[92]

Their switch to anarchism demonstrates that, in the initial months of 1918, the most radical of the avant-gardists had lost most of their confidence in the Bolsheviks, and begun to assume that Lunacharsky was intent on the restoration of an establishment in the arts. In response, they proceeded to oppose him aggressively and openly.

Before long, the avant-gardists were called on in the pages of *Anarkhia* to make their voices heard not only in the field of cultural policy, but also in support of 'revolutionary anarcho-futurism', and to fight for a total anarchist revolution in Russia. The call came from a poet and author who published articles in *Anarkhia* under the hip pseudonym of Bayan Plamen ('accordion flame').[93] His plea was successful. Malevich, Rodchenko, Tatlin and Morgunov wrote a response to Bayan Plamen's call to arms, pledging their steadfast support to the anarchist cause:

RODCHENKO: 'We will join you, dear comrade-anarchists! In you we
see our former, unknown friends. This moment in the world of art
belongs to the artist-anarchists!'
MORGUNOV: 'All power means death to the arts!'
TATLIN: 'I call to all those of my craft to step through the gate
presented here, to overthrow the old and to open up the spirit to
the possibilities of anarchy.'[94]

They also began to speak out more strongly against the very notion of
government power – understandably, as the rejection of all state author-
ity is the fundamental principle of anarchism. Rozanova, Udaltsova,
Varvara Stepanova and Rodchenko all issued powerful statements
against the idea of government power and state involvement in the
arts.[95] The most radical of them all was Malevich, who in early April pub-
lished an article identifying the state as a primal evil. He wrote, 'however
we build the state, the moment it becomes a state, it will automatically
become a prison'. More than once, Malevich had already described the
revolution as the destruction of the material world; now he equated
the material world with the state as an institution, saying it should never
be allowed to return: 'We demand the destruction of everything and
of the foundations of the old, so that neither the state nor the material
world can ever rise again from the ashes.'[96]

At the time, the decision to align politically with the anarchists was
not as peculiar as it may now seem. In early 1918 the anarchists still con-
stituted a serious threat to the Bolsheviks, and even those who were more
politically savvy than Malevich or Tatlin found it difficult to say who
would come out on top. The anarchists had taken control of appreciable
parts of society, largely facilitated by their lack of scruples towards squat-
ting in houses and appropriating property from the nobility. In fact, they
constituted a second, 'parallel power'.[97] The Bolsheviks were certainly
not in total control of the cities, and in Moscow especially, hopes of a far
more drastic revolution had not been fully extinguished.

Several striking memoirs have been preserved of the anarchists'
activities and their interest in the arts. Konstantin Korovin, an impres-
sionist and an influential lecturer at the Moscow School of Painting,
recalled how his home was invaded by a group of anarchists. The almost
sixty-year-old Korovin was afraid for his life, for although the anarchists
were occasionally satisfied simply with food or drink, their arrival often
signalled pillaging and theft, and very occasionally, shocking abuse and

murder.[98] An actor by the name of Mamont Dalsky – who was staying with Korovin as a guest – had 'reported' him to the anarchists via the opera singer Fyodor Chaliapin.

> Dalsky screamed: 'Here he is,...he is ours. If he wants to drink champagne, then let him drink champagne. We are anarchists, and deny nobody their personal lives. He is free, but today we arrest him. You must come with us, to the home of a millionaire, who has built a museum in his own house. Our goal is to protect it [from being ransacked]. We ask you to come with us, to determine whether the paintings have any artistic value.'
>
> The anarchists surrounded me, led me down the stairs and put me into a car. Dalsky sat beside me – his odd companions went in another car.
>
> They took me to the home of [the sugar manufacturer] Kharitonenko.
>
> The paintings hung on the second floor of the mansion. Dalsky asked: 'Well?'
>
> These paintings are from the French Barbizon school, I answered. This is a Corot, that one is a Daubigny.
>
> Suddenly three shots rang out from the riverbank. Dalsky hurried to the garden terrace and fled, the others followed him. I remained alone.
>
> I left, there was not a soul anywhere around.[99]

During the first year of the revolution, however, the anarchists were not the only ones to use violence and looting, and the written history of their role is probably biased. Later, and for understandable reasons, some of the avant-gardists were party to this erroneous historiography. One example is Rodchenko's own 1941 account of his role in the occupation of Aleksei Morozov's mansion. Morozov was the eldest scion of a dynasty of entrepreneurs and collectors, and had amassed a considerable number of artworks. When the anarchists squatted in the mansion, Rodchenko – who at that time was certainly one of the most avid supporters of the anarchists – was put in charge. In his account, he presents himself as an outsider and caricatures the anarchists, whom he paints as a horde of wild hippies.

Despite the historical inaccuracies, his description of the atmosphere in the mansion is very convincing:

> I was put in charge of the Morozov mansion, with all of its etchings and porcelain. A group of 'anarchist-communists' had set up shop there.

I went there every day, and made sure that everything of artistic value was taken to one room, to which I held the key. There were a few anarchists there, including several women. What they did in the evenings I don't know, as I always went home at around five or six....The mansion had various chambers, a porcelain museum and two rooms full of etchings. In the hall there was a large painting, a *panneau* by Vroebel, *Faust and Marguérite*. None of that art interested me at the time, though I knew what it was and studied it. To me, it was all nothing more than the accursed past. I carefully preserved and guarded it, but held no esteem for it whatsoever.

I wandered through the foreign rooms with their alien art, and none of it excited me. I looked at the anarchists....What kind of people were they? I saw nothing special about them, except for the name they bore....They produced nothing new, neither in their everyday lives, nor in their relationships with one another. They slept where they could, ate where they could. In the same manner they played their mandolins, and got into fights.[100]

It is worth mentioning that the anarchists did not restrict themselves solely to occupied mansions. They also gathered in the artists' cafés, such as Pittoresk and the Poets' Café, and planned their joint campaigns.[101]

The anarchists and the avant-gardists quickly grew closer. Both their public and social platforms (*Anarkhia* and the futurist cafés) were dominated by the anarchists.

The anarchists' position was, of course, unacceptable to the Bolsheviks, whose goal was to monopolize power as quickly and as convincingly as possible. Ideological and political pluralism was not tolerated, and the fact that so many revolutionary artists were so explicitly associated with an alternative revolutionary ideology was a problem for Lunacharsky. He wanted to win over the radical artists for his People's Commissariat, but on his own terms. In March 1918 he even entered into discussions with the futurists in the hopes of converting them to Bolshevism. He arrived at the Poets' Café, where he announced (turning up his nose at their iconoclastic slogans) that the October revolution had not heralded the arrival of 'Cain the Cannibal, who comes to trample the flowers in your garden, but of a brilliant child – the Russian people. You must help it to find the right path.'[102]

According to the poet Ryurik Ivnev, Lunacharsky arrived at ten o'clock exactly.

David Burlyuk had a bell in his hand. Lunacharsky walked on stage, and the young but already corpulent Burlyuk toyed with an eccentric lorgnette and shushed the audience: – 'Comrades! I present to you our good friend and guest, Anatoly Lunacharsky.'

Once the applause had died down, Lunacharsky started talking in his usual free and easy manner, while walking back and forth along the stage. – I am convinced that all participants in the discussion, however different their opinions, were united in their desire for the young Soviet state to reflect the great changes taking place in our country. And that the future belongs to art. – Mayakovsky's thunderous voice resounded: 'The future is futurism!' – Lunacharsky retorted: 'Only if it reflects the great changes in the proper manner.'[103]

While the artists considered Lunacharsky's olive branch, the Bolsheviks' political steamroller pressed on. In early April 1918 they launched a fierce campaign (some would say a pogrom) against the anarchists, who in the accompanying propaganda were labelled not as political opponents, but as 'criminal elements'. On the night of 11 April 1918, the centres of the anarchist movement were surrounded by the newly formed secret service, the Cheka. Everyone there was disarmed, and around six hundred were arrested. Malevich responded as he always did, from his 'cosmic', otherworldly perspective, but was truly shocked: 'I try to visit Moscow less often, especially after the anti-anarchist razzia – an extremely uncivilized act. A giant boot has come crashing down on individuals, using them as a platform for its footsteps.'[104]

As part of the anti-anarchist campaign, the Poets' Café was forced to close on 14 April, followed several months later by Café Pittoresk. *Anarkhia* was shut down by the Bolsheviks on 2 July.

The avant-gardists thus lost their meeting places and their primary communication channel. Any hopes that the anarchists would help reform the political revolution into a creative one had been destroyed. And so, in mid-April 1918, the avant-gardists were in a far worse position than they had been before the revolution. They had lost their key patrons (people like Filippov and Davydova had fled the capitals), their platforms had disappeared and they seemed to have backed the wrong political horse. How could they now achieve their revolutionary ambitions?

Lunacharsky and the Healthy Spirit of the Proletariat

Shortly after the raids against the anarchists, the definitive rapprochement took place between the Bolsheviks and the avant-gardists. What was it that possessed Lunacharsky to open up the People's Commissariat to the abominable futurists – especially now – and why did they accept his invitation?

The complex web of reasons why Lunacharsky decided to enter into a coalition with the avant-garde in April 1918 will be dealt with in the following chapter. In any case, it is clear that he was not ready to do so before March 1918, and still doggedly tried to win the loyalty of the Tsarist cultural establishment.

Even if Lunacharsky had wanted to alter his position during that time, he would have had to contend with the even greater antipathy towards the futurists felt within the upper and middle Bolshevist tiers. This attitude is evident in the following merciless tirade published in *Izvestia* by K. Zalevsky, a prominent Bolshevik from the early days. Lunacharsky's pedantic mutterings pale by comparison: 'The stronger the new sociopolitical system becomes in Russia, the more the intelligentsia tries to latch onto the proletariat. We can expect a large influx of artists especially. The proletariat must try to distance itself from them as resolutely as possible,...and guard the purity of the source of its creativity with vigilance. Futurists who penetrate proletariat circles may infect the healthy spirit of the proletariat with the rotten poison of the decomposing bourgeois corpse.'[105]

Zalevsky's was quite a different take. Here, rather than being dismissed as uncultured hooligans, the avant-garde were dismissed as undercover representatives of the perfidious bourgeoisie, double-agents and authors of a treacherous conspiracy aimed at undermining the revolution. Zalevsky's text contains almost all of the rhetorical vitriol that would later become commonplace in the fight against the avant-garde, including the typical 'physical' metaphors of parasitism ('latching onto') and disease ('infecting...with rotten poison').[106]

It was polemic of this type that undoubtedly prevented Lunacharsky from rushing into the arms of the futurists.

In this context, it is really quite astounding that Lunacharsky, especially in historiography outside Russia, is regularly presented as a staunch supporter of the avant-garde.[107] Nothing could be further from the truth: even while he briefly adopted an attitude of leniency – for

opportunistic reasons, as we shall see – at best he regarded the avant-garde as a curiosity, one of the peculiar growing pains of history that would pass quickly enough.

It took a long time – far too long – for the avant-gardists to realize that it was not the intellectual representatives of the former St Petersburg elite who were their enemies, but rather characters like Zalevsky: fresh, hardened, unscrupulous propagandists advocating a proletarian culture that had been purified of all blemish.

Initially, however, the type of criticism unleashed by Zalevsky was still a rarity, and the Bolshevik leaders had only a vague notion of what 'futurists' even were, exactly. Prior to the October revolution, Lenin never said anything about futurism; Trotsky did occasionally, but with reference only to poets. Even after the revolution, Lenin remained uncertain as to whether an artwork was futuristic or not – all he knew was that he rejected futurism.[108] One artist would later remark that the avant-gardists had used the 'artistic naivety' of the Bolsheviks to secure a foothold within the structures of the revolutionary state, and that this naivety was what led to 'the myth that the Bolsheviks supported the avant-garde'.[109] While this is true, it should be noted that not only were the avant-gardists just as naive in the field of politics, but they were also completely unprepared for the political battle that awaited them. They may have been experts at formulating their ideological principles and stirring up trouble, but when it came to forming coalitions they were utterly incompetent.

During his student days, the linguist Roman Jakobson was once present at an encounter between Malevich and the radical poet Alexei Kruchyonykh, and noted with surprise that, to both Malevich and his interlocutor, compromise was taboo. 'Compromise is out of the question', and artists who were prepared to accept a middle way were immediately declared 'unacceptable to the entire group'.[110] Jakobson showed a keen perspicacity, for a naive inflexibility was indeed one of the most characteristic traits of the avant-gardists. They also completely lacked the discipline (at least in public) to present a united front, or to act in consort as a single, monolithic entity, setting aside their aggressive internal competitiveness and philosophical conflicts.

Their lack of political experience and adroitness would fatally undermine their position in the revolutionary state from the very beginning.

Monumental Propaganda! Or: Avant-Gardists in Public Service

1918 – 1919

1918 was a triumphant year for the avant-gardists. The unthinkable had happened: the previously marginalized, maligning and maligned artists had obtained positions of high office in the new Soviet state; they could exert major influence on cultural policy, and had the opportunity to reform art education. They also prominently displayed their art in public spaces, especially during the grand October festivals celebrating the first anniversary of the revolution. The most sensational of these consisted of several immense, suprematist installations set up on Petrograd's Palace Square in the heart of the imperial capital, directly in front of the Winter Palace, which is now the Hermitage Museum.

For hundreds of years, the 5-hectare Palace Square – twice the size of Red Square, and four times that of Trafalgar Square – was emblematic of the limitless imperial ambitions of the Russian tsars. The square's central point, the Alexander Column, consisted of a pedestal over 10 metres (32 feet) in height, atop which a monolith 25 metres (82 feet) tall was placed, towering above all other existing structures of its type in the world. The monolith was a powerful metaphor for the Tsarist autocracy: singular and indivisible, it stood unsupported on its pedestal, utterly static and untouchable, held securely in place only by its own colossal weight.

For the festivities, the square was dragged into the new age with enormous, brightly coloured abstract decorations. Nearly 15,000 metres (50,000 feet) of fabric were used to decorate the palaces and the immense partitions between them.[1] The most eye-catching element was the gargantuan construction surrounding the Alexander Column: a joyful display of suprematist fire in contrasting shades of yellow, orange and red, neutralizing the column's grave immobility and transforming it into a quirky, colourful firework being launched into the sky.[2]

Nathan Altman, *Design for the Decoration of Uritsky Square* [Palace Square] *in Petrograd on the First Anniversary of the October Revolution*, 1918.

For the first few weeks of that year, however, there had been no indications that such a radical transformation would take place.

On 29 January 1918, Lunacharsky established the Department of Fine Arts within the People's Commissariat for Enlightenment, and charged it with the task of designing Bolshevist art policy. Nobody yet knew who was to populate the department, not even Lunacharsky. He was still having great trouble finding suitable people to fill the roles, especially among visual artists. It was also clear that whoever came to work in the department would exert a great influence on its eventual policy, and it seemed highly unlikely that the futurists would be able to dominate the department.

By early April 1918, the situation seemed little different. The political alternative dreamt of by the avant-gardists – an anarchistic, creative revolution – had been quashed by the suppression of the anarchist movement. However, their vision (the free practice of their art without any involvement by the state or of capital) was still firmly in place, and with it, their opposition to Lunacharsky. Some avant-gardists had shown signs of willingness to work with him subject to certain provisos, while

Group photograph, taken in front of the decoration of the Alexander
Column on Palace Square, Petrograd, 1918.

others seemed irreconcilable in their opposition to a national cultural
ministry. Lunacharsky had grave doubts about futurism as an artistic
movement, but that was nothing compared to the disgust of some of his
Bolshevist comrades, who saw futurism as nothing less than the class
enemy itself.

So why *did* he decide to appoint the avant-gardists to high positions
in the Department of Fine Arts of his own People's Commissariat in the
second week of April? And why did they accept?

Let us examine Lunacharsky's own commentary on the matter. He later
twisted himself into all kinds of knots to defend his choice, one which
the establishment quickly judged an unprecedented faux pas. In one
instance, he tried to explain why the avant-garde made sense in the
context of the moment, referring to the parallels between the social and
artistic revolutions and to the position of the avant-garde as an oppressed,
impoverished group that he claimed was 'close to the proletariat'.[3] 'But
ultimately,' he admitted, 'I extended a hand first to the avant-gardists
because the People's Commissariat for Enlightenment needed a serious

collective of creative artistic forces to rely on. These I found only here, among the so-called "leftist" artists.'[4] Lunacharsky reiterated in various texts that he had had no other option, that there were 'no other artists on hand'. This rationale then regularly appeared throughout the historical literature, without qualification.[5]

This version of events, however, is at the very least incomplete. The boycott by the Cultural Workers' Union was not absolute. Various artists and intellectuals were prepared to accept some individual responsibilities in the revolutionary administration. This is almost immediately evident from a brief survey of the meeting reports issued by the numerous (sometimes spontaneously formed) revolutionary arts committees, many of which contained established names.[6] Symbolists Kuzma Petrov-Vodkin and Pavel Kuznetsov had already expressed a willingness to work in the post-revolutionary order in December 1917, and on 1 January, an entire group of famous Moscow artists including Viktor Vasnetsov, Abram Arkhipov, Konstantin Korovin and Leonid Pasternak (Boris Pasternak's father) sent a joint letter to the Moscow Soviet.[7] In early January, in response to the question 'Can the intelligentsia collaborate with the Bolsheviks?' poet Alexander Blok responded in the press with: 'They can and should.'[8] Even very successful academists such as Boris Kustodiev and Isaak Brodsky – both ex-pupils of Ilya Repin who had found a broad and sustainable market for their art for many years – made no secret of their willingness to work for the revolutionary cause, and would later become two loyal pillars of support for Soviet art. The Russian intellectual tradition of 'artistic management' – artists who used their abilities for the common good – was alive and kicking.[9]

Lunacharsky could have opted to gain the trust of these people slowly, and to effect the gradual integration of reliable left-wing workers into his People's Commissariat. In that way he could have built up his network of public servants carefully over a period, without the sudden influx of one specific group and all the risks associated with it. But he was evidently in a hurry.

Lunacharsky's decision was determined by a range of pressing circumstances that primed him to seek an alliance with the futurists. Ultimately, however, there was one specific matter of the utmost urgency that forced him to enter into immediate negotiations.

Lunacharsky's Dilemma

First, the pressing circumstances.

By January 1918, the principal cultural needs had been met: the museum collections had been largely rescued, and the palaces and historic monuments safeguarded from further ransacking. The next few months, however, would require the implementation of new policy, which in turn demanded a high level of political engagement from the public servants carrying out the work. Would the same established names who had helped him until now still be prepared to follow him into 'precarious' territory, such as the reform of art education? Lunacharsky planned to open up and radically democratize the art academies, and knew that he would encounter serious resistance from the institutions themselves.

The avant-gardists were the ideal group for the job. Most had no sentimental connection to these academic institutions, having either been expelled from them, or never admitted in the first place. They also had explicit and powerful ideas about the new forms that education should take, and the desire to distil them into policy. Even if Lunacharsky found their educational notions too radical, he still needed the avant-gardists to act as a battering ram to break through the resistance of the conservative academists.

The Bolsheviks also had their international reputation to consider. A global revolution would require the mobilization of left-wing European powers, and Lunacharsky knew that the avant-garde was respected by progressive Europeans. At a time when the Bolsheviks still saw themselves as the vanguard of an imminent global revolution, he could not simply ignore the opinions of progressive European intellectuals.

Lastly, there was a consideration that was less political or opportunistic, and more philosophical in nature. Lunacharsky believed that art and artistic movements played a unique part in the historical process. Art not only reflected reality, but also played an active – even crucial – role in the processes of shifting communal consciousness that must precede the transition into a new historic era.

Interpreting these processes was not easy. But one thing was certain: it could not be coincidental that so many futurists embraced the revolution, even if their personal preferences differed. Lunacharsky remained true to the conviction that futurism represented a certain 'final form' of conventional culture. Had futurism already served its purpose, or did it

still have a part to play in the transition from a bourgeois to a communist society? If it did, he was duty bound to facilitate that role.

A range of social circumstances also mitigated his aversion to the futurists. In recent months, he had become acquainted with more and more radical artists (mostly writers) in Petrograd, and their company had softened somewhat his attitude toward the avant-garde. The key figure in this respect was Mayakovsky, who continued to impress him in spite of everything. There was also the futurist poet Ryurik Ivnev, who worked as his secretary for some time, and Pavel Mansurov, a very young radical artist who ran errands and performed sundry services for him. The enthusiastic commitment of these young people to the revolution did not escape Lunacharsky's notice. There were also men of his own age and background whom he respected, including Vsevolod Meyerhold, who openly revered radical artists such as Tatlin. Nikolai Punin was a little younger than Lunacharsky, but an intellectual with considerable knowledge of art history and a belief in the universality of art that Lunacharsky himself also cultivated. Punin, too, was an outspoken supporter of the futurists, even their most radical theoretician, and regarded Tatlin as the most prominent artist of his generation.

A key role in Lunacharsky's overtures to the avant-gardists was played by the first minister of the Department of Fine Arts appointed by Lunacharsky in January: the unknown modernist David Shterenberg.

Shterenberg had nowhere near the prestige of Benois, to whom Lunacharsky had already offered the ministership in November. He had other qualities to recommend him, however: for years he had already been a member of the General Jewish Labour Bund, a socialist party with whom the Bolsheviks had just entered a coalition, and which therefore supported the revolution unequivocally. As a young Jewish man in his home town of Zhitomir, he had joined an outlawed Jewish self-defence militia, and fought against anti-Semites in the three-day government-supported pogrom of April 1905. After that he was forced to leave Russia,[10] and his deep-seated distaste for the Tsarist empire made him a loyal comrade to the Bolsheviks. He was efficient, incorruptible and hard-working, and felt no need to step into the spotlight or to seek public recognition.

After fleeing Russia, Shterenberg spent over ten years in the La Ruche artists' colony in Paris, where he happened to meet Lunacharsky. Like Lunacharsky, he did not return to Russia until shortly before the October revolution.

David Shterenberg, 1922.

Shterenberg was well acquainted with the Russian artists resident in Paris, but had had little or no contact with those living and working in Russia. Many artists were dumbfounded that this quiet, pensive man had suddenly become the most powerful artistic figure in the country. Even the well-informed critic Abram Efros said that when 'nobody had ever heard of Shterenberg', he himself thought he was a photographer.[11] Though appointing an outsider like this did not immediately solve all of Lunacharsky's problems, it did offer some advantages. An artist without a network could operate outside the existing cliques, after all, and would not be in any position to pursue his own political ambitions.

According to one of his later pupils in Moscow, Shterenberg was 'utterly devoid of any external qualities. He was shorter than average, with a large head, curly hair, and bald patches on his temples.' But his speech lent him an inimitable charm. 'The accent of his youth, carried through all Montparnasse and Paris, had taken on a tender French melodiousness....He supplemented his limited vocabulary with gesticulation.'[12] Though Lunacharsky's characterization of him as a

'determined modernist' was accurate, he was no iconoclast or visionary, and eschewed the avant-gardists' boisterous and expansive qualities completely. His paintings, predominantly still lifes, are of an intimate, searching and tranquil nature. Often dominated by monochromatic planes, they are not abstract and always contain at least one or two recognizable objects. Lunacharsky called him an 'extremely honest man' which – in spite of the zeitgeist and Lunacharsky's own loose notions of truth and falsehood – seems to have been the case.[13] In the occasionally aggressive milieu of the leftist artists, he always tried to adopt a central position. Few expressed an outright dislike of him, except for Malevich, who was simply unable to muster any sympathy whatsoever for anyone prepared to make compromises.

Though Shterenberg's temperament and skill set placed him in the margins of history, still he would play a crucial role in the development of the arts in Russia. For despite his reserved character, he was still a fervid devotee of the radical arts, and would consistently defend them throughout his years of service as a prominent public official. At the same time, he was completely loyal to Lunacharsky, who would increasingly come to rely on Shterenberg's support to get things done.

Lunacharsky first sent Shterenberg to see Benois, probably in the hopes of convincing him to accept a position in the new Department of Fine Arts after all. Alas, it was not to be. Benois could not suppress his disdain for 'that small, grey, typical Jew'. After their second meeting, Benois wrote in his diary that Shterenberg 'spoke with a vulgar accent, and had the tendency to slip into French, which also smacked of vulgarity....He seemed rather pathetic to me, and the others found him positively disgusting.'[14] Later, too, Benois continued to describe Shterenberg in the most condescending, occasionally anti-Semitic terms, with constant references to his unattractiveness and poor manners.

Slowly but surely, Shterenberg began to form his own clique. The only artist who Shterenberg knew well was Nathan Altman, who had been his neighbour in Paris and, like Shterenberg himself, hailed from a Jewish family in modern-day Ukraine. Altman was immediately appointed head of the Petrograd division of the Department of Fine Arts, allowing Shterenberg to focus more on national governance.

The need for loyal people in the administration became more acute in late February/early March, when the decision was made to move the entire Russian government from Petrograd to Moscow. This relocation,

a crucial event in twentieth-century Russian history, would ultimately convert Moscow into the capital of the Soviet Union on 16 March 1918.

An inevitable consequence of the move was that Moscow would increasingly become the centre of attention. It was a foregone conclusion that its new status as the capital ought to be reflected in every government area, including arts and culture. Lunacharsky had a limited arts network in Moscow, and no following to speak of. Furthermore, Lunacharsky was the only People's Commissioner who had decided to stay in Petrograd for the time being, which only intensified the need for a firm hand in Moscow.

Shterenberg's contacts in Moscow were few, but not zero. They included Popova and Udaltsova, who had also lived in Paris for some time. He may have also met Tatlin while in Paris, though that is pure conjecture. On his return to Russia in 1917, just before the October revolution, he worked for one week under Malevich while he was still the chairman of the arts section of the Soviet of Soldiers' Deputies.[15] All of these contacts were superficial, however. In February or March, Nikolai Punin had joined the small group led by Shterenberg. Unlike Shterenberg, Punin did have an extended network in Moscow, and was also a fierce defender of the futurists, and of Tatlin especially.

This was the situation in early April. For various reasons, Lunacharsky had gravitated towards the futurists, but was still not totally convinced. He suspected they could be useful, but was wary of their unpredictability. He formulated his own doubts as follows: 'Given that the futurists' best representatives embrace the communist revolution, they are better suited to stepping up as virtuosi to the drum of our red culture. At the same time, however, they are the product of a certain old world aesthetic satiety, and have a penchant for stunts, antics, and all that is strange and unheard-of.'[16]

Lenin's Plan

The final push that gave the Moscow futurists control of the Department of Fine Arts manifested suddenly. Sometime between 5 and 8 April (the exact date is unknown), Lenin held secret, extended talks with Lunacharsky about a new plan.[17] The plan envisaged a radical metamorphosis of public spaces, based on a treatise by the seventeenth-century Italian utopian philosopher Tommaso Campanella entitled *The City of the Sun*. The treatise, according to Lunacharsky (who was paraphrasing Lenin), describes a perfect city where the walls are painted with frescoes 'as visual materials

for teaching the young about science and history, and encouraging a sense of civic responsibility. In short, they form part of the upbringing and education of new generations.' Throughout the city, statues were planned not only of historic revolutionaries, but also of scientists, poets, authors and artists. Existing statues of tsars, politicians or notable nobles were to be torn down and destroyed to make room. In addition, inscriptions were to be placed throughout the city proclaiming Marxist principles and slogans, or 'concise formulations commemorating some great historic event or other'.[18] A new historic canon was thus to be reinforced. Additionally, Lenin wished to celebrate public holidays such as 1 May and the anniversary of the October revolution in the most extravagant manner, completely transforming cities and decorating them with mottoes and imagery that glorified workers and the working-class state. He named his vision the Plan for Monumental Propaganda, and it was to be implemented without delay. Around one week later, Lenin's proposals were set out in a decree stipulating that by 1 May 'the most monstrous idols' should be removed and 'the first models of new monuments erected'.[19] Lenin, Stalin and Lunacharsky all signed the decree personally. The grim presence of the terrorist Stalin at the signing of this minor cultural edict is surprising. Did he happen to be in the area, or was he perhaps brought in by Lenin deliberately, to intimidate Lunacharsky?

Whatever the case, Lunacharsky now faced a new challenge, one that would require a considerable workforce to administer and put into practice, and which was to be executed under the scrutiny of the party's most prominent leaders. It was clear that he could not pull off such a tour de force with committees full of grumbling has-beens. The removal of statues especially was set to ruffle the feathers of people like Benois. Who else would be prepared to do it but the futurists, who only recently had called for the streets to be purged of the old monuments, whose 'foul boots still crushed the throats of the young streets'?[20]

Lunacharsky, therefore, turned to the futurists because they were in a position to solve a problem for him. Or, as he candidly admitted: 'We cannot afford to...become hostile towards them, for they may be of use to us.'[21] There were many who believed that Lunacharsky embraced the futurists because he had converted to futurism and planned to institute it as a kind of state art. Keener observers, however, saw even then that the situation was different. The critic Abram Efros noted: 'The power dispute [in the arts] was resolved not by a preference for art, but by a preference for people. Futurism was not necessary, but the futurists were.'[22]

The Avant-Gardists Get to Work

Lunacharsky was also pressed for time. Only a few days after his meeting with Lenin, he sent Altman and Punin to Moscow to sound out the avant-gardists. The first on their list was Tatlin. He had the support not only of Punin, but probably also of Mayakovsky. Tatlin had also increased his administrative activity during the winter of 1917–18, and expanded his network. He seemed open to the prospect, and was invited to become the president of the Moscow division of the Department of Fine Arts.

Tatlin's rapid acceptance of the role is not so strange. The appointment reinforced his position as a leader among the avant-garde, which in turn gave him opportunities for collaboration. Erecting monuments and organizing the celebrations in May and October would give him the chance to further develop his ideas for art installations and theatrical fantasies on a mammoth scale – an irresistible temptation for an eternal dreamer such as Tatlin. The necessary ideological about-face – from anarchist-futurist to a public servant in the Bolshevik government – was less of a disgrace to him than to the other avant-gardists. In truth, Tatlin was not interested in day-to-day politics and had no pretensions in that direction, so he suffered little loss of face. His association with the anarchists had been fleeting, and in his only article for *Anarkhia* he had not openly attacked all forms of government power.

For many of the most radical artists in Moscow – including Malevich – things were different. His opposition to a unification between artists and the state had been more fierce, and his alignment with the anarchists more profound. He immediately published a fiery piece in *Anarkhia*, denouncing the arrival of the 'terrorists' Altman and Punin, who were attempting to break through the ranks of the Moscow avant-gardists from Petrograd 'with their bombs and steel rods, for the banners of Moscow'. Malevich attacked all and sundry, claiming that 'artistic Moscow was hiding in fear', and that those from Petrograd were essentially proponents of 'Benois' boudoir'.[23]

Malevich's violent reaction was, of course, provoked by the fact that his arch-rival Tatlin had been chosen by the Bolsheviks. Still, he was not alone in his opposition – Rodchenko, too, had spoken out fiercely against Tatlin's appointment and the rise of the 'state futurists': 'One of our own has truly been elected to government. But this triumph is a horror to us....Look, there is the aquarium where our chosen artists swim deftly about, but between us is a thick layer of glass. See them dancing

Vladimir Tatlin, 1911.

our defiant dance. And we applaud them, while our teeth chatter from the cold.'[24] Several days later he attacked Tatlin once again, saying how he had 'stolen his way...into lucrative commissariats'.[25]

Tatlin's appointment, therefore, led immediately to considerable tensions among the avant-gardists, and everybody felt the need to take sides.

Within several weeks of Tatlin's acceptance, several other artists applied to the Moscow branch, including at least Tatlin's girlfriend Sofia Dymshits, Nadezhda Udaltsova and her husband Alexander Drevin, Georgy Yakulov and Olga Rozanova. Several moderate modernists also stepped up, however, such as Ilya Mashkov and Pavel Kuznetsov.

Udaltsova wrote that her "'friends' turned their backs' on her for the choice she made.[26]

> Tatlin's office was on Prechistenka Street, to this day one of the most beautiful streets in the old city. When his friend Vera Pestel came to visit, she saw how Tatlin laughed, and said, as he spread open his red hands: 'It's a miracle. Lunacharsky came to me in his car, and now here I am.' We both laughed, it was so strange, we still couldn't believe it. Tatlin, the man who used to wear an old grey twill jacket both winter and summer, no gloves, and all year round had worn the same stiff felt hat, a kind of boater that he had dubbed 'Tatlinovaya', who got lunch from the Vesnins and who rented rooms from friends... that doubled as his studio – that same man now suddenly had his own studio and wore a fleece-lined coat with a fur collar. The coat was secured with a belt, since otherwise it fell completely open. And on his head was a fur cap with earmuffs, and he wore felt boots. This is how he was dressed, sitting in his office in the Department of Fine Arts of the People's Commissariat.[27]

Tatlin had already amassed an appreciable entourage by early May, but there was still much resistance. He secured a small victory in early June, when he successfully enlisted Wassily Kandinsky.[28] Despite his unmistakeable reputation as a radical artist and pioneer of abstract art, among the Moscow avant-garde Kandinsky was still an outsider. He was from an entirely different generation, even older than Lunacharsky and Benois – fifty-two, to be exact. Even the relatively old Malevich was thirteen years his junior. Tatlin was thirty-three at the time, and most of the other artists were in their twenties. Kandinsky was from the nobility, and had graduated in law. For years he had lived in the stately city of Munich, and was as distant from the rough radicals in Moscow as the frivolous chic of the Parisian *bohèmes*.

Many progressive European artists saw Kandinsky as a living legend, even if the appellation of 'genius' was bandied about more readily then than it is now. In April 1917, without the least reservations, Swiss Dadaist Hugo Ball said of him: 'Kandinsky is liberation, consolation, deliverance and peace. Visiting his paintings is a pilgrimage: they are an escape from the confusion, defeat and desperation of our time. They are the liberation from a collapsing millennium. Kandinsky is one of the great innovators, distillers of life. The vitality of his intention is astounding, and just as unprecedented as Rembrandt's was in his time, or the vitality of Wagner, a generation ago.'[29]

Wassily Kandinsky, 1910.

Before the war Kandinsky had exhibited in Paris, London, Rotterdam and Amsterdam (as well as all the major German cities), in Scandinavia, and received commissions from the United States (Plate 16). In this regard, not a single radical artist in Russia could compete with him. Despite his many years in Germany, Kandinsky had never cut ties with his home-land and still considered himself a Russian artist. He never sold his enor-mous house in Moscow, still visited almost every year, corresponded with other Russian artists, and took part in radical art exhibitions in Moscow, Petrograd and Odessa. When the war broke out, he was forced to leave Germany within twenty-four hours. Other artists from his circle, such as Alexej von Jawlensky and Marianna Veryovkina (later: von Werefkin), moved to Switzerland, but Kandinsky decided to spend the war years in Russia, where he would eventually live until 1921. In the summer of 1917 he had a son there, Volodya. After the Treaty of Brest-Litovsk he could easily have left Russia and returned to Germany, as he had the money and the contacts to do so. He chose to stay, however, and offer his services to Lunacharsky, who in 1911 had described him as a man 'in the final stages

of mental degeneration'.[30] Kandinsky would remain active in the People's Commissariat for three years, and play a major role in the establishment of a new education system and museum culture.

To summarize, Kandinsky's participation lent prestige to the Department of Fine Arts, and cannot but have drawn Malevich's attention.

Still, this was not the only ingredient necessary to win over Malevich and calm his strenuous opposition. In mid-June, he attended a number of meetings of the new Moscow Fine Arts division as an observer, and probably received several proposals, the nature of which made him realize the feasibility of implementing part of his anarchistic programme under the new Bolshevist policy.

But...was he prepared to sit alongside Tatlin, especially while the Bolsheviks were running pogroms against his friends, the anarchists? A letter from Malevich to Tatlin, probably sent around the end of April, shows that the two had already discussed a potential partnership. Malevich decided to put him to the test:

Vladimir Evgrafovich.

During the anarchist arrests, the young artists Spassky, Kuzmin and Senkin were also captured. Morgunov knows them too, they are people with wonderful souls.

Take action so that their blood does not darken our consciences, do so as soon as possible....They are guilty of nothing.

And Malevich's magnificent conclusion: 'And then, for my part, I am ready. Let their hands tear open the gates of my breast and rip out my heart, removing my free Self from its altar.'[31]

Leaving aside his eternal penchant for the dramatic, this final sentiment is a testament to Malevich's serious doubts when it came to associating himself with the Bolsheviks, whose tolerance for personal freedoms proved rather patchy.

At the top of the letter, Tatlin wrote in pencil: 'Permission granted. The artists have been released.' This statement is also striking, for it seems that Tatlin held sufficient sway to facilitate the release of prisoners.

Malevich threw himself immediately into his work, and made proposals that mostly concerned the income of artists in post-revolutionary society. He wondered how artists could survive without the patronage of either an imperial court or private collectors. His solution was to put artists in charge of a chain of modern museums that would systematically purchase art from living artists – in essence an 'enlightened' form

of state patronage that gave the artistic community a mandate to define artistic value.

During meetings and interviews, it became clear that the Department of Fine Arts would also set up a museums department led by artists themselves, where he had probably already been promised a leadership role early on.

To bolster his position, Malevich read out a new manifesto that was far more concrete than his usual theoretical texts, titled 'The Declaration of Artists' Rights'. In it, he argued for an acknowledgment of the unique position of artists in society, one which justified the granting of extraordinary rights. The text was written directly after the brutal suppression of the anarchists, and also certainly bears witness to Malevich's fear of the violent reflexes of an omnipotent state. More than that, it was an anarchist manifesto that defined individual freedoms and inviolability as its sole values and laws.

1. Life and death belong to the artist, as inalienable property. No person or law whatsoever may exert violence on the artist's body, even at times when the state, the Fatherland, the nation, is under mortal threat.
2. The inviolability of the artist's home and studio.[32]

The next four lines are no less interesting, and pertain to the economic position of artists in a capitalistic society (whereby Malevich implies that Russia, despite the revolution, was still in a capitalist phase). He stipulates that artists must always retain control over what happens to their artworks, suggesting that while collectors may purchase them, they may not be sold on without the artist's permission. He also stipulates that the state may purchase artworks, but only for inclusion in publicly accessible museums with an educational function.

The manifesto is less utopian than it may first appear, for the fundamental problem of artists in a capitalist society remained unsolved, a fact of which Malevich was well aware. The art market is governed by supply and demand, yet artists are motivated to work by an intrinsic need to create, meaning there is constant oversupply and prices are low or non-existent. At the same time, artworks – once they are severed from their makers and become unique, irreplaceable objects in a world where almost everything else can be copied or mass-produced – are highly sought-after as status symbols, investment objects, or even currency. The resulting and surprising paradox is that artists are poor, and art is expensive. Malevich clearly wrote his Declaration intuitively

and within a short space of time, as the ideas in it have no precedent in his earlier writings, but keenly address and foreshadow the troubles of artists who work for the market (i.e. poverty) or for the state (servitude).

Malevich read out his Declaration at a meeting of the Moscow Soviet, where it was decided that a committee should be formed to 'rapidly address and flesh out the declaration of rights in further detail'.[33] This confirmation, and the offer for him to take charge of the new museum division within the department, were ultimately what won him over. Malevich had one bitter pill to swallow, though, and that was to tolerate Tatlin as head of the department. However, there are indications that the tensions between the pair eased somewhat during these few months, and that their shared ideals even enabled occasional collaboration.

On 6 July, Malevich joined the Moscow Department of Fine Arts, probably followed some time later by Rodchenko, grumbling and full of self-pity.[34] He, too, realized that working for the Bolshevist government had become inevitable if the avant-gardists wanted to realize their grand artistic dreams in a post-revolutionary world. The consolidation of power effected by the Bolsheviks had eliminated every possible alternative. Economic motivations were naturally an additional concern, as the collapsed economy had left open hardly any other avenues for generating income. Thus the avant-gardists were widely denounced for acting in their own self-interest, and not only by their sworn enemies. Viktor Shklovsky, for example, wrote: 'Why have some artists entered the service of the Soviets, why did they not stay true to their independence, hungry but proud? Only because right now, aside from the government, there are no buyers, no exhibitions, and no theatres besides those of the Soviets.'[35] This conclusion, however, is short-sighted. For both Tatlin and Malevich – indeed, for nearly all the avant-gardists – the prospect of being able to realize part of their artistic programme within the government apparatus was the deciding factor. They were too uncompromising to reach such a decision for purely practical or financial reasons.

Furthermore, it was clear that a refusal to participate by the avant-gardists would lead to the triumph of conservative forces, thus dashing all hopes for the establishment of any revolutionary culture. This was the argument put forward by Osip Brik in the winter of 1917–18. According to Brik, the Bolsheviks' cultural policy was 'impossible' and the results had 'little to do with culture'. But, he added, collaboration with the Bolsheviks was the only way to combat their backward and, in his view, counter-revolutionary policies.[36] The avant-garde, therefore,

had to serve the Bolsheviks' cultural agenda, since the only way it could be fought was from within.

The claim that the avant-gardists became rich at the government's expense is also untrue: for his service, Malevich received a modest salary of 600 roubles per month, which was often issued either after a significant delay, or not at all.[37] For comparison: a kilogram of sugar cost at least 20 roubles at that time, and probably more.[38]

In any case, it was clear that the marriage between the avant-gardists and the Bolsheviks was rocky from the start. Both parties had disparate and partially conflicting reasons for wanting to work together, and it should come as no surprise that their alliance proved highly volatile. Tatlin would never feel completely at home in the Bolsheviks' bureaucratic universe, and Malevich would never lose his disdain for Bolshevist ideology.

It would be too easy, however, to claim that the avant-gardists and Bolsheviks were purely enemies. They still had much in common.

The above applies more to Malevich than to Tatlin. Malevich's association with the Bolsheviks points to a deep-seated contradiction in his personality and convictions. His anarchistic mentality was closely related to his ideas on the dissolution of the tangible world, and to his belief in the transformative quality of his painting that was intended to free the spirit from its material chains. These ideas, however, were predicated on rigid, anti-liberal foundations. He held a deep aversion to pluralism and to a liberal view of freedom and private ownership. He may have believed in freedom of expression, but not as an inalienable right. To him, after all, there could be only one truth, a single incorruptible understanding of reality; the rest was ignorance and lies. Freedom of expression might be useful for as long as that single truth remained undiscovered, but not as a smokescreen for spreading falsehoods and confusion. The belief in the existence of a unique truth and the right to freedom of expression are problematic concepts to reconcile.

There were other similarities between Malevich and the Bolsheviks that were not ideological in nature, belonging instead to the domain of mentality. Malevich was a devotee of professional discipline and strict organization. He enjoyed propping up his ideas with dogged and unflappable determination, even the most bizarre and fantastical, using far-fetched and paradoxical abstractions. He believed that the dissemination of truth was best served by agitation, rather than calm and rational argument. This shared mentality ensured that he felt at ease

among the Bolsheviks, as though they spoke a common language despite their ideological differences.

There was another side to Malevich, however, that usually receives far less attention. He organized his daily life with great sobriety, he was generous and benevolent, domestically inclined and had a great *joie de vivre*. He enjoyed good food and, whenever there was enough, always put on weight. As Irina Vakar rightly pointed out, he felt no need whatsoever to pursue a career in bureaucracy. The day-to-day wielding of power, and political influence on matters unrelated to art or art education, did not interest him in the slightest. Ultimately, there was nothing more important to him than the free, intrinsic life of the individual – character traits that contrasted sharply with those of Malevich the activist and zealot.

The Department of Fine Arts

The structure of the Department of Fine Arts was formalized in the summer of 1918. The 'pan-Russian' umbrella board was chaired by Shterenberg, with sub-committees for Petrograd and Moscow. Lunacharsky ensured that, at its inception, the local representatives would be appointed, not elected.[39] The Moscow division, headed by Tatlin, was more radical than its Petrograd counterpart, since most of the avant-gardists were based in Moscow.

Nathan Altman became the local delegate in Petrograd, alongside the active and influential Punin. Each local board ran several sub-committees representing the various artistic disciplines: literature, theatre, museums, and so on. The most prominent member of the Petrograd literature department was Mayakovsky, supported by his friend, the aforementioned Osip Brik. Brik was a sinister figure: he worked as an informant for the People's Commissariat for Internal Affairs (the NKVD) and had contacts high up in the party organization.

Alongside Tatlin as chair, the Moscow contingent included Lyubov Popova, Kazimir Malevich, Nadezhda Udaltsova, Olga Rozanova, Alexander Rodchenko and Wassily Kandinsky (among others). This list is striking, even today. Whatever the Bolsheviks' general intentions, or those of Lunacharsky in particular, they created a situation unique in history. Never before, and never again since, had such an exceptional group of artists been appointed to such high positions of bureaucratic office, and received real powers of authority to shape cultural policy as they wished.

The artists who joined the People's Commissariat for Enlightenment were – to put it mildly – ill-prepared for their responsibilities. Shterenberg himself later admitted that prior to his appointment, he had 'never performed any kind of organizational work before',[40] and Olga Rozanova admitted that she had 'never held any kind of post'.[41] Sofia Dymshits, Tatlin's girlfriend and the department secretary, tried to forestall criticism in her very first public report from the department, saying that any critics should 'bear in mind that those serving in the department are all artists, who have never had to perform any organizational work on a national scale before'.[42]

Their attention was not always focused on acute problems of a practical nature: 'The issues brought up during the meetings,' the secretary later recalled, 'were so broad and multi-faceted that their solution would require not months, but years or more to implement'.[43]

At times, Lunacharsky was clearly entertained by the quixotic antics of the avant-gardists. As one of their first orders of business, they wished to 'immediately make contact with artists all over the world, in order to consult on artistic problems. The letters have already been written.' Sofia Dymshits was sent to Lunacharsky, to ask for resources to put the plan into immediate action.

> There was a civil war on, the Entente was raging, all borders were shut, but the artists' dreams were boundless. With the minutes of the meeting under my arm, I travelled to Leningrad to report everything to Anatoly. Jerking slightly in his chair and barely able to control his laughter, he said that though it was indeed a serious and significant matter, he would have to think about it. So I left empty-handed.[44]

Another problem was that none of the artists, not even Shterenberg, was a party member, nor wanted to be. Among the artists there was a kind of collective belief that the political arena was irreconcilable with the artistic calling. When Pavel Filonov, the ascetic leader of the one-man utopia 'Universal Flowering', was asked shortly before the revolution whether he wished to join the Bolsheviks, he replied: 'I already belong to a party, the party of the Universal Flowering. I am the party's only member, and I shall never join the Bolsheviks.'[45] This anti-political attitude meant the artists lacked a power base, and were dependent on Lunacharsky for everything. He, of course, found the situation ideal, and there is reason to suppose that active attempts were made to keep the avant-gardists out of the party after their admission to the Commissariat. When Rodchenko

(certainly the most politically radical member of the group) tried to join the party, his application was declined, ostensibly due to 'insufficient education'.[46] It seems likely that Lunacharsky had a hand in the refusal.

The only exceptions were Malevich and Tatlin. While they, too, lacked any kind of administrative experience, they had been organizing events for ten years and had natural leadership qualities. Though Malevich's official remit was to reform the museums, as a member of the collegium he involved himself in all kinds of other matters, especially those concerning education and the international contacts of the People's Commissariat. It appears that Tatlin granted Malevich a long leash in this respect, probably because he realized that without the Pole's strong organizational bent, the set objectives would not be achieved. They even acted in concert on several occasions, seemingly burying their rivalry temporarily.

With Kandinsky as the only exception, the Moscow contingent was a colourful hodgepodge of squatters, hobos and birds of paradise. 'The offices,' wrote Vera Pestel, 'were not heated. Aside from some chairs, tables in some of the rooms and a few shabby desks, the rooms were empty.'[47] One of the artists even said that they had brought in the tables and chairs themselves.[48] 'We all walked around in fur coats and scarves, dressed for the tram, and came and went whenever we pleased. Everybody was regarded as an employee, and even received a salary now and again.'[49]

The Department of Fine Arts proved to be hamstrung from the beginning, however. Though a museum department was set up, with Malevich at the fore, the management of the existing museums – such as the Hermitage and the Tretyakov Gallery in Moscow – and their associated large budgets rested with a separate body, whose board members included Alexandre Benois and Igor Grabar. This alternate committee, in turn, was financed by yet another People's Commissariat, meaning that the Department of Fine Arts had no idea what kind of funds were being channelled to the existing museums.[50] The Benois/Grabar committee later turned out to be both more richly endowed and better organized than the Department of Fine Arts, undoubtedly because it was made up of professionals. What is more, it competed openly with Fine Arts on several fronts, and undermined its authority. Lunacharsky trivialized the conflict, and acted as though Benois and Grabar were concerned with different matters entirely.[51] Malevich's museum department was given the far-reaching task of establishing new centres of contemporary

art and acquiring new artworks, but its budget and staff complement were Lilliputian compared to those of Benois and Grabar.

Lunacharsky employed a similar divide-and-conquer strategy in the management of the literary world. The Literature sub-committee under the Department of Fine Arts, for example, had Mayakovsky at the helm. But he had nothing to do with the separate, independent literary committee – titled LITO – that was external to Fine Arts, run by the symbolist Valery Bryusov, and primarily representing the interests of the pre-revolutionary intelligentsia. In the summer of 1918, the People's Commissariat also set up its own publishing house, *Vsemirnaya Literatura* (World Literature), led by Maxim Gorky, which also received independent funding and could support its own labour force. Mayakovsky sat comfortably among the other futurists in a single department, as they loudly blew the futurist trumpet from their ivory tower, but it was Gorky and Bryusov who decided who got the money, and how it was used.

According to one historian, Lunacharsky created a 'bastion of futurism' within his People's Commissariat. However, a more accurate term may have been 'enclosure'.[52] By concentrating all of the futurists into a single department, he could easily isolate them and keep them in check. The futurists could be the public face of his new regime and do battle with the art education boards, but the power and budgets were distributed and certainly not exclusively theirs to control. They had their own kingdom, true, but within the realm of the People's Commissariat they were relatively small, and surrounded by public servants who wanted little or nothing to do with them. It goes without saying that their isolated position rendered them vulnerable to political attacks from both within and outside the new regime.

The Department of Fine Arts, moreover, was embroiled in a power struggle with the Moscow Soviet, the former Soviet of Workers' and Soldiers' Deputies. This struggle was typical of the initial years of the revolution, when the Bolsheviks attempted to centralize power and draw it away from the local revolutionary 'councils'. Officially, these local soviets were under the authority of the People's Commissariat, but in practice they often charted their own course. Many of the members had not forgotten the slogan 'All power to the soviets', and though well disposed to the People's Commissariats, they viewed them as a temporary phenomenon.

The local soviets had their own departments of education and fine arts, and had no intention of simply surrendering their power to the

People's Commissariat. The Moscow Soviet – the city's de facto municipal council – was, therefore, on the lookout for a chink in the political armour of the People's Commissariat for Enlightenment, and the position of the infamous futurists in upper management was just such a weakness. Any attack on Lunacharsky would have to go via the futurists, which is precisely what happened, as we shall see.

Bakunin and Marx's Beard

Tatlin shouldered the most politically delicate responsibility himself: erecting the monuments of communist heroes and their historic predecessors. The pressure was great, as everyone knew that the project had Lenin's particular attention. Tatlin immediately risked his neck, coming at once into conflict with his enemies, and thus with Lenin himself. The enemies of the avant-gardists were those members of the Moscow Soviet's fine arts committee who had themselves been overlooked for the job. Most were conservative artists.

On 27 May, Tatlin was officially charged with the task. He promptly set about making a plan, and drew up a list of suitable historical figures. He delivered it on 18 June to Lunacharsky, who in turn presented it to Lenin. The Council of People's Commissars (the SOVNARKOM) reviewed Tatlin's work and approved the list, which included communist heroes such as Marx, Engels and Bakunin, terrorists such as Khalturin and Perovskaya, revolutionary dictators such as Robespierre and Garibaldi, as well as the Ukrainian nationalist Taras Shevchenko, Jean-Jacques Rousseau, the adroit poet-diplomat Fyodor Tyutchev, and artists Vrubel and Cézanne. This final addition came from Malevich, who was consulted on the list.[53] A major part of the plan was the removal of existing statues, especially those of the Romanov family. For this purpose, Tatlin instituted a working party, which became active in early August. In September, the Moscow Soviet proposed collecting the old statues in the Great Kremlin Palace and transforming it into a 'museum of poor taste'.[54] Tatlin later defended the idea as follows: 'A cabinet of curiosities for mediocre, tasteless objects. No entrance fee, so the public can learn to hate ugliness.'[55] Nothing came of this plan, and even the removal of the statues was decidedly slow. The creation of new revolutionary monuments took priority.

One curious aspect of this history was the construction of a monument for the fallen 'heroes of the revolution', on the Field of Mars in Petrograd. Plans for the monument had already been in place since after

the February revolution, as a means of interring and commemorating the victims of the first revolution. Because it had already been initiated earlier, it is not officially considered to be part of the Plan for Monumental Propaganda, but its execution and construction did not fully commence until after the latter plan had come into force. The architect was Tatlin's friend Lev Rudnev, who was also (probably through Tatlin's intervention) a member of the Department of Fine Arts in Petrograd. Nikolai Punin was appointed to supervise the construction process, and it is barely conceivable that Tatlin was not involved in the development of the monument.[56] This is of especial importance, as the monument later served as a model for Lenin's own mausoleum, and would come to save Tatlin's life, more than five years later (see Chapter 8).

Managing an organization during revolutionary times was impossibly difficult. Almost no public institutions – including banks and the post offices – were still functioning. Everybody wished to speak to the new officials, since all were in a state of uncertainty and desperate need. Sofia Dymshits, Tatlin's girlfriend and his greatest source of support at that time, recalled how they worked every day until midnight. As the secretary, it was her task (alongside her regular duties) to take the minutes of the endless meetings. This work created backlogs everywhere else, and so she asked Nadezhda Krupskaya – Lenin's wife – for a minute-taker. Krupskaya responded immediately, and sent her 'a shell-shocked comrade from the front'. The poor fellow was virtually incapacitated, and all of his work needed checking, but Sofia still saw it as a 'partial victory'. The main problem was the organization of payments and other transactions. Dymshits recounted how she was

> required to personally attend all meetings of the Commissariat's finance department, and I ran like a mad thing between the decrepit minute-taker and the interminable meetings....We had no safe, and stored the money under our management as follows: Tatlin and I went to the finance department to receive the necessary funds, which were presented to us as large sheets of uncut banknotes. Tatlin wrapped them around his naked body, and he and I rode like that on the side of a tram down to Tatlin's studio in Basmannaya Street. The tram was free, and people hung off it on all sides like bunches of grapes. Tatlin tried to find somewhere to stand, and I carefully protected him from close by against the many thieves and urchins. Once in the studio, the endless discussion continued: where should we store the money? We, Tatlin and I, decided to pry up some planks

and hide the money under the floor. That seemed like the right idea to me. But that night, when I got home – and I lived on the Arbat on the other side of town – I had another thought. There was a food shortage, and the rats might gnaw at the banknotes. Without even waiting for the tram, I got up and ran to Basmannaya Street in the middle of the night.

When I told Tatlin of my fears, he agreed and decided we should think of something else. Because he had always worked with various materials, he found a piece of sheet metal somewhere and fashioned it into a flat box. After placing the money inside, we put it back under the floor. As for paying the money out, we proceeded as follows: Tatlin's studio door was closed to the public. Only I had access. I received visitors on the stairwell landing, where there was a table that I used to process the invoices. Once an invoice was complete, I entered the studio to obtain the required amount from Tatlin, who sat there with his scissors and cut out the notes. This was our department's accounting process....Once again I decided to ask Nadezhda Krupskaya for help, and she sent us an injured bookkeeper from the front.[57]

Tatlin probably told Khlebnikov of his solution for protecting the government funds from hungry rats, for shortly thereafter, he wrote in his diary: 'Instruct Tatlin to build a tabernacle for manuscripts, a storage space for the objects of the mankind-to-come: an iron skull, with an ordinary cast-iron forehead, for the safekeeping of our belongings and our thoughts. So the vermin of time do not gnaw them away.'[58]

The first monument was completed in August, a bust of the eighteenth-century reformer Alexander Radishchev, to be erected in Petrograd. A second bust, of Karl Marx, was completed two weeks later. To save time, Lenin ordered copies of both busts to be produced, for placement in Moscow. The Radishchev bust was ready first, followed by Marx. Tatlin organized the transportation of the first copy (of Radishchev) to Moscow, along with a large number of plaques containing 'robust calls to action'. But before he could pick up the delivered transport, his enemies in the Moscow Soviet had secretly confiscated it.

The man responsible, an incorrigible liar and cheat by the name of Vinogradov, then reported to Lenin on the progress. He complained of delays, the incompetence of Tatlin's committee and the 'disappearance' of the bust of Radishchev and the plaques – the very ones that

he himself had confiscated. He also declared that Tatlin's crew had not even started work on the Marx copy, in the full knowledge that the completed copy had been dispatched to Moscow that same day.

Lenin exploded in fury: 'I am outraged to the depths of my soul. Still not a single bust is ready; the disappearance of the Radishchev bust is a farce...I hereby publish a reprimand due to criminal and negligent behaviour, and demand to receive a list of responsible names so they may be brought before the court. Shame on these bungling saboteurs!'[59] The scandal might have brought a sudden end to Tatlin's brief career as a public servant, not to mention his life. Tatlin responded with calm and determination. He wrote a letter reporting on the latest progress (including documentary evidence), and dismissing the lies spread by Vinogradov. The letter demonstrates just how quickly Tatlin had got to grips with the reigning bureaucratic jargon of the Bolsheviks:

> We have received word that comrade Vinogradov has cast a tendentious light on the direction and results of our work. He has reported his unfounded opinion to comrade Lenin, and in this manner has tried to blight the activities of the Department of Fine Arts....The work on the monuments is being carried out with great enthusiasm and industry by the artists....The pace has been accelerated as much as possible, while retaining maximum artistic quality and attention to detail. We can currently report that around thirty monuments will be completed by early November. Moral support for this laborious task is provided by an awareness of the sympathy of the toiling masses – in the person of their representatives, the People's Commissars – for the artists' work.[60]

When Lenin received the letter and supporting documentation, he became enraged once again, but this time his merciless shafts were aimed at Vinogradov and his associates: 'The entire Presidium and Vinogradov must, in my view, spend a week in prison for malingering....Forgive me for speaking my mind so candidly, and please accept a communist greeting, in the hopes that a jail sentence for negligence will teach you a lesson. Signed, Lenin, whom you have deeply outraged.'[61]

Despite all the internal machinations, Tatlin did indeed manage to complete thirty monuments by the October celebrations – an exceptional achievement by any measure. Owing to time pressures and the general state of destitution, no valuable materials such as marble, granite or bronze were used; they were replaced with cement, reinforced

concrete, or even plaster. The resulting implication is that the sculptures were not being made for the ages, which in principle would have made them ideal for artistic experimentation.

But nobody dared. Of all the avant-gardists, almost none were employed as artists on the completion of these monuments, not even Tatlin himself. The omission is understandable, as the statues were to resemble well-known personages, and the avant-gardists had collectively almost bid farewell to the portrayal of recognizable reality four years earlier, in 1914. Tatlin had most likely been put under pressure to avoid radical design choices, or perhaps he simply understood that they would not be tolerated. In any case, Lenin had informed Lunacharsky that he was concerned about the proper depiction of Marx's beard, and it was Lunacharsky's job to 'impress upon' the artists that the hair 'should resemble the real thing, so that people get an impression of Karl Marx that is comparable to his portraits'.[62] Tatlin could harbour no illusions whatsoever.

There was one important exception to the above guideline, namely the dynamic futuristic sculpture dedicated to nineteenth-century anarchist Mikhail Bakunin, made by Boris Korolyov.[63] The work embodies something of the character of contemporaneous sculptures by the likes of Arkhipenko and Zadkine in Paris, but while these artists were making small pieces for the salons of ultra-chic connoisseurs, Korolyov's was a thunderous work of monstrous proportions (8 metres [26 feet] tall, and cast in cement). This contorted, alien monolith immediately gives a dynamic impression of pent-up strength, as though the anarchist were trapped in hard cement and might explode his prison at any moment. Erecting such a statue in a public space was a unique, bold statement, and would have been unthinkable in Paris, or indeed in any city other than Moscow.[64]

As such, it aroused much outrage, not least from Lenin, who declared the statue a 'betrayal' and a 'deformation' of his original idea. 'How is it possible that this decadent garbage has been placed in our proletariat streets. Who needs such empty forms that say nothing?'[65] Of course, this was music to the ears of the Moscow Soviet, who took measures to ensure the statue was never properly consecrated, and that it was removed from the street in March 1920.[66] Lenin remembered the affair only too well. When he asked Lunacharsky a year later about a potential design for a monument dedicated to 'liberated work', he noted with relief that Lunacharsky did not wish to erect 'another futuristic scarecrow'.[67]

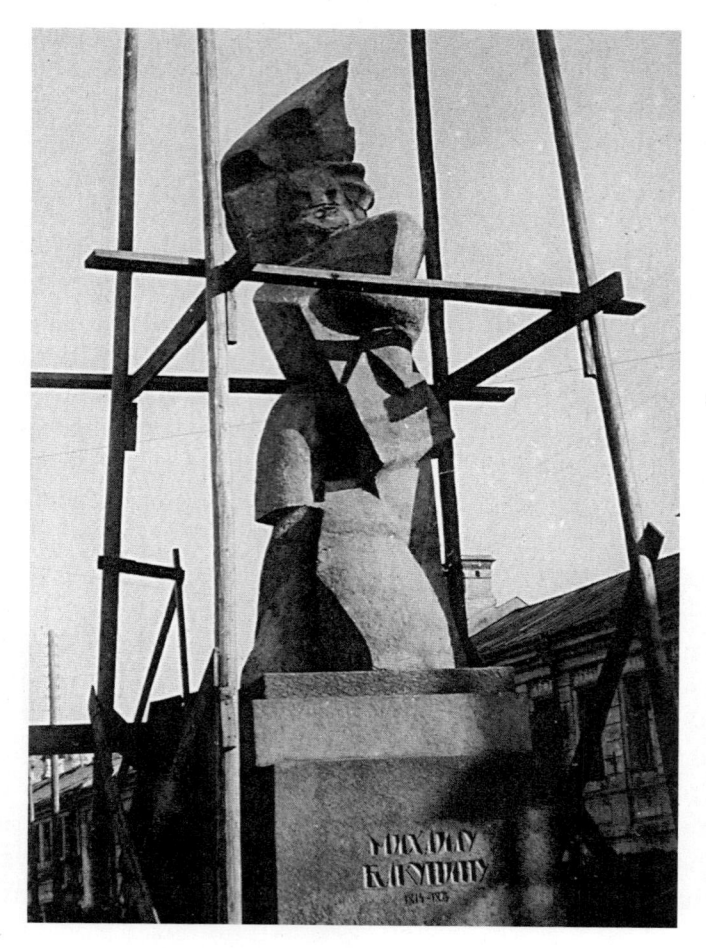

Monument to Bakunin by Boris Korolyov, installed at Myasnitskie Vorota, 1919.

Tatin's efficiency and dedication earned him little credit with the party leadership. There was one positive result, however, though it would not manifest for some time. During his work on the Plan for Monumental Propaganda, Tatlin conceived of an idea for a different type of monument, a concept that was far more ambitious and extravagant than Lenin's paltry schoolboy dreams. The execution of this plan would occupy his undivided attention over the years to come, and culminate in the most iconic artwork of the revolutionary period.

Monument to Bakunin in the studio of the artist,
Boris Korolyov, 1918.

Exegi Monumentum (Goldschmidt)

Almost immediately after the announcement of Lenin's project, Vladimir Goldschmidt went in search of a way to ridicule it. As an anarchist acolyte, and recently unemployed owing to the closure of the Poets' Café, he had little sympathy for state and government involvement. In response, he decided to erect a statue to himself.[68]

Shortly beforehand, the newly opened Darwin Museum had asked him to be the model – because of his 'spectacular figure' – for a sculpture of the Cro-Magnon human that was to form part of the museum's

permanent exhibition. The sculptor later reported that Goldschmidt 'willingly agreed, but on the condition that the sculpture be made as he wished, meaning that I was to depict him as follows: walking proudly, with a dog biting his heels. It transpired that he wished to be portrayed as a progressive person, hindered in his advancement by petty townsfolk and the bourgeoisie.'[69] Goldschmidt asked for a plaster cast of the Cro-Magnon, which he then transported by sleigh to the square in front of the Bolshoi Theatre. The policeman on duty, dazed and weak from malnutrition, and by that time accustomed to the most bizarre and unexpected circumstances, merely waved his hand. Goldschmidt, dressed in shorts, swept the snow aside, placed a temporary pedestal on a frozen flowerbed in the centre of the square, and put the plaster Cro-Magnon statue on top of it. A crowd gathered. When asked what he was doing, he merely replied 'I am erecting a monument'. Once the statue was properly installed, he called out, 'Moscow comrades, behold the temporary monument to the genius life-futurist, Vladimir Goldschmidt'. Then he started reciting poetry. The crowd maintained a fearful silence, under the impression that Goldschmidt was some important Bolshevik or other. His friends applauded, crying out 'Hooray!' or 'Police!' in the hopes of a scandal. A journalist who was present wrote: 'The shameful display came to an end. The futurist horde melted away. What remained was the sculpture of the naked Goldschmidt on the flowerbed.' In another version, the performance concluded with the arrival of the Red Army. They spat upon the statue and pushed it over, whereupon Goldschmidt beat a hasty retreat, and the crowd dispersed.[70]

The performance was one of Goldschmidt's last. At the end of the year he appeared once more in the centre of Moscow 'dressed like Adam' and flanked by two naked women (probably Yelena Buchinskaya and his sister Anna Goldschmidt), who carried a banner bearing the text 'DOWN WITH SHAME' in large black lettering. They proclaimed that there was 'nothing more beautiful in the world than the human body, and that covering it was blasphemy'. Their display led to a brawl, and an old lady started thrashing the naked women with an umbrella. Goldschmidt intervened and seized the umbrella, whereupon the old woman fell over and started yelling. The crowd then turned on the curious naked futurists, and the situation became dangerous. The police stepped in, arresting Goldschmidt and the two women. The naked futurists were ordered to leave Moscow, and were banned from entering any of the six largest cities in the Soviet Republic.[71]

A few months earlier, the ever-boisterous 'father of Russian futurism' David Burlyuk had left Moscow, never to return. Thus it was that, slowly but surely, the poets and artists who held the carnivalesque, erotic, anarchistic and provocative aspects of radical art so dear trickled away. Few understood at the time that this was the initial step in what was to be first the exhaustion, and later the annihilation, of the avant-garde. For without the ridiculous and the ecstatic, the driving force behind their creativity, they would cease to exist.

The Free Studios

However exciting it may have been to transform Moscow and Petrograd into futuristic dream cities, the avant-gardists ultimately cherished a more important objective: the large-scale reform of art education. To this end, in the months leading up to the summer of 1918 the new cultural officers made a series of rapid and far-reaching resolutions.

Immediately before the avant-gardists came to power, the most prestigious art degree in Russia, at the Imperial Academy of Arts, was 'liquidated'.[72] This meant that the management and teaching staff from the programmes in Petrograd and Moscow were dismissed, but also that 'the academy ceased to exist as the vessel of artistic canons'.[73]

Both institutions were reformed by the avant-gardists into 'Free National Art Studios', in which they themselves became the most prominent teachers. Many of the former teachers were immediately reappointed, however, provided they were willing to comply with the new structure and curriculum.

The avant-gardists' entry into these monumental buildings – or palaces, rather – of the former Imperial Academy of Arts must have been a moment of unbridled triumph. The institutions that had previously rejected them now welcomed them as leaders and pedagogues.

The building in Moscow, on Myasnitskaya Street, also housed apartments for the teaching staff, and several were now occupied by the avant-gardists, including Tatlin. For the old guard, the arrival of the futurists was, therefore, a twofold humiliation. Not only did some of them lose their jobs (or run the risk of losing them), but they might now also lose their homes, or – as was happening everywhere – be forced to admit other families to live in 'superfluous' rooms in their apartments.

The new structure in the academies was radically democratic. Not a single qualification was required for admission – the desire to become an artist was sufficient – and the students could choose their own teachers. Preparatory courses were offered to students who were illiterate.[74] Eleven days after the liquidation of the academy, a plenary conference for workers in the arts was held, where the principles of the new programme were shared and worked out in further detail. The conference's concluding declaration stated: 'Every region, every city, every person has the right to demand creative freedom, and the acknowledgment of the artist's freedom in the state'; 'The primary precondition for the existence of art is complete freedom. All centres and powers that unilaterally try to control spiritual life are therefore our enemy'; 'The decentralization of art is our motto'; 'Away with diplomas, rank, status and privilege, all of which dishonour the great name of the artist!'[75] Comparable programmes were set up in eight provincial cities, including one in Vitebsk, modern-day Belarus, which would later be of great importance to the avant-garde. The pluriformity of studios offered by the new academy was striking: of course, Tatlin and Malevich each had their own studio, but there were also those led by more moderate artists, neo- or post-impressionists, and even by traditional realists. Every teacher tried to stand out clearly from the rest with their own studio and methods. Malevich hung up banners bearing slogans such as 'LET THE DESTRUCTION OF THE OLD ART WORLD BLACKEN YOUR PALMS', and 'LET US BURN RAPHAEL!'[76]

As part of the democratization of education, not only could students choose their own teachers, but the school's administrative board was also appointed via general election. The avant-gardists approached the elections brimming with confidence, but failed to consider the fact that the vast majority of students had been admitted long before the revolution, and were loyal to the old body of teachers. Most students, even the newer ones, had never heard of Malevich or Tatlin, and had chosen the academy based on the reputation of the prominent artists who had worked there previously.

Times were hard even for the 'professors' who remained at the academy. They lost their titles and their official rank, which had afforded them status and financial benefits. The students, too, were worse off. Previously they had enjoyed the same legal status as university students, which offered all kinds of privileges, and they could wear a uniform that distinguished them from their non-enrolled peers. They had now lost their privileges, and all uniforms were abolished.

During their studies, moreover, students were exempt from military service, and so none of them wished to graduate while the war was continuing. The number of students had, therefore, increased tremendously. This community of 'perpetual students' was alarmed at the changes, and they had all been at the academy for so long that they identified strongly with the pre-revolutionary policy.[77]

The elections were held in September 1918, and ended in disaster for the avant-gardists. There were around twenty electable candidates, including Malevich and Tatlin. Of the 554 votes cast, Malevich and Tatlin received 4 and 8 votes respectively. The clear winner, with 88 votes, was Abram Arkhipov: a realist from the Repin school who specialized in folkloric peasant portraits and genre art, and who – *nota bene* – had been teaching at the dreaded academy since 1898.[78] The students had opted en masse for the most conservative candidate on the list, and the only true reactionary.

The outcome prompted a strong reaction from the avant-gardists, who immediately used the full weight of their bureaucratic authority to overturn the vote. In a letter to the acting dean of the school, they demanded that the 'elections be immediately suspended until further notice'. Tatlin and Malevich personally visited the academy board to put pressure on the members – the fact that these two sworn enemies worked in consort is a testament to the importance they placed on the reformation of art education. They insisted that the students be informed beforehand that the elections were meant to serve 'the actual reform of the school'. Otherwise 'the funds earmarked for the Free National Art Studios would not be released'.[79]

Ultimately a compromise was reached: the elections would go ahead, but from a list of 'nominated' candidates pre-selected by a separate committee (some of whose members were students). The academy board would also continually remind the 'participants' that the purpose of the elections was genuine reform. At least one of the meeting reports noted that 'if the results of the elections are not in accordance with the expectations of the board, they may be declared invalid'.[80]

In hindsight, the political naivety of the avant-gardists is dumbfounding. Did they really think they stood any chance whatsoever of being elected? The rapid rise of the avant-gardists, their isolated lives within a small circle of dedicated supporters and opponents, and their conviction that they were the obvious ambassadors of the revolution had probably blinded them to reality. They no longer saw just how marginal

and unknown they were, and how few people shared their radical views. Nor, it seems, had they considered the possibility that the establishment at the school would do its utmost to prevent the students from voting for the newcomers.

Their defeat was a harsh lesson, and afterwards, Malevich at least frequently voiced his disapproval of democratic processes in art education.[81] The anti-democratic response by the avant-gardists was later used (by Soviet historians in particular) as evidence for their elitist and undemocratic views. There may be some truth in that, but first and foremost it was a sign of their political naivety. Nobody before or since had ever attempted such a radical democratization of education. In the avant-gardists' defence, it should be noted that even after this public disgrace, they still maintained a certain degree of democracy at the school and diversity among the staff complement – which is more than can be said of the later heads of Soviet academies. In Moscow, no avant-gardist would ever become director of the academy, not even after their interference with the elections, and the pluriform character of the school remained intact until it was eventually abolished by a higher power, to the detriment of the avant-gardists.

The World Has Never Seen!

Another job for the Department of Fine Arts at the People's Commissariat was the organization of the first major public event on 1 May 1918, International Workers' Day, on which the new revolutionary state was to make its presence felt. The Bolsheviks understood from the very beginning that their government mandate had insufficient democratic legitimacy, and therefore required continuous symbolic reinforcement. Grand festivities involving large sections of the population were used as a tool for this purpose from the outset. The first Workers' Day celebration was, therefore, an important event, but came at a time when the Bolsheviks were embroiled in a life-and-death battle to maintain their hold on power. Several informal preparations may have taken place over the course of March, but Lenin's cabinet (whose remaining members counted only Stalin and Lunacharsky) did not officially release funds for the 1 May celebrations until 12 April. The brief stipulated not only the decoration of the city and the organization of festivities, but first and foremost the choreography of large public gatherings and parades. Or, in a more precise formulation, 'organizing the harmonious movement

of the masses'. The first meetings of the planning committees were held on 14 April in Moscow, and on 16 April in Petrograd. On 23 April, Shterenberg wrote to Lunacharsky that he had still not 'received the promised resources and materials' necessary to start work, and added that for this reason, he had decided to 'relinquish all responsibility for executing the approved decorative plan'.[82] Several days before the celebrations, Petrograd had insufficient electricity to illuminate all of the Winter Palace at once. On 29 April, the working party issued an emergency request for 'a small quantity of bread, conserves, sausage and biscuits' for three hundred people, 'for the workers are completely exhausted'.[83] As one artist later noted: 'The Soviet powers fed the workers not with bread and meat, but with meetings.'[84]

The limited resources led to the decision to decorate the city primarily with flags and canvas, with the addition of some painted displays. The management concentrated on the most important streets and squares – Palace Square in Petrograd, and Red Square in Moscow. A colourful assemblage of artists assisted with construction and design. Nearly all of the avant-gardists took on an active role, although in most cases it is impossible to determine precisely which buildings or streets were in their charge. Malevich was responsible for the decoration of the current Moscow City Hall on Tverskaya Street, which he executed with enormous, probably suprematist treatments.[85]

It is unclear which artists created some of the most radical conceptual artworks. On the square in front of the Bolshoi Theatre, the many trees – still saplings – were wrapped up in blue gauze, creating a fantastical 'blue landscape'. The artist behind this conceptual piece of 'packaging art', made seventeen years before the birth of Christo, is unknown.[86] The artwork was so impressive and was talked about so often that it was even noted by the *De Stijl* movement in the Netherlands. Theo van Doesburg, who certainly only knew the project from hearsay, called it a form of 'cubist open-air theatre, with entire clusters of trees architectonically pruned and used as a framework for stretching painted linens, which served as scenery'.[87]

Whatever the case, the chaotic, haphazard organization of the 1 May festivities was reason enough to start planning the October revolution anniversary celebrations well in advance, and to ensure the availability of more resources. Moscow and Petrograd were to be completely transformed: façades were to be decorated with paintings, with banners stretched

across entire boulevards bearing revolutionary slogans. Large provincial towns were instructed to follow suit as best they could. Coordinated music was ordered everywhere, with large bands and enormous choirs parading in strictly regimented fashion, while processions and groups of dancing artists blended in harmoniously as part of the whole. Tatlin and Sofia Dymshits planned a grandiose fireworks display, the likes of which 'Moscow or even western Europe had never seen'. To do so, they collaborated closely with military departments and engineers. The artists' initial plan has not survived, but was intended to 'illuminate the entire city with spotlights, placed both around the outskirts and at various central points. The spotlight beams will produce a complex, moving pattern in the sky, designed by the group of artists.' Additionally, the entire city was to be illuminated with 'bright rockets and flares, ignited in synchrony and with a fixed sequence in various parts of the city'.[88] Although the required budget for this spectacle – at its highest, 350,000 roubles – was not attained, a large portion of the plan was still carried out.

The urban centres were, therefore, to become the platforms for a *Gesamtkunstwerk* of unprecedented proportions, incorporating elements of visual art, music, dance and applied arts. The populace was to act as both observers and participants, and feel as though they were part of a magnificent and unparalleled historical experience, one that galvanized the revolution and the rule of the Bolsheviks as an utterly self-evident, inevitable force of nature. 'The October revolution was the greatest event in the world,' read an official statement, '...the victory and celebration of the proletariat, in the joy and the solid, bright conviction of its ultimate triumph. But the battle is not over. The celebrations must therefore...take on a serious and severe character, for there is still a proletariat, and there is still capital.'[89]

The celebrations were to last three days, from 7–9 November, and with preparations to start immediately. The party was still utterly preoccupied with domestic conflict, however. June and August saw fatal attacks on high party officials, followed by a narrowly avoided assassination attempt on Lenin himself, on 30 August, which led to an intensification of the Red Terror. It was clear that the suppression of the anarchists, which had so shocked Malevich, was only the beginning. The acts of terror were, most likely, still not obvious to most of the artists, allowing them to stick their heads in the sand. No such luxury was afforded to Lunacharsky, who knew exactly what was going on. He had always spoken out against terrorism, and just a few months earlier had proudly

written: 'I shall stand with my comrades in the government until the very end. But I would choose surrender over terror. It is better to suffer the greatest misfortune than to bear the slightest guilt.'[90] Talk of this kind was meaningless the moment it was uttered, however.

While all this was going on, the famine began to take on dramatic proportions. Abandoned dogs roamed the streets, lonely and estranged from humanity. The lion in the Petrograd zoo was fed a vegetarian mash, and presented a sorry sight.[91] A terribly cold winter was on the way, and would have a devastating effect on the traumatized, starving population. One of the first students of the Free Studios described the situation as follows:

> country is in the midst of civil war. Moscow still shows the signs of the most recent skirmishes. Destruction. Hunger. There are hardly any trams, and the same goes for coachmen – the last horses have been eaten. Narrow, trampled pathways have formed in the deserted, snow-covered streets. The barely visible shape of a pedestrian appears, laboriously pulling along a sack of frozen potatoes or cabbage on a sled. It is cold. There is no heating indoors. At home we are wrapped up, with the temperature 2–4 degrees below freezing. To go to bed we first need to warm it up with hot water bottles. In the morning, the battle with the cold begins once again, for all the clothes have frozen during the night.[92]

The poverty among the students led to a high dropout rate, and was certainly a source of concern for the heads of the academy. Unfortunately, the teachers fared little better. One such teacher, Amshey Nurenberg, recalled that he and one of his colleagues, the Cézanne acolyte Alexander Osmyorkin, burned their furniture and books in order to stoke the furnaces. Money was of little value, for all goods were in short supply and food was rationed with stamps. For those in the know, there was the black market. Nurenberg recounted that Ukrainian *salo*, a kind of lard rich in calories, was the most coveted food item. 'We knew that we could only obtain the salo from demobilized soldiers, who engaged in "petty speculation." The soldiers were mighty afraid of round-ups, and hid in courtyards, fleeing at the first sight of police.'[93]

While preparing for the October celebrations, the avant-gardists tried to take stock of the situation. The revolution was almost a year old. They had finally obtained access to the elite: they had crawled from the fringes to the centre, and had taken power. Over the last six months they had worked tirelessly to develop their artistic platform, but everywhere

Decorations by Pavel Kuznetsov to commemorate the first anniversary of the revolution, Petrograd, 1918.

they encountered staunch opposition, and remained unable to truly implement their radical plans anywhere. A delegation of avant-gardists, including Tatlin and Malevich, went to Petrograd to discuss a plan of attack with their local representative, Punin. The next morning he wrote a brief summary in his diary, but was not optimistic: 'Many interesting and challenging ideas were raised that evening, but which of them will ever be implemented? Tatlin is right, the time for talk is so far in the past that it now seems frivolous. So where is this future or present determined by action? It does not exist, a fact that leads to even narrower thinking and deeper disappointment among our number. Did we come here only to be ejected by power games? Where are the indelible traces of our work? Where are you, my great futurists?'[94]

Preparations for the October celebrations did not truly begin until late September. Though chaotic, the results were spectacular nonetheless. The streets and bridges in the centre of Petrograd were all extravagantly decorated. Artists were given much autonomy (since there was no time to coordinate everything), resulting in a wild variety of styles and forms. Although traditional artists were still in the majority, the avant-gardists were allocated the most prominent locations. It was Nathan Altman, Shterenberg's confidant, who had the privilege of creating the gigantic

abstract installations around the Alexander Column in the Palace Square, and also those adorning the alleyways leading up to it. Nowhere in the world had modern art ever been given such a prominent platform for display, or on such a colossal scale. To keep everybody working, extra food was issued to labourers and artists. Those involved could count on extra rations: two pounds (about a kilogram) of rye bread, a half-pound of jam or baked goods, two pounds of fresh fish, a half-pound of butter and one hundred (!) cigarettes.[95] Soup kitchens were also opened, where free food was distributed.

Ehrenburg wrote: 'It was the era of hunger and street carnivals.'[96] There were light displays and fountains on the Neva, and outrage at large murals of naked men and women representing labourers and peasants (the order to remove them was never executed, however). Mottoes and slogans were hung all over town, often chosen by the artists themselves. Sennaya Square bore slogans by Karl Marx, Vladimir Bakunin and – perhaps unexpectedly – the apostle Paul:

MARX: 'Violence is the midwife of a society wishing to give birth
 to a new one.'
BAKUNIN: 'The passion for destruction is also a creative passion.'
AND PAUL: 'Those who do not work shall not eat.'[97]

Other slogans, often original, were more poetic: 'Holy are the bayonet and the printing press, in service of the proletariat!'[98]

Outdoors, various historical revolutions were re-enacted as large-scale, spectacular dramas: the French Revolution, but also the Spartacus slave revolt and Pugachev's rebellion from the eighteenth century. In a separate performance, the torching of the Bastille was recreated with Bengal light, illuminated by warships anchored on the Neva. Shows were given in theatres everywhere: operas by Rimsky-Korsakov, plus works of a more 'rousing' character including – in all seriousness – *The Good Hope* (*Op Hoop van Zegen*) by Dutch playwright Herman Heijermans.[99] One of the artists recalled that on 6 November, on the eve of the celebrations, 'the weather was awful,…the technicians hanging up the canvasses dropped their hammers, their hands were so numb from the cold. The canvasses on the Admiralty building were torn away by the harsh winds during the night, and had to be reattached the next morning. This was achieved not with scaffolding, but by using simple wooden fire

ladders.'[100] It was not only the outsides of the buildings that were decorated; Malevich and Matyushin worked with their students to create an enormous *panneau*, 300 square metres (3,230 square feet) in size, for one of the halls in the Winter Palace.[101]

In Petrograd, Tatlin, Punin and the chairman of the music committee Arthur Lourié rode around in Punin's work automobile, which was 'decked out in bright red cotton, for maximum effect'.[102]

The Martyr

Olga Rozanova, the creator of the spellbinding *Green Stripe*, also played an active role in the preparation and running of the festivities. Among other things, she was responsible for the decorations on Moscow's busiest boulevard, Tverskaya Street, which ran from modern-day Pushkin Square up to the Kremlin. According to a newspaper report, the street was adorned with 'red materials', most likely large panels in various colours. At night a large car drove past, equipped with 'an enormous red spotlight, whose beam made everything erupt in fire and flame'. Elsewhere in the city, Rozanova had installed colour projectors onto the roof of a palace, producing 'light paintings'.[103]

These astonishingly advanced public artworks by Rozanova were the culmination of her development over the previous years. Though only thirty-two, she had recently grown into a notably well-rounded and self-assured artist. Her first abstract paintings were probably completed in 1913–14. When developing this abstract visual language, which was based primarily on colour studies, she dared to go further than virtually all other avant-gardists. She experimented with abstract collages, most of which she used for book designs in collaboration with her partner, the radical poet Alexei Kruchyonykh. Rozanova also wrote her own poetry, and in her final years, some inflammatory critical texts.

At the Department of Fine Arts, she was responsible for the development of traditional artisanal crafts and industry. She conceived of a new system that would allow remote industrial centres to communicate and share knowledge with each other. She tried to convert existing icon workshops into new centres of traditional industry. Within a short time, and under extremely adverse conditions, she travelled hundreds of kilometres from Moscow to visit the distant studios and transform them into open educational institutions. Famine was worse in the countryside than in the cities, and disease ran rampant.

Chapter 4

176

Decorations by Alexander Osmyorkin to commemorate the first anniversary of the revolution, 1918.

It was probably during one of these excursions that she contracted the illness that would ultimately spell her end. In the summer she fell ill, but in June, July and August continued to work hard on the establishment of both the Free Studios and the new curriculum. On 7 October she was elected the head of the textiles studio at the academy. In late October she worked feverishly at Moscow airport on the enormous panels for her light shows on Tverskaya Street, in conjunction with the People's Commissariat for War, who supplied the spotlights. Her condition was already serious at the time: 'Ill, she worked as hard as she could on the decoration of the Moscow streets and squares. She was duty bound, and

Olga Rozanova, 1915.

knew that her help was necessary, which is why she could not say no. On 31 October they brought her, completely exhausted, from the airport to the home of one of her artistic comrades. On 1 November, doctors diagnosed her with diphtheria, and she was sent to hospital.'[104]

During times of famine and civil war, the hospitals must have been horrendous – the last places one would want to go with any hopes of surviving diphtheria. Rozanova died on 7 November, the precise anniversary of the October revolution. Her friend Ivan Klyun wrote in her obituary: 'As the rows of demonstrators processed through the streets, accompanied by music and surrounded by her artworks, the artist Olga Rozanova lay in hospital, dying of diphtheria.'[105]

The avant-gardists were shocked by Rozanova's death. They asked for permission to bury her in Red Square beneath a suprematist artwork. They were refused, of course. On 13 November her body was processed to Novodevichy Convent. Malevich led the procession, his trembling hands holding a black flag bearing a white square. According to the artist Antoine Pevsner, 'he wore felt boots that were far too big for him, he looked as though he had sunk into them down to his waist. His gaunt, teary face was a tragic and pitiful sight. When he saw me, he said rather quietly: "We will all be crucified. I have already made my own cross; you, of course, have seen it in my paintings."'[106]

Thus it was that the avant-gardists, in their own solemn, sorrowful and quirky fashion, bade farewell to Rozanova. In the graveyard she was buried beside Anton Chekhov.

Even as the avant-gardists mourned their first martyr – who had quite literally worked herself to death for the revolution – the ground beneath their feet began to crumble. To large groups of revolutionaries, the enormous futuristic constructions in the centres of Moscow and Petrograd suddenly made clear exactly what kind of beasts the futurists were, and what kind of art they produced. This realization led to fervid discussions in the middle tiers of the party, causing the more vociferous members to denounce the futurists' art as incomprehensible nonsense that was hostile towards the proletariat. These voices became louder after 23 February, when Moscow was once again adorned with futuristic decorations. Newspapers gave letter-writers free rein to express their discontent: 'The sacred blood that was spilled for the socialist revolution is being desecrated by a malevolent, slanderous orgy. See the soldiers of the Red Army clothed in ridiculous colourful robes, and the workers with their sawn-off, triangular faces. What counter-revolutionary could make a more pernicious mockery of the workers' revolution?' Or: '"What a diabolical mess" – this was how two women from the crowd characterized the splotches before them....But it was a labourer who gave the most apt description of the cubists' pointless, degenerate artwork: "Vomit! It makes me sick to my stomach." He spat and walked on without a moment's pause.'[107] Such attacks by ordinary communists put wind in the sails of the avant-gardists' critics, and in the spring of 1919 they launched a relentless campaign against the authority of the futurists in the Department of Fine Arts. Again, most of the discontent came from the Moscow Soviet. The opposition to the avant-garde – which until then had been fierce, but still sporadic and incidental – now took on a more coordinated and official character. Increasingly, the avant-gardists were publicly called on to justify themselves, and everywhere they were subjected to negative judgments and forced onto the defensive.

Tatlin's Tower

1919–1921

If 1918 was the year of victory for the avant-gardists, then 1919 was the year of their defeat. They were exhausted from the stress of their organizational work and the constant opposition to their cause. Protests against their presence in the Bolshevik bureaucracy increased, and many of their newly acquired powers and privileges were revoked. The conflicts between the artists themselves also grew in intensity. The stakes in, and rewards for, their ideological and aesthetic debates (which had always been heated) rose to new levels, since the ideas that won out had an instant effect on government policy. They were undoubtedly becoming more aware of the fact that only one artistic ideology would survive. A communist society that is based on the sweeping implementation of a single ideological system – no matter which one – cannot tolerate ideological pluralism of any kind. Whoever won the debate on the ideological role of art in society would win everything. The losers would simply disappear.

Their discussions sometimes degenerated into petty bickering over jobs and money. The avant-gardists had never wielded power, let alone managed budgets; now that they were doing both, they proved unable to allocate the funds in a manner that others considered fair and proportional. They drifted apart, just when they needed each other the most.

On top of all this, they also had to contend with the unrelenting and destructive power of humankind's two oldest and closest enemies: hunger and disease.

The avant-gardists were already at the end of their strength before joining the Arts Department of the People's Commissariat. Malevich's friend Ivan Klyun had been forced to pull his fourteen-year-old daughter out of school, and send her to do heavy labour for the railroads. Though she was not paid, she was at least given buckwheat gruel to eat. His other

daughter, who was ten years old, walked each day to the municipal food bank, where she received a bottle of gruel and some rye bread.[1] Now that the artists enjoyed a reasonable income as Soviet workers, Klyun could at least send his children back to school.

Lack of food remained an acute problem, however. 'I am terribly tired of this madness, and the constant search for food,' Rodchenko wrote in his diary in early January. The Russian words for 'hunger' and 'cold' – *kholod* and *golod* – differ by only one letter, and are always closely intertwined in all diaries and memoirs. Hunger demoralized all of the artists, and even drove them to work for the Soviet power, for without their positions at the People's Commissariat, their chances of survival would plummet immediately. 'I am already faring poorly,' wrote Rodchenko, 'and if they transfer me or send me away, finding food will be even more difficult. If I don't die first, that is...'[2]

Working at the ministerial offices was not easy, however. 'During the day I am freezing cold in that unheated office, where it's colder than it is outside.'[3] Chaos reigned out on the streets, and everybody was on their guard against thieves and muggers. Even indoors, one could not be too careful. During a moment of inattentiveness, Udaltsova's vest and over-shoes were stolen from her office.[4]

Typhoid was rampant, and the only readily available source of vita-mins was garlic. For practical (or superstitious) reasons, many people constantly carried garlic with them, attached to a string under their shirt or in their pockets. The smell of garlic even permeated the streets.[5] Everyone who entered the city, Naum Gabo recalled, was required to have their clothes disinfected.[6] Udaltsova noted dryly: 'There is typhoid in our house. Will I be spared? If I do not die within the next few days, I will need to properly arrange my things....It will be a pity though if I die, now that I have learned how to work so well.'[7]

Despite the dire circumstances, or perhaps even because of them, the demand for arts and culture was unprecedented. One of Tatlin's students described how 'in the cinemas, theatres and concert halls, a new kind of audience arrived: suburbanites, labourers. They were given free tickets by their unions. Despite the cold (the audience wore fur coats in the auditorium) the actors appeared heroically on stage in suits, tailcoats and evening dresses. The audience was very appreciative and rewarded the actors with thunderous applause. We, the students, snuck in "on the sly," there were no strict checks.' Not only had a new audience appeared, but a new type of artist also emerged. In addition to

professional exhibitions (which, in a certain sense, continued much as before), numerous 'unregistered' artistic groups also came into being, in which anybody could participate 'who wished to do so'. These events were held 'in whatever rooms were available, did not last long, there was no catalogue or advertising, and of course there was no public resonance, but they were a typical expression of the thirst for social initiative'.[8]

All of these new cultural events and the new audiences sparked heated discussion. Everybody had an opinion, and the distinction between experts and laymen became blurred. Vladimir Stenberg, a young artist who later became famous for his poster designs, wrote that 'after the performances, people didn't hurry off as they do now, rushing to the cloakroom to collect their jackets and bags. They stayed in the auditorium to discuss the production. The art historians, artists, sculptors, writers and actors who were present spoke up and gave their opinion – the general public did too. They walked on stage to say what they thought.'[9]

Revolutionary fervour generated universal momentum, no topic was taboo, and anything seemed possible. That is why so many were prepared to accept the hardships and the restrictions to their liberties: the future was full of promise, and the past seemed more distant than ever.

Life Lessons

However demanding their official duties in the People's Commissariat, most artists still saw their pedagogical work as a top priority. Nearly all of the avant-gardists – certainly Malevich, Tatlin, Kandinsky, Rodchenko, Filonov, Popova and Ekster – were dedicated, confident teachers who continued to support their pupils and followers until the end of their lives. The same could not be said of their American and European counterparts – Picasso, Léger, Mondrian or Duchamp – who undertook little or no teaching, and lived off the proceeds of their creativity. For the Russians, teaching was an integral component of artistic practice. It forced them to consolidate and further develop their ideas, and was also used to trial new concepts and collaborate with students on new joint projects. Teaching was a source of income, of course, but even when they no longer held official teaching posts, they still gave instruction in a domestic setting for free. Even while they were employed to teach, they continued to give private tuition to external students who asked for it. The relationship between teacher and pupil may have been hierarchical,

but it was also warm and intimate. To the avant-gardists, teaching entailed so much more than simply delivering a fixed curriculum. The most loyal students became part of a clan, and what was instilled into them was a mentality more than a set of skills. 'There was rarely any talk of anatomy or perspective, brush strokes, texture or line,' one student remembered, 'but all the more about beauty, truth, character, authenticity and sincerity.'[10]

The students' memoirs consistently reveal just how invested the avant-gardists were in their students' development. In the early spring of 1919 this concerned not only the cultivation of their minds, but also care for their physical health.

Tatlin's students remembered him as tall and strong, dressed in a sailor's shirt and tall boots, and moving in a manner that was 'angular, but not abrupt'. He was a man of few words, but when he chose to speak, it was theatrical and imposing.

> On certain days he would enter the studio carrying a large, round, brown loaf under his arm (it must have been an additional ration). People from other studios, who had seen the bread, tried to shuffle in behind him, but we loudly chased them away. Vladimir took a knife out from his boot, and cut off a large chunk for each of the young people in the studio, sometimes accompanied by an onion. Then he said: 'Your work is hard and serious, this is to help you get through it.' We didn't eat up all the bread at once, most students saved some for the people at home. If he was in a good mood, Vladimir read us poems by Khlebnikov and Mayakovsky, and occasionally played his bandura.[11]

Bread was not the most important thing Tatlin fed to his students. Sometimes he would suddenly break his silence, and while the students' stomachs growled, dish up a utopian vision about the world of the future, which was almost within their grasp. The cities would be made of glass, and built by artists, artists like them, infused with an appreciation for the quality of materials, volumes and proportions: 'Our houses will sparkle like diamonds. And the diamonds shall be used for cutting glass.'[12]

The situation became truly dire during the winter months. The plumbing stopped working, as did the sewage system. All the students were hungry and freezing. The academy was allocated a plot of land in the Sokolniki forest (which is now a suburb of the city, but in those days was largely undeveloped) to provide wood for the furnaces. The students felled the trees themselves, chopped them into firewood and transported it on sleds to the centre of Moscow. 'But,' one student added, 'we

continued to hope for the blossoming of revolutionary art'.[13] Obtaining art supplies was sometimes impossible. If there was any paint at all, it needed to be defrosted in the morning – provided there was wood to burn. All nude models had fled, except for one: Stanislava Osipovich, 'a full-figured redhead with pink skin',[14] who enjoyed the unfettered adoration of all the male and female students and teachers. She was outspoken, voluptuous, cheerful, warm-hearted, unflappable, dedicated and the only model willing to pose under such conditions. While the students sat working, dressed in thick pullovers and felt boots, the model stood 'heroically in the nude by the steaming hot, cast-iron stove. One side of her was baked and red, while the other was frozen, greenish-blue.'[15]

The classrooms, with their large windows, were the coldest. 'Now and again we stepped into the corridor to warm up a little, it was warmer there, partly because many students gathered there from the other studios.' In this manner, knowledge and ideas were also shared. 'We talked about painting and sculpture, and debated, debated endlessly.'[16]

In Petrograd, the academy had likewise made way for the Free Studios. Malevich and Tatlin each had their own studio there too, and they shuttled back and forth between Moscow and Petrograd to meet with students and criticize their work. The state of affairs in Petrograd was even worse than in Moscow. Almost all the studios closed in the winter, and those that remained open sent students to the country to work at the woodstores. They were paid in kind, with firewood, that they then used to heat the studios. In the summertime, the students worked collectively in vegetable gardens to grow food for the winter. Art lessons were given outdoors, in between doing chores in the garden.[17]

Nightlife was virtually non-existent. People stayed at home, and in the forced proximity relationships either grew stronger, or perished. Tatlin's relationship with Sofia Dymshits-Tolstaya had started in 1917 and had thus already lasted two years – a long time by his standards. But in 1919 they were still devoted to each other. Sofia was a Jewish artist who had lived for years with the aristocratic poet Alexei Tolstoy, who was cousin to Leo Tolstoy. The Tolstoys were one of the oldest and most renowned families in the empire, and for a Jewish woman to bear such a refined name was regarded by conservative Russians as an unforgivable profanity, and proof of the catastrophic decline in social morals. '"Countess Tolstaya" is how she signs her paintings', noted one condescending socialite. 'She was reputed to be a very handsome woman, though I cannot remember her face at all, only her tasteless, pretentious

Martiros Saryan, *Woman with Mask* (portrait of Sofia Dymshits-Tolstaya), 1913.

outfit: a plunging neckline, and a long ostrich feather, which descended from her hair – who knows why, or in imitation of whom – and covered her naked back.'[18] She was educated and well-travelled, and much more worldly than Tatlin or any of the other male avant-gardists. She had lived in Paris for years, where she had associated with the entire Russian art community, and she knew all the Russian poets (Mandelstam, Gumilyov, Akhmatova, Mayakovsky and the rest). The painter Martiros Saryan told how, on one occasion, three artists competed to paint Sofia, 'with her characteristic smile'.[19]

She probably met Tatlin in 1916, while taking part in one of his exhibitions (and having already divorced Alexei Tolstoy). From 1917 onwards, she and Tatlin were virtually inseparable, though Sofia always kept her own apartment. Tatlin collected her from the station during the early days of November 1917, amid the whistling of bullets and the thundering of cannons. For the first few days they were cloistered inside Tatlin's tiny apartment and saw nobody else, partly because of their desire to be together and partly to avoid the violence on the streets.

Sofia Dymshits-Tolstaya, 1909.

They worked closely together, both in an artistic sense and in their political and administrative roles. Dymshits was Tatlin's official secretary, and led the Fine Arts 'international department' (as it was called). She was cheerful, self-assured and a feminist. In 1907 she had been baptized in order to evade the official anti-Semitism. When the Provisional Government abolished all anti-Jewish laws in 1917, she immediately renounced her debasing conversion and returned to Judaism. When she divorced Tolstoy she refused to accept any money, even though they had a daughter together.

For Tatlin, it was an incredible experience to cohabit with such a worldly, confident woman, who was just as dedicated to the arts as he was. From 1918 on, they lived together in the building that also housed the Free Studios on Myasnitskaya Street, and were constantly entertaining guests. Hunger and the cold caused people to clump together – they could keep warmer in groups, and there was always somebody who brought food. One visitor remarked:

> Tatlin's room seemed low[-ceilinged]. There was hardly any furniture, but there were plenty of stacked shelves and easels. In the corner, on a trestle bed, sat a beautiful woman with her legs tucked up and

a braid around her head. I realized that it was Tatlin's wife. Without getting up, she greeted the guests in a friendly and calm manner. She seemed accustomed to hordes descending on their home like this. We had brought vodka and some simple bites to eat. We put a crate in the centre of the room, placed an old, shabby suitcase on it, and deposited the bottles and glasses onto this improvised table. Everybody sat where they could, and we drank and talked.

I was completely absorbed by Tatlin. He was still young then: tall and strong, with powerful hands, white-blond, and a kind of drowsy face. His eyelashes surprised me: they were sturdy, straight and long (like a cow's). And completely white.

When the bottles were empty, Tatlin stood up, tall as a tree, crept under the divan, or inside it, and procured a bandura. He sat down and took up the instrument – firmly but with care, with the sure hand of an artisan. He dusted it off with his sleeve, and started to tune it. He listened, closing his eyes behind the curtain of his bushy white eyelashes, and sang Ukrainian songs, both in Russian and Ukrainian.

His barefoot wife sang the second part softly. His voice was entrancing, full of pathos, and sang the grief of many, many people. He did not open his eyes while singing. But more than his songs, I remember the tear that rolled onto his eyelash, becoming entangled in its thickness. I kept waiting for it to roll down and fall off. But it clung fast to Tatlin, not wanting to leave him. He sang as the blind sing: with infinite sadness, and listening attentively to the sound within himself.[20]

Many artists combined romantic or familial relationships with professional partnerships, which seemed only to grow stronger in the terrible living conditions. The brothers Antoine Pevsner and Naum Gabo lived and worked together, as did the Vesnin brothers. The same applied to the couples Varvara Stepanova and Alexander Rodchenko, and Katarzyna Kobro and Wladislaw Strzemiński. Nadezhda Udaltsova had a relationship with her student Alexander Drevin, whom she had taken on shortly beforehand as her assistant. They remained together as lovers and artistic soulmates until 1938, when Drevin was executed, shot by a Soviet bureaucrat in one of Stalin's slaughterhouses. On 7 March 1919, Udaltsova wrote of the partnership in her diary: 'I know deep down, with a kind of sacred stringency and clarity, that he will not betray me, and will stay with me. Drevin, dear Drevin.' And five days later: 'How wonderful that Drevin is here. I am proud of his love, and feel strength in his support. I believe in the great Drevin.'[21]

Exhibitions

In addition to their work at the People's Commissariat and at the Free Studios, the avant-gardists also made plans for future exhibitions. Within the Department of Fine Arts, a bureau was created to facilitate the organization of state exhibitions, which were held very regularly at various city locations and were freely accessible to the public. This Bureau of Exhibitions was led by two young avant-gardists: the Polish artist Wladislaw Strzemiński, and Antoine Pevsner, who had lived in Germany for many years and returned to Russia after the revolution, following in the footsteps of so many others.[22] Both were answerable to Malevich, who supervised them from within Fine Arts. Despite this, most of the exhibitions had no connection whatsoever with 'leftist art'.[23] On 11 January 1919, a posthumous exhibition dedicated to Olga Rozanova opened, displaying 250 of her works. It was the first exhibition organized by the new bureau, and Malevich immediately took full control of its curation.

Malevich had trodden on the toes of the young avant-gardists once before, when he led Rozanova's funeral procession while carrying an enormous black flag with a white square on it. This time he intended to affix a large black square to the external wall beneath the exhibition poster, on a painted canvas presumably several metres in size. Inside the exhibition, too, he planned to hang up suprematist decorations, which one report said would occupy entire sections of wall. Many believed that this was his way of presenting Rozanova as one of his acolytes. The younger artists associated with Varvara Stepanova and Alexander Rodchenko were particularly furious, and accused Malevich of trying to appropriate Rozanova's *oeuvre* and 'mark Rozanova with his own brand'. Malevich defended himself by saying that 'Rozanova came from him', that she was one of the artists who signed the suprematist manifesto, and that the black square was the emblem of suprematism.[24]

As these arguments took place, Stepanova (and her partner Rodchenko, who took his lead from her) pulled down all of Malevich's decorations and his black square. The situation escalated and became terribly melodramatic, with shouting, cursing and slamming of doors. Accusations flew, and people were forced to choose sides. At a time when the avant-gardists should have been exploiting their position and consolidating their power in order to implement their ideas, they were instead caught in an internal skirmish, scrabbling for leadership and autonomy within their own ranks.[25]

Malevich refused to take part in the next exhibition with Rodchenko, but attempted a reconciliation several months later. This tentative ceasefire would eventually lead to one of the most astounding exhibitions from the early years of the Soviet Union: the tenth state exhibition. It was possibly the first in the world to be dedicated in its entirety to abstract art, and included pieces by Malevich, Rodchenko, Stepanova, Klyun, Popova and Rozanova (among others). It was the first time that Malevich showed the integral series of 'white-on-white' paintings, to which Rodchenko responded with a series of abstract works whose defining characteristic was 'line' rather than the 'plane', and a series of 'black-on-black' paintings. Rodchenko's response may seem simplistic, but the works in the series are impressive in their own right. The alien shine and minute distinctions on the black surfaces are the result of varying the direction of the brush strokes, which reflect the light in subtly different ways. Rodchenko hung up various large posters with messages such as 'Rejoice, for today the revolution of the spirit stands before you. See how we throw off the centuries-old chains of the photographic, the stereotypical, the narrative. We are the Russian Columbuses of the arts, the discoverers of new pathways in creativity. Today is our triumph!'[26]

The exhibition was ignored by the press, however, and Rodchenko was almost taken to court over his inflammatory posters which, according to the state supervisor on duty, were 'a criminal waste of public funds'. Only after Rodchenko proved he had paid for them himself was he left in peace. 'What does it matter,' Stepanova wrote in her diary, 'the future is ours!'[27]

This one exhibition could not repair the damaged relationships, however. As of spring 1919, the avant-garde in Russian was split not only by the stylistic divide between Malevich and Tatlin, but also by a generational conflict between these two and a group of 'young people', in which Rodchenko was vying for leadership. All of this took place during the crucial months when their position within the revolutionary structures was under attack on all fronts. The protests against their official position, which had started after the October festivals, continued unabated, originating from both the middle and top tiers of the Communist party.

As a consequence, the Soviet leadership in Petrograd warned Lunacharsky 'not to entrust the organization of the [next] festivities in May 1919 to the futurists under any circumstances'.[28] The Moscow Soviet echoed these sentiments, and even lobbied to 'terminate all government support for the futurists'.[29] Though they had not yet been

completely cut off, the radical artists did lose control over the October festivals in Moscow and Petrograd. This was the first step in the process that would ultimately lead to their complete exclusion from the professional art world.

The bitterest accusation from the cultural sector was the claim that the avant-gardists were plotting to monopolize all activities of a cultural nature, begrudging other artists and art forms their very existence. Though not entirely unfounded, the accusation was strongly exaggerated, as evidenced by the emerging museum and purchasing policy.

Rivalries and Roubles

The Department of Fine Arts became responsible for establishing what were known as Museums for Artistic Culture, which were intended to form the basis for a new communist branch of the art world. From Lunacharsky's perspective, the planned museums were also intended to provide an economic framework for contemporary artists – after all, with no art market or private patronage, the state was obliged to take responsibility for supporting the creators of its art.

Tatlin and Sofia Dymshits eagerly shouldered the task, but Tatlin increasingly left the organization in Moscow up to Malevich, probably owing to his preoccupation with the Plan for Monumental Propaganda. At first there seemed to be no conflict, as the two artists were generally in agreement at the time: museum institutes were to be established throughout the country, and to dedicate themselves to the acquisition, conservation and exploration of contemporary art forms. Heated discussions did surround the ultimate model to be adopted, however. Malevich believed that the new museum should not be a place for conservation and academic study, but rather a laboratory for artistic innovation. 'We do not need to live in museums. Our path lies in open space, not in a suitcase crammed with relics from the past.'[30] Malevich believed that museums ought to reflect contemporary life and the future through artistic 'projects', and that the mandate of a contemporary art museum should be 'the husbandry of modern projects; moreover, only those projects that can be applied to a real-life context, or that present a new context for life, can be preserved for time'.[31] It is surprising how progressive these ideas were – the notion that a museum could be reserved exclusively for contemporary art and function as a platform for 'projects' did not become commonplace in Europe until long after the Second World War.

As the avant-gardists continued to flesh out these museum plans, procurement committees were established whose purpose was to acquire art from living artists. The entire gallery system, including the organization of large-scale selling exhibitions, was outlawed. In its place, a system of 'state exhibitions' was introduced. No entrance fees could be charged, and sale of paintings was officially forbidden – only the state was authorized to purchase art via the procurement committees.[32]

The resulting 'state fund' for contemporary art was intended to provide the financial basis for the new museums, and a pan-Russian network of Museums for Artistic Culture was planned. The avant-gardists also decided that 'only artists, as the sole experts in matters of contemporary art...may concern themselves with the acquisition thereof', as there was 'sufficient reason to assume that artists can determine with scientific accuracy and almost mathematical precision' which items were valuable and which were worthless.[33] Indeed.

Procurement committees were set up in both Moscow and Petrograd, but the Moscow committee, led by Malevich and Tatlin, was larger and financially better endowed, since it was also responsible for purchasing art for the provincial museums. The committee was allocated a budget of around 200,000 roubles per (irregular) instalment – hardly exorbitant, considering that, around the time of the revolution, an exhibiting society known as the Peredvizhniki (Wanderers) sold around 100,000 roubles' worth of art per exhibition.[34]

Other members of the committee included Tatlin's comrades, Putin and Sofia Dymshits. Although more moderate artists also regularly attended the meetings, it was Malevich and Tatlin who set the tone and the agenda, and often also the results of the voting.

Right from the outset, Malevich, Tatlin and Punin tried to plot a radical course by exclusively purchasing and displaying the work of avant-gardists. The sets of meeting minutes show a general pattern: while Malevich and Punin lead the proceedings in their passionate and uncompromising manner, Tatlin maintains silence, but votes in accordance with his brothers. Whenever moderate figures propose a middle ground – the inclusion of a modest amount of work from earlier or alternative art movements, for example – they are consistently turned down. In the end a compromise was reached, which ultimately did allow for some conservative modernists to take part. In early September 1918, Malevich presented a list of thirty-nine artists whose work he deemed suitable for purchase by the People's Commissariat.[35]

He unscrupulously put himself at the top of the list, followed by Tatlin, Rozanova and a whole slew of other avant-gardists. Lunacharsky was appalled, and had an alternative list drawn up which, though based on Malevich's, contained no fewer than 143 artists, not all of whom were avant-gardists – far from it, in fact. Near the very bottom of the list, for example, at number 140, appeared his old favourite Alexandre Benois.

Malevich paid Lunacharsky little heed, however. When the money for purchasing became available to him one month later, he limited himself to a list of twenty-four artists: half were avant-gardists, and the rest conservative modernists. Once again, the list of acquisitions was headed by himself, followed by Tatlin. The four best-paid artists were also those who occupied the highest official positions: Tatlin, Malevich, Shterenberg and the symbolist Pavel Kuznetsov, who received 20,000, 21,000, 19,000 and 20,000 roubles respectively. They were followed by two highly placed women, Rozanova and Dymshits, and then Kandinsky, each of whom received 12,000 roubles. Between them, these seven public servants received a combined 116,000 roubles, over half of the total available budget.[36]

Clearly, the funding allocation was based on the settling of old scores, with a sense that the tables had turned, which is understandable enough. Viewed in this light, the situation was a typically revolutionary one, in which power had been radically transferred to those groups who beforehand had been the most economically disadvantaged.

But the avant-gardists clearly did not realize the precariousness of their own situation, nor that their mode of operation incited opposition. Indeed, the publication of the procurement list was met with vociferous indignation from the vast majority of artists who had been overlooked: 'All were overcome by a seething jealousy,' wrote the respected impressionist Konstantin Korovin.[37]

Everywhere, the avant-gardists were accused of lining their own pockets. Malevich seemed unable to suppress a sense of triumph at all this, and it was with wry delight that he told Rodchenko, Popova and Stepanova of how people responded to him at social engagements. When he attended an exhibition, 'artists chased after him', knowing that he was a 'state controller', and thus in charge of art budgets. People he had never met greeted him and said, 'Have we not met before?'[38]

Nor was Malevich one to take a humble view of his position; the art of self-deprecation was unknown to him, and his parading around as a 'state controller' certainly did nothing to ameliorate the aversion felt toward

the avant-gardists as a whole. It should be noted, however, that before the revolution, almost nobody wished to buy their work. The art market was then dominated almost exclusively by conventional academic art, with the Peredvizhniki as the most beloved group. This hierarchy had been obliterated in one fell swoop, and artists who had spent decades building up impressive reputations looked on helplessly as the market collapsed and the lunatic futurists – who had never sold anything in their lives – siphoned government funding off to themselves and their friends.

The accusations of embezzlement must be qualified somewhat. The question remains, for example, as to whether the artists even received their ordinary salaries, and if so, what they were worth during a time of hyperinflation. The amounts they allocated to themselves under the procurement budget were, either fully or partially, compensation for their day-to-day work – a conclusion supported by the strict division of funds, with the largest amounts going to those in the highest positions.

It is also true that these first procurement instalments represented only a part of the total budget. A similar amount was most likely channelled to artists who did not work for the People's Commissariat – not to mention Petrograd's own procurement committee, which acquired works from a far broader range of artists.

Last but not least, their work was undoubtedly deserving of significant emolument. The avant-gardists were incredibly productive during the initial years of the revolution: they held multiple teaching positions, developed new curricula and occupied three or four positions at the People's Commissariat (often involving heavy responsibilities and impossible deadlines), all in the face of constant opposition from middle management and competing departments, and subject to scrutiny by the highest authority. And that is not to mention their own work and exhibitions, with all that this entailed. Their names were mentioned everywhere, from meeting reports and travel declarations to student diaries.

Even with these caveats, Malevich and Tatlin's behaviour was, at the very least, self-destructive. By agreeing to be paid from procurement funds, they incriminated themselves in the eyes of outsiders. This type of tolerated corruption also reinforced the notion that they were not being recompensed for their talent, effort or performance, but rather for loyalty to their patron. More importantly, it led to a certain moral degradation, which is the implicit purpose behind this kind of corruption: weakening the ethical resolve of subordinates makes them less inclined to protest immoral behaviour from their superiors.

The practice did not stop after the first batch of acquisitions. On 15 January 1919, another procurement proposal was submitted – a 'bacchanal' in Stepanova's estimation – in which Malevich once again allocated the largest sums to himself and Tatlin (28,000 roubles each). Most other artists received 20,000 or 14,000 roubles. Rodchenko was left out completely, as punishment – according to Stepanova – for the arguments surrounding Rozanova's funeral.[39] It seems that Malevich was also using his position to settle scores of a personal nature. All of this had an inevitable and devastating effect on mutual relations among the artists.

The next in an endless series of reorganizations within the Department of Fine Arts meant that, immediately after the second round of allocations, Malevich and Tatlin lost control of the budgets. Authority was transferred to the inaugural board of the newly formed Museum of Pictorial Culture, chaired by Wassily Kandinsky. He was far more diplomatic than Malevich, and successfully reintroduced some stability. From that moment on, a wider range of artists benefited from the procurement budgets, although Kandinsky still allocated most of the funding to artworks by the avant-gardists.

To summarize: during the initial months of 1919, Malevich and Tatlin found themselves in a morass of envy and dubious ethics. The atmosphere became unbearable for many, and Tatlin and Sofia Dymshits openly considered moving abroad. Dymshits had lived in Paris for some time, spoke French, and was familiar with the opportunities and difficulties of living in Europe; Tatlin, however, was useless anywhere outside Russia, and their plans never came to fruition.[40] Malevich, too, thought about leaving Moscow for a while, and concentrating on Petrograd instead. But the situation would have to become even more dire before he and Tatlin could bring themselves to leave Moscow.

They would not have to wait long, however: fairly soon afterwards, the first public responses to their procurement policy emerged and a scandal formed around the most prominent and beloved of the futurists, Vladimir Mayakovsky.

The Anti-Futurism Campaign

After the first round of acquisitions, the party newspaper *Pravda* responded immediately with a hostile article attacking the procurement policy of the People's Commissariat for Enlightenment. Lunacharsky

and Shterenberg were forced to defend themselves in the press. They denied that futurists exclusively were benefiting from the policy, but admitted that the majority of purchases were from artists 'who had been prosecuted under the reign of the bourgeoisie' and 'led a pitiable existence'. It was therefore only right to 'purchase the art by these predominantly young and therefore still officially less-popular artists'.[41] This defence immediately characterized any support for the avant-gardists as an emergency welfare measure. Lunacharsky would never publicly defend the avant-garde again, however, even on these limited grounds.

This was made abundantly clear by the next attack on the avant-garde, which followed barely one month later. It was provoked by the inaugural edition of the newspaper *Iskusstvo Kommuny* (Commune Art), a new publication created jointly by Vladimir Mayakovsky and Osip Brik, and funded by the People's Commissariat. From its inception, it was intended as a mouthpiece for the avant-gardists. The fact that the journal appeared at all may have been due to Brik's deep ties with the security department, which allowed him largely to circumvent Lunacharsky's supervision. Although Malevich, Chagall and Shterenberg contributed now and again, the most polemic and substantial articles were written by Punin and Mayakovsky. The latter published poems on the covers of the first and second issues, which attracted immediate interest. The first was titled 'Join the Army of the Arts', which included the famous lines that were later ubiquitously quoted:

Comrades!
To the barricades
The barricades of heart and soul.
The only righteous communist
Is he who burns the bridge of retreat.
Enough walking, futurists!
Leap into the future! ...
Enough half-penny truths.
Erase the past from your hearts.
The streets are our brushes.
The squares are our palettes.
In the thousand-leaved book of time
the revolutionary days go unsung.
To the streets, futurists,
Drummers and poets!

The second poem sparked even more protest. It was a typically futurist piece of writing, in which Mayakovsky gave no quarter to the devotees of the traditional arts. He used wordplay on the name 'Rastrelli' (the Italian architect who designed the Winter Palace) and the word *rastrel* (shooting, fusillade), and by intermingling 'Pushkin' with the word *pushka* (cannon, gun). The poem concludes with the following lines:

> They built cannons here on the edge,
> Deaf to the weasels of the White Guard.
> But why was Pushkin not bombarded?
> And the other canonical-generals?[42]

It was a vicious, but highly ingenious and witty poem – and, one might say, only a hypocrite would take it literally. But it was the age of hypocrisy. To some, the fact that Mayakovsky produced such iconoclastic writings as a pre-revolutionary scoundrel was offensive enough, but that he did so as a prominent public servant, and in an official government publication, was viewed by his opponents (perhaps not unjustly) as overstepping the boundaries. The biting criticisms reached Lenin, who called Lunacharsky to account.[43]

Lunacharsky then wrote a rebuttal titled 'a spoonful of antidote', in which he paternalistically called the avant-gardists to order. The attacks on the avant-gardists were so intense that both *Iskusstvo Kommuny* and the associated monthly *Tvorchestvo* (Creation) dedicated entire issues to defending the position of the avant-gardists.[44]

The fiercest opposition came, once again, from the highly educated professionals in the new order, this time from literary theorist Vladimir Friche, a board member of the Literature Department of the People's Commissariat for Enlightenment. Friche published a series of damning articles, most of which appeared in *Izvestia*. *Izvestia* was a far larger and more widely read publication than *Iskusstvo Kommuny*, so in this respect, too, the avant-gardists were at a disadvantage. Although Friche's attacks were predominantly aimed at the literary avant-garde, the visual artists suffered almost as much.

Friche was a formidable opponent, for in addition to his ministry work he was also active in various departments of the Moscow Soviet – the city council, a body that was constantly locked in a power battle with the People's Commissariats. In the soviet, Friche was (among other things) president of the Department for Public Celebrations, which was responsible for organizing the October and Workers' Day festivities

(from which the futurists were ultimately excluded, partly due to Friche's machinations). Additionally – and unlike most of the futurists' other opponents – Friche was a seasoned theoretician and dedicated Marxist, who bolstered his anti-futurist campaign with an arsenal of sociological and philosophical theories. Lunacharsky could certainly have put pressure on Friche, who was his subordinate, and asked him to refrain from publicly demonizing the policy of his Commissariat – but he did not, most likely because Friche had the support of those highest in the party, especially Fyodor Kalinin, the brother of the powerful Bolshevik Mikhail Kalinin. Fyodor supplied the strongest ideological basis for the battle against the futurists when he wrote: 'Futurism is a phenomenon of the capitalist structure....It represents the death throes of the bourgeois spirit, the delirium preceding the downfall.'[45]

In response to the tsunami of criticism, Lunacharsky imposed far-reaching measures. The publication of *Iskusstvo Kommuny* ceased in April 1919; the controversial journal would ultimately release no more than nineteen issues. Earlier, in March, Lunacharsky had organized a large gathering of the Petrograd and Moscow branches of the visual arts committees. Mayakovsky, Shterenberg and Brik travelled to Moscow from Petrograd, where they met with Malevich, Tatlin, Rodchenko, Kandinsky, Udaltsova and Stepanova. Brik and Shterenberg decided to oust Tatlin as president of the Department of Fine Arts, and to install Brik temporarily in his stead. Next, the members of the procurement committee were to be elected. According to Kandinsky, the meeting resembled 'a stock exchange more than a business meeting. There was commotion, hubbub, shouting and swearing.'[46] The Moscovites were furious and divided. When Shterenberg asked for nominations, everybody fell silent, and when he took the initiative and nominated Tatlin, they again remained silent. Nobody seconded the motion, and so Tatlin's nomination was lost. The same happened to Malevich, causing both rivals to lose their posts on the influential committee. Stepanova rightly concluded that the Moscow avant-gardists 'destroyed themselves through internal conflict', and that 'the "two generals" [Malevich and Tatlin] fought each other to death'.[47]

Afterwards, however, the two men did join forces for a short time. In conjunction with Sofia Dymshits and several other artists, they looked for support to Lunacharsky, who believed that Brik and Tatlin should lead the Moscow Department of Fine Arts together. Eleven days later, however, elections were held for a new committee (this time called

a 'presidium'), during which Rodchenko and Stepanova stood against Tatlin. He received only nine votes – not enough. With support from the 'younger' artists, Wassily Kandinsky was elected to the presidium. Shortly thereafter, in a rare display of solidarity with Tatlin, Malevich asked Rodchenko why they had treated Tatlin this way. Rodchenko, a wily conspirator, could not resist the temptation to fan the competitive fire between the two men. 'But you are the elixir of life to Tatlin, and he calls you his student. Tatlin makes a fool of you, and yet you support him.' His remark immediately had the desired effect. Malevich responded: 'Then why are you always giving me a hard time, and never Tatlin?'[48]

The fact that two such gifted and inspired human beings could fight so selflessly for a major social cause, while simultaneously losing themselves in such destructive mutual conflict, remains an intriguing psychological study.

Malevich and Tatlin had now lost their most critical bureaucratic posts, although they were both still board members and had responsibilities to fulfil. The Petrograd leaders, Shterenberg and Brik, had been asked to move to Moscow to take over the leadership, and both men now had much readier access to power than the two Moscow 'generals'. Neither Tatlin nor Malevich could accept that they now had to ask for permission, and both expressed the desire multiple times to move to Petrograd, since a power vacuum had emerged there and they held out hopes of winning back a degree of autonomy. From April onwards they both regularly spent long periods in Petrograd. On 25 April 1919, Tatlin handed in his resignation to the school in Moscow, which was officially accepted five days later.[49] Probably by way of compensation, he was then offered the leadership of the Free Studios in Petrograd, and in early September he moved – to his regret, he later admitted – to that city. 'Tatlin is leaving for Petrograd for good,' wrote a student of his in early September, 'with tears in his eyes, as he is not understood in the faculty. He took his orders, and left.'[50] Malevich visited Petrograd various times in April, and for various reasons; but the most important one was to see if he, too, might succeed in creating a position for himself there.

It seemed inevitable that this crisis would bring Malevich and Tatlin closer together. Their mutual enmity was, after all, an expression of the tacit respect they nurtured for one another: they would waste no energy on lesser rivals. Yet that respect brought about no real reconciliation. Even now, after their shared defeat, they could not set aside their anger and outrage.

During their third joint visit to Petrograd, they butted heads once again, most likely over Tatlin's newest plan to build a colossal monument of iron and steel. Malevich disliked the idea, as he believed it would cost a ridiculous amount of money. 'Malevich lectured Tatlin for refusing to see past the end of his nose, and because his horizons were hemmed in by steel.'[51]

Dymshits, who recalled the spat, said they were 'simply the greatest rivals of their time, fierce and irreconcilable'.[52] Though this is true, at the same time the duo had an almost comic reputation. One can almost picture their escalating arguments as scenes from an old black-and-white movie. Off they go together, the Pole and the Russian, the former short and stout, the latter tall and thin. They travel as a pair, cooped up together for hour upon hour in train carriages, in waiting rooms, in boarding houses. The short, stout one is always dominant, long-winded and patronizing; the tall, thin one is silent and sullen, but never intimidated. Tensions rise. Short-and-stout talks non-stop, louder and louder, ever more certain, goading out a response, while tall-and-thin maintains a deliberate silence, feigning detachment. Then comes the inevitable eruption – comedy gold.

Yevgeny Katsman, Brother-in-Law and Enemy

Despite his efforts, Malevich probably had little inclination to follow Tatlin to Petrograd, in light of the distinct possibility that he would fall under Tatlin's authority once again. There were other reasons, too, for staying in Moscow. Unlike Tatlin, Malevich had a large family of in-laws in the city, the Rafaloviches, to whom his wife Sofia was very attached. Various family members regularly visited the summer cottage owned by Sofia's mother in Nemchinovka, a village outside of Moscow not far from other trendy, modern-day towns such as Barvicha and Zhukovka. The region was picturesque, fertile and popular, and Malevich enjoyed working there. The house was sparsely furnished but rather large, with two storeys and a garden. Malevich loved going outside in the morning, while everybody else still slept, to paint beneath a large oak tree.[53] Large families like this never left each other in the lurch, especially in times of chaos and hardship.

The family ties were not without problems, however. Sofia's mother was a dominant and unpredictable woman, who did not hesitate to exert considerable emotional pressure on her children. She felt such disgust

for the man whom her youngest daughter Anna married that she refused to sit at table with him. Her relationship with Kazimir was reasonable, although he, too, was put through the wringer occasionally.

Malevich's biggest problem was not his mother-in-law, but the husband of Sofia's other sister, Natalia. The man in question, Yevgeny Katsman, was also an artist. He was Jewish, but had been forced into baptism by the grandmother in order to gain permission for marriage. He was twelve years younger than Kazimir and a tried-and-true realist, who painted mostly portraits.

Even in his early student days, Katsman came out as a staunch anti-futurist, and during discussions always took a firm stance against the avant-gardists. Whenever he and Malevich were in Nemchinovka at the same time, they avoided each other, despite frequently staying in the same house.

Though understandable given the two men's deep-rooted artistic convictions, their mutual differences need not have had any dramatic consequences. However, Katsman developed an acute aversion to and jealousy of his brother-in-law, which only increased when Malevich suddenly became a powerful figure in the art world. Shortly after the revolution, Katsman had obtained a teaching position at the RABFAK – the 'workers' faculty' – of the Free Studios, or the bridging programme designed to prepare illiterate or poorly educated workers for potential admission to the art programme proper. The professional distance between his own position and that of the powerful professor Malevich was great. Malevich received larger rations, had authority, and as a member of the People's Commissariat was entitled to travel by tram – a privilege unattainable by most Moscow citizens. Malevich had no time for his struggling brother-in-law, and perhaps bore an air of condescension.

Few contemporaries were impressed by Katsman's talent. Writer Kornei Chukovsky, a great fan of Repin, disparagingly called him 'a portraitist suitable for illustrated European journals'.[54] What Katsman did possess was a well-honed political instinct, as well as the kind of authentic cynicism necessary to reap the benefits from it. He quickly built up an influential network within the party and the other authorities. Prior to the revolution, he had lived in a 'commune' with several Bolsheviks including Naum Antselovich, who would remain a powerful Soviet bureaucrat until his death and even became a member of the Central Committee. After the revolution, Antselovich became chairman of the Central Committee of Trade Unions. In addition to his teaching

post, Katsman also worked as a secretary at the artists' union (probably thanks to Antselovich's intervention). His third job, however, presented the most ominous threat: he worked in the Public Celebrations department of the Moscow Soviet, as secretary to none other than the arch-futurist-hater Vladimir Friche,[55] and here his deep-seated aversion to the futurists found fertile soil. Malevich's brother-in-law was, therefore, intensely involved in the fight against the avant-gardists immediately following the revolution. His vengeful jealousy would ultimately bode ill for Malevich.

For a time, however, Malevich's connection to the Rafaloviches grew stronger. Sofia became pregnant, probably unintentionally, in the summer of 1919, but the couple decided to keep the child (abortions were quite common at the time). Because of the pregnancy, the couple decided to remain in Moscow for the time being, close to Sofia's family.

Tatlin's Plan

While Malevich stayed in Moscow, Tatlin moved permanently to Petrograd. For the first time in many years, the two men did not live or work in each other's immediate vicinity.

Tatlin's goals were certainly not limited to teaching. Even then, and probably since the beginning of 1919, he had already started working on the preparatory sketches for an exceptional artwork that he wished to realize within a short space of time. For this reason, in Petrograd he went looking for a particular studio space where he could work with his students. The most important prerequisite was the height of the ceiling, which had to be at least 7 metres (23 feet). He ultimately found a suitable space in the mosaic workshop of the former art academy.

In March of that year, Punin had already published an extensive article titled 'On Monuments', in which he comprehensively described the artwork in question – then still completely conceptual – based on several interviews with Tatlin. The article outlined a monument which, while conceived as a commemoration of the revolution, nonetheless differed fundamentally from Lenin's own conventional Plan for Monumental Propaganda. Tatlin's monument was not intended to reference specific acts or achievements, but instead a communal revolutionary spirit. At the same time, it was to align with the traditional Russian cultural reality. In Russia, sculptures had only been a part of public culture since Peter the Great. The Orthodox church allowed no

sculptures in its buildings, nor did any appear in public spaces. Russian rulers wishing to erect a monument would always settle on a church or chapel – traditional Russian monuments were, therefore, buildings, never statues. For this reason, Tatlin's monument also had to be a building, but one such as had never been built or even conceived of before.

The initial article was a description of the monument's conceptual purpose more than its physical form. In any case, the building was to consist of

> the simplest geometric shapes. Cubes, cylinders, spheres, cones.... Some of the simplest shapes (the cubes) will accommodate lecture theatres, gymnasiums, 'agitation' spaces and so forth, as well as other facilities as needed. Under no circumstances should they contain museums or libraries, for their ongoing dynamism is paramount. The monuments must also contain an agitation centre, responsible for circulating appeals, proclamations and brochures throughout the city. Special motorcycles and automobiles, of a single specific type and branded with the logo of the monument, can serve the community's dynamic and ever-ready propaganda centre quickly. For immediate dissemination of information, the monument will house its own radio broadcaster with a global reach, telephone and telegraph stations (of modest dimensions) and other potential information technologies. In addition...the monument should contain projection equipment in one of its spaces, used to project light-letters onto the clouds. These letters can be arranged into various slogans or mottoes, according to current events. The monument may also contain a series of small centres reserved predominantly for artistic purposes, such as spaces for artistic innovations, a publishing house, and perhaps a dining hall.[56]

This summary already contained some of the final design's key hallmarks: the use of geometric forms as building-blocks, the propagandistic purpose and the dynamic character. Nevertheless, it would be a fundamental error to view Punin's article as a blueprint or basis for the final piece. The text presented the design as a multimedia propaganda machine, thus reducing it to its practical and modern features. Tatlin's intentions were broader and more contradictory, as we shall see. We might also note that practicality was never the artwork's main purpose. The article was primarily meant to generate political support for the project – although its success in this regard was only partial. All the same, Tatlin would focus almost exclusively on developing his monument from the summer of 1919 onwards.

Nikolai Punin, *Monument for the Third International*, 1920. Cover design: Vladimir Tatlin.

Tatlin had probably already conceived of the basic structure during that summer, basing it on 'completely new architectonic principles, completely new architectonic forms that have never before been applied'.[57] The fact that these 'completely new architectonic principles' had been formulated by an artist who had neither completed secondary school nor consulted a single engineer on the subject demonstrates that feasibility was not his top priority.

Tatlin's monument took the form of a tower 400 metres (over 1,300 feet) in height, exceeding the tallest human-made structure in the world at the time – the Eiffel Tower – by 100 metres, and dwarfing the world's tallest building, the Woolworth skyscraper in New York, by nearly 200 metres.

The planned tower, an open, self-supporting steel structure, slanted up to the sky in the form of two concentric, tapering spirals, bound together on one side by a large, inclined girder. Trusses between the two spirals, some vertical, provided structural support, while enhancing the sense of organic unity. Inside this skeleton, four immense glass solids were placed – a cube, a pyramid, a cylinder and a hemisphere – mostly intended for offices serving a variety of functions. Each solid revolved around its own axis at a different speed, but all extremely slowly, so that the revolution was almost imperceptible to the naked eye. The purpose of this effect was to make the colossal structure appear different every day, owing to the changing relative positions of the four glass shapes.

On the one hand, the tower's slant suggests an extrusion, an outward eruption from deep inside the Earth. On the other, the tower seems as though it might collapse at any moment, succumbing to the Earth's gravitational pull. Such ambivalence is crucial to any understanding of this outlandish object, which ultimately became emblematic of many aspects of the Russian avant-garde. In one sense, the monument's epic proportions make it a typical representation of the totalitarian state; it is also riddled with the kinds of modern technologies aimed at exerting control over individuals via propaganda. In another sense, its lack of structural balance is at odds with totalitarian sensibilities, as monuments to the establishment are always the epitome of stasis and symmetry, and seek to emphasize the permanence – not the changeability – of the regime. And what kind of statement is a monument to the revolution that is so patently unfeasible?

Tatlin's contemporaries saw the tower first and foremost as a monument for the modern age, as a hopeful (or disconcerting) reference to an industrialized, democratized and mechanized world. They saw a form that was defined by a logical, regular pattern, the embodiment of an innate, decipherable logic. From this perspective, the tower does indeed resemble a monstrous machine, an object firmly rooted in a technical blueprint: logical and predictable.

This rationale falls short, however, as has been discovered time and again by the astonished artists and architects who tried to build Tatlin's

design at scale. As the two spirals move upward, they are neither symmetrical nor uniform. They loop upwards at different rates – now relaxing, now shooting upwards again – and at no altitude do they mirror each other's movement, thus defying any kind of symmetry.[58] In other words, the structure is decidedly not mechanical: it is organic.

The organic nature of the monument is reinforced by its symbolic connection to the Earth and the universe. The angle of the tower's slant is an extension of the Earth's own axis, and the revolutions of the glass solids imitate the orbits of the Earth and the moon: the lowest cube would take a year to rotate once, the pyramid one month, and the cylinder one day. Even the height of the tower is a wry reference to cosmic proportions: the prescribed 400 metres (1,312 feet) is almost exactly one-thousandth of the Earth's circumference at the equator. These deliberate references immediately associate the tower with eternity, nature and the cosmos, rather than with the future and technology. Tatlin never specified a particular site for the tower, but did say that it was more suited to a large, open space than the historic city centre. The arches at the base were included so that the tower could be built atop a river, allowing the water to flow through underneath.[59]

The tower inevitably also conjures up symbolic, cultural and historical references, the most obvious being the biblical Tower of Babel. The visual resemblance is immediately striking, as the spiral structure of Tatlin's tower mimics most artistic representations of the Tower of Babel, Breughel's being the most well known. Tatlin was probably also familiar with images of the Great Mosque of Samarra, whose famous minaret has a similar spiral shape.

The comparison does not stop there, however. The Bible story tells of the Babylonians' desire to build a tower to heaven in order to reach God. For their presumption, the ever-vengeful Old Testament God issues a harsh punishment: he has the various peoples start speaking in different tongues, so that the builders cannot understand one another and the tower remains unfinished. The resulting lack of mutual comprehension also leads to centuries of conflict between the peoples, giving rise to a bloody history. Tatlin conceived of his monument explicitly as the opposite: he called it the Monument to the Third International, a tribute to the organization aimed at uniting workers worldwide into a global revolution. By associating his tower with the revolution's international aspirations, he made it expressly a manifestation of the unifying and pacifist ideals of the communist experiment. The comparison between

Tatlin and his assistants at work on the model of the Monument, 1920.

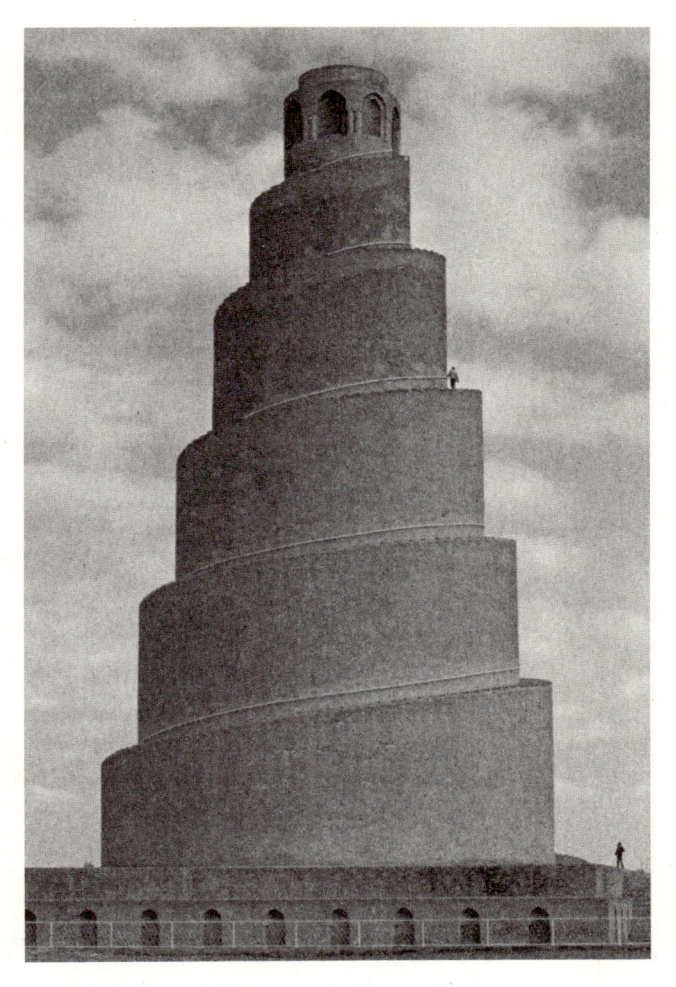

Great Mosque of Samarra, Iraq.

the Babylonian tower and Tatlin's monument is, therefore, not a parallel, but a juxtaposition: whereas the Tower of Babel was responsible for dividing humanity up into hostile nations, Tatlin's tower symbolized their coming unification under the Third International.[60]

By the end of 1919, Tatlin's design was ready to be presented to the board of the People's Commissariat, and he was commissioned to produce a model to be displayed during the 1920 October celebrations.[61]

Tatlin's contract with the People's Commissariat fitted onto a single page. The description of the monument in it seems not to be from the hand of Tatlin himself, but written by his co-signatory David Shterenberg

(though Tatlin was most likely consulted on the wording). One striking aspect is that the monument's artistic aspects were outlined first, preceding the functional ones: 'The Monument is to be an artistic expression of the greatest achievements of relief art (whose basic constituent elements include painting, sculpture and architecture).' The word 'artistic' was added to the typed page in Tatlin's handwriting. Only after that were the 'social services' mentioned, such as the radio and telegraph stations, and the propaganda facilities. The official commission made no mention of revolving offices or dimensions exceeding those of the Eiffel Tower, nor of Tatlin's utopian symbolism. All in all, the contract was of rather modest scope, as was Tatlin's compensation – nothing, to be precise. Tatlin would be paid for his work only once the 'preliminary model was approved as a monument', or in other words, if the Commissariat decided to proceed with construction. In that event he would receive 15,000 roubles – less than his customary fee for the sale of a painting. Even that modest sum was denied him, for the monument was never built.

Only his expenses and materials would be reimbursed. It was clearly evident from the contract that the People's Commissariat had no great expectations when it came to Tatlin's work. Whether Lunacharsky ever saw the contract is unclear; it is possible that he deliberately had Shterenberg sign it alone, as a means of ensuring plausible deniability of any involvement in the project later.[62]

For Tatlin, however, the contract ticked one important box: he could now rightfully proclaim that the People's Commissariat for Enlightenment had 'commissioned him' to construct a monument for the Third International.[63] That meant he could start beating the drum, declaring himself to all and sundry as the official visionary and prophet of the revolutionary state.

Wild rumours rapidly spread about the project, and in particular the majestic sum that Tatlin would receive for it. In an official article from the industrial city of Samara, the indignant artist N. Popov stated that Tatlin was to receive eight million roubles for his monument. He, Popov, also wished to build a spiral-shaped revolutionary monument in Samara made of glass and steel, with projectors and geometric symbolism. He found the one-million-rouble budget (!) allocated to him far too modest, however, while 'the capital is paying comrade Tatlin eight million for a monument of comparable style!'[64] Popov had studied at the Free Studios in Petrograd in 1919, where Tatlin was working on his model. How could anyone possibly doubt his authority on the subject!

When the snowballing rumours reached Malevich's ears, he could not resist exacting vengeance. He wrote a vitriolic critique of both the NARKOMPROS policy and the implementation of the Plan for Monumental Propaganda, culminating in an open attack on his rival: 'Tatlin, the eccentric, wants payment for building a utilitarian monument without a shred of new meaning....Enough with these obelisks, these sarcophagi, that crush the red living squares of our community.'[65] The tirade would be published in the students' weekly at the Free Studios in Moscow, where everybody read it and became embroiled in destructive debate.

When Shterenberg got wind of the article, he was understandably furious. The conflicts between Tatlin and Malevich had hitherto always played out behind closed doors. Shterenberg had always tried to protect the avant-gardists from attacks by the Commissariat and the cultural community, and now Malevich had taken their squabbling to the streets. Shterenberg was, moreover, a co-signatory to Tatlin's contract, and therefore partly responsible for its success. He ordered the entire print run of the journal containing Malevich's article to be incinerated, but could not prevent several escaped copies from circulating at the school and within the Commissariat. Though Malevich played down the incident, it did damage his reputation. Tatlin heard about it soon enough; he was beside himself, of course, and proceeded to tell everyone (and his students especially) to side either with him or Malevich. All hope of unity within the world of the avant-gardists was now gone.[66]

Terror

Whatever the historic verdict may be on the internal conflicts among the avant-gardists, it is impossible to understand them without a consideration of the backdrop against which they took place: the devastating and dehumanizing civil war that completely uprooted society and put relationships everywhere under pressure. 'My nerves are making me constantly angry and irritable,' Rodchenko wrote in his diary in late 1918.[67]

The civil war reached its climax in the autumn. Everywhere there were dead to be mourned: Lyubov Popova's husband died of typhus, after which she became infected herself and only barely survived. Alexandra Ekster, who had returned to Kyiv shortly after the revolution, lost her husband to the same disease in the summer of 1919. At that time, the Red Army was poised to retake Kyiv from the White armies, and seemed to have the advantage everywhere. The artists in Moscow and

Petrograd had it tough, but their troubles were nothing compared to the lives of the avant-gardists in Ukraine, who had been caught on the front lines of the war several times. Ekster had opened a studio in Kyiv, where she worked on clothing and set designs, as well as her own paintings. She also taught there, held lectures and debates, and immediately became one of the most prominent figures in the Kyiv art scene. Her friend Natalia Davydova, the sponsor of Supremus, was also in Kyiv. When the Bolsheviks attempted to take Kyiv for the first time in January 1919, Ekster fled to Odessa to be with her mother-in-law, and tried to continue her activities. The port city was in the grip of near-total lawlessness, however, and her mother-in-law died of starvation only a few days after her arrival.

The Bolsheviks took Odessa in March–April of that year, and one of their first orders of business was to organize lavish Workers' Day celebrations. Ekster was one of the two principal supervisors, though it is unclear whether her participation was voluntary. What is certain is that work on the decorations was carried out under the constantly watchful eyes of armed Bolsheviks. Ekster recalled how one of the exhausted artists in her team once accidentally knocked over a tin of black paint, staining a portrait of a member of the Red Guard. The Bolshevik on duty nearly exploded with rage, put a pistol to Ekster's temple and demanded that she find a way to remove the stain.[68]

In June, Ekster took part in a major exhibition that opened in Odessa, and in August she was asked to teach the painting class in an art programme that was under development at the time. She had hoped for a return to Kyiv, but the letters she received from Natalia Davydova described such dire circumstances that she postponed her plans.

Meanwhile, back in Kyiv, Davydova tried to save herself and her family. The Bolsheviks had fought a vicious battle in the Ukrainian city, where they had largely been met with hostility. After their victory, they carried out terrorist acts against everyone they viewed as a political enemy. Coming from a rich family, Davydova had reason to fear the Bolsheviks. In letters to her dear friend, the Polish composer Szymanowski, she painted a horribly vivid picture of the situation: 'You know, *chéri*, Kyiv has seen terrible times. Nights when we could hear nothing but killing, killing, killing without end. I cannot walk through Lypky [a wealthy suburb of Kyiv] without trembling. It seems as though every stone, every house, conceals a monstrous tragedy. Imagine: all the houses in Sadova, Ivansky and Elisaveta Streets stained with blood, and

the parks are filled with the dead. Every day somebody is murdered, and our circle of friends grows ever narrower.'[69]

In the summer, both Kyiv and Odessa were retaken by anti-Bolshevist troops, then retaken again in October by the Bolsheviks, triggering a massive exodus of Poles and nationalist Ukrainians. 'It was horrible,' Davydova wrote, 'that rainy morning on 1 October, when Kyiv awoke to the realization that they, the Bolsheviks, were already on the outskirts of the city. And the exodus that began! It was a chilling sight – all those pale faces running towards the Dnipro, the tens of thousands of civilians and soldiers, trying to save themselves.'[70]

Davydova subsequently also fled to Odessa, in the hope of being able to work with Ekster or to escape to Europe. In Odessa, however, fate had other plans. Her son Kirill, barely fifteen years old, wanted to join the anti-Bolshevist volunteer army, and she could do nothing to stop him. Their housemates in Odessa found out, and reported them to the Cheka. They were promptly arrested on suspicion of counter-revolutionary activities, and imprisoned in putrid conditions. The cells were crowded, there was hardly any food, and the sick simply lay on the cold cell floor, waiting for death to come. Kirill died after a full month, from exhaustion and illness. Natalia was not permitted to say a final goodbye, but his lifeless body was carried out past her cell, where she caught a glimpse of him before he was taken outside, without a coffin. She herself was released after two months, completely demoralized and exhausted.[71] She remained in Odessa for some time, staying in Isaak Babel's apartment, but eventually succeeded in fleeing to France, where she tried to make a fresh start under impoverished conditions.[72]

Six months after her release, Davydova wrote a now lost letter to Malevich. It is unclear whether she told him exactly what had happened – letters were read by the secret service – but he got at least a general impression of the situation. 'The poor soul has been through so much,' he wrote to a mutual friend of theirs.[73]

In the autumn of 1919, Malevich decided to leave Moscow. One important motivating factor was the arrival of an exceptionally talented designer and architect, Lazar Lissitzky, who would later be known as El Lissitzky. In the spring of that year, he had started working as a teacher at an art programme in Vitebsk, and visited Moscow to try to tempt Malevich to do the same. He had already met Malevich once in 1917, when he served under him for some time in the soldiers' council, shortly before Malevich's appointment as commissar to the Kremlin. Lissitzky

successfully convinced Malevich by proposing Vitebsk as the location where it would be possible to publish the new brochure that Malevich had been working on that summer, a hope that he could not possibly entertain in Moscow.

The food situation was also better in Vitebsk, which may also have been the deciding factor in the move, especially since Sofia's new baby was due half a year later. The circumstances in Moscow were worsening by the day. One artist noted that even the pigeons had left the city.[74] On 29 October, Malevich submitted his letter of resignation to the Free Studios: 'Though it is my express wish to work here in the studios, I have no apartment (I live in an unheated dacha), no firewood, no light, and must therefore accept the invitation of the studios in Vitebsk and leave my work in Moscow behind me.'[75] In November he left with his family, with the intention of returning to the capital as soon as he could. But there would be no swift return, and although he would visit Moscow quite often during the rest of his life, it would never again be a base for his artistic or professional activities.

Of the original small group of avant-gardists – those who had displayed works at the various futurist exhibitions in 1914–15 – at least five were no longer in Moscow: Tatlin was in Petrograd, Malevich in Vitebsk, Ekster in Kyiv, Rozanova was dead and Davydova was in Odessa. The younger avant-gardists, too, were leaving Moscow. Katarzyna Kobro and Wladislaw Strzemiński went initially to Minsk, and later to Smolensk to establish an art college. The position of the avant-gardists had never been so weak, and it seemed as though the politicians could sense it. In December, one of the most senior party leaders, Zinovyev, said: 'At one time, we permitted this most laughable futurism almost to pass for the official school of communist art....It is time to put a stop to it.'[76] And so they did. If the avant-gardists still held any sway, it was due only to the leadership's relatively low interest in art education. Now, the accepted view was that futurism could no longer claim any exclusive association with the revolution. On the contrary – the two were considered mortal enemies.

The Model

Meanwhile, Tatlin continued work on his monument. The model turned out to be around 6.5–7 metres (21–23 feet) tall and was made almost exclusively of wooden planks. Tatlin and his workers had no access to

Tatlin and his assistants at work on the model of the Monument.
(Left, Sofia Dymshits-Tolstaya, with Vladimir Tatlin beside her.)

mechanical saws or other equipment, and so the model was subject to construction requirements completely different from those of the original steel design. The model, in fact, became an independent artwork, one that was based on the original concept but not a faithful model serving as a blueprint. The ultimate model is far less symmetrical than the plans and embodies a fragile quality. The 'struts', or vertical connecting bars, are far more closely spaced than would have been necessary for a steel construction, and obscure the solids contained within the outer frame. These, incidentally, also deviated from the design, being made of wood instead of glass, and covered in thin paper. The cube at the base, the largest of the solids, was replaced by a cylinder, mainly for aesthetic reasons.

Tatlin asked some of his Moscow students – Tevye Shapiro and Yosif Meyerzon – to help him with the project, and they moved to Petrograd to do so. Dymshits-Tolstaya also helped every day, and her responsibilities included creating the paper skins for the geometric solids. The initial model included no internal mechanism for making the solids turn, but one of Tatlin's assistants did say it could be added later.

As always, Tatlin succeeded in creating a fantastical working atmosphere that was occasionally almost childlike, but always inspiring. Friends were constantly dropping by of their own volition to help out. When Punin came to the workshop to assist one day, Dymshits made a large pot of porridge.

> They eat like sea rats and vermin, nicking each other's food with but a brush of the hand, the same hands that can break horseshoes during their work. I choose not to take part; I am simply not strong enough and offer the excuse of my delicate constitution. They devour the entire pot, which again, does not interest me, but it is a cheerful sight, like being at home in the nursery. They squabble with one another as best they can, with all their might, about painting, visual art, modernism, and so on. If somebody's fixture doesn't fit properly on the beam, they cry 'Modernism!' – and Tatlin speaks with a slow, serious and admonishing tone: 'Not to worry, comrades, that's a product of the *fin-de-siècle* obsession with graphics; it will work, the bastard, and all will be right again.'[77]

The furnishings in the studio were spartan; there were no chairs or tables. The pedestal under the tower, eventually meant to house the turning mechanism, was described as an 'altar', and that is where Tatlin and his assistants sat to eat, with their backs turned to one another and

their faces turned outwards. One of the assistants called it 'Tatlin's anti-table': 'To ask someone a question, you had to lean backward and twist sideways; your interlocutor was required to make a similar snake-like motion in your direction....Now you might say that it was an "anti-table," the opposite of an ordinary table, where people have sat for centuries, their gazes fixed upon one another.'[78]

Another of Tatlin's students wrote that the scene was far from the solemn birthplace of a revolutionary, technically superior, utopian structure, and more reminiscent of 'a medieval alchemist's laboratory'.[79] Perhaps the months of unbroken concentration in the seclusion of the workshop had led to an ever-increasing detachment from day-to-day reality, allowing eccentricity and whimsy to gain ground increasingly over efficiency and practicality.

Several months later the model was complete, and in the studio it stretched almost to the workshop's ceiling. It was clear that Tatlin had made a variety of practical and aesthetic choices that deviated from the original concept, producing a result that was more sculptural than architectural in nature. It now betrayed the aesthetic sensibilities – the 'hand' – of a creative individual, thus ceasing to be the illustration of a utopian concept, and instead becoming a work of art.

Tatlin's own perspective on his creation is best illustrated by the manner in which he wished to present it during the October festivities. He proposed organizing a mass spectacle on one of Petrograd's large squares, whereby the monument would be assembled before the public over the course of several hours, accompanied by – we might assume – music, choreography, light shows and other support acts. A plan to this effect had been approved two months in advance, and also announced in the press.[80] In this manner, two pillars of Tatlin's artistry – his aesthetic sense for materials and construction, and his creative dedication to the theatrical, fantastical and ephemeral – were united.

Although Tatlin had received approval for this mass spectacle, it never took place, probably because all of the attention and funding had been siphoned off to a different performance: a 're-enactment' of the storming of the Winter Palace. The recreation involved tens of thousands of participants, and was a palpable reflection of the avant-gardists' absence from the organization of the October festivities.

To ensure that the presentation of his model was not eclipsed by the other extravaganzas and festivities, however, on the day before

the official opening of the celebrations Tatlin decided to organize an 'artistic-political meeting', in the very space where the model had been constructed. He beat the drum as loudly as possible, and asked Punin to muster all of his contacts. 'Do everything within your power to generate as much attention as you can...in particular: invite everyone in politics, hold lectures, meetings, make announcements in suitable newspaper and magazine articles; in short, take all necessary measures to create as much propaganda for our work as possible.'[81]

After the presentation in Petrograd, which lasted exactly three weeks, the enormous model was taken apart and transported to Moscow. There it was reassembled, and also fitted with an internal mechanism that would allow the solids to rotate within the frame. It was put on display in what was known as the Dom Soyuzov ('House of the Unions'), as part of the fringe programme during the eighth All-Russian Congress of Soviets held in December 1920. Representatives of all local soviets travelled to the conference – the highest official decision-making body in the Republic – to discuss and ratify government policy. Tatlin's monument was the *pièce de résistance* in an exhibition dedicated to a range of achievements and ongoing projects in the new Republic.[82] At such a prominent forum, it naturally received plenty of attention. A reporter from *Izvestia* described the tower on the front page as 'an enormous, enigmatic object made of glass and steel'.[83] Tatlin and his assistants were in the exhibition hall, ready to answer any of the visitors' questions.

As expected, the responses to the tower varied widely. Mayakovsky was enthusiastic in his welcoming of this 'first monument without a beard'.[84] However the Bolsheviks, Ehrenburg noted, preferred 'Marx's plaster beard'.[85] Viktor Shklovsky described the monument of 'steel, glass and revolution' in epic terms:

> The days race past like wagons, full of many and varied carts, cannons, and crowds of people making a commotion about something or other. The days roar like a steam hammer, blow by blow, and the blows are already merging into one another, and now, already, nobody hears them anymore, in the same way that people who live by the sea no longer hear the sound of the water....We are living in a roaring silence, and it is in this tremendous atmosphere that the iron spiral of the monument project was born.[86]

Even among the leftist intelligentsia, though, there was criticism to be heard. Some emphasized the 'ideological absurdity' of the design; others

Tatlin and his assistants. From left to right:
Yosif Meyerzon, Tevye Shapiro, Vladimir Tatlin,
Sofia Dymshits-Tolstaya.

ridiculed its practical unfeasibility, saying that in the heat of summer, the glass offices would be useful only as greenhouses 'for growing pineapples'.[87] Tatlin's salvation came from the monument's international reception. In 1920, the borders between Europe and Russia gradually reopened once more, and many European artists and left-wing intellectuals looked on with excited interest at the experiment playing out in Russia. In this context of an information vacuum and high expectations, Tatlin's monument – photographs and illustrations of which quickly made the rounds – made a grand impression. In the spring of 1920, the German press wrote that even in his new projects, Tatlin 'takes immediate inspiration for his forms from the world of machines, and builds up his work "mechanically". He is not afraid to show his "mechanized heart", and approaches the "urban monstrosity" with calm and confidence.'[88] Once the *Frankfurter Allgemeine* had heard of the Russian tower, the news quickly spread throughout Europe. In the Netherlands, the *Rotterdamsch Nieuwsblad*, *Algemeen Handelsblad* and even the *Provinciale Noord-Brabantsche Courant* wrote about the 'New tower of Babel to be built by the Bolshevists'.[89] The reports in the international media, which spoke of the mechanical nature of Tatlin's art, were frequently repeated verbatim and fanned the Tatlin hype.[90] All of Europe was suddenly talking about 'Tatlinism' and Tatlinists, who had declared art to be dead in Russia and thenceforth only worshipped technology.

Tatlin beside his completed model, November 1920.

That summer, at the Dada Fair in Berlin, Dadaist Raoul Hausmann exhibited his collage *Tatlin at Home*, depicting Tatlin as a refined gentleman with a mechanized brain (Plate 18). At the same exhibition, two other Dadaists – John Heartfield and George Grosz – were photographed holding a large sign bearing the slogan 'ART IS DEAD – LONG LIVE TATLIN'S NEW MACHINE ART'. At that time, the only exposure to Tatlin's art that either man could have had was via a few illustrations, and the same applied to nearly all others who took part in the heated discussions surrounding Tatlinism and Tatlin the 'machine man'.[91] This interpretation dominated the attitudes of Tatlin's champions and opponents alike. Even the serious intellectual Jan Romein wrote in 1927, his words brimming with fervent disgust, about 'Tatlin's machinism' as

Een moderne Toren van Babel. Ontwerp van 't te
Moskou op te richten expressionistische reuze-
gedenkteeken voor de 3e Internationalé van
Tatlin.

Illustration from the *Provinciale Noord-Brabantsche Courant*
of 'A modern Tower of Babel' by Tatlin, 10 June 1920.

though it were a real-world phenomenon.[92] In a certain sense, this per-
spective was fuelled by Russian publications issued in German, espe-
cially those by Ehrenburg and Punin, which pushed the image of Tatlin
as a modern 'technical' visionary.

International interest in Tatlin's monument was further intensified
by the celebration of the Third International, held in 1921 in Moscow. The
model was still in the Dom Soyuzov, but now formed part of a new exhi-
bition on the technical achievements of the Republic, such as the rapidly
expanding telegraph network and plans for the full electrification of
Soviet Russia. Because Moscow was flooded with the representatives
of international communist parties, Tatlin's tower was seen first-hand
by thousands of foreign visitors, including Henriette Roland Holst and
Gerard van het Reve senior, father to the famous Dutch authors Karel
and Gerard.

Almost none of these first European visitors ever met Tatlin in person.
George Grosz, when he travelled to Russia and met him in 1922, noted

how the image propagated of Tatlin was vastly different from the man himself.

Though Grosz was a tried-and-true communist, he did not lack scepticism and was disinclined to allow his keen, sobering view of reality to be clouded by idealistic beliefs. He described Tatlin as a true Russian, a paragon of dependability. Tatlin trotted out his usual repertoire of autobiographical legends, and the tale of how Emperor Wilhelm had heard him play the bandura at the folk art exhibition was dusted off for the occasion. Tatlin talked of how he had 'once belonged to a famous balalaika orchestra and choir, and had performed at the court of Emperor Wilhelm', and showed drawings of his Monument for the Third International. Grosz, a perspicacious type, quickly realized that Tatlin was not a typical representative of the new Russia at all, and that there was actually no place for him there. After visiting Tatlin's studio with a small group, he went back the next day to see him alone.

> I visited Tatlin again, the lanky buffoon. He lived in a small, old, dilapidated apartment. The chickens he kept slept in his bed, and laid eggs in the corner. We drank tea, and Tatlin chattered about Berlin, the Wertheim department store, and about his performance at court. Behind him, against the wall, was a completely rusted bed made of steel wire, where a few chickens lay sleeping, their heads tucked behind their wings. Such were dear Tatlin's circumstances, and when he played his bandura [Grosz called it a 'balalaika'] by the curtainless window, where some of the panes had been replaced with small bread boards, and dusk was descending....At that moment he looked nothing like an ultra-modern constructivist, but instead like an authentic relic of the old Russia, as though he had stepped out of a book by Gogol, and at once an air of melancholy spread throughout the room. I never saw him again after that, and never heard anything more of the Tatlinism that was so often discussed at the time.[93]

This version of Tatlin, with his chickens and his bandura, was a far cry from the idealized Tatlin – the one who bared his 'mechanical heart' thanks to his 'tremendous comrade, the sovereign machine' – as he was portrayed in the German press.[94] But this more docile image was slow to seep through to Europe, and the hype surrounding his character persisted for some time. This fact did not go unnoticed by the Bolshevist leaders, and – though not entirely genuine – it shielded Tatlin from the authorities, to a limited extent, for several years.

Lenin in Moscow, on his way to the Bolshoi Theatre, 1918.

In any case, Tatlin had successfully attracted the attention of the party leadership – so much so in fact that Lenin, who was constantly in attendance at the Union Congress, came to view the model in person, at Lunacharsky's invitation. The aim was to show the great leader how the internal geometric 'glass' forms rotated about their axes. At the time, rather than a motor or other device, Tatlin's assistant Meyerzon was instead hidden inside the pedestal, and was to turn the solids manually. Lenin came, Meyerzon started turning, but the mechanism jammed and there was no movement to be seen. Lenin watched, said nothing, and walked away.[95]

Had Tatlin bitten off more than he could chew? Had he bragged about the revolving shapes when the machinery was still underdeveloped? Or did Lenin's visit take him by surprise? He seemed to be the type who regularly sabotaged his own projects; the kind of person who, after periods of frenetic activity, suddenly lost all focus and fell victim to a sudden, inexplicable carelessness, much to the perplexity of the outside world. The visit was certainly not the sole cause of Lenin's displeasure with Tatlin and the avant-gardists; but shortly afterwards the leader decided that enough was enough, and took it upon himself personally to combat futurism.

6

The Avant-Gardists Take to the Provinces

1919–1922

Before the First World War, the small city of Vitebsk (where Malevich moved in the autumn of 1919) was home to a population of just over one hundred thousand people, around half of whom were Jewish. The other half consisted of Poles, Lithuanians, Russians, Belarusians, Ukrainians and some even smaller minorities. Vitebsk was a relatively prosperous trading city and a regional cultural centre, with some industry, several rigorous educational institutions and reasonable accessibility from Petrograd. The streets in the city centre were paved with cobblestones but, farther out, roads were either unsurfaced or simply did not exist. The predominantly wooden homes were built haphazardly in the open space, without any clear urban framework.

The city benefited from its location, in between the two Russian capitals on one side and more western-lying centres, such as Minsk and the Baltic states, on the other. The relative affluence and rapid modernization of Vitebsk is indicated by the fact that it had three movie theatres, all of which were built prior to 1914.[1] Yet, on the surface, it appeared little different from other regional hubs (such as Smolensk) and, all things considered, was not the place one would expect to find an especially aspirational art college.

The February revolution was generally welcomed with enthusiasm by Jewish communities, in Vitebsk and elsewhere, as it ended the oppressive and institutional anti-Semitism perpetuated by the Tsarist regime. Pre-revolutionary anti-Jewish laws had limited access to universities, and prohibited Jews from becoming members of political parties and social organizations. Jews were not permitted to settle freely under Tsarist rule, except in the so-called Pale of Settlement: a vast region that covered modern-day Belarus and much of northern Ukraine. But even there, the oppressive discrimination continued.

Vitebsk's most famous scion, Marc Chagall (whose name then was still Moishe Shagal) recalled that Jews were charged 50 roubles – a considerable sum at the time – to attend the public schools that were free to non-Jewish children.[2]

The majority of Jewish communities were distrustful of the Bolsheviks, for while they combatted anti-Semitism, they were still averse to religions in general, including Judaism. The civil war, however, brought about an alliance of sorts between the Jews and the Bolsheviks, due to the anti-Semitic violence of many anti-Bolshevist troops. A hundred thousand Jews were murdered in 1919 in Ukraine alone, mostly by the White Army. White General Denikin's Cossack regiment unleashed a reign of terror among the Jewish communities. During one such pogrom, they buried the Jewish men up to their necks and rode over their heads on horseback. The Jewish communities thus automatically sought refuge with the Bolsheviks.[3]

In the new Soviet state, the relatively well-educated Jews took the greatest possible advantage of the opportunities afforded them by the revolution. They received access to higher education and to positions in bureaucracy and cultural institutions, which in turn led to a truly revolutionary integration of Jewish people into the elite of Soviet society. The state benefited as never before from the drive and initiative of these new, fully fledged citizens. However tragically the Soviet Union would later lay waste to its own achievements, the liberation and emancipation of the Jews in the early years of the revolution represented a glorious humanitarian triumph.

Yehuda Pen's Art School

The historical events outlined above set the scene for the sudden rise of Vitebsk as a centre for progressive culture in the revolutionary state, a development in which several exceptional artists played a crucial role: Marc Chagall, El Lissitzky and their teacher Yehuda Pen. With the support of local patrons, Pen, an alumnus of the Imperial Academy of Arts in St Petersburg, started a private art school from his living room in 1892. There, he gave academic tuition to children, some of whom were very young indeed. Pen hand-picked his pupils himself, and tried to convince parents to entrust their children to him. The groups were small, and over the course of his career spanning multiple decades, his pupils barely totalled one hundred.[4] El Lissitzky, when his name was still Lazar

El Lissitzky, 1912.

Lissitzky, commenced lessons with Pen when he was only thirteen years old, probably at the same time as his classmate, the future sculptor Ossip Zadkine. Chagall was several years older, but knew the other boys well, both from primary school and through Pen.[5] They all cherished fond memories of their art teacher, probably not least because Pen – despite his reserved, academic approach – was very tolerant of a wide range of new opinions, in both society and the arts.

Pen remained in touch with his former pupils, treated them as equals, and enjoyed heading outdoors to paint with them. He was often seen with Chagall, for example, even after his ex-pupil had become famous in Europe. It was during one such session that Chagall painted his world-famous *The Blue House*.[6]

Chagall had already returned to Vitebsk from Paris before the war, and remained there until well after the revolution. He was undoubtedly

in touch with David Shterenberg and Nathan Altman, both of whom had been his neighbours in the La Ruche artists' colony in Paris. Lunacharsky probably also knew him from Paris, and though he was more positive about Chagall than many of his radical contemporaries (such as Kandinsky), he was hardly effusive in his praise. In 1913 he referred to Chagall's work as 'pretentious drivel' and an expression of 'demented taste'. One year later, with a certain grudging respect, he wrote: 'Ignoring the infantilism and absurdity of the drawing, which is as simplistic as it is unclear and incoherent, one suddenly discerns a keen perspicacity and powerful expression.'[7]

There are no indications that Lunacharsky ever changed his opinion of Chagall, though he was very familiar with his reputation. In early 1918, Lunacharsky asked him to become the commissar for the arts in Vitebsk, probably at Shterenberg's behest. Chagall became responsible for the May and October celebrations, establishing a museum, and most importantly, setting up an art school.[8]

Chagall was, strictly speaking, not an avant-gardist, primarily because he lacked the historic mindset that was shared by his avant-garde peers: the belief that art was the reflection and foreshadowing of history in motion, that art should express objective truths, and that the best artists could sense and predict the course of history. Chagall lacked all of these convictions. He was interested in the intimate, not the public, and his goal was to depict a unique and personal reality, not grand, collective movements in history (Plate 19).

However, Chagall did invest unprecedented amounts of energy into helping to advance the city of his birth. And he was convinced that left-wing art had a decisive part to play in the formation of the revolutionary state. Much later, after he had become a French citizen and achieved worldwide fame, he described his involvement in the revolutionary effort with faux naivety: 'All I knew was that Marx was Jewish and had a beard.'[9] But in October 1918, he was still passionate, and wrote:

> Make way for us! We, too, celebrate the anniversary of revolutionary art, of the fall of the academy, of the 'professors' and the establishment of the power of leftist art. Granted, not all artists in all fields will understand. But if they are at all viable, then someday they will....We have persistently and powerfully obeyed the internal voices of our artistic conscience, and presented and imposed our ideas, our forms, the forms and ideas of a new, revolutionary art, and have the courage to think that the future is ours![10]

However, in a proletarian society, he quickly became pessimistic about the opportunities for popularizing the type of art he was making,[11] and quickly switched to merely defending the autonomous position of artists, and maintaining a niche for modernist art as 'the art of the minority'.[12]

In early November 1918, Chagall was made responsible for the first anniversary celebrations of the revolution. He hired all the shop-sign painters he could find, and gave them designs to be reproduced and enlarged onto large canvasses. On the day itself, he noted that his 'colourful beasts decorated the entire city, billowed out by the winds of the revolution. Workers marched past, singing the Internationale. Looking at their joyful faces, I was certain they understood me. The commissars, on the other hand, weren't so happy. Why, pray tell, was that cow green, and why was that horse flying through the air? What do they have to do with Marx and Lenin?'[13]

Chagall placed an article in a Moscow newspaper, calling on artists and scholars to leave the Russian capitals and move to Vitebsk to take up teaching positions at his new art school, which, like the Free Studios in Petrograd and Moscow, was run democratically. One major attraction was the food situation, which was far better in Vitebsk than in the two capital cities. Various artists found their way to the province, including the married avant-gardist couple Ksenia Boguslavskaya and Ivan Puni, who had sponsored and organized the 0.10 exhibition four years earlier. They were followed in 1919 by Lissitzky, who had returned from Germany several months before the revolution. Despite the radical direction championed by Boguslavskaya, Puni and Lissitzky, the curriculum was explicitly pluriform – in addition to the avant-gardists, Chagall had also asked his former teacher Pen to work at the school. This pluriformity, and the relative amity among the various artistic factions, set the Vitebsk school apart from its counterparts in Moscow and Petrograd.

The arrival of the Polish suprematist, however, would soon put an end to this relaxed atmosphere.

Though the food situation was relatively good in Vitebsk, the raging civil war still put continual pressure on day-to-day life. The Jewish population lived in constant fear of invasions (and the associated pogroms) by Tsarist troops. No such invasion ever took place, though there was some fighting not far from the city. One of Chagall's students remembered how, in 1919, he encountered forty Jewish corpses, piled high and left

behind by a horde of 'Whites'.[14] The draft was another lingering threat: whenever the Red Army launched a local campaign against the Whites, new soldiers were often recruited from the local population. Refusal and desertion were punished with immediate execution. Chagall was always on the alert, trying to keep his students out of military service.[15]

Chagall's admission policy was democratic and casual. Once, when he took his winter coat to the local tailor to have it 'reversed', he noticed the man's son drawing and recognized a particular talent. He nagged at the father until he agreed to send the boy to Chagall's school. The lad, Yefim Royak, was twelve or thirteen years old at the time. The school's official minimum age for admissions was fifteen, but this rule was not strictly observed.[16]

In their memoirs, both Chagall and Pen appear in an uncommonly gentle and friendly light. Each of them placed a continual emphasis on personal development, both their students' and their own. Of paramount importance was the intimate experience of the creative process, and a respect for the ideas and lived experience of others. Such a humane approach is particularly moving – indeed, astounding – when one considers the unprecedented atrocities being committed everywhere around them, atrocities that Pen ultimately could not escape. In 1937, already in his dotage, he was found dead at home from knife wounds, probably inflicted by a member of the security service.[17]

Marc Chagall, Commissar

Truth be told, Marc Chagall was not suited to life as a public figure, especially in such a politically charged climate. From the outset he yearned to return to his studio in Paris and devote himself entirely to artistic practice. There was a shortage of all supplies in Vitebsk – paper, paint – and every link in the supply chain was strained to its limit. Even paying salaries demanded Chagall's constant attention. His administrative duties were such a burden on him, in fact, that even before Malevich's arrival he asked the People's Commissariat to relieve him of his responsibilities. Once his students got wind that he might step down, however, there was such a commotion that he had no choice but to carry on. Chagall was worshipped by all in Vitebsk, and perhaps with good reason, for he lent the city a certain dignified and dynamic quality, and within a very short time it developed into a cultural centre matched only by such places as Moscow, Petrograd and Kyiv.

El Lissitzky's involvement in the school, from May 1918 onwards, brought tremendous improvement. Lissitzky knew Vitebsk from his youth, was fully committed to the revolution and had lofty pedagogical ambitions. His arrival at the school in Vitebsk brought continuity and a youthful vibrancy. Lissitzky was only twenty-eight when he arrived, slightly younger than Chagall, but he was far better educated, as he had completed an architecture degree in Darmstadt.

At that point, Lazar (or Elièzer) Lissitzky was not yet the radical avant-gardist he would later become. He was still making small illustrations and rather traditional book covers, often inspired by Jewish folklore. However, these early works are a testament to the speed, virtuosity and ease with which he could assimilate the ideas and methods of older artists, even surpassing them in some cases. His long sojourn in Germany had also moulded him into a different kind of artist from the Jewish-Russian bohemians who had settled in Paris before the war, including the likes of Shterenberg, Chagall and Altman. Even during his studies, he was deeply influenced by the architect Henry van de Velde, and was probably familiar with the discussions surrounding the architectural theories by Peter Behrens and Walter Gropius.

To a more conventional figure, these architectural debates might have been sufficient preparation for the encounter with Malevich's art, which took place in the early autumn of 1919. But there was nothing conventional about Lissitzky. And despite his earnest character, comprehensive education and international experience, he still retained the capacity to be surprised and swept away. I know of no other great artist (and by 'great', I mean an artist who consistently expresses a highly personal artistic vision in their work, and in so doing, exerts a deep and long-lasting influence on contemporaries both during and after their lifetime, as Lissitzky did) who arrived at their personal artistic vision solely through a confrontation with a single other artist at one specific moment in time. Lissitzky's meeting with Malevich in 1919 had precisely this effect. That moment was a biographical revelation for Lissitzky, a conversion on the road to Damascus, nothing less than a complete transformation of his artistic persona. Simply browsing through a catalogue of Lissitzky's works will reveal two Lissitzkys – one from before, and one from after mid-1919 – each bearing very little resemblance to the other. The truly baffling aspect is the speed with which the 'new' Lissitzky settled into his artistic niche, at once becoming the mature, balanced Lissitzky beloved by museum curators and design teachers the world

over. There was no intervening period, short or long, of servile emulation or experimentation, no hybrid 'transitional' stage. The mature Lissitzky appears suddenly and completely, like Athena rising from the head of Zeus, already fully formed and equipped.

There are very few documented details of the meeting itself; however, the few surviving remarks do give us some understanding of what moved Lissitzky so much.

In a letter to Pavel Ettinger, he writes: 'I spoke to you [earlier] of Kazimir, an exceptional figure of our time. But then I did not know him, like I knew nobody in Moscow.' [In the autumn] 'I was back in Moscow, and went to see Malevich. We entered into each other's confidence, and I took him with me.'[18]

The extent of this confidence was illustrated by Malevich's swift resolve to move to the Vitebsk school. He met Lissitzky in mid-October, and by the 29th of that month had submitted his official resignation from the Free Studios in Moscow. This drastic decision can indeed have been based on little more than confidence, for Lissitzky had no guarantees from higher up that Malevich would even be appointed, or that there would be a salary waiting for him.[19]

Malevich did know that there were other like-minded artists in Vitebsk besides Lissitzky, the most important of whom were two women who had moved there from Petrograd shortly before, Vera Yermolaeva and Nina Kogan.

Yermolaeva had been an artist of some repute in Petrograd since well before the revolution and had allied herself with the avant-garde several years earlier. In her youth, she was a famous beauty (Chagall called her 'the Vitebsk Mona Lisa'), but her legs became crippled first by falling from a horse, and later by staying too long in the bitter cold of Siberia while visiting her brother, who had been interned in a camp by the Tsar's secret police. Yermolaeva was an efficient organizer and worshipped Malevich, and would come to play a crucial role in his success during his time in Vitebsk.

Much less is known about Nina Kogan; almost her entire artistic output has been lost. A brief description of her by a good friend (one of the few descriptions of her that have survived) speaks volumes: 'She is an exalted being, and lives solely for artistic matters and the spirit of innovation. She admires all bearers of new ideas, and especially those willing to see her as a pupil and source of support....for Malevich she would have leapt from the balcony, if his capricious heart had desired it.'[20] Malevich

El Lissitzky, 1917.

certainly knew both women already – at least well enough to be sure that they would both stand by him, and be prepared to work to further their common cause.

Of crucial importance was Lissitzky's promise to publish Malevich's final major text, the pamphlet titled *On New Systems in Art*. Malevich was running into more and more barriers trying to get his work published in Moscow, and Lissitzky undertook to take care of it for him. The promise was made without any real assurance of its success, but Malevich trusted him regardless. And indeed, Lissitzky succeeded in

publishing one thousand copies of Malevich's book within a month. Such a rapid turnaround and relatively large print run was no mean feat, given the prevailing shortages.

Malevich was grateful for Lissitzky's efforts, and – uncommonly for him – found the means warmly to express his gratitude. He called the edition 'a record of my journey, and the beginning of our collective movement'. In the signed copy that he gave to Lissitzky, he wrote: 'Let our footprints appear like rainbows after the rain. Like clouds, we shall give birth to rainbows of footprints.'[21]

Lissitzky's excitement at having met Malevich is also palpable in a letter he wrote to Ettinger. By that time he had already adopted Malevich's ideas completely, including elements of his style and vocabulary: 'Kazimir showed himself to me via his planetary system of unadulterated natural power, and the inevitable progression [of events]. Here I saw, for the first time, the image of a pure, intuitive ear, and the keenness of blind clairvoyance. I saw an artist moving through the nature of painting towards the nature of the entire world. Before us lies a mighty ascent that will lead to the supremacy of the spirit – of religion. The Old and New Testaments will be replaced by the SUPREMATIST TESTAMENT.'[22] These are not the words of a mere admirer or ally, but rather of an apostle, which is precisely the role that Lissitzky would come to fulfil in the years to come.

Over the ensuing months, he would further develop and incorporate the ideas contained in the letter into an oration: 'It was via Suprematism... that the sign and plan emerged, in total purity, for a kind of new, never-before-seen world, one based solely on our being that unfurls from the universe and begins to form only itself. [Suprematism] will free everybody in creativity and lead the world toward a pure act of perfection. We expect this act from Kazimir Malevich. Thus, the Old Testament bore the New, the New bore Communism, and Communism will ultimately give birth to the Suprematist Testament.'[23]

The Suprematist Movement

Malevich's journey to Vitebsk was exhausting. He travelled in a goods wagon, probably for more than four days, at a speed of 5 to 12 kilometres (2 to 7½ miles) per hour. 'The cars were full,' he wrote on his arrival, 'we slowly crawled forward, and lay spooning one another (with amicable mutual consent). We collected firewood for the locomotive, spent the

night in Smolensk, where there were inspections in the open air [by the Red Army]. One really needs energy to endure such horror.'[24]

Vitebsk lived up to his expectations, at least in a material sense. 'I was aghast,' Malevich wrote to a friend, in his delightful Russian. 'Immediately upon arrival in Vitebsk, I saw every street stall full to the brim with bread, and other cereal goods, along with dangling sausages and a range of meats.'[25] Malevich was determined to make a dramatic impression on the provincial officials and the students during his presentation at the school. To this end, all students and teachers were told to gather in the lobby, a large open space with a wide, straight staircase leading to the upper level. Following an announcement by Chagall, Malevich slowly and silently descended the stairs, 'while swinging his outstretched arms and making broad circles in the air'. Once on the ground floor, he continued walking – still silently gesticulating – to the dais.

The students were so baffled by his arm-swinging entrance that they later referred to it as the 'suprematist movement'. Years later, nobody could remember whether Malevich had actually said anything afterwards.[26]

After his arrival, Malevich plunged immediately into frenetic activity. He gave lectures and designed decorations for the façades and interiors of several local government buildings. The 'White Barracks', as it was known, was draped in stark, colourful suprematist shapes: triangles, squares and circles. Lissitzky and Malevich joined forces to design a new theatre curtain for the city's main theatre.

Malevich quickly realized that he could get more done in Vitebsk than in Moscow. Nevertheless, he still saw his time there as temporary, and had hopes of a swift return 'from exile...to the centre'.[27] There was also another reason for him not to cut ties with Moscow: before his departure, Malevich had arranged for a personal retrospective exhibition of his entire *oeuvre* there, scheduled to open in the late autumn of 1919. The show was part of the vast slough of state exhibitions – the sixteenth, to be exact.

Malevich had started planning the exhibition in December 1918, when he was still a powerful figure in the Department of Fine Arts.[28] The exhibition was not held in a museum, but instead in a private (now nationalized) exhibition space. Perhaps it was not the city's most prestigious venue, but it was the first retrospective of work by a living artist to be organized by the new department, and therefore a testament to the prestige that Malevich enjoyed, in spite of everything. He certainly also

saw the exhibition as an opportunity to maintain a presence in Moscow, a city that had become very hostile towards him.

At the same time, he was fully aware of the opportunities afforded him by his new place of residence – in such a small city, it was much easier for him to form a close-knit group of followers, if only because the competition was less fierce.

Vitebsk was also less hectic: the struggle for survival was not as draining, and bureaucracy far more transparent. Malevich was, therefore, better able to dedicate himself to his work, which in those days consisted primarily of writing and teaching. His whirlwind of new writings also extended to his correspondence, which increased tremendously both in quantity and scope. Malevich had no desire to lose touch with his friends and partners in Moscow and Petrograd. His main pen-pal during those years was the renowned Jewish literary scholar and philosopher Mikhail Gershenzon. Malevich had met him previously through Natalia Davydova. In Vitebsk their friendship blossomed, perhaps because of their correspondence.

Gershenzon had always lived from his pen (before 1917, of course, employment at the university was impossible for a Jew), but never became a penny-a-liner or journalist. At first glance, his friendship with Malevich may seem unlikely. He was a Russian intellectual of the most erudite kind, and a Pushkin specialist to boot – so what business had he fraternizing with a poorly educated Polish artist, one who was eager to relegate all of cultural history to the scrapheap? The fact is that Gershenzon was also a unique individual who had little interest in keeping up appearances or touting accepted ideas, and in this sense the two men absolutely shared an intellectual connection. Gershenzon, for example, believed that reality was inspired by an all-encompassing 'soul', a notion that he combined with a radical end-of-days (Manichaeistic) worldview. Both concepts were compatible with the fundamentals of Malevich's life philosophy.

In his first letter to Gershenzon from Vitebsk, Malevich described his initial impressions, which took him back to his childhood years and 'the even deeper provincial fields'. The result was a poignant and moving egodocument. 'Back then,' Malevich wrote,

> all seemed to fall silent; everything spoke, but one felt it inside, as though the rays being emitted by the fields, the sky, the forests and the mountains pounded on one like a piano. The mute sounds of one's

inner self inflated the chest and pulled one upward – it was like rising up on tiptoe, to see what is hidden beyond.

I loved – and love, to this day – a summit or crack through which the undulating fields were visible, the mountains extending to the horizon. In my youth, I sought out high places, and imagined that there I could hear all that was happening in the distance. I saw how the painted surface of the Earth ran with colourful ribbons in all directions.

I wrapped myself up in them, from head to toe, these were my trappings, and, clothed in them, I entered the big city, and smelled it the way an animal recognizes the smells of iron, grass, stone and leather. And I arrived, like an animal, in my robes, in the city of catacombs, where the sky, the rivers, the sun, the sandy ground, the mountains, and the forest had disappeared, and there I hung out my colourful robes, they were canvasses of fields.

Now that I have returned, I will assure myself that they are put away, and that new robes will quickly colour the city.[29]

The evidence was clear: here was an artist with renewed self-confidence, who had returned once again to the roots of his artistry.

The Lectors and the Futurist

Now that a new leader had emerged in Vitebsk, Chagall felt that his time had come at last, and he asked Moscow for a position in the capital so that he might finally leave the smaller city. His petition was granted, but once again the teachers and students in Vitebsk held him back with a public upsurge of their demanding affection. And once again, Chagall capitulated to the masses, and remained.[30]

Chagall may have tried to leave too soon, for the love between Malevich and the Vitebsk establishment had not yet been fully consummated (so to speak). Despite the overwhelmingly warm welcome that Malevich received in Vitebsk, he nonetheless managed to land himself in immediate controversy and conflict. The local art teachers – or 'lectors' – were probably already frustrated enough at the futurist's arrival; they had, in any case, already heard from their superiors that they were 'weak and insignificant' compared to Malevich, who for his part did little to contradict that impression. Malevich reported on his first encounter with these 'lectors' to Gershenzon. Though his text is positively dripping with Moscovian self-importance, it is not without humour or self-deprecation:

On the third day [after my arrival], a delegation approached me with the request to give a lecture on cubism and futurism. The delegation included the lectors, who informed me that they had already briefed the intended public on impressionism and some aspects of cubism. The artists present in the delegation immediately began accusing the lectors, saying that the public knew nothing of the sort, and I only barely succeeded in calming their tempers. Then came a disaster – I promised to give a lecture on futurism and cubism.

Their faces took on expressions of unparalleled seriousness and joy, and after thanking me, they exited the room backwards and closed the door. The din of the lectors did not subside until they had reached the stairs....Finally, the long-awaited day came. The auditorium was full, and the spectacle was hotly awaited, as I had been advertised as 'The famous world-champion, for the first time in Vitebsk'. The hour chimed – the celebrity took his place at the table. Some lady or other set down a pot of tea, and whispered into my ear that it contained sugar. I bowed. Silence returned, and the lectors stood quaking directly behind me....After the lecture, the majority were furious, emitting cries of outrage and disappointment. They screamed at me, saying that talk of the incomprehensible was pointless. They had come to learn about cubism, to hear the truth. The women commented on my hairstyle.[31]

Still, Malevich claimed to have done everything in his power to satisfy them. 'I strove for clarity, and limited myself to the essence of the question. But I reached the conclusion that the clearer the formulation, the less people will understand it. The clarity of my presentation was utterly inscrutable to the outer circle of listeners. Greater precision led to greater obscurity.'[32]

Fun and games, to be sure. But, as he so often did, Malevich underestimated the power of his opponents' rancour. Among the offended 'lectors' was the art historian Alexander Romm, and probably also the artist Max Friedländer. They were hardly enamoured of the manner in which they had been publicly brushed aside, and would later play a major part in the efforts to sabotage Malevich's work in Vitebsk. Both had lived in Europe for some time, and knew the modern art community in Paris. Friedländer had even given his own lecture in Vitebsk earlier that month, in which he directly attacked futurism. They viewed themselves as well-informed, cosmopolitan intellectuals, and felt belittled and misunderstood by the pockmarked Pole.

Malevich was invited to give a second lecture, which was much more successful, and once the public buildings in Vitebsk were actually bedecked with the designs by him and Lissitzky in early December, an uncommon sense of pride shone through in his writings: 'Life is vibrant here. Yesterday the Vitebsk proletariat marched with suprematist banners. I will send you and all the reactionaries a full report later, so you are aware that the proletariat is not at all of the same mind as the reactionaries! The theatre auditorium, too, where the workers' soviets meet, is decorated in suprematist style.'[33]

The effect of the decorations was indeed astounding: Lissitzky, Malevich and their rapidly growing following had painted 1,500 square metres (more than 16,000 square feet) of canvas, and used it to adorn the façades of three buildings, as well as the interior of the theatre.[34]

Malevich's decorations were unveiled on 17 December, one week after the closure of the October celebrations, which had featured Chagall's designs. Part of the city was still covered in his 'long-bearded old men on bright-green dappled horses' and 'an inordinate number of green goats'.[35] Tatlin's girlfriend Sofia Dymshits, who had travelled to Vitebsk to obtain provisions, noted how Chagall's flying Jews blended in wonderfully with Malevich's 'suprematist decorations'. 'I thought I had arrived in an enchanted city, but in those days anything was possible. It was magnificent, and the residents of Vitebsk became bona fide suprematists during that time.'[36]

The Vitebsk era was characterized by two major trends in Malevich's life: a focus on the development of his philosophical framework, and his attempts to flesh out and 'institutionalize' a system of education. In truth, that philosophical development had started with the appearance of *On New Systems in Art*, the brochure edited and published by Lissitzky. Its publication represented a new phase in Malevich's theoretical development and was the first in a whole series of longer philosophical works in which he cultivated an almost mystical worldview.

The book was not typeset, but written out by hand, and the illustrations – largely reproductions of his own works – were produced by Malevich himself. It therefore embodies a spontaneous or even amateur quality, while also exuding authenticity, which was undoubtedly the purpose behind these stylistic choices. The text is both a theoretical treatise and a set of instructions and would form the basis for his pedagogical work in the years to come.

Kazimir Malevich, *On New Systems in Art*. Design: El Lissitzky, 1919.

Using simpler language than he had in the past, Malevich reiterated his claim that the development of all art serves but a single purpose: 'to work its way upwards to a united creativity'.[37] This artistic development would foreshadow the complete 'centralization' of 'all peoples, states and nationalities', converging on a single, non-objective world. It needed no clarification that the right road to this development could only be found in suprematism, and the Black Square.

The Black Square appeared in the brochure four times. One might call it the brochure's protagonist, but at the same time it took on the new role of an emblem. More so than previously, Malevich began to emphasize the conceptual facets of his artwork, and started using them as tokens, logos representing his own artistic production and that of his followers.

Malevich was thus striving for the ultimate centralization, the unification of all arts – and by extension, all life – in suprematism. In Vitebsk, his ambition would find form in a new organization that he named UNOVIS, an abbreviation of Utverditeli Novogo Iskusstva (The Champions of New Art). The use of such a neologism as *Utverditeli* ('champions') was, of course, typical of the avant-gardists, and served their goal of describing revolutionary art with equally revolutionary terminology.

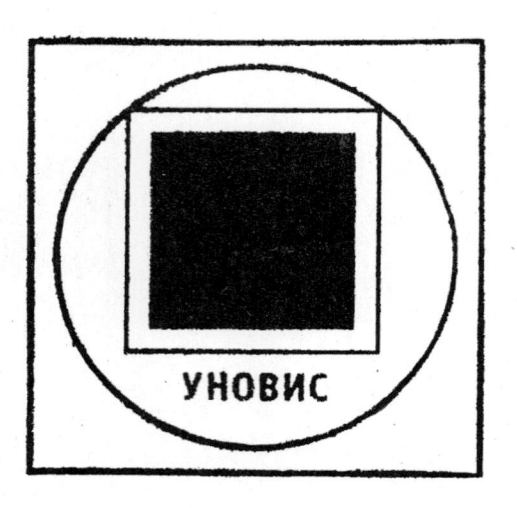

Emblem of UNOVIS.

By setting up UNOVIS, Malevich was seeking alignment with a new Soviet mentality, as though trying to 'sovietize' his artistic vision. The structure of UNOVIS is evidence of these intentions: the group presented itself not as a school or studio, but as a party. The students were 'members' and, when joining, were required to complete a questionnaire much like the one the Communist party had been using for some time. The management board of UNOVIS (chaired by Malevich) called itself the Central Creative Committee, analogous to the Central Committee of the Communist party, or the Central Executive Committee of the USSR. Even the 'party regulations' had been partially copied from the Communist party, and included quasi-democratic elections for issuing 'non-binding' recommendations to the board.[38]

UNOVIS also had an anthem and, as mentioned above, an 'emblem' – the black square that the 'members' wore on their lapels or sleeves. All were elements of an organization with a strict collective signature. Malevich worked hard to integrate UNOVIS into Soviet bureaucracy in a politically justifiable manner. His passion for systematization and centralized, collective management meant that he did not view bureaucracy or the new language of policy as anathema (unlike Chagall, for example). He was also highly disciplined, kept his promises and became irate when correspondence from public servants or artists was tardy or inadequate. In all aspects of his conduct, he wished to show that the image of artists as bohemian, anti-social dreamers, lost in their creative fervour, was a thing of the past.

Despite these attempts to integrate into the rapidly developing Soviet system, there was, of course, much about UNOVIS that was not 'Soviet' in the slightest. Attention-grabbing, arm-swinging, esoteric lectures, and painting houses with coloured squares and circles, left the young Soviet bureaucrats scratching their heads. In the best case it was viewed as unnecessary and pointless, especially in times of significant need and daily struggle. The presentation of UNOVIS was both an emulation and a caricature of the Bolshevist party spirit, a paradox very suggestive of the same type of ambivalence present in the futuristic performance stunts from before 1917, with their similar spirit of subversive transvestism.

The party leadership became more and more alert to all kinds of independent revolutionary organizations that, while embracing the Soviet state, still wished to push 'parallel revolutions' within it – another reason why UNOVIS raised suspicions.[39] Of course, UNOVIS sounded just as 'Soviet' as NARKOMPROS, IZO and other Soviet constructions, but was that enough to pass as truly Soviet? These abbreviations were first and foremost intended as a means to create a transparent system of bureaucratic terminology, easily decipherable to those in the know. But what, in the name of Marx and Engels, were 'Champions of New Art'?

This typically futuristic ambiguity of UNOVIS became problematic, for in contrast to the zany stunts and cliquish behaviour from before the revolution, UNOVIS was a bona fide organization, with real responsibilities and a concrete budget, acting under serious bureaucratic supervision. It represented, therefore, a growing internal conflict when it came to Malevich's projects: his tendency to adapt to political reality and identify strongly with the Soviet model clashed with his stubborn desire to retain the autonomy and eccentricity that were so utterly at odds with that model.

Leaving aside the growing conflict both in Malevich's projects and within himself, as an artistic organization UNOVIS was an immediate success – perhaps Malevich's greatest ever achievement as an organizer and pedagogue.

Within the first six months of its inception, UNOVIS ran a great many cultural activities. On 6 February 1920, a 'front-week' was held, with meetings between artists and non-artists (as described literally by the posters), a performance of *Victory over the Sun*, the 1913 futurist opera by Mikhail Matyushin for which Malevich had designed the sets and costumes, and a 'suprematist ballet' by Nina Kogan involving a changing display of geometric shapes against a suprematist backdrop – in

essence, a series of suprematist 'tableaux vivants'. Not long afterwards, the group produced a publication (a so-called *Almanak*) under the direction of Lissitzky, who took care of both the principal texts and the layout. In addition to Lissitzky's writing and many illustrations of artworks by UNOVIS members, the almanac also included pieces about the theatre, and two articles outlining UNOVIS's educational methods, written by Yermolaeva and Kogan. The primary goal of the educational philosophy was to establish a genuine 'collective creativity', intended to replace the outdated notion of individual artistic expression. For this reason, no works ever issued by UNOVIS were signed; at most they were branded with a communal emblem.

The group also obtained government commissions. The organization and implementation of city decorations for the 1920 Workers' Day celebrations was placed largely in the hands of UNOVIS. The artists and their students succeeded in decorating large sections of the city with suprematist designs, and trams, shops and public grandstands were also covered in suprematist shapes and slogans. Vitebsk 1920 was probably the largest – and certainly the most consistent – example of urban transformation by the avant-garde, and the effect was unmistakeable. One month later, film director Sergei Eisenstein visited Vitebsk with a contingent of artists, and he was deeply impressed by the decorations: 'In the main streets, the red bricks are covered in white paint, forming a backdrop that is covered in green circles, orange squares and blue rectangles. That was Vitebsk in 1920. It was the brush of Kazimir Malevich that graced the brickwork....The suprematist confetti has been strewn over the bewildered city.'[40]

Incidentally, these celebrations probably represented the avant-gardists' last opportunity to decorate a city on such a large scale. By that time they had already been denied any part in organizing the October celebrations in Petrograd and Moscow, and from 1920 onwards, the same would apply to Vitebsk.

Chagall Leaves Vitebsk

UNOVIS was officially still part of the Vitebsk art school. All of the teachers' facilities and salaries were paid for by the school, but UNOVIS's ambitions were far grander. Malevich planned to set up 'chapters' of UNOVIS throughout Russia, and made contact with other provincial centres such as Perm, Saratov, Samara, Odessa, Orenburg and Smolensk. Chapters were

Photograph of a poster designed by El Lissitzky, Vitebsk, 1919.

indeed opened in Orenburg and Smolensk in 1920, and close ties were maintained with the art programme thousands of kilometres away in far-distant Perm, in the hopes of converting it into a UNOVIS chapter. 'Soon, very soon, UNOVIS departments will be opened throughout the country,' Malevich announced to an enraptured group of students. He then played to the provincial ethos of his audience, painting an image of Vitebsk as the centre of the entire world. 'Young art makers [Malevich's own term] will unite in UNOVIS. The cities will be decorated solely in our canvasses. We run the artistic committee of UNOVIS here in Vitebsk, whence the orders for the army of the arts are issued.'[41] 'Our studios will provide the blueprint for all studios in Russia, and throughout the world, in order to generate infinite creativity, a taste of which we serve here!'[42]

Such boldness can only have made a deep impression on the students. Not only was their city of Vitebsk already a stage for all manner

of magical, 'suprematist' performances, but also it was to become the capital of an artistic renaissance destined for nothing less than the complete transformation of Soviet Russia. Malevich laid claim to the future, and the other instructors – even Chagall – were suddenly relegated to the rheumatic world of yesteryear. Because students in the post-revolutionary system were able to choose their own instructors and studios, UNOVIS grew while Chagall and the others withered away.

In April 1920, Chagall had already written that the school was witnessing 'an extremely agitated formation of "trend-based" groups', and that only two such groups remained: his own, and Malevich's.[43] For Chagall, the situation offered both advantages and disadvantages: on the one hand, he was understandably upset that his students were leaving him, and that Malevich and Lissitzky occasionally characterized him as a relic. On the other, the situation would perhaps allow him finally to leave Vitebsk, which he had been hoping to do for months.

In May, Chagall travelled to Moscow to pick up some materials for the school. When he returned to Vitebsk on 21 or 22 May, several of his students were waiting to announce their decision to join UNOVIS and leave his tutelage.[44] A sign had been hung above his classroom door, saying 'Studio Malevich'.[45]

Chagall no longer had any reason to stay. On 5 June 1920 he left Vitebsk, the city of his birth, for good and moved to Moscow.

Kazimir's Vitebsk Spring

For Malevich, the spring of 1920 was a time of unprecedented growth and prosperity. Despite the many obvious problems, hardships and shortages, he had created something remarkable in Vitebsk. For the first time, suprematism seemed genuinely to reign supreme, and the first step towards a new suprematist reality seemed finally to have been taken. A few months earlier, on 25 March to be exact, his retrospective exhibition had opened in Moscow. His full artistic development was there on display, from his early post-impressionist paintings to his latest suprematist works: the 'white-on-white' paintings from 1918. Several additional unpainted canvasses even proclaimed the end of painted art itself.

There is very little documented information about the curation, preparation and reception of this exhibition. There was no catalogue, and the two reviews – one lukewarm, the other rather negative – offer little clarity. The fact that it was possible to produce such an exhibition at all,

and that funding had been made available for it, suggests that Malevich still commanded some respect within progressive circles, regardless of his modus operandi or his cultural and political ideas.

On a personal note, his Vitebsk spring was crowned by the birth of a daughter, Una, on 25 April.

Malevich now more or less ruled the roost, and continued to implement his programme with determination. His priority was now the composition of new theoretical texts. Students recalled how he 'sat at his desk for days at a time to write, write, write. On the desk was a large sheaf of written pages; beneath the table were piles of paper. He wore a white robe over his suit, and a white hat on his head. His professorial appearance and his dry, quiet but extremely confident voice lent him a magnetic charisma. We, the members of the creative committee of UNOVIS, were subdued and sat mesmerized, listening to his every word.'[46]

Various students describe the same hypnotic charisma in their memoirs. One art student from the UNOVIS chapter in Smolensk recalled an occasion when Malevich visited from Vitebsk to give a lecture. There was much scepticism among the local students, and they prepared to give him a critical assessment, but he succeeded in silencing them with a single thunderous phrase. 'Malevich commanded our attention.' And through the use of 'logic, historical parallels and other rhetorical devices, he led his oration along its inevitable course. And he did so in such a well-reasoned and fascinating manner, that without even breathing a word about suprematism, his listeners believed they were hearing about something new and absolutely essential.' After his lecture, the students felt 'a vague desire to break free from all earthly routine'.[47]

Malevich demonstrated the same utter conviction when analysing others. With a complete lack of consideration for their individuality or self-esteem, he often gravely insulted people. His assessments of others' work and personalities were always categorical and all-encompassing, and he gave no quarter. He unleashed these ruthless evaluations on all and sundry, including his most dedicated allies. Nina Kogan, who was wholly devoted to him, suffered terribly from these attacks, and others became so frazzled or anxious that they would burst into tears, even when being praised for their work.[48] To make matters worse, Malevich often made his pronouncements in the absence of the person in question, 'behind their back'. Take Smolensk, for example, where the UNOVIS chapter was led by Wladislaw Strzemiński, a brilliant Polish artist who first followed Tatlin but later fell under Malevich's spell. Malevich once

Teachers and students from the art school in Vitebsk, 1920: Kazimir Malevich in the centre, on the left Vera Yermolaeva, on his right successively Marc Chagall, Yehuda Pen and probably El Lissitzky. Note the very young children in the foreground.

said to one of Strzemiński's pupils: 'Strzemiński is not without talent, of course, and there is steadfastness in his work. But he still has far to go before reaching the level of abstraction required of suprematism. He is still firmly rooted in the Earth's gravity.'[49] This was a mortal blow, clothed in UNOVIStic jargon. The fact that Malevich could say such a thing to a pupil of Strzemiński's, undermining the authority of a faithful ally who had moved mountains to disseminate Malevich's art and body of thought, was improper in a personal sense and destructive in a political one. But Malevich was blind to such consequences – the truth was paramount, after all, and there was no point in holding back or beating about the bush. As an aside: historians who cite Malevich's political aptitude are consistently contradicted by anecdotes such as these.

This rigid, intractable desire always to give his opinion, no matter the consequences, created problems for Malevich time and again. Yet compromise was not an option. Also, it was his very intransigence, his iron will and the unshakeable conviction that he was right that lent him the hypnotic authority he commanded over his students and followers. And without this rigidity, he would never have become the transformative artist that he was.

Malevich's mesmerizing influence was magnified by the age difference between him and his brood. At UNOVIS's inception he was forty-two, at least ten years older than his direct colleagues Lissitzky, Yermolaeva and Kogan. Most of his pupils were younger still, many under eighteen. Ilya Chashnik, who became a famous suprematist porcelain designer, entered the school at age sixteen, as did artist Lev Yudin. Lazar Khidekel, later a renowned architect, was only fifteen, and although this was the official minimum age for entry, exceptions were often made. In addition to the aforementioned Yefim Royak, Valentin Zeylert started at the school when he was only eleven, and was thirteen when he joined Malevich's studio; Tatyana Meyerzon was admitted at age fourteen. Being teenagers, they were of course eager to surrender their heart and soul to a doctrine that was simultaneously mysterious, complex and uncompromising. The pompous fuss with the emblem, anthem and communal rituals formed part of the mystique. These youngsters were proud to wear the black square on their collar, which set them apart from their peers in the city.[50]

Almost all of the students were from the Jewish parts of town and had been educated in Jewish intellectual traditions, either at the Talmud school or elsewhere. They would certainly have been no strangers to the intellectualism, mystique and end-of-days character of suprematism, nor to Malevich's sectarian zeal.

The Pole's inflexible personality also meant that he treated everyone equally, which of course only increased his prestige. He drew no distinction whatsoever between men and women, young and old; there were no 'favourites' or black sheep. In that sense, it is very important to note that no ethnic or cultural tensions whatsoever existed between the Polish Malevich and his almost exclusively Jewish consort. The casual anti-Semitism so characteristic of the pre-revolutionary intelligentsia was utterly foreign to him.

Lastly, Malevich had the ability to place full and immediate confidence in his colleagues and students. They were given serious responsibilities, and complete freedom in their execution. Nathan Efros recalled how Malevich put him at the head of the UNOVIS theatre department without any preamble, once he discovered that the boy had a talent for acting. Efros was seventeen at the time.[51]

Nina Kogan instructed the youngest pupils, whose most important task was to make copies of Malevich's works. One of the children recalled how they diligently reproduced the boxes and circles and then coloured

them in with watercolour paint: 'In many paintings, the composition of the figures was quite complicated. The shapes often intersected and partially overlapped each other, creating the impression of a unified whole that was in a constant state of motion (at least, that was what the adults, Malevich's followers, said).'[52]

The children also attended the classes of the older students, those in their late teens and early twenties. There they saw how a painted black or red square was carried into the studio and hung up in a variety of different places, allowing for a discussion of the spatial effect created by each position of the square.

An Excursion to Moscow

Twice in 1920 the students were taken on an excursion to Moscow. The first such occasion was on 5 June, when a famous photograph was taken of Malevich, Lissitzky and around thirty 'members' of UNOVIS, including nine women and at least six young children. The photograph is a snapshot: some members are standing on the station platform, others on the footboard leading to the goods carriage where they would sit out the multi-day journey. An emaciated Malevich, surrounded by his followers, cradles a circular artwork by Lissitzky in his left arm; his right arm is outstretched (in what was perhaps the 'suprematist movement'). Black squares are visible on some lapels and sleeves, with a large version also affixed to the carriage itself. No other photograph from the era so clearly portrays the dynamic, pure and concentrated energy of this group of teachers and students.

To Malevich, the trip was of crucial importance: he was to take his students to see his own retrospective exhibition, the opening of which (on 25 March 1920) he had been forced to miss. He would also take his students to the pan-Russian conference of art teachers and students in Moscow, and wished to impress all of the attendees with his clutch of young followers. Everybody would be there: Lunacharsky, Brik, Mayakovsky, Shterenberg, Tatlin and Kandinsky. And his achievements were, indeed, impressive: within a period of barely six months, he had transformed what had been a provincial school into a beacon of radical art, where dozens of young (sometimes very young) artists from the humblest of backgrounds created art akin to that of the most advanced practitioners, even those in Europe. The entire photograph is redolent of the provincial aspiration to give the snobs in Moscow what for.

Group photograph of UNOVIS upon their departure to Moscow, June 1920, with Malevich in the centre. El Lissitzky (with dark woollen hat and beard) stands to the left of the circular dish held by Malevich. The black square is clearly visible on his sleeve.

The political significance of the trip was even greater. Many decisions would undoubtedly be made at the conference that would influence art policy in the years to come, and Malevich wished to make his voice heard by marching in with a group of boisterous supporters. He wanted UNOVIS to be recognized as a national 'brand', and to extract funding both for the improvement of the situation in Vitebsk, and in order to open new chapters in other cities.

Imagine their disappointment when, upon their arrival on 8 June, they discovered that the conference had already started on 2 June and was scheduled to end the following day. They had arrived six days late, as

the result of a miscommunication (or a lack of communication) between Chagall and Lissitzky during the bitter days preceding Chagall's departure from Vitebsk.[53]

Fuelled by desperation, during the final two days Malevich and Lissitzky initiated damage-control mode, throwing themselves into the remaining discussions. Their pupils had brought paintings with them, which were used to create an exhibition within a single day, to show the Moscovites what Malevich's students were capable of after only a few months of instruction.

Malevich led his students through his retrospective and showed them his own development. They also visited the Shchukin and Morozov collections to see the Cézannes, Van Goghs and Picassos. To the children of Vitebsk – who had been hearing the names of these artists for months and had made do with descriptions or the occasional black-and-white illustration – it must have been a magical experience.

While in Moscow, Malevich stayed mainly at his family's summer cottage in Nemchinovka. Sofia had travelled ahead with little Una, and would spend the entire summer there.

The students viewed their trip to the capital as a great success. They handed out flyers with the UNOVIS proclamation: 'To everyone, under the flag of UNOVIS, let us garb the Earth in the cloak of a new form and new meaning.' Some of the works by the Vitebsk students were acquired by the Museum Bureau of the Department of Fine Arts – an unprecedented triumph for the seventeen- and eighteen-year-old artists. Some of these paintings still remain in provincial Russian museum collections, where, as Shatskikh writes, 'heroic museum staff preserved and protected them in times of catastrophe'.[54] Most of the historical significance of the UNOVIS exhibition, however, came from the fact that El Lissitzky showed his first impressive PROUN (pro-UNOVIS) paintings there. Over the previous months, Lissitzky had developed his own variety of suprematism that united Malevich's artistic quest for the infinite with the meticulousness of typography and the rigour of blueprints (Plate 21). The PROUN works left a deep impression on other avant-gardists (including Malevich, though he would never admit it). Some of Lissitzky's artworks were also purchased for display in provincial museums. One ended up in a museum in Azerbaijan, and another in Khabarovsk, in Russia's far east.

Despite these successes, after two weeks Malevich had no choice but to commence the long journey back to Vitebsk. Any hopes of a 'triumphant return' to Moscow would have to wait.

Constructivism at Vkhutemas

Over the previous year, the Moscow art world had been rocked by new discussions that were taking place primarily in the corridors of the Free Studios. Young instructors and students were searching for an answer to the question of what the role of the artist should be in a new society that was dominated by democratized work and production, and which promulgated a radical interpretation of equality. In the autumn of 1920, the Free Studios were reformed and given a new name: Vkhutemas, an acronym denoting the 'Higher Art and Technical Studios'. The new system placed a greater emphasis on the more technical and utilitarian subjects, such as architecture and design, and this change would exert a major influence on the ongoing discussions.

Many believed that romantic artists – who first and foremost expressed their individual perceptions and experience, with aesthetic ideals as their only external benchmark – were no longer viable in the new society. But what should artists do? Adopt a completely subservient attitude, and evaluate their art solely in terms of its measurable 'utility' in society? And if so, what kind of utility?

As part of these discussions, this fundamental social issue became entwined with Tatlin's revelation concerning new means of artistic expression, namely abandoning the distinction between two- and three-dimensional representation, and the addition of 'materials' and 'construction' to the spectrum of conventional means of artistic expression, such as colour and line.

They also linked the societal question back to the old debate surrounding the synthesis of artistic disciplines. The Moscow avant-gardists mainly pursued a merger of painting, sculpture and architecture, rather than a blend between the visual arts, music and poetry as had been attempted by previous generations.[55]

The central figure in these discussions was Alexander Rodchenko. He matured tremendously, and made his presence felt everywhere both as an artist and an organizer. He started making spatial 'constructions' that detached themselves completely from the wall, and were presented on stands or hung from the ceiling by strands of thread. It is possible that Rodchenko started experimenting with these techniques as early as 1918; though some caution is required, as Rodchenko, too, would later antedate much of his work in order to appear more like a historical 'pioneer'. What is certain is that he was working on his spatial

installations in 1919, and that he exhibited them from 1920 onwards.[56] The young artist Naum Gabo, who had returned from Germany in 1917, started producing abstract installations that same year; in 1919 he made a kinetic metal sculpture with a motor, and in 1920 a plastic construction. All of these objects are sensational artworks, based on concepts and materials that were untested anywhere in the world. At virtually the same time, several students at Vkhutemas – the brothers Georgii and Vladimir Stenberg, Konstantin Medunetsky and Gustav Klutsis – also began making spatial constructions, each more outlandish than the last. They were still extremely young – Georgii Stenberg was nineteen when he started exhibiting, and his brother Vladimir was only a year older.

All forms of collective work were investigated and encouraged. Artworks were exhibited anonymously, such as in the shows by the 'OBMOKHU' (Society of Young Artists). Occasionally artists acted collectively and signed as a group, as did the group of friends identifying as SMS: Stenberg, Medunetsky, Stenberg.[57]

The objects on display were not viewed as completed artworks, but instead as the results of 'experiments' and 'laboratory research'. By using this quasi-scientific terminology ('construction', 'laboratory', 'experiment', and so on), they emphasized the fact that their work was no longer the expression of a highly individual field of experience, but instead part of a collective quest for new art forms in a new society.[58]

From this point, it was only a small step to the realization that artists could create utensils, interiors and architectonic installations, broadening somewhat later to include textiles, clothing, posters and porcelain. From that time on – say, mid-1921 – a tsunami of creative production flooded out of the Vkhutemas studios and those of the associated artists. Lyubov Popova also made spatial installations, textile designs, and worked in a factory for some time. Alexandra Ekster, who had returned to Moscow from Kyiv, designed interiors and pavilions. Rodchenko designed lamps, chairs, interiors, posters and books.

Visual artists, painters and graphic artists had, of course, already been designing furniture or utilitarian objects. But their efforts had always been excursions, temporary outings from the realm of autonomous art to the realm of applied art. Things were different now: the old distinction between autonomous and applied art had fallen away completely, leaving the domain of human creativity completely open. Artists could now be anything they wanted: painters, sculptors, designers, architects, fashion designers. And to all of these various fields – which hitherto had

been populated exclusively by specialists – they brought their exceptional aesthetic sensitivity. In the new era, their efforts would cause 'aesthetic elements to penetrate life itself, the everyday, in the form of the day-to-day household'.[59] This idea provided an answer to the question of what role artists should play in the formation of a new society. As one historian put it: 'The opportunity to take part in the organization of daily life, through the organization of objects, utensils and design [of interiors, architecture and public spaces], gave them wings.'[60] This period also saw the rise of a new term: constructivism. The word was most likely used for the first time in 1921, and in published writings in 1922 by the Stenberg brothers. The success of the new nomenclature was overwhelming. It was in the air, one might say, as though it had been on the tips of people's tongues for months. And once it had been revealed, all started scrabbling to define and appropriate it for themselves. Via the avant-gardists' contacts abroad, the term also left Russia and was eagerly discussed in late May at the 'Congress for International Progressive Artists' in Düsseldorf, leading to the proclamation of an international faction of 'Constructivists'. Their manifesto was published by Theo van Doesburg in *De Stijl* on 8 August of that year, and it was the first time that a concept of Russian origin, an '-ism', was given resonance throughout Europe.

The theoreticians of constructivism, who included Alexei Gan, quickly became more radical than the artists themselves. In Gan's vision, constructivism would do away with the last vestiges of aestheticism or spiritual pretention in art. He therefore declared 'an irreconcilable war against art!' and claimed that 'all creative labour should serve a practical social purpose'. Artistic production should shun all that was 'incidental or unfounded', and restrict itself to the 'technically purposeful and functional'.[61] In a certain sense, Gan's conclusions were the logical endpoint of all discussions positing that artists should submit themselves to the Marxist historical view. Other theoreticians, such as the Marxist ideologist Boris Arvatov, went a step further, saying that artists should concern themselves with the formation of 'human materials' and contribute to the 'psycho-physical reformation' of all of society.[62]

It is theories such as these that supply the necessary fodder for various historians who accuse constructivism (and in some cases, the entire avant-garde) of being 'utilitarian' to the Soviet state, and by extension 'totalitarian', owing to their contribution to the 'complete reconstruction of humankind and society' envisaged by the Soviet Union.[63]

Such views, though, are a reduction and simplification of constructivist art, and equate the political rhetoric of their theoreticians (some of whom did indeed exhibit totalitarian tendencies) to the artistic output and perspectives of the associated artists. Even at that time, the schism was growing between the artists' intimate reality and the political rhetoric used to legitimize it. In practice, the avant-gardists continued to view themselves (to a greater or lesser extent) as autonomous artists, and individual expression remained a salient aspect of their work. Even Rodchenko and Stepanova, the artists who identified most closely with constructivism, rejected Gan and Arvatov's radical stances. This 'utilitarian' view would even drive Malevich to reject constructivism completely, and to revile the movement as his greatest ideological opponent. According to him, the constructivists had become 'slaves to reality', to 'objects', and 'to the repulsive face of life'.[64] The notion of collective artistry never truly gained momentum, however. Though Tatlin did make an attempt to redefine the social role of the autonomous artist by proclaiming artists as 'the initiating unit within the creativity of the collective', it was certainly not his wish to do away with individual artistry completely. 'The only thing that three people can do together,' he later said, 'is sweep the floor'.[65]

The totalitarian argument also lacks weight considering that the vast majority of constructivist projects never left the drawing board, or were only ever produced as prototypes. The attempts of a small number of artists to establish partnerships with factories were, with a few exceptions, unsuccessful.[66] The brilliant textile and fashion designs by Stepanova and others were only ever worn by the artists themselves. The interior designs by Rodchenko and the Stenbergs were presented at exhibitions, but never permanently installed. The notion that constructivism is the embodiment of totalitarian political principles is, therefore, problematic, as nothing can be simultaneously both totalitarian and non-existent.

What is certainly true, however, is that constructivism exerted an enormous influence on the development of the arts in Russia and the rest of the world. Its key legacy was undoubtedly the destruction of the barrier between autonomous and applied art, and the idea that artists with a broad education can play a part in design processes, from household items to public spaces. This new awareness led to a wave of creative innovation in everything that is denoted today by the word 'design': that magic word that is, in a certain sense, the brainchild of

the constructivist ethos. The influence of constructivism was probably most prominent in architecture, although it is true that the most gifted architects – such as Konstantin Melnikov and Ivan Leonidov – could only realize their ideas to a very limited extent. And it is not unthinkable that it was precisely this status of 'untapped genius' that contributed to an ongoing fascination with their projects.

Constructivism is unmistakeably the endpoint of the avant-gardist mentality. The qualities that made the avant-garde so irresistible – the raucous exuberance, the blend of profound earnestness and utter nonsense, the rough but cheerful and non-violent provocation, their antisocial, enigmatic and maladjusted nature, and the uncompromising surrender to the imagination – all these were sacrificed by constructivists in exchange for clarity, serious professionalism, self-proclaimed rationalism, dubious moralism and a willingness to serve processes in society. Despite all its successes, constructivism is therefore, in my view, the product of a great culture in decline, and much of what is presently associated with constructivism was no longer a part of the avant-garde.

The most negative side-effect of the advent of constructivism was the intensification of the internal conflicts within the small and vulnerable avant-gardist community. Some constructivist theoreticians were even less compromising or open to conciliation than Malevich or Tatlin. Their urgent call to a 'communal creative discipline' had, in the words of Anatoly Strigalev, 'a suffocating effect on individual creativity, and introduced elements of intolerance and sect-formation in the art world'.[67]

The Battle Against the Futurists

Meanwhile, the civil war slowly came to an end. By the spring of 1920, most contingents of the White Army had been defeated, and the Red Army was able to send millions of soldiers back home. The constant state of war had plunged the country into an unprecedented crisis, however. An estimated seven to eight million people had lost their lives, around five million of whom were civilians.[68] Agricultural and industrial production had dropped by several tens of percentage points. Because city-dwellers had fled to the country en masse to find food and avoid military service, urban populations had plummeted. Petrograd and Moscow alone had already lost half of their collective four million inhabitants.[69] This unprecedented crisis led to growing civil unrest directed at the Bolsheviks, prompting the party leadership to strengthen its ideological

grip on the country. Although any genuine political opposition had all but disappeared, various groups still existed who saw themselves as loyal to the revolution, but offering an 'alternative' to the orthodoxy of the party and with different views on how the revolutionary state should be organized.

As a result, Lunacharsky felt it was necessary to speak out against futurism in public, and in the presence of Lenin: 'Everybody must realize that we [at the ministry] have nothing to do with futurism, and that I have never been a futurist; I am not a futurist, and will never be a futurist,' he blustered. And, completely truthfully, he added: 'I have written a whole series of articles that make clear how futurism is a typical expression of bourgeois culture.'[70]

No matter how adamantly Lunacharsky distanced himself from the futurists, the attacks continued. On 1 December 1920, the state's topmost authority, the Central Committee of the Communist party, published its views in an open letter to *Pravda*. The article made mention of 'ridiculous, perverted tastes (futurism)'. Though only a side note in a much longer tirade directed at a far more threatening political opponent – the Proletkult – these few words, spoken from the highest political pulpit, were enough to forever brand the term 'futurism' as an anti-revolutionary phenomenon. Bolstered by this officially sanctioned stigma, the avant-gardists' many enemies saw their chance and redoubled their efforts.

Ten days after the article in *Pravda*, the Central Committee received a letter from a student and an instructor at Vkhutemas. They claimed that 'the futurist movement' still dominated the decision-making in the art programme, and was 'charting a course diametrically opposed to the interests of the proletariat'.[71]

The teacher who signed the letter was none other than Malevich's brother-in-law, Yevgeny Katsman. It was a highly detailed letter, and written in a very businesslike tone. The futurists ruled the roost, he claimed, but 'had been elected by no-one...developed vague theories about industrial art, and rejected accessible forms of art' and their work was based on 'the latest convoluted, bourgeois-idealistic philosophical ideas' and 'inscrutable to the highly cultivated'. The suggestion that the students had no choice and were unable to pursue realistic forms of painting was an outright lie. The programme in those days was highly pluriform – avant-gardists constituted approximately one-quarter of all instructors – and almost all movements were represented, including

realism.[72] By that time, however, anything smacking of futurism had become so suspicious that the facts were no longer relevant.

The letter was, therefore, taken very seriously, and within several days had been sent via the Central Committee to Lunacharsky, with a request for immediate action. It should be said that Lunacharsky did all he could to defend himself against this attack – especially since he was aware of its mendacity, and did not care to be at the mercy of Katsman and his cohorts, whom he regarded as mediocre artists. Lunacharsky leant strongly on David Shterenberg, who wrote an extensive and powerful rebuttal, based on documented fact, that was sent to Lenin. Later, Lunarcharsky would frequently employ Shterenberg's arguments internally. The artist Lentulov noted (rightly, according to the evidence) that Shterenberg 'exerted a special influence on Lunacharsky, and they resemble one another. David speaks just like him, and waves his arms in the same manner.'[73]

Of course, it was extremely impudent of the letter-writers to address the Central Committee directly, casually bypassing the leadership of the People's Commissariat. The pressing question is: why did Katsman dare to do it? Lunacharsky was his boss, after all, and could have dismissed him immediately had the letter caused any problems.

The fact is that Lunacharsky could not have done away with the rebellious artist so easily. Katsman had an extensive network even then, particularly in the Moscow Soviet, and was therefore embroiled in the power struggle between the Commissariat on the one hand and the Soviet on the other. He was also the secretary of the artists' union – another institution that competed openly with the power of the People's Commissariat.

Malevich's brother-in-law was an agile networker with a nose for political power. There are many documents in Katsman's archives (letters, diary entries) that establish connections between him and the most highly placed party and state leaders: first and foremost with defence minister Kliment Voroshilov and Józef Unszlicht, the second-in-command at the Cheka, who was charged with the repression of intellectuals and artists. Later, Katsman even had personal contact on several occasions with Joseph Stalin. He was given his first access pass to the Kremlin in November 1918, probably so that he could attend Soviet meetings.[74] In the mid-1920s, he was awarded the rare privilege of his own studio in the Kremlin. It seems inconceivable that he was awarded such an honour purely on his artistic merits – and, indeed, his diaries

reveal that he was an informant for the Cheka, and provided them with information on people and events in the art world for years.[75] Katsman, incidentally, was not the only spy active within the artistic community. The most prominent, of course, was Osip Brik, Mayakovsky's friend and housemate, and a proponent of the avant-garde. But even the realist painter Fyodor Bogorodsky worked for the secret service from early 1918 onwards, as he shamelessly noted in his memoirs.[76]

Katsman was persistent. Shortly after his letter to the Central Committee, he wrote a personal letter to Lunacharsky, once again stressing the nefarious influence of the futurists. Why, he wondered, did the revolutionary state continue to tolerate them? 'I am surprised and am begging you, my dear, dear Anatoly Vasilyevich. I love you so, you are a great man. But I do not understand you, and have ceased to understand the revolution.' He complained that the futurists received the full support of the Commissariat, that they had done nothing for the revolution, that they were 'nothingists', and he believed that Lunacharsky should announce a change, steering cultural politics towards realism. Uncommonly for him, he mentioned not only realism but also the *bespredmetniki* – a nickname used for creators of abstract art. That term was so closely associated with Malevich that Katsman can only have intended it as a personal attack on his brother-in-law. Katsman made it clear that he would not rest until the futurists had disappeared – simply marginalizing them was not enough. Though it might not be necessary, he conceded, 'to tip them over the railing. Though they do the same to us, the realist artists, in the most despicable manner, and behind your back, Anatoly Vasilyevich.'[77]

A man capable of such toadyism, who was simultaneously prepared to sacrifice a family member for his own personal gain, was a political opponent deserving of serious attention. This fact did not escape Lunacharsky and, therefore, he decided personally to act as chair for the negotiations surrounding a new model for Vkhutemas. A lengthy series of meetings, letters and investigations followed, including one by the education inspectorate. More meetings ensued, and roles and staff were reshuffled. Poor Shterenberg was forced to surrender his post, but was replaced by his friend Altman. Finally, a proposal was made that granted a range of privileges to the 'realists', and was submitted for approval to the 'professorship' of the school. Malevich was included in these sessions, and he travelled from Vitebsk to Moscow specially, though he was not even a professor at Vkhutemas at that time.[78] Malevich could not have attended

9 Vladimir Tatlin, costume designs for *Zhizn za Tsarya* (A Life for the Tsar) by
 Mikhail Glinka, 1913. Cardboard, pencil, Indian ink and gouache,
 48.8 × 64.4 cm (19 ¼ × 25 ⅜ in).

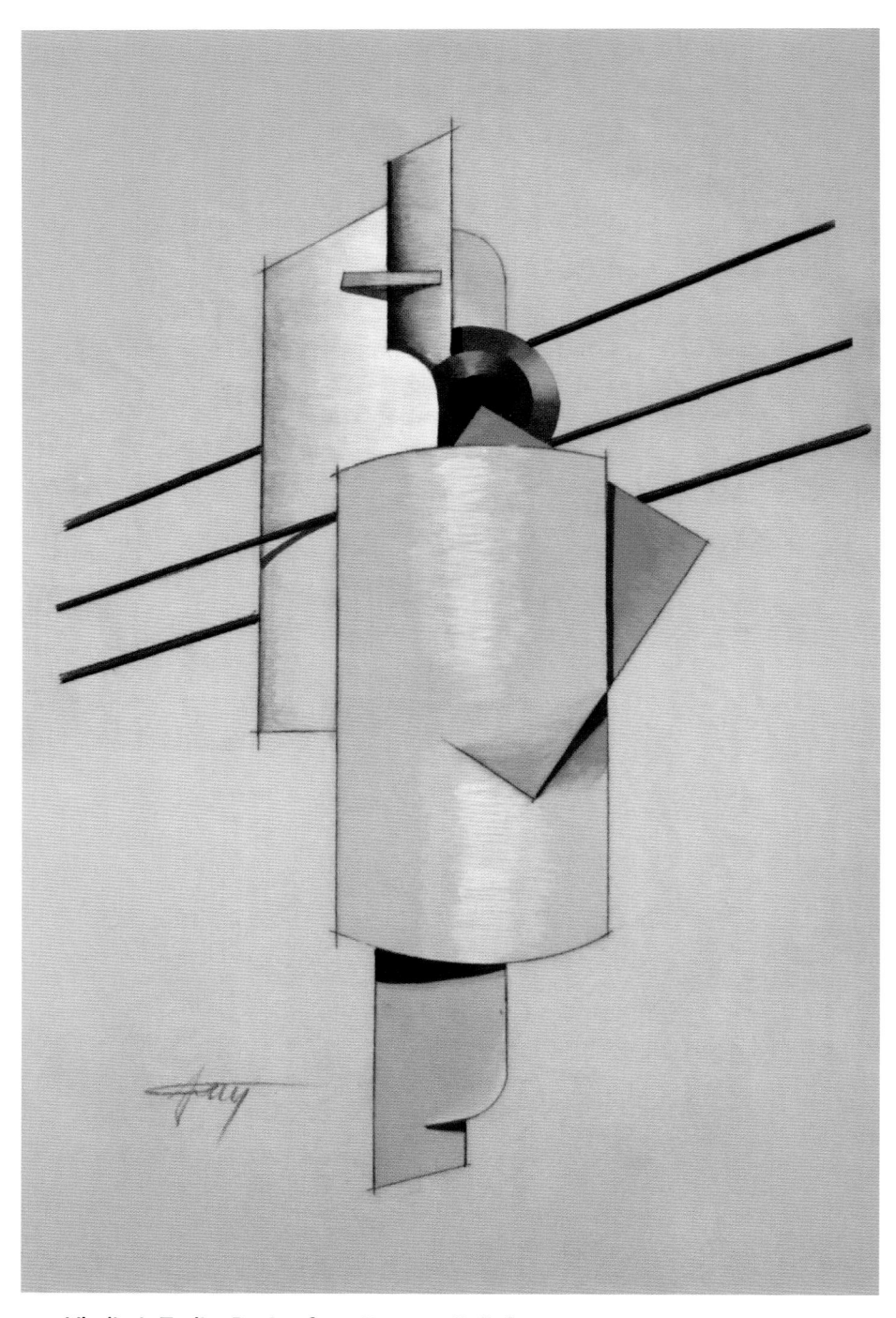

10 Vladimir Tatlin, *Design for a Counter-Relief*, 1914–15.
Gouache and charcoal on paper, 50 × 34.6 cm (19 ⅝ × 13 ⅝ in).

11 Vladimir Tatlin, *Corner Counter-Relief*, 1914.
Iron, copper, wood and cables, 71 × 118 cm (28 × 46 ½ in).

12 Ivan Puni, *Relief*, *c.* 1915–16. Oil paint, wood, cardboard and zinc on wood, 36.8 × 24.1 × 7.3 cm (14 ½ × 9 ½ × 2 ⅞ in).

13 Olga Rozanova, *Green Stripe*, 1917.
Oil on canvas, 71.2 × 49 cm (28 × 19 ⅜ in).

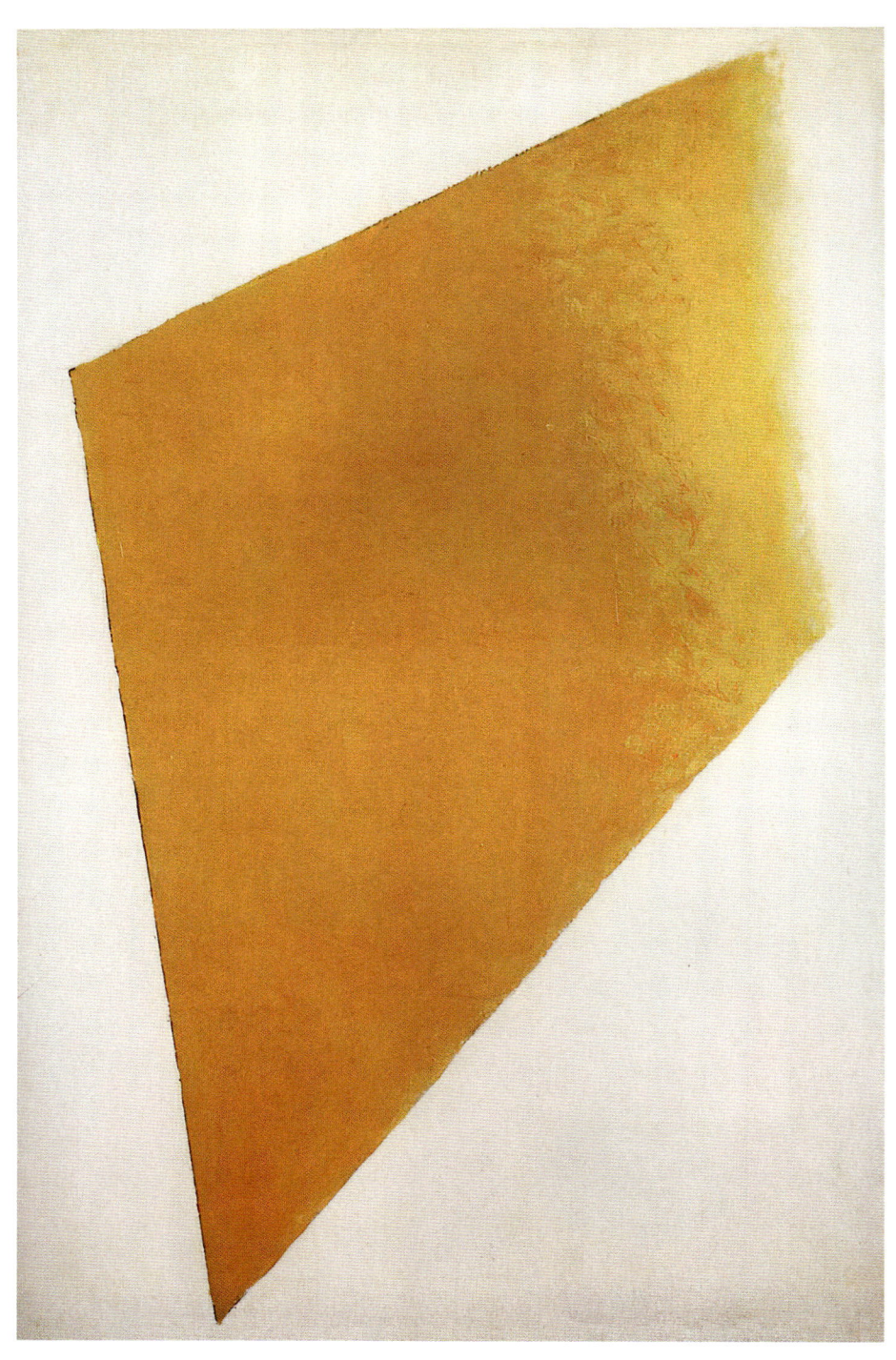

14 Kazimir Malevich, *Yellow Plane in Dissolution*, 1917.
Oil on canvas, 109 × 73.5 cm (43 × 29 in).

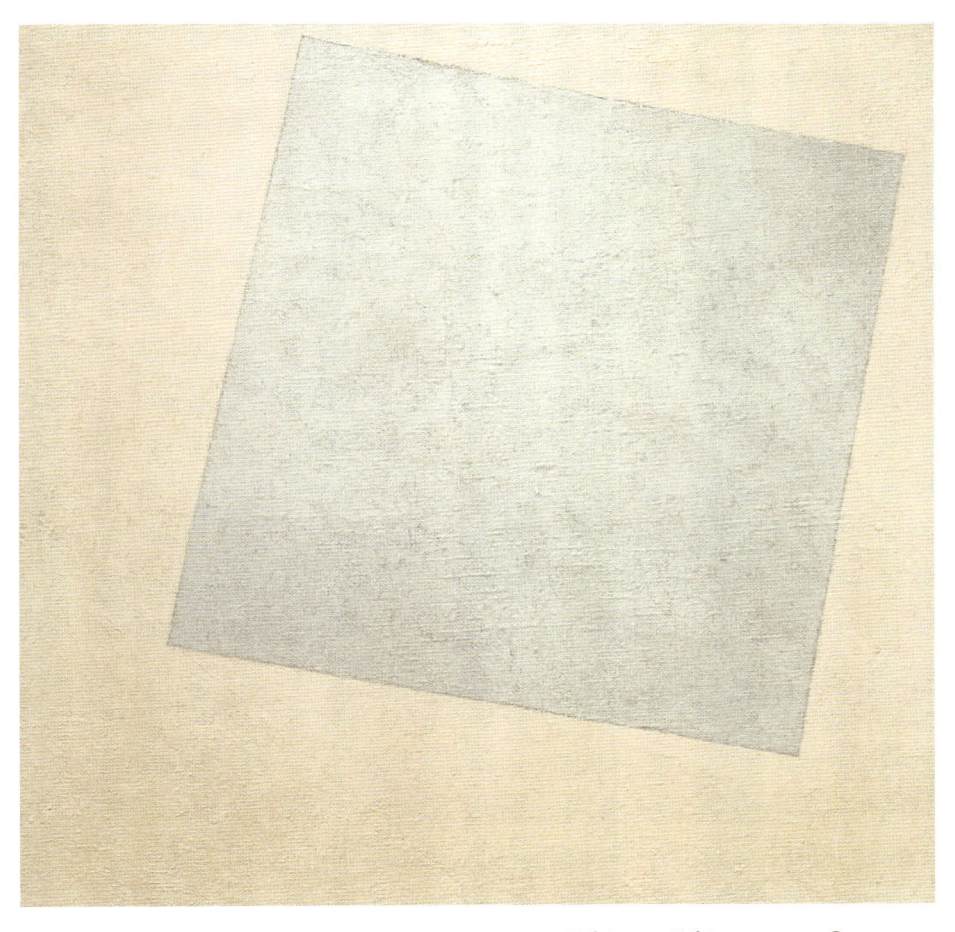

15 Kazimir Malevich, *Suprematist Composition: White on White*, 1917–18.
Oil on canvas, 79.4 × 79.4 cm (31 ¼ × 31 ¼ in).

16 Wassily Kandinsky, *Improvisation no. 34*, 1913.
Oil on canvas, 120 × 139 cm (47 ¼ × 54 ¾ in).

these meetings without Lunacharsky's approval, but one can understand why he was invited: his stubbornness and perseverance were well known and he refused to be intimidated by anyone. With the help of Rodchenko and Lentulov, he successfully defeated the proposal.[79]

After months of negotiations, the realists were back where they started. Katsman and his right-hand man, a student called Bogdanov, sent a new letter, this time addressed to Lenin personally. It was far less detached than the previous one, and more bent on branding the futurists as corrupt saboteurs. The writers claimed that the futurists' sole intent was to 'create a situation of material privilege for themselves', despite the fact that they supplied 'only ugliness in return for the public resources they devoured'. 'The country is at risk of being left behind without seriously trained artists.'[80]

All these claims were made by two artists whose work has been completely forgotten, in Russia and everywhere else. The opposite is true of the instructors under attack, who included Wassily Kandinsky, Alexander Rodchenko and Naum Gabo. These three teachers alone would have made Vkhutemas 1920–21 into one of the most fascinating art education programmes of the entire twentieth century.

During the negotiations, brothers-in-law Malevich and Katsman faced off directly, and may have even sat opposite one another at the conference table several times. Malevich spent the evenings in the dacha in Nemchinovka, close to Katsman's family – the same village where the one-year-old Una was growing up with her two cousins, the two-year-old Marina and the newborn Kira, Katsman's children.

However fierce and vindictive the fight between the two artists, Malevich always observed familial discretion and never publicly criticised his brother-in-law's actions nor expressed superiority over him. The same cannot be said of Katsman, who nearly twenty-five years later devoted a horribly caricaturesque and mendacious memoir to his brother-in-law.

In the battle for Vkhutemas, Katsman emerged the victor. From 1920 onwards, the official line on the avant-gardists was set in stone. Lenin charged his wife Nadezhda Krupskaya with upholding the fight against the avant-gardists. She supported the Central Committee's position in her articles in *Pravda*, where she wrote that the futurists 'represented the worst aspects of the old art, dragging it down to a lower level'. She claimed that art was 'the expression of human emotions', but that the futurists transformed it into 'the expression of the most disturbing and utterly

abnormal perceptions'.[81] The party and the government were not yet in a strong enough position to completely silence specific groups of artists, or to prohibit the public display of objectionable art. Over the ensuing years, the avant-gardists would create several small enclaves for themselves where they could create and display works (with the support of a benevolent local official, for example). But these places would become scarcer with time, and the party had made it abundantly clear that the only desirable form of art in the Soviet Republic was popular realism.

During the few years when Vitebsk was the epicentre of radical culture, Malevich's educational aspirations reached their apex. His instruction and leadership produced a cavalcade of students who would uphold suprematist ideas and methods for generations to come, albeit as part of an increasingly marginalized and suppressed counterculture.

Vitebsk spurred on Lissitzky's development, and from 1919 he continued to produce his first PROUNs. Lissitzky was one of the first great abstract artists, perhaps even the very first, not to have developed abstract painting more or less independently (as Mondrian, Kandinsky and Malevich did), but who instead adopted the style as a student. Though this in itself was not necessarily a great achievement, Lissitzky did demonstrate something else, namely that abstract art was not the endpoint, the inevitable culmination of ever-greater simplification and concentration in painting, as is so often claimed. He proved that abstract art provided the opportunity to develop an independent idiom and served as the starting point for a new type of artistry, since abstract depictions were far more easily relatable to other forms of visual art: designs for book covers, posters, buildings, interiors and exhibitions. Lissitzky blended these worlds together with seeming effortlessness, rendering an inestimable service to the avant-garde. Whereas the first-generation avant-gardists – Malevich and Tatlin – expanded their art to include creative disciplines that had previously been considered utilitarian and, essentially, unartistic, Lissitzky was the first Russian to navigate all disciplines with equal non-hierarchical ease, and the first for whom painting, graphic design and architecture formed an integral whole.

To Malevich, Vitebsk was first and foremost a period of intellectual development. His contact with Gershenzon broadened his horizons, and Lissitzky's presence expanded his knowledge of the world.

The most puzzling encounter of the Vitebsk era was between Malevich and the legendary cultural philosopher Mikhail Bakhtin, one of the greatest Russian thinkers of the twentieth century.

Bakhtin had arrived in Vitebsk in more or less the same manner as Malevich: he was offered a position in the revolutionary state, and had to accept it, if he wished to eat. The philosopher immediately developed a great interest in the artist, though he had most likely never heard of him before. The two men remained friends for several years, partly – as Bakhtin himself admitted – 'because my wife was quite taken with Malevich; she found him very charming'. Bakhtin's recollections of Malevich are vibrant and full of detail, but are particularly interesting because he himself was at the periphery of Malevich's entourage. After their time together in Vitebsk, the two men lost touch.[82]

In an interview from the 1970s, Bakhtin described his first meeting with Malevich, during a visit to the school. It is to this interview that we owe one of the few descriptions from Malevich himself explicating his own relationship to his art. He showed Bakhtin a new sculpture (most likely a new arkhitekton) and tried to explain his perspective as an artist on this freshly created object, as well as outline the physical and metaphysical questions raised by the relationship. The result was one of the clearest expostulations that Malevich ever gave, and which showed that every artwork is first and foremost an invitation to a fundamentally philosophical meditation.

> Look, here is a sculpture. It has three dimensions....And me, the artist who created it – where am I? Surely I am outside these three dimensions that I have just created? You might say: you also have but three dimensions. But those three are different, a separate three dimensions. I meditate on the other dimensions, and as a meditating creator my perspective is outside those three dimensions, in the fourth dimension, if we are to proceed arithmetically. But it is impossible to proceed in this way; there are not three dimensions, but thirty-three, three hundred and thirty-three – there are infinitely many.

Though the explanation is perhaps a little abstruse, Malevich is essentially asserting that both the creation and perception of art are fundamentally cosmic activities, a way of determining one's position in the universe through the juxtaposition of the 'self' with another object located outside the self, which is observed and recognized as 'the other'. The purpose of this act is not observational – the perception of beauty or perfection – but rather the realization of one's own transcendental nature. The relationship between artwork and observer is, therefore, also

'dialogical': the artwork emits no wondrous, enrapturing monologue to which the observer can listen and perhaps learn from, or lose themself within for a time. No, the artwork enters into an immediate relationship with the observer, and only takes on meaning in the dialogue between the observer and the object. This rationale shows how deeply Malevich's vision on creativity was rooted in the painting of icons and the organization of religious life. An icon, after all, was not an independent artwork, but a conduit, a portal between the believer and divine reality, a door opened by a prayer directed at the object. Bakhtin also noted how utterly concrete Malevich found this relationship, saying that he 'was free of all pretence and theatrics. He was sincerely convinced.'[83]

The Jewish Theatre

The largest single piece of art that Vitebsk ever produced – though it was not in Vitebsk itself – was, surprisingly, not by Malevich or Lissitzky, but by Marc Chagall, the local hero who had kickstarted the city's magical transformation. One year after moving to Moscow, he was commissioned to create wall decorations for the recently opened Jewish State Theatre.

Yiddish theatre began flourishing in Russia in around 1850. But in 1883, all theatre productions in the Jewish vernacular were prohibited as part of the anti-Semitic response during the reign of Alexander III. The fact that the revolutionary state not only gave Yiddish theatremakers free rein, but also provided financial support and a fixed place in the cultural infrastructure of the capitals, is yet another sign of the exceptional emancipation that Jewish culture experienced during the first years of the revolution. New Jewish theatre troupes were established throughout the country, though the company in Moscow remained the most prestigious.

The auditorium of the small theatre, about the size of a large classroom, was decorated by Chagall. According to the stories, Chagall did so on his own initiative.[84] He had but one month to complete the mammoth task – the same month in which the space was to be completely renovated. During this brief period, Chagall painted a surface area of around 43.5 square metres (468 square feet), completely unaided – an astonishing physical achievement in and of itself. The artwork that he delivered was a close-knit ensemble of eight separate paintings on canvas. The largest of these, titled *Introduction to the Jewish Theatre*, was nearly

Marc Chagall, 1920s.

8 metres (26 feet) wide and 3 metres (10 feet) tall. Nearly all the walls, and even the ceiling, were hung with painted canvas. Chagall's decision not to paint the walls directly, but to opt instead for the more enduring medium of paint on canvas, suggests an aspiration to create something more substantial than mere decorations. He viewed the paintings as autonomous artworks, which, as such, should also be suitable for display beyond the walls of the theatre (Plate 20).

The intensity of the work and the stress induced by the production process are reflected in the diversity (to put it mildly) of the surviving written recollections. Chagall himself wrote that the 'workmen and actors' simply traipsed across the canvasses laid out on the floor. 'Piles of sawdust lay among my paint tubes and sketches. There were cigarette butts and breadcrusts everywhere.'[85] The theatre management, on the

other hand, was primarily concerned with the fact that Chagall 'kept all the doors locked', did not leave the room, and 'let nobody in'. Only for those bringing food did he open the door a crack.[86]

Whatever the historic reality of the production process, the result was an artistic triumph. Chagall presented a series of dynamic figures – humans, animals, objects – tumbling helter-skelter through the artistic space. We see a painter, Chagall himself, borne aloft on the shoulders of the man who commissioned the artworks, Abram Efros. Elsewhere there is a headless violinist, a green goat, a peasant tickling the buttocks of a cow flying backwards through the air, a Jew urinating on a small pig, three acrobats doing headstands, musicians, Yiddish and Hebrew texts (including the ten commandments), and more. There are also myriad references to Vitebsk and to his encounter with the avant-gardists. Several figures, including the urinating Jew, wear trousers bearing suprematist motifs; one of the acrobats has a black cube on his head. There is also a black square, balancing on its corner above the roof of a wooden house. Although Chagall dethrones the sanctity of these suprematist symbols, the entire carnivalesque entourage is also arranged in geometric fashion – as triangles, semicircles, and so on. The artist thus employed the lessons learned from the suprematists to give rhythm and form to physical space. Taken together, the panels are reminiscent of the descriptions of the Vitebsk May Day celebrations, when the city's houses were decorated with both suprematist figures and Chagall's goats and people. The whole is simultaneously a reckoning and an acknowledgment, both mockery and self-ridicule.[87]

The theatre murals are devoid of the sentimentality that so mars some of Chagall's works, the later ones especially. The lines are sharp, intelligent, not vague or blurred. The intense colours familiar to us from Chagall's other works are absent here, as they would become unbearable on such a large scale. The dominant colour is an opaque white that constitutes the basis for the entire ensemble, creating an impression of lightness and occasional transparency that is quite rare in Chagall's work. The highlight is undoubtedly a large *panneau* that was hung on the narrow wall of the auditorium, titled *Love on the Stage*. This solitary work eschews the joyful banality, satire and capricious dreamlike world of the other pieces. It consists almost entirely of large, occasionally overlapping white planes in varying shades, with several small highlights and lines in light grey. Almost imperceptibly, amid this ethereal world, the image of two intertwined ballet dancers emerges. This effect

is already dramatic and moving enough. But by adding this final painting to the ensemble, Chagall creates an artistic whole that encapsulates both the rambunctious vulgarity and the most elevated aspirations of humanity in glorious completeness.

Chagall's paintings for the Jewish Theatre are a unique monument of international modernism. Let us not forget, after all, that in 1921 most modernists in Europe created work only for appreciation by a small group of progressive insiders. Only a few – celebrities such as Picasso or Matisse – could normally afford to produce radical art on such a grand scale. And yet even Matisse's enormous panels for the palace of Sergei Shchukin are dwarfed, both physically and psychologically, by Chagall's. The fact that these unique modernist works by Matisse and Chagall were displayed a stone's throw from one another in the centre of Moscow amid the ravages of war, revolution and famine, rather than in Paris, Munich or Vienna, is a curious but not entirely random quirk of history).

Chagall was well aware of the quality of the artworks he had produced within the span of a mere month, and was intent on ensuring that they would not be viewed solely by theatregoers (which in this case would be limited to the Moscow Jewish community). He requested, therefore, that the auditorium be opened to the general public. 'Surely you understand,' he wrote with cheerful sarcasm to the theatre management, 'that as an artist, I will find no inner peace until the "masses" have seen my work, etc.' 'It is as though my things have ended up inside a cage, visible only to a hundred jostling Jews, if there even are that many (forgive me for saying so).' 'I love the Jews very much (for which there is evidence enough), but I am also fond of Russians and other foreigners. And I am accustomed to painting serious works for a range of "nationalities".'[88]

Although several public viewings would indeed take place, the venue remained a theatre, and enjoyment of Chagall's paintings was reserved primarily for playgoers. Chagall himself left Russia for good in 1922 and moved to Paris, where he would never produce anything better. Two years later, the Jewish State Theatre moved to a new building where Chagall's paintings were once again put on display, though in a larger space, which disrupted the continuity somewhat. In the summer of 1937, while the actors were on holiday, the panels were taken down and secretly transported to the Tretyakov Gallery to protect them from the wave of barbarism sweeping through the Soviet Union at the time (around three or four months after the murder of Yehuda Pen in Vitebsk).

It would be many decades before these works, which lay rolled up in a repository, would be unfurled and put on public display once more. Not until the late 1980s were the highly damaged works finally restored and included in several European exhibitions. Since then they have been on display at dozens of locations worldwide, and they did not return to the Tretyakov Gallery's permanent collection until 2017.

Malevich's First Arrest

Chagall's last two winters in Russia (1920–21 and 1921–22) were the most devastating since the revolution. The grain harvests of 1920 and 1921 had dropped to 53 and 43 per cent respectively of the pre-war (1909–13) average, hardly enough calories to feed the entire population.[89] The result was an exacerbation of the famine that would claim an estimated five million victims throughout Russia, and in the Volga region especially.[90] The situation in Vitebsk was also dire, owing to the flaring-up of the Polish–Russian war. The Polish army was approaching Vitebsk, and so all available food was channelled to the defending Red Army. There was no more firewood in the city, and barely anything edible. Malevich was forced to sell almost all of his personal belongings (including, as he wrote in a letter to Lunacharsky, his trousers and underwear) in order to buy food. A report from the education inspectorate stated that he contracted tuberculosis due to malnourishment.[91] Though that is untrue, he did suffer a dangerous infection to his hand. He also had grave concerns for his daughter, who was six months old in the autumn of 1920. His wife received no food stamps, and was malnourished. Malevich wrote urgently to Shterenberg: 'My child needs milk, and so her mother must eat. For the last time, I beg you to issue rations to my family. In the event that they die of exhaustion, the blame will lie entirely with the Department of Fine Arts.'[92]

The famine triggered a major crisis among the party leadership. To stem the rising flow of public criticism, the Cheka was given new administrative powers. In 1921, the security service arrested just over 200,000 people, around 9,000 of whom were executed. Another thousand died in prison without trial. Rather than political prisoners, these were, for the most part, petty criminals. Nor do these figures include the dead who fell during the suppression of uprisings, such as the sailors' rebellion in Kronstadt of that year.[93]

The suppression measures now extended to intellectuals and well-educated professionals, who had hitherto been spared due to their

critical role in education and bureaucracy. But they, too, needed reminding that the Soviet powers were not to be trifled with, and the associated campaign extended to the avant-gardists. In Petrograd, a case was manufactured surrounding Vladimir Tagantsev, a geographer and instructor at the University of Petrograd. In early August, he and at least 833 other people were arrested on suspicion of counter-revolutionary conspiracy. Among them was Nikolai Gumilyov, one of the most brilliant poets produced by Russia in the twentieth century. Nikolai Punin, the great futurist advocate and theoretician behind Tatlin, was also taken from his bed one night by twelve agents.[94] Tagantsev, Gumilyov and sixty others were shot dead that same month. Punin escaped with his life, probably because Lunacharsky wrote a sternly worded letter to Józef Unszlicht, one of the leaders of the Cheka, in Punin's defence.[95]

Three days after Punin's arrest, Malevich was arrested in Vitebsk, and most likely detained for two weeks.[96] Malevich wrote Lunacharsky an angry letter: 'If the Cheka are already on my doorstep, then clearly they have nothing better to do.'[97] No documentation of Malevich's arrest survives, and so we are in the dark as to his supposed felony, but within the intellectual and artistic community 'his arrest was linked to that of Punin'.[98] This wave of arrests affected mainly members of the old intelligentsia, who were generally regarded as hostile towards the new establishment. So it was that Alexandre Benois' oldest brother, the respectable, sixty-five-year-old architect Leon Benois, was arrested along with his son and two daughters, and detained for eight months. The upshot of all this, Benois wrote in his diary, was that 'every night, every Russian citizen goes to sleep with the feeling that in two or three hours, the powers that be might come knocking, and violate the sanctity of one's home'.[99]

The subjugation of the intelligentsia also manifested itself at institutional level. New departments were formed within the People's Commissariat for Enlightenment, designated by perfectly horrendous acronyms such as GLAVPOLITPROSVET, GLAVPROFOBR or GUBPROFOBR, and charged with the bureaucratic supervision and homogenization of schools and museums. This they did through the imposition of increasingly stringent professional standards, in the hopes that marginal and eccentric phenomena (such as UNOVIS) would automatically disappear. The Vitebsk school was also subjected to this treatment, and it was crystal clear that, although Malevich had tried to formulate the UNOVIS curriculum in Soviet-friendly terms, it was still not in line with the new standards.

The ideological homogenization of society was also effected directly through censorship. Existing press censorship was tightened, and transparency in decision-making deemed unnecessary. The latter made it more difficult for victims to submit complaints and gave the censors free rein. A large-scale 'purging' operation was also carried out in the libraries. 'Harmful or counter-revolutionary' books were removed from the general catalogue and locked away in separate cabinets, and could only be consulted for 'scholarly and literary' purposes. The 'purge' was carried out with such dogged fervour that initially even books by Lenin, Marx, Herzen and Pushkin were included on the blacklist.[100]

The End of UNOVIS

The suppression of fringe movements also reached Vitebsk, and the city council was ordered to clean house in the art school. Because the institution enjoyed a certain popularity in the city, a coordinated campaign was necessary. The school suddenly received negative inspection reports and was attacked in the press.[101]

Two of the 'lectors' who had been ridiculed by Malevich on his arrival, Alexander Romm and Max Friedländer, played an important part in the fall of UNOVIS. Romm wrote a letter to the Department of Fine Arts in Moscow, criticizing the instruction at the school and asking pointblank for Malevich to be replaced. Friedländer (whom Malevich consistently referred to as 'the schoolboy') even travelled to Moscow to vent his spleen to Shterenberg in person. He declared that 'the studios are virtually no longer in use, the students do not attend them, and the maintenance department has let everything go'.[102] Against such lies, there was little to be done.

In late November 1922, most of the school's state funding was suddenly withdrawn, bringing an immediate halt to the supply of firewood and suspending food rations. The instructors struggled with hunger, and the students suffered from the cold. Yermolaeva requested permission to sell an unused cabinet with a mirrored door (which she described as an 'extravagant luxury') from the school's inventory in order to purchase firewood. Her request was denied.[103]

Fuelled by desperation, Malevich and his followers forged on as best they could. But all his reasons for being in Vitebsk (the freedom to implement his pedagogical ideas, and sufficient food for himself and his family) had ceased to apply. Sofia and Una had returned to Moscow

some time before, and the separation from his family weighed down on him. For all these reasons, Malevich decided to leave the province, and return to either Moscow or Petrograd. In the summer of 1922 he left Vitebsk and settled in Nemchinovka.

History was not yet done with Vitebsk. The fact that the city's buildings had emerged unscathed from the First World War and the civil war was, of course, miraculous in itself. Even the devastating famine that would ravage the west of the Soviet Union in the early 1930s, as a result of Stalin's barbarous policy of collectivizing agriculture, would leave Vitebsk more or less unaffected. The same cannot be said of the Second World War, however. Vitebsk was quickly taken by Germany, after which the city made the acquaintance of some genuinely new brands of human – the SS, and members of the German Einsatzgruppen (death squads) – who easily put the bloodlust and mercenary efficiency of even Stalin's agents to shame. Within six months of the German invasion, almost the entire Jewish population of Vitebsk had been killed or deported to labour and concentration camps. The Red Army eventually retook the city in 1944, by which time the war, deportations and genocidal killing sprees had whittled down the city's population from over one hundred thousand to precisely 218.

7

The Last Laboratory

1922 – 1925

In the early 1920s, the Bolsheviks were confronted with a nigh impossible task. Both the civil war and the war against Poland had ended, largely in favour of the Soviet Republic, but the country was utterly devastated. The cities had been vastly depopulated and industrial production had shrunk by 70 per cent since 1914, heavy industry by as much as 80 per cent.[1] If the Bolsheviks did not radically turn the tide, they would almost certainly be done for.

Lenin's response to this challenge was the introduction of the New Economic Policy (NEP), the crux of which was to readmit a restricted form of entrepreneurship, in the hope that private enterprise would get industrial and agricultural production back on track. The return of market forces to society was seen as a painful compromise, and presented expressly as a temporary measure.

Lenin believed that the greater economic freedoms under the NEP should be accompanied immediately by further constraints on intellectual and political freedoms – in this manner, an ideological 'step forward' would compensate for the economic 'step back'.[2] The most visible outcome of this campaign was the deportation of a large number of Russia's most prominent intellectuals on what became known as the 'philosophers' steamboat'. These boats (there were in fact two of them) transported Nikolai Ilyin, Sergei Bulgakov and Lev Karsavin to Germany, on pain of immediate execution should they ever attempt to return. The philosophers' steamboat was a targeted and vigorously publicized campaign intended to sow fear in the minds of dissidents, and formed part of a wider deportation operation by the Bolsheviks that ultimately carted over two hundred prominent intellectuals over Russia's borders. Trotsky justified the campaign concisely: 'We sent them away as an act of mercy, otherwise we would have had to kill them.'[3] The exiled intellectuals saw

things differently. One of them wrote: 'For many, the banishment was a genuine tragedy; they did not like Europe at all, their whole lives were bound to Russia in a manner uniquely and inextricably linked to the purpose of their existence.'[4]

These campaigns hit their mark, and many intellectuals feared that they, too, might be expelled from the country and forced to leave behind their families, jobs and all that they had worked for. Six months later, the rumour circulated that Tatlin and Malevich would be deported – Punin, who was generally well informed, had heard it from two independent sources. 'It is nonsense, I think,' he responded, 'but it would be very typical, and where there's smoke, there's fire.'[5]

The NEP was, at least in terms of productivity growth, an unqualified success. Industrial production increased eightfold between 1920 and 1926. Grain harvests doubled, bringing them roughly back to where they had been in 1913. Although total industrial production in 1926 slightly exceeded the 1913 levels, there were sectors (such as steel, coal and cotton production) that had still not completely recovered by 1926.[6] Nevertheless, it can be suggested without exaggeration that, without the NEP, the Bolshevik powers would not have survived the 1920s. It is a further testament to Lenin's unparalleled political nerve, cynicism and unbending authoritarianism that he was able to save a communist experiment – to which many millions had already been sacrificed – through the partial reintroduction of a market economy.

The effects of the NEP also extended beyond the industrial and agricultural sectors. Private publishing houses were re-established, and the Russian cinemas overflowed with foreign films, mostly from Hollywood. Douglas Fairbanks, Buster Keaton, Harold Lloyd and Charlie Chaplin in particular were huge celebrities in the Soviet Republic in the twenties. Malevich saw many international films, mostly comedies, and according to his daughter, he was a fan of the French comic Max Linder.[7] Between 1918 and 1931, 1,700 international films were shown, around half of which were American. During that same period, approximately 700 Soviet films reached the silver screen.[8] Commerce returned to the streets. Shops reopened, and marketplaces sprang up. Café Pittoresk, which had been closed since 1919, opened once again, and was transformed back into a large covered market hall, as it had been before the revolution.[9]

The NEP affected the art world in various ways. There, too, market forces were reintroduced, and artists were expected actively to search for sponsors and buyers for their art. The system of 'state exhibitions'

was suspended, and financial support for cultural institutions drastically reduced. The organizations were instructed to pay their personnel from ticket sales.[10] Selling exhibitions were held once more, and the purchase and collection of art were again permitted, and even encouraged.

The rise in economic growth and activity primarily benefited those who had already held a strong market position before the revolution. To the avant-gardists, however, the NEP was a bitter disappointment. They saw little to no benefit from the return of the commercial art market, but still felt the pain of the austerity measures. In an ideological sense, the NEP was a shock to many of them. Their aversion to bourgeois culture and its conservative tastes was just as strong as it had been before the revolution, and all the sacrifices that the avant-gardists had made to try to build on a new, anti-bourgeois society seemed to have been for naught. The shrinking cultural budgets affected the avant-gardists' incomes, and the campaign against intellectual freedoms and dissidence limited their opportunities for expression. To the avant-gardists, the NEP was nothing but bad news.

In Petrograd, the college of the Free Studios reassumed its previous appellation: the Academy (no longer 'Imperial Academy', naturally) of Fine Arts. Nearly all leftist artists, including Tatlin and Altman, were given a stern talking-to. Tatlin was allocated no more students and was regularly put through the wringer by malicious inspectors. He decided that the best defence was a good offence, and tried to become rector of the new programme, but to no avail. In August 1922, he was asked to clear out his studio for good.[11]

The Museum for Artistic Culture

The NEP also had a disastrous effect on the Moscow branch of the Museum for Artistic Culture. The museum had opened in 1919, with Wassily Kandinsky as its first director. Its opening (with those of its sister locations in Petrograd and elsewhere) was the most tangible result of the avant-gardists' attempts to create a museum culture in the revolutionary state. They had been developing their plans for a new kind of museum since joining the People's Commissariat for Enlightenment, rejecting the traditional model of museums as temples for the preservation and display of historic artefacts. They wanted their new museum to serve as a platform for the development of contemporary art. Their opinions differed, however, on exactly what form it should take, what

programmes should be implemented, and what role should be played by any potential collections. From the outset, funding and accommodation were provisional, insufficient, or simply non-existent. Again, they were subjected to active sabotage by the middle management of the People's Commissariat. They were also forced to do battle with the old cultural elites, who were still at work in the traditional museums and who saw the aspirations of the avant-gardists as a threat to their own position.

Driven by their insatiable thirst for action, the avant-gardists nonetheless succeeded in achieving some rapid and noteworthy results. They agreed on a name – the Museum for Artistic Culture – and opened their first sites in Moscow and Petrograd in early 1919.[12] Shortly thereafter, new branches were opened in twelve different regional capitals. Initially, the regional venues consisted of nothing more than a room in an existing museum or education institution; however, they were allocated substantial collections of avant-garde art to put on display. This unique instance of regional art dissemination means that, even today, it is possible to encounter works by Kandinsky or Malevich in Siberia and Central Asia.[13]

The conceptual development of these museums was still in flux, and the avant-gardists decided to continue discussions on the new institutions' form and purpose after they had opened. Of course, they had hoped to present the museums as a fait accompli. Though understandable, this strategy left the new museums vulnerable – especially when the NEP was introduced, and their already meagre budgets were slashed.

Because of the radical theories that were being developed at the Museums for Artistic Culture, they have garnered quite a reputation, and some lustre in historical writings on the avant-garde. This applies to the Moscow branch especially, thanks to the directorship of first Kandinsky and then Rodchenko, and to the influence of constructivism on the development of Bauhaus and on the body of thought surrounding art and art education across the world.

All of the major Moscow avant-gardists were involved or associated with the museum via INKHUK, the 'institute' that acted as its 'research branch'. It ran conferences, and there were various working parties that discussed the role of painting, public art, architecture and design. Architects, composers and choreographers all contributed, and it was there that Kandinsky began to consolidate his theories on education. Popova investigated whether there was a place for painted art in the new world; Lissitzky, Rodchenko and Stepanova frequently gave lectures;

and when Kandinsky was obliged to make way for Rodchenko in 1920, the Moscow museum became a constructivist think-tank.[14]

However, these success stories mask the fact that, throughout its existence, the museum enjoyed only limited functionality as a public institution. It was never allocated permanent accommodations, and its avant-garde collection was continuously shuttled between travelling and temporary locations, none of which were official museum spaces. The material conditions were lamentable from the start, and only worsened from 1921 onwards. It was up to the new director, Alexander Rodchenko, to try to save the museum. Towards mid-1921 especially, his complaints to his superiors became ever more dramatic, claiming that they 'disregarded the interests of the museum entirely'.[15]

Rodchenko's increasingly terse reports on the state of affairs at the museum read for all the world like a Monty Python sketch: the offices had 'no paper, and no light'. There was 'only cold water, and no functioning toilets'. The staff salaries were paid partially and too late, or not at all. There was 'no money for postage stamps'. Rodchenko asked for new shoes for his museum couriers, 'because there was no money for the tram', and no telephone. They had no means by which to hang the paintings on the walls, nor any packaging materials for their safe transport.[16] There was nowhere to hang the artworks anyway, so they were 'dumped in a corner' or 'in crates'. Within several months, 'the paintings had been hauled from place to place six times'. His final report was hand-written: 'The secretary did not receive his promised rations, and so there is no secretary. There is no money, the typewriter is broken.'[17]

One might say it was the beginning of a truly non-objective world – literally.

On 8 November, Rodchenko asked to be 'relieved of his duties', quite innocently adding the request: 'Could you come and pick up the collection?' Then again, on 21 December, 'I hereby take leave of my responsibilities....Everything has reached a complete standstill.' It would ultimately be nearly six months – during which time the museum remained closed – before his resignation was accepted.[18]

For several years, under the auspices of a different director, the collection remained on display in the showrooms of Vkhutemas, the art academy in Moscow, where it was principally accessible to students.

These events notwithstanding, the avant-gardists' position in late 1921 was not yet hopeless. In spite of the harsh attacks by the realists, Vkhutemas had managed to retain, and even somewhat strengthen, its

position as a bulwark of progressive thought, since the majority of students now supported the school's innovative trajectory. It grew in size and professionalism, and the avant-gardists came to see it as a reliable source of income, of working space and of social status. During the first year of the NEP, its personnel included Kandinsky, Klyun, Udaltsova, Rodchenko, Gabo, Ekster and Yakulov.

The Petrograd branch of the Museum for Artistic Culture saw fairer weather than its Moscow counterpart. This was due largely to the ambitious intervention of Tatlin, who, in conjunction with his fellow member of the 'daily management' Punin, determined its policy direction. Thanks to Tatlin's informal leadership, the museum in Petrograd flourished into a local centre for the avant-garde. The economic situation in Petrograd was far worse than in Moscow, which in a certain sense worked in the avant-gardists' favour. The population had plummeted owing to the departure of aristocratic families and the transfer of government to Moscow, and the city was full of enormous empty buildings, ripe for appropriation for cultural purposes. Tatlin and Punin succeeded in obtaining the magnificent Myatlev building, a classical eighteenth-century palace prominently located in the heart of the city, in the middle of Isaak Square. The building had been abandoned in 1918 with the original interiors left partially intact, and offered space not only for a museum, but also for studios and even living quarters.

So it was that in 1922, two bastions of the avant-garde remained: Vkhutemas in Moscow, and the Museum for Artistic Culture in Petrograd. It also seemed as if a consolidation were under way, and that although the avant-gardists had lost much, these final enclaves could no longer be taken from them.

The Avant-Gardists in Europe

Their tentative hopes were bolstered by successes outside the Soviet Republic. While the avant-gardists' position at home was becoming more and more tenuous, their fame and reputation in Europe was on the rise. The most tangible manifestation of this development was the (now legendary) First Russian Art Exhibition, a comprehensive presentation of Russian art held in Berlin's Van Diemen Gallery in 1922. The exhibition travelled on to Amsterdam (where it was hosted by the Stedelijk Museum) and would go down in history as one of the most influential exhibitions of the twentieth century.

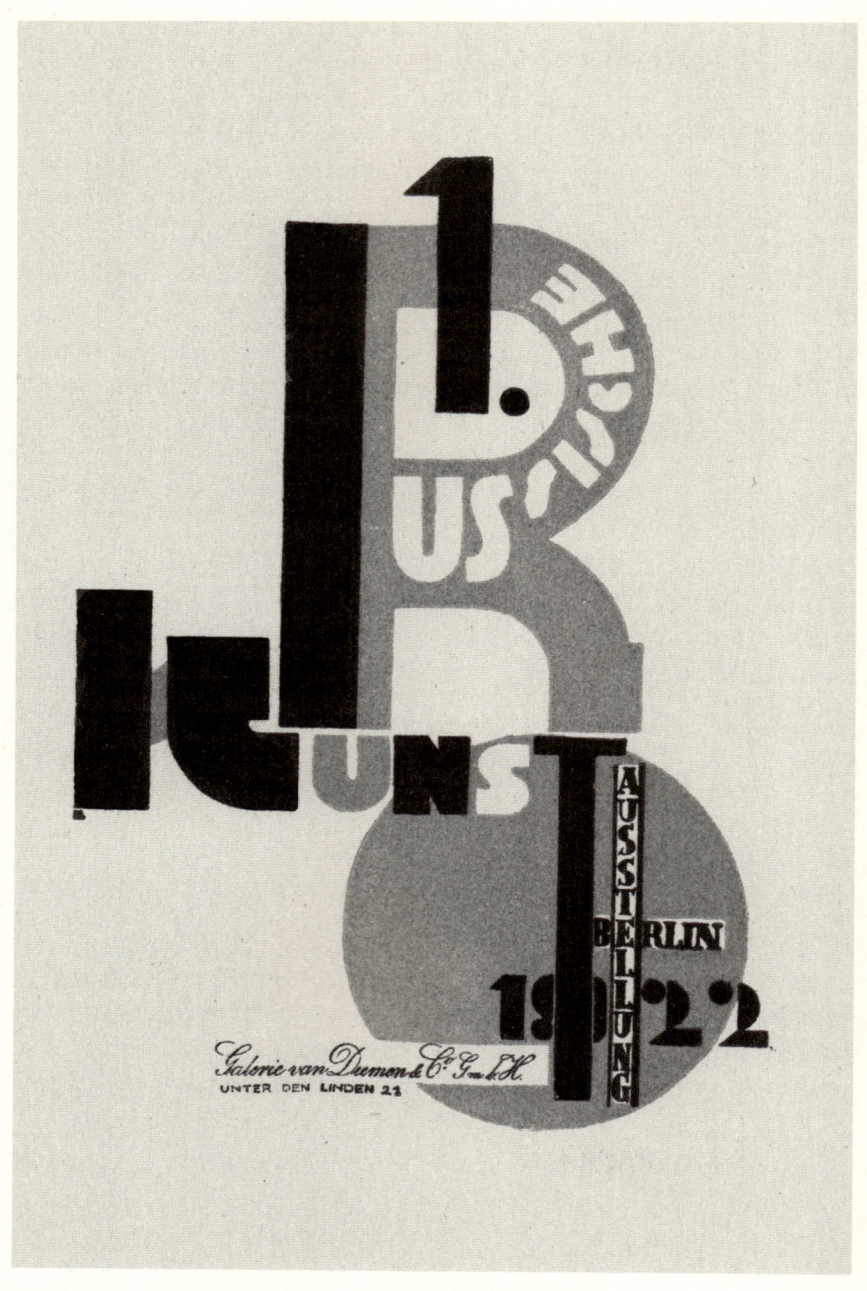

Catalogue of the First Russian Art Exhibition in Berlin, 1922, and the Amsterdam version, with city and museum names stuck to the cover on pink strips of paper.

Room in the First Russian Art Exhibition, 1922, with a
relief by Tatlin on the wall and a sculpture by Naum Gabo
in the foreground.

The avant-gardists' growing international reputation did have some
prehistory, however. As early as January 1919, the Department of Fine
Arts had set up an 'International Bureau' whose job it was to reach out
to progressive artists and institutions in Europe. It was a direct offshoot
of the Komintern founded in 1919, the organization intended to cham-
pion the worldwide revolution. Sofia Dymshits was the president of the
International Bureau, with her boyfriend Tatlin as her deputy and secre-
tary. The fact that the bureau acted officially in the political interests of
the Komintern is evident from their manifesto, which listed 'the battle
to realize global socialism' as its primary goal. The typical avant-gardist

belief that artists should be at the vanguard of such developments is also evident from the manifesto, in which the artists state that they should work for 'the unification of progressive champions of new art, in the name of a new global artistic culture'.[19] Via the International Bureau, the avant-gardists hoped to 'initiate a direct dialogue about artistic issues with artists all over the world'.[20] As usual, the programme was launched with unbridled energy, unparalleled ambition and a complete lack of any financial resources. Among other things, the bureau planned the publication of a journal (the *Art International*), to be published in seven European languages. The preparations were in full swing – Malevich had designed the cover, he and many others had written articles, and translations had been produced (all unpaid, of course) – when the publication was cancelled because the People's Commissariat refused to supply any paper.

Not long after the journal's failure, Tatlin and Dymshits moved to Petrograd, leaving the organization without its two leaders, and the bureau entered a comatose state. Shortly thereafter the International Bureau was shut down, as the avant-gardists in the People's Commissariat went into free-fall.[21]

During its brief existence, though, the bureau did manage to chalk up some major successes. Thanks to the efforts of Sofia Dymshits and her staff, the German journal *Das Kunstblatt* published in March 1919 an article by Lunacharsky outlining the policy platform of the People's Commissariat for Enlightenment.[22] It was a summary in short sentences of the various branches of the Department of Fine Arts, including their presidents and portfolios, which showed the Germans that such artists as Tatlin, Malevich and Kandinsky occupied important management posts in the new People's Commissariat. The article elicited responses that were both passionate and positive: in the Netherlands, these included pieces by Theo van Doesburg in the April 1919 edition of *De Stijl*, and by Willem Steenhoff, then co-director of the Rijksmuseum, in *De Nieuwe Amsterdammer*. These were followed in January 1920 by a Dutch translation of the article from *Das Kunstblatt* in *Wendingen*, the journal issued by the Amsterdamse School. One month later, Wassily Kandinsky sent an open letter to the German newspaper *Die Freiheit*, containing an enthusiastic report on the burgeoning cultural life in the Soviet Republic. In it, Kandinsky praises the Plan for Monumental Propaganda, and the collaboration between architects and sculptors. This letter, too, was eagerly received by like-minded Europeans, including Henriette

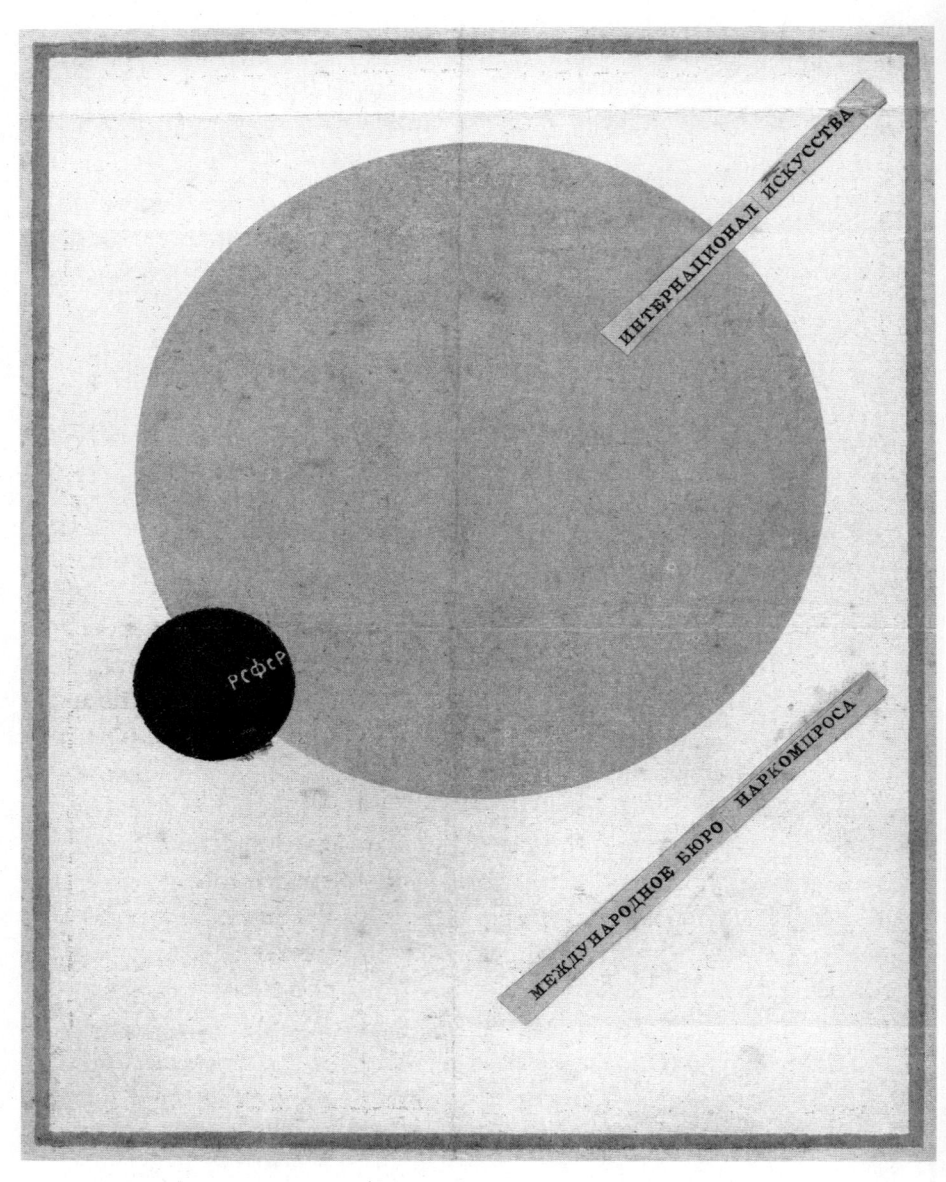

Kazimir Malevich, cover design for the *Art International*, 1918.
Occasionally attributed to Alexei Morgunov.

El Lissitzky, cover design for *Wendingen*, 1921.

Roland Holst, who lavishly cited Kandinsky in a laudatory article in *De Nieuwe Tijd*.[23]

The engagement of progressive artists in Europe was a clever move. One example of its effectiveness was a campaign to improve Dutch–Soviet relations launched by several Dutch artists, including Chris Beekman and Robert van 't Hoff (who worked for *De Stijl*), and Amsterdam sculptor Hildo Krop. The Netherlands did not acknowledge the sovereignty of the Soviet Republic, and had even halted all postal communication between the two countries. The artists wrote to the Lower House of the Dutch Parliament, requesting that the post be reinstated in order to allow communication among artists.[24] The attachments to the letter included the *Das Kunstblatt* article by Lunacharsky, one by Steenhoff from the Rijksmuseum, and notes by Theo van

Doesburg, stating with some admiration that 'the Commissariat has secured the collaboration of the most progressive "radical" artists – including Kandinsky'.[25] Kandinsky! That was the name they chose to make an impression on the members of Parliament. The letter was published in its entirety in *De Tribune*, a communist newspaper, and became the subject of fervid discussion in progressive circles.

The letter's political effect was limited. It ended up with Foreign Affairs, who wrote to the House about it then took no further action. But Lunacharsky still had reason to be happy – he had shown that his international cultural politics were capable of galvanizing the Europeans, and sparking discussion in their political elite. A success of this nature was no trivial matter for the young Soviet state, which still remained unrecognized by all of the large European nations.

Strangely enough, all of this took place when the avant-gardists had already begun their tailspin within the government bureaucracy. By the time Van Doesburg and his friends launched their campaign, Tatlin and Malevich had already left Moscow, followed by Kandinsky soon after, and their leadership roles in the People's Commissariat were no more.

Lunacharsky was reminded, all the same, that the avant-gardists had contributed to the formation of a positive image for the Soviet state, and so he continued to support their international promotion. In so doing, he helped widen the ever-increasing and problematic gulf between the art actually propagated in the Soviet Republic, and the art that progressive Western audiences expected from it.

The avant-gardists themselves had their own reasons for cooperating with international efforts. After years of isolation, they were eager to pit themselves against the European competition, to disseminate their own ideas and adopt those of others. And, as was the case everywhere, foreign praise brought domestic status. They undoubtedly also hoped – however dimly – for income from abroad. Lastly, international exchanges paved the way to accessing a highly coveted document that was becoming increasingly difficult to obtain: a travel visa.

Travel visas played a crucial part in Bolshevik power politics. Although the Bolsheviks had demanded the abolition of passports prior to the revolution, they instituted passport checks almost immediately thereafter, followed by emigration restrictions two months later. The party leaders understood that the steady exodus of the well educated constituted a threat to the continuity of the revolutionary state, and decided to permit foreign travel only under strict conditions. To this end,

June 1919 saw the introduction of general travel visas (known as 'foreign passports'). They were issued by the secret service, and only to citizens who were 'loyal to the Soviet Republic'. The move was an unprecedented limitation of individual freedoms, and one that potentially turned all citizens of the Soviet Republic into slaves of the state.

Opinions in the government were divided on exactly how to stem the exodus of the intelligentsia. Lunacharsky, who saw great value in international exchange among artists, was diametrically opposed to Felix Dzerzhinsky, the head of security and architect of the 'Red terror'. Lunacharsky consistently approved applications for travel visas, provoking the ire of Dzerzhinsky, who complained to the Central Committee. He argued for a blanket travel ban on all artists, stating that hitherto 'not a single one of the "artists" supported by Lunacharsky has returned', and that many of them were now 'conducting malicious campaigns against us [in the West]'.[26] Lunacharsky countered with a technocratic argument, claiming that a blanket travel ban would only lead to illegal emigration, which he believed was already happening on a large scale. He stated that 'their shameful exodus will only stop if we cautiously give artists the opportunity to travel abroad on a temporary basis'.[27] He also proposed making the artists' institutions partly responsible for their return, to allow sanctions to be imposed in cases of desertion.[28]

This conflict in the leadership remained temporarily unresolved, and Lunacharsky continued to send artists to Europe for some time, though internal criticism of his 'indulgent actions' increased. It is well to note that Dzerzhinsky and Lunacharsky both wholeheartedly supported the notion that the revolutionary state should be a prison, and that escapes should be prevented at all costs. Their disagreement merely concerned the method to be employed: Dzerzhinsky believed in stricter monitoring of the walls and fences, while Lunacharsky felt that escape attempts could be reduced by granting the prisoners occasional leave.

Malevich was especially eager to present himself in Europe. His ambitions had always been supranational – indeed, to him the concept of 'nationality' was nothing more than 'a grave error, a logical misunderstanding'.[29] That he himself was a Polish provincial who spoke neither German nor French was irrelevant. He was also well aware that Kandinsky and Tatlin had aroused foreign interest, and his untempered ambition to be the leader of the avant-garde movement required that he should attain the same status outside of Russia.

Polina Khentova, Berlin 1922.

Malevich's ambassador was Lissitzky, whose task it was to facilitate the rapid expansion of Malevich's European network. Lissitzky had stayed on in Moscow as the UNOVIS chargé d'affaires, after Malevich and his pupils returned to Vitebsk in 1920. He represented Malevich's interests, and visited his wife Sofia and daughter Una in Nemchinovka.

Lissitzky wrote long letters to Malevich, reporting in meticulous detail on everything he did, as though he needed to account for every minute spent in the absence of his master. His letters, therefore, lack the elevated, intellectual aplomb and disdain for mundanity that so characterize Malevich's writing. He liberally sprinkles his letters with obligatory pleasantries and anecdotes, seemingly trying to curry favour with Malevich. He flatters him by saying that Una, then just seven months old,

'is the type of daughter one would wish for oneself. Everybody says she takes after her father, which is true'.[30]

Malevich had charged Lissitzky with campaigning for him as president of the International Bureau – evidently the news of the bureau's closure had not reached Vitebsk. Not long afterwards, Lissitzky learned from Shterenberg that he had assembled a committee to organize an exhibition of Russian revolutionary art in Germany. Lissitzky immediately offered his services to Shterenberg, listing his familiarity with the German art world among his qualifications.

Lissitzky's reasons for wanting to visit Germany were not exclusively professional, however. For some time, he had been deeply in love with Polina Khentova, a sculptress who, just like him, had studied under Yehuda Pen in Vitebsk. She had left for Berlin, and Lissitzky wanted to pursue her. He was, therefore, especially eager to go to Germany, and his businesslike determination did not fail him.

Shterenberg was irritated by Lissitzky's persistence, and believed that he would never be granted a travel visa – only he himself enjoyed sufficient regard to receive such an honour. Lissitzky, unperturbed, responded: 'Well, we will see about that.' Shterenberg replied by saying that if Lissitzky were permitted to go to Europe, he would undoubtedly never return. It was a bold accusation, but Lissitzky answered coolly: 'There is a crystal-clear reason for me to come back.'

SHTERENBERG: 'Let me guess, you want to go to the West to tout
 UNOVIS.'
LISSITZKY: 'You haven't the faintest notion of what UNOVIS is.'
SHTERENBERG: 'Oh yes I do. I got hold of one of your Vitebsk
 pamphlets, with Malevich's square on it.'
LISSITZKY: 'We are not taking art to the West – we are taking
 communism.'[31]

Lissitzky was perfectly sincere, and had every right to try to dispel Shterenberg's suspicions. He was a confirmed communist and, to him, disseminating avant-garde art was a part of propagating communism. The controlled manner in which he countered Shterenberg's arguments, and his apparent confidence in his ability to obtain a travel visa, also suggest that he had access to connections and avenues within the bureaucracy that were unknown to Shterenberg.

In any case, Lissitzky eventually obtained his visa, with or without Shterenberg's help. In December 1921 he left for Germany, and he would return to the Soviet Union of his own accord in 1927.

Kandinsky Leaves the Soviet Republic

Another important 'intermediary' between the Russian avant-garde and the West was Kandinsky. He was by far the greatest international celebrity, with a reputation in Europe dating from long before the First World War. He was more diplomatic than Malevich and Tatlin, and his legal background helped him to deal with the bureaucracy of working in the People's Commissariat for Enlightenment. His age distanced him somewhat from the younger artists, but indubitably also afforded him a sort of status. Lunacharsky and Shterenberg were utterly convinced that his efforts, reputation and seniority were invaluable. In any case, it is clear that Kandinsky's star began to rise quickly in 1919. In addition to his role as director of both the Moscow Museum for Artistic Culture and the INKHUK research institute, he was also awarded an honorary professorship at the University of Moscow, and received many opportunities to publish his writings in both Russia and Germany.

Shterenberg, however, was afraid that the burgeoning ties with Germany would lead to a mass exodus among artists. Kandinsky was his greatest concern, for the artist had expressed a desire to visit Germany for six months, and had been granted a travel visa to do so. To convince Kandinsky not to go, or at least to return of his own volition, he sent one of the Vkhutemas instructors, Amshey Nurenberg, to his door. Nurenberg had spent a long time in Paris and was friends with Chagall, as well as being a sophisticated individual who could (it was hoped) engage with Kandinsky on an equal footing. In his highly romanticized memoirs, Nurenberg describes the task given to him by Shterenberg, and his final meeting with Kandinsky:

> 'Make sure,' said Shterenberg at length, but gesticulating wildly with his right hand (his usual, characteristic manner of speaking), 'that he gets this stupid, pointless idea out of his head. Try to convince him that in a year's time, the Moscow streets will be full of plump, buxom women selling meat pies and dressed in white jackets....And the tea rooms will be restored and festively decorated, and friendly serving girls will serve sweet Indian tea with lemon, and white sushki, of course....Talk to him about his art, and convince him that plenty of articles praising his work will be written and published. And if the critics are not prepared to do so, then I – Shterenberg – will write them. I think that will have an impact on him.'

Nurenberg then went to see Kandinsky at his home.

'Colleague, what brings you to me?' he asked softly.

'At Vkhutemas, there is a stubborn rumour that you plan to leave Moscow. Is this true?'

'Yes! In several days' time I travel to Petrograd, and thence to Germany, where I am eagerly awaited. They love and appreciate me there.'

'We do not understand what moves you to leave Moscow. We appreciate and respect you here too. What else do you need? More press? That can be arranged.'

He was silent for a long time, as he considered his response. Then, staring intently at me, he said with anguish:

'Cold and hunger I can suffer, I have the strength for that. But indifference – and insulting indifference, especially – that I cannot endure. It is beyond my ability. Working at Vkhutemas is a burden to me.'[32]

Though there is no doubt that Kandinsky was exhausted by the constant battle to defend his artistic ideas, that was not the whole story.

His growing sense of alienation was the result of differences not only in ideas, but also in mentality. His politeness and aristocratic mannerisms were at odds with revolutionary mores, and were ridiculed by new realists and avant-gardists alike. In response to a 1919 exhibition in which Kandinsky presented fifty-seven works, a young, right-wing critic wrote: 'Kandinsky has delicate, feminine handwriting. His style is that of a woman convinced that she has fallen pregnant without the help of a man (by the Holy Spirit). Kandinsky's painting was born of "our nervous era" – which has already perished under the roar of 40-inch cannons – and is now living out its final days in inertia.'[33] This opinion came from the right, but the leftist view was barely an improvement. The avant-gardists found Kandinsky just as passé, a typical product of the pre-revolutionary era, with his penchant for subjective, spiritual art. Lissitzky labelled Kandinsky as a 'purely episodic phenomenon' and wrote that his paintings had 'no uniformity, no clarity, no substance'.[34] From Petrograd, Nikolai Punin kept things simple: 'Away, away with Kandinsky!' and 'Everything about his art is arbitrary and individualistic.'[35]

Kandinsky was not one to fight endlessly against attacks of this sort, and nor did he need to, for he still had some capital and enough of a reputation in Europe and the United States to establish a professional life outside Russia. But Russia did offer him the opportunity to develop new institutions, and to reinforce and safeguard for generations to come the

Alexander Rodchenko, *Self-portrait with Varvara Stepanova*, 1922.

ideas he had produced during his long career. It was these opportunities that kept him bound to the Soviet Republic.

Also, he was not estranged from all young artists: Alexander Rodchenko and Varvara Stepanova were close friends of his, despite being younger than him by twenty-five and twenty-eight years respectively, and saw him as a kind of mentor. After the campaign against the anarchists, Stepanova and Rodchenko were evicted from the apartments where they were squatting, and became homeless. Kandinsky offered them accommodation for approximately one year during 1919 and 1920 in his large family home in Moscow, where they had the use of the entire second floor. Kandinsky instructed his housekeeper to lend Stepanova and Rodchenko whatever furniture or household items they needed.[36]

This friendship between the refined Kandinsky and the two former squatters (who affectionately referred to him as 'Vasilich') may seem surprising. 'Kandinsky loves us,' Stepanova wrote in her diary, 'but is probably not entirely thrilled with us, because of our constant chaos and mess.'[37] She may have been right, but it is also clear that the relationship was of great importance to Kandinsky. He defended Stepanova against attacks by conservatives, and ensured that she and Rodchenko retained their bureaucratic posts.

Even so, when the young artists moved in, there were immediate frictions (Stepanova said, superstitiously: 'Black cats scampered between us') and relations became strained. In the autumn of 1920, as fate would have it, Stepanova and Rodchenko rebelled against Kandinsky and thwarted his plans for INKHUK, which they said had been 'Kandinskied out'.[38] Kandinsky thus lost his final link to the revolutionary youth in Moscow. The ambitious research programme that he had created for the institute was voted out, and with it, the means to develop his intellectual ideas at an institutional level.

Kandinsky had invested much in the development of his programme, which was without doubt one of the greatest theoretical texts he ever produced. It outlines a concrete process for investigating the correlation and interaction between various forms of art: music, dance, visual art and poetry.[39] He sent a copy of it to another key figure in the avant-garde: Walter Gropius, the theoretician and founder of the Bauhaus school, which would rapidly grow into one of the most important centres for global avant-garde art.[40] Kandinsky's contact with Gropius gave him (Kandinsky) confidence that in Germany, his ideas would be taken seriously.

Lastly, Kandinsky's son Volodya died in the summer of 1920, having just turned three. Nothing is known about the background to this tragedy: Nina Kandinsky wrote nothing about the birth or death of Volodya in her memoirs, and the subject remained taboo thereafter. It was never publicly discussed, nor even mentioned in their correspondence, which only serves to underscore the severe impact it had on the family. In short, there was little reason to stay in a place that was the focus of such sorrow.

On 5 October 1920, Kandinsky was given permission to travel abroad as a delegate from the Academy of the Arts for a period of six months, 'to establish connections and foster long-term partnerships with persons and institutions of cultural significance', with his wife Nina in the role of secretary.[41] Some time between 16 December and Christmas of that year, he left his fatherland, never to return.

The Letter from Beekman and Van 't Hoff

Before his departure from Russia, Lissitzky had already established contact with various avant-garde artists in Germany and in the Netherlands, and collected journals and visual materials by German,

Dutch and possibly also Hungarian artists. Lissitzky clearly expressed his opinion of the artworks in a letter to Malevich: 'We can learn nothing more from them.' He did note, however, that abstract art was advancing everywhere, and that this fact could be used in their battle against the rise of populism and conservatism they had observed in Russia. 'Though it is true that those in the West are extremely interested in the Russian revolutionary art movement, their knowledge and opinions of it come exclusively via Kandinsky. This must stop.'[42]

In the spring of 1921, Lissitzky arranged a meeting between Malevich and some international artists who were visiting the Soviet Republic. At least one of these was the Dutch communist artist Peter Alma, who attended the third congress of the Komintern that April.[43] He had brought a letter with him from two members of De Stijl, Chris Beekman and Robert van 't Hoff, who invited Malevich to seek contact with De Stijl and other leftist artists. Shortly thereafter, Peter Alma published an article on contemporary Dutch art in the journal *Tvorchestvo* (Creation).[44]

Nearly all artists in the De Stijl movement were more or less confirmed communists, though only a few actually belonged to the Communist party.[45] Theo van Doesburg, Peter Alma, Chris Beekman and Robert van 't Hoff nurtured especially high hopes for the Russian revolution, and had been attempting to make contact with artists in revolutionary Russia for some time. Van Doesburg had already sent De Stijl's manifesto to Lunacharsky in 1919.

Malevich now had the material from Alma, and the letter from Beekman and Van 't Hoff. Whether he knew anything further about radical Dutch art is unknown, but it was more than enough to arouse his interest. 'The works are still hobbled and flat, and although we can say the Dutch are better and more progressive than the rest, still they need to learn from us.'[46] He started writing a long letter addressed to his 'Dutch comrades'. Given the effort he put into the letter and its length, it was no triviality to Malevich. Exactly how much he knew about De Stijl is unclear. Had the material from Beekman and Van 't Hoff included Mondrian's work? Or other abstract works? This seems likely, and Malevich appears to refer to this when ending his letter with the salutation 'Long live the non-objective Netherlands!' – an exclamation that is now almost endearing in its unworldliness.

There are two versions of the letter: a draft from September 1921, and the version ultimately sent to the Netherlands in March 1922. Extensive revisions were made during the intervening period, perhaps even carried

out by Lissitzky. Although Malevich might have been expected to keep in mind the prying eyes of the secret service, there is little evidence that he did so: both versions include an extensive and highly critical description of the state of Russian art, though the unrevised version is more emotional and personal in tone. In the second draft, for example, Malevich writes that 'the barbaric conditions of our life here make it impossible for me to photograph and send our work to you. Nor can we publish our reams of written articles, not even in a newspaper'. He follows on immediately with a caustic polemic against the state of cultural policy, which once again was giving free rein to artistic organizations such as Mir Iskusstva. 'It is nothing but an artist's graveyard, their stagnation is terribly saddening, the sign of death or the magic circle hangs above their heads.' He then associates his disdain of these bourgeois artists with a powerful rejection of a new group of artists, 'the constructivists', whom he judges for their utilitarian interpretation of art. In fact, his opposition to the movement – which he clearly identifies as his final ideological arch-nemesis – forms the core of the letter, perhaps because he could sense that the Dutch artists who wrote to him were themselves tempted to trade in the utopian, philosophical view of revolutionary art for a far more pragmatic, utilitarian variant. All in all, the letter exudes an air of genuine disappointment and fierce internal conflict, an attitude that optimistic communists such as Beekman, Van 't Hoff and Alma could certainly have done without. The unedited letter even concludes by lamenting the failure to set up a Museum of New Art in Moscow, whereupon Malevich notes, crestfallen, that 'the other [conventional] museums have not yet shut up shop, and are permeated by the smell of death. That is the situation here, and it is probably no better where you are. But you can all be forgiven, since you did not have a revolution.'[47] It is difficult to believe that Malevich hoped to rouse enthusiasm for the Soviet model with such observations. If so, he did not succeed – the letter fell on barren soil. In late 1919, Beekman and Van 't Hoff even distanced themselves from the utopian form of communism championed by Van Doesburg and Mondrian, and instead dedicated themselves and their art to the emancipation of workers. One consequence was their rejection of abstract art and their departure from De Stijl, with its philosophical and intellectual aspirations. Even though Beekman had sent reproductions of his abstract works (from 1919) along with the letter, by the time Malevich's answer arrived, he had already switched to a figurative, illustrative style of painting full of healthy labourers, preparing

themselves for their entry into a new world. No serious correspondence ensued, although Beekman and Van 't Hoff did send several more reproductions of their own works years later. Malevich must have been disappointed, as he had spent those years doing all he could to establish contact with like-minded international artists.

When he heard from Lissitzky that Shterenberg was preparing an exhibition in Berlin, Malevich was immediately beside himself and wrote an angry letter to Shterenberg stipulating which of his works should be put on display. The entire letter smacks of desperate powerlessness and rage, since he felt ostracized in Vitebsk, and at the mercy of those who simply refused to comprehend the fundamental and obvious interests served by the dissemination of the new art. Malevich came to view Shterenberg increasingly as a failed bureaucrat, one who was responsible for ceaselessly eroding the position of the avant-garde. 'You, David Petrovich [Shterenberg], are at the helm, and must therefore answer to history as a statesman. That is why I turn to you, for you hold the power. I have ideas but no power, which is why you must do what I ask of you in this note.'[48] The fact that Shterenberg was actually the only person still defending the futurists at the People's Commissariat, and that he tried to salvage what he could through compromise, was irrelevant to Malevich. He himself never compromised, after all: what was compromise, if not defeat?

The First Russian Exhibition

Unsurprisingly, Shterenberg took little notice of Malevich's demands. There were far too many other interests at stake. The exhibition was being held in the context of the approaching conciliation between the German Reich and the Soviet Republic, which would ultimately lead to the Treaty of Rapallo (in April 1922) and the restoration of diplomatic and economic relations between the two governments. Shterenberg was navigating a diplomatic minefield, especially since Lenin had granted the project his personal approval.[49] Shterenberg bypassed Lissitzky, instead asking Kandinsky to submit the exhibition proposal to the German authorities.[50] Shterenberg curated the exhibition, which contained works from as many different movements and artists as possible, including Alexandre Benois and other members of Mir Iskusstva.

The exhibition opened on 15 October 1922 in the Van Diemen Gallery in Berlin, a large commercial exhibition hall on Unter den Linden. The choice of venue was prompted by the Russians' desire to sell some of the

art on display and donate the proceeds to famine relief. The catalogue lists nearly 600 numbered items, but many individual numbers refer to multiple artworks: ten of Lissitzky's PROUNs, for example, were listed as a single item in the catalogue, as were 11 abstract works on paper by Rodchenko. Altogether the catalogue lists over 750 artworks and another 100 pieces by students, 100 porcelain objects, 40 posters, 36 carved semi-precious stones, 26 toys made by children, 10 artisanal craft objects, 35 sewing patterns and 2 dresses. They total over 1,100 works – and even this figure is probably on the conservative side. Shterenberg gave the approximation of 'over one thousand works by around 180 artists'.[51]

There can be no doubt that the avant-garde drew the most attention. Information on the exhibited works is patchy, but an estimate based on the catalogue suggests that some 20 or 25 per cent of them were by avant-gardists, and a far larger proportion by conservative modernists, impressionists, post-impressionists, Cézannists, etc. The new realists (such as Katsman) were conspicuous by their absence. An estimate puts total visitor numbers at 15,000. The greatest success, however, was the coverage of the exhibition by the French and German press.[52] Various purchases also made the news, such as that of Malevich's large 1912 painting, *The Knife Grinder* (see Plate 5).

Shterenberg made great efforts to have the exhibition travel to other European capitals, but he was thwarted by the lack of available funding. Ultimately the exhibition made its way to the Stedelijk Museum in Amsterdam, which was willing to make its rooms 'available for free', and arranged for duty-free passage of the artworks through customs.[53]

The exhibition opened in late April in Amsterdam and garnered much interest – even on the front page of *De Telegraaf*. Opinions were divided, and many journalists struggled with the spelling of the artists' names (referring to 'Sissitzky' in the 'Prechakovskaya Gallery'). Shterenberg – presented as a 'Russian of German origin and Israeli ethnicity' – was granted a long article in *De Telegraaf*. Conservative critics waxed facetious about the Russians' 'stovepipeism' and their 'artistic hocus-pocus'. Dutch museumgoers of 1922 proved to be no different from those of today. Confronted by the 'art' of 'extreme modernists' such as Tatlin and Malevich, they 'insisted on knowing what it meant and what it was good for'.[54] Peter Alma gave guided tours every Saturday and Sunday afternoon, and Willem Steenhoff gave introductory lectures.

Though Lunacharsky made a good impression on progressive European groups, for his audiences at home he felt the need to issue

Deputy director of the Rijksmuseum, Amsterdam, and Russian-art propagandist, Willem Steenhoff.

strong criticism of the exhibition. He was well aware that it was far too 'left-leaning' and radical for his own rank-and-file, and so he let loose in a long article for *Izvestia*: the exhibition should not create the impression, he wrote, that radical art was the 'victor' in the Soviet Republic. The avant-garde only dominated in Berlin because the 'right-wing' realists 'asked too much for their work'. Although he admitted that the art on display was 'second-rate', he noted that 'it was still heartening to see that even this exhibition of secondary paintings and sculptures, with its strongly leftist bias and undertones, was still a flattering success for us'.[55] With clever phrasing such as this, Lunacharsky successfully distanced

himself from the exhibition's content, while still claiming credit for its success. Quite a feat.

Through Lissitzky, however, we know that the avant-gardists themselves were disappointed with the exhibition, precisely because it was not radical enough, with 'far too much variety' and 'lots of unnecessary padding'.[56]

Lissitzky's description, however, does an injustice to the event. How could the exhibition be anything other than radical and provocative, when it contained dozens of suprematist and abstract paintings and drawings by Malevich, Rodchenko, Popova, Kandinsky, Klyun and others? Not to mention a counter-relief by Tatlin and over twenty constructivist sculptures, including a number of 'constructivist heads', plus glass and kinetic sculptures by Naum Gabo. No other country in Europe at the time could have displayed such a variety of innovative and highly developed conceptual art.

The exhibition caused the reputations of the avant-gardists to skyrocket, as the most progressive artists in Europe, and ensured an ongoing interest in the production of radical art from the Soviet Union. One of the knock-on effects was the increase in European commissions offered to Soviet artists, which allowed some of them to try their luck at careers in Europe. Gabo, for example, developed a light show for Berlin, gave lectures throughout Europe and worked for a range of architects. The effects were also palpable at the Bauhaus school, where both Kandinsky and Van Doesburg taught in 1922. Gabo drew the attention of not only Peter Behrens, but also of other artists such as Kurt Schwitters, Hans Richter and Marcel Duchamp. Lissitzky, who had been in Germany since May 1922, already knew everyone there was to know. He single-handedly filled an entire edition of *De Stijl*, and made the designs for another journal, *G*, in 1923. In that same year he gave lectures in Rotterdam, Amsterdam, The Hague and Hannover, and did the layout for the journal *Wendingen*. Some of the artists who had travelled to Berlin, including Wassily Kandinsky, Naum Gabo and Lissitzky, did not return to Moscow. Their departure made the avant-gardists' position at home even more fragile – the loss of Kandinsky in particular was sorely felt.

None of the artists saw their 'exodus' from the Soviet Republic as permanent, however. Lissitzky returned to Moscow several years later, and Kandinsky – so as not to cut ties with Russia completely – retained his membership at the Academy of the Arts until 1929.[57] Gabo even considered returning to Russia, until 1937.[58]

Organisers of the First Russian Art Exhibition in Berlin, 1922, including David Shterenberg (seated), Nathan Altman and Naum Gabo (second and third from right). In the foreground is Gabo's *Constructed Torso*, 1917.

One month after Malevich's letter arrived in the Netherlands, Van Doesburg met Lissitzky in Berlin. The two men felt an immediate affinity with each other's work and thought. Lissitzky also talked extensively about Malevich with Van Doesburg, who subsequently became enraptured by the former's *Black Square*. Independently of Malevich, he had himself reached the conclusion that 'the square means to us what [the cross] meant to the first Christians....The synthesis of a new faith.' Shortly thereafter, he voiced his desire to proclaim 'the International of the Square'. To him, the square was not merely a symbol, but 'a sign or emblem enabling the unification of the universal', and he even spoke of 'the religion of the square'.[59] Van Doesburg's enthusiasm is also evident in the amount of space he dedicated to the avant-garde in several editions of *De Stijl*.

In June 1922 he published Lissitzky's article 'Proun', and the September edition included his own article titled 'Balance of the New: Visual Russia' (*Balans van het nieuwe: Beeldend Rusland*) in which he identified the Russian artists as the greatest leaders in the international development of the arts. No other nation on Earth, wrote Van Doesburg, 'could come to the profound realization that new art is the result of the

Wassily Kandinsky, by Hugo Erfurth, 1924-28.

intrinsic maturity of humanity'.[60] The article also contained reproductions of works by Russian avant-gardists, the most significant of which was *Black Square*; it was the artwork's first appearance in an international publication.

The curious kinship between Malevich and the artists at *De Stijl* did not go unnoticed. In Germany, Ilya Ehrenburg described with amazement how it was precisely the forced isolation of the war years that seemed to result in revolutionary ideas, which were occasionally reflected in the art of other countries:

> During the war, everyone...was isolated from one another. But in 1918, after a four-year separation, painters and writers realized that, without knowing it, they had arrived at the same conclusions. Russia offers an even better example: four years of total isolation followed by another three of near-complete separation, no books, no journals, no letters. The result: the abstract art of Malevich, Rodchenko etc. Mondrian and Van Doesburg stumble across it in the Netherlands.... One idea, one will, one work. Those seven years did not pass in vain.[61]

Ultimately, however, these curious parallels did not lead to a more intensive exchange or a deeper connection between the Russian and Dutch

artists. Part of the reason was because Malevich, after his departure from Vitebsk and the closure of UNOVIS, was forced to put all his energy into creating a new platform for his activities.

Tatlin's 'New Everyday'

As mentioned above, Tatlin had found a permanent position in the Petrograd Museum for Artistic Culture, where he lived and worked. The small museum, which did not officially open until April 1921, was staffed and run almost exclusively by avant-gardists, nearly all of whom were friends or supporters of Tatlin. Second-in-command was his loyal comrade Nikolai Punin, and together they were the driving force behind the institution.[62]

In Petrograd, Tatlin again naturally gravitated to the head of the avant-garde. He established and led a new artistic society, 'New Directions in Art', an informal partnership among the city's leftist artists. Under this new banner, he organized lectures and exhibitions, and publicly presented his own readings and manifestos.

It was during this period that he continued to develop his ideas on 'material culture', which served as a response to the cosmic and philosophical pretensions of Malevich and his circle. Tatlin presented an alternative earthly and organic vision, in which the artist serves as the discoverer of the hidden reality of 'the material'. He also polemicized against the Moscow constructivists and their conviction that art should be utilitarian and reproducible – although he did agree with the constructivist position that the role of artists had radically changed, and that they should have a part to play in 'everyday life'. But effectively demoting themselves from autonomous artists to 'designers' contributing to industrial production processes was not the way. Artistic intuition was still a vital aspect, as was the 'creative impulse'. According to Tatlin, artists played a key role in society as 'material researchers', and as initiating figures with a duty to use their exceptional understanding of 'material, volume and construction' to create new artistic forms. In this way, 'pure artistic forms' could be combined with 'utilitarian purposes'.[63] The precise meaning of these statements was, of course, unclear, which can only have been intentional.

Tatlin's slogans do not constitute any 'system' or well-developed, coherent theory; on the contrary, they are always ambivalent. They are enigmatic pronouncements, intended to allow the continued survival of a purely artistic mentality, and to give autonomous creativity and

necessity a new aura in an industrializing society where everything was evaluated according to its utility, measurable growth and applicability to 'the masses'.

His definition of artists as 'researchers' (a view that is completely uncontroversial today), or as 'initiators of the new' and 'constructors' served a twofold purpose: on the one hand, he was expressing his engagement with the new industrial, democratized society. On the other, it was a response to the gnawing presentiment that such a society could only give rise to soulless efficiency and monotony, and that there would no longer be any place for the whimsical, the eccentric, the ridiculous – for creative impulses, inertia, dreams, vagueness and joyful hedonism. Tatlin did not reject the new society, that much is clear, but he was looking for a way to give artistic sensibilities – and everything that hybrid concept entailed – a central, integrated position within it. Only thus could someone like himself – an utterly poetic and desultory, but passionate, man – continue to play an important role in society.

His research into materials and constructions led to the design of various products for the 'New Everyday', including standardized workers' garb (which he called 'normal attire'), a stove and a multi-purpose kitchen pan. The label 'New Everyday' (in Russian, *Novy Byt*) was an umbrella term for day-to-day life following the revolution. Newspapers and journals devoted daily space to discussions of the topic, which included contributions from the most powerful politicians. In July 1923, Trotsky announced his new book, *Problems of Everyday Life*, and Lunacharsky made reference to it in his speeches: 'Let us cast off the grey suits imposed upon us by the small-minded bourgeoisie, and wear instead the joyful colours and hues of the masses.'[64]

Tatlin's 'normal attire' (and the long coat that was part of it) consisted of one basic component to which all manner of additions (such as pockets) could be attached. It had several layers of lining that could be added or removed as desired, allowing it to function as both summer and winter wear. The kitchen pan, with its various modular components, could serve as a frying pan, saucepan or kettle. The stove was to be constructed from the simplest possible materials, so that even a village smithy could fabricate it, and had to be able to use anything as fuel.

It might seem as though Tatlin was conforming to a utilitarian view of artistic labour and, indeed, he is often described as a propagandist of 'production art'.[65] Still, this view fails to recognize the ambivalent quality of these objects. Tatlin presented them as examples of a 'New Everyday',

Vladimir Tatlin, collage of newspaper clippings and photographs.
Top: Tatlin in a winter coat before a stove, both of his own design.
Bottom: Tatlin in his 'normal attire'.

yet one look tells us that these primitive, simple designs reflect the unprecedented impoverishment, all-encompassing scarcity and lack of the most basic survival needs that characterized the initial years after the revolution. Were these the 'joyful colours and hues of the masses'?

Furthermore, his designs were not suitable at all for mass production, but were planned so that a simple tradesperson or even a handy DIY-enthusiast could construct them. He chose items such as the stove, pan and coat because these were the first line of defence against *kholod*

and *golod*: cold and hunger, the true defining 'qualities' of day-to-day, post-revolutionary life. The items represented a standard issue for survivors, not the materialization of a glorious utopia. 'With his stove, Tatlin brought us back to reality,' Punin noted.[66] Rather than being a part of Bolshevistic utopianism, these objects make a mockery of it. Tatlin's designs represent an autarkic lifestyle, in which people live as self-sufficiently as possible.

Although Tatlin complained publicly of the meagre support he received to put his designs into production, he himself did little to make them suitable for industrial fabrication. Instead, he asked the state for a motorcycle so that he could visit the factories and disseminate his ideas among the workers himself. Clearly, this was no serious attempt to manufacture industrial art, but rather a reincarnation of the 'futuristic stunt' for which the avant-gardists had become famous ten years before. Tatlin's designs were mocked and derided for a reason: the influential theoretician Miklashevsky stated that Tatlin promoted himself not as a proletarian artist, but instead as a 'chosen one' and as a 'priest through the grace of God'.[67] In Moscow, Rodchenko equated Tatlin's behaviour to that of the typical 'Russian holy madman', due to his faith in artistic 'mysticism'.

Tatlin's unsettling ambivalence was noted by almost everyone – even Punin. Initially, the prospect of Tatlin's vision of the 'New Everyday' was anticipated with excitement. The designer of the utopian Monument for the Third International was expected to conceive of a similarly grandiose vision for the future 'salvation state'. Serious preparations were made for a film in which Tatlin would show and talk about his designs; but the plan fell through, officially due to a 'lack of financial resources'.[68] A photo report was made for a popular journal, *The Red Panorama*, for which Tatlin wore the suit he had designed. The photographs depict a well-groomed, but otherwise sombre and lanky-looking, Tatlin in his oversized 'normal attire'. Nothing in the photographs recalls the optimism of the previous years, nor the energy that had fuelled his conceptualization of the Monument for the Third International. The readers of *The Red Panorama* were served up images of the former utopian craftsman Tatlin not as the embodiment of the ideal post-revolutionary human, but as a melancholy Pierrot in a Soviet smock.

While Malevich was making efforts to launch an international career, Tatlin withdrew more and more. He focused on his students, with whom he shared a warm companionship. He made fewer public appearances, cloistered himself away in his studio (where he also slept) and worked

on his projects, aided by several devoted students. To wash, he travelled to the student dormitories on Vasilyevsky Island. One student recalls how they 'drew the bath for him. He always arrived in worker's clothing. Along the way, he would pick up pieces of abandoned rubbish from the streets, which he then tied into a bundle with wire and slung over his shoulder. This is how he walked, with other "materials" found along the way, like a fool, towering high above everybody else, to our dormitories. Once with us he took a bath, and often I dried the "master's" rippling back, while admiring his athletic figure.'[69]

After the ritual of the bath, a classical wrestling match was organized, where Tatlin played the role of instructor, and 'we finished off by singing old songs'.[70]

All would-be leaders in the revolutionary landscape were forced to fight for status and visibility. The battle for supremacy on Olympus's narrow summit was continual. While Malevich seemed fully cognisant of this fact, Tatlin appeared less and less interested in the 'public' aspect of his art. His modest presence at the Van Diemen exhibition would seem to confirm this summation. Only three works by Tatlin were included in the catalogue, including one counter-relief. And although his name was mentioned frequently in the introduction to the catalogue and in the critics' responses, his limited involvement is conspicuous nonetheless.

His model of the Monument for the Third International had remained in Moscow, in the Dom Soyuzov. Tatlin had hoped it would find a permanent home there, but instead of lobbying and generating political support, he seems to have simply let events take their course. The colossal structure was undoubtedly taking up space, and served only to remind all those who saw it of the futurists' ongoing presence, and what were seen as their imbecilic, deformed monstrosities.

The tower's days in its prominent position were numbered. This became abundantly clear in the autumn of 1922, when it came under sudden, and seemingly unprovoked, attack by Lunacharsky in *Izvestia*. 'Guy de Maupassant wrote that he was prepared to leave Paris simply to avoid having to look at that iron monstrosity, the Eiffel Tower. Well if you ask me, the Eiffel Tower is a vision of beauty compared to comrade Tatlin's twisted nonsense. I cannot be the only one who would be genuinely sad to see Moscow or Petrograd marred with this, the creative output from one of our most prominent leftist artists.'[71]

The outlook was grim. Six months later Tatlin suddenly received word from Moscow that his monument was being dismantled, to provide

'kindling for the samovar'. He was in Petrograd and could do nothing to intervene. He wrote an urgent letter to Mayakovsky: 'Please, take whatever measures are necessary, and speak up loudly at a meeting or lecture. You know what to do. Create a scandal to ensure the thing is preserved. I shake your hand.'[72] Mayakovsky's efforts – if he made any – were in vain. The mammoth tower model disappeared into the flue of a samovar and was never seen or heard of again.[73]

The unceremonious destruction of Tatlin's largest and most ambitious project – and one of the most talked-about artworks of the twentieth century – is quite astounding. If the avant-gardists ever did participate in a genuine iconoclasm, then this sole act of retribution settled the score three times over. And fire would continue to follow wherever Tatlin worked, as we shall see. It hardly seems possible that this event played no part in the new crisis in which Tatlin now found himself. 'Tatlin is at an impasse, and has been depressed now for a year or two,' wrote Nikolai Punin in his diary.[74] It was also during this period that Tatlin and Sofia Dymshits went their separate ways. After years of living and working together intimately, she – ever independent – had decided to move on. Though Tatlin would not remain alone for long, their separation must have left its mark. Sofia had been with him since the revolution, and they had remained inseparable through the triumphs of 1918 and 1919 – their appointments to the People's Commissariat, and the construction of the Monument.

Khlebnikov Leaves the Earth

Tatlin's impasse was interrupted by a piece of news that spread quickly, and deeply affected all of the avant-gardists. In the village of Santalovo, 100 kilometres (62 miles) south-east of Novgorod and nearly three times that distance from Petrograd, Velimir Khlebnikov had fallen gravely ill. His best friend, the artist Pyotr Miturich, wrote to Punin: 'Great misfortune: Velimir has suffered a paralysis affecting his legs, and partially also his abdomen and bladder.'[75] Urgent funds were required to pay for medicines and food, and to transport him to Moscow. The artistic community in Petrograd immediately took up a collection, but Khlebnikov's condition rapidly deteriorated.

Khlebnikov had been frail for several months, owing to chronic malnourishment. Now and again he received food from his friends, including the poet Osip Mandelstam and his wife Nadezhda. In her famous

Pyotr Miturich, 'Thus we rode to Santalovo', 1922
(page torn out of a sketchbook).

memoirs, Nadezhda wrote that during his last two months, Khlebnikov
had been 'closed off and sealed away':

> He sat silently on a straight-backed antique chair, sitting up straight
> and tall, and mumbling all the while with his lips. He was so withdrawn,
> he did not even hear when we asked him a question....Although his
> lips were always muttering, the rest of his face remained motionless.
> Even his head remained stock-still atop his stiff neck. He never leant
> forward over his plate, but brought the spoon up to his mouth – quite
> a long way, since his torso was very long. I do not know what he
> was like before, but I had the impression that he was in the bonds of
> approaching death.[76]

When Khlebnikov took a turn for the worse, Miturich decided to look after him. His diary, which documents Khlebnikov's final days in great detail, relates a typically Russian drama.

The poet had already been taken ill in Moscow, most likely with malaria. To aid his recovery, Miturich took him to his summer house in the village of Santalovo. Through the interminable pouring rain, they travelled by train in a fully packed, leaky goods car and slept on the bare floor. 'Velimir trembled and slumbered in his sheep's fleece.' Having reached the station, they travelled on to Santalovo by horse and cart. The road was so poor and full of rocks and potholes that Khlebnikov – already deathly ill – fell out of the cart. Once in the summer cottage, his condition initially improved, but then took another downward turn. He used what little strength he had to put his manuscripts in order. Doctors refused to come, saying that the hamlet was 'outside their district'. When he was taken by haycart to a hospital in a slightly larger town nearby, the doctors initially refused to admit him. After strong insistence, they eventually conceded. Money and bread were needed for the doctors and nurses. 'Women came, who gave the patient butter and eggs out of pity.' Miturich wrote letters to Moscow and Petrograd asking for financial help. But how was he to deliver the letters? The postal services were patchy at best, especially to Moscow. His friend Olya was prepared to take the train to Moscow and deliver the letters. She walked 35 kilometres (over 20 miles) to the station (there were no horses or wagons available) and took Fopka, the nursemaid, with her. At the station, the service-desk employee refused to issue them tickets because their identification papers had expired. All Olya could do was send the letter by post to Petrograd, and then walk all the way home with Fopka. Her feet were ruined by the long trek.

In the hospital, Khlebnikov's condition worsened: he developed bedsores, gangrene and swollen legs. His fever rose to 39.9 degrees. The news that there was an ailing poet in the district putting his manuscripts in order, being cared for by an artist who was sending letters to Petrograd, drew the attention of the authorities, who sent a police officer to arrest Miturich. He explained the situation, and the arrest was averted. Khlebnikov became so ill that the nurse and the porter refused to care for him, saying 'his tongue is black and swollen'. He left the hospital and was taken back to Santalovo, this time on a makeshift stretcher and covered by a sheep's fleece, on an ordinary open cart. On 23 June he and his carers arrived in Santalovo, where 'the whole village came out to see'. A bed was assembled in the bathhouse, with two mattresses made by the

Pyotr Miturich, *Santalovo*, 1922.

village women, and Khlebnikov was laid on top of them. A yellow jug with flowers was placed on the window-sill. One day later, a package arrived from Petrograd containing medicines and a catheter. Khlebnikov's throat began to swell up. Punin arranged for a bed in the hospital in Petrograd, but Khlebnikov was already too weak to travel – he was barely able to move, and his speech was unintelligible. On 27 June he lost consciousness, and his breathing became shallow. The next day Miturich wrote in his diary: 'Velimir left the Earth at nine o'clock this morning.' The nurse-maid Fopka bathed the body. She was fearful of zombies – a common superstition in those days – and so she gave the deceased a stern talking-to: 'Don't you dare come frighten me during the night!'

Khlebnikov was buried in the graveyard of a nearby village. On his coffin, Miturich drew a blue globe with the caption: PRESIDENT OF THE WORLD, VELIMIR I.[77]

The news of Khlebnikov's death sent shockwaves through the artistic community. From Vitebsk, Malevich wrote to Lissitzky in Germany: 'Khlebnikov is dead. To hell with all these oppressive bureaucrats, and those who support them! He died on 28 June, tortured by hunger. Tatlin and I are next.'[78] Malevich's emotional response is particularly

Велемир Хлебников ✝ 28 июня 1922.
Первый Председатель Земного Шара.

Pyotr Miturich, *Khlebnikov on his Makeshift Deathbed*, 1922.

interesting; clearly, he blamed the public officials, in part, for Khlebnikov's death, and also implicitly stated that he and Tatlin were still the leaders of the visual avant-garde.

If the poet's death came as a shock to Malevich, to Tatlin it was nothing less than 'the most significant event of our time'[79] and triggered a profound recalibration of his artistic universe. The two most important artistic projects he would initiate over the next eight years, *Zangezi* and Letatlin, were directly associated with Khlebnikov.

Khlebnikov was so beloved because he had never for a moment betrayed the avant-gardist mentality. He was equally unconcerned by public success and by his legacy. He had no political ambitions whatsoever, and wanted nothing to do with bureaucracy; he lived solely for his poetry and new forms of art. His stolid non-conformity became a beacon of sacred hope to the tormented, depressed Tatlin, and from that moment on he developed a personal cult surrounding the poet's work. 'If he were to walk barefoot on the sand, I would kiss his footprints. What a man was he! He owned nothing whatsoever that chained him to life, and remained unfettered by anything earthly...'[80]

To raise awareness of Khlebnikov's death, Tatlin hastily threw together an installation consisting of three enormously long, black-painted

Cover of Khlebnikov's poem *Zangezi*, 1922. Design: Pyotr Miturich.

boards, one of which was over 11 metres (36 feet) tall, and ten posters each proclaiming the same text: KHLEBNIKOV IS DEAD. 28 JUNE 1922. This monumental expression of mourning was included in an existing joint exhibition in Petrograd that already contained works by Tatlin, and of course has not survived. Drawing on the same idea, Tatlin conceived of a far grander and more ambitious plan for an entire performance based on Khlebnikov's final major work, *Zangezi*. This 'supersaga' unfolds the fates and voyages of discovery by the prophet Zangezi through the worlds of sound, language and *Zaum* (a term usually translated as 'transrationality'). It includes sound poetry, lyrical extravagances, mathematical formulas and prophecies from a number of 'deities' with names such as Shangti, Erot and Unkulunkulu.

The performance consisted of multiple sections that can be roughly described as 'scenes'. Khlebnikov called them *ploskosti*, which in mathematical nomenclature translates as 'planes'. The work is structured as a dramatic dialogue, with a range of protagonists who take turns to speak. Khlebnikov certainly never intended it for live performance, at least not in the traditional theatrical sense. He once cheerfully joked with Mayakovsky, saying that he was considering a work involving 'the participation of all of humanity, all three billion of them, and their participation is mandatory. But conventional language is unsuitable, and I must create a new one, step by step.'[81]

Khlebnikov's brazen exaggerations are sometimes taken very seriously. A fairly recent and authoritative publication posits that in the poem, Khlebnikov's 'ideas on sound and word, on the history of humanity, on space and time blend together into a "measure of the Earth."'[82] That may be; I personally believe, however, that greater justice is done to Khlebnikov by comments such as the following, by the Dutch translator of *Zangezi*, Aai Prins: 'We can only be grateful that Khlebnikov succeeded in capturing an utterance by Unkulunkulu that characterizes the deity so utterly: "Rapr, ghrapr, apr! Zhai! Kaf! Bzui! Kaf!"'[83] Or, in a rather more conventional formulation by Nikolai Punin: 'Khlebnikov's poem can only be understood by experiencing his lunacy.'

> I sing in ecstasy,
> I leap and dance in terror.[84]

Unusually for Tatlin, he wrote his own introductory text to the live installation, explaining that his work was not intended as a 'performance' of the poem, but rather as a three-dimensional counterpart to it.

He took three roles in the production: director, designer and lead actor. The other parts were played by students from the university, the art academy and the mining institute, wearing their own day-to-day working attire. The poster said: 'Performance of Khlebnikov's dramatic poem *Zangezi*. Produced by the "constructor" Tatlin. Participants: machines, humans, spotlights.'[85] Ultimately three performances were held, in the large hall of the Museum for Artistic Culture.

All that survives of Tatlin's installation is a few indistinct photographs of several schematic diagrams. The main structure was placed in a corner of the room: made of wood, metal plates, ropes, fabric and other materials, it reached all the way to the ceiling. The entire structure towered diagonally upwards from the ground, like an enormous rock, atop which Tatlin sat, straddling the apex, in his role as Zangezi. And indeed, the structure did include several 'machines', though their number and appearance is unknown. Later that year, Tatlin put the designs for one of the machines, 'Iverni-Vyverny', on display. During the performance, painted 'boards' with sounds written on them were lowered down from the top of the structure. As each board reached the ground (there were sixty in total, each with its own colour), its arrival corresponded with a moment in the poem at which the relevant sound played an important part. Thus, Tatlin attempted to create a material counterpart to Khlebnikov's 'language of the stars'. The extent of the 'Iverni-Vyverny' machine's involvement is unknown. The walls of the entire hall were plastered with large posters displaying quotes from Khlebnikov's poems, as well as important biographical details from his life. The spotlight 'drifted from one place in the installation to another, in order to create order and a sense of progression'. The roving beam would also seem to be a material parallel to Zangezi's language, which Tatlin described as a 'ray of light, slowly descending...from above the thinker's head to the uncomprehending crowd below'.[86]

This last remark by Tatlin implicitly contradicts the view that art should be understandable to the masses, an argument that was becoming more common in debates surrounding the arts. And although Tatlin also said that Khlebnikov's great work should be 'made accessible to the general public', this does not necessarily imply that it should be comprehensible.[87] On the contrary, the 'uncomprehending crowd', represented by the group of students, adopted a 'hostile – cautious, but hostile' attitude to the elevated prophet Zangezi on stage.[88]

Performance of *Zangezi* in the Museum for Artistic
Culture, Petrograd, 1922. Scenography: Vladimir Tatlin.
Tatlin sits straddling atop the installation.

Both before and after the performance, lectures on Khlebnikov were
given by Punin and the linguist Yakubinsky. During the interval, the per-
formance continued in the foyer, where Tatlin – dressed in his Zangezi
costume and holding several of the detached sound-boards – expounded
on Khlebnikov's poetry to the students in attendance.[89]

The *Zangezi* performance was a new step in Tatlin's weird and wonder-
ful artistic career, and all the evidence suggests that it brought him great
satisfaction, comparable to the development of his counter-reliefs or the
Monument for the Third International. *Zangezi* was innovative first and
foremost owing to its multidisciplinary character. Tatlin was no stranger

to the combination of multiple disciplines: the presentation of his reliefs had been accompanied by recitations and music, and the unveiling of the Monument to the Third International was also initially conceived as a large public performance. *Zangezi* took things much further, however, and represented a synthesis between literature, recitation and theatrical installation. Such attempts had been seen before, of course, but the exceptional – and indeed, revolutionary – facet of Tatlin's new work was his determination to avoid any semblance of a 'theatrical performance'. First of all, it took place in a museum hall without a stage or platform, changing the experience immediately. He installed the main structure in the corner of the hall, further blurring the lines between what the audience perceived as auditorium and performing space. 'Action' did not constitute the core of the production, as it did in drama, but was instead subordinate to the elements of recitation and installation. Rather than playing before a set or scenery, the performers instead formed an integral part of the installation. There was probably no audience seating, so the performers may have mingled with the public. Tatlin used students instead of actors, justifying the choice as a means of distinguishing the installation from a theatre performance: 'Professional actors are trained in the traditions of the theatre, both ancient and modern. *Zangezi* is too new to be boxed in by any traditions, whatever they may be.'[90] In short, *Zangezi* was not a piece of theatre, but was instead what would be referred to decades later as a 'museum performance', making it potentially the most forward-looking conceptual artwork in all of Tatlin's vast and heterogeneous *oeuvre*.

The work had a compelling effect on audiences. According to one of the students involved, the hall was 'packed full of young people. The audience responded enthusiastically to the performance, however incomprehensible it was.'[91] Another observer noted that although 'the young people were passionate, in general the response from the hall was tepid'.[92]

This 'tepidity' should come as no surprise. Older audience members, after all, could see that the performance was extremely anti-utilitarian and anti-democratic, and were undoubtedly mindful of the fact that one should be careful when applauding such things.

Tatlin received little feedback on the performance, except from his most trusted circle of admirers and supporters. While the discussion on his Monument to the Third International had reached far-distant shores only a few years before, *Zangezi* went virtually unnoticed.

Molecule

One ray of hope for Tatlin was the arrival of a new love. In early 1922, while visiting his friend Valentina Khodasevich, he was introduced to her bosom friend Maria Geyntse, a very petite and elegant doctor. Her nickname was 'Molecule' (Molekula),[93] and she was part of Maxim Gorky's entourage. Her father, a friend of Gorky's, was a famous progressive activist who had been killed in 1905 by a right-wing extremist.[94] Gorky took Molecule under his wing, and ever since she had lived in his house in Petrograd, in the commune that had taken shape around him. In other words, she was a member of the highest proletarian nobility within the revolutionary state. Khodasevich had spoken of Tatlin to Molecule before, describing him as a man 'who possessed the ingredients of genius'. According to Khodasevich, 'many girls dreamt of being impregnated by a genius, or in any case by a great talent, with the intention of bidding farewell to the progenitor after the child's birth and becoming a single mother, in the conviction that raising a future genius is a matter for mothers only. Molecule was one such girl.' It was a time when progressive groups campaigned openly for the 'abolition of jealousy' and the dissolution of the nuclear family.

> When Tatlin appeared, Molecule immediately let 'her eye fall upon him'. And her eyes are dark, with whites of light blue, and long lashes. I noticed that Tatlin was not unaffected. And because he had his bandura with him, he immediately began stroking its strings. Molecule quickly fell pregnant to him and moved to the Myatlev house on St Isaak's Square, where Tatlin lived and worked. I rejoiced in her happiness, but Tatlin was a complex man, and I do not know if he was equally happy. They had a son, Volodya. Molecule forgot about her belief in single motherhood, though she did find the life very hard, which is probably to be expected when dealing with such a brilliant talent.[95]

Tatlin also found family life difficult. He himself had never had trouble making material sacrifices for his art, but now he was a father, responsible for a child. His living conditions were extremely primitive. There was no kitchen in the apartment, and Molecule cooked Volodya's potatoes on a camping stove in a corner of the studio where Tatlin produced his artworks.

Malevich Moves In

To make matters worse, it was in this state of stress and bleakness that Tatlin was suddenly confronted by Malevich, who demanded space in the museum and slowly but steadily began appropriating power. Tatlin's rival had come to Petrograd in the autumn of 1922. He was granted his own studio in the Museum for Artistic Culture in December, which he opened with some of the old members of UNOVIS who had followed him from Vitebsk.

Malevich tackled everything with his usual brusque determination and was almost certainly intent on turning the museum into a research institute. Over the years, he had honed his organizational skills considerably. His habit of arguing with determination and tenacity for his ideas, liberally sprinkling them with abstract and theoretical concepts, made an impact on officials. Also, his experience at the head of UNOVIS had taught him how to navigate the rapidly expanding Soviet bureaucracy. The members of the museum committee – more or less responsible for the daily management of the institution, and including Tatlin – saw the potential value in Malevich's presence and allowed him to work on his power base. Malevich subsequently introduced his own network to the museum, all people who had followed him to Petrograd from Vitebsk, and their presence quickly tipped the balance of power. By August 1923, barely one year after his arrival, Malevich had worked his way up to the post of general manager. He had no real authority to make decisions – that power lay with the museum committee and the department heads, such as Punin, Tatlin and Matyushin. However, his position as general manager did give him access to the administrative supervisors, with whom he proceeded to develop an excellent relationship. His power, therefore, increased rapidly, and within a short time he became the most influential figure at the institute, pushing Punin and Tatlin into the background.[96] Though the organization (and even its funding) improved tremendously under Malevich's direction, it was also a time of uncertainty, instability and frustration. The most prominent historian from this period gave a terse summary: 'The arrival of Malevich represented the destruction of a more or less stable situation, in which the roles had been allocated and reputations firmly established.'[97]

Tatlin was extremely frustrated by Malevich's rapid ascent, and many within the organization shared the same aversion to his dictatorial management style. They understood, however, that Malevich *was* the best

suited to the task of massaging the bureaucracy, a skill that Tatlin possessed in relatively meagre measure. Tatlin's inability to express his ideas using theoretical or political jargon became an increasing liability to his position. Even Punin, Tatlin's greatest source of support, felt that Malevich's rise to power was their own fault. In a letter to a friend, he wrote: 'We are locked in battle with the Jesuit Malevich, who due to our own passivity has managed to push us aside....We are simply too inert, too ironic, and respond to nothing, besides money.'[98]

The museum needed a firm leader such as Malevich. The finances were a mess: promised funds were issued far too late or not at all, so that salaries often could not be paid, and everything was in short supply. Malevich sometimes had to postpone correspondence for months, as there was no money for postage stamps.[99]

Not long after his arrival, Malevich was also allocated an apartment in the museum complex, directly above Tatlin's. Now the two rivals both lived in the same building, where they maintained their studios, taught students and received guests. Malevich's immediate proximity became an obsessive fixation for Tatlin. His competition with Malevich – which was real enough – had been a part of his personal mythology since 1915, and he had exaggerated, dramatized and made public their rivalry. The measures he now took were even more extreme, and he seemed less and less able to distinguish between their real-world artistic competition and his unbridled fantasy.

Valentina Khodasevich, a good friend of Tatlin's, described the scene at the opening of an exhibition at the museum:

> Without stopping to look around, I rushed excitedly to Tatlin's room (no. 4). As I walked past room no. 2, I noticed the suprematist works of Malevich and his students. Tatlin quickly asked me to stand guard at the entrance to his room, and if I saw Malevich or 'his brood', I was to prevent them from entering the exhibit at any cost. Tatlin said he would 'run to the entrance and deal with them, and if they break through, I will rip off their noses and ears'. I was mortified, since I believed he was genuinely capable of doing so. But ultimately I grew bored of his silly nonsense, and I went in to look at his artworks. Tatlin caught me red-handed, and accused me of being unreliable...'Now I will stand guard, and let nobody through.' His complexion was grey-green, and the whites of his eyes seemed yellow. I quickly left. As I went down the stairs, I met Malevich, who issued me a calm and courteous greeting, and continued upstairs. I pitied poor Tatlin.[100]

From that time on, accounts of Tatlin's paranoia become increasingly numerous and bizarre. Tatlin shut the windows to his studio to prevent the 'villain Malevich' from looking inside.[101] 'If ever he heard Malevich's footsteps in the apartment above, he would point meaningfully to the ceiling and say: "He walks."'[102] He locked his studio with seven locks, 'and made a peephole in the wall covered by a flap, so that he could see who was at the door. If he saw Malevich walking past his studio, he issued his students with axes and told them to "guard the secrets of the studio". It was all in fun, a stupid joke, a silly game.'[103]

Tatlin's peculiar distrust was indeed a game, a complex and intricate charade designed to draw attention to his independence and eccentricity, a strategy akin to the competition often exhibited by rival student fraternities or sports teams. His obsession with extreme secrecy was no laughing matter, though, and it was not provoked solely by Malevich's proximity – when they both lived and worked in separate cities a few years later, he continued to cultivate suspicion and secrecy. A possible explanation might be Tatlin's desire to screen off his personal artistry from a society in which the state and the dominant ideology were penetrating ever deeper into the lives of citizens, steadily restricting the scope for free expression and eccentricity. Only in the strictest isolation could Tatlin recreate the utopian climate in which his artistry could flourish.

That aside, his rivalry with Malevich was still genuine, of course, and both artists seemed incapable of recognizing the fact that, along with their differences, they also had mutual interests – such as the continued survival of the vulnerable institute where they were both employed. But no: instead, their conflict continued to escalate, and would soon come to a head. And Tatlin, who already had his own internal struggles, would come off second-best.

The Battle of GINKHUK

The death of Lenin on 21 January 1924 shook the young Soviet state to its foundations. Several days later, to commemorate the fallen comrade, the city named after its original founder, Tsar Peter, was renamed 'Leningrad'.

Robbed of their charismatic leader, the Bolsheviks feared for the legitimacy of their rule. The party leadership, therefore, launched a new campaign aimed at consolidating power and suppressing dissidents. To strengthen their grip on the art world, they replaced non-partisan administrators of art institutions with party members. The People's

Commissariat for Enlightenment also launched a campaign promoting a 'unified' cultural policy, allowing for one single acknowledged form of Soviet art and leaving no room for individual experimentation.[104]

Faced with this perilous situation, Malevich tried to fortify the museum's defences by having it recognized as a research institute. He succeeded: in September 1924 he received final approval, and the museum was renamed the Institute for Artistic Culture. In March 1925 it was even renamed again as the State Institute of Art Culture, or GINKHUK (not to be confused with INKHUK in Moscow, where Rodchenko had hitherto held sway). Though a victory for Malevich and for the museum, it was not without casualties. Malevich acted with his usual stubborn tactlessness. He regularly bypassed his department heads (including Punin and Tatlin), presented them with fait accomplis, publicly voiced his displeasure at the 'buffoon' Tatlin, who had let the institute go to seed while he was in Vitebsk, and so on.[105]

His triumph was also overshadowed by family problems. In 1923 his sixty-five-year-old mother moved in with him. At around the same time, in the spring, Sofia was diagnosed with tuberculosis that soon developed into 'galloping consumption', in which the infection spread rapidly from the lungs to the rest of the body. She needed care, and so she travelled to Nemchinovka in early 1924, where she was nursed by her mother and sister. Una was there too. Kazimir's ageing mother had also become ill in the meantime, and he had to look after her while also regularly travelling from Leningrad via Moscow to Nemchinovka to visit his wife and daughter, and petition for food stamps and medicines. In October of that year, Sofia became bedridden, and all hopes of recovery fled. Because nursing the dying Sofia was so exhausting, and perhaps also to spare the child from witnessing her mother's death, the four-year-old Una was sent back to Leningrad, where she was cared for by Kazimir.

Because of the transition to a new bureaucratic structure with increased supervision, the museum's director and the department heads were asked to produce detailed reports justifying their departmental programmes and establishing plans for the future. To Malevich this was no problem (he could churn out official documents by the dozen), but to Tatlin the task was a nightmare. He agonized over his reports and submitted them days late; they were deemed 'unsatisfactory' by officials who were on good terms with Malevich. Tatlin was then obliged to provide supplementary reasoning, and he felt cornered once again.[106]

It should come as no surprise that Tatlin's maintenance of total secrecy regarding both the methods and the products of his studio found no favour with the officers in question. In June 1924, Tatlin was reprimanded by a high official because his studio was in 'total isolation' from the rest of the institute. The rebuke was justified, for as we have seen, Tatlin let nobody inside. There was even a threat to close his department.

In October 1924, the institute was visited by an inspection committee. Tatlin was reasonably well prepared for their arrival, and showed the inspectors several of the products created in the studio, such as the conceptual designs for a stove and a suit. These were well received, and the committee praised Tatlin for his 'originality' and his 'objective, intellectual approach to the creative process'. But they reiterated their demand that Tatlin do something about the isolation of his studio.[107]

Tatlin and Punin started concocting a plan to undermine Malevich's dominance. His authoritarian management style had begun to rankle with even his most loyal supporters (such as his old friend Matyushin), which undoubtedly gave Tatlin and Punin confidence.[108] The greatest opposition to Malevich, however, came from another artist, the young Pavel Mansurov (who was seventeen years Malevich's junior). He had been closely involved with the Petrograd community of avant-gardists from 1918 onwards, and had built up some standing within GINKHUK. He himself left a wonderful recollection of his first encounter with the revolutionary artists and the prevailing atmosphere: 'A kindred freshness emerged from Tatlin, Matyushin and especially Malevich. We immediately began contradicting one another, and cursing even followed, but we forever became a kind of family....Yes, we were "enemies" in a sense. But our conflicts were merely a physical medium from which new ideas were born. At night, we mulled over the day's "skirmishes." But I believe that we were all of one heart, and that without the others, each of us was as a ruined village.'[109]

Although Mansurov was right that the artists' feuds played a productive role in the creative process, the conflicts frequently got out of hand, and the resulting wounds cut deeper and deeper.

In December 1924, Mansurov went on the offensive, and found Tatlin and Punin were on his side. Together they wrote a letter to the inspectorate of the People's Commissariat, stating that the institute had become completely isolated from other academic institutions under Malevich's leadership, and that his methods were arbitrary. They asked for a new director, 'an objective figure, with authority in both academic/

artistic circles and within the party'. They also named the person they had in mind: Sergei Isakov, a friend and supporter of Tatlin, and a party member with reasonable experience as a cultural manager.[110]

Tatlin and Mansurov were playing with fire. By accusing Malevich of mismanagement, they risked unleashing forces within the bureaucratic apparatus that until then had left the small institute relatively undisturbed. But they refused to see the danger.

Around ten days after sending the letter, Mansurov spoke during a meeting of the museum committee and went straight to the heart of the matter. He declared that 'Malevich makes work impossible for the other departments, he is coercive, spreads intrigue, and should be expunged from the directorate and replaced by Isakov. The latter is a communist with a network, and will dedicate himself to the institute.' Then Tatlin asked to speak, repeated Mansurov's words almost verbatim, and then addressed his old rival Kazimir directly: 'Go away, Kazya, leave us in peace, and all will be well. Go, will you? Tomorrow we will officially ask Isakov...'[111]

Thus, the pontificating Pole and the eccentric Russian went head-to-head, while still addressing one another with pet names.

Malevich managed to deflect the frontal assault by stating that the decision should be taken by the full management committee, in the absence of the academic staff. Having successfully bought some time, he spent that evening telephoning his network within the inspectorates of the People's Commissariat. The next morning, Malevich met two public servants in the city, Karpov and Lekht, who pledged him their full support.

The sword of Damocles still hung over Malevich and GINKHUK. Shortly thereafter they were visited by the president of the inspectorate, a certain Petrov, who had probably been alerted by Tatlin's letter. Although he only visited one studio on that first day, the threat of closure was immediate.

Tatlin panicked, and wrote Punin a letter that expressed both his bitter sense of powerlessness and his utter dependence on his friend: '[The commission] has announced they will come and see me tomorrow. I find it hard to talk to them. You must come and explain things for me. I will talk to them about other things, but it is important that you talk about material culture. If you are busy, whatever it is, I beg you to set aside all your affairs, for tomorrow will be a decisive day....Please do all you can, I am being threatened with closure.'[112]

All hope seemed lost. In any case, Tatlin refused to admit the inspectors the next day, and openly argued with them. The inspectorate subsequently concluded that Tatlin was 'poorly educated', 'mentally deranged', 'paranoid' and disruptive 'to normal life at the institute'.[113] Soon, the ultimate sanction was issued. The inspectorate recommended that Mansurov be dismissed, and that Tatlin and Punin be relieved of their posts as assistant managers. Tatlin's department was to be 'reprofiled'. Thus, Tatlin's campaign backfired not only on him, but on the entire institute.

Malevich remained calm, for Karpov and Lekht stood behind him and pleaded his case. They then organized a large conference attended by twenty-five academics in Hotel Europa, the most luxurious hotel in the city. The academics' task was to assess whether the institute was 'scholarly' enough. Malevich gave a lengthy oration, stating that 'we live in an historic age, in which artists are finally collaborating with academia, and where artists take part in academic discussions "on equal footing."' Of course his views were criticized, and Malevich was forced to defend himself against accusations of 'vagueness' and 'subjectivity'. But he parried every attack. He was indefatigable as always, and utterly convinced that he was right. 'It was a brilliant result for Malevich,' Vera Yermolaeva wrote in her diary. 'Petrov voiced his confidence in Malevich as an "academic activist," and charged him with the ongoing management of the institute. Tatlin and Mansurov hung their heads. Punin began to sound the retreat as soon as their utter failure became clear.'[114]

Malevich's astonishing victory shows once again just how convincing and imposing he could be. Irina Vakar noted that Malevich adopted the typical mannerisms of a Soviet bureaucrat like no other, with his 'energetic, highly exaggerated motions, and somewhat abrasive speech'.[115]

Malevich seemed to have rescued the institute, though Tatlin's position remained extremely tenuous. Malevich sacked Mansurov but not Tatlin, though he did distance himself from his rival in his correspondence with the government.[116] Several months later, Tatlin was called to account once again, when the inspectorate demanded final clarity on the institute's policy line, and wished to put an end once and for all to the 'isolation' of Tatlin's studio. To Tatlin, this meant he simply could not go on, for he could only work in total privacy.

Punin wrote: 'Tatlin is once again consumed by a wild and stupid rage, he is completely impossible. Recently he destroyed several doors in the museum, and he throws himself frantically at Malevich.'[117] And

shortly thereafter: 'Tatlin came by, completely dejected by his material need. He said: "If I must die, then I will burn and destroy all of my work, I will leave them nothing. You know, I am so furious…"'[118]

Tatlin was indeed completely desperate and seemed on the verge of psychosis. Valentina Khodasevich described a visit to him and her friend Molecule during that time: 'Tatlin was not there. Molecule was in tears, and told of something terrible that she had been powerless to prevent.…Tatlin and some of his students were burning all of his magnificent drawings and paintings. She hastened to put out the flames, but he pushed her away. He was on the verge of insanity, and shouted: "*Now* let them look. Open the windows!"'[119]

Punin wrote, crestfallen: 'The cause of our downfall? Someday they will understand.'[120]

Under the circumstances, Molecule decided that she and Volodya would return to the Gorky commune, where Tatlin would be able to visit them. Tatlin's separation from Molecule gave him one less reason to remain in the city, and he began to consider leaving Leningrad.

Paris briefly twinkled on the horizon. The Soviet Union desired a grand presence at the Paris World's Fair in 1925 and, in line with Lunacharsky's policy, the avant-garde was to have a major presence in the Soviet presentations. Konstantin Melnikov, Russia's most progressive architect, was commissioned to design a pavilion, and Alexander Rodchenko was to curate the exhibitions (the same Moscow museum director who had had no space to hang up paintings, and no money to replace a broken typewriter). Tatlin was asked to create a new model of his Monument for the Third International. He eagerly accepted the offer, if only to ensure the resurrection of his most famous artwork. He applied for a visa to travel to France and supervise the installation of the tower, but was declined. So while Rodchenko, Shterenberg and Mayakovsky were allowed to travel, Tatlin stayed at home – probably because the security services were afraid that now, without his relationship, he had one less reason to return home. It was already common policy at that time to issue exit visas only to those who were leaving a family behind.

In his loneliness, Tatlin embarked on an affair with Nadezhda Mandelstam, author of one of the most striking memoirs in world literature. She entered into the relationship primarily to spite her husband, the poet Osip Mandelstam, who was himself involved in a romantic extra-marital affair. Nadezhda had decided to move in with Tatlin. But when he came to collect her, as she stood ready with her suitcase packed,

Osip arrived and said that he had left his mistress and wanted to return to her. Nadezhda thus had no option but to send Tatlin home. 'There was a mild scene, Tatlin complained that he was forty years old and had no wife....I advised him to go to Ukraine, where there were plenty of women. As luck would have it, he had just then received an invitation to go. He took my advice, and we parted ways. He brought a woman home with him. And so it was that I played a part in his life, and not just in the bedroom.'[121]

The Flood

Just as the power struggle between Malevich and Tatlin reached its climax, Leningrad was hit by the biggest flood it had seen in a hundred years. The waters rose nearly 40 metres (over 130 feet), and within a few hours the river had reached the first floor of houses in the city centre. The next day, Malevich wrote of how the previous morning he had noticed 'a significant migration of birds':

> I was surprised at the sight, and wondered where they were flying to – the swallows, jackdaws, crows and smaller birds. At noon I noticed rats and a few mice running hither and thither. In Demidov Lane I counted 16 rats...which I immediately associated with a natural disaster. [On the street] I heard about a sudden and powerful rise in the waters of the Neva; and indeed, the movement of the water was so strong that I could hardly make my way home across St Isaac's Square. The scene was frightening. The Neva raged and spat, with its white-crested black waves crashing against the artificial channel created for it; none of the barriers helped. By around six o'clock the water on the square had reached the high steps of St Isaac's Cathedral. At six-thirty my apartment began to flood. The telephone stopped working. Light, darkness, water splashed, and the wind hissed....We went to the balconies, where we hauled people out of the water. And on top of everything, a large fire broke out somewhere.[122]

Tatlin did not notice the rising waters until the museum began to flood. Khodasevich later heard from Molecule what happened. Realizing that Molecule and Volodya, who lived on the other side of the city, might be in danger, he 'hid his tobacco and matches under his cap, and waded from St Isaac's Square to the Palace Square, with the ice-cold water up to his waist'. Tatlin was risking his life, for the currents were at their most power-ful and turbulent close to the river. 'He had to swim from Khalturin Street

to the Field of Mars, braving the waves and the strong current.' At the Field, the storm winds rose to hurricane force. He was exhausted but clung to the 2-metre-tall (7-foot) monument to the heroes of the revolution that stood in the centre of the square. The monument had been built in 1919 by Tatlin's friend Rudnev, during the Plan for Monumental Propaganda. There, 'on the monument's highest point, he waited out the storm'. 'That was how he reached his family.'[123]

Exactly one hundred years earlier, the city had suffered another flood of biblical proportions, which was given a legendary treatment by Pushkin in his epic poem 'The Bronze Knight'. Pushkin presented the flood as a metaphor for the authoritarian reforms by Peter the Great, which brought about the small man's downfall. In the poem, the 'small man' is the lovestruck Eugene, who tries to rescue his beloved Parasha during the flood. Upon his arrival, Parasha's house turns out to have been destroyed by the catastrophe, and Eugene dies of a broken heart. Everyone in St Petersburg is familiar with the poem and its political significance, and in 1925 many must have felt the symbolic parallels to the very disaster they were witnessing.

Tatlin narrowly avoided Eugene's fate – he survived both the flood and his own personal crisis, though the latter did require a drastic decision on his part.

In mid-1925 he accepted a post in Kyiv, at the theatre and film department of the Kyiv Art Institute.[124] He left Leningrad, the city where he had lived and worked for the previous five years, where he had created the Monument for the Third International, and where he had nurtured his own personal, independent universe.

Meanwhile, in April of that year, the International Exhibition of Modern Decorative and Industrial Arts (the World's Fair) opened in Paris. There, Tatlin's second tower model was prominently presented to the public at the top of the monumental staircase in the Grand Palais, as the altarpiece of the national presentation by the Soviet Union. The millions of visitors to the Grand Palais saw Tatlin's work immediately upon their arrival. It had been decked out with lights to illuminate the cube, the pyramid and the cone for the occasion. The tower was illustrated in the official catalogue, and was awarded a gold medal by the international panel of judges.[125] The maker of this sensational artwork was denied the privilege – by his own government – of attending the opening, and shortly thereafter, as a marginalized figure, left the city that had become Lenin's namesake. In Kyiv, Tatlin continued his efforts on an artwork

that he had been developing for some time (in strict secrecy, of course). Unlike the Monument to the Third International, the subject of this new piece was not humanity as a collective, but the human individual. It paid tribute to the inspired singular entity, the winged being in search of ultimate freedom: a new Daedalus.

8

Family Ties

1925 – 1927

While Malevich vied for his position and fought to save the Museum for Artistic Culture, he received word that his wife Sofia had died on 29 May 1925 in Nemchinovka.

He and Sofia had lived together for over fifteen years, and their marriage – according to all surviving memoirs – had been a happy one. Sofia adored Malevich, who was home-loving and shared the domestic duties. He enjoyed family life, mopped the floor, did the shopping and cooked for the family and their many and frequent visitors. Sofia's large family, the Rafaloviches, created a relaxed atmosphere where Russian and Ukrainian songs were often sung. His daughter Una said that Kazimir 'had a high tenor. He enjoyed singing, folksongs especially. When he sang, he always put his hand to his mouth, that was his way.'[1] Village life in Nemchinovka really suited him better than life in the city, and he enjoyed country walks and swimming in the creeks and streams.

His mother-in-law simply adored little Una, surrounding her with love but also increasing possessiveness. She did not wish to give up her granddaughter and let her return to Leningrad with her father. Given all the circumstances, it did seem best for Una to stay where she was. Malevich was extremely busy in Leningrad and still had to look after his ailing mother; also, the food supply was better in Moscow and its environs. So Una remained in Nemchinovka to be raised by her grandmother. In that way, Malevich retained a connection to his beloved village, and he tried to visit as much as possible to be close to his daughter. He noticed that whenever he was in Nemchinovka, the little girl was all aflutter. 'She says, I love both you *and* grandma, and when she gives me a kiss, she quickly runs to her grandmother to give her one too, so that nobody feels left out.'[2]

Katsman's Guile

During Una's time in Nemchinovka, she occasionally visited the family of Yevgeny Katsman, whose career over the previous years had progressed in leaps and bounds.

In March 1922, Katsman had founded a new artists' collective called AKHRR: the Association of Artists of Revolutionary Russia. All of these artists were realists, faithful followers in style and technique of the nineteenth-century itinerant Peredvizhniki, such as Ilya Repin, whose genre paintings had depicted the Russian countryside and its people.

Even in their very first manifestos, the AKHRR artists defined their work as communist pop culture: art 'of a classless society', intended to appeal to the widest possible audience. They tried to have the public participate in their projects by visiting factories and painting portraits of workers in canteens. They also made no secret of whom they saw as their enemies: 'We paint a true image of reality, no made-up abstractions that bring our revolution into discredit in the eyes of the international proletariat.'[3]

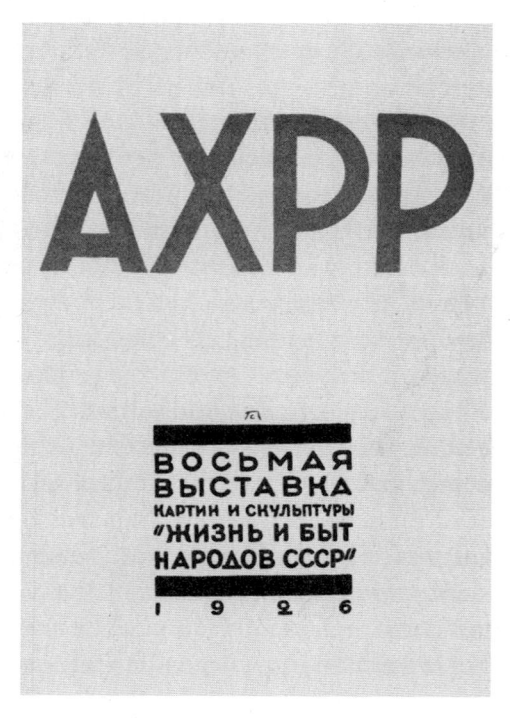

AKHRR catalogue, 1926.

Katsman was secretary of the AKHRR – traditionally a very powerful position in any organization – and his friend Viktor Perelman became president. They tried to present their art as the inevitable outcome of the revolutionary process, and proved immensely adept politically and in their dealings with the media. They promised to donate the proceeds from their first exhibition to 'famine aid', for example. The exhibition committee (to which Katsman belonged) excluded participation by modernists and avant-gardists, making it seem that the members of the AKHRR were the only ones committed to this cause. The fact that not a cent was raised, as Katsman notes in his memoirs, was ultimately irrelevant.[4] The artists did not seek support from the People's Commissariat for Enlightenment, but instead turned to other potential sponsors within the government. They sought finance from the army and unions – and with success. Their second exhibition was sponsored by the army and consisted mainly of drawings and sketches of military life. Their third large exhibition was funded by the central umbrella organization for the various unions, the VTSSPS. The military proved to be a particularly loyal and generous patron. Katsman appealed personally to Leon Trotsky, who had been at the head of the armed forces since the start of the civil war. Trotsky immediately saw the potential of the initiative, and supported the AKHRR not only financially, but also by attending the exhibition opening.[5]

Trotsky's mighty leadership was generally viewed as the deciding factor in the Bolsheviks' victory. After the civil war, he used his reputation as a general and his unimpeachable position in the Red Army to expand his power base. Under these circumstances, the military developed into a separate entity within the state, with its own social and cultural facilities.[6] Katsman and Perelman noticed these developments and took advantage of them. Katsman could not, of course, foresee that his connection to Trotsky would land him in major political difficulties later.[7]

From its inception, the AKHRR worked like a political organization, aiming to increase its influence within the Communist party and government institutions. One of its first official acts was to send an outright declaration of loyalty to the Central Committee, placing 'ourselves and our art in the full service of the party', and asking the Central Committee to 'aid the work of the association with proper and targeted guidance'.[8] It was this unconditional submission to the will of the Communist party that determined the future success of the AKHRR. Members also showed their dedication to the party by painting portrait after portrait of party

leaders and displaying them at their exhibitions. The obsequiousness of the 'AKHRRovstsy' occasionally crossed a line. In the guest book of one of the AKHRR exhibitions, Trotsky wrote: 'Excellent, but I forbid any pictures of generals for the next five years.'[9] It was jests like this – which were in fact pats on the back – that let the realists know they were on the right track.

The AKHRR quickly grew into the largest and most richly endowed exhibition organization of the Soviet Union. By early 1924, their members totalled at least 133. The main papers reported extensively and frequently on their exhibitions and other activities, which as a result were attended by tens of thousands.[10] Katsman also benefited personally from his new status in many ways, and (most likely in 1924 or 1925) received the greatest honour that could ever be bestowed on a Soviet artist: a private studio in the Kremlin. So it was that this well-educated, but otherwise banal and second-rate, artist became one of the official portraitists to the new Soviet elite. He regularly received high officials and government leaders in his studio, and always painted them in a very flattering manner. During these initial years, his subjects included Felix Dzerzhinsky (head of security), Mikhail Kalinin (the Soviet Republic's official head of state), Leon Trotsky and, of course, Vladimir Lenin.[11]

A Return to Order

The AKHRR roused no genuine enthusiasm among artists, however, not even the more conventional ones. The association's tremendous appeal was more a result of its organizational and business acumen. In a certain sense, it functioned as an employment agency: the management tirelessly visited factories and government institutions, where it obtained its collective contracts. The work was then distributed among its members; all the association asked in return was loyalty, and an acceptance of the 'heroic realism' they preached.[12] The AKHRR had its own printing house, whose publications included postcards showing reproductions of works by the members, including many 'portraits of leaders'. These were distributed on a grand scale and generated much income for their creators.

Quite soon after the revolution, a tendency emerged among the modernists to return to figurative art, to craftsmanship and tradition. Some of the reasons for this development can be easily intuited: after the countless horrors of both the war and the civil war, artists and their

I. Pavlov, *Portrait of Yevgeny Katsman*, 1935.

audiences were seeking to reconnect with traditional values as a means of restoring their shattered worldview. The need to re-establish social cohesion also discouraged any adherence to polarizing artistic views.

Many artists attributed the return to a familiar, more conventional visual language to personal disappointment in their avant-gardist ideals. Robert Falk, a Cézannist who had even taught in Vitebsk under Malevich, wrote to his friend Alexander Kuprin: 'Everything transforms into lifeless patterns, that are merely the expressions of previously completed formulas. In other words, our art lost the spirit of art itself – its substance...leaving only a dead body in its place – its form.'[13]

Aristarkh Lentulov, an artist who worked with Mayakovsky and Burlyuk around the time of the revolution, and who contributed spectacular light shows to the October festivities of 1918, gave a comparable

explanation. In a letter to the same Kuprin (who, it seems, acted as a kind of confessor to various artists), he wrote: 'We have destroyed the soul in our art. Too often we have chosen the path of methods and experiments...and we no longer look at nature from an emotional perspective, with wonder and feeling, but instead with a view to its objective applications in our artistic methods and formulas...we arrived at an impasse, a kind of academism of methods and principles, etc., soulless, lifeless formulas (suprematism, cubism in part), formulas on which I now declare war.'[14]

The younger generation of artists, too, felt the need to return to familiarity, to craftsmanship and comprehensibility. Many of them had returned severely traumatized from fighting in the civil war, and felt estranged from the utopian and philosophical pretensions of the avant-garde. 'Many Vkutemas students,' one of them wrote, 'who knew the civil war not only from newspaper headlines, were the first to feel a need to tear themselves away from the vague world of abstraction, and return to the Earth, to the unforgiving but also uplifting realism....And not for the joy of a brush stroke, but because in spite of everything, "life was beautiful..." Especially for those of us who had been to the front in the civil war – that was also a school. And what a school!'[15]

Opinions of this kind were voiced by nearly all conservative modernists and post-impressionists, such as Falk, Mashkov, Konchalovsky and Lentulov, but also the cubist Nadezhda Udaltsova, who had been closely associated with Malevich for some time, and her husband Alexander Drevin. From the 1920s onwards, all of them once again returned to figurative art as the basis of their practice.

Although many artists perceived this change as a genuinely autonomous, individual and authentic development, they were – at the very least – encouraged by the tastes and political ambitions of their new masters, the Bolsheviks. The movement towards a conservative visual language, and ultimately a homogenizing Soviet style, was unmistakeably a 'top-down' movement, spurred on and partly even imposed by the party and the government. This pressure from above, however, was legitimized to a large extent by a 'bottom-up' movement: a wave of disillusionment with artistic modernism that was shared by many artists in Soviet society.

It is interesting to note that Lentulov, Falk, Udaltsova, Drevin and all the others each manifested their 'return to order' in a slightly different manner. Their paintings were not 'realistic' or propagandistic like those

of Brodsky, Katsman and other 'proletarian' artists. But their regressive about-face did mean that the avant-gardists became increasingly alienated, even within their own progressive community.

The tendency was not limited exclusively to Russia, but was prominent in all countries that had experienced the horrors of the First World War. The neo-classicism of Pablo Picasso, André Derain and Giorgio de Chirico, and the advent of what was known as New Objectivity in Germany and the Netherlands, were all manifestations of the same 'return to order'.[16] More broadly, this movement formed part of a general conservatism in European society that was expressed in a desire for order, hierarchy, collectiveness and social stasis, and an aversion to individual freedom, emancipation and social dynamism.

Via publications and correspondence, the avant-gardists were well aware of the conservative trend in Europe and felt the need to present a robust response. To them, the return to a familiar, 'classical', non-modernistic visual language was doubly nonsensical: not only was figuratism an artistic dead-end, but so too was the medium of painting itself. Malevich, for example, wrote of the regressive artists: 'As painters, they have no choice but to follow the path of painting. But there are no new painting-paths any longer, and so they return to those of the tried-and-tested painters, to the well-trodden highways of Ingres, Poussin, Renoir, Manet, Corot and Rembrandt, and try to depict modern life in the incomparable trappings of the great classicists. In other words, the painters' brigade does not live, but merely coughs up paintings as a result of their centuries-old painter's bronchitis.'[17]

However fierce Malevich's initial resistance to this regressive tendency, he himself would not remain unaffected by it, as we will see.

Realists, Soldiers and Spies

The People's Commissariat for Defence remained the strongest source of support for the AKHRR, and the new leader of the Commissariat, Kliment Voroshilov, assumed the role of public patron. He not only ensured lucrative contracts, but also mediated conflicts and helped secure exhibition spaces and studios at prestigious locations.[18] He liked being surrounded by artists and had them regularly paint his portrait in flattering poses. Lenin's favourite painter, Isaak Brodsky, quickly joined the AKHRR and maintained a very close relationship with his patron Voroshilov. Brodsky's letters to the commissar give a clear indication of

the balance of power: 'Dear and beloved Kliment,' he wrote, 'all artists see their salvation in your countenance, and they are not mistaken. It is true. You are the only one who has their best interests at heart, and who wishes them well.' 'I have always said that if Repin had only visited Voroshilov for an hour, he would have emerged a Bolshevik.' Or: 'What a pity you are not the People's Commissar for the arts, what a glorious flourishing there would be!'[19]

The AKHRR's shameless kowtowing coincided with a growing interest in the visual arts at the State Political Directorate (GPU, the successor to the Cheka). Previously, exhibitions and public communications had been subjected only to censorship by the People's Commissariat for Enlightenment. Now, new art organizations were obliged to register with the GPU, and their manifestos and announcements required the GPU's advance approval.[20]

The security service strengthened its ties with the AKHRR in order to gain a stronger hold over the art world. The linchpin of these efforts was the close personal relationship between Katsman and Józef Unszlicht, the GPU's second-in-command, who had been charged with monitoring intellectuals and artists. Unshlicht also facilitated a personal introduction for Katsman to Felix Dzerzhinsky, the security service's fearsome founder and leader. Katsman was granted the privilege of painting Dzerzhinsky's portrait, and was introduced to the offices of the GPU.

When Dzerzhinsky died in 1926, the AKHRR was authorized to prepare and issue a commemorative publication. Katsman wrote proudly of the warm, personal connection he had fostered with 'Iron' Felix over the previous years, describing how his 'introduction to the GPU' had started in the Lubyanka offices ('where cleanliness, silence, and discipline reigned'), how he worked on Dzerzhinsky's portrait, with his 'uncommonly beautiful face' and 'his incredibly refined profile'. Katsman's grovelling admiration for the architect of the Red terror occasionally becomes unbearable: 'The tall, slender man, with his upright posture,' so 'delicate and attentive in his conversation'. He did not fail to mention the fact that Dzerzhinsky often took him home in his motor-car (which actually made Katsman feel uneasy, for if an attempt was made on Dzerzhinsky's life, Katsman would be suspected as an accomplice), and even called him up at home on the telephone. 'When I heard "This is Dzerzhinsky speaking" for the first time, I realized that he was a genuinely thoughtful and refined person.' On the night after Dzerzhinsky's death, Katsman was admitted to see him. The architect of terror lay in

**Yevgeny Katsman, *Death Portrait of Feliks Dzerzhinsky*
(from the special edition dedicated to his passing by AKHRR).**

state, 'in some kind of short jacket', and Katsman sat painting his death portrait from three o'clock until six in the morning. 'Once again I was struck by the uncommon beauty of his face,' Katsman wrote. 'It seemed to me that his profile had become even more exceptional.'[21]

Katsman's obsessive sycophancy towards those whom he deemed his protectors was balanced by an equally excessive hatred towards those he considered to be his enemies: the avant-gardists. He stopped at nothing to damage and blacken their reputations. His loathing was sincere and insatiable, his narcissism and irritability beyond all bounds. He continued to play the victim in any and all circumstances, believing that he had the supreme right to inflict harm on his perceived enemies because he, Katsman, had been wronged. Even when his opponents were languishing in captivity while he went from success to success, nothing could temper his enmity.

What is the explanation? As a young Jew from Ukraine, he had certainly known a life of poverty, and probably also violence, discrimination and exclusion. But the same was true of Marc Chagall, Nathan Altman and the man whom he despised more than anyone, David Shterenberg, and these individuals succeeded in retaining their humanity, conscience and good sense. In his memoirs, the artist Amshey Nurenberg paints Katsman credibly as a traumatized and perhaps bipolar figure. His description is extremely unflattering, if not damning – and

Nurenberg was a friend of Katsman's. They shared the same artistic views (Nurenberg was a member of the AKHRR) and because he, like Katsman, was a Ukrainian Jew, he was very familiar with the often traumatic circumstances of his background.

> Katsman! A provincial fellow of provincial spirit, mind and art….He is prone to severe bouts of depression, they return almost every year, and he withdraws completely into himself. At the end of these periods, he becomes incredibly active, even aggressive. We all prefer it when he is depressed, because then at least you can deal with him.
>
> His naivety in matters of art is boundless. It is impossible to talk to him about art: 'Degas is not bad, but Brodsky is the great master.' To him, Kotov is no worse than Renoir.
>
> The man is difficult, belligerent and moody. Though not devoid of wit, he is hardly of a subtle nature. He likes to gossip and pontificate, being pompous and rhetorical. He sees everybody else as idiots, as excrement. Perelman said of him: 'He does not like music, children, or animals.' Very revealing.
>
> Both he and Perelman attribute his difficult character to his 'traumatic youth'. His father was an alcoholic, and used to beat his mother and children. Terrible environment. Yevgeny had nowhere to develop normally. And here, so they say, are the results – so just let him be! But that does not make things any easier for those of us who have to deal with him.[22]

In mid-1926, Vera Yermolaeva described the situation in a letter to Mikhail Larionov in Paris:

> Everywhere, on every front, we must retreat. The AKHRR is occupying all positions, AKHRR is the official art, AKHRR controls the Leningrad academy and the schools of applied art. Only the AKHRR gets two hundred columns in the paper, we get nothing. The AKHRR arranges studios in every district in the main cities, and receives funding to maintain them….And you have no idea how horrible it all looks. Their exhibitions are a sea of talentless canvasses, devoid of any naturalistic skill, but still based on the most explicit revolutionary themes.[23]

Lunacharsky witnessed this development with mixed feelings. He was sceptical about the avant-garde, yet saw the realism of Katsman and Brodsky as provincial and nostalgic. His personal benchmark remained art from the *fin de siècle,* post-impressionism and symbolism. He valued the potential of realism as an instrument for propaganda and art

education. At the same time, he believed that the AKHRR could never take the place of serious art, and in this light, the patronage of Voroshilov and Unszlicht posed a direct threat to his position as exclusive benefactor to the art world. Behind the scenes, he worked to undermine the organization's monopolistic aspirations and maintain a pluriform system. Initially, he ensured that space remained in art programmes (in Moscow in particular) for more progressive artists, and so offered his protection to the constructivists in Vkutemas, and also allocated them a prominent role during international presentations. The Soviet Union's pavilion at the Paris World's Fair in 1925 was one such occasion, where in addition to Tatlin's second tower model, Rodchenko's marvellous Workers' Club interior was also displayed inside a pavilion built by Konstantin Melnikov, which is now generally regarded as one of the most significant early examples of radical modernism in architecture.

In public, he applauded the rise of the AKHRR. The exhibitions were an 'impressive celebration of the people', 'a decisive step forward in the advancement of our culture', and 'deeply artistic, original, striking and new, fresh and unexpected'.[24] When it came to art education and international cultural policy, however, the influence of the AKHRR remained limited for as long as Lunacharsky was commissar.

As the AKHRR rose, the avant-gardists were marginalized. The death of Lenin in 1924 was seized as an opportunity by both groups to reinforce their position as the inevitable representatives of true revolutionary art. A deification of the great Bolshevik ensued, and it was clear that whoever could be publicly associated with him during that process would garner immense social and political advantage. Mayakovsky dedicated a monumental poem to the leader ('It is time, I shall begin my story about Lenin'), and within the span of four days, Malevich produced a lengthy essay titled *From the Book of Non-Objectivity*. In it, he proposes honouring Lenin's memory by immortalizing him as a cube, positing that 'every Leninist should have a cube at home as a memento of the undying, eternal doctrines of Leninism'.[25] Not all of the claims and analyses in the essay were so bold, and Malevich made a serious attempt to appropriate the materialistic, authoritarian Leninism that was such anathema to him by dragging it, kicking and screaming, into his own realm of thought. He also issued unveiled criticism of the circumstances in which the Soviet Union found itself, and condemned the oppression and lack of understanding shown towards the avant-gardists. He sincerely believed that his peculiar thesis, based on awkward paradoxes, would be taken seriously

by the Bolshevist establishment, and he sent typed copies of it to such Bolshevist leaders as Nikolai Bukharin, Felix Dzerzhinsky and Anatoly Lunacharsky, and to Lenin's widow, Nadezhda Krupskaya.[26] There is no indication that any of them ever responded to it. Several months later, however, Malevich did manage to show his model for a Lenin monument to a panel of municipal officials in Leningrad. In a strange quirk of history, the only report of this event comes to us from the correspondent for the journal *Artnem*, a weekly arts publication from New York. The account is clearly biased, falling under the category of 'tales from mad Russia', already the most popular genre of reporting on Russia at the time. As the only surviving piece of journalism on the matter, it is still interesting enough to cite here.

> Malevich...proudly exhibited a huge pedestal composed of a mass of agricultural and industrial tools and machinery. On top of the pile was the 'figure' of Lenin – a simple cube without insignia.
>
> 'But where's Lenin?' the artist was asked. With an injured air he pointed to the cube. Anybody could see that, if they had a soul, he added. But the judges without hesitation turned down the work of art.[27]

The party leaders had already shown their true artistic colours when they commissioned Yevgeny Katsman to draw and paint Lenin's death portrait in the House of the Unions in Moscow, while people came in their hundreds of thousands to pay their final respects to the father of the Bolshevist revolution.

Over the two ensuing years, 1925–26, the AKHRR opened two major exhibitions and Katsman was given the opportunity to start the official historical documentation of his own artistic movement. He published a widely circulated booklet titled *How the AKHRR was Founded*, in which he once again fiercely lashed out against the avant-gardists in general, and his brother-in-law in particular. Continuing the protest he had instigated four years earlier against the futurists in the Free Studios, he perpetuated the lie 'that over three hundred students categorically refused tuition from Malevich and comparable "masters."'[28] His personal attacks against the avant-gardists became more and more grotesque: 'The leaders of art were Malevich, who like a blind man created his little squares in black, red and other colours; Kandinsky – now an emigrant – who depicted a particular sort of amorphous coloured panels; and Tatlin, who deformed train tracks and the like.' This onslaught no longer had anything to do

with the competition between two rival groups of artists. The avant-gardists were already marginalized, hardly constituted a threat to the hegemony of the AKHRR, and were relevant only to underscore his rev-olutionary and proletarian credentials: 'And we, when we founded the AKHRR in February 1922, battered against that rotten phenomenon, we broke their back and eliminated this source of European infection. And we started making art from the living reality of our Soviet Union.'[29]

From 1925 onwards, the AKHRR's potential for expansion seemed boundless. It opened local departments in over thirty cities and gen-erated enormous media attention for their exhibitions. Hundreds of artists joined the organization's ranks.[30]

Of course, some artists rejected the AKHRR's rigid utilitarianism, its willing submission to the Communist party and its aggressive intoler-ance. This attitude was no longer limited to the avant-gardists, but was shared by a variety of conservative modernists, symbolists and post-impressionists – essentially, nearly everybody who found the popular, simple, documentary realism of the AKHRR to be mind-numbing and soulless, and was prepared to fight for an art world that supported the existence of alternative forms of artistic production. The allocation of an unprecedented 75,000-rouble subsidy to the AKHRR in 1925 made it abundantly clear that the realists had secured exclusive access to the existing power structures. In response, a diverse group of artists from Moscow, representing a wide range of aesthetic mindsets, wrote a letter to the country's highest level of government, expressing their displeas-ure at the preferential treatment on display. The letter's first signatory was David Shterenberg, alongside Alexander Rodchenko and the mod-ernists Pavel Kuznetsov and Lev Bruni. Granted, Shterenberg was no longer as powerful as he had been several years before, but he still occu-pied several roles in the People's Commissariat for Enlightenment and enjoyed the protection of Lunacharsky.

More interesting than its content, perhaps, was the letter's addressee: Joseph Stalin. Although at that time (late 1925–early 1926) Stalin was without doubt already the most dominant figure in the Communist party, this fact was unknown to the outside world. Officially, he was still one of the members of the governing Politburo.

Writing to Stalin personally, rather than to the Politburo, suggests that the artists were up to date on the latest political machinations. First and foremost, of course, was the fact that Stalin was leading the charge against Trotsky, who was the main source of support for the AKHRR. It

is unlikely that Shterenberg and his co-signatories would have had the knowledge, or the nerve, to make such a bold move without some inside information from the highest levels of government. And, indeed, their letter received immediate internal support from Lunacharsky.

The letter had some success. In any case, it ensured that the invitations to submit works for the exhibitions celebrating the ten-year anniversary of the October Revolution were not reserved exclusively for AKHRR artists. The contributions by the avant-gardists were minimal, however; Malevich submitted two arkhitektons (sculptures resembling residential blocks that he had only just started working on), and Tatlin sent three sketches.

In spite of everything, GINKHUK continued to exist, and the work being produced in Leningrad was still of challenging substance. Despite the depressing political and artistic climate, there were still young artists who felt drawn to Malevich and his tireless defence of an all-encompassing and ambitious artistry, one that was immune to the vices of political power or personal gain. In 1925, Malevich was approached by a number of young poets and theatremakers who felt a strong connection to the most radical aspects of the literary avant-garde – the rejection of rationality and a focus on the fundamental building-blocks of language, such as sound and symbol. Their number included Alexander Vvedensky, Nikolai Zabolotsky and Daniil Kharms, who would ultimately achieve world fame through his absurdist, anti-rational poems and stories.

The group (which would later call itself OBERIU, the Association of Real Art) included one other figure: the author and director Igor Terentyev, who would ultimately give a sinister twist to the story. Malevich had known Terentyev since 1923, and held him in high regard. Years later, however, under pressure from the secret service, Terentyev would act as one of the key informants against the avant-garde, using his obscenely productive imagination to fabricate so many lies that his interrogators (and torturers?) were in all likelihood dumbfounded by the wealth of incriminating evidence being thrown into their laps.[31]

That would come later, however. When the poets contacted Malevich to ask him to support one of their theatre productions, he saw them as kindred spirits: 'I am an old rascal, you are all young rascals, let us see where things lead.'[32] He said that space would be made available for them, and that they could start rehearsals the next day. From that moment on, Kharms and his troupe were slowly integrated into the 'extended family' of GINKHUK.

Various stories and poems by Kharms display a connection with Malevich's realm of thought, including a short text on the famous artist Michelangelo that contains the following passage: 'They say a famous artist once observed a rooster. He looked and looked at it, and came to the conclusion that the rooster did not exist.' The artist told this story to a friend, who broke into laughter. 'Well then, how can he say it doesn't exist, when he is standing there, he says, and I, he says, can clearly observe him?'[33]

'Living off the Public Purse'

The attacks on Malevich by the AKHRR were not solely of a personal nature, but also extended to the entire institute under his management. After the dramatic events of 1925 that had culminated in Tatlin's departure, the dust had not yet settled at GINKHUK. During the annual show involving all departments, a controversy arose concerning the presentation by Pavel Mansurov. Although Malevich had dismissed the young artist, Mansurov still maintained a presence at the institute in the form of a personal studio where he could freely pursue his artistic development (albeit without a salary). His presentation at the show consisted of photographs and drawings, accompanied by lengthy texts issuing sharp criticisms of the Communist party's artistic policy, with phrases such as 'The result of the reigning political philosophy is the physical extinction of the artist, akin to the destruction of art education, which is already complete.' 'Our brothers in art who arrive in your urban paradise either die of hunger, or hang themselves in anguish.'[34]

Although this outpouring undoubtedly expressed the opinions of many artists known to Mansurov, saying such things in public was, of course, unprecedented – and dangerous. The response came swiftly. Eleven days later, under the pseudonym of 'Sery', a publicist named Ginger who was associated with the Leningrad branch of the AKHRR published an article in the party newspaper *Leningradskaya Pravda*, holding the entire institution responsible for Mansurov's criticisms. He denounced the institute, not without some degree of polemic aplomb, as 'a monastery living off the public purse'. 'Under the guise of a state institution there is a cloister, populated by holy fools, who, perhaps unbeknownst to them, are occupied with openly counter-revolutionary preachings that ultimately make a mockery of our academic Soviet organizations. As for the artistic significance of the "work" of these

monks: their creative impotence is self-evident the moment one sees it.' He then calls for an 'inquiry into the squandering of public monies on this state-funded cloister'.[35]

This new attack was more dangerous than the many that had gone before. Sery's article was not one of the usual disagreements between artistic concepts, but an exposé of a supposed counter-revolutionary clique operating within a state-run institution. Malevich understood the severity of the situation and immediately mounted a counter-attack. He wrote a long letter to the Scientific Council (the so-called GLAVNAUKA) attempting to ridicule Sery's criticism. At the same time, he also distanced himself strongly from the younger artist, stating that Mansurov was not on the institute's payroll and could not, therefore, be considered representative of its work. He asked for a new inspection in the hopes of clearing the institute of all blame. Depending on the outcome, he would 'lodge a case against Sery to hold him legally accountable for defamation'.[36] All the same, Malevich was well aware that the new inspection could lead 'to the end, and the termination of all GINKHUK activities, which could otherwise do so much for artistic exploration, and the unravelling of its roots'.[37]

Several weeks later, the AKHRR in Moscow launched its own attack. Katsman gave a lecture at the opening of a new exhibition, to an assemblage of party bigwigs, dedicated entirely to the fight against the avantgarde. The event was titled: 'Call Them to Account'. He once again recalled the privileged position that he believed had been appropriated by the avant-garde, asking: 'And what have the leftist artists given back to the revolution? Nothing, of course.' Katsman did not accuse Malevich personally – he did not need to, for his friend and right-hand man Viktor Perelman did it for him. He produced a small booklet, compiled by Katsman and distributed at the same exhibition, in which Malevich's name was ridiculed over the course of several paragraphs. Perelman wondered, for example, whether Malevich's theories were not simply the 'ravings of a paranoid lunatic' or 'the impudent mockery of common sense'. 'And,' he decided, 'it is on this counter-revolutionary hogwash that our artistic youth has been raised; for five years they have been crippled and fed this refuse, instead of the living water of pure art for the masses.'[38]

Malevich had little defence against such an onslaught. 'The AKHRRs are singing our requiem,' he wrote to Punin, 'as the last remnants of art sink away into the morass, the horrors of which cannot be told in any

fairy tale, or described by any pen.'[39] Although many intellectuals and creatives were outraged by the aggression and intolerance of the AKHRR, nobody felt able to stop it. AKHRR had connections in the popular media, the major institutions and, of course, the party leadership. Thus the organization could mobilize public opinion and create a general sense of urgency surrounding the 'threat' of the avant-gardists, despite the latter's already marginal position. This was the final straw for some avant-gardists, who lost their faith in communism for good; others were confused and baffled more than anything, proving unable to draw the ultimate conclusion. Rodchenko, for example, wrote in his diary: 'How is this possible – I stand behind the Soviet power with all my soul, I work for it with all my strength, with belief and love, and suddenly we are the enemy? Occasionally I have thought of suicide. How was I supposed to work? Follow Katsman's example? That characterless, mediocre, servile, superficial, soulless hack...?'[40]

Although material circumstances had improved noticeably over the previous five years, and it had also become increasingly difficult to leave the country, many artists and intellectuals still managed to emigrate. Mansurov, who had endured so much suffering, was granted the opportunity to leave by Lunacharsky. 'If this is life, then it is not worth living,' he said.[41]

Between 1922 and 1927, Marc Chagall, Wassily Kandinsky, David Burlyuk, Naum Gabo, Alexandra Ekster, Pavel Mansurov, Ksenia Boguslavskaya and Ivan Puni (the organizers of the 0.10 exhibition) all emigrated. Olga Rozanova, Lyubov Popova and Velimir Khlebnikov were dead. Those who remained were scattered across the land – Tatlin in Kyiv, Malevich in Leningrad and Rodchenko in Moscow – with their presence becoming less and less visible. Their opportunities to exhibit had dwindled to practically nothing, and hardly any pieces were written about them. In 1927, Alexei Gan published a short article on Malevich's arkhitektons in the journal *Sovremennaya Arkhitektura* (Contemporary Architecture), and dryly noted: 'Nobody here writes about Malevich.'[42] For his own part, Malevich wrote of the evidently repellent effect he had on writers and critics: 'I am a scarecrow in the world of art, especially in Russia.'[43]

The avant-gardists faded away in a manner similar to that of the Cheshire Cat in *Alice in Wonderland*, whose grin was the last of its features to disappear. A contemporary noted: 'Many left. But it seemed like even those who remained had also departed.'[44]

The Last Bastion Falls

Malevich held on for another six months in 1927, until the tide became too strong and GINKHUK was forced to close. Malevich and most of the other staff were transferred to the nearby Art History Institute, where they were given research posts. Malevich's salary was 160 roubles per month, Matyushin's was 80 roubles, and Yermolaeva's 70. At the time, one kilogram (2¼ pounds) of sugar cost around 75 kopeks, and the same amount of cabbage around 25 kopeks. Though Malevich's income was relatively high, for the breadwinner of a family it was hardly lavish.[45] These salaries contrasted sharply with those of the realists: Brodsky received 15,305 roubles from the AKHRR's publishing house alone in 1925 and 6,444 roubles in 1926. These amounts doubtless represented only a fraction of his total income.[46]

The AKHRR's various campaigns were almost certainly coordinated. Two weeks before publishing his contentious article, Sery had already sought contact with Malevich and asked him to send photographs of recent artworks. His younger brother, V. S. Ginger, was also active in the AKHRR and a good friend of Katsman's. It would seem logical, therefore, that Sery also contacted Katsman for information on Malevich –

Joseph Stalin during the Fourth All-Russian Congress of Soviets, 1927.

if Katsman himself was not the instigator of the article in the first place. A member of the AKHRR later noted that 'Sery's help in our fight was very useful'.[47]

In a more general sense, Sery's article was of course related to the political developments in the Soviet Union at the time, namely the definitive transition to a totalitarian society under the leadership of Joseph Stalin. Via his contacts at the security service, Katsman was well aware of how the wind was blowing, and also knew that the battle could be intensified further.

Stalin consolidated his power in 1926 and 1927, permanently eliminating his rival Leon Trotsky. Almost immediately he set out several regulations for the Politburo that would lay the foundations for a terror offensive such as the modern world had never seen. Stalin's proposals give a precise blueprint for the basis of a totalitarian state: persons spreading oppositional views should be considered dangerous accomplices of external and internal enemies of the Soviet Union, and declared 'spies' by GPU administrative decree; and the GPU must organize a large network of agents in order to identify hostile elements in the state apparatus, up to its highest levels, and within the party, including its leading bodies. 'Everyone who arouses even the slightest suspicion must be eliminated.'[48]

The first Five Year Plan was announced at around the same time, which was intended to bring about an unfeasible increase in industrial production. Part of the plan was the so-called collectivization of agriculture, aimed especially at producing explosive growth in grain harvests. These plans triggered a disruption to the daily lives of millions that can only be compared to the misery of the civil war.

The increase in state-inflicted terror is clear from the exponential rise in the number of arrests by the security service. There were a little over 75,000 in 1927, then nearly 112,000 in 1928, over 200,000 in 1929, and almost 380,000 in 1930: a fivefold increase over the course of three years.[49]

Stalin simultaneously began a new campaign to banish pluriformity and free thought among the intelligentsia for good. Ten years after the revolution, it was time for the well educated finally to realize that only a single ideological framework could survive. Stalin's comrade Nikolai Bukharin proposed that academics, writers and artists needed to be 'trained in a fixed ideological schema'. And with the brevity so characteristic of the Bolsheviks, he added: 'Yes, we will die-cut the intellectuals, mass-produce them like a factory!'[50]

As part of his consolidation of power, Stalin also began to purge the bureaucratic apparatus. Directors and department heads were dismissed left, right and centre, and replaced by party members under the assumption that they would be more loyal to Stalin, and less compromising in their implementation of the requisite policy. Though Stalin's reforms undoubtedly achieved this effect in part, such all-encompassing operations are often (or actually, always) accompanied by various unexpected side-effects, some of which undermine the desired outcome. In the art world, for example, the bureaucratic purge led to the appointment of Mikhail Kristi as director of the Tretyakov Gallery, and Pavel Novitsky as dean of Vkhutemas. Although both men belonged to the 'old Leninist guard' and had joined the Communist party well before the revolution, on a personal level they were still well disposed to the avant-garde.[51] The reforms also led to a crisis within the AKHRR. The appointment of new managers meant that Katsman had to rebuild his network, while simultaneously trying to sweep his association with Trotsky under the carpet. It was perhaps for this reason that Katsman carried out an extensive purge among his own ranks (possibly prompted by Unszlicht), reducing the membership by half. He remained on good terms with Unszlicht, however, and therefore also with the GPU.

The various upheavals gave Malevich the brief hope that the avant-garde might finally make a comeback in the late 1920s. Full of enthusiasm, he wrote to his new girlfriend Natasha (whom we shall meet later): 'The AKHRR has launched yet another campaign against the new [artistic] movements, but now my line is taking over, and so their efforts will be in vain.'[52]

The unpredictability of government policy led to an increased reliance on personal contacts in both the public and private sectors. A strong personal network could protect public servants from the caprices of the leadership, giving them at least some sense that they had a say in how policy was implemented, and offering ways of reporting information on the processes (and problems) to the leadership, which was impossible through the usual bureaucratic channels. Public servants exchanged favours, occasionally supplemented with money or goods, but more often through a certain confidential reciprocity and informal IOUs.

For artists, too, these networks became increasingly important and led to the emergence of patrons and benefactors in high bureaucratic positions. The patrons received no concrete favours, however; rather, their relationships with artists were complex and emotional. The artists

brought depth and open-heartedness to the private lives of their bene-
factors, offering a welcome distraction from the desensitizing monotony
of public life. Through their support of the artists, the patrons principally
gained a sense of self-worth and personal morality as a counterweight to
the execution of their public duties, which increasingly constituted acts
of brutality and tyranny.

Throughout their long careers, Malevich and Tatlin had cultivated
extensive informal networks, and both had various patrons. Malevich,
for example, had Kiril Shutko, an old Bolshevik and revolutionary whom
he had known since 1905 and who had been at the top of Soviet cinema
since the 1920s. Another was Mikhail Kristi, who occupied various
high positions on the cultural scene and directed the Tretyakov Gallery
from 1928.[53]

One of Tatlin's patrons was the architect Lev Rudnev, who developed
a glorious career under Stalin. Tatlin had known Rudnev at least since
he became president of the Department of Fine Arts in 1918. Rudnev was
the architect of the immense necropolis on the Field of Mars that saved
Tatlin's life during the great flood of 1924. Another contact was Pavel
Novitsky, an old Bolshevik who was appointed director of Vkhutemas in
1926. Tatlin was even an occasional guest in the home of Maxim Litvinov,
the commissar of Foreign Affairs.[54]

It was these connections that allowed Malevich and Tatlin to survive
the late 1920s and early 1930s, and even enjoy some late successes. It goes
without saying, though, that the artists' dependence on their patrons
made them very vulnerable. Conversely, the patrons also ran a clear risk
by supporting the avant-gardists. This was demonstrated to Kristi after
the death of Malevich, when he was briefly arrested because of the help
he had provided.[55]

Tatlin in Kyiv

After leaving Leningrad, Vladimir Tatlin went to live in Kyiv. He had been
appointed manager of the Theatre, Photography and Film Department at
the Kyiv Art Institute by Ivan Vrona, the institute's progressive director.

Kyiv and Kharkiv were important centres of avant-garde art, where
freedom occasionally seemed more readily available than in Moscow or
Leningrad, especially since Ukraine still enjoyed significant autonomy
in the mid-1920s. Kyiv was home to the avant-garde theatre run by Les
Kurbas, some of whose costumes and set designs had been exhibited at

the Paris World's Fair in 1925. A potential collaboration with Kurbas was Tatlin's most important motivation for travelling to Kyiv.[56]

The avant-gardists Oleksandr Bohomazov and Viktor Palmov taught at the institute, as did the theatre designer Vadim Meller. The great poet and 'panfuturist' Vadim Semenko lived in Kharkiv, where he published (among other things) the influential journal *Nova Generatsia* (New Generation) – one of the most significant avant-garde journals ever to have existed in the Soviet Union. Kharkiv was also home to Vasyl Yermilov, an artist who did much work for Kurbas and, along with his friend the author Valerian Polishchuk, had developed the theory of 'spiralism', which was clearly derived from Tatlin's work.[57] Tatlin, therefore, had plenty of kindred spirits in Ukraine; plus he already knew the country from his youth, spoke the language and had other friends and acquaintances there.

Tatlin's aim was to produce a new version of *Zangezi* with Kurbas. Kurbas was of a different mind, however, and their collaboration never eventuated. In Kyiv, Tatlin avoided public life, but still managed to surround himself with a small group of young fanatics. His fame (or 'crooked glory', as he put it) was still considerable, although the new generation of his fans did not know exactly how Tatlin had earned his reputation.[58] He contributed to two journals, took care of the design and layout for a poetry collection by Semenko, and for the first time in years did some design work for youth and other theatre productions. Not much more is known; the documentary trail of his almost two-year stay in Kyiv consists only of fragmentary snippets. Almost all of the available information comes from a few memoirs dating from the 1960s or later, and though they certainly describe genuine events, the details are not always verifiable. What is clear is that despite his prestigious appointment ('Professor Tatlin' was his official title), he lived a secluded life. 'Everybody loved Tatlin,' said one of his students, 'but his visits were sporadic, and not even to the classroom. Usually we spent time chatting to him in the corridors.'[59] He started a relationship with Maria Kholodnaya, a stunning twenty-four-year-old painter from a well-known family of intellectuals and artists. At the same time, he maintained warm relations with both Molecule and his young son, Volodya.

Our knowledge of his work in youth theatre comes from the few memoirs featuring Tatlin as a theatrical designer. For one of the shows, he was hired to design a set featuring the Carpathian Mountains. His concept was to depict the dark, barren crags in black steel. 'Only that

An 'agitation train', based on a design by Ukrainian artist Vasyl Yermilov.

physiognomy in the right lighting,' he said, 'can produce the right image.' But where to obtain the sheet metal, 'which was in such short supply at the time'? Tatlin and the theatre's artistic leader decided to visit the Arsenal steel factory in person. They were received by the deputy director, and 'Tatlin immediately started explaining our cause. He spoke passionately about art, about theatre and about the role of the artist in the design of the production. He lost himself completely, gesticulated wildly, and spoke of much that had nothing to do with our request. With a wry grin, the deputy asked: "How many sheets?" Tatlin answered: "Around forty or fifty."'

The deputy, enchanted, agreed. 'It is true,' the artistic director later wrote, 'that the actors slipped over on the mountains and plunged into the abyss, to the constant rumble and roar of iron sheets, but for the designer it was a triumph. "This is exactly what I envisaged: the authentic breath, the true life of the Carpathians."'[60] Despite the unintentional slapstick, the show was a great success. Across Kyiv, suddenly 'the children began drawing sheet-metal mountains'. More than this we do not know – none of the photographs or design sketches has survived.

345

In Kyiv, Tatlin lived in Dikaya Street at the edge of the city, with a stork in his room. 'He has ruined the whole floor,' said a later resident of the same apartment. 'Look, that was where a galvanized trough used to be, where the frogs lived in the winter. He bred frogs and lived with a stork. These were the stunts he pulled. The police were called several times, but the landlady, a former noblewoman, was too partial to him. She bewitched the police – clearly she bribed them. [Tatlin] was a diffi-cult character.'[61] According to another (somewhat less credible) memoir by a former student, Tatlin was said to have kept a 'tethered condor' in the courtyard of his apartment, which he sketched as it attempted to fly away.[62]

Birds certainly did begin to play a major role in Tatlin's daily life. This new interest was related to a project that he started working on daily in Kyiv, and which he guarded with even greater vigilance than usual. By researching bird flight, he hoped to create an aircraft that could be used to leave the Earth's surface using human strength alone.

Tatlin called his project 'Letatlin', a portmanteau of his surname and the Russian verb *letat* (to fly). However, it is also a reference to *Letatelnyi snaryad*, an old-fashioned collocation meaning something akin to 'flying projectile' or 'flying equipment'. Being possessed of an extreme poetic sensitivity as he was, Tatlin must also have been aware that when written in Cyrillic, 'Letatlin' is a near-anagram of Liliental: the family name of the greatest European aviation pioneer of all time, Otto Lilienthal.[63]

Inspiration to create an artwork dedicated to the childhood dream of 'the flying man' probably came in the early 1920s, perhaps even shortly after Khlebnikov's death. In 1924, during a visit to Nikolai Punin and in the company of the poet Anna Akhmatova, he first spoke about his plan.

> Tatlin is enthralling...constantly possessed by grand designs. He is simultaneously both a wunderkind and a giant. In passing, he mentioned the construction of an aeroplane that he is evidently working on. He can't stand the construction and appearance of the existing models. They don't know – or refuse to see – how birds fly, yet they all claim wisdom. 'I,' says Tatlin, 'have no faith in their books of calculations, but shall fly in my own way, the way I breathe, the way I swim. My method of flight will always be more perfect than their devices with their suction engines.' I got the impression that Tatlin genuinely wants to fly using his arms....He is obsessed with the idea.[64]

It is also a known fact that during his final years in Leningrad, he and his girlfriend Molecule studied the skeletons and musculature of birds. Molecule, who was a doctor by profession, directed the dissection of the specimens. This probably explains why Tatlin had several microscopes in his studio.[65]

Despite Tatlin's obsessive secrecy, stories emerged of the 'wings for the Soviet man' taking shape in his studio, and those in the know started calling him 'Tatlin-Letatlin', as though he and his project were one and the same.[66] But he did not think that he would be able to complete his machine in Kyiv. In early 1927, he wrote to his friend Pyotr Miturich: 'It is difficult for me to stay here in Kyiv, it is too far away from everything. I want to come to Moscow. Not to Leningrad, Malevich is there....Ask around for me, and see what people think.' Of course, Miturich was not permitted to reveal any secrets: 'Tell no-one of my work, there is no need. Write when you can.'[67]

Tatlin succeeded in finding a position in Moscow, and in May or June of 1927 he settled there permanently.

Malevich: A New Love and Recognition in Europe

Whenever the intensity of the situation in Leningrad permitted, Malevich tried to visit Nemchinovka, where Una played happily with Kira and Marina, the daughters of his rival Katsman. The fierce battle being waged by the two brothers-in-law – or more accurately, the merciless attacks by the one on the other – seemed to leave their family lives relatively unaffected, even after the death of Sofia. The ferocious grandmother protected her pride and joy, Una, rendering Malevich's status within the family untouchable. During his regular visits to Nemchinovka, his position as father was respected, and Una 'refused to let go of her father's hand for a second'. She went for horse rides on his back, and played with the presents he brought back for her.[68]

During the second half of the 1920s, Katsman visited Nemchinovka less and less often. He had, in the meantime, become a well-to-do gentleman. In addition to his studio in the Kremlin, he had an apartment in the suburb of Plyushchikha – a distinguished part of town where Tolstoy, Herzen and Kandinsky had lived, and which is now the embassy district. His archives contain documents referencing international bank accounts.[69] He described the impoverished Nemchinovka with disgust:

When I am in Nemchinovka and see all those hands and mouths, and we bring fifty roubles' worth of all kinds of food, but it is only enough for 2 kopeks per mouth....All there is, is a practically frozen house and that absurd life, collecting firewood and work, work, work, with your tongue hanging out and eyes forced open, all just to keep warm. Nemchinovka is like a prison camp with life-long forced labour. My children cannot see it, they have romanticized Nemchinovka and grandma. To me it represents an awful, miserable and disastrous end to life.[70]

Katsman's absence from Nemchinovka was probably good for relations. However, approximately six months after Sofia died, the peaceful situation was threatened when Kazimir met another woman – Natalia Manchenko – with whom he entered into a relationship. Natalia (customarily known as Natasha) was originally Ukrainian, twenty-one years his junior, and was slightly acquainted with Malevich's in-laws.[71] In company she was reserved and phlegmatic, but the letters written to her by Kazimir were uncommonly passionate and show an unexpectedly poetic side to the pontifical, even bombastic Malevich.

To whom do you belong, whom do you love... Do you love me?
Natashenka, Natashette, my pet. My dearest love. To whom do you belong, whom do you love, do you love me?
I am thinking and thinking, how can I get away from here, how can I bring us together in one place.
You are my gold, dear Natasha, how I would love to go with you somewhere new, I grow weary of Leningrad, and long to leave so as not to see anybody.
Do you miss me? What do you think?
Do you love me?[72]

If Una's grandmother did not accept Malevich's new love, he would lose Nemchinovka, and the caring and protected environment that Una enjoyed with her grandmother would be impossible in Leningrad. The introduction of Natasha demanded tact and a knowledge of the old woman's naive psychology. Many years after his death, stories circulated within the family of how Malevich 'reeled in' his mother-in-law. She knew of the budding relationship, and Malevich spoke again and again of how much he missed Sofia. At the right moment he said: 'I dreamt of Sofia last night.' To which the grandmother replied: 'Things are hard with you by yourself. You should marry Natasha.'[73] Kazimir and Natasha became

engaged, and agreed to live together in Leningrad while Una remained in Nemchinovka.

Before their marriage could take place, Malevich had another dream to realize: a tour of Europe to present his work. For a year he had been receiving invitations from abroad to give lectures and exhibitions, facilitated to a large extent by the diaspora of emigrant avant-gardists in Europe and the United States. Mikhail Larionov tried to draw him to Paris, Wladislaw Strzemiński arranged an invitation from Warsaw, and through David Burlyuk – who had made it to the United States – an invitation was even sent from New York.

Malevich had placed his greatest hopes in the vast network of El Lissitzky in Germany, and indeed, it did seem as though Lissitzky could arrange an exhibition in Hannover. Yet relations between Malevich and his disciple had cooled. Lissitzky had enormous personal problems that he kept hidden from Malevich. His love for Polina Khentova was completely unrequited, and Lissitzky was so devastated that he attempted suicide. He shot himself in the chest. The bullet missed his heart, but caused serious lung damage that resulted in a chronic state of ill health.[74]

This dramatic affair meant that Lissitzky had less time and attention available for Malevich, who as usual had little patience for anyone who was not as dedicated to art – and to himself – as he was.

Lissitzky, incidentally, had developed into one of the most well-known and appreciated avant-garde artists from the Soviet Union. He had an extensive network, received commissions and was on good terms with several traders and patrons dealing in avant-garde art. For this reason, too, Lissitzky felt distanced from Malevich's world, which now seemed utterly provincial compared with his own cosmopolitan milieu. Ultimately, Lissitzky played only a small role in Malevich's European tour, and they never even met each other face-to-face.

Once the preparations for the exhibition in Warsaw were well underway, another invitation followed for a solo exhibition in Berlin. Malevich set about trying to arrange travel visas for himself and various workers. These included at least Nikolai Punin and Ilya Chashnik, who had been working with him since Vitebsk. The applications were refused time and time again, however, as travel visas were still only issued in rare instances. In any case, Malevich's own supervisory body, the Scientific Council (GLAVNAUKA), would have to grant its approval before any visa could be issued. The council members were hesitant for, as his official superiors,

they would be held responsible if he did not return. His frustration at being consistently turned down was evident: 'If the Scientific Council refuses to grant the necessary resources for an exhibition [abroad] or for a ticket for a single manager, then I ask…the Council to approve a visa…for me to travel to France via Warsaw on foot, which I propose to start on 15 May in order to reach Paris by 1 November, and to return by train on 1 December.'[75] Malevich's stubborn tenacity eventually got the better of his superiors, and he was granted a visa. He was not allowed to take any assistants or staff with him. On 1 March 1927 Malevich travelled to Warsaw, ahead of a cargo transport carrying over seventy paintings, a large number of sketches and several architektons, plus over twenty works known as 'analytical charts', based on the teaching method that had been developed at INKHUK. The transport represented the core of his artistic production from the previous fifteen years, and reveals the scope of Malevich's ambitions for the tour, since he was well aware of the risks: 'One actually needs to be insane to travel with so much capital,' he wrote in a letter home.[76]

The authorities feared that Malevich planned to remain in the West for far longer than he was prepared to admit. He later wrote to Natasha that they tried to impress upon him 'not to remain abroad, or to try to convince you to join me. I replied that nobody flees from what is good.'[77] However, various testimonies suggest that Malevich did, indeed, have more or less concrete plans to extend his stay – perhaps indefinitely – in Europe. Several months earlier, in a letter to Natasha, he speculated rather openly about the possibility of obtaining Polish nationality.[78] Shortly before his departure, Matyushin wrote to him: 'Will we ever work together again? At least we have done so for three years, and achieved much. We can be proud that we did not eat Soviet bread for nothing. If you do go away, then take our friendship with you. And when you are at work and rising to stardom, think of me occasionally, your humble comrade. Let me also bask in the rays of your glory.'[79]

At least one surviving document proves that Malevich intended to leave part of his *oeuvre* in the West. During the preparations for the Polish exhibition, two of the organizers wrote that they 'expect Malevich's arrival soon. He will be bringing his paintings with him, which he plans to leave in Warsaw.'[80]

Malevich's plans went beyond merely presenting his art at an exhibition, and reveal his intention to remain abroad, if not permanently, then at least longer than the few months permitted by his visa. He took

Kazimir Malevich, teaching at GINKHUK, 1925.

BEISPIEL DER FORMENANALYSE DER 4 ELEMENTE DES KUBISMU: ERHALTEN DER FRAGMEN
TE
VERBINDUNGEN UND LINIEN.

Kazimir Malevich, *Analytical Chart*, 1927.

with him the manuscript of his principal theoretical work, *The World as Non-Objectivity*, which he hoped to have translated into various languages. He also took the scenario for a suprematist animated film that he had been working on with his assistants for some time, and for which he hoped to find an artistic partner or producer in Europe.[81] The series of 'analytical charts' that he brought along (several of which had been prepared by Matyushin) had been made specifically for the tour, and some of the accompanying texts were in German, clearly as an attempt to pave the way to an appointment in a German art institution.

The Warsaw exhibition was small and held in two rooms of the Hotel Polonia. It was not exactly a prestigious location for a public debut, but the in-crowd knew where to look. The opening banquet was a veritable who's who of the Polish avant-garde: Katarzyna Kobro and Wladislaw Strzemiński, the artists who intended to establish a Smolensk chapter of UNOVIS; poets Aleksander Wat and Tadeusz Peiper; the architect Helena Syrkus; and many others. The paintings were hung in a clustered hodge-podge, some even above the doorway. 'It is a minuscule exhibition,' Kazimir ('Kazik') wrote to his friend Matyushin, 'only thirty paintings, everything here is tiny, clean and proper.'[82] In addition to his paintings, he also displayed manuscripts in a small neighbouring room, including the latest edition of the journal *Praesens*, in which sections of *The World as Non-Objectivity* had been translated into French and Polish.[83]

The first letters from Warsaw betray a state of exuberance uncommon for Malevich: he was in seventh heaven from all of the attention and appreciation being lavished on him. He proudly sent his Leningrad students a copy of the invitation to the 'banquet in honour of Kazimir Malevich'. Despite its small scale, the event was still covered by the press – mostly by favourable critics, but also from more politically engaged media, including the Russian-language newspaper *Segodnya* (Today), a forum for anti-Bolshevist emigrants that was published in Riga. Malevich agreed to talk to them, on the condition that they would not ask him any politically charged questions. To his old friend Matyushin he wrote, 'O, the attention here is so wonderful. Glory comes pouring down like rain.'[84]

In Poland, several of his admirers made attempts to keep him in the country. Strzemiński approached the Polish authorities to try to obtain residency permits for him, and Tadeusz Peiper – who was his constant companion – made an impassioned plea in the art journal *Zwrotnica* for Malevich to remain:

17 Lyubov Popova, *Composition*, 1917.
 Gouache on paper, 33 × 21 cm (13 × 8 ⅜ in).

18 Raoul Hausmann, *Tatlin at Home*, 1920. Collage of glued paper and gouache, 40.9 × 27.9 cm (16 ⅛ × 11 in).

19 Marc Chagall, *Over the Town*, Vitebsk, 1918.
Oil on canvas, 45 × 56 cm (17 ¾ × 22 ⅛ in).

20　Marc Chagall, *Introduction to the Jewish Theatre* [fragment], Moscow, 1920. Tempera and gouache on canvas, 284.2 × 787.2 cm (112 × 310 in).

21 El Lissitzky, *Proun. Design for Street Decorations* [in Vitebsk], 1921. Gouache on paper and painted photograph mounted on cardboard, 53.8 × 71.5 cm (21 ¼ × 28 ¼ in).

22 Kazimir Malevich, *Female Torso*, 1928–29.
Oil on plywood, 58 × 48 cm (22 ⅞ × 19 in).

23 Kazimir Malevich, *Complex Premonition: Torso in a Yellow Shirt*, 1932. Oil on canvas, 99 × 79 cm (39 × 31 ⅛ in).

Polish artists should feel deep regret that the Pole Malevich is not working by their side. Artists of his calibre are in short supply where we are. Our Warsaw comrades should do their utmost to keep him in Poland, and offer him at least the same working conditions as he enjoys in Russia. We need Malevich. Although we would like to welcome him with an orchestra of joyous cries, we cannot. Our voices are suppressed by regret at the fact that our countryman only comes to us as a guest. Malevich should not be our guest! Malevich should not be our guest![85]

Peiper clearly did his utmost to create the impression that Malevich had had no input into the article whatsoever, but even so it is doubtful whether Malevich was entirely pleased with it. When writing letters, Malevich was extremely conscious of the security service peering over his shoulder. He ends one letter to Natasha with a direct request to the censor: 'My fellow readers, please do not withhold these letters. By God, they are of no interest to you.'[86]

Malevich was extremely careful – especially by his own standards – and tried not to say anything that could be considered critical of the Soviet Union. And so he was furious when he was sent a copy of the article published in *Segodnya*, which contained the following excerpt: 'As we have already noted, we asked Prof. Malevich no political questions, nor did we interrogate him on the general living conditions in the Soviet Union, as we did not wish to create any difficulties for him upon his return to St Petersburg.'

Though this insinuation alone was certainly dangerous enough, what followed must have sent chills down the artist's spine: 'But various comments, words and phrases from our interviewee have allowed us to form a general impression of life in modern-day St Petersburg regardless, and a rather discouraging one at that. The gradual disappearance of the intelligentsia, the poverty that even the most famed of its inhabitants must endure, and the vandalism leading to such excesses that the average passer-by on the street can have a stone pitched at them without warning – all of this paints a picture that is utterly foreign to any European understanding.'[87]

Malevich lashed out venomously in response, calling the author of the article an 'imbecile' and a 'child of the devil', but by then the damage had been done.[88]

On 29 March he travelled by train to Berlin, where he was to prepare a solo presentation or *Sonderausstellung* (special exhibit) as part of

MALEWITSCH: Suprematistisches Bild

100

SONDERAUSSTELLUNG
MALEWITSCH

Die Entwicklung des russischen Malers Kasimir Male-
witsch ist charakteristisch für die Entwicklung der Kunst
der Gegenwart. Der 1878 zu Kiew geborene Künstler be-
gann als Naturalist, um zuerst zu den Impressionisten und
später durch die Cezanneisten zu Futurismus und Kubis-
mus zu kommen. 1915 begründet er die Gruppe der Supre-
matisten, welche Richtung er inaugurierte. Der Supre-
matismus ist die gegenstandslose, ideenlose Kunst, für die
Form und Farbe lediglich Mittel zur Wiedergabe von Emp-
findungen sind.

Es ist charakteristisch für die neuere Kunstentwick-
lung, daß der in Paris lebende holländische Maler Piet
Mondrian, von ähnlichen Voraussetzungen ausgehend, im
Gegensatz zu dem Dynamismus Malewitschs zu einer voll-
kommen statischen Kunstauffassung gekommen ist.

In einigen architektonischen Entwürfen zeigt Male-
witsch die Anwendung der Methoden des Suprematismus
auf die Dreidimensionalität des Raumes.

Malewitsch ist Leiter des experimentellen Labora-
toriums des staatlichen Instituts für Kunstgeschichte in
Leningrad.

Diese Sonderausstellung zeigt zum ersten Male in
Westeuropa das Werk eines Malers, der hier wesentlich
durch seine Schüler bekannt ist, im historischen Ablauf
seiner Entwicklung.

Two pages from the catalogue of the Great Berlin Art Exhibition
(*Grosse Berliner Kunstausstellung*), 1927.

the 'Great German Art Exhibition', an annual variety trade fair where
many hundreds of local artists, art organizations and art dealers could
present their works. A small delegation was sent to welcome him upon
his arrival at Berlin-Zoo station, but however loudly the train conductor
called 'Professor Malevich' across the platform, no Malevich appeared.
The artist had, by mistake, alighted at Berlin-Friedrichstrasse where,
helpless and forlorn, he had been inveigled into a coach by an oppor-
tunistic driver who spoke five words of Russian. 'How the devil could he
have known that I was Russian?' Malevich later wondered. This question,
even more than his lack of knowledge of the train system, betrayed his
provincial mentality.

The coachman dropped him off at a Russian boarding house which, to
Malevich's horror, was full of 'Whites', or anti-communist refugees – pre-
cisely the people he had been trying to avoid so as not to alert national
security forces. Thankfully, his Berlin hosts did some speedy detective
work, and liberated him the next day from his incriminating lodgings.[89]

His exhibit opened on 7 May in the Glass Palace beside Lehrter Bahnhof station,[90] a venue of international calibre where he could present a retrospective of his entire development as an artist. In contrast to Warsaw, the Berlin public was more diverse and international, and viewed his work differently. The catalogue's brief introductory text said: 'It is characteristic of contemporary artistic development that the Dutch painter resident in Paris, Piet Mondrian, while proceeding from the very same artistic principles, has arrived at a completely static artistic approach, in contrast to the dynamism of Malevich.'[91] Though a rather asinine observation (what exactly is characteristic about this contrast?), it nonetheless placed Malevich squarely in the vanguard of the greatest artistic movement in Europe. And Kazimir was happy. He rode up and down the enormous exhibition hall on a bicycle, and sent triumphant messages home to Leningrad.[92] 'My work in Germany is progressing so well, knowledge of it will spread throughout the world. If you only knew how easy it is to work here – the feeling is feather-light. I want to share it all with you.' And two weeks later:

> Here in Germany everything works differently, and takes shape more clearly....If my visa is not extended I must return, which I absolutely do not wish to do. Things are so good here, you cannot imagine anything better. The Germans have welcomed me like never before. I would so like for you all to see how they approach me here, in a different state. I do not believe that any artist has ever been received so warmly. They regard my opinions as axioms....The only disadvantage is that nobody thinks to slip a banknote in amongst all their laurels. They think that as a famous artist, I must already be fully provided for.[93]

It has been claimed that Malevich only sent these reports to bolster the spirits of his students, who had remained loyal to him in the face of adversity. And of course he only relayed part of his reception, sweeping the inevitable criticisms of his exhibitions under the carpet. But he also wrote of how happy he was to his closest friends (such as Matyushin), and included some less-positive details (such as his remark about the banknotes).

Malevich was openly astounded at the prosperity in Europe, as modest as it may have been in Germany, which was groaning beneath the weight of the reparation payments under the Treaty of Versailles. He found the wealth of artists particularly striking: 'The academy has excellent studios for graduates. There are cheap eateries, nobody wears rags, everyone is dressed to the nines.'[94]

Malevich's biggest problem was that he spoke not a word of German, nor any other Western European language. He was thus entirely reliant on interpreters and mediators at every turn, which hampered his two greatest qualities: his tenacity, and the ability to wow his audiences with complex theories.

Tadeusz Peiper, one of the Polish organizers who accompanied Malevich to Berlin as an interpreter, described a party held in Malevich's honour that was well attended by poets and artists. 'It was a rowdy affair, and the company juggled with words thick and fast..., only Malevich sat silently, his hands folded on his lap. Like a deaf man, he looked from one person to another, in the vain hope that he might deduce the meaning of their conversation from the movement of their lips.'[95]

In Berlin, Malevich stayed with Gustav von Riesen and his family at Wilhelm-Hauffstrasse 4/5 in Friedenau. They had strong ties with Russia, and Gustav's two sons, Alexander and Hans, were artists who both spoke fluent Russian. The von Riesens helped Malevich establish contacts and plan meetings. An important role was played by Hugo Häring, who was married to a Russian-born actress. Häring was a member of the 'Ring' group of architects, whose members also included Walter Gropius, Ludwig Mies van der Rohe and Bruno Taut. Malevich's introduction to the group was probably thanks to Lissitzky, who had visited Häring the year before. Häring was also responsible for initiating and organizing Malevich's exhibition in the German capital.

In Berlin, Malevich met Ludwig Mies van der Rohe, the Dadaist Hans Richter and the critic Ernst Kállai. His contacts also arranged a visit to the Bauhaus school, an art institute located just over 120 kilometres (75 miles) from Berlin in Dessau. He had pinned his hopes on obtaining a teaching position at the institution, and had already been in touch with the management. Also, of course, he knew Kandinsky, who had taken up a post there after leaving the Soviet Union. Relations between Malevich and Kandinsky had never been truly warm, however.

On the afternoon of 7 April, Malevich and Peiper arrived in Dessau. The school was closed for the Easter holidays, so they tried calling Kandinsky from a café. Gluttonous as ever, Malevich drank three cups of tea. Peiper later wrote that when they went for a walk around the neighbourhood, Malevich 'stopped at every illuminated shop window. He sighed at the appearance of rain jackets, tablecloths, suitcases, and joked about buying a bed.'[96] After another fruitless attempt to call Kandinsky, they tried the Bauhaus founder and director Walter Gropius.

He immediately offered Malevich a bed for the night and arranged meetings with brilliant Hungarian artist László Moholy-Nagy and architect Hannes Meyer, who would become head of the institute for several years in 1928.

Kandinsky eventually also appeared, but the reunion between him and Malevich was stilted. Peiper writes: 'One might have expected an engaging, even heartfelt encounter between the Russian working in Germany and the Pole working in Russia. But no. Kandinsky greeted Malevich with a paltry hand gesture, and quickly vanished again without a trace.'[97] The next day Kandinsky and Malevich met once more with only Peiper in attendance, and the atmosphere was more relaxed. Kandinsky lived on the school grounds in a spacious artist's residence designed by Gropius, which he had kitted out with furniture designed by himself and Marcel Breuer, supplemented with his own antique furniture. The colour palette throughout the residence was Kandinsky's own. 'The walls were soft pink, except for the short wall behind the divan, which was ivory-white. The doors were black, the ceiling grey, and one niche was covered in gold-leaf.' Malevich was shocked that an artist could live in such a fashion. Peiper wrote: 'He saw, looked on in wonderment, and sighed.'[98]

Von Riesen later recalled that Malevich was disappointed on his return from Dessau. He had asked Gropius point-blank whether he might teach at the Bauhaus school. Ise Gropius, the director's wife, wrote in her diary that 'Malevich is eager to remain in Germany, and is trying to find sources of income'.[99] Gropius diplomatically replied that there was no room in the budgets, however. He was undoubtedly sincerely interested in Malevich, but the utter helplessness of his Russian guest meant that he could hardly give him serious consideration as a teacher.

Yet Malevich still had reason to be happy, for he had managed to make arrangements for the publication of *The World as Non-Objectivity* in the prestigious Bauhausbücher series, which was read and studied by progressive artists and architects worldwide. It is principally due to this publication (which appeared under the slightly erroneous title of *Die gegenstandslose Welt* – 'The Objectless World') that Malevich enjoyed fame in the modern art world in the 1930s, even though little of his work had been on display outside of Russia.

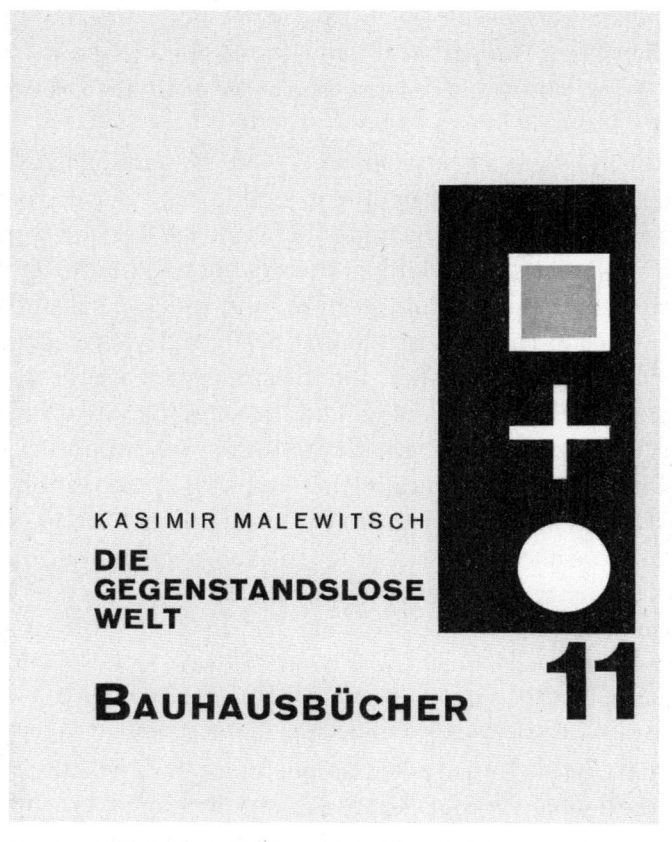

Bauhausbücher 11: Kasimir Malewitsch, *Die gegenstandslose Welt* (The Objectless World), 1927.

Malevich made several attempts to extend his visa at the Russian embassy in Berlin. After the opening of his exhibition, he planned to travel on to Paris in order to take part in a group exhibition of Russian artists at Galerie Bernheim-Jeune that was scheduled to open on 7 June.[100] He was not granted an extension, and instead in early June he was ordered to return immediately to the Soviet Union. His Berlin exhibition was still running, and he was forced to leave his works behind in the hall. He took his manuscripts to von Riesen, to whom he added 'rather solemnly for him' that 'if we did not hear from him during the next twenty-five years, the package could be opened and the contents dealt with as we saw fit'.[101] Attached to the package was a hastily written declaration that has attained legendary status in the Malevich literature:

'In the event of my death or indefinite imprisonment, and if the owner of these manuscripts wishes to publish them, it will first be necessary to have them studied and translated into another language, for, since I was under revolutionary influence during my time, they may contradict the form of defence of Art that I now hold, that is to say, in 1927. These claims must be considered valid. 30 May, 1927, Berlin.'[102]

It is a curious text, written in Malevich's ungrammatical Russian. Precisely what kind of authorization is being granted here is unclear. Two things *are* evident, however: firstly, that he was already aware even then of his own impending long-term ('indefinite') imprisonment; and secondly, the note was his first clear attempt to distance himself from the convictions he had held when he was 'under revolutionary influence'. The architect Helena Syrkus, who had translated Malevich's texts into Polish that year, described in her memoirs the difficulty she had in dealing with 'Malevich's deep pessimism and premonition of his future fate, which was not entirely unfounded'.[103]

Malevich would never again see the artworks he left behind. They were put into storage and kept hidden from the Nazis. Most of them are now in the collection of the Stedelijk Museum in Amsterdam.

His manuscripts remained in the von Riesens' cellar, until the house on Wilhelm-Hauffstrasse was destroyed by a Soviet missile during the battle for Berlin in 1945. Everything in the home was considered lost. That is, until many years later in 1953, when the rubble was cleared and the cellar turned out to be intact. Malevich's manuscripts emerged from the wreckage almost completely unscathed.[104]

The history of the avant-garde is replete with resurrections of this kind. Sadly, before one can rise from the dead, one must first die.

The Flying Bicycle

1927–1932

Immediately upon his return from Germany, Malevich was arrested. There is no documented evidence of the event – all information comes from the written memoirs of friends and family. These sources indicate that he was detained from anywhere between several days and several weeks.[1] According to his assistant Anna Leporskaya, officers escorted him away from the station (most likely on 7 June 1927), and interrogated him twice about his foreign 'experiences'. Malevich is reported to have said to another assistant that the first interrogation lasted thirty-six hours, and the second thirty-two. Though this seems exaggerated, it is certainly not impossible.[2]

Arrests entailed great risks, and not just from the dangers that awaited in prison. Salary payments were always halted directly, even during the period of detention preceding a trial, thus plunging the arrestee's family members into immediate financial difficulty. For those who were on remand long enough, processes of social exclusion began to take effect. Whenever an artist was arrested, friends and close colleagues had no choice but to distance themselves. The artist Viktor Elkonin, then still a student at Vkhutemas, described the process in the case of Nikolai Padalitsyn, a recently graduated graphic artist and member of an organization that called itself 'The 4 Arts'. This was a diverse group of artists who were mostly united by their mutual hatred of the AKHRR, but had little else in common. El Lissitzky and Ivan Klyun had some involvement, but the group's most active members were modernists such as Pavel Kuznetsov, Kuzma Petrov-Vodkin and Konstantin Istomin. Elkonin writes that the group was called together after Padalitsyn's arrest:

> Istomin dryly informed us that Padalitsyn had taken part in a counter-revolutionary conspiracy, for which he had been arrested (and later executed by firing squad)....Nobody expected it, and the members

were shocked....Of course it was impossible *not* to ban Padalitsyn from the society, but not a word was said on the matter. At no point was any judgment passed on the 'perpetrator', and calls to purge the ranks were left unspoken. In dejected silence, and without exchanging a single word, the members of The 4 Arts went their separate ways.[3]

Malevich's situation was not yet so dire, and after his brief imprisonment he was free to resume his work. But he had now felt the genuine threat of arrest for the first time.

During that summer and autumn of 1927 the Communist party conducted a campaign to put more party members in leadership posts. It is a sign of the occasionally bizarre contradictions that emerged in Soviet society under the pressure of Stalin's reforms that Malevich, shortly after his arrest, was asked to become a member of the Communist party. He refused. In his defence, he said that although he 'fully supported the principles of communism, it would distract him from his calling'. Such a position was unheard-of, for in spite of everything, the offer of party membership was a highly coveted privilege. 'The party committee answered his refusal with a tirade of abuse, and Malevich walked off.'[4] Whether he truly did 'support the principles of communism' is up for debate. At around the same time he wrote in a notebook: 'Communism represents ongoing hostility and a disturbance of the peace, as it attempts to subjugate and destroy all thought. Communism produces a slavery such as no slavery has ever seen.'[5]

Malevich's political ideas had never been precisely defined, and he knew little of modern political theory. This applied even to Marxism, his knowledge of which was fragmentary and based on what he had picked up in discussions rather than on any independent study of Marxist writings. He had never shown any interest in other political systems, such as liberalism. In truth, none of the avant-garde artists – not even Kandinsky – seemed to attach any value to, or even have a vague understanding of, liberal ideas. The principle of individual rights, limited freedom, separation of powers, the value of ideological pluralism – none of these were taken seriously. In reality they were never even brought up. When Malevich was in Berlin, he was surprised by the pluralism that existed in the art world, calling it 'the wondrous inviolability of every -ism'. 'All movements' coexisted side-by-side.[6] For the first time he seemed to doubt his own maximalism, and his disdain for compromise, gradual progression and tolerance.

In a philosophical sense, the avant-gardists were extraordinarily ill-equipped to offer any fundamental criticism of Marxism or Leninism. As a counterweight to the essential lack of freedom in the Soviet system, they posited their utopian ideal of anarchist freedom. In addition, Malevich, Tatlin and many other avant-gardists consistently acted against the radical materialism of the Bolshevist doctrines. On a more practical level, Malevich's attacks on the bureaucracy testify to an awareness of the oppressive and violent aspects of absolute state power.

Malevich had never been a communist, and was now even less likely to become one. It was also clear that he had definitively given up any ambition to obtain an administrative or management post. To Matyushin, he wrote that upon his return he 'would work solely as an artist, and as nothing else'.[7]

The New Figuratism

Malevich's European travels also made him radically re-evaluate his own theoretical principles. He started painting again, with an initial hesitation that quickly gave way to great vitality and productivity. And in these new paintings appeared – much to the surprise of his contemporaries and subsequent audiences – recognizable human figures, inhabiting spaces that are unmistakeably landscapes. Some of the new figurative artworks harkened back to the figures and motifs from the peasant paintings he created between 1911 and 1913.

Why? Was suprematism over? Had Malevich suddenly begun to doubt the necessity of a non-objective visual language? Had he capitulated to socio-political pressures, and made a return to conventional realism?

The last question can be answered easily in the negative. The new figurative works were as far removed as ever from the artistic norms being promulgated by the AKHRR and its Soviet sponsors, which were certainly not responsible for any kind of 'rehabilitation' of Malevich as an artist.

The riddle of Malevich's sudden and radical about-face is further obscured by the fact that he never publicly said anything about his motivations for the change, not in any article or manifesto. Indeed, he produced almost no theoretical writings at all after 1928, only several historicizing texts. Kazimir Malevich – who more than any other twentieth-century artist had bared his internal struggles in public, who

had become a philosopher and written in a language that was as clumsy and cumbersome as it was magical, and who blithely violated all norms of coherence, transparency and good taste – became dormant just as quickly as he had erupted nearly ten years before. 'Malevich the theoretician' first saw the light of day in 1918, eclipsing 'Malevich the painter'; likewise, the theoretician was rendered mute when the painter rose again from the ashes. His non-painting period lasted nearly ten years.

Still, it is possible to identify some circumstances that may have prompted his decision. His return to painting may have been partly influenced by the preparations for his exhibitions in Warsaw and Berlin; the confrontation with his artistic history and the recognition he received from fellow European painters of his generation possibly helped him appreciate the ongoing relevance of his painted works. As preparation for his exhibition he had also restored old works, and even made copies of several of his pre-war paintings. The reacquaintance with canvas and brush, with the simple physical act of painting and the accompanying enlightening concentration, undoubtedly reawakened, to some extent, his desire to start painting again.

The preparations for his international tour also gave him a new perspective on his artistic development, as he was forced to review and reassess his entire artistic *oeuvre*. To explicate his artistic history to his German audience, he had created a series of informative 'analytical charts': cardboard sheets each measuring around 70 × 100 centimetres (27 × 39 inches), containing a schematic representation of the progression of painted art from Cézanne to suprematism. He and his students also went through all of his old theoretical works, which he himself now needed to come to grips with once more. Although the texts had been born of intuition, and were 'therefore correct', they had since become all but inscrutable, even to him.[8]

In conversations with pupils, he revealed that he no longer saw suprematism as a necessary endpoint: 'K. M. is planning to live another fifteen years, and witness the future deviations and quests of art. To find out himself whether or not art will pass by suprematism or not. He wants to see the end....He also spoke about the union of the bourgeoisie and the proletariat against everything new in art.'[9]

The reasons behind Malevich's new urge to paint were so many and varied that it is difficult to rank them in importance; what we *can* attest, however, is that this urge did not originate from a desire to illustrate any

kind of social 'issues'. The decision he ultimately took sprang not only from personal considerations, but also from serious discussions within the community of radical artists.

One such occasion was an exhibition that opened in Leningrad in 1927, containing works by former Malevich adept Nadezhda Udaltsova and her husband Drevin. Both artists had returned to a figurative visual language, though one still very far removed from the photographic realism of the AKHRR. Some of Malevich's pupils defended his choice of figuratism, while others 'refused to forgive such experiments'. Some of his youngest pupils said outright: 'we are as unforgiving of the artist's capitulation as of those who try to defend it'. 'We can no longer stay silent. We must express our sincere belief in the possibilities offered by the new art. We can delay it no longer.'[10]

However, similar breaks with suprematism appeared even in the front line of Malevich's most loyal followers. Ivan Klyun, a born-and-bred suprematist, also returned to figuratism at around the same time. Klyun lived in Moscow, where he held a job as a bookkeeper but continued to work steadily on suprematist paintings in his spare time. Malevich and Klyun had always remained good friends. Whenever Malevich was in Nemchinovka, he insisted that his friend come and visit, and the two men would go for long walks in the countryside.

Malevich responded with uncompromising but jovial bluster, and unabashedly accused 'the objective swine' Klyun of betrayal and apostacy. Klyun responded teasingly that he had 'already been called too far from the Gospel' and that Malevich was

> the only one still wandering in the non-objective desert, like a King Lear, withdrawn from the world, with the umpteenth square still clenched in your hands....You must take up the brush once again, the time has come, now, to return from the desert. I will not try to prescribe how and what to paint, but I do know that you must make paintings, and you will see for yourself how strongly your voice will resound as it once did. It is now necessary....Farewell, write to me.[11]

Although Malevich did not appear to give an inch, Klyun's new convictions undoubtedly gave him food for thought. His discussions with the youngest members of GINKHUK, the poets that had gathered around Kharms, were even more dramatic. During heated debates, the poets more and more frequently drew a line between themselves and Malevich's non-objective world. The rejection of the non-objective by so

many young, yet radical and unswerving, creative minds cannot have left Malevich unaffected. One of the inviolable tenets of his theory was that the arts constituted an expression of the passage of time, and that artists must constantly hone their intuition in order to get a sense of the era and the immediate future. But was it possible for time to step backwards, allowing for a return of past phenomena?

He hinted at this idea several years later in a letter to Meyerhold, to whom he felt the need to defend himself. While several phrases, such as the references to 'socialist advancement' and 'proletarian revolution', seem primarily directed at the censors from the security service, the other remarks remain purely theoretical: 'But currently, during the period of socialist advancement, a matter in which all forms of art are involved, art must return to its former terrain and become figurative once again. Painting has returned from its immaterial path to that of the image; the painting movement has led back to the visual domain of its previous home, where it had destroyed the image, but along its way had already encountered a new image, one presented by the proletarian revolution.'[12]

And yet nearly all specialists agree that Malevich's new paintings represent no radical departure from the rest of his *oeuvre*, and that a broad general undercurrent runs throughout his creative output. Charlotte Douglas, an American Malevich specialist, defines it as follows: 'The transcendent unification, through art, of man with the cosmos.'[13] I would like to note here that 'transcendent' should be interpreted according to the sense in which it is used in 'transcendental meditation', that is to say, as an exceptional state of consciousness, unrelated to its use in 'supernatural', spiritual or religious contexts. The unification of humankind with the cosmos remained a central tenet of Malevich's artistic philosophy.

The new figurative style did enable him to imbue his works with experiences and images from his own reality. It is often noted that, in a number of his paintings, Malevich responded not only to the horrific disasters that befell Russian and Ukrainian countryfolk from 1927 onwards, but also to his own personal suffering.

Malevich himself brought out the continuity in his work by reintroducing a variety of themes and methods from his pre-revolutionary period. Why he made these various artistic choices in the stream of paintings that he produced from that moment on – a series later categorized as his 'second peasant cycle' – remains a matter of speculation and

discussion. One thing is certain, however: the new paintings, particularly those from 1927 and 1928, allowed Malevich's greatest creative powers to come to the fore, and they are among the finest that he ever produced.

What is most striking is the monumental nature of the works, and their generally static character. Malevich frequently opts for a symmetrical composition, placing the often full-body figures in the centre, and almost always from a frontal perspective. The motionlessness in most of the works reinforces their monumental appearance. Looking at the magnificent *Female Torso* from 1928–29, for example (Plate 22), we see how the monumental nature of the figure is emphasized by a subtle 'white-on-white' pyramid shape incorporated into the background. The elongated *Female Figure* in black and dark green (a very uncommon colour combination for Malevich) on a bright white background suggests a grand, solitary and indomitable independence.[14] It is impossible to view these powerful figures as the work of an artist in doubt of his artistic trajectory, or as the result of a compromise or a 'step backward'.

Though they are occasionally grave and ominous – particularly the many peasant figures produced from 1930 onwards – by far the majority of these paintings are energetic, clear and positive. The creative pleasure experienced during their production is also evident in the multitude of visual sources that Malevich either drew from or incorporated into the works. In addition to 'motifs' from his pre-revolutionary period, he also responded to work from students (Suetin in particular), Yermolaeva and European contemporaries such as Giorgio de Chirico and Willi Baumeister.[15] He used 'primitive' sources, such as religious wooden sculptures from Perm and Archangelsk (rediscovered in the 1920s), Ukrainian dolls and Italian Renaissance portraits. He experimented with various techniques, applying the paint in subtle, thin layers in some places to create evenness, and with thick, impasto strokes in others.

The flurry of activity maintained by Malevich around this time was stimulated by the prospect of new exhibitions. His European contacts remained active, and in 1929 there was again serious talk of an exhibition in Paris. Though it did not take place, Malevich was granted a personal retrospective in the Tretyakov Gallery. This event – whose very occurrence was incredible enough, given the political climate of the day – was yet another unintended side-effect of the radical reformation policy being enforced by Stalin's new elite. The exhibition was an initiative by the director Mikhail Kristi, who had been appointed the year before and still honoured his old ties with Malevich. Kristi and the rest of

his management team, however, had to tread carefully. So as to draw as little attention as possible from keen Stalinist eyes, nobody was allowed to announce or advertise the exhibition in any way. The newspapers agreed not to write anything about it[16] – an unprecedented form of anti-marketing that Malevich accepted without complaint, as he knew that any press at all could only have a negative impact.

During the final weeks before the exhibition, he was in Moscow. The nine-year-old Una went with him every day to the museum, where he was busy arranging the halls. Despite the cone of silence surrounding the event, he was relatively hopeful. The presentation was well received within the walls of the museum, and the intended public had little trouble finding it – so little, in fact, that the museum management felt the need to adjust the official visitor numbers downwards (at least, there are strong indications that this was the case).[17]

The following year, however, his hopes of any improvement to the political situation were dashed. Malevich lost his position within the Art History Institute (he himself said he had been 'purged') and nobody would offer him work.[18] All evidence pointed to the imminent and total social exclusion of the avant-garde. 'Tatlin, Filonov and myself, and the young people who are with us, who are creating a truly great art, remain shock workers,' he wrote to his friend Shutko. Still, the authorities had to 'be made aware of the living conditions of artists in Leningrad....for we will soon be declassified as kulaks'.[19] A scheduled retrospective exhibition of Filonov's work in Leningrad did not go ahead, as his work was 'alien to the proletarian worldview, and replete with bourgeois tendencies'.[20]

The Malevich Affair

On 14 April 1930, Mayakovsky committed suicide. The entire artistic community was in shock, as they understood that his desperate act stemmed, in part, from the hopeless situation in which all free-thinking intellectuals and artists found themselves. 'I know not what to do,' wrote Malevich shortly thereafter, 'going to Moscow will not help, but I no longer have the strength to remain here [in Leningrad]. Following Mayakovsky's example seems rather unappealing.'[21]

The poet's burial was accompanied by much pomp and circumstance, though nobody could escape the feeling that the end of an era had come. Although Mayakovsky and Tatlin had hardly spoken in the

Mayakovsky after his suicide, 1930.

previous years, the latter took it upon himself to decorate the funeral carriage. One student recalled how

> when Mayakovsky died, teachers and many students started gathering in the courtyard of Vkhutemas. The question was: how should we bury Mayakovsky? The institute was to organize the funeral, for he had studied there, and he visited often. Someone proposed a gun carriage, and there were other suggestions. Then Tatlin came. Until recently he had been in a fight with Mayakovsky, but there he was. Everyone said: 'Here's Vladimir, he'll sort it out.' And indeed, in two hours' time everything was ready. Tatlin said that he needed slats and new sheets of roofing iron. The slats were fixed to the outside of a truck, to which the steel plates were attached. It became a 'steel' platform, on top of which a red coffin on legs was placed. His design was not arbitrary, but captured the essence of Mayakovsky, the essence of the event.[22]

It was atop this steel platform that Mayakovsky's body was taken in procession through Moscow to the crematorium, attended by a crowd sixty thousand strong.

After the closure of Malevich's exhibition in Moscow, the works were packaged and shipped to Kyiv for display in the Kyiv Art Institute. That exhibition ended on 5 June. Malevich requested that the works remain in Kyiv for the time being, as he did not know where he would be working in the coming academic year.

On 20 September 1930, rather unexpectedly, Malevich was again arrested by the GPU. It was immediately clear that this second arrest was of a different order entirely from the first. His home was searched and his typewriter, letters and manuscripts confiscated. Malevich was placed in temporary custody in the prison at 39 Nizhegorodskaya Street, cell number 167 (and not in the famous 'Kresty' prison, as some sources claim). This institution was in regular use by the GPU, and was also where executions were held. Malevich was arrested on suspicion of espionage under Section 58.6 of the Penal Code, the punishment for which was at least three years in prison and full or partial confiscation of the prisoner's possessions. The maximum penalty was death by firing squad.[23]

It is useless to speculate on the grounds for Malevich's arrest. Legislation and statutory powers had long become instruments for the suppression and homogenization not only of dissidents or enemies of the state, but of all citizens. Laws had been designed with this purpose in mind, and formulated in such a way that anybody could be considered suspect and arrested at any time. Because the suppression of the general populace was the goal, these means were implemented extremely arbitrarily. It was this arbitrariness to which Malevich fell victim.

Natasha tried in vain to see Malevich. From his cell in prison, he was allowed to write her and Una a letter. He feared the seizure of his belongings and that his home might be taken from him, but also worried about Natasha and Una's financial situation, since they would no longer be receiving his salary. The 'second attack' to which he refers might have been of a mental or medical nature, or a second violent interrogation. It is a desperate letter, written in haste.

Dear, sweet Natasha,

I believe that you will protect the family, protect the room, I hope that justice will prevail and that we will see each other again soon. I had a second attack, it is bad, and my longing for you and Una is unbearable. If you do not have enough money for [illegible], then they must help you. Write to the museum in Kyiv, tell them to keep the paintings until my release, if they wish to sell them, how much will they give, my paintings are valuable; how much they give. Kisses from your loving Kazik. Dear Unochka, be good, live in friendship with everyone, study and be obedient, I send kisses to you and grandma...[24]

Malevich was interrogated multiple times during his three-month imprisonment, but he denied all allegations. After three months he was released, likely after involvement by Shutko.

Did Malevich emerge unscathed? Most certainly not: his imprisonment was traumatic, and there are grave indications that he was tortured during his time in prison. These indications have never been thoroughly investigated or analysed, however, and conclusions as to their veracity are hampered by the fact that officially, torture in the Soviet Union did not exist. Although the overwhelming majority of personal accounts leave no doubt as to its deployment in Soviet prisons, torture is never mentioned in any legal documents. Records make no mention of the interrogation techniques used, and the interrogation reports were edited and redacted before their inclusion in the relevant case files. With this in mind, the absence of any reference to torture in Malevich's file does not exclude the possibility.[25]

Personal testimonies are the only sources that can be used to reach a conclusion, but these, too, are often lacking. Once released, prisoners could not speak openly of any atrocities they had endured, for doing so would only put themselves and their interlocutor in danger. Such claims would undoubtedly be branded as mendacious allegations towards the state, constituting further grounds for arrest and abuse. Any such experiences could, therefore, only be intimated to one's closest friends and family. The few family members with whom Malevich probably shared knowledge of his time in prison would not have dared speak of it to anyone else, and when they eventually did so (in the 1980s and 1990s), the events in question had transpired over fifty years earlier, calling the testimonies' accuracy and credibility into question.

In the case of Malevich's incarceration, the most important testimony comes from his sister, Viktoria Zaitseva. In the early 1980s, shortly before her death, she told a Ukrainian avant-garde scholar that Malevich 'underwent torture to make him confess to being a German spy'. That scholar, Dmytro Gorbachov, subsequently published her testimony in a Ukrainian journal in the 1990s.[26]

Though we have no reason to doubt Zaitseva or Gorbachov's sincerity, the scope of this claim is rather limited, consisting as it does of a single sentence. Moreover, it was not published until after Zaitseva's death, contains no verifiable historic details, and there are no other independent accounts that confirm the torture.

The ever precise and cautious Irina Vakar casts doubt on this account, primarily because the very same Viktoria Zaitseva told her she had had 'no contact with Malevich since 1929'.[27] Vakar thus surmises that Zaitseva could not possibly have known about Malevich's experiences in

prison. The most important testimony in the matter – from Malevich's own sister – thus consists of contradictory statements. Could the ageing Zaitseva have been mistaken? Were her memories confused? This is certainly a possibility, although it would seem easier to get confused about a date than about the possible torture of a family member.

Vakar's hesitation is, of course, completely justified, and Zaitseva's testimony cannot be considered hard evidence. Vakar also notes that the 'nature of Malevich's declarations' (that is, the final declaration from the interrogations) 'make clear that no "special measures" were applied'.[28] In other words: Malevich was not tortured because he did not confess. This theory is not entirely devoid of logic. No person can resist torture forever, and victims will ultimately be prepared to confess to any allegations, no matter how absurd. But the suggestion that there cannot have been any torture at all simply because he did not confess is, I believe, going too far. Torture can also be used as a means of intimidation, or perhaps the conscience of the officer on duty had not been erased completely, and he decided that several sessions were enough.[29]

What is the historic context in which we should interpret Zaitseva's statement? Though torture was not legally permitted in the Soviet Union, from 1936 onwards there were confidential internal guidelines that did allow for the application of extreme methods. Torture was also regularly used prior to 1936, though on a smaller scale and in less extreme forms than during the peak of the great terror (1937–38). The most favoured methods prior to that were what modern secret services characterize as 'enhanced interrogation techniques': marathon interrogations, sleep deprivation, imprisonment in cages, degradation, and so on. Direct physical contact – beating with fists or bludgeons – was far less common, as were methods of extreme sadism targeting areas such as the nails, genitals or internal organs. These latter methods only became customary after 1936.

In 1930, torture was primarily used on a specific category of prisoners, the 'kulaks' (former serfs who now owned property) and so-called 'saboteurs'.[30] The latter was the designation for well-educated professionals who were arrested on suspicion of counter-revolutionary agitation, as defined in Section 58 of the Penal Code. This was the section under which Malevich was arrested, or more specifically, section 58.6, which dealt with the most serious form of counter-revolutionary agitation: espionage.[31] It is, therefore, entirely possible that Malevich was subjected to the aforementioned 'enhanced techniques'.

There are several other circumstances and accounts that can shed some light on the matter. Various memoirs show that after his release, Malevich became extremely fearful of any possible 'international' associations. He severed all contact with his German and Polish friends and asked no more questions about the artworks he had left behind in Germany. Another anecdote, from the daughter of Ivan Klyun, brings this fear into even sharper relief by revealing Malevich's refusal to accept foreign currency of any kind. At the time, she was working for the Soviet Trade Delegation in Copenhagen. When she saw how needy Malevich and Natasha were (when she visited them, they could only offer her 'potatoes and butter'), she tried to offer some Danish crowns that could be used to purchase goods in a currency-exchange store. But Malevich refused to accept the crowns and said he wished to avoid the store at all costs: 'Neither myself nor any member of my family will go anywhere near that store.'[32] Such a statement coming from the pre-1930s Malevich would have been unthinkable, and it seems obvious that it was his experiences in prison that gave rise to such paranoia.

Lastly, there is a single diary entry by Pavel Filonov that cites Malevich's own account of his incarceration. Filonov describes a meeting with Malevich that took place on 12 November 1932, around two years after he was released. After a brief discussion relating to a business disagreement, Malevich suddenly opened up about his imprisonment: 'He told me he had spent three months in prison,' Filonov writes, 'and was subjected to an interrogation. The officer asked him: "What Cézannism are you talking about? What cubism are you preaching?" "The AKHRRs all wanted to destroy me," he said, they said: "Destroy Malevich, and all of formalism will disappear." "But they did not destroy me. I survived. Malevich cannot be exterminated that easily."'[33]

The last two sentences in particular give food for thought. Even taking into account Malevich's habitual theatricality of expression, it is difficult to interpret these lines as anything other than an acknowledgment that his incarceration was not only a psychological ordeal, but also a physical one.

How was Malevich affected by his physical and psychological suffering? He withstood the ordeal and confessed to none of the fabricated allegations – he must have seen his resilience as a triumph, an interpretation supported by his conversation with Filonov. Yet something in him was clearly broken, and his experiences in prison had turned him suddenly

into a frightened man. He had always been physically strong and cultivated the image of a strapping peasant lad. He had several weights at home, old-fashioned lead balls with handles, that he used for strength training. When guests came, he even juggled with them.[34] His muscular strength and stout physique were part of his imposing image. Now, he had become timid. 'About what happened in the prison,' said his beloved student Konstantin Rozhdestvensky, 'he never spoke a single word, ever.'[35]

He was set free on 6 December. Family members were not informed of their relatives' release, and so Malevich walked the 5 kilometres (3 miles) home from prison in the freezing cold. 'When he got home, he rang the bell,' the same student later recalled:

> he rang and nobody opened the door... Do you know the steps leading to his apartment?...The first few steps go downwards, before they go up again. It's an awful set of steps, like some medieval bunker, and very, very narrow. He sat down on the first steps with his bundle of clothes and waited, waited around an hour. That gave him an awful feeling, as though he had arrived home and nobody needed him, no-one was prepared to accept him. At that moment he felt – so he told me – a terrible loneliness, and bitterness, damnation. He had left the prison behind him, but was surrounded by a crypt, and nobody knew what would happen next.[36]

He was free but had no notion of what the future would bring. In any case, having seen a prison from the inside, he had become a vulnerable man, despite the statement in his file that 'the allegations could not be confirmed during his interrogation'.[37]

Tatlin in Moscow

After returning from Kyiv, Tatlin went to live in Moscow, in a courtyard apartment at Vkhutemas. His girlfriend had followed him to the city, and started working as a porcelain designer. She had a son from a previous relationship, Petrus, whom Tatlin also saw often, though Petrus did not live with his mother. Tatlin also saw more and more of his own son Volodya, and the two boys played together.[38]

At Vkhutemas Tatlin was employed in the Faculty of Woodwork and Metalwork, and later also in Ceramics. He had Pavel Novitsky to thank for his appointment; he was an admirer of Tatlin's and had become dean

Vkhutemas: exhibition of students' work from the 'Volume' course, 1927–28.

of the college shortly before. Novitsky was a fervent advocate of production art, a field for which he believed Tatlin could provide a powerful artistic basis.

In the late 1920s, Vkhutemas was a multicultural and democratic institution. Students came from all over the country, including the Central Asian republics such as Turkmenistan and Uzbekistan, from far-eastern Siberia, the far north, Ukraine and Crimea. Despite its rather prosaic title, the Faculty of Woodwork and Metalwork was the most progressive department at Vkhutemas.

Alongside Tatlin, Alexander Rodchenko and El Lissitzky also taught at Vkhutemas. Lissitzky's position was unique, as he was one of the few Soviet artists – and the only avant-gardist – who was regularly permitted to travel abroad. In his role as an exhibition designer (which he considered to be his primary artistic activity) he worked between 1925 and 1930 on Soviet exhibits in Dresden, Hannover, Cologne, Stuttgart, Leipzig and Dresden once again.[39] He also took extended sabbaticals, including one to the Netherlands in 1926. Exactly how Lissitzky came to enjoy such unique privileges is not entirely clear. What is certain is that he had the trust of both his superiors and the GPU, a confidence that rested on his

'Pressa' exhibition in Cologne, 1928. Design: El Lissitzky.

immovable political convictions, his professionalism, the prestige he enjoyed in Germany, his overall discretion and caution, and his avoidance of the spotlight. He was no flamboyant pontificater like Malevich, nor an enigmatic, anti-social outsider like Tatlin; rather, he was a level-headed, urbane and intelligent man of the world. He represented a new kind of person, the professional avant-gardist: radical in an intellectual and artistic sense, but reliable and predictable in his comportment, immaculate in clothing and manners, well spoken, and not averse to bureaucracy or hierarchy. In other words, a man of the kind most probably embodied for the first time in Le Corbusier; Mart Stam and Cornelis van Eesteren belong to the same category. Lissitzky had become estranged from the first generation of avant-gardists, from Tatlin, and from his great master Malevich. He no longer had many (or any) dealings with Tatlin, and he vehemently rejected Malevich's new figurative art.

Rodchenko ultimately remained closer to his older predecessors, but even he had hardly stayed in contact with Tatlin. Rodchenko was an exceptionally successful pedagogue, and the great international reputation of Vkhutemas – as one of the most important schools where modern design was practised and developed as an independent discipline for the first time – is largely reliant on his work. He created

teaching methods for product and graphic design, and produced a constant stream of highly qualified students. Rodchenko's wide-ranging versatility remained his greatest asset. He designed furniture, clothing and scenography, but his most well-known work during this period was his graphic design for books, posters, packaging, and so on. His greatest focus, however, was on photography, a terrain left unexplored by virtually all Russian avant-gardists. Typically for Rodchenko, he quickly mastered the new idiom, and within the space of a few years became the greatest Russian photographer of the twentieth century.

At Vkhutemas, Tatlin more or less pursued his own course. His personal pedagogical system did not fit neatly within the existing curriculum framework, and he was allowed to form his own 'branch' within the faculty.

In his seemingly naive, imploring style – which was better suited to declamation than publication – he wrote a number of new manifestos, calling into question the relationship between humans and objects, and declaring war on 'dressers and drawers'. In his view, an object should not be 'a hallmark of one's wealth' but a 'unit' capable of performing a range of functions in various circumstances. Knowledge of the material being revealed in the object was the goal, not the manufacture of conventional industrial goods that served one specific purpose. 'Our entire lives, and the production process as well, are beleaguered by objects, and especially objects that contain other objects. We must strive to destroy them.'[40]

The naivety of Tatlin's proclamations may have been deliberate. With clever, paradoxical use of language, Tatlin thus succeeded in packaging his anti-materialistic vision and ideals for an autonomous, perhaps even autarkic existence into terms that seemed compatible with the typical rhetoric employed in the Five Year Plan, which focused on the new organization of society and on the hegemony of technology and industrial production.[41]

At Vkhutemas he made a number of extremely diverse objects that were the result of experimentation on materials and structures. Though Tatlin always allocated authorship to his students, there is usually no doubt who was the conceptual father. Of these objects, those known include the frame for a sleigh, a divan, and various chairs, including what became known as the 'cantilever chair' made of curved beechwood, electrical wire and 'fabric'. None of these objects have survived, except in some photographs. The 'cantilever chair' is one of Tatlin's most oft-reproduced works, though there is doubt as to whether he made a truly

working example. The only published photograph is probably of a scale model, and there are also signs of photo-editing. Despite various serious attempts, there has never been a successful reconstruction of the chair – at least not one that a person can actually sit on. And yet, Tatlin proudly boasted that his chair was far better and cheaper than modern Western cantilever chairs made of 'bicycle frames', and that his chair had 'more than enough suspension', and 'sufficient stability, shall we say, to guarantee the safety of the occupant'.[42]

Though bragging about a chair that did not exist and that could not possibly function does seems like pure Tatlinism, his intentions were not necessarily deceptive. He had faith in the concept, and that was enough – providing working proof was a needless endeavour. Because of capers like this one, many contemporaries looked on the 'inspired fool' Tatlin with pity.[43] Of course, this is not the only reason for Tatlin's renown as an artist. This mythical chair takes on greater significance, however, if we consider that it was conceived during the first Five Year Plan, when society was devoted solely to the mass production of industrial goods. In this context, instead of a light-hearted jibe, it takes on the quality of a carnivalesque subversion, a minor provocation, understandable only to those in the know.

Letatlin: The Bird in the Convent

Thanks to Novitsky's support, Tatlin could now make a start on the construction of his aircraft, and put his years of research on birds and materials into practice. The opportunities granted Tatlin in Moscow were astounding, given the political climate. He was given access to a spectacular atelier in the seventeenth-century clock tower of the abandoned Novodevichy Convent, one of Moscow's grandest historic sites. It was a relatively narrow space on the third floor, but with ceilings over 10 metres (32 feet) high.[43] He was also allowed to hire several assistants, who even received payment – 25 roubles, to be exact.[44] At the time, such privileges were unheard-of for 'leftist' artists, and were only made possible through Novitsky's patronage.

Tatlin created the ideal working atmosphere in Novodevichy Convent. The place had everything: there was enough room to hang up his various aircraft (of which he would ultimately make three), and he could arrange for secrecy and seclusion as he wished. The furnishings were spartan, and there was no heating or any other facilities whatsoever, but the glorious

architecture made up for many of the inconveniences. The tall windows afforded a panoramic view of the entire city. Tatlin and his students slept in the former convent halls, where their hands and feet stiffened from the cold, and they disappeared almost completely from public life between 1930 and 1932. All of this contributed to Tatlin's typical, legendary working atmosphere, and to the development of the mythology by which the project automatically became enveloped.[45] Of course he never spoke publicly about an aircraft, or an ornithopter, but instead about 'his bird' or 'a flying bicycle'.

The young assistants he engaged were also overwhelmed by Tatlin's personality. The age difference was expanding: Tatlin was now forty-three years old. One of the assistants, Alexei Sotnikov, described how their partnership evolved:

> I was completely overcome during his very first lecture. He proved to be an incredible orator, despite his claim that in his youth he could hardly string two words together. Everything he said had meaning. I found him miraculous....I was mesmerized by him. He seemed to notice that fact, and invited me to visit him at his home. Then once more. Maria Kholodnaya was tall and slender then. After that, Tatlin invited me to his studio, where only a select few were admitted....
> The studio was in the clock tower of the Novodevichy Convent, on the third floor. The ceiling was around 11 or 12 metres [36 or 39 feet] high. There was no water or heating. I spent eight years there.[46]

Tatlin's tales had become no less outlandish with the passage of time. He once told a young director – quite convincingly, it seems – that he had been a snake-charmer in Egypt.[47] With lashings of vivid and uncommon detail, he spoke of his time as a 'wrestler in the circus', and how he was paid to throw the fights, which were 'choreographed in detail beforehand'. His reward was 'a golden fiver', and occasionally a 'golden tenner'. He always looked forward to the applause for the victor – not for himself, mind you, but for the victor! The more loudly the hoodwinked public applauded, the greater his satisfaction, as he lay pinned to the floor on his belly. Only then would people see what a titan he truly was, and how nobody was a match for him.[48]

His students became part of his family, an inner circle to which almost nobody else was admitted. Though Tatlin was a demanding foreman, he was also a father figure and his students regularly visited him at home. It is impossible to say how often the children Petrus and Volodya were

there; however, it is clear that Tatlin identified far more strongly in general with children during this period than he had before. In Kyiv he had provided the scenography for two children's shows, and in Moscow he befriended the immensely popular children's author Samuil Marshak, who allowed his young son Jakob to play at Tatlin's home. It was probably through Marshak's intervention that he collaborated with Daniil Kharms to produce the lovely children's book *First of All, Second of All*, whose main characters are two children and an extremely tall man, along with a goat, a dwarf, a boat, a car and an elephant. Their first meeting for the project took place at Marshak's home, probably in the summer of 1927.[49] The two men quickly hit it off, as Kharms was just as brilliant a fantasist as Tatlin. He was fascinated by Letatlin, and listened with rapt amazement to Tatlin's stories, including his apparently successful attempts at 'levitation'. Kharms later told a friend 'so convincingly as though he had seen it with his own eyes': 'Imagine: Vladimir lies down on his back on a rug in total silence, shuts himself off from every irrelevant thought, focuses his will with otherworldly strength, and…then slowly rises up from the ground, to a height of twelve to fifteen centimetres.'[50] The book was his only collaboration with Kharms, probably because the absurdist character of the book earned it a merciless lambasting in the press. The pedant in question, a certain D. Kalma, did not mince words, saying that Kharms and Tatlin's book was 'incomprehensible, ridiculous, monstrous' and as part of a 'cult of absurdity…unacceptable in terms of both form and content'.[51]

In conjunction with his student Sotnikov, Tatlin worked on the very first set of children's crockery: an original, and also touchingly designed, set of ten porcelain drinking vessels for infants, the shape of which was 'reminiscent of a mother's breast'. The vessels were closed using a metal clip that created a tight but not hermetic seal, so that the liquid could only be extracted by sucking on the spout. The set of pots, intended for use in the hundreds of thousands of crèches being built everywhere, could be transported conveniently and safely in a cane tray. Although Tatlin, as usual, credited a student with its authorship, the student in question made no secret of who the work's spiritual father was: 'I created them based on his insights, his lectures, his needs and requirements.'[52] It is a work of exceptional economy and perfection, and quite simply the most beautiful and original set of porcelain pieces ever produced in the Soviet Union.

Vladimir Tatlin, cover and illustration for *First of All, Second of All*
by Daniil Kharms, 1929.

These projects, however, were all mere excursions, and were not to distract him from the great task he had set himself: the final completion of Letatlin.

Though perhaps a naive artist's dream, Tatlin's 'birdman' was not as far removed from reality as it may seem. In the 1920s, there was still no consensus as to whether humans could ever fly without an external source of power. Charles Lindbergh had crossed the Atlantic in a motorized aircraft in 1927, but at around the same time flight engineers were still making serious attempts to produce working 'ornithopters' – machines with flapping wings, based on the principles of bird flight. Gustav Lilienthal, Otto's younger brother, worked on an aircraft with beating wings until the early 1930s. In 1932 another German inventor, Fritz Ellyson, made the international press as a *Vogelmensch* (birdman) in 1932.[53] Alexander Lippisch, who later became chief engineer of Messerschmitt, tested a manned ornithopter in 1929.

The difference between Tatlin and these inventors was, of course, the fact that Tatlin was not an engineer but an artist, and one with hardly any education beyond primary school. Tatlin designed his ornithopter based on two principles: the observation and imitation of avian flight, and a

The first infants' crockery set. Design: Vladimir Tatlin and Alexei
Sotnikov, 1930.

study of the natural materials he was working with in order to maximize
their potential. He always kept Otto Lilienthal's book *Bird Flight as the
Basis of Aviation* (translated into Russian in 1905) on hand, and used it
as the basis for his research. Engineers and aviators regularly came to
visit, including Konstantin Artseulov, essentially the most famous fighter
pilot from the civil war, with whom Tatlin had established a friendship.
Another pilot and arctic explorer, Boris Chukhnovsky, was also involved
and would later conduct one of the test flights.

These contacts with the conventional aviation sector did nothing
to alter Tatlin's intention to base Letatlin not on analyses of physics or
mechanical engineering, but instead on an intuitive and 'organic' crea-
tive process that would produce results through intuition and trial-and-
error. The most important facet of Letatlin, however, was its implicit
aesthetic rationale: the idea that, rather than being an emergent property
of functionality, beauty was what led naturally to superior functionality.
'I do not want this thing to be understood as a utilitarian object,' he said in
an interview, 'I made it as an artist. Look at the curved wings: we see them
as aesthetically perfect. Letatlin gives the impression of aesthetic com-
pletion, does it not? Like a soaring seagull, no?'[54] A text of his own, issued
at the presentation, was even more adamant on this point. It began: 'My
machine was built according to the principles of living, organic shapes.'

Contemporary installation of the only remaining Letatlin at Museum Tinguely, Basel.

And then: 'The consideration of these shapes brought me to the conclusion that the most aesthetic forms are also the most functional. The labour performed to shape the material in this manner, is art.'[55]

In line with this rationale, he decided to exhibit Letatlin in the Pushkin Museum of Fine Art (and not in the polytechnic museum), even though Novitsky needed to move heaven and earth to make it happen. The museum's large entrance hall contains several gigantic copies of Renaissance masterworks, including Michelangelo's *David* and a knight statue by Donatello. One of the Letatlins was hung from the ceiling, hovering proudly above the statue of David; another hung in the centre of the room, almost at eye level, producing a dramatic effect through its dimensions alone (the wingspan was over 9 metres [29½ feet]). It was a singular presentation, at a time when nobody at all was accustomed to oversized installations in museum halls.

One of the visually stunning aspects of his flying machine was the horizontal trusses or 'longerons', which took on a slightly curved, figure-of-eight shape. Tatlin called them his *Venus de Milo*.[56] He also compared his design to those of other artists who explored the 'birdman' concept. Letatlin clearly resembles the ornithopter designed by Leonardo da Vinci, adopting at least the same horizontal position for the pilot. Tatlin also identified with the most famous of all mythological artist-aviators: not Icarus, an oft-drawn comparison, but his father – the great artist, sculptor, inventor and architect of the labyrinth at Knossos, Daedalus.[57]

Tatlin regarded himself primarily as an artist, yet his ambition to be an exceptional artificer and craftsman was part of his identity, and after years of building musical instruments (which, alongside banduras, probably also included guitars) and other practical items using all kinds of materials, he could now apply his experience to the extremely challenging construction of his ornithopter.

He wanted the aircraft to be built from as many natural, unprocessed materials as possible. The only industrial material that he used was Duralumin, one of the first aluminium alloys, which was also used in the construction of Zeppelins. The other materials included ash wood (due to its high elasticity), whalebone and willow stems. The pilot was strapped into the fuselage in a prone position, with feet on the pedals and hands on the handles. Thus, the aircraft was intended to 'merge with its human pilot, and become a birdman'.[58] This blending of man and machine was another concept important to Letatlin. Tatlin wanted to demonstrate that the world of technology should always incorporate organic and natural elements. Rather than placing humans and art in the service of technology, Tatlin wanted to integrate them into it. It was the principle of 'art in technology', as stated on the programme notes he distributed at the museum presentation. In a world where humans were made subservient to machines, it was his aim to humanize the latter.[59]

And Yet It Flew

Shortly before the opening, Tatlin ran several test flights of his machine on the testing grounds at Zvenigorod. They were hampered by rain, which drenched Letatlin's silk wings and meant that several tests had to be abandoned. They also could not guarantee the safety of the pilots, and the aircraft 'was restrained with a cable once a maximum height of 5 metres [16 feet] was reached'.[60]

Though it is an established fact that Letatlin did fly, the question remains as to whether the device was propelled solely by human power. At the very least it could glide; if the 'bird' was released from a hill and the wind was just right, perhaps it could also have ascended several metres, like an enormous kite, or the pilot's muscle power might have kept it aloft for another few minutes. After these quasi-failures, a conference was held, attended by several engineers who had run tests in a wind tunnel and concluded that the wings provided too little lift. Tatlin responded stoically, saying: 'I do not believe in your tunnel.' Many around him took

Letatlin test flight, 1932.

pleasure in his defeat, and Letatlin's failures became a popular joke. The scorn was not entirely justified; shortly thereafter Tatlin was invited to a far larger conference of aviation engineers, of which a written report has survived. Various engineers examined Letatlin, and though none of them believed that any ornithopter could ever fly on human strength alone, they were almost unanimously impressed by various aspects of 'the Tatlin system'. They lauded the wings' hinges, the overall elasticity of the design, and the unorthodox choice of materials. Tatlin's contraption therefore certainly had technical virtues, but one thing it did not do was 'fly like a bird'.[61]

Many have wondered whether Tatlin himself believed he would be able to fly in it. 'Was it,' Strigalev asked rhetorically, 'perhaps all a grandiose provocation?' This is a seductive thought. Provocation was unmistakeably a part of Tatlin's personality, 'embedded', one might say, in everything he did. And the ornithopter was a provocation, though not exclusively. 'Letatlin,' Strigalev continues, 'embodies the will of an artist, who convinces us that even if one cannot fly with this device, it certainly points in an irresistibly tempting direction.'[62] Letatlin, in short, was the embodiment of an idea, or rather, a conceptual world. And yes, if it had functioned properly as an ornithopter, it would have ceased immediately to qualify as art. For artworks exist by dint of their very ambiguity, their essential contrariety, or in the theories of the Dutch Slavicist Karel van het Reve, the sensation that something is real and not real at the same time.

Of the three Letatlins that were built, one survives, and was returned to its proper home in the Tretyakov Gallery in 2017. Letatlin cannot be fully appreciated, however, by regarding it simply as a museum exhibit. It was a conceptual artwork, and the spectacle that Tatlin created around it – the secrecy, the clock tower, the scientific conferences, the avian research, the museum presentation, test flights, lectures, and so on – was an integral part of the 'project'.

As with all conceptual art, the historic context is also crucial; in this case, it was the era of the Soviet Union's first Five Year Plan. Alexander Kovalyov, a Soviet scientist who wrote one of the first serious articles on Letatlin, described the circumstances as follows:

> The experiment of converting an agricultural nation into a 'metal power' was implemented quickly and effectively, and led rapidly to a social and economic catastrophe: the annihilation of spiritual values, the rule of the absolute minority over the crushed majority, genocide, slave labour and forced dependency. The radical break with a system of human relationships that had evolved organically through the centuries, which outlawed the principles of freedom, honour, virtue and faith, suppressed by ideological myths, *and* by the eerily efficient terror machine – these are all various aspects of the historic conditions in which Letatlin was created.[63]

The Five Year Plan created a society that was defined by the bottom line of industrial production, the aim to create a rational, systematic design for reality, and the nullification of the individual in favour of the collective. Contrary to all of this, Tatlin's project prioritized organicism over industrialism, beauty above practicality, intuition above rationality, and the individual over the collective. In this sense, it was absolutely a provocation.

How was it possible at all? How could Letatlin have been put on display for several weeks in 1932, and not just anywhere, but in the Museum of Fine Arts – one of the most prestigious museum institutions in the country? If Tatlin's piece was so provocative, how could it find space in a political environment where deviant attitudes were so consistently suppressed?

Tatlin's public provocativeness was made possible because he simultaneously embodied multiple manifestations of Soviet mythology. His labourers' garb, tall physique and measured, simplistic use of language were all attributes of the typical Soviet worker. As the self-appointed 'constructor Tatlin', he also embodied the Stalinist paradox of

the proletarian engineer: the workaday man of thought and action, who without pretensions, claims of scholarship or critical distance, was able to bring about the industrial supremacy of the communist state. Tatlin was a model Soviet labourer – in much the same way that Jeff Koons was a typical Wall Street banker.

His ambiguous identity meant that he could not simply be dismissed out of hand, nor branded outright as an enemy of the people. But Tatlin's actions did, of course, create alienation and suspicion, for many felt that he was ultimately a completely different being, something utterly irreconcilable with the Stalinist utopia.

Various keen critics saw just how provocative Letatlin was, as evidenced by the reactions to the museum exhibit. One such review stated: 'The ideological depths representing Letatlin's point of departure are the condensed, heavily reactionary prejudices of the outgoing class: the worship of nature, the rejection of the mechanical, the naive belief in the "wisdom" of organic forms, and a retreat from the industrial world.'[64]

Perhaps the critic was right. Tatlin's ornithopter was partly a rejection of a positivistic worldview and an industrial, productivity-based society, of which the Soviet Union was ultimately one of many manifestations. As a typical avant-garde project, it united the utopian dream, instigated by the miraculous blossoming of science, with its opposite: a return to the roots of being human, including animalistic and childlike elements, accompanied by our most primitive spiritual and emotional desires.

These concepts were at the core of the very first futurist experiments in Moscow and St Petersburg in 1913 and 1914, experiments of which Letatlin was the last, moving example.

10

Farewell

1932 and afterwards

In 1932, Malevich created one of his most impressive late paintings: a faceless man in a yellow peasant smock, with a rectangular red hut in the background. There is a caption on the rear of the canvas, which reads: 'Complex premonition, 1928–1932. This composition consists of various factors: a sense of emptiness, loneliness and the hopelessness of life' (Plate 23).[1]

That year, the Central Committee introduced a new policy renewing the contract between the state and those working in arts and culture. Its purpose was roughly as follows. The state wished to pacify the cultural scene (eliminating the last vestiges of public dissatisfaction and disunity); homogenize it (forming a single, recognizable and popular 'Soviet style', emphasizing the longevity and popular legitimacy of the regime); and instrumentalize it (deploying it efficiently for education, propaganda and entertainment purposes). Art was to become a form of social mobilization, a means of promoting loyalty to the regime among the people.[2] In exchange, writers, artists and creatives were assured of a more stable income and broader career prospects. Arts and culture spending rose spectacularly: those willing to comply were eligible for state commissions, and could be assured of purchases by museums. Between 1931 and 1935, the budget for state-commissioned art rose from around 60,000 roubles to 2.5 million.[3] It is little wonder that the new cultural policy enjoyed widespread popular support, despite the increased limitations on artistic freedoms.

The government established separate unions for the various disciplines (one each for writers, artists, composers, and so on) and membership was a prerequisite for state commissions. Although the guidelines and directives came directly from the government, each union had its own governing board, staffed by its own members. This structure

ensured a certain degree of autonomy at the level of implementation, and made public servants partly responsible for policy. Or, in the words of another historian, 'the purpose was not so much censorship as it was to "governmentalize" the creative process'. In this way, a system of total control was developed, beginning with supervision of the artistic creation process, and ending with 'control of how the final product is ultimately embedded in the memory of Soviet and global culture'.[4] The Soviets were the first to investigate the phenomenal manipulative potential of modern pop culture, and to develop a model for harnessing it and turning it to their advantage.[5]

All other artist associations, societies and clubs were prohibited. Previously, the government had determined the face of Soviet art only through the distribution of funding, while their policies still officially upheld pluriformity and artistic freedom. The new policy eliminated that contradiction.

Virtually all artists joined the union, including Malevich, Tatlin and their adherents and students. Membership was easy to obtain when the unions were first founded, but became more difficult after the initial wave of applicants. Access to the union became a test of the applicants' willingness to reject their individuality. All artists were also clearly informed that any independent exhibitions were punishable by expulsion, which would mean a loss not only of income, but also of lodgings and studio. In such a case, one's fate was virtually decided, as the police rounded up the homeless and sent them to labour camps as 'socially harmful elements'.

The unions held grand meetings, at which members debated a wide variety of topics: they discussed which projects the union should support, or how the government directives or the leaders' pronouncements should be interpreted and converted into policy. The meetings were intended to give the artists a sense of consultation, and certainly also to act as a sounding board for the party, allowing them to keep their finger on the pulse of the artistic community. Quickly, however, the meetings degenerated into a forum for expressing adulation of the leadership, confessing one's own unworthiness, and identifying and demonizing 'the enemy'.

Some avant-gardists did try to use the meetings to express their opposition to the general policy. David Shterenberg, Alexander Labas and Vladimir Tatlin often voiced extremely critical opinions.

The practical reformation of cultural policy had already commenced years before, and was the reason for Anatoly Lunacharsky's dismissal.

He was succeeded by Andrei Bubnov, a seasoned politician who had made a name for himself during the civil war.

Lunacharsky became president of the Scientific Council to the Executive Committee, and represented the Soviet Union in the negotiations for joining the League of Nations. He still enjoyed a clear status in both positions, and had direct access to the government and to Stalin. He was also an informal foreign policy adviser. The old party stalwarts knew Europe through and through, as they had lived there for years as exiles. The members of Stalin's new elite were far more provincial, a quality that was exacerbated by the Soviet Union's international isolation and Stalin's new doctrine of 'socialism in one nation'. Lunacharsky gave lectures and workshops for top diplomats, stunning his auditors by revealing that the stress in the English Prime Minister's name fell not on the 'Mac' of 'MacDonald', but on the 'o'. Lunacharsky was granted an audience with Stalin now and again, though the leader paid little heed when Lunacharsky warned him about Hitler.[6]

In public discussions and articles, the art of the avant-gardists and modernists was labelled as 'formalism', which meant little more than that it was governed by 'form'. The realists, on the other hand, proposed their own *idyeinoye*: art in which society, ideology and political engagement were the critical concepts. It was a stroke of genius, for it allowed them to successfully stigmatize the avant-gardists as both elitist *and* trivial, both incomprehensible and banal. The unmistakeable prestige of the 'formalists' in Europe was also used as evidence for their decadence. The European reputation of the avant-gardists had once been a lifeline, their last hope for official recognition. Now that international reputation was being used to justify persecution and slander.

'Fifteen Years of Artists at the RSFSR'

Concurrently with the introduction of this new policy, an enormous exhibition was organized, titled 'Fifteen Years of Artists of the RSFSR' (the Russian Socialist Federative Soviet Republic). The exhibition aimed to provide a complete retrospective of the Republic's artistic production from the previous fifteen years, and encourage the wider public to engage in the development of art as active citizens. Given that the avant-garde had played an undeniable role in those fifteen years, they deserved a place at the exhibition. The organizers were thus presented with a thorny challenge: how could they allow the avant-garde to take

part, while clearly communicating that they were nothing but outdated relics of Soviet history?

The exhibition opened twice, once in Leningrad (on 13 November 1932) and once in Moscow (17 June 1933). The Leningrad exhibition was put together by a legion of artists and art historians. These included Nikolai Punin, and it was undoubtedly thanks to his efforts that the avant-garde still enjoyed some representation. The compromise achieved by Punin was to allocate Malevich and Filonov one room each at the extreme ends of the exhibition hall. The organizers framed them explicitly as an isolated phenomenon, a bygone anomaly. In any case, their work was shown openly, to limited castigation.[7] They also succeeded in showing work by some of Malevich's students, including Yermolaeva and Suetin. Of course, the AKHRR artists were profusely represented, Brodsky and Katsman especially; they had the opportunity to shine with portraits of Lenin, Stalin and Kamenev. The most striking artistic presence was the group surrounding David Shterenberg, who propagated a modernist form of figurative art. They called themselves the OST – the Independent Artists' Society. Besides Shterenberg, this society also included the popular Alexander Deyneka and, without a doubt the most interesting artist of the group, Alexander Labas.[8] Those conspicuous by their absence were the radical Moscovites, such as Rodchenko, Lissitzky and, especially, Tatlin. It is inconceivable that Punin made no efforts to include Tatlin in the line-up, and his ultimate absence can only be attributed to powerful and, evidently, insurmountable opposition. The exact source of that opposition was never made known. Tatlin was bitter, and blamed his fellow artists for 'excluding him from their ranks'.[9]

Even without Tatlin and Rodchenko, the exhibition was far from an all-encompassing ode to the AKHRR – a strategy that was not without its risks, as Punin would find out. On the evening of the opening, highly placed officials inspected the exhibits and demanded that the entire section of 'extreme leftist' artists (Malevich, Filonov, and so on) be removed. Of course, the result would have been chaos and a delay to the scheduled opening. Eventually, none other than Sergei Kirov, the party leader in Leningrad, was called to the scene, and declared that the exhibition should open as planned.[10] Kirov undoubtedly allowed the exhibition to go ahead solely to avoid a scandal. He also had a word with the press, in order to limit ideological criticism as much as possible. The conflict surrounding the Leningrad exhibition must have been the reason for the far more clear-cut ideological profile of the second opening in Moscow.

Malevich's works at the exhibition titled 'Fifteen Years of Artists from the RSFSR', 1932.

The opening in Leningrad – by new Commissar Bubnov – was nonetheless a gala event, and most artists were relieved. When Bubnov 'cut the ribbon, everyone raced into the halls...red carpets had been laid across their full length, and there were flowers everywhere'.[11] 'There were so many people, it was impossible to see any paintings.'[12]

Those who attended the exhibition received the impression that there would continue to be a place for divergent and alternative art. Many young artists and critics were exposed to Malevich's work for the first time – his paintings had not been on display in Leningrad for nearly ten years. Young art historian Andrei Chegodaev knew Malevich only through the stories told by his grandfather, Malevich's old friend Mikhail Gershenzon. Chegodaev told his wife of how he met the old artist (Malevich was fifty-three at the time), whom he regarded with respect, albeit as a living fossil: 'His suprematist works (non-objective, made of little rectangles, etc.) are extremely beautiful.' 'Malevich is short, aged and a little fat, with a shaven, podgy face, round glasses and wearing a hat that sinks deeply on his head – simple and seemingly good-natured,

and a little (or perhaps more than a little) crazy.' 'I spoke to him twice, he was immediately very friendly to me, and in our second conversation he expounded on all the advantages and logic of non-objectivity in art.'[13]

The opening was followed by a gala dinner that featured subsequently in the memoirs of many, and was attended by the People's Commissar. Malevich's description of the event in a letter to Klyun is delightful:

> The grandest part of it all was a banquet dinner at Hotel Astoria, with comrade Bubnov in attendance. The banquet was for around three hundred people, and between every second or third person there lay hams on the bone, ordinary and Westphalian hams, Dvina salmon, various types of sturgeon, lamprey, lobster vinaigrette, caviar, butter, game meats, goose, chicken and ice cream. The servants stood behind the chairs, dressed in old Moscow style wearing white trousers and frock-coats. They poured vodka and wine, and served the meals. Lentulov gobbled up a whole tin of caviar, spoonfuls at a time, and drank before and after every speech. He told the servants to relax, poured his own drink, pouring until the spherical perspective [the rim of the glass], and started making a toast – nobody knew why – to Euclidean space. When they asked him why Euclidean space, he said it just popped out of his mouth. He wanted to make a toast to the achievements of the art world, and why he ended up saying Euclidean space, he had no idea.
>
> The situation before the start of the banquet was unimaginable. At the sight of everything on the table, all our glands and internal secretions, reflexology and mucous membranes became overstimulated, everybody felt it and we all had to swallow our drool. Those few minutes were unbearable, when everybody was seated but Bubnov had not yet arrived, and we all had to wait. Old sinner that I am, I could not resist, and stuck three pieces of salmon on my fork to hold back the waters, but it only made my salivary glands work harder. I suddenly had the sensation that we had been transported, or had returned to the pre-socialist times, to 1910. As if we had ended up back in [clubs such as] Yar or The Bear, and the memory still makes my mouth water. It was as though the old world had carved a rift into the socialist era.[14]

The lavish dinner was especially absurd considering that it took place during the winter of the greatest famine in Soviet history, which cost many millions their lives.

Although the ravages of the famine were greatest in rural areas – which were plundered by the bloodthirsty and violent security services – hunger was still palpable in the cities. Malevich concluded his letter to Klyun on the day after the exorbitant dinner with the following remark: 'And now we sit here again, hungry like dogs. We have nothing, and can only scrape lunch together with the greatest difficulty.'[15]

In Moscow, the former AKHRR members were given free rein with the exhibition. Alexander Labas recalled that Katsman and Bogorodsky in particular (both of whom worked for the GPU) were actively involved in the organization. There was a general sense that now, in Moscow, the new artistic canon was being formed. Katsman wrote in his diary that everything revolved around the question of 'whom to exhibit, and whom to deport'.[16] The scale of the Moscow exhibition was even grander than in Leningrad, and it was accompanied from the outset by much more political 'supervision', to provide ideological streamlining and send a clear message to the public regarding what could and could not be considered good Soviet art.

To avoid a last-minute crisis such as the one in Leningrad, the party leaders inspected the exhibition space a full two weeks in advance. The specially formed evaluation committee (consisting of Bubnov, Lunacharsky and the exceedingly banal realist Boris Ioganson) evaluated the halls for almost a full day, and then implemented their changes. Afterwards, Katsman could not contain his excitement, and wrote in his diary:

> Look at what the Bubnov committee has done! They have all but destroyed formalism, and chased away that European rot....Oh my Lord, the committee made absolute mincemeat of the formalists. And how I fought for fifteen whole years against that scum, that blemish on Soviet art, and yet I was considered the crank, the fool, the reactionary! And why has the AKHRR emerged victorious? Because AKHRR chose to merge with the party, the government...and the Soviet power is now beginning its forward flight - it is flourishing, and growing strong...and those who would parasitize Soviet culture are being crushed in Moscow, ground to a pulp in Soviet style! To put it simply: the AKHRR is taking its art to the Soviet fields, and has its own, rich Soviet kindred spirits...while formalism is in Paris, being slapped on the behind. And David Shterenberg's balls will be bursting with envy...And all those Paris whores, the Shterenbergs and Drevins, have been put to shame and pummelled to death.

These are merely fragments from one single entry in his diary – the very same day, in line after line, he goes on about 'those bastards', 'syphilitics', 'mongrels' and 'thieving whores'.[17]

And yet, two weeks before the opening, Katsman remained anxious. There was still time for the formalists to reach some agreement or somehow exert their influence. In his diary he addressed himself in the third person, as he often did. 'Alright, Katsman, pull yourself together. Say nothing for the moment. There is still a ways to go before total victory.' But when the exhibition opened one week later, the message was clear. The formalists' downfall was complete. There was only one poorly lit nook containing works by avant-gardists. Of those by Malevich, only five remained; Filonov had three.

Tatlin went to extreme lengths to ensure he could show work in Moscow. He was by far the most prominent avant-gardist at the Moscow exhibition, and even managed to include Letatlin. He had no control, however, over precisely how his work would be displayed.

The one area devoted to the avant-gardists was dominated by a large printed quote by Lenin that left no doubt as to how the art should be received: 'I am unable to see works of expressionism, futurism, cubism, and other "isms" as the greatest manifestation of artistic genius. I do not understand them. They give me no joy whatsoever.'[18] This single quote from the father of the revolution – who had by then been virtually deified – worked its magic like a medieval curse.

Katsman was beside himself with joy: 'We experienced a colossal triumph. The formalists were obliterated. They have all been put to shame, and now they will know whom the Bolsheviks respect. Victory, damn it, victory! Those formalist scum...have been defeated, defeated on all counts!'[19]

Unlike its Leningrad counterpart, the Moscow exhibition was supported by an enormous media campaign. The day after the opening, *Izvestia* dedicated exactly half of the newspaper to the exhibition. The most significant contribution was a long article by Nikolai Bukharin, an economist and Bolshevist theoretician. Bukharin was once a powerful man: he joined the Central Committee of the party in 1917, and even worked for its most powerful body – the Politburo – between 1924 and 1929. He had turned away from Stalin's collectivization policies, and fallen into disfavour in 1929. Yet he still enjoyed much power, influence and even status as a patron of the arts. He was a serious amateur painter himself, and knew many artists and authors personally. He was close

friends, for example, with Maxim Gorky, and also the patron of Osip Mandelstam. His ideas on visual art were unquestionably conservative, and he believed in ideological consolidation and unconditional loyalty to the party. In short, Bukharin was an authority figure whose convictions were not to be called into question. The article also gave him an opportunity for some ideological absolution. It was one long, theoretical polemic against the avant-gardists, and Tatlin, being the most prominent, bore the brunt of the attack. Bukharin built his argument on the assumption that the avant-garde was purely a product of European modernism.

> The abstraction of the subject matter led to the death of painted art...
> there is a zone where painting is 'liberated' from its materials: using
> scissors, glue, thread, bits of tin, nails, matches, buttons etc., they
> 'assemble' these alien, monstrous representations of things and ideas
> (Kurt Schwitters, Tatlin, et cetera).
> ...
> The area allocated to the group of formalists and non-objectivists
> (Black Square, et cetera) was completely screened away. This
> was also where the infamous Tatlin exhibited his works. The
> entire developmental trajectory of Soviet art leads clearly to the
> destruction of formalism, as demonstrated by the group's evident
> and complete isolation.[20]

Malevich's commentary on the situation was clear: 'At the exhibition our brothers were isolated, as wild formalists, as enemies, as the already extirpated bourgeois art. It was our end.'[21]

In addition to the general media coverage, there was also a large targeted campaign aimed at increasing visitor numbers. Through a variety of channels, including the unions and other organizations, workers and public servants were encouraged to attend the exhibition. Records show that ultimately 700,000 did so. This figure may have been exaggerated, but even if the true number were only half as great, still it would represent an enormous success.[22]

Of the few remaining avant-gardists, the majority chose to accept their marginalization. They took on no major state commissions, and painted no portraits of leaders. In the last few impoverished years of his life, Malevich sought out a minor commission and painted a rather pitiful landscape, but he never made any portraits of Stalin or of the efficient barbarians who surrounded him. The destitute Filonov did paint

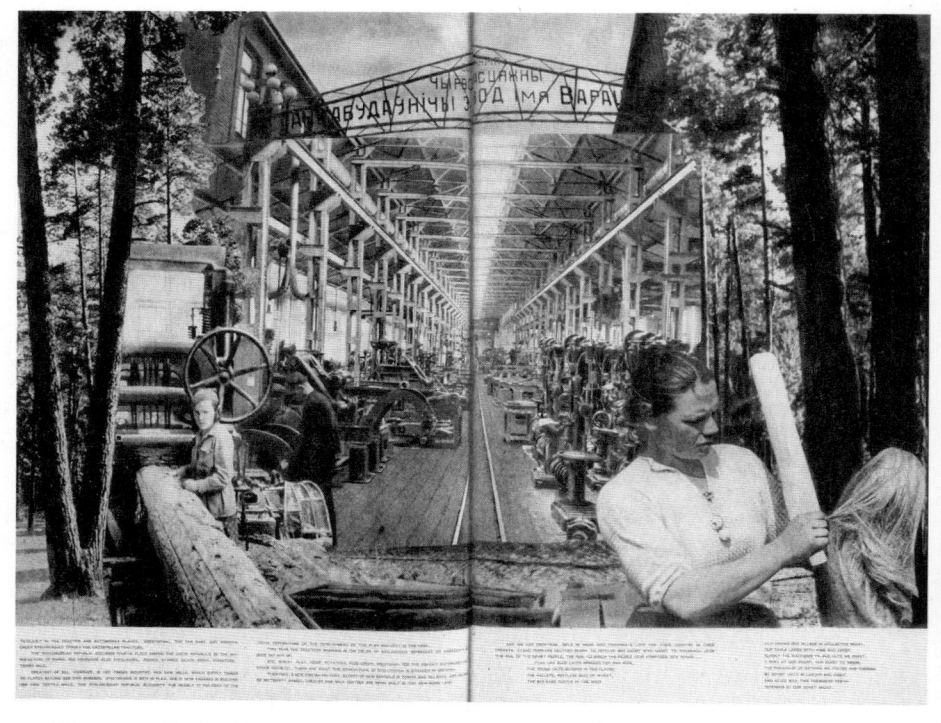

The USSR Under Construction, 9 December 1937.
Graphic design: El Lissitzky.

a portrait of Stalin, but had his stepson Pyotr accept and sign for the commission, unwilling to associate his own name with the piece. Klyun, Shterenberg, Udaltsova and Drevin modified their methods somewhat, but created few or no socialist works in realist style, and certainly no portraits of leaders.

The only two avant-gardists who did produce large amounts of propaganda art were Lissitzky and Rodchenko. Lissitzky did the design work for the propaganda journal *SSSR na Stroike* (The USSR Under Construction), which was published in various languages. The exceptional graphic design in these journals makes them popular collector's items today, despite the political and ethical disgrace they represent. Rodchenko, in particular, compromised his principles by accepting an invitation to photograph the construction of the Belomor Canal (the White Sea–Baltic Canal). Construction of the canal lasted from November 1931 to 1933. It was the first major project created through forced labour – in essence, large-scale slavery. More than 100,000

Alexander Rodchenko, construction of the Belomor Canal
(White Sea–Baltic Canal), 1932.

prisoners lived in a purpose-built concentration camp. Conditions in the camp and at the site were truly inhumane. Thousands died: the confidential GPU figures list around 11,000 deaths in 1932 and 1933.[23] Rodchenko surely cannot have been unaware of the dehumanizing conditions.

Over the preceding years, Rodchenko had come under severe pressure because he had been branded as a formalist by various journals. Rodchenko – who, of all of the avant-gardists, had been most actively involved with the political revolution – found the label almost intolerable, and wanted to show his critics that he was still a militant supporter of the revolutionary cause. During three long journeys to the canal construction site, he took thousands of photographs that were later published in a separate issue of *SSSR na Stroike*. He deliberately idealized the workers' situation, covering up their appalling treatment and saying nothing of the thousands of deaths.

Rodchenko was certainly not obliged to make these trips. Of course, he felt some pressure to save his career and to retain a reliable source of income for his family. But Tatlin also received an invitation to travel to the Belomor Canal with an artists' brigade, to which he never issued any response. Nor did he contribute in any way to the publicity and propaganda campaign,[24] despite the fact that his financial situation was similar to Rodchenko's. He also had a young child, and he, too, had been branded a formalist.

Nor can Rodchenko's compliance be attributed solely to opportunism. It would seem that he internalized the propaganda, and started to believe he was making a positive contribution to society. The tragedy of it all was that his efforts were in vain. The formalist label refused to come off, and he suffered from the same marginalization that affected all avant-gardists – simply because he was unwilling (or unable) to reinvent himself as a socialist-realist. He thus lost his social status despite sacrificing his integrity.

There are signs that, to a greater or lesser extent, Rodchenko was aware of his disgrace. His diary entries from the late 1930s and 1940s are terribly sombre; he seems to have fallen victim to deep depression and insecurity. In the 1940s he wrote a number of texts expressing admiration of Tatlin, which can be seen as a tribute to a fellow artist who, unlike himself, did retain his integrity and honour.

The First Wave of Terror

The climax of Stalin's repression, generally referred to as 'the great purge' or 'great terror', would take place in 1937 and 1938, and result in over one-and-a-half million arrests. Even before that, arrests by the security services saw an initial spike between 1931 and 1933. In 1931 there were 445,000 (nearly twice the amount from the previous two years), a figure that grew to 635,000 in 1933. Of these, 250,000 were what would today be referred to as 'political prisoners'.[25] In contrast to the 1937 and 1938 arrests, however, in the early 1930s relatively few prisoners were killed.

The spike from 1931–33 can be interpreted as a response to the failed and violent collectivism of agriculture and the resulting famine. Although the rural humanitarian catastrophe was carefully omitted from the press, most of the population had some awareness of events, and the government aimed to quell any possible form of protest immediately. The avant-gardists also fell victim to the rise in arrests, especially those in Leningrad. In December 1931, the members of OBERIU (the group of poets surrounding Daniil Kharms) were arrested, including both Kharms himself and Alexander Vvedensky.

Igor Terentyev – the avant-gardist poet and director, and a friend of Kharms – was arrested in Ukraine that same year, and during months of interrogations made several 'confessions' of counter-revolutionary activities among the avant-gardists. The court investigation file containing the reports on Terentyev's interrogations is the largest known legal report in which futurism and formalism are defined as hostile and criminal activities. During his 'confessions', Terentyev lists extensively and in detail nearly the entire community of avant-gardists (including Malevich, Tatlin, Matyushin and Kharms) as 'members of a counter-revolutionary organization'.[26]

The biggest scare to the entire intellectual community, however, was the arrest of Osip Mandelstam in early 1934. Although Mandelstam had been unable to publish any poetry for years, still he was a beloved and admired personality, even among the country's highest leaders. He was one of the last untouchables, who, despite his inability or unwillingness to write the kind of poetry desired by the Soviet publishers, remained sacrosanct. The reason for his arrest was ominous.

Because Mandelstam could not publish, he generally recited his works aloud to his closest friends and small groups of admirers. Earlier that winter, he had read out his essay 'A Conversation About Dante' in

the company of Tatlin and Boris Pasternak.[27] During another session he recited a short verse caricaturing Stalin. An informant was present, and Mandelstam was arrested several months later. The Stalin poem contained the following lines:

> And where we speak a private word,
> The Kremlin master's name is heard.
> His fingers worm-like, fat and red,
> His words crash down like chunks of lead....
> Though all may simper, whine and moan,
> The right to blame is his alone;
> His edicts, forged like horseshoes, fly
> At groin, at forehead, eyebrow, eye.
> All executions are a treat
> To him, the broad-chested Ossete.[28]

One of the attendees at the recitation was the eccentric Alexander Tyshler, whose paintings and drawings depict a fantastical and childlike world. Tyshler was a well-known figure in avant-garde circles, lived in the Vkhutemas complex on Myasnitskaya Street, and was a good friend of Tatlin's. Shortly after the recitation, Tyshler told a female friend that he had been to visit Mandelstam, and that he had 'read his verse about Stalin'. 'It was terrifying!' Tyshler added, 'How could Mandelstam be so certain of all those in his home?'[29] The artistic community in Moscow knew very well why he had been arrested, and also understood the implication: anybody who criticized Stalin, no matter where or how, would be persecuted, and the state had eyes and ears everywhere.

The increasingly aggressive climate had no room for a man such as Lunacharsky. He was promoted to ambassador of Spain, sent away by Stalin, and fell ill on the way there. He stayed in Paris for some time, then went on to Menton, a beach resort that teemed with Russian emigrants. He died there on 26 December 1933.

The precise evaluation of the role played by Lunacharsky in constructing the Soviet state will undoubtedly remain controversial, for he was an ambiguous figure in more than one sense. He was neither an unscrupulous idealist like Lenin, nor a paranoid mass-murderer like Stalin; he was in all senses more civilized and better educated than the other party leaders, but bore a special responsibility as a result. His administrative abilities, charisma and oratorical skills lent the party a considerable, but certainly undeserved, aura of sophistication. He was its human, well-mannered face. Many Russian intellectuals and well-educated

professionals believed that Lunacharsky was a man with whom one could do business, and so they chose cautious collaboration over resolute rejection. And this was precisely Lunacharsky's role, as Lenin well knew. Lunacharsky's job was to motivate educated professionals, public servants and teachers to join the revolutionary state. Although he was aware of the oppression, the suppression of fundamental civil liberties and the political murders, he chose to rationalize and ignore them. Zinaida Gippius, the malicious and sharp-witted enemy of the Bolsheviks, was perhaps a little biased when she called him 'a disgraceful barber', yet the characterization is not entirely inaccurate.[30]

There was more to Lunacharsky than simple hypocrisy. On several occasions he took risks to help those he held in high esteem. He ensured that Alexandre Benois was able to leave the Soviet Union in 1926, and when he made attempts to return in 1927, Lunacharsky warned him against doing so. He said openly to Benois that it would be better to remain in Paris and to 'await the political outcome'.[31] There are several such anecdotes.

Lunacharsky elicits neither disgust and fear, like Stalin, nor disdain and pity, like Katsman. When I imagine Lunacharsky, I get a bitter taste in my mouth and feel a sense of loss and anger. Looking at the few surviving moving images of him, one is immediately struck by how attractive and charismatic he was. I believe without question that his speeches were inspiring and compelling, and would like to have heard one or two. He may have been unoriginal as a thinker and author, but his extant writings are a clear testament to his fluid, ingenious and energetic intellect. He must have been one of those people with an incredibly effective and precise memory – an enviable talent. But alongside these many dazzling human traits, he was also cowardly and lazy: vices that are virtually universal in some measure, and that we must all fight against (this is perhaps the cause of the aforementioned bitter taste), but to which he freely surrendered. I would fully forgive him his tendency to allow himself to be swept along with the political current and the unprecedented historical events of his day. Still, once it became clear to him that he had become the servant of tyrants and sadists, he should have admitted defeat. He could have opted to withdraw from public life, and await his fate as an intellectual in the Soviet Union. In all likelihood, he would have survived. He could have travelled to Europe, and led a mundane and comfortable life as an emigrant with a job at a university. He may have missed the inspiring intellectual and creative life in Russia, but could at least have gone to

sleep at night without fear. However, both options would have required him to eschew the exceptional status he enjoyed, and to acknowledge his own errors of judgment. And this he did not do – he walked away from the difficult decisions, and allowed himself to be used as a pawn by the thoroughly immoral men he had chosen as his superiors.

Death of the Suprematist

Precisely when Malevich fell ill is unclear. Some say it was during his time in prison; in any case, he had been unwell for some time when a doctor diagnosed him with prostate cancer in late 1933. The situation was so dire that, in early December, he wrote a final will and testament to the artists' union, asking to be cremated (then still an uncommon practice) and for his ashes to be interred beneath a tombstone in the rural surroundings of Nemchinovka. He also wrote a second letter, addressed to 'The government – the Kremlin' asking that his family receive a pension after his death, 'that they might be given the chance to survive'.[32] The reply to his letter came nearly one-and-a-half years later. Shortly after his death, a letter arrived saying that the pension had been denied, 'due to a lack of resources'.[33]

In early 1934 he was still accepting new students, but by August 1934 his condition had become critical. Although he received surgery and radiotherapy, the doctors could not stop the cancer spreading. 'Kazimir's psychological condition is very serious,' Suetin wrote to Meyerhold at the time, 'not to mention the physical torments of the sickness itself.' His family and friends asked for help, and even hoped (against their better judgment) that he might be given permission to go Paris to recover.[34]

Although Malevich's awareness of political developments is uncertain, the arrests of Kharms and Vvedensky cannot have escaped his notice. Whether he knew of the arrests of his beloved assistants Vera Yermolaeva and Nina Kogan, who had supported him since Vitebsk, is not known. They occurred in late December 1934, when he was bedridden, and his loved ones did not tell him everything, so as not to worsen his already fragile mental state.

Nearly all of Malevich's former students were either called in for interrogation, or arrested. His pupil Konstantin Rozhdestvensky acted as informer.[35] Yermolaeva was abused, sentenced to hard labour and killed in 1937 by a bullet to the back of the neck. Kogan was released in March 1935. Kharms and the other poets in his group were also released

after months of interrogation – only to be seized by the secret service again several years later. In addition to Yermolaeva, Malevich's pupil Vladimir Sterligov was sentenced to hard labour. Another artist arrested (and named by Rozhdestvensky) was Lev Galperin, who was also sentenced to hard labour and ultimately shot dead in 1938.[36] The terror gained new momentum on 1 December 1934 when Sergei Kirov, the party leader in Leningrad, was murdered – probably on Stalin's orders. The dictator took advantage of the situation to intensify the terror against civilians.

In a moment of shocking honesty during an interview conducted decades later, Rozhdestvensky revealed that he had also named Malevich during his incriminatory statements, whereupon the investigator, a certain A. Fyodorov, interrupted him and said: 'Shall we agree to leave the old man in peace?' Fyodorov 'said so in a firm and businesslike manner', Rozhdestvensky recalled. 'I then realized that they had decided internally to leave him be.'[37] The secret service, of course, already knew that he was terminally ill.

Malevich was cared for by his wife and mother, but his students – those who had not already been imprisoned – also visited nearly every day: Suetin, Anna Leporskaya (who later became famous for her ceramics and porcelain) and Konstantin Rozhdestvensky, who seemed unaware of any wrongdoing on his own part. Ivan Klyun regularly travelled to Leningrad from Moscow to offer support to his old friend. The two men had become closer again in the foregoing years, and whenever Malevich was in Nemchinovka, Klyun had often visited and the two of them took long walks through the countryside.

Even during his final months, Malevich did not lose the urge to testify to his artistic revelations. The attending physician, urologist Natan Puterman, was so captivated by the dying man's orations that he wished to know everything about the non-objective world. The story goes that 'Puterman visited almost every day, even though Malevich was incurable, and he did not even treat him (the situation was hopeless), but Malevich did teach him to understand leftist art'.[38] At the end of one of Klyun's final visits, Malevich asked him to pass on a message to Mikhail Kristi, the director of the Tretyakov Gallery. 'Tell Kristi in Moscow that I consider my *Black Square* to be the greatest work they have there in the Tretyakov!'[39]

Klyun described his final visit to Malevich, several hours before his death. Though many who have ever held a vigil beside a dying friend will have similar recollections, the scene is moving nonetheless:

Ivan Klyun, *Malevich One Day After His Death*, 1935.

Ivan Klyun, *Malevich on His Deathbed, Several Days Before His Death*, 1935.

The patient and I were the only ones in the room. Suddenly he gave me a straight, stern gaze, and for a moment his face took on a light, happy expression, the corners of his lips moved, but he lacked the strength to produce a smile, and his head dropped down once more. His face betrayed a deep pain and sadness, and his eyes welled up. When I saw the tears flow down his cheeks and drip on the pillows, it became too much for me, and I could barely contain my own. I ran to the kitchen and surrendered to my tears. Everybody threw themselves at me: – 'What happened? What happened?' – 'He recognized me, he is crying,' I said through my weeping.

His wife, daughter and mother ran to him, to dry his tears.[40]

Malevich died on 15 May 1935 in his apartment in Leningrad. He had taken it upon himself to make extensive plans for both the design of his funeral and the details of the ceremony. According to Klyun, Malevich wished to be laid in state in a cross-shaped coffin, and be carried through the streets of Leningrad to his grave, like a crucified Christ. However, Klyun later wrote, such a procession 'did not align with the zeitgeist'.[41] Indeed, he was right. Burying a formalist as a crucified martyr amid the tense political situation of the day would have been inconceivably dangerous for all those involved.

Suetin, therefore, made a coffin conceived as an arkhitekton, with both a square and a circle on the lid. Malevich's wish to be laid in state in a white shirt, black trousers and scarlet shoes was honoured, however. In Catholic circles, the wearing of red shoes is a privilege reserved for popes, a fact of which Malevich (as a former Catholic) cannot have been unaware.[42] Suetin made a death mask, and a plaster cast of his hand.

There was no money for a memorial service, and so Suetin and Klyun mobilized their own and Malevich's old networks to raise the necessary funds. Their success was unprecedented, and one final sign of the respect that Malevich still enjoyed in many circles – including official ones – in spite of everything. The Leningrad municipal council pledged 2,000 roubles, and when that proved insufficient, the actor and pedagogue Yury Yuryev, one of the most prominent theatre personalities in the city, came to the rescue by promising to make up any shortfall out of his own pocket.[43] With the proceeds, Malevich's friends organized two funeral services: one in Malevich's apartment, and a second, public service in the Leningrad Artists' Union building at 38 Bolshaya Morskaya Street, a stone's throw from his home. Ivan Klyun, Konstantin

Rozhdestvensky, Anna Leporskaya and Nikolai Suetin formed a committee that Klyun later referred to consistently as 'The Four Suprematists'. They would plan and organize the services.

The first service especially, intended for close friends and family, was a strictly organized suprematist performance that showcased Suetin's burgeoning qualities as a director. Malevich was laid out with his head below a large black square on the wall along with an assortment of his final paintings. On the left was his last self-portrait, and on the right a portrait of Una. There was music, and Kharms recited a poem titled 'On the Death of Malevich'.

> Memory, its stream interrupted,
> You look around, your face crushed in pride.
> Your name – Kazimir.
> You look on, as the sun of your salvation fades.
> The mountains of your land, supposedly torn from their beauty,
> There is no space to support your figure.
> Give me your eyes! Open that window to your mind!
> What kind of man are you, your face crushed with pride?
> Your life is but suffering, and your desire a fat feast.
> The sun of your salvation shines no longer.
> Thunder shall lay the helmet of your head at your feet.
> Pe is the inkwell of your words.
> Trr is your desire.
> Agalton is your withered memory.
> Hey, Kazimir! Where is your table?
> Apparently there is none, and your desire is Trr.
> Hey, Kazimir! Where is your friend?
> She is here neither, and the inkwell of your memory is Pe.
> Eight years ticked by in your ears,
> Fifty minutes rattled your heart,
> Ten times the river flowed before you,
> The inkwell of your desire, your Trr and Pe ceased.
> 'That's the thing,' you say, and your memory is Agalton.
> Here you stand, as though spreading the smoke with your hands.
> The proud, broken expression of your face fades with pride,
> Your recollection vanishes, and your desire Trr. [44]

However Hermetic this poem may seem, still there were plenty of recognizable elements to move the mourners: the repeated use of words such as 'vanish', 'wither' and 'fade'; references to the (fictitious) mythological

Kazimir Malevich lying in state, 1935.

figure of Agalton; and references to the sun, streams and smoke, which imbue the poem with a primitive ritual character, as though Malevich were an Egyptian or Greek priest – quite an apt metaphor, in my view. The table and inkpot were elements from Malevich's day-to-day life, familiar to all those present. In his study he had a large, old-fashioned desk, where he received all of his visitors. He used the inkpot daily. Several years later, Kharms reused many of these images in a philosophical prose poem exploring his thoughts of immortality – which, according to him, was the only authentic goal of life. That text ends with the sentence: 'He is right, to whom God gave life as a perfect gift.'[45]

For the second service, the Four Suprematists bore the coffin to the nearby artists' union building. The stairwell of the apartment was so steep and narrow that the coffin had to be carried outside almost on its end. This second service was a public affair, calling for greater caution and more conventional expressions of grief. There were no eulogies by friends, and Kharms did not recite his poem again. The room filled up with people known and unknown wishing to say their farewells. El Lissitzky had come from Moscow. Although the relationship between Lissitzky and Malevich and his clan had completely dissolved, and none

Kazimir Malevich's tombstone in
Nemchinovka, with Natalia Malevich
in the background.

of the many witnesses to the services even mention his name, he is
clearly recognizable in several photos taken of the ceremony.

After the service, the coffin was hoisted onto a funeral car, a small
truck with a large black square affixed to the grille. They drove Malevich
in procession from Bolshaya Morskaya Street to Moscow station. The
Four Suprematists walked beside the truck as an honour guard, after
which Malevich's body was loaded onto a cargo wagon coupled to a pas-
senger train heading to Moscow, where the cremation would take place
in Donskoy Monastery. The trip across Nevsky Prospekt, St Petersburg's
most famous thoroughfare, became a grand spectacle, and it was clear
that not only was the avant-garde's leading artist being carried to the
grave, but the entire avant-garde was accompanying him. Everywhere
people came to see the advancing funeral procession, and because the
group was so large, more and more people had the courage to join in and
follow. When they arrived at the station, the crowd had grown to hun-
dreds of people. The large black square was taken from the truck and
attached to the side of the train carriage.

In Moscow, the procession continued from the station to Donskoy Monastery. A smaller group had gathered there; many of Malevich's Moscow colleagues decided not to show up. The close friends and family who had travelled with the coffin were joined by several Moscovites. David Shterenberg was there with his daughter, as well as Nadezhda Udaltsova and Alexander Drevin. There was Tretyakov director Mikhail Kristi, Yuvenal Slavinsky, a powerful cultural officer, artist Boris Ender and Nikolai Khardzhiev. Rozhdestvensky noticed one unexpected guest: 'And Tatlin was there, he came after all!' Udaltsova, too, saw Tatlin, and noticed that he was crying.[46]

Over fifty years later, Khardzhiev recounted that Tatlin walked up to Malevich's body, carefully looked him up and down, and said: 'He's just pretending.'[47]

Of the small group in attendance, the security service would ultimately shoot two – Drevin and Slavinsky – in the back of the neck in 1938.

Later that day, the urn containing Malevich's ashes was interred in the countryside close to Nemchinovka, at a location that Malevich had designated several years earlier. A provisional memorial was erected – a small cube with a black square on top – that had accompanied him from his apartment in Leningrad. The small monument quickly fell into disrepair as the terror and war advanced, and Malevich's name became tainted. Natasha withdrew into isolation, and relatives distanced themselves as much as possible. One of Malevich's grandchildren said that her husband forbade her from 'even telling anyone that Malevich was her grandfather. At that time, it was impossible'.[48]

The tiny monument was forgotten, and by the 1950s it had vanished entirely. The exact location of Malevich's interment is still unknown today.

The Anti-Formalist Campaign

In the mid-1930s, the Soviet elite became increasingly frustrated with developments on the cultural scene. At that time, 'alternative' forms of artistic expression – such as futurism and its various 'formalist' offshoots (suprematism, constructivism) – had already been wiped away. The various systems of censorship (including self-censorship) ensured that artworks virtually always conveyed an overt morality that was serviceable to the formation of Soviet society.

And yet, a range of artists remained active who, while ostensibly supporting the Soviet experiment, still wished to create a complex

and ambiguous artistic world in their artworks to undermine the clear moralistic message. One good example was Dmitry Shostakovich, the most celebrated of the Soviet composers. His major musical theatre works from the 1930s, such as the ballet *The Golden Age* and opera *Lady Macbeth of Mtensk*, celebrated a clear and unequivocally Soviet morality. At the same time, however, the music was full of dissonances and jarring rhythms, pastiches of popular and triumphant music, and incredibly grating, heart-rending passages of personal suffering that lent the triumphant sections a bitter aftertaste. The socialist regime was certainly not averse to satire or tragedy, but just as in any Hollywood drama, it could never become too pronounced, lest it render the requisite happy ending less credible. Shostakovich's music was too complex, too ambiguous, too restless and unsettling to be effective as a means of mass manipulation. Artists of his kind continued to cling to an elitist and individualistic interpretation of art, despite the edict that they now, definitively and unconditionally, contribute to a completely clear and accessible 'popular' culture.

As the Bolshevik leaders became more confident and powerful, this anti-elitist sentiment – which was, of course, deeply rooted within the broader revolutionary movement – took on a more vindictive and aggressive tone. Many years later Mikhail Frunze, one of the most celebrated generals of the civil war, made the intention crystal clear when he stipulated 'utter comprehensibility' and 'the elimination of any form of intellectualism' as prerequisites for all art.[49] The Bolsheviks were intent on introducing a new style of painting that would make art suitable for propaganda, education and entertainment, but their desire was fuelled by a genuine resentment of both the intellectual and the artistic in general, and of intellectuals and artists.

A second source of rising perturbation among Soviet administrators was the 'elitist' artists who still wished to be part of a progressive pan-European culture. The increasing international isolation of the Soviet Union and the explosion of xenophobic sentiment in European politics made public administrators distrustful of any cosmopolitan aspirations in the arts.

In early 1936, a targeted and coordinated campaign was launched, with the aim of ridding art of any elitist or cosmopolitan tendencies. The trigger for the campaign came in late 1935. At a congress of the artists' union, the intrepid David Shterenberg gave a speech that culminated in a full-frontal attack on the recent cultural policy. He demanded

'freedom of association' and declared that there was 'no creative freedom' in modern Soviet society, that creativity had been 'straitjacketed' and become 'corrupt policy'.[50] These claims were 'drowned out several times by applause and shouts of approval'. Writer Ilya Ehrenburg voiced his fierce support for Shterenberg. It was the extent of this public approval, in particular, that unsettled the informers present at the event. The security service, therefore, sent an 'urgent message' to Stalin, which included a verbatim report of parts of the gathering, and of the 'counter-revolutionary' sentiments expressed. The security service's message was dated 2 December 1935, and we can assume that Stalin read it several days later.[51]

Shortly thereafter, Stalin decided to carry out a comprehensive purge of the cultural scene. The man he put in charge acted under the pseudonym of Platon Kerzhentsev, only sporadically using his real name, Platon Lebedev. As a writer he also published under a third name: V. Kerzhentsev. He was a typically elusive Soviet figure, with a multifaceted, changeable identity: intelligent, efficient and with a keen sense of which way the ideological wind was blowing.[52]

Even a brief summary of Kerzhentsev's various occupations gives an impression of his chameleon-like personality. He was a productive publicist with a broad knowledge of cultural policy, an Ireland expert, a translator from French, an organizational specialist, and for some time director of the Soviet marketing bureau ROSTA, where he worked closely with Mayakovsky. He was also deputy director of the central statistics agency and ambassador to Stockholm and Rome. As an organizational specialist he published several influential books and developed the Soviet variant of what we now call 'time management'. Under his various pseudonyms, he published over thirty books and countless articles between 1917 and 1936. At the end of the 1920s, his star rose higher still, allowing him to occupy various powerful positions in the early 1930s. He was secretary of the Ministerial Council, head of Soviet Radio, and between 1936 and 1938 was the head of the Committee for Fine Arts. He occupied all of these posts for a short time only, generally two years, and rarely more than three. Tenures of this length were probably just short enough to disguise his incompetence (as a jack of all trades, but master of none). He was what in modern nomenclature might be called a 'consultant' or 'interim manager'; a strange combination of pundit and bureaucratic wizard. Every step he took was determined by strategy, never by conviction.

He knew the avant-gardists well – not just Mayakovsky, but also Meyerhold, with whom he spent time as a friend. Before the revolution, he had even collaborated once with Malevich. As an ambassador in Rome, he had made attempts to bring Meyerhold and Diaghilev together.[53]

To expedite the campaign, Stalin decided first of all to bring the entire cultural sector under his own control. All creative institutions – the theatres, film studios, concert halls, museums and all institutes of art education – were consolidated into a new Committee for the Fine Arts and made answerable immediately to the Council of People's Commissars (known as the SOVNARKOM), of which Stalin was president. The entire bureaucratic management of the cultural sector was thus taken away from the People's Commissariat for Enlightenment and placed squarely in Stalin's hands. When the Committee for Fine Arts was established, he appointed Kerzhentsev as chairman.

These changes were implemented with an astonishing alacrity that is perhaps typical of such sweeping operations: the higher the speed, the lower the risk of any bureaucratic obstacles. Some time in early or mid-December, Stalin would have read the report of the turbulent conference and of Shterenberg's rousing speech. Kerzhentsev was appointed on 17 January 1936, and by 28 January the smear campaign was already under way, with the publication of an article titled 'Chaos Instead of Music' in *Pravda*, aimed at Dmitry Shostakovich.

As the campaign was getting started, the power-consolidation process in the arts sector continued. On 31 January, three days after the appearance of the first article, the editorial departments of all cultural journals and publishers were placed under the authority of the Committee. The transfer of power was not fully complete until late May.[54]

The aim of the purge was to promote an ideological about-face, and to force artists to exhibit loyalty to the cultural policy. It was not intended to imprison, kill, or expunge them from the unions en masse. Kerzhentsev's strategy was as follows: *Pravda* would publish a number of editorial articles, maligning formalist artists from various disciplines in no uncertain terms, and accusing them of revolutionary treason. Similar articles were published in other national papers, such as *Komsomolskaya Pravda*. The smear campaigns then continued in the specialist media, such as *Literaturnaya Gazeta* (a literary newspaper) and journals including *Sovietskoye Iskusstvo* (Soviet Art), *Sovietskoye Foto* (Soviet Photography) and *Sovietskoye Kino* (Soviet Cinema).

For maximum effectiveness, Kerzhentsev selected the most renowned artists within each discipline as his scapegoats, making it abundantly clear that nobody in the Soviet Union was exempt from the obligation to popularize and submit to the party ideology. He focused especially on artists who had a major international reputation: Dmitri Shostakovich for music, Vsevolod Meyerhold for theatre, Sergei Eisenstein for cinema, and Konstantin Melnikov for architecture. Art was more problematic, since all the active, prominent formalists had disappeared. Malevich was dead, and Tatlin had not painted anything since the revolution. In an anti-elitist campaign, moreover, Tatlin was difficult to attack owing to his working-class image, while Rodchenko and Lissitzky were unknown outside a small professional circle. Besides, Rodchenko was a photographer and Lissitzky was an exhibition designer – hardly prime targets for a populist attack on elitist art. So for the visual art offensive, Kerzhentsev chose painter and illustrator Vladimir Lebedev. He had been a friend of Tatlin's and after the revolution, when he was making abstract paintings and reliefs, he exhibited briefly with all the prominent avant-gardists. Later he concentrated on illustrating children's books, and became the art director of the Leningrad branch of Detgiz, the state publishing house for children's literature. In this capacity he was influential, and furnished many independent artists with work. It is in part thanks to him that Russian children's book illustrations from the 1920s achieved worldwide renown. Lebedev himself was the most famous illustrator in the Soviet Union; an attack on him would, therefore, have a widespread effect not only on his own work but also his vast professional network.

As mentioned above, the campaign started on 28 January 1936 with the publication of 'Chaos Instead of Music' in *Pravda* (blackening Shostakovich's reputation), followed on 6 February by 'Ballet Betrayal' (aimed again at Shostakovich). Next came 'Cacophony in Architecture' (against Melnikov) on 20 February, followed by 'On Smudge-Painters' (against Lebedev) and 'Formalist Grimaces in Art' on 1 and 6 March, respectively. Not long before, on 14 and 15 February, *Komsomolskaya Pravda* had published several articles condemning formalism in art, in which Lebedev was also the target.

Of course, newspaper attacks on formalists were nothing new. But rather than mere incidental opinion pieces, these were editorial articles in *Pravda*, and therefore represented the open and unadulterated opinion of the party. The articles also closely resembled one another in terms of structure, formulation and argument. Even their titles were similar. One

Vladimir Lebedev, drawing for *Okhota* (The Hunt),
Leningrad: Raduga, 1925.

of the articles targeting Lebedev, modelled on 'Chaos Instead of Music',
was titled 'Smudges Instead of Drawings'. Shortly after the article 'Against
Formalism and Clichés in Visual Art' in *Komsomolskaya Pravda*, the
specialist journal *Detskaya Literatura* (Children's Literature) published
'Against Formalism and Clichés in Children's Book Illustrations'. The
homogeneity of the articles emphasized the coordinated nature of
the campaign, and everybody understood that an operation on such a
scale would be impossible without approval from the very top.

Particularly striking was the use of language, which became even more
inflammatory than usual. In the *Pravda* article of 1 March, Lebedev's
spirited and tasteful children's illustrations were described thus: 'One
leafs through this book with disgust, like a pathologist's or anatomist's
textbook, full of all possible monstrosities conceived in the mind of the
child-mutilator: terrifying rickets on stilts with bloated bellies, children
without eyes or noses, monkey-children, feeble-minded boys, degen-
erate and malformed girls. The adults are also abominations, and the
animals crippled. And the worst of it: here we have a stripped carcass, all
that is left of the horse.'[55]

Vladimir Lebedev, drawing for *Okhota* (The Hunt),
Leningrad: Raduga, 1925.

Altogether, the national dailies published around fifteen articles written either by Kerzhentsev himself, or under his direct supervision. The articles were not always anonymous – some were even written by close friends or willing supporters wanting to advance their career. Part of Kerzhentsev's strategy was, of course, to ensure that the smear campaigns would be kept going by bandwagon-jumpers and opportunists acting on their own initiative. While this certainly did occur, the extent to which the campaign's momentum was maintained by such independent initiatives is impossible to determine with any precision.

What is certain is that the campaign quickly spread to the various cultural unions, who held multi-day conferences where artists were urgently invited to discuss the *Pravda* articles. The first conference of the Moscow artists' union began on 8 March, only eight days after the first article on formalism appeared. Here, too, speed was the order of the day, perhaps to encourage the sense of crisis and urgency. The conferences were intended to generate increased public outcry against formalist artists, leading to humiliating admissions of guilt from those accused.

These occurred with some regularity. Nadezhda Udaltsova and Alexander Drevin, for example, made a show of contrition, though they did not admit to all the allegations levelled at them. But Shterenberg stood up for himself once again, denying every accusation and proudly proclaiming: 'It is just as well Malevich is dead. He would be skinned alive for his *Black Square*.'[56]

Nobody was as adamant and unruffled as Tatlin, who had turned fifty not long before.

Recently I have attended debates in various sectors – among writers, and the theatre industry. A typical feature of these discussions is that people stand up and criticize themselves until they drop. They find no single redeeming quality within themselves that makes them worth anything in our lives.

During a theatre meeting, for example, the director Okhlopkov came forward, and began chiding himself so severely that all his hair fell out [laughter]: he had worked so hard that he was now worthless. There were various other such figures. The same thing happened among our kind [the artists]. There were outstanding, sincere artists who criticized their work from a formalist perspective. There were even some who said that we did not even take formalism seriously [laughter].

I would like to comment on this phenomenon, as it is important for the state to know what is going on in the mind of every artist.

I have long been engaged with analytic art, and was involved with it before the revolution. I fought against stunted morals, against the bad kind of academism that was dominant at the time, and enjoyed special rights and privileges.

I therefore cannot say now that I did not take it seriously. I did it with all that I had, with sincerity, believed that it was the truth and that all strength resided within it. So I will not put my earlier works behind me, I will not burn or destroy them, but will simply continue to work and to make use of the knowledge and skills I have obtained. I see them as noble and necessary, and whoever does not possess them will remain beggarly, a kind of naked, indecent person.[57]

A *Pravda* journalist who was present reported on the meeting, and cited Tatlin's final words in the newspaper. 'Sadly,' the journalist added with rancour, 'these ridiculous claims were not met with the necessary opposition during the meeting.'[58]

Shortly thereafter, during a brief interlude at another conference, Tatlin openly rebuked Kerzhentsev, calling him 'ignorant, incompetent and crude'. His subsequent remark on 'the chronic dullness of Kerzhentsev's eyesight' was greeted with applause from the auditorium.[59]

Such open opposition had its price, however. Although there was no explicit policy to silence formalist artists (by expelling them from the unions, for example), their marginalization and gradual excision from the arts scene continued. The tormented Vladimir Lebedev was dismissed from his post as director of the state children's publishing house, and instead was issued many smaller jobs.

Tatlin's work began to dry up, and people worked openly to thwart and frustrate him. In 1935 he was hired as a scenographer for two large theatre productions, but had barely any work in 1936 and 1937. His son Volodya was now twelve, and ate as much as an adult male. In April 1936, the artists in the surrounding neighbourhood saw him 'take his scarf to the pawn shop'. He received 100 roubles for it.[60]

Tatlin still had his atelier in the clock tower of St Catherine's Convent, but he was evicted in 1937. According to one of his friends, he was made to do so because Stalin occasionally visited the grave of his wife Nadezhda Allilueva, who had been buried on the convent grounds. The security service feared that Tatlin might try to assassinate Stalin from the clock tower.[61]

He was allocated a new, far smaller studio on the top floor (the seventh) of the sizeable Maslovka residential complex for artists. One year later, he was briefly expelled from the artists' union, after which he was required to register once more, implying that he was subjected to a humiliating evaluation by a panel of realist artists.[62]

Some time later (it is not known exactly when), an attempt was made to rob him of his new studio too. Tatlin's good friend Alexander Labas (Tatlin always addressed him with the nickname 'Shura' or 'Shurochka') recalled that Tatlin enlisted the help of his 'patron', the influential architect Lev Rudnev. Labas wrote in his memoirs that Rudnev managed to 'block the decision at the highest levels' and informed Tatlin of his success. 'The next day,' Labas writes:

Tatlin ran into Ryazhsky [formerly a prominent member of the AKHRR and then a union board member], who told him that they had changed their mind, so to speak, and decided to let him keep his studio after all. Tatlin did not reveal that he already knew as much from another

source, and responded to Ryazhsky: 'Oh, yes of course, I knew that you people weren't so bad as to take my studio from me.' 'Not such bad people,' he laughed bitterly, 'can you imagine, Shurochka? What scoundrels. We "changed our mind," so to speak...'[63]

Tatlin still received occasional commissions, especially as a theatre designer. During the 1930s and 1940s he worked as scenographer on around fifteen theatre productions, which constituted more or less all of his paid work. Shterenberg, Lebedev and other artists who had been branded as formalists also still received commissions, though their positions were marginal. There was room for them because the cultural scene had witnessed a general expansion: much state funding was being invested, books were being published, new theatres opened, and many exhibitions organized, producing a broader cultural landscape that could accommodate marginal figures. Rodchenko and Stepanova also continued to work, primarily as graphic designers of books, magazines and posters. El Lissitzky still enjoyed considerable regard as a production designer. Malevich's students Suetin and Rozhdestvensky were also able to continue working in this capacity, with Suetin moonlighting as a porcelain designer.

The fact that all of these artists could continue to work even after the anti-formalist campaign is nowadays often taken as a sign that the campaign was less radical than it seemed, and that the Stalinist cultural landscape was, in fact, more heterogeneous than is often proposed. This nuanced view, of course, has some validity, if only because reality is nearly always more complex than accounts in history books. Such nuances, however, should not be used to understate the dominant reality of cultural life under the Stalinist regime.

What some historians forget is that these artists did not continue to work because they were freely and openly encouraged to do so, but because they were highly motivated workers of superior talent, who left a trail of indisputable quality wherever they went. Lebedev was and remained an illustrator of exceptional skill; of course writers and publishers wanted to go on working with him. He was more productive, had a more original perspective and inspired those around him. Theatre directors wished to continue collaborating with Tatlin, despite the inevitable internal rebukes and the increased likelihood of negative reviews. They did not do so from a desire to help Tatlin, or owing to any broadminded cultural policy, but because his superior designs improved the quality of their productions, even when he was forced to work within a

more restricted idiom. Despite the political pressures and Tatlin's ever-problematic personality, creative people wished to be near him, in the hope that a little of his talent might rub off on them.

Rodchenko was able to continue to publish his photographs, because they were better – far better – than those of his closest competitors, such as Shaikhet or Baltermants. Those two, incidentally, were not bad at all; Rodchenko was simply better. He and Stepanova continued making lavishly produced editions for the army and foreign delegations, because even mediocre bureaucrats could see that nobody made more beautiful books than they did.

Those branded as formalists continued to work because of their own resourcefulness and the power of their creativity, which proves only that the party's control over the arts was never truly universal.

Evidence that the anti-formalist campaign ultimately did become permanent in character comes from Kerzhentsev's final achievements in office: the banishment of avant-garde art from the collections of public museums. As strange as it may sound, until 1936 avant-gardist works still graced museum walls – including those in the Tretyakov. They were displayed in special, clearly marked rooms. In the Tretyakov Gallery, for example, the area was designated the 'capitalism department'.[64] The artworks hung there, including *Black Square* and several reliefs by Tatlin, were furnished with accompanying notes such as 'Bourgeois art at a dead-end'. No room for interpretation there. Yet even these completely biased presentations remained a thorn in the side of Kerzhentsev. On 19 May 1936, he wrote to Stalin and Molotov asking for permission to remove these 'disgraceful works' from the walls for good, and have them stored in the depots.[65]

Unsurprisingly, Stalin agreed, and Kerzhentsev used the leader's decision to launch another attack on the avant-gardists in *Pravda*. 'For some reason or other, the Tretyakov Gallery deems it necessary to display even the laughable works of Kandinsky and Malevich. Kandinsky's "painting" is titled *Composition* – quite an ironic name, for its amorphous lines and splatters harbour only chaos, so typical of this artist. The museum even exhibits such a scandalous object as Malevich's *Black Square*.'[66]

It was probably only a few days later that the last avant-gardist works were removed from the walls and banished to the depot, where they would remain in storage until the late 1980s.

Professional marginalization went hand-in-hand with social exclusion, and at social events it was advisable to avoid artists who were

branded as formalists. Ivan Klyun, Malevich's old friend, wrote in his diary around this time: 'I noticed that various artists and art historians were very friendly and gregarious when they met me in the street, and invited me to visit them at home to catch up, but during the opening of an exhibition, in the presence of the "leadership", they simply greeted me and walked on, only daring to shake my hand in the corner, afraid of incriminating themselves by talking to a formalist.'[67]

Shortly before his death, Malevich had written something similar in a letter to Nikolai Punin. 'Everybody has become so afraid of me that they walk away, afeared of my thoughts and of my ideology. Personally I have the impression that all of these people greet me not because they recognize a friendly face, but only so that they can say hello and run away again as fast as possible....Everyone, it seems, tosses a crust into my lonely cave, then runs off without so much as a glance.'[68]

The gradual impoverishment of the old avant-gardists reinforced their status as outcasts. Their social exclusion is also evident in historical sources. Throughout the 1920s, for example, Tatlin's name can be readily found throughout a wide range of letters and memoirs. This is not the case for the 1930s, when he retired somewhat from social life and people were probably more hesitant to mention his name. Occasionally he pops up – like the ghost of Elvis – in the margins of a written memoir. In the mid-1930s, during a party where a group of artists – first gingerly, and later encouraged by drink – began a conga line 'through the corridors and rooms' of the actors' club, Tatlin's presence was noted as 'the second-last in line, sticking out like a beanstalk'.[69]

The Great Terror

In the summer of 1937, Stalin began a new mass terror campaign that unleashed a wave of violence on the civilian population unprecedented during peacetime in the modern age. The numbers of people taken into custody increased astronomically. In 1936, security services had detained a little over 175,000 people; just one year later, this figure had risen to 945,000 (not including ordinary police arrests). In 1938, the figure rose by over 641,000. During 1937 and 1938, nearly 682,000 people were executed by a bullet in the neck, often within several weeks of their arrest. Death sentences required legitimization by confession, and so were nearly always preceded by horrific torture.

Police photographs of Alexander Drevin, 1937.

The majority of those arrested were sentenced to forced labour in the gulag, where mortality rates were very high. In 1937, for example, over 100,000 people died of hunger or disease in the camps. By late 1937, the prison population had risen to nearly two million. Considering that around 94 per cent of the prison population was male, we can conclude that around 3 per cent of Russia's male population had been sent to the camps.[70] This percentage would continue to rise.

The terror effectively consisted of two parallel operations. The first targeted a group known as the 'kulaks' and members of the urban under-class – the unemployed, homeless and petty criminals. However, it also included a cleansing of the party, and a general ideological purge. The second operation was an ethnic cleansing operation, aimed primarily at those of Polish, Lithuanian and German descent, as well as members of smaller 'ethnic' groups. Around two-thirds of all arrests were made under the kulak operation, and the remainder as part of the ethnic cleansing.[71]

Although intellectuals and artists were not specifically targeted, they could still fall victim to the ideological or ethnic campaigns. Alexander Drevin, Udaltsova's husband, and the constructivist Gustav Klutsis were arrested because of their Lithuanian heritage on the same day, 17 January 1938, and both murdered five weeks later. Vera Yermolaeva, Malevich's mainstay in Vitebsk, had already been arrested and sentenced to prison in 1935. She was accused once again while in prison, and executed on 26 September 1937. Igor Terentyev was arrested again in late May, and although he had already done all he could to clear his name by

Photographic portrait of Alexander Rodchenko, by his friend Georgy Petrusov, 1933.

denouncing the avant-gardists as anti-revolutionary, after three weeks he, too, was shot in the neck. Tatlin's assistant Roman Semaskevich was arrested on 2 November, and shot dead on 22 December. His wife recalled how 'they arrested him at night, put him in a black Gaz M-1 and drove him away. They also took two hundred of his paintings with them, which were never returned. They thus murdered him twice.'[72] Valentina Kulagina, Klutsis's wife, left a very detailed recollection of the arrest.

> At around four in the morning I heard a short, loud knock. I waited. When the knock came a second time, I stood up, quickly put on a dressing gown and opened the door. There were two soldiers. They asked: 'Does Klutsis live here?' I knew straight away what it meant, and remained surprisingly calm the whole time. It was not until they had taken him, and I was standing by the window, that I had the urge to run downstairs and say goodbye one last time...It was already morning by then. When he had said goodbye to Edik [their two-and-a-half-year-old son] and came out of the bedroom, his eyes were red.[73]

The policy was not to give wives or other family members any information about the arrestee, not even after their execution. The women kept asking for information. They visited the prisons, and wrote letters to the secret police, to the minister and sometimes even to Stalin himself.

The confusion and lack of information fuelled people's fear and incredulity. Why were the arrests taking place? Who had ordered them? How was it possible that devoted communists and public servants were suddenly suspected of the most heinous crimes? The pervasive fear and distrust gave rise to all manner of wild urban legends and horror stories. One artist recalled that 'rumours circulated in Moscow about children being lured away with sweets, to turn them into soap or mincemeat'.[74]

It was during this time, in the words of Nikolai Khardzhiev, that 'one could sense in the air the sound of skulls cracking apart', 'and people started looking like worms in jars'.

Punin said to friends who succumbed to apathy: 'Do not lose your desperation!'[75] Those who could still feel desperate had not lost their humanity, after all.

Punin himself would become well acquainted with desperation in all its forms. After a brief detention in 1935, in 1949 he was arrested once more and sentenced to forced labour in a gulag – in the camp at Abez, to be precise, north of the Arctic Circle. His denouncer was a realist artist, Vladimir Serov (no relation to the great artist Valentin Serov). The charges listed the defence of formalism as a form of anti-Soviet conduct, and he was one of the few who were genuinely sentenced for their support of formalism. He died in the camp several years later, of exhaustion and disease.

In Moscow, Tatlin's circle became smaller and smaller – not only due to the social exclusion affecting all formalists, but also because of his persistently thorny character. He was at loggerheads with all of the former avant-gardists and could not set his quarrels aside, not even under the prevailing dire circumstances. He and Alexander Rodchenko now lived in the same complex, but had no contact with each other. Tatlin was angry that Rodchenko was now listening to the constructivists and had adopted a utilitarian art style.

Tatlin had also broken off contact completely with Vsevolod Meyerhold, despite the fact that he now worked for the theatre and Meyerhold was undoubtedly the most interesting director still active. They had forged great plans together in 1917, but had since fallen out and Tatlin no longer had a kind word to say about the other man. That changed,

however, when Meyerhold was viciously attacked in *Pravda* in 1937. Because his theatre was due to close, Tatlin attended the final performance as a display of public support. One of Tatlin's young admirers, the author Daniil Danin, did his level best to arrange a meeting between Tatlin and Meyerhold after the show. Tatlin felt ashamed and hesitant, but ultimately accompanied Danin backstage. 'We walked through the ever-thickening crowds in the foyer,' Danin recalled,

> then turned left into a service room that was just as long as the foyer itself. A woman at the closed doors tried to stop us. I recall how nervous I was that Vladimir might change his mind again at the last minute. I convincingly lied that the director was expecting us. We went inside, took a few steps, but Tatlin would go no further. He said that he would wait there, and there was no use trying to persuade him. I ran along the wings, and he stayed back among the bulky crates and old scenery. A young actress directed me to Meyerhold....My speech was so chaotic that at first, Meyerhold did not understand what was going on. Then suddenly he raised his head and assessed the situation. 'So where is he?' he asked, followed by, 'Lead on!'
>
> And so they met, among the old theatre props that had all served their time. They hugged without kissing, just shaking each other by the shoulders. I can still hear their conversation now, 'Well, hello Vsevolod...' and 'My God, Volodya!' There they stood, both tall, slouching slightly, greying and strikingly different. Meyerhold's light profile contrasted with Tatlin's heavy one. A bow tie and a thick sweater. All that Tatlin could manage was 'How are you now...?' and a faint smile. And Vsevolod talked nineteen to the dozen, with a nervous, uncontrollable merriment; frantically joking, he suggested to Tatlin that they row up the Volga and build a log cabin there ('You are the master, Volodya, and I will be your assistant.'). He said to hell with civilization...and proposed inviting all their Moscow friends there. He also suggested inviting all of their enemies, and drowning them in the Volga (again, merrily adding 'You are the master, Volodya, and I will be your assistant!').
>
> Upon their farewell, they shook each other's hand and promised to call. And as he walked off, Meyerhold called out that they would see each other again. 'This will all blow over, Volodya!'[76]

But it did not. That year, Meyerhold tried to salvage what he could of his career, but could get nothing off the ground. One night, a little over a year later, he was arrested. To extract a confession, he was interrogated

Police photograph of Vsevolod Meyerhold, 1939.

by members of the security service for weeks and subjected to monstrous torture. Under such pressure, he confessed to being a German and Japanese spy, though he later recanted. In two letters to Molotov he described how he was treated:

> They beat me, a sick, ageing man of sixty-five. They laid me on the floor face-down, and beat the soles of my feet and my back with a rubber truncheon. Then they put me in a chair and they beat me with the same truncheon, from my knees to the tops of my legs. And in the days that followed, when my legs were covered in a multitude of contusions, they used the rubber truncheon to beat the red, blue and yellow bruises. The pain was excruciating, it felt like boiling hot water was being poured over the most sensitive parts of my legs (I screamed out and cried from the pain)...
>
> Lying face-down on the floor, I learned how to wriggle, writhe and squeal like a dog being whipped by his master....The whole time, the interrogator said threateningly: 'If you do not sign, we will beat you again. Only your head and your right hand will be spared; the rest will be transformed into a shapeless, bloody, disfigured mess.' So I signed everything until November 16, 1939.[77]

Meyerhold was sentenced to death. On 2 February 1940, he was killed by a shot to the back of the neck, by a specialist from the security services.

Early in the Second World War, large sections of the Moscow population were evacuated. Rodchenko and Stepanova were sent to Perm. Tatlin initially went to Ekaterinburg, but in late 1942 moved to Nizhny Novgorod. A local artist and former pupil of his, Andrei Kikin, gave him and his son Volodya accommodation for several months. Being such a large man, Tatlin found the rations far too small. He probably also saved food for his son, and developed kwashiorkor (oedematous malnutrition) as a result. For several months he lived in a barracks, which had most likely been converted into some kind of asylum-seeker refuge. In late 1942, Volodya – who had just turned eighteen – was drafted into military service. He was wounded twice, patched up in hospital, and sent back to the front. He died in January 1943, probably in the battle of Stalingrad.[78]

Rodchenko and Stepanova returned to Moscow in early 1943. Their daughter Varvara (whom they always called 'Mulya') remained in the vicinity of Perm for some time, probably because food was easier to come by. Rodchenko wrote to her often, revealing a caring, uncommonly gentle side. He started painting again, and even produced some abstract works. 'It makes no sense,' he wrote in his diary, 'and is perhaps foolish. But I enjoy it, and find it interesting.'[79] His diary entries are often addressed to the then seventeen-year-old Mulya, whom he missed terribly. In the following note from August of that year, he confesses all his desperation with brutal honesty.

> It is evening. I am alone. As I look around my studio, at the walls where my works are hanging, I wonder…Might one day an older Mulya sit here, with her children, and look at my work and think: 'Oh, what a shame that father did not live until this moment, now that his work is recognized and in demand. The people are buying it, and it is hanging in museums. And he made all of this. Was he convinced that this would happen, or not? It would have been nice for him if he had been.'
>
> Dear Mulya of the future, your dead father can tell you with a pure heart: he was not at all certain, not one bit. And the uncertainty was like a disease. He did not know why he kept working. And just like now, he often thought that all his work would be destroyed, thrown away, until no trace of it was left.

Portrait drawing of Vladimir Tatlin by his girlfriend
Alexandra Korsakova, 1953.

Dear Mulya! You, too, might one day be poisoned with the same scourge. But I wish you no ill. It would be better for you to toss it all away, and live an ordinary life, 'just like everybody else.'

But I was esteemed, and had a name in Europe, I was known in France, Germany and America.

And now I have nothing.[80]

After the war, Tatlin started a relationship with the dancer and circus artist Alexandra Korsakova, who remained his partner until the end of his life, although they did not live together. Every day, Tatlin continued to walk up the seven flights of stairs to his studio, since the lift hardly worked. He had lost nearly all his friends, though he did still enjoy a legendary status in some places. A young artist who knew him only by name and from old photographs was shocked by a chance encounter with him on the stairs, as his former powerful physique had withered into that of a 'hunched figure, with a wrinkled, deathly-white face and the eyes of an old, sick dog'.[81]

Alexander Labas was the only one he still saw nearly every day. 'People saw Tatlin as a closed figure,' Labas recalled,

but to me he was always open, sincere and natural, just like his talent....I loved him incredibly much, and the character flaws that were always attributed to him and which people love to bring up again and again - his sternness, austerity, and yes, even the cruelty he could show to those close to him - he may have had those flaws, but his good qualities, including several notable ones, were far greater. By nature he was a man who could feel deeply, with great empathy, and he loved with a pure love. But the harsh circumstances cannot but have left their mark on his vulnerable and sensitive character. And this man, with such a great, authentic talent, was neglected, essentially worn-out, and completely isolated.[82]

Rodchenko blamed himself for not having sought contact with Tatlin, even though his admiration for him had only increased. In the 1940s, Rodchenko wrote of Tatlin in his diary:

I learned everything from him: how to approach the profession, the object, the material, one's living, and life in general, and his instruction has influenced my whole life.

He was just so suspicious of everyone, always thinking they were out to hurt or betray him, or that his enemies - Malevich in

particular – might send someone to steal his creative ideas. That's why he shut himself off from me more and more, he was always on his guard.

But his efforts were in vain. I was utterly devoted to him, and even now, after not having seen each other in years, I still believe that he might one day regret his mistrust and our lost true friendship. On the other hand, since I was trained by him, I am just as distrustful and somewhat egotistical, which is why I myself take no steps to rekindle our friendship. Even though it is my responsibility to do so. But he has planted something inside me that prevents me from doing it, in the knowledge that our friendship is irreparable. Among all the contemporary artists I have known, there was nobody who could measure up to him.[83]

Tatlin died on 31 May 1953. One source puts the number of funeral attendees at eight or nine. At the farewell, Lev Rudnev said: 'A true artist has left us, a giant, who will only be loved and appreciated in times to come.' And: 'Today we bury our conscience.'[84]

In the time before his death, Tatlin was visited by the young theatre director Georgy Tovstogonov. Tatlin took him into his studio, where Tovstogonov saw one of Tatlin's reliefs. To a Stalinist-era man of the theatre, it must have resembled an extra-terrestrial object. In an interview from the 1980s he said of the encounter: 'We went all the way to the top, and through a long corridor. Tatlin said to me from behind: "To the left, to the left. Tatlin is as left as you can get!" He had attached decorative constructions to the wallpaper. Not simply stuck there, but installed in three-dimensional space. A strange sight. When Tatlin noticed my surprise, he said to me: "Without riddles, my dear boy, there will be no art."'[85]

Notes

All original Russian quotations were translated into English by Brent Annable.

Introduction

1 See: Krusanov, I (2), p. 19.
2 Krusanov, I (2), pp. 16–17.
3 Krusanov, I (2), p. 17.
4 Krusanov, I (2), p. 24.
5 KMSob, II, p. 140.
6 Mikhail Matyushin, 'Vospominania futurista', *Volga*, 1994, no. 9–10, p. 87.
7 V. E. Meyerhold, *Perepiska, 1896–1939* (comp. V. P. Korshunova and M. M. Sitkovetskaya), Moscow: Iskusstvo, 1976, p. 29.
8 Ibid.
9 Frederick Starr, 'Le Corbusier and the USSR [New documentation]', *Cahiers du monde russe et soviétique*, April–June 1980, vol. 21, no. 2, pp. 210–11.
10 Alexander Blok, *Polnoe sobranie sochineniy i pisem* (20 vols), Moscow: Nauka, 1997, vol. 1, pp. 68–69; E. Zamyatin, *Sobranie sochineniy* (5 vols), Moscow: Russkaya kniga, 2004, vol. 3, p. 123.
11 E. Zamyatin, *Sobranie sochineniy*, vol. 3, p. 123.

Chapter 1

1 See: *Moskovsky voenno-revolyutsionny komitet, oktyabr-noyabr 1917 goda* (ed. V. A. Kondratiev), Moscow: Moskovsky rabochy, 1968, p. 265. Malevich's appointment was publicly announced on 15 January in *Izvestia Moskovskogo Soveta rabochikh deputatov*. Malevich's exact title as 'Commissar for the Preservation of Valuables in the Kremlin' was taken from this publication.
2 See, for example: Y. S. Ananeva, 'Problemy obespechenia muzeynykh kollektsii v Ermitazhe v gody Pervoy mirovoy voiny i revolyutsii 1917 g.', *Noveyshaya istoria Rossii*, no. 1, 2012, p. 55.
3 KMSob, I, p. 134.
4 KMSob, I, p. 33.
5 Ibid., p. 55.
6 From the Russian cubo-futurist manifesto, 'Poshchechina obshchestvennomu vkusu' ('A Slap in the Face to Public Taste'), by Vladimir Burlyuk, Velimir Khlebnikov, Vladimir Mayakovsky and Alexei Kruchyonykh, 1912.
7 'Idite k chertu!' ('Go to Hell!'). Manifesto by Mayakovsky, Khlebnikov, Burlyuk, et al., 1914.

8 Nikolai Punin, 'Futurizm – gosudarstvennoe iskusstvo!' ('Futurism is State Art!'), *Iskusstvo kommuny*, no. 5, 5 January 1919.
9 *Russian Futurism through Its Manifestos, 1912–1928*, Ithaca and London: Cornell University Press, 1988, p. 15.
10 Cited in: *Mnemozina: dokumenty i fakty iz russkogo teatra XX veka* (comp. and introd. V. V. Ivanov), Moscow: Gitis, 1996, p. 11.
11 See: Elizabeth Kridl Valkenier, *Ilya Repin and the World of Russian Art*, New York: Columbia University Press, 1990, p. 179.
12 Vakar and Mikhienko, I, p. 106.
13 See: Lapshin, pp. 133–34.
14 Lapshin, p. 138; and KMSob, I, pp. 58–59, including the commentary, pp. 329–30.
15 KMSob, I, pp. 58–59, including the commentary, pp. 329–30.
16 See: Vakar and Mikhienko, I, p. 106.
17 See: V. Sedelnikov, 'Posle obstrela Kremlya', *Zvenya, istorichesky almanakh*, 1991, no. 1, p. 441.
18 Ibid.
19 This example is from Y. N. Podkopaeva and A. N. Sveshnikova (eds), *Konstantin Andreevich Somov. Pisma. Dnevniki. Suzhdenia sovremennikov*, Moscow: Iskusstvo, 1979, pp. 553–54.
20 See: Episkop Nestor Kamchatsky, *Rasstrel Moskovskogo Kremlya* (ed. and comp. N. S. Malinin), Moscow: Stolitsa, 1995. See also: Sedelnikov, 'Posle', pp. 439–50. A Western perspective can be found in Catherine Merridale, *Red Fortress: History and Illusion in the Kremlin*, London: Allen Lane, 2013, pp. 275–78.
21 Sedelnikov, 'Posle', p. 446.
22 M. Dobuzhinsky, 'Rasstreliannoe iskusstvo', *Russkie vedomosti*, 21 November 1917.
23 A. Rostislavov, 'Oktyabrskoe sobytie', *Apollon*, 1917, no. 6–7, p. 80.
24 See: Burlyuk to Ehrenburg, 1932, in: D. D. Burlyuk, *Pisma (iz kolektsii S. Denisova)*, Tambov, 2011, p. 8.
25 I. G. Ehrenburg, *Portrety russkikh poetov* (ed. A. I. Rubashkin), St Petersburg: Nauka, 2002, p. 168.
26 V. V. Mayakovsky, *Polnoe sobranie sochineniy v dvadtsati tomakh*, vol. 1, Moscow: Nauka, 2013, p. 116; commentary, p. 506.
27 See: Abram Efros, *Profili: ocherki o russkikh khudozhnikakh*, St Petersburg: Azbuka-Klassika, 2007, p. 52.
28 Ehrenburg, *Portrety*, p. 168.

29 Sheila Fitzpatrick, *The Commissariat of Enlightenment. Soviet Organization of Education and the Arts under Lunacharsky, October 1917–1921*, Cambridge: Cambridge University Press, 1970, p. 14.

30 Ibid., p. 14.

31 KMSob, I, pp. 138–39.

32 See: A. N. Benois, *Moy dnevnik, 1916–1917–1918*, Moscow: Russky put, 2003, p. 297 and p. 302. See also n. 87 and n. 88 below.

33 S. D. Garnyuk, *Moskovskaya vlast. Sovetskie organy upravlenia, mart 1917–dekabr 1993*, Moscow: Izd. Glavnogo arkhivnogo upravlenia goroda Moskvy, 2011, p. 109.

34 See: Benois, *Moy dnevnik, 1916–1917–1918*, p. 297 and p. 302.

35 See: Garnyuk, *Moskovskaya vlast*, p. 244.

36 See, for example: Natan Efros, *Zapiski chtetsa*, Moscow: Iskusstvo, 1980, p. 24.

37 See: Vakar and Mikhienko, II, p. 159 (Katsman: 'village priest') and p. 360 (Kharms: 'prelate').

38 See: ibid., I, p. 382. Or: Nakov, IV, p. 13. See also: Vakar and Mikhienko, II, pp. 577–621.

39 Vakar and Mikhienko, II, p. 21.

40 See for example: ibid., pp. 298–310.

41 Ibid., p. 382.

42 Ibid., p. 581.

43 Ibid., p. 17, commentary.

44 Ibid., p. 21.

45 Alla Povelikhina and Yevgeny Kovtun, *Russian Painted Shop Signs and Avant-garde Artists*, Leningrad: Aurora, 1991.

46 Cited in: *Rech*, St Petersburg, 21 December 1912.

47 Malevich, *Glavy iz avtobiografiy khudozohnika*, in: Vakar and Mikhienko, I, p. 21.

48 Ibid., p. 23.

49 Ibid., p. 25.

50 See: ibid., p. 25, n. 17.

51 Malevich, *Glavy*, in: Vakar and Mikhienko, I, p. 27.

52 See: Vakar and Mikhienko, I, p. 45.

53 Now in the Khardzhiev Collection/Stedelijk Museum Amsterdam.

54 Malevich, *Glavy*, in: Vakar and Mikhienko, I, p. 27.

55 In: K. Malevich, 'O muzee', in: KMSob I, p. 133.

56 Malevich, *Glavy*, in: Vakar and Mikhienko, I, p. 29.

57 See: Vakar and Mikhienko, II, p. 582.

58 Nakov, IV, p. 23.

59 See: Vakar and Mikhienko, II, p. 62, n. 9.

60 Ibid., p. 61.

61 *The Triumph of the Skies* (1907, GRM), *Nude with Hands Raised* (1908, Khardzhiev Collection/Stedelijk Museum Amsterdam), *Assumption of a Saint* (1907–1908, Khardzhiev Collection/Stedelijk Museum Amsterdam).

62 Vakar and Mikhienko, II, p. 14.

63 See: Anatoly Strigalev, 'Zhurnal "Zolotoe Runo" v khudozhestvennoy zhizni 1900-kh godov', in: *Yevropeysky simvolizm* (ed. I. E. Svetlov), St Petersburg: Aletea, 2006, p. 277.

64 See, for example: Mikhail Matyushin, 'Vospominania futurista', *Volga*, 1994, no. 9–10, p. 89. And: Yelena Kochneva, 'Chelovek Yevropy', *Nashe nasledie*, 2016, no. 119, pp. 101–11 and n. 52.

65 Larionov published his memoirs in 1957, in: *Aujourd'hui. Art et Architecture*, no. 15, pp. 6–8.

66 *The Sower* (Nizhny Novgorod), *The Woodcutter* (Stedelijk Museum Amsterdam), *The Knife Grinder* (Yale University Art Museum) and *An Englishman in Moscow* (Stedelijk Museum Amsterdam).

67 Tatiana Goryacheva, 'Suprematism and Constructivism: An Intersection of Parallels', in: *Rethinking Malevich* (ed. Charlotte Douglas and Christina Lodder), London: Pindar Press, 2007, p. 78. See also: KMSob, V, p. 217 and p. 223.

68 The organisers were the artists Ivan Puni (later: Jean Pougny) and Ksenia Boguslavskaya.

69 Alexandra Shatskikh, *Vitebsk: zhizn iskusstva, 1917–1922*, Moscow: Yazyki russkoy kultury, 2001, p. 227. This is the most comprehensive study on the avant-garde in Vitebsk.

70 N. Punin, *O Tatline*, Moscow: RA, 2001, p. 52. See also: KMSob, V, p. 110.

71 See: KMSob, III, p. 7, n. 2.

72 A. Benois, 'Poslednyaya futuristicheskaya vystavka', *Rech*, no. 8, 1916, cited in: Krusanov, I (2), p. 654.

73 A. N. Benois, 'Vystavka Soyuza molodezhi', *Rech*, 21 December 1912.

74 A. N. Benois, 'Khudozhestvenny spor', *Letopis*, [March?] 1917, no. 2–4, p. 361.

75 See: A. N. Benois, 'Vystavka sovremennoy russkoy zhivopisi', *Rech*, 2 December 1916.

76 Vakar and Mikhienko, I, p. 99.

77 Ibid., p. 98.

78 Ibid., p. 99.

79 Alexandra Shatskikh, *Kazimir Malevich i obshchestvo Supremus*, Moscow: Tri kvadrata, 2009, p. 191.

80 Krusanov, I (2), pp. 84–85.

81 KMSob, V, p. 81.

82 KMSob, I, p. 164.

83 See: V. Khlebnikov, 'Oktyabr na Neve', in: *Sobranie sochineniy v shesti tomakh* (ed. R. V. Duganov), Moscow: IMLI-RAN 'Nasledie', 2000–2006, vol. 5, pp. 179, 183–84.

84 Vakar and Mikhienko, I, p. 107.

85 I apply Vakar's interpretation (ibid., p. 107, note) rather than Nakov's (Nakov, II, p. 277).

86 Vakar and Mikhienko, I, p. 107.

87 Benois, *Moy dnevnik, 1916–1917–1918*, p. 297. Benois uses the word *autodafé*.

88 Ibid., p. 302, see also n. 32 above. The cited publication erroneously lists 'Manevich and Malinovsky'.

Chapter 2

1 See: *Agitatsionno-massovoe iskusstvo pervykh let Oktyabrya: materialy i issledovania* (ed. E. A. Speranskaya), Moscow: Iskusstvo, 1971, p. 128.

2 Vasily Kamensky, *Put entuziasta. Avtobiograficheskaya kniga*, Perm: Permskoe knizhnoe izdatelstvo, 1968, p. 210.

3 *Agitatsionno-massovoe iskusstvo pervykh*, p. 129.

4 *Der Blaue Reiter Almanach* (ed. Vasily Kandinsky and Franz Marc), Munich: Piper, 1912, pp. 13–19.

5 See: Benedikt Livshits, *The One and a Half-Eyed Archer* (translation, introduction and annotations by John E. Bowlt), Newtonville: Oriental Research Partners, 1977, p. 250. See also: ibid., pp. 176–77.

6 *Mercure de France*, 16 April 1914.

7 V. Komardenkov, *Dni minuvshie (iz vospominaniy khudozhnika)*, Moscow: Sovetsky khudozhnik, 1972, p. 76.

8 Description by Vera Pestel, 'Vospominania i zapiski', RSL, f. 680, k. 1, ed. khr. 2, l. 89, p. 18.

9 See: Andrey Sarabianov, *Zhizneopisanie khudozhnika Lva Bruni*, Moscow: RA, 2009, p. 53.

10 Vladimir Tatlin, 'Initsiativnaya edinitsa i tvorchestvo kolletkiva. Tezisy', in: *Formalny metod. Antologia russkogo modernizma* (ed. Sergey Ushakin), vol. 3, Moscow: Kabinetny ucheny, 2016, p. 875.

11 N. Punin, 'Kvartira No. 5', in: *Panorama iskusstv*, 1989, vol. 12, p. 193.

12 Daniil Danin, 'Uletavl', *Druzhba narodov*, no. 2, 1979, pp. 233–34.

13 See: Larissa Alekseevna Zhadova (ed. and comp.), *Tatlin*, London: Thames & Hudson, 1988, pp. 313–14, p. 159.

14 See: Velimir Khlebnikov, *Sobranie sochineniy, v shesti tomakh* (ed. R. V. Duganov), Moscow: IMLI–RAN 'Nasledie' 2000–2006, vol. 2, p. 261. And: Sarabianov, *Zhizneopisanie*, p. 53.

15 V. V. Kamensky, *Stepan Razin. Pushkin i Dantes. Khudozhestvennaya proza i memuary*, Moscow: Pravda, 1991, p. 622. And: Alexander Rodchenko, *Opyty dlya budushchego. Dnevniki, statji, pisma, zapiski*, Moscow: Grant, 1996, p. 212.

16 See, among others: Zhadova, *Tatlin*, p. 178, n. 23.

17 See: Lapshin, p. 436. Yakulov's poster design was dated 26 December. See: Viktoria Badalyan, *Georgi Yakulov (1884–1928). Khudozhnik, teoretik iskusstva*, Yerevan: Natsionalnaya galerea Armenii, 2010, p. 138.

18 Konstantin Umansky, *Neue Kunst in Russland, 1914–1919*, Potsdam/Munich: Gustav Kiepenheuer/Hans Goltz, 1920, pp. 35–36.

19 *Agitatsionno-massovoe iskusstvo pervykh*, p. 101.

20 See: Valentina Khodasevich, *Portrety slovami*, Moscow: Sovetsky pisatel, 1987, p. 118.

21 Komardenkov, *Dni minuvshie*, p. 46.

22 Rodchenko, *Opyty*, p. 211.

23 Rodchenko, *Opyty*, pp. 212–13.

24 Ibid.

25 Pestel's memoirs (see ch. 2, note 8), 'Vospominania', RSL, f. 680, k. 1, ed. khr. 2, l. 89, p. 13.

26 See: Anatoly Strigalev, '"Universitety" khudozhnika Tatlina', *Voprosy iskusstvoznania*, 1996, vol. 9, no. 2, pp. 405–38.

27 See: Strigalev, '"Universitety"', pp. 408–409.

28 Zhadova, *Tatlin*, p. 321.

29 Ibid.

30 I. V. Klyun, *Moy put v iskusstve: vospominania, statji, dnevniki*, Moscow: RA, 1999, p. 85.

31 Strigalev, '"Universitety"', p. 408.

32 Memoirs of V. P. Smirnov, GTG, f. 159, ed. khr. 319, page 7, l. 7.

33 See: Memoir by Anna Begitseva, RGALI, f. 2089, op. 2, ed. khr. 40, l. 31.

34 See: Strigalev, '"Universitety"', p. 412.

35 Smirnov, GTG, f. 159, ed. khr. 319, l. 8.

36 Begitseva, RGALI, f. 2089, op. 2, ed. khr. 40, l. 25.

37 Yelena Tolstaya, *Klyuchi shchastia, Alexey Tolstoy i literaturny Peterburg*, www.elenatolstaya.com/?cat=-mon&id=64, p. 156 (accessed March 2018).

38 Begitseva, RGALI, f. 2089, op. 2, ed. khr. 40, l. 31.

39 RGALI, f. 680, op. 2, ed. khr. 1801, l. 2, cited in Strigalev, '"Universitety"', p. 413.

40 Smirnov, GTG, f. 159, ed. khr. 319, l. 8.

41 Begitseva, RGALI, f. 2089, op. 2, ed. khr. 40, l. 27.

42 See: R. F. Leslie, *The History of Poland since 1863*, Cambridge: Cambridge University Press, 1983, p. 81; Anna Geifman, *Death Orders. The Vanguard of Modern Terrorism in Revolutionary Russia*, Santa Barbara: Praeger, 2010, p. 33; Robert E. Blobaum, *Rewolucja: Russian Poland, 1904–1907*, Ithaca and London: Cornell University Press, 1995, p. 207; Norman Davies, *God's Playground. A History of Poland*, vol. 2 (rev. ed.), New York: Columbia University Press, 2005, p. 275.

43 Strigalev, '"Universitety"', p. 416.

44 Ibid., p. 417.

45 See: Marian Burleigh-Motley, 'Tatlin's "Sailor": A New Reading', *Notes in the History of Art*, 1992, vol. 11, no. 3–4, pp. 47–52.

46 Begitseva, RGALI, f. 2089, op. 2, ed. khr. 40, l. 48.

47 See: Margit Rowell and Deborah Wye, *The Russian Avant-Garde Book, 1910–1934*, New York: The Museum of Modern Art, 2002, pp. 88–89; John E. Bowlt and Béatrice Hernad, *Aus vollem Halse: russische Buchillustration und Typographie*, Munich: Prestel, 1993, pp. 67–68.

48 Rodchenko, *Opyty*, p. 212.

49 From: 'Uchitel i uchenik (1909–1912)', in: Velimir Khlebnikov, *Sobranie sochineniy,*

v shesti tomakh (ed. R. V. Duganov), Moscow: IMLI-RAN 'Nasledie', 2000–2006, vol. 6, book 1, p. 43.

50 See: Anatoly Strigalev, 'Tatlin i Khlebnikov', *Iskusstvoznanie*, 2007, no. 3–4, pp. 385–424.

51 Ezra Pound, *ABC of Reading*, London: Faber & Faber, 1991, p. 39.

52 The nude and the self-portrait (1911) are currently in the Tretyakov Museum in Moscow; the second nude (1912) is in the Russian Museum in St Petersburg.

53 Anatoly Strigalev, 'Tatlin i Pikasso', in *Pikasso i okrestnosti: sbornik statei* (ed. M. A. Busev), Moscow: Progress-Traditsia, 2006, p. 120.

54 See: Nina Serpinskaya, 'Flirt s zhiznyu. Glavy iz "Memuarov intelligentki dvukh epokh"', *Nashe nasledie*, 2003, no. 65, pp. 54–71.

55 Khodasevich, *Portrety*, p. 91.

56 Zhadova, *Tatlin*, p. 184.

57 Tatlin denied this. See also: Vakar and Mikhienko, II, p. 361, n. 20.

58 Klyun, *Moy put*, p. 85.

59 See: Varvara Stepanova, *Chelovek ne mozhet zhit bez chuda. Pisma, poeticheskie opyty, zapiski khudozhnika*, Moscow: Sfera, 1994, p. 59.

60 See: Vera Pestel, 'Vospominania', RGB, f. 680, k. I, ed. khr. 2, l. 89, l. 12.

61 Khodasevich, *Portrety*, p. 90.

62 Ibid.

63 See: Anatoly Strigalev, 'O poezdke Tatlina v Berlin i Parizh', *Iskusstvo*, 1989, no. 2, p. 40.

64 See: George Grosz, *Ein kleines Ja, und ein grosses Nein: sein Leben von ihm selbst erzählt*, Hamburg: Rowohlt, 1983, pp. 172–73.

65 Ibid., p. 41.

66 Nadezhda Udaltsova, *Zhizn russkoy kubistki: dnevniki, statji, vospominania*, Moscow: RA, 1994, p. 166.

67 See: Kliment Redko, *Dnevniki, vospominania, statji*, Moscow: Sovetsky khudozhnik, 1974, p. 105.

68 Strigalev, 'Tatlin i Pikasso', p. 121.

69 Ibid., p. 114.

70 See: Alexandra Shatskikh, *Kazimir Malevich i obshchestvo Supremus*, Moscow: Tri kvadrata, 2009, p. 92, n. 48. The publication in question was *Les Soirées de Paris*, no. 18, 15 November 1913.

71 Strigalev, 'O poezdke', *Iskusstvo*, 1989, no. 2, p. 42.

72 Yakulov as described by Vasily Komardenkov: Komardenkov, *Dni minuvshie*, p. 56.

73 Popova to Udaltsova, 8 April 1914, in: Strigalev, 'O poezdke', *Iskusstvo*, 1989, no. 3, p. 29.

74 Original: GRM, f. 121, op. 117, l. 64.

75 See: *Vladimir Tatlin, Retrospektive* (ed. Anatoly Strigalev and Jürgen Harten), Cologne: Dumont, 1993 (cat.), pp. 248–49.

76 See: Krusanov, I (2), pp. 575–76, p. 1019, n. 1851. And: Anatoly Strigalev, 'Proidemsya po vystavke "nol-desyat" ("0,10")', in: *Russky avangard,*

problemy reprezentatsii i interpretatsii (ed. Irina Karasik and Yevgenia Petrova), St Petersburg: Palace Editions, 2001, p. 104, n. 72, p. 105, n. 77.

77 See: Linda Boersma, *0,10: The Last Futurist Exhibition of Painting*, Rotterdam: 010 Publishers, 1994, p. 33.

78 See: Christina Lodder, 'Colour in Vladimir Tatlin's Counter-Reliefs', *The Burlington Magazine*, vol. 150, no. 1258, January 2008, pp. 31–32.

79 Pestel, 'Vospominania', RSL, f. 680, k. 1, ed. khr. 2, l. 89, p. 12.

80 N. Punin, *Mir svetel lyubovyu. Dnevniki, pisma* (ed. L. A. Zykova), Moscow: Artist, Rezhisser, Teatr, 2000, p. 107.

81 Sarabianov, *Zhizneopisanie*, p. 41.

82 Dymshits-Tolstaya, GRM, f. 100, ed. khr. 249, l. 17.

83 Pestel, 'Vospominania', RSL, f. 680, k. 1, ed. khr. 2, l. 89, p. 12.

84 One such letter ending with the instructio to destroy it has been preserved: Malevich to Matyushin, 24 September 1915, in: Vakar and Mikhienko, I, p. 69.

85 See: ibid., II, p. 212.

86 Ibid., I, p. 69.

87 See also: Boersma, *0,10*, p. 65.

88 S. K. Isakov, 'On Tatlin's Counter-Reliefs (1915)', in: Zhadova, *Tatlin*, p. 334.

89 V. Y. Tatlin, 'Nasha predstoyashchaya rabota', *VIII syezd Sovetov (yezhednevny byulleten syezda)*, no. 13, 1 January 1921, p. 11. English translation ('The Work Ahead of Us') published in: Zhadova, *Tatlin*, p. 239.

90 Stepanova, *Chelovek*, pp. 61–63.

91 See: Y. A. Voronina and I. T. Salakhov, 'K istorii izuchenia kartiny "Cherny suprematichesky kvadrat" 1915 goda K. Malevicha iz sobrania Tretyakovskoy galerei', in: *Tretyakovskie chtenia 2016* (ed. L. I. Iovleva and T. V. Yudenkova), Moscow: GTG, 2017, pp. 264–73. Another source in which Tatlin tells of his use of varnish: Alexander Samokhvalov, *V gody bespokoynogo solntsa*, St Petersburg: Vsemirnoe slovo, 1996, p. 135.

92 Stepanova, *Chelovek*, p. 60.

93 Krusanov, I (2), p. 656.

94 Review in *Golos Rusi*, 22 January 1916, cited in: A. Strigalev, 'Proidemsya', in: *Russky avangard, problemy reprezentatsii i interpretatsii* (ed. Irina Karasik and Yevgenia Petrova), St Petersburg: Palace Editions, 2001, p. 92.

95 Krusanov, I (2), p. 655.

96 Punin, 'Kvartira', p. 183.

97 Quote from Punin, in: Sarabianov, *Zhizneopisanie*, p. 41.

98 Udaltsova, *Zhizn*, p. 12.

99 A. M. Rodchenko, *Statji, vospominania, avtobiograficheskie zapiski, pisma*, Moscow: Sovetsky khudozhnik, 1982, p. 85.

100 Cited in: Krusanov, I (2), p. 698.

101 See: Sarabianov, *Zhizneopisanie*, p. 34 and p. 173, n. 216.

102 Punin, 'Kvartira', p. 193.

103 Yevgeny Poletaev and Nikolai Punin, *Protiv tsivilizatsii* (preface by A. Lunacharsky), Petrograd, 1918.

104 N. Punin, 'Iskusstvo i revolyutsia (glava iz knigi)' (introd. Irina Punina), *Iskusstvo Leningrada*, 1989, no. 5, p. 11.

105 Punin, *Mir*, p. 103.

106 Velimir Khlebnikov, 'Tatlin, tainovidets…', in: *Sobranie sochineniy, v shesti tomakh* (ed. R. V. Duganov), Moscow: IMLI-RAN 'Nasledie', 2000–2006, vol. 1, p. 374. Translation into English by the author of this book.

107 Punin, *Mir*, pp. 99–100.

108 See: Kamensky, *Stepan Razin*, p. 626.

109 Khlebnikov, *Sobranie sochineniy*, p. 185.

110 Sofia Dymshits, SPB, f. 100, ed. khr. 249, p. 46.

111 Quoted in: *A. N. Tolstoy, materialy i issledovania* (ed. A. M. Kryukova), Moscow: Nauka, 1985, pp. 355–56.

112 Rodchenko, *Opyty*, p. 214.

113 Memoir by Aristarkh Klimov in: 'Vospominania o V. V. Mayakovskom' (ed. N. I. Abroskina), *Vstrechi s proshlym*, 1990, no. 7, p. 329.

114 Punin, 'Kvartira', p. 193.

Chapter 3

1 A. Z. Okorokov, *Oktyabr i krakh russkoy burzhuaznoy pressy*, Moscow: Mysl, 1970, p. 310.

2 See: Dmitri Bykov, *Vremya potryaseniy, 1900–1950*, Moscow: Eksmo, 2018, p. 229.

3 From: Karel van het Reve, 'Lenin heeft echt bestaan', in: *Verzameld Werk*, vol. 5, Amsterdam: G.A. van Oorschot, 2009, p. 461.

4 Decree on divorce, 16 (29) December 1917, www.hist.msu.ru/ER/Etext/DEKRET/i7-i2-i6.htm (accessed 16 April 2018).

5 See: A. N. Benois, *Moy dnevnik, 1916–1917–1918*, Moscow: Russky put, 2003, p. 343.

6 V. I. Lenin, *Polnoe sobranie sochineniy*, vol. 50, Moscow: Gos. izd. politicheskoy literatury, 1967, p. 106.

7 Ibid., pp. 142–43.

8 See: A. V. Krusanov, 'Materialy k biografii Nikolaya Burlyuka', *Russian Studies*, 2001, vol. 3, no. 4, pp. 178–83.

9 Nadezhda Udaltsova, *Zhizn russkoy kubistki: dnevniki, statji, vospominania*, Moscow: RA, 1994, p. 38.

10 Quote by David Burlyuk, cited in: Bengt Jangfeldt, *Majakovskij and Futurism*, Stockholm: Almqvist & Wiksell, 1976, p. 19.

11 Vasily Kamensky, *Put entuziasta. Avtobiograficheskaya kniga*. Cited in: *Nekto 1917* (ed. I. Vakar), Moscow: Gos. Tretyakovskaya galerea, 2017 (cat.), p. 58.

12 V. V. Mayakovsky, *Polnoe sobranie sochineniy v trinadtsati tomakh*, Moscow: Khudozhestvennaya literatura, 1955–1961, vol. 12, p. 8. First publication was in *Gazeta futuristov*, 15 March 1918.

13 Alfred Barr and Camilla Gray in particular are responsible for establishing this idea. See: Alfred Barr, *Cubism and Abstract Art*, New York: MoMA, 1936, p. 16. And: Camilla Gray, *The Russian Experiment in Art, 1863–1922* (revised and extended, ed. Marian Burleigh-Motley), London: Thames & Hudson, 1996, p. 230. An example of a recent study is *Words in Revolution: Russian Futurist Manifestoes, 1912–1928* (ed. Anna M. Lawton and Herbert Eagle), Washington, DC: New Academia Publishing, 2005, p. 41.

14 Margarita Tupitsyn, 'Being in Production: The Constructivist Code', in: *Rodchenko and Popova: Defining Constructivism* (ed. Margarita Tupitsyn), London: Tate, 2009, p. 13.

15 A. A. Rylov, *Vospominania*, Leningrad: Khudozhnik RSFSR, 1977, p. 198.

16 See: *Olga Rozanova* (introd. and ed. Vera Terekhina), Moscow: RA, 2002, p. 249. And: ibid., p. 251. See also: Udaltsova, *Zhizn*, pp. 41–42.

17 See: Ryurik Ivnev, *Chasy i golosa*, Moscow: Sovetskaya Rossia, 1978, lunacharsky.newgod.su/bio/rurik-ivnev-iz-vospominanij (accessed 9 May 2017).

18 Ilya Ehrenburg, cited by V. P. Smirnov, GTG, f. 159 (Tatlin), ed. khr. 319, l.

19 Memoir of Vasily Komardenkov, cited in: A. Y. Nikich, *Osmerkin. Razmyshlenia ob iskusstve. Pisma. Kritika. Vospominania sovremennikov*, Moscow: Sovetsky khudozhnik, 1981, p. 206.

20 See: Sergey Spassky, *Mayakovsky i ego sputniki, vospominania*, Leningrad: Sovetsky pisatel, 1940, p. 97.

21 A. M. Argo, *Zvuchit slovo… Ocherki i vospominania*, Moscow: Izd. 'Detskaya literatura', 1968, p. 53; Ilya Ehrenburg, *Lyudi, gody, zhizn: vospominania*, vol. 1, Moscow: Sovetsky pisatel, 1990, p. 260.

22 Matvey Royzman, *Vse, chto pomnyu o Yesenine*, Moscow: Sovetskaya Rossia, 1973, p. 18.

23 A. Bukhov, 'Po cherepu stukayut. Literaturny felyeton', *Ekho* (Kaunas), no. 16, 22 January 1921.

24 See: Irina Sirotkina, *Shestoe chuvstvo avangarda, tanets, dvizhenie, kinestezia v zhizni poetov i khudozhnikov (izdanie vtoroe)*, St Petersburg: Izd. Yevr. universiteta, 2016, pp. 120–25.

25 T. Fokht-Larionova, 'Vospominania', in: *Rossisky arkhiv: istoria otechestva v svidetelstvakh i dokumentakh XVIII–XX vv.: almanakh*, Moscow: Studia TRITE, 2001, vol. 2, pp. 653–54.

26 See: Yelena Tolstaya, *'Degot ili med': Alexey N. Tolstoy kak neizvestny pisatel (1917–1922)*, Moscow: RGGU, 2005, p. 165.

27 See: Alexandra Shatskikh, *Kazimir Malevich i obshchestvo Supremus*, Moscow: Tri kvadrata,

2009, pp. 75–86, pp. 95–113. See also: *Rukodelie, Marina Losyak* (ed.), Moscow: Proun, 2009.

28 See: Harvey Sachs, *Rubinstein: A Life*, New York: Grove Press, 1997, p. 119.

29 See: Karol Szymanowski, *Korespondencja, tom I: 1903–1919* (ed. Teresa Chylińska), Warsaw: Polskie Wydawnictwo Muzyczne, 1982, p. 610. Also: Shatskikh, *Malevich*, p. 80, p. 91, n. 30.

30 Shatskikh, *Malevich*, pp. 82–86.

31 See: Charlotte Douglas, 'Suprematist Embroidered Ornament', *Art Journal*, 1995, vol. 54, pp. 42–45. See also: Shatskikh, *Malevich*, pp. 75–86, pp. 95–113.

32 Vakar and Mikhienko, I, p. 97.

33 I. A. Aksenov, *Iz tvorcheskogo naslediya v 2 tomakh* (ed. and comp. N. L. Adaskina), Moscow: RA, 2008, vol. 1, p. 81.

34 The most detailed information on 'Supremus' and the journal of the same name can be found in Shatskikh, *Malevich*. See also: *Olga Rozanova* (introd. and ed. Vera Terekhina), Moscow: RA, 2002, p. 284, n. 4.

35 Udaltsova, *Zhizn*, p. 40.

36 Ibid.

37 See: ibid., p. 39.

38 KMSob, V, p. 103. See also the commentary: KMSob, V, p. 490.

39 Ibid., p. 105.

40 *Yellow Plane in Dissolution*, 1917, Stedelijk Museum Amsterdam.

41 *Dissolution of a Plane*, 1917, collection of Galerie Gmurzynska.

42 KMSob, III, pp. 323–24.

43 KMSob, IV, p. 14.

44 Vakar and Mikhienko, II, p. 312.

45 KMSob, IV, pp. 108–9.

46 Vakar and Mikhienko, II, p. 165.

47 Popova, cited by Natalia Adaskina, 'Zakat avangarda v Rossii', *Voprosy iskusstvoznania*, 1997, vol. 11, no. 2, p. 266.

48 Sheila Fitzpatrick, *The Commissariat of Enlightenment. Soviet Organization of Education and the Arts under Lunacharsky, October 1917–1921*, Cambridge: Cambridge University Press, 1970, pp. 1–2.

49 See: Robert Russell, *Russian Drama of the Revolutionary Period*, Totowa, NJ: Barnes & Noble Books, 1988, pp. 27–28.

50 *Aristarkh Lentulov. Put khudozhnika. Khudozhnik i vremya* (ed. E. B. Murina and S. G. Dzhafarova), Moscow: Sovetsky khudozhnik, 1990, p. 226.

51 Varlam Shalamov, 'Dvadtsatye gody', in: *Sobranie sochineniy*, vol. 4, Moscow: Terra-Knizhny klub, 2013, p. 321.

52 Dmitri Bykov, *Sovetskaya literatura*, Moscow: Prozaik, 2013, pp. 34–35.

53 See: Vitaly Manin, *Iskusstvo i vlast: borba techeniy v sovetskom izobrazitelnom iskusstve 1917–1941 godov*, St Petersburg: Avrora, 2008, p. 95.

54 Diaghilev's opinion, noted in Prokofiev's diary, 21 March. Sergei Prokofiev, *Dnevnik, 1907–1933* (2 vols), Paris: Sergei Prokofiev Estate, 2002, vol. 2, p. 561.

55 Mark Etkind, *A. N. Benois i russkaya khudozhestvennaya kultura*, Leningrad: Khudozhnik RSFSR, 1989, p. 362. See also Etkind's note in ibid., p. 466, n. 13.

56 From his 'Parizhskie Pisma', in: Lunacharsky, I, pp. 225–31.

57 Ibid., p. 171.

58 See, among others: *V. I. Lenin i A. V. Lunacharsky: perepiska, doklady, dokumenty*, Moscow: Nauka, 1971, p. 52. Lunacharsky's letter of recommendation to Lenin was dated 'early 1918'.

59 See for example: Mark Etkind, *Alexander Nikolaevich Benois, 1870–1960*, Leningrad/Moscow: Iskusstvo, 1965, p. 174, n. 4.

60 These include the *Petrogradskaya gazeta* on 9 March, and *Rampa i zhizn* on 19 March. See Lapshin, p. 89 and n. 244 and n. 245.

61 See: Benois, *Moy dnevnik, 1916–1917–1918*, p. 160.

62 See, for example: Prokofiev, *Dnevnik*, vol. 1, p. 647.

63 See: Lapshin, p. 335.

64 Ibid., p. 334.

65 Ibid.

66 Benois, *Moy dnevnik, 1916–1917–1918*, pp. 176–77.

67 In Moscow, the names of the 'blocs' were official: 'seniors', 'centre' and 'youth'.

68 Lapshin, p. 159.

69 In addition to this union, a multitude of new arts organizations also emerged. The union remained the organization with the greatest authority. See: Manin, *Iskusstvo*, p. 20.

70 *Olga Rozanova*, p. 327.

71 See: Nina Gurianova, '"Deklaratsia prav khudozhnika" Malevicha v kontekste moskovskogo anarkhizma 1917–18 godov', www.hylaea.ru/pdf/malevich-anarchist.pdf (accessed March 2018).

72 Decree on the establishment of a state committee for education, 9 November 1917, www.hist.msu.ru/ER/Etext/DEKRET/index.html (accessed March 2018).

73 Benois, *Moy dnevnik, 1916–1917–1918*, p. 190.

74 Ibid., p. 231.

75 Ibid., p. 202 and p. 232.

76 Ibid., p. 232.

77 Benois' activities in these committees were described on an almost daily basis: Benois, *Moy dnevnik, 1916–1917–1918*, pp. 209–300. See also: Etkind, *A. N. Benois*, pp. 297–300.

78 See for example: Igor Grabar, *Moya zhizn: etyudy o khudozhnikakh*, Moscow: Respublika, 2001, pp. 262–64.

79 A. Goncharov, 'Vstrechi, razmyshlenia, vospominania', www.a-goncharov.ru/article/15. html (accessed 18 December 2017).

80 Grabar, *Moya zhizn*, p. 264.

81 Statement by Lunacharsky, 16 February 1920, cited by Mark Etkind, in: Etkind, *A. N. Benois*, p. 320.

82 Observation by Osip Brik, cited in: Fitzpatrick, *Commissariat*, p. 128.

83 Benois, *Moy dnevnik, 1916–1917–1918*, p. 312.

84 See: Lapshin, p. 236.

85 See: Fitzpatrick, *Commissariat*, p. 118.

86 Lunacharsky uses the word 'sabotage' in 'Ob otdele izobrazitelnykh iskusstv', in: Lunacharsky, II, pp. 79–82.

87 N. Punin, 'V dni Krasnogo Oktyabrya', *Zhizn iskusstva*, 8 November 1921.

88 KMSob, I, p. 61.

89 KMSob, V, p. 97. And: ibid., p. 83.

90 KMSob, I, p. 67.

91 Alexander Rodchenko, *Opyty dlya budushchego. Dnevniki, statji, pisma, zapiski*, Moscow: Grant, 1996, p. 63.

92 See: Yelena Obatnina, 'Khudozhnik i istoria, ili kak sdelan pamyatnik pogibshim anarkhistam', *Novoe literaturnoe obozrenie*, 2013, vol. 122, no. 4, https://www.nlobooks.ru/magazines/novoe-literaturnoe-obozrenie/122-П10–4–2013/article/10545/ (accessed March 2018).

93 The identity of whoever was hiding behind the pseudonym Bayan Plamen was never revealed. Occasionally Vladimir Sidorov's name is cited.

94 A. Rodchenko, 'Tovarishcham anarkhistam', *Anarkhia*, 28 March 1918, no. 29, p. 4; A. Morgunov, 'K chertu!', *Anarkhia*, 29 March 1918, no. 30, p. 4; V. Tatlin, 'Otvechayu na "Pismo k futuristam"', ibid.

95 See also: Olga Burenina, 'Anarkhia i vlast v iskusstve', *Syuzhetologia i syuzhetografia*, 2016, no. 2, pp. 120–37. See also: Nina Gurianova, *The Aesthetics of Anarchy, Art and Ideology in the Early Russian Avant-garde*, Berkeley/Los Angeles/London: University of California Press, 2012.

96 KMSob, I, p. 65.

97 See: Gurianova, *Aesthetics*, p. 237.

98 See: I. S. Ratkovsky, *Krasny terror i deatelnost VTSK v 1918 godu*, St Petersburg: Izdatelstvo Sankt-Peterburgskogo universiteta, 2006, pp. 68–83.

99 Konstantin Korovin, 'Vospominania', in: *Nashe nasledie*, no. 14, 1990, pp. 102–3. Published (abridged) in: *Konstantin Korovin vospominaet* (ed. I. S. Zilbershteyn and V. A. Samkov), Moscow: Izobrazitelnoe iskusstvo, 1990, p. 242.

100 Rodchenko, *O Tatline*, in: Rodchenko, *Opyty*, pp. 61–62.

101 See, among others: Hubertus Gassner, 'The Constructivists: Modernism on the Way to Modernization', in: *The Great Utopia, The Russian and Soviet Avant-garde, 1915–1932*, New York: Solomon R. Guggenheim Museum, 1992, pp. 302–3.

102 Lapshin, p. 214.

103 See: Ryurik Ivnev, *Chasy i golosa*, Moscow: Sovetskaya Rossia, 1978, lunacharsky.newgod.su/bio/rurik-ivnev-iz-vospominanij (accessed 9 May 2017).

104 Malevich to Gershenzon, 19 April 1918, in: Vakar and Mikhienko, I, p. 88.

105 D. Zalevsky [S. S. Trusevich], 'K voprosu o novom iskusstve', *Izvestia*, 29 December 1917. Cited in: Fitzpatrick, *Commissariat*, p. 123. The Russian was also partially cited in Lapshin, p. 273. See also: M. P. Lazarev, *David Shterenberg: khudozhnik i vremya. Put khudozhnika*, Moscow: Galaktika, 1992, pp. 152–53.

106 See: John E. Bowlt, 'Some Thoughts on the Condition of Soviet Art History', in: *The Art Bulletin*, December 1989, vol. 71, no. 4, pp. 542–50.

107 See for example: Timothy Edward O'Connor, *The Politics of Soviet Culture: Anatolii Lunarcharsky*, Ann Arbor: UMI Research Press, 1983, pp. 75–76.

108 See: Hans-Jürgen Drengenberg, *Die sowjetische Politik auf dem Gebiet der bildenden Kunst von 1917 bis 1934*, Berlin: Osteuropa-Institut an der Freien Universität, 1972, pp. 73–74.

109 Remark by Strzemiński, in: Vakar and Mikhienko, II, 534.

110 Roman Jakobson, *My Futurist Years* (ed. Bengt Jangtfeld and Stephen Rudy, transl. Stephen Rudy), New York: Marsilio Publishers, 1992, p. 25.

Chapter 4

1 See: Y. Tugendhold, *Iskusstvo Oktyabrskoy epokhi*, Leningrad: Academia, 1930, p. 18.

2 See: Mark Etkind, *Nathan Altman*, Dresden: VEB Verlag, 1984, pp. 49–54. And: James von Geldern, *Bolshevik Festivals, 1917–1920*, Berkeley and Los Angeles: University of California Press, 1993, pp. 95–97.

3 Sheila Fitzpatrick, *The Commissariat of Enlightenment. Soviet Organization of Education and the Arts under Lunacharsky, 1917–1921*, Cambridge: Cambridge University Press, 1970, p. 127.

4 Lunacharsky, II, pp. 112–18.

5 Lunacharsky repeats it in his piece on Meyerhold: *Teatr Meyerkholda*, in: *Izvestia* from 25 April 1926. And: A. V. Lunacharsky, *Sobranie sochineniy* (8 vols), Moscow: Khudozhestvennaya literatura, 1964, vol. 3, pp. 294–301.

6 See for example: *Iz istorii stroitelstva sovetskoy kultury, Moskva 1917–1918* (ed. V. N. Kuchin), Moscow: Iskusstvo, 1964, pp. 142–52.

7 See: V. P. Lapshin, *Soyuz russkikh khudozhnikov*, Leningrad: Khudozhnik RSFSR, 1974, p. 150.

8 Lapshin, p. 280. See also: Lapshin, p. 215.

9 See: Isaiah Berlin, 'Artistic Commitment. A Russian Legacy', in: *The Sense of Reality. Studies in Ideas and their History* (ed. Henry Hardy), London: Pimlico, 1996, pp. 194–231.

10 See: Yevgenia Anferova, *David Shterenberg. Symbol and Metaphor in the Artist's Work*, Jerusalem: Gesharim, 2005, p. 75 and p. 119.

11 Abram Efros, *Profili: ocherki o russkikh khudozhnikakh*, St Petersburg: Azbuka-Klassika 2007, p. 287.

12 T. A. Lebedeva, 'Kartiny i khudozhniki. Nabroski vospominania', *Panorama iskusstv*, 1982, vol. 5, p. 202.

13 Anatoly Lunacharsky, 'Ob otdele izobrazitelnikh iskusstv', *Novy mir*, 1966, no. 9, pp. 236–39.

14 A. N. Benois, *Moy dnevnik, 1916–1917–1918*, Moscow: Russky put, 2003, p. 390.

15 See: M. P. Lazarev, *David Shterenberg: khudozhnik i vremya. Put khudozhnika*, Moscow: Galaktika, 1992, p. 151.

16 A. V. Lunacharsky, *Sobranie sochineniy* (8 vols), Moscow: Khudozhestvennaya literatura, 1963, vol. 3, p. 39.

17 See: 'V. I. Lenin i izobrazitelnoe iskusstvo' (comp. A. Pavlyuchenkov), *Iskusstvo*, 1977, no. 1, p. 10. See also: n. 1 on that page.

18 A. V. Lunacharsky, 'Lenin o monumentalnoy propagande', in: *Agitatsionno-massovoe iskusstvo. Oformlenie prazdnestv, 1917–1932* (ed. V. P. Tolstoy), Moscow: Iskusstvo, 1984, p. 8.

19 Published in: ibid., p. 43.

20 Vladimir Majakovskij, *Memoirs and Essays* (ed. Bengt Jangfeldt and Nils Ake Nilsson), Stockholm: Almqvist & Wiksell International, 1975, pp. 155–56. See also: Yelena Obatnina, 'Khudozhnik i istoria, ili kak sdelan pamyatnik pogibshim anarkhistam', *Novoe literaturnoe obozrenie*, 2013, vol. 122, no. 4, n. 28.

21 Lunacharsky, *Sobranie*, vol. 3, pp. 253–78.

22 Cited in Svetlana Dzhafarova, 'The Creation of the Museum of Painterly Culture', in: *The Great Utopia, The Russian and Soviet Avant-garde, 1915–1932*, New York: Solomon R. Guggenheim Museum, 1992, p. 476.

23 KMSob, I, p. 73.

24 Alexander Rodchenko, 'Novy komissariat (Khudozhestvennaya kollegia)', *Anarkhia*, 21 April 1918, no. 43.

25 Rodchenko, *Anarkhia*, 30 April 1918, no. 50.

26 Nadezhda Udaltsova, *Zhizn russkoy kubistki: dnevniki, statji, vospominania*, Moscow: RA, 1994, p. 45.

27 Pestel, 'Vospominania', RSL, f. 680, k. 1, ed. khr. 2, l. 97, p. 20.

28 See: Dmitri Sarabianov and Natalia Avtonomova, *Vasily Kandinsky, put khudozhnika, khudozhnik i vremya*, Moscow: Galart, 1994, p. 144.

29 Hugo Ball, *Flight Out of Time: A Dada Diary* (ed. and introd. John Elderfield, transl. Ann Raimes), Berkeley and Los Angeles: University of California Press, 1996, pp. 226–27.

30 Lunacharsky, I, p. 171.

31 *Kazimir Malevich, Letters and Documents* (ed. and comp. Irina Vakar and Tatiana Mikhienko) [English translation of Vakar and Mikhienko with several supplements], London: Tate Publishing, 2015, vol. 1, p. 108.

32 See: KMSob, I, pp. 124–25.

33 Vakar and Mikhienko, I, p. 393.

34 Rodchenko is referred to as a 'co-optive' artist. See: *Agitatsionno-massovoe iskusstvo pervykh let Oktyabrya: materialy i issledovania* (ed. E. A. Speranskaya), Moscow: Iskusstvo, 1971, p. 126, n. 190.

35 Viktor Shklovsky, 'Khudozhestvennaya zhizn bolshevistskoy Rossii' (original, 11 December 1918), *Russian Studies*, 2001, vol. 3, no. 4, p. 175.

36 Osip Brik, 'Moya pozitsia', *Novaya zhizn* 193 (187), 5 (19) December 1917, p. 4.

37 Vakar and Mikhienko, I, p. 394.

38 See, for example: Benois, *Moy dnevnik, 1916–1917–1918*, p. 394.

39 See: *Iz istorii*, pp. 118–21.

40 Lazarev, *Shterenberg*, p. 151.

41 Nina Guryanova, *Olga Rozanova i ranny russky avangard*, Moscow: Gilea, 2002, p. 181.

42 S. Dymshits-Tolstaya, 'Chetyre mesyatsa raboty', *Vestnik zhizni*, 1918, no. 1, p. 71.

43 Memoir of Dymshits-Tolstaya, GRM, f. 100, ed. khr. 249, p. 46.

44 Ibid., p. 49.

45 *Pavel Filonov: realnost i mify* (comp. Lyudmila Pravoverova), Moscow: Agraf, 2008, p. 195.

46 See: Vakar and Mikhienko, II, p. 156.

47 Vera Pestel, 'Vospominania i zapiski', RSL, f. 680, k. 1, ed. khr. 2, l. 97–98, pp. 20–21.

48 Dymshits-Tolstaya, GRM, f. 100, ed. khr. 249, p. 38. Partially published in Krusanov II (1), p. 58.

49 Krusanov, II (1), p. 58, n. 31.

50 See, for example: Igor Grabar, *Pisma 1917–1941*, Moscow: Nauka, 1977, pp. 17–18 and pp. 298–300, nn. 13–15.

51 See: *Kultura, nauka, i obrazovanie. Oktyabr 1917–1920. Protokoly i postanovlenia Narkomprosa RSFSR v trekh tomakh* (ed. L. A. Rogovaya), Moscow: Rosspen, 2012, vol. 1, pp. 503–8. And: ibid., pp. 793 and 505.

52 See: Bengt Jangfeldt, *Majakovskij and Futurism*, Stockholm: Almqvist & Wiksell, 1976, p. 11.

53 See: Vakar and Mikhienko, I, p. 393, n. 4.

54 Krusanov, II (1), p. 65.

55 Natasha Kurchanova (ed. and introd.), 'Anna Begicheva: How I Remember Tatlin', *RES*, 2013, no. 63–64, p. 309.

56 See: Anatoly Strigalev, 'Pamyatnik Geroyam Revolyutsii na Marsovom pole', in: *Voprosy sovetskogo izobrazitelnogo iskusstva i arkhitektury* (ed. I. M. Shmidt), Moscow: Sovetsky khudozhnik, 1975, pp. 105–78. On Punin's role, see: ibid., p. 134.

57 Dymshits-Tolstaya, GRM, f. 100, ed. khr. 249, pp. 38–40.

58 V. Khlebnikov, notebook, 1921, in: Khlebnikov, *Sobranie*, vol. 6, book 2, p. 99.

59 Anatoly Strigalev, 'Uchastie V. Y. Tatlina v organizatsii i provedenii monumentalnoy propagandy', *Problemy istorii sovetskoy arkhitektury*, 1975, no. 1, pp. 51, 52.

60 Tatlin to Lunacharsky, late September 1918, in: *Khudozhestvennaya zhizn Sovetskoy Rossii 1917–1932: sobytia, fakty, kommentarii, sbornik materialov i dokumentov* (ed. V. P. Tolstoy), Moscow: Galart, 2010, p. 72. This letter was erroneously dated August 1918. See also: Strigalev, 'Uchastie', pp. 65–66.

61 *Khudozhestvennaya zhizn Sovetskoy*, p. 72.

62 Hans-Jürgen Drengenberg, *Die sowjetische Politik auf dem Gebiet der bildenden Kunst von 1917 bis 1934*, Berlin: Osteuropa-Institut an der Freien Universität, 1972, p. 73.

63 See: Krusanov, II (1), p. 70, and Anatoly Strigalev, 'Nonarchitects in Architecture', in: *The Great Utopia, The Russian and Soviet Avant-garde, 1915–1932*, New York: Solomon R. Guggenheim Museum, 1992, p. 676.

64 See for example: S. O. Khan-Magomedov, *Boris Korolev*, Moscow: Fond 'Russky avangard', 2007, pp. 33–78.

65 Memoir of Bronts-Bruyevich, in: *Khudozhestvennaya zhizn Sovetskoy*, p. 63, n. 2.

66 See: *Boris Korolev, 1885–1963*, St Petersburg: Palace Editions, 2011, p. 33, n. 1; Strigalev, 'Nonarchitects', p. 676.

67 See: Drengenberg, *Politik*, p. 282.

68 See: *Khudozhestvennaya zhizn Sovetskoy*, p. 41, n. 1. See also: Krusanov, II (1), pp. 322–23 and p. 716, n. 325.

69 Ilya Kremlev, *V literaturnom stroyu: vospominania*, Moscow: Moskovsky rabochy, 1968, pp. 29–30.

70 See: Ilya Ehrenburg, *Lyudi, gody, zhizn: vospominania* (3 vols), Moscow: Sovetsky pisatel, 1990, vol. 1, p. 260. And: Matvey Royzman, *Vse, chto pomnyu o Yesenine*, Moscow: Sovetskaya Rossia, 1973, pp. 18. And: Fedor Bogorodsky, *Vospominania khudozhnika*, Moscow: Sovetsky khudozhnik, 1959, p. 102. See also: Krusanov, II (1), pp. 322–23.

71 Royzman, *Vse*, p. 73.

72 See: *Izvestia* from 14 April 1918.

73 See: Vitaly Manin, *Iskusstvo i vlast: borba techeniy v sovetskom izobrazitelnom iskusstve 1917–1941 godov*, St Petersburg: Avrora, 2008, p. 38, n. 70.

74 See: ibid., p. 40.

75 See: ibid., p. 39.

76 Krusanov, II (1), p. 102.

77 See: Alma H. Law, 'A Conversation with Vladimir Stenberg', *Art Journal*, 1981, vol. 41, no. 3, p. 224.

78 See: Vakar and Mikhienko, I, p. 422.

79 See: ibid., pp. 423–25.

80 Ibid., p. 424.

81 See: KMSob, I, pp. 208–31.

82 *Agitatsionno-massovoe iskusstvo pervykh*, pp. 13–14.

83 Letter from Yatmanov in: ibid., p. 50, n. 34.

84 Georgy Kovalenko, 'Alexandra Ekster v Odesse, 1919–1920', *Iskusstvoznanie*, 1999, no. 2, p. 412.

85 See: *Agitatsionno-massovoe iskusstvo. Oformlenie prazdnestv*, p. 52, n. 8.

86 Y. S. Zernova, *Vospominania monumentalista*, Moscow: Sovetsky khudozhnik, 1985, p. 34.

87 Theo van Doesburg, 'Rondgang', *De Stijl*, June 1921, vol. 4, no. 6, p. 93.

88 *Agitatsionno-massovoe iskusstvo pervykh*, p. 106.

89 Ibid., p. 15.

90 *Politicheskie deyateli Rossii, 1917: biografichesky slovar* (ed. R. V. Volobuev), Moscow: Bolshaya russkaya entsiklopedia, 1993, p. 195.

91 Konstantin Korovin, *Vospominania, rasskazy, pisma, v dvukh knigakh*, vol. 1, Moscow: Russky put, 2010, p. 79. The lion in Petrograd: Valentina Khodasevich, *Portrety slovami*, Moscow: Sovetsky pisatel, 1987, p. 147.

92 S. A. Luchishkin, *Ya ochen lyublyu zhizn: stranitsy vospominaniy*, Moscow: Sovetsky khudozhnik, 1988, p. 46.

93 Amshey Nurenberg, *Vospominania, vstrechi, mysli ob iskusstve*, Moscow: Sovetsky khudozhnik, 1969, p. 95. (On the burning of books, p. 99.)

94 N. Punin, *Mir svetel lyubovyu. Dnevniki, pisma* (ed. L. A. Zykova), Moscow: Artist, Rezhisser, Teatr, 2000, p. 119.

95 *Agitatsionno-massovoe iskusstvo pervykh*, p. 117, n. 75.

96 Ehrenburg, *Lyudi*, vol. 3, p. 206.

97 *Agitatsionno-massovoe iskusstvo pervykh*, p. 61, n. 145.

98 Ibid., p. 41.

99 Ibid., p. 100.

100 Ibid., p. 51.

101 See: Krusanov, II (1), p. 668, n. 218. This artwork did not survive.

102 Arthur Lourié, 'Nash marsh', in: *Russky futurizm: stikhi, statji, vospominania* (comp. V. N. Terekhina and A. P. Zimenkov), St Petersburg: Poligraf, 2009, p. 710.

103 *Olga Rozanova* (introd. and ed. Vera Terekhina), Moscow: RA, 2002, p. 33.

104 Ibid., p. 328.

105 Excerpt from Rozanova's obituary, cited in: ibid., p. 331.

106 Vakar and Mikhienko, II, p. 165.

107 Krusanov, II (1), p. 81.

Chapter 5

1 Vakar and Mikhienko, II, p. 41.

2 Alexander Rodchenko, *Opyty dlya budushchego. Dnevniki, statji, pisma, zapiski*, Moscow: Grant, 1996, p. 69.

3 Ibid., p. 79.
4 Nadezhda Udaltsova, *Zhizn russkoy kubistki: dnevniki, statji, vospominania*, Moscow: RA, 1994, p. 56.
5 See: Kliment Redko, *Dnevniki, vospominania, statji*, Moscow: Sovetsky khudozhnik, 1974, p. 54.
6 Cited in Christina Lodder, 'Gabo in Russland und Deutschland', in: *Naum Gabo, Sechzig Jahre Konstruktivismus* (ed. and comp. Steven A. Nash and Jörn Merkert), Munich: Prestel Verlag, 1986, p. 56, n. 56.
7 Udaltsova, *Zhizn*, p. 56.
8 S. A. Luchishkin, *Ya ochen lyublyu zhizn, stranitsy vospominaniy*, Moscow: Sovetsky khudozhnik, 1988, p. 46.
9 Recollection of V. Stenberg, cited in: Alma H. Law, 'A Conversation with Vladimir Stenberg', *Art Journal*, 1981, vol. 41, no. 3, p. 226.
10 Recollection of G. Chulkov, cited in: A. Shchokin-Krotova, 'Stanovlenie khudozhnika', *Novy mir*, 1983, no. 10, p. 216.
11 See: V. Komardenkov, *Dni minuvshie (iz vospominania khudozhnika)*, Moscow: Sovetsky khudozhnik, 1972, pp. 55–56.
12 Redko, *Dnevniki*, p. 64.
13 Y. S. Zernova, *Vospominania monumentalista*, Moscow: Sovetsky khudozhnik, 1985, p. 32.
14 Ibid., p. 28.15 M. A. Birshtein, *Kartiny i zhizn*, Moscow: Sovetsky khudozhnik, 1990, p. 20. See also: A. Y. Nikich, *Osmerkin. Razmyshlenia ob iskusstve. Pisma. Kritika. Vospominania sovremennikov*, Moscow: Sovetsky khudozhnik, 1981, pp. 202, 214, 270.
16 From the diary of R. Idelson, cited in: Shchokin-Krotova, 'Stanovlenie', p. 215.
17 See memoirs of Mikhail Matyushin, in: 'Vospominania futurista', *Volga*, 1994, no. 9–10, p. 102.
18 Vladimir Pyast, *Vstrechi* (ed. and introd. R. Timenchik), Moscow: Novoe literaturnoe obozrenie, 1997, p. 370.
19 M. S. Saryan, *Iz moey zhizni*, Moscow: Izobrazitelnoe iskusstvo, 1985, p. 202.
20 Tatiana Lugovskaya, *Kak znayu, kak pomnyu, kak umeyu: vospominania, pisma, dnevniki*, Moscow: Agraf, 2001, pp. 318–21.
21 Udaltsova, *Zhizn*, pp. 55–56.
22 See: Krusanov, II (1), pp. 122–23. See also: *Afterimages of Life, Wladislaw Strzeminski and Rights for Art*, Lodz: Muzeum Sztuki, 2011, pp. 187–88; and N. Z. Sidlina, *Naum Gabo, russky avangard*, Moscow: S. E. Gordeev, 2011, p. 52.
23 See: Krusanov, II (1), pp. 122–54.
24 Varvara Stepanova, *Chelovek ne mozhet zhit bez chuda. Pisma, poeticheskie opyty, zapiski khudozhnika*, Moscow: Sfera, 1994, pp. 62–66, 69–70.
25 See also: Krusanov, II (1), pp. 124–30.
26 Alexander Rodchenko and Varvara Stepanova, *The Future Is Our Only Goal* (ed. Peter Noever), Munich: Prestel Verlag, 1991, ill. 35.
27 Stepanova, *Chelovek*, p. 102.
28 *Agitatsionno-massovoe iskusstvo pervykh let Oktyabrya: materialy i issledovania* (ed. E. A. Speranskaya), Moscow: Iskusstvo, 1971, p. 39.
29 Krusanov, II (1), p. 82, n. 180.
30 KMSob, I, p. 135.
31 Ibid.
32 See: *Nekto 1917* (ed. I. Vakar), Moscow: Gos. Tretyakovskaya galerea, 2017 (cat.), p. 57.
33 Declaration by the Department of Fine Arts, 7 February 1919, in: *Muzey v muzee, russky avangard iz kollektsii Muzea khudozhestvennoy kultury* (comp. Irina Karasik), St Petersburg: Palace Editions, 1998, p. 353.
34 See: *Nekto 1917*, p. 54.
35 See: 'Protokol sovmestnogo zasedania…', 11 September 1918, in: Vakar and Mikhienko, I, p. 400.
36 Ibid., pp. 401–4. See also the commentary on documents 12 and 13 on the given pages.
37 Konstantin Korovin, *Vospominania, rasskazy, pisma, v dvukh knigakh*, vol. 1, Moscow: Russky put, 2010. Unpublished: RGALI, f. 2789, op. 1, ed. khr. 174, p. 9.
38 Stepanova, *Chelovek*, p. 62.
39 See: ibid., p. 72.
40 Ibid., p. 70.
41 A. Lunacharsky and D. Shterenberg, 'O printsipakh gosudarstvennogo priobretenia khudozhestvennykh proizvedeniy', *Iskusstvo kommuny*, December 1918, no. 1, p. 7, cited in: Lunacharsky, II, p. 348.
42 V. V. Mayakovsky, *Polnoe sobranie sochineniy v trinadtsati tomakh*, Moscow: Khudozhestvennaya literatura, 1955–1961, vol. 1, p. 124.
43 See: 'V. I. Lenin i izobrazitelnoe iskusstvo' (comp. A. Pavlyuchenkov), *Iskusstvo*, 1977, no. 1, p. 15.
44 See also: Bengt Jangfeldt, *Majakovskij and Futurism*, Stockholm: Almqvist & Wiksell, 1976, p. 48.
45 Krusanov, II (1), p. 82.
46 Stepanova, *Chelovek*, p. 80.
47 Ibid., p. 81.
48 Ibid.
49 See: Vakar and Mikhienko, II, p. 166, n. 13.
50 *The Great Utopia, The Russian and Soviet Avant-garde, 1915–1932*, New York: Solomon R. Guggenheim Museum, 1992, p. 262; Vakar and Mikhienko, II, p. 166, n. 13.
51 Vakar and Mikhienko, II, p. 167.
52 Ibid.
53 Vakar and Mikhienko, II, p. 22.
54 Korney Chukovsky, *Sobranie sochineniy* (15 vols), Moscow: Terra, 2001–2009, vol. 12, p. 578.
55 See: *Avtobiografia Katsman*, RGALI, op. 2, ed. khr. 227. And: V. N. Perelman and A. M. Lesyuk, *Yevgeny Alexandrovich Katsman*, Moscow: Vsekokhudozhnik, 1935, p. 22.
56 Nikolai Punin, 'O pamyatnikakh', in: N. Punin, *O Tatline*, Moscow: RA, 2001, p. 16. Another

fascinating reference is Strigalev's legendary article from 1973: Anatoly Strigalev, 'O proekte "Pamyatnika III Internatsionala"', in: *Voprosy sovetskogo izobrazitelnogo iskusstva i arkhitektury* (ed. V. E. Khazanova), Moscow: Sovetsky khudozhnik, 1973, pp. 408–52.

57 Strigalev, 'O proekte', p. 416.

58 See: Julia Vaingurt, *Wonderlands of the Avant-garde*, Evanston: Northwestern University Press, 2013, p. 111.

59 See also: Alexander Samokhvalov, *V gody bespokoynogo solntsa*, St Petersburg: Vsemirnoe slovo, 1996, pp. 135–36.

60 Strigalev, 'O proekte', p. 424.

61 See: ibid., p. 416, n. 13.

62 Contract between the Department of Fine Arts and Tatlin, 2 September 1919, GARF, f. R4390, op. II, d. 264, l. 7.

63 See: Punin, *O Tatline*, p. 18. And: Larissa Alekseevna Zhadova (ed. and comp.), *Tatlin*, London: Thames & Hudson, 1988, p. 265.

64 See: Y. Speranskaya, 'K istorii proektirovania pamyatnika III Internatsionala v Samare (1921)', in: *Voprosy sovetskogo izobrazitelnogo iskusstva i arkhitektury* (ed. V. E. Khazanova), Moscow: Sovetsky khudozhnik, 1973, p. 457.

65 See: Vasily Rakitin, 'Malevich posle anarkhizma', in: *Russky avangard, lichnost i shkola* (ed. Irina Karasik), St Petersburg: Palace Editions, 2003, pp. 26–28.

66 See: *In Malevich's Circle. Confederates, Students, Followers in Russia, 1920s–1950s* (comp. Irina Karasik), St Petersburg: Palace Editions, 2000, p. 53.

67 Rodchenko, *Opyty*, p. 70.

68 See: Georgy Kovalenko, 'Alexandra Ekster v Odesse, 1919–1920', *Iskusstvoznanie*, 1999, no. 2, p. 412.

69 Karol Szymanowski, *Korespondencja, tom I: 1909–1919* (ed. Teresa Chylińska), Warsaw: Polskie Wydawnictwo Muzyczne, 1982, p. 595.

70 Teresa Chylińska, *Karol Szymanowski: His Life and Works* (transl. John Glowacki), Los Angeles: University of Southern California, 1993, pp. 143–44.

71 See: Natalia Davydova, *Polgoda v zaklyuchenii: dnevnik, 1920–1921*, Berlin, 1923.

72 See: Alexandra Shatskikh, *Kazimir Malevich i obshchestvo Supremus*, Moscow: Tri kvadrata, 2009, p. 81.

73 Vakar and Mikhienko, I, p. 134.

74 Korovin, *Vospominania, rasskazy*, vol. 1, p. 73.

75 Vakar and Mikhienko, I, p. 434.

76 Zinovyev, December 1919. Cited in Jangfeldt, *Majakovskij*, p. 103.

77 N. Punin, *Mir svetel lyubovyu. Dnevniki, pisma* (ed. L. A. Zykova), Moscow: Artist, Rezhisser, Teatr, 2000, pp. 134–35.

78 V. Milashevsky, *Vchera, pozavchera: vospominania khudozhnika*, Leningrad: Khudozhnik RSFSR, 1972, p. 202. See also John

Bowlt's brilliant interpretation of Tatlin's tower, in: *Vladimir Tatlin, Leben, Werk, Wirkung. Ein internationales Symposium* (ed. J. Harten), Cologne: Dumont, 1993, p. 410.

79 Sergey Adlivankin, cited in: Punin, *O Tatline*, p. 7, n. 8.

80 Strigalev, 'O proekte', pp. 416–18.

81 Punin, *O Tatline*, p. 22.

82 See: Maria Gough, 'Model Spectacle', in: *Tatlin, neue Kunst für eine neue Welt. Internationales Symposium* (ed. Anna Szech), Ostfildern: Hatje Cantz Verlag, 2013, pp. 254–55.

83 *Izvestia*, 29 December 1920, p. 1 (reporter Mikhail Koltsov).

84 N. Khardzhiev and V. Trenin, *Poeticheskaya kultura Mayakovskogo*, Moscow: Iskusstvo, 1970, p. 10.

85 Ilya Ehrenburg, *Und sie bewegt sich doch* (transl. L. Amberg), Baden: LIT Verlag, 1986, pp. 24, 26.

86 V. Shklovsky, 'Pamyatnik Tretyemu Internatsionalu', *Zhizn iskusstva*, 5, 8 and 9 January 1921. Translated in (among others): Zhadova, *Tatlin*, p. 343.

87 Konstantin Miklashevsky, *Gipertrofia iskusstva*, Petrograd: Academia, 1924, p. 65.

88 Konstantin Umanski, 'Die neue Monumentalskulptur in Russland', *Der Ararat*, March 1920, no. 5/6, p. 32.

89 *Algemeen Handelsblad* from 23 June 1920, *Rotterdamsch Nieuwsblad* from 24 June 1920.

90 Zhadova, *Tatlin*, p. 35.

91 See: ibid., p. 35.

92 Jan Romein, 'Machinisme en Monumentalisme', *Elseviers Geïllustreerd Maandschrift*, July–December 1927, vol. 74, p. 240.

93 George Grosz, *Ein kleines Ja, und ein grosses Nein: sein Leben von ihm selbst erzählt*, Hamburg: Rowohlt, 1983, pp. 172–73.

94 Konstantin Umanskij, *Neue Kunst in Russland, 1914–1919*, Potsdam/Munich: Gustav Kiepenheuer/Hans Goltz, 1920, pp. 20, 32.

95 See: Vakar and Mikhienko, II, p. 395; and Strigalev, 'O proekte', p. 444.

Chapter 6

1 Recollections of Yeremey Shkolnik in: 'Vitebsk moey yunosti', *Nashe nasledie*, 2005, no. 75–76, pp. 183–85.

2 See: Marc Chagall, 'Svedenia o sebe', GTG, f. 31, ed. khr. 2073, l. 1.

3 See: Peter Kenez, 'The Prosecution of Soviet History: A Critique of Richard Pipes' *The Russian Revolution*', *The Russian Review*, July 1991, vol. 50, no. 3, p. 347.

4 Alexandra Shatskikh, *Vitebsk: zhizn iskusstva, 1917–1922*, Moscow: Yazyki russkoy kultury, 2001, p. 18. Pamela Kachurin erroneously mentions one hundred students: Pamela Kachurin, *Making Modernism Soviet: The Russian Avant-garde in the Early Soviet Era,*

1918–1928, Evanston: Northwestern University Press, 2013, p. 38.

5 See: Shatskikh, *Vitebsk*, p. 19, n. 4.

6 Ibid., p. 18, n. 3.

7 Lunacharsky, II, p. 207 (1913 comment) and Lunacharsky, II, pp. 33–36 (1914 comment).

8 See also: Krusanov, II (2), p. 104.

9 Marc Chagall, cited in: *Marc Chagall, The Russian Years* (ed. Christoph Vitali), Frankfurt: Schirn Kunsthalle, 1991, p. 34.

10 Marc Chagall, cited in Krusanov, II (2), p. 105.

11 See: Shatskikh, *Vitebsk*, p. 23, n. 1 and n. 2.

12 Marc Chagall, in an article for *Vitebsky listok*, on 7 November 1918. Included in: Marc Chagall, *Ob iskusstve i kulture* (ed. Benjamin Harshav), Moscow: Tekst, 2009, pp. 53–55.

13 *Marc Chagall, The Russian Years*, p. 35.

14 Solomon Gershov, 'Vospominania', *Byulleten Muzea Marka Shagala*, 2006, no. 14, p. 26.

15 *Marc Chagall, The Russian Years*, p. 37.

16 See: Claire Le Foll, *L'école artistique de Vitebsk (1897–1923)*, Paris: L'Harmattan, 2002.

17 See: Shatskikh, *Vitebsk*, p. 12, n. 4.

18 Vakar and Mikhienko, II, p. 214.

19 The only document that mentions a salary is dated 29 December 1920, one year after Malevich's arrival. See: ibid., I, p. 447, n. 1.

20 Pyotr Miturich on Nina Kogan, in: P. Miturich, *Zapiski surovogo realista epokha avangarda. Dnevniki, pisma, vospominania, statji*, Moscow: RA, 1997, p. 67.

21 Vakar and Mikhienko, I, p. 114.

22 Ibid., p. 214.

23 Sophie Lissitzky-Küppers, *El Lissitzky. Maler, Architekt, Typograf, Fotograf. Erinnerungen, Briefe, Schriften*, Dresden: Verlag der Kunst, 1967, pp. 329–30.

24 Vakar and Mikhienko, I, pp. 110–11.

25 Ibid., p. 120.

26 See: Shatskikh, *Vitebsk*, p. 50.

27 Vakar and Mikhienko, I, p. 133.

28 See: ibid., pp. 411–12.

29 Ibid., pp. 111–12.

30 Shatskikh, *Vitebsk*, p. 53.

31 Vakar and Mikhienko, I, p. 113.

32 Ibid.

33 Ibid., p. 119.

34 *El Lissitzky 1890–1941, k vystavke v zalakh GTG* (ed. T. Goryacheva and N. Masalin), Moscow: GTG, 1991, pp. 128–29.

35 I. Abramsky, 'Eto bylo v Vitebske', *Iskusstvo*, 1964, no. 10, p. 69.

36 Vakar and Mikhienko, II, p. 167. See also: Shatskikh, *Vitebsk*, p. 78.

37 KMSob, I, p. 164.

38 See: Kachurin, *Making*, esp. pp. 40–70.

39 See Sheila Fitzpatrick, *The Cultural Front. Power and Culture in Revolutionary Russia*, Ithaca, NY: Cornell University Press, 1992, pp. 20–22.

40 Vakar and Mikhienko, II, p. 345.

41 Natan Efros, *Zapiski chtetsa*, Moscow: Iskusstvo, 1980, p. 24.

42 Krusanov, II (2), p. 116.

43 Chagall to Ettinger, 2 April 1920, in: *Marc Chagall, The Russian Years*, p. 73.

44 Shatskikh, *Vitebsk*, p. 98.

45 See: Vakar and Mikhienko, II, p. 200.

46 Efros, *Zapiski chtetsa*, pp. 24–25.

47 Vakar and Mikhienko, II, pp. 209–10.

48 Ibid., p. 203.

49 Ibid., p. 209.

50 See: Efros, *Zapiski chtetsa*, p. 26.

51 See: ibid. And: Shatskikh, *Vitebsk*, p. 244.

52 Recollection of Yeremey Shkolnik, 'Vitebsk', pp. 183–85.

53 See: Shatskikh, *Vitebsk*, p. 99.

54 Ibid., p. 102.

55 See, for example: Christina Lodder, *Russian Constructivism*, New Haven and London: Yale University Press, 1983, p. 60; *Boris Korolev, 1885–1963*, St Petersburg: Palace Editions, 2011, pp. 45–52.

56 Stepanova's diary does not mention the constructions until 1919, which is why Krusanov applies this date. See: Krusanov, II (1), p. 146.

57 See: S. O. Khan-Magomedov, 'Klassiki rannego konstruktivizma – bratya Stenbergi. V poiskakh rabot pervykh dizainerov i pervykh konstruktivistov', in: *Russkoe iskusstvo, XX vek: issledovania i publikatsii*, vol. 3 (ed. G. F. Kovalenko), Moscow: Nauka, 2009, p. 405.

58 From 1919 onward, the term 'laboratory' is used with increasing frequency to denote both creative spaces (studios) and pedagogical spaces (classrooms). See for example: S. O. Khan-Magomedov, *Vkhutemas* (2 vols), Moscow: Ladya, 1995, vol. 1, p. 332.

59 D. Arkin, 'Vechnoe iskusstvo', 1920, cited in: Krusanov, II (1), p. 161.

60 Ibid.

61 Alexei Gan, *Konstruktivizm*, Tver: Tverskoe izdatelstvo, 1922, p. 3, p. 19.

62 Boris Arvatov, *Iskusstvo i proizvodstvo, sbornik statey*, Moscow: Proletkult, 1926, p. 109 and Boris Arvatov, cited in John E. Bowlt, 'The Ideology of the Furniture. The Soviet Chair in the 1920s', *Soviet Union/Union Soviétique*, 1980, vol. 7, no. 1–2, p. 138.

63 The key proponent of the notion that the avant-garde had its own totalitarian platform was the philosopher Boris Groys, in: *The Total Art of Stalinism: Avant-garde, Aesthetic Dictatorship and Beyond*, Princeton: Princeton University Press, 1992.

64 See, for example, Alexandra Shatskikh, *Black Square: Malevich and the Origin of Suprematism*, New Haven/London: Yale University Press, 2012, pp. 265–66.

65 Tatlin, cited in: Anatoly Strigalev, 'Iskusstvo konstruktivistov: ot vystavki k vystavke (1914–1932)', *Sovetskoe iskusstvoznanie*, 1991, no. 27, p. 141.

66 This long-accepted conclusion has become convincingly nuanced in recent years, especially by Maria Gough's impressive study, *The Artist as Producer: Russian Constructivism in Revolution*, Berkeley and Los Angeles: University of California Press, 2005. Still, even after Gough's relevant insights, the general conclusion is still justified that the constructivist artists hardly penetrated the industrial production process at all.

67 Strigalev, 'Iskusstvo', p. 123.

68 *The Cambridge History of Russia, III: The Twentieth Century* (ed. Ronald Grigor Suny), Cambridge: Cambridge University Press, 2015, p. 166.

69 Ibid., p. 168.

70 *V. I. Lenin i A. V. Lunacharsky: perepiska, doklady, dokumenty*, Moscow: Nauka, 1971, p. 652.

71 Ibid., p. 706.

72 A complete list of the teaching staff is given in Krusanov, II (1), p. 672, n. 319.

73 Varvara Stepanova, *Chelovek ne mozhet zhit bez chuda. Pisma, poeticheskie opyty, zapiski khudozhnika*, Moscow: Sfera, 1994, p. 102.

74 See: RGALI, f. 2368, op. 2, ed. khr. 205.

75 Katsman had a studio in the Kremlin for eighteen years. See: T. V. Khvostenko, *Vechera na Maslovke bliz 'Dinamo', tom II: za fasadom proletarskogo iskusstva*, Moscow: Olympia Press, 2003, p. 317. For the 'many telephone calls to the GPU, his declarations, conversations... the requests from the GPU for lists of those who could not be trusted', see ibid., p. 32.

76 See: Fyodor Bogorodsky, *Vospominania khudozhnika*, Moscow: Sovetsky khudozhnik, 1959, p. 100.

77 RGALI, f. 2368, op. 1, ed. khr. 39, 1919–1929, l. 2.

78 See: Vakar and Mikhienko, I, pp. 141–43.

79 *V. I. Lenin i A. V. Lunacharsky*, p. 716.

80 See ibid., p. 718. The letter (and its copy) has two signatories, Bogdanov and the 'secretary'. The latter was Katsman.

81 Article by Krupskaya in *Pravda*, February 1921. Cited in: *AKHRR, sbornik vospominaniy, statey, dokumentov* (comp. I. M. Gronsky and V. N. Perelman), Moscow: Izobrazitelnoe iskusstvo, 1973, p. 11.

82 See *Besedy D. V. Duvakina s M. M. Bakhtinym*, Moscow: Progress, 1996, pp. 137–41.

83 Vakar and Mikhienko, II, p. 202.

84 See: *Marc Chagall, The Russian Years*, p. 80. See also: Abram Efros, *Profili: ocherki o russkikh khudozhnikakh*, St Petersburg: Azbuka-Klassika, 2007, p. 203.

85 Chagall, *Ob iskusstve i kulture*, p. 63.

86 Efros, *Zapiski chtetsa*, p. 204.

87 Ziva Amishai-Maisels offers an alternative view, in: *Marc Chagall en het Joods theater* (ed. E. van Voolen and E. Wouthuysen), Zwolle: Waanders, 2002, pp. 44–74.

88 Marc Chagall, letter to the management of the Jewish State Theatre, 12 February 1921, in: *Marc Chagall, The Russian Years*, p. 89.

89 Alec Nove, *An Economic History of the USSR. New and Final Edition*, London: Penguin, 1992, p. 86.

90 *The Cambridge History of Russia, III*.

91 See: Vakar and Mikhienko, I, p. 150. See also: ibid., p. 467.

92 Ibid., p. 136.

93 Figures on repression by the security bodies are taken from O. B. Mozokhin, *Pravo na repressii, vnesudebnye polnomochia organov gosudarstvennoy bezopasnosti*, Moscow: Kuchkovo pole, 2011. The 1921 figures are on pp. 348–52. For an interpretation, see pp. 37–41.

94 See: A. N. Benois, *Dnevnik, 1918–1924*, Moscow: Zakharov, 2010, p. 265.

95 N. Punin, *Mir svetel lyubovyu. Dnevniki, pisma* (ed. L. A. Zykova), Moscow: Artist, Rezhisser, Teatr, 2000, pp. 142–43.

96 The education board in Vitebsk wrote a letter to the Vitebsk Cheka department that was stamped on 17 or 18 August, twelve days after the arrest. See: Vakar and Mikhienko, I, p. 457, document 32, and the accompanying annotation.

97 Ibid., p. 149.

98 Benois, *Dnevnik, 1918–1924*, p. 265.

99 Ibid., p. 252.

100 K. K. Krylova, 'Istoria spetskhrana nauchnoy biblioteki Tretyakovskoy galerei', in: *Tretyakovskie chtenia 2016* (ed. L. I. Iovleva and T. V. Yudenkova), Moscow: GTG, 2017, pp. 362–63.

101 See: Shatskikh, *Vitebsk*, p. 157; Krusanov, II (2), pp. 117–18.

102 Romm, in: Krusanov, II (2), p. 117, n. 572; Friedländer: see Shatskikh, *Vitebsk*, p. 163, n. 3.

103 Shatskikh, *Vitebsk*, p. 156.

Chapter 7

1 Alec Nove, *An Economic History of the USSR. New and Final Edition*, London: Penguin, 1992, p. 62.

2 See: Sheila Fitzpatrick, *The Russian Revolution*, 3rd revised edition, Oxford: Oxford University Press, 2007, pp. 96–98.

3 Paraphrase of Trotsky by Osorgin, in: Mikhail Osorgin, *Vremena, proisshestvia zelenogo mira*, Moscow: Intelvak, 2005, p. 181 (1st edition: Paris, 1955). For a comprehensive historical treatment, see: Stuart Finkel, 'Purging the Public Intellectual: The 1922 Expulsions from Soviet Russia', *The Russian Review*, 2003, no. 62, pp. 589–613; for the historical Trotsky quote, p. 606.

4 Osorgin, cited in Finkel, 'Purging', p. 590.
5 N. Punin, *Mir svetel lyubovyu. Dnevniki, pisma* (ed. L. A. Zykova), Moscow: Artist, Rezhisser, Teatr, 2000, p. 187.
6 See: Nove, *Economic History*, p. 89.
7 Vakar and Mikhienko, II, p. 35.
8 See: Tim Harte, *Fast Forward: The Aesthetics and Ideology of Speed in Russian Avant-garde Culture, 1910–1930*, Madison: University of Wisconsin Press, 2009, p. 172.
9 See: Yuri Gerchuk, 'Kuznetsky, dom 11', *Nashe nasledie*, 1997, no. 43–44, p. 183.
10 See: Pamela Kachurin, *Making Modernism Soviet: The Russian Avant-garde in the Early Soviet Era, 1918–1928*, Evanston: Northwestern University Press, 2013, p. 80.
11 See: Pamela Kachurin, 'Working (for) the State: Vladimir Tatlin's Career in Early Soviet Russia and the Origins of the Monument to the Third International', *Modernism/Modernity*, January 2012, vol. 19, no. 1, pp. 30–31; Larissa Alekseevna Zhadova (ed. and comp.), *Tatlin*, London: Thames & Hudson, 1988, p. 340. See also: Veronika Bogdan, 'Akademia khudozhestv 1920-e nachalo 1930-kh', *Zhurnal 'Tretyakovskaya Galereia'*, 2013, no. 2, pp. 62–66.
12 See especially: Krusanov, II (1), pp. 218–59.
13 An initial overview of these provincial collections of avant-garde art is *Neizvestny russky avangard, v muzeakh i chastnykh sobraniakh* (comp. A. Sarabianov), Moscow: Sovetsky khudozhnik, 1992.
14 See, for example, S. O. Khan-Magomedov, *Vkhutemas* (2 vols), Moscow: Ladya, 1995, vol. 1, pp. 37–38, pp. 43–53.
15 Krusanov, II (1), p. 258.
16 Kachurin, *Making*, pp. 21–22.
17 Krusanov, II (1), p. 258. And: Malevich to Altman, 9 May 1921, in: Vakar and Mikhienko, II, p. 468.
18 Krusanov, II (1), p. 258.
19 The International Office's schedule of activities was published in the inaugural issue of the NARKOMPROS internal newsletter. See: *Vestnik Otdela izobrazitelnykh iskusstv Narkomprosa*, 1919, no. 1, p. 3.
20 Vakar and Mikhienko, II, p. 166.
21 See: ibid., n. 9.
22 'Das Kunstprogramm des Kommisariats für Volksaufklärung in Russland', *Das Kunstblatt*, 1919, no. 3, pp. 91–93.
23 *De Nieuwe Tijd*, 1919, no. 24, pp. 357–58. The letter by Kandinsky, 'Kunstfrühling in Russland', appeared in *Die Freiheit*, 9 April 1919. See also: Vasily Kandinsky, *Izbrannye trudy po teorii iskusstva (izdanie vtoroe, ispravlennoe i dopolnennoe)* (2 vols), Moscow: Gilea, 2008, vol. 2, pp. 19–21.
24 See: Lieske Tibbe, *Een revolutie gaat aan gekijf ten onder: De Stijl en de 'Russische kwestie',*

najaar 1919. Een briefwisseling tussen Theo van Doesburg, Chris Beekman, Robert van 't Hoff, J. J. P. Oud en Antony Kok. Electronic publication, Radboud Universiteit Nijmegen, 2006, hdl. handle.net/2066/27565 en/of dare.ubn.kn.nl/ handle/2066/27565 (accessed 1 February 2016).
25 Ibid., p. xiii, paraphrase.
26 Memo from F. E. Dzerzhinsky to the Central Committee, 19 April 1921, in: *Vlast i khudozhestvennaya intelligentsia: dokumenty, 1917–1953* (comp. Andrey Artizov and Oleg Naumov), Moscow: Demokratia, 1999, p. 15.
27 Ibid., pp. 19–20.
28 Ibid.
29 KMSob, III, p. 274.
30 *In Malevich's Circle. Confederates, Students, Followers in Russia, 1920s–1950s* (comp. Irina Karasik), St Petersburg: Palace Editions, 2000, p. 52.
31 Ibid., p. 55.
32 Amshey Nurenberg, *Odessa – Parizh – Moskva. Vospominania khudozhnika*, Düsseldorf, 2009, p. 235.
33 Krusanov, II (1), p. 150.
34 El Lissitzky, 'Neue russische Kunst' (1922), in: Sophie Lissitzky-Küppers, *El Lissitzky. Maler, Architekt, Typograf, Fotograf. Erinnerungen, Briefe, Schriften*, Dresden: Verlag der Kunst, 1967, p. 336; and El Lissitzky, 'Vystavki v Berline', *Veshch*, May 1922, no. 3, p. 14. See also: John E. Bowlt and Nicoletta Misler, 'Uncharted Territory: Vasily Kandinsky and the Soviet Union', *Experiment*, 2002, no. 8, pp. 15–22.
35 N. Punin, 'Retsenzia na knigu V. Kandinskogo "Tekst khudozhnika"', *Iskusstvo kommuny*, 2 February 1919, no. 9, p. 3.
36 See: A. M. Rodchenko, *Statji, vospominania, avtobiograficheskie zapiski, pisma*, Moscow: Sovetsky khudozhnik, 1982, p. 153. And: Varvara Stepanova, *Chelovek ne mozhet zhit bez chuda. Pisma, poeticheskie opyty, zapiski khudozhnika*, Moscow: Sfera, 1994, p. 127.
37 Stepanova, *Chelovek*, p. 127.
38 Ibid., p. 148.
39 See: Kandinsky, *Izbrannye*, vol. 2, pp. 53–73.
40 See: Bowlt and Misler, 'Uncharted Territory', p. 21; Kurt Junghanns, 'Die Beziehungen zwischen deutschen und sowjetischen Architekten in den Jahren 1917 bis 1923', *Wissenschaftliche Zeitschrift der Humboldt-Universität*, 1967, no. 3, pp. 369–70; Manfredo Tafuri, *The Sphere and the Labyrinth: Avant-gardes and Architecture from Piranesi to the 1970s* (transl. Pellegrino d'Acierno and Robert Connolly), Cambridge, MA: MIT Press, 1987, p. 137.
41 See: Dmitri Sarabianov and Natalia Avtonomova, *Vasily Kandinsky, put khudozhnika, khudozhnik i vremia*, Moscow: Galart, 1994, p. 151.
42 *In Malevich's Circle*, p. 55.

Notes

43 See: Ger Harmsen, *Chris Beekman, een kunstenaarsleven, 1887–1964*, Nijmegen: SUN, 1999, p. 60.

44 Peter Alma, 'Zametki o sovremennom iskusstve gollandii', *Tvorchestvo*, 1921, no. 4–6, pp. 60–6145

45 See: Nicholas Bueno de Mesquita, 'Theo van Doesburg and Russia: Utopia Thwarted', in: *Utopian Reality: Reconstructing Culture in Revolutionary Russia and Beyond* (ed. Christina Lodder, Maria Kokkori and Maria Mileeva), Leiden: Brill, 2013, pp. 57–78; and Tatiana Goryacheva, 'Posylka Malevichu iz Gollandii', *Pinakoteka*, 2007, no. 24–25, pp. 168–72.

46 Vakar and Mikhienko, I, p. 142.

47 Ibid., pp. 143–47.

48 Vakar and Mikhienko, I, p. 137.

49 See: Peter Nisbet, 'Some Facts on the Organizational History of the Van Diemen Exhibition', in: *The First Russian Show: A Commemoration of the Van Diemen Exhibition, Berlin 1922*, London: Annely Juda Fine Art, 1983 (cat.), pp. 69–70, n. 12.

50 Ibid., p. 69, n. 7.

51 M. P. Lazarev, *David Shterenberg: khudozhnik i vremya. Put khudozhnika*, Moscow: Galaktika, 1992, p. 171. See also: V. P. Lapshin, 'Pervaya vystavka russkogo iskusstva. Berlin, 1922', *Sovetskoe iskusstvoznanie*, 1982, no. 1, pp. 349–50. And: Natalia Avtonomova, 'Pervaya khudozhestvennaya vystavka russkogo iskusstva. Berlin 1922 god', *Iskusstvoznanie*, 2003, no. 2, pp. 636–46.

52 The figure of 15,000 visitors comes from Shterenberg's report to Narkompros. See also: *Stationen der Moderne: die bedeutendsten Kunstausstellungen des 20. Jahrhunderts in Deutschland*, Berlin, 1988, p. 196.

53 See: Lapshin, 'Pervaya vystavka', p. 350.

54 *Handelsblad*, 10 May 1923, p. 3. Article by Shterenberg in *De Telegraaf*, 22 April 1923, p. 9.

55 Lunacharsky, II, pp. 94–100.

56 See: *The First Russian Show*, p. 71, n. 18.

57 Bowlt and Misler, 'Uncharted Territory', p. 21.

58 See: Christina Lodder, 'Naum Gabo as a Soviet Emigré in Berlin', *Tate Papers*, 2010, no. 14, www.tate.org.uk/research/tate-papers/14/naum-gabo-as-a-soviet-emigre-in-berlin (accessed 8 January 2023).

59 Evert van Straaten, *Theo van Doesburg: Constructeur van het nieuwe leven*, Otterlo: Kröller-Müller, 1994, p. 24.

60 Theo van Doesburg, 'Balans van het nieuwe. Beeldend Rusland', *De Stijl*, September 1922, vol. 5, no. 9, pp. 130–35.

61 Ilya Ehrenburg, *Und sie bewegt sich doch* (transl. L. Amberg), Baden: LIT Verlag, 1986, p. 52.

62 See: *Muzey v muzee, russky avangard iz kollektsii Muzea khudozhestvennoy kultury* (comp. Irina Karasik), St Petersburg: Palace Editions, 1998, p. ii.

63 See: Hubertus Gaßner, 'Auf der Suche nach Materialgerechtigkeit. Mißverständnisse und gekrümmte Linien', in: *Vladimir Tatlin: Leben, Werk, Wirkung. Ein internationales Symposium* (ed. Jürgen Harten), Cologne: Dumont, 1993, p. 37; on the creative impulse, see: A. Strigalev, 'From Painting to the Construction of Matter', in: Zhadova, *Tatlin*, p. 26; see also the excellent essay by Jean-Claude Marcadé, 'Über die neue Beziehung zum Material bei Tatlin', in: *Vladimir Tatlin: Leben, Werk, Wirkung*, pp. 28–36.

64 Lunacharsky, in *Izvestia*, 29 April 1923, lunacharsky.newgod.su/lib/o-kino/doklad-na-4-m-vserossijskom-sezde-rabotnikov-iskusstv/ (accessed April 2018).

65 See, for example: James Nisbet, 'Material Propositions on the Individual/Collective: The Work of Vladimir Tatlin', *Modernism/Modernity*, January 2010, vol. 17, no. 1, p. 128.

66 N. Punin, 'Iskusstvo i revolyutsia (glava iz knigi)' (introd. Irina Punina), *Iskusstvo Leningrada*, 1989, no. 5, p. 12.

67 Konstantin Miklashevsky, *Gipertrofia iskusstva*, Petrograd: Academia, 1924, p. 68.

68 See: Yulia Demidenko, 'Novaya odezhda dlya novogo mira, kostyumy V. Y. Tatlina na fone epokhi', *Teoria mody*, no. 39, pp. 241–47.

69 Vakar and Mikhienko, II, pp. 396–97. See also: V. I. Kurdov, *Pamyatnye dni i gody: zapiski khudozhnika*, St Petersburg: Arsis, 1994, p. 54.

70 Kurdov, *Pamyatnye dni*, p. 54.

71 A. Lunacharsky, 'Sovetskoe gosudarstvo i iskusstvo', *Izvestia*, 22 January 1922, p. 2.

72 Zhadova, *Tatlin*, pp. 245–46.

73 This is the version by Yevgeny Kovtun, described in: *Sluzhenie russkomu avangardu, pamyati Y. F. Kovtun*, St Petersburg: Palace Editions, 1998, pp. 10–11.

74 Punin, *Mir*, pp. 148–49.

75 Ibid., p. 151.

76 Nadezhda Mandelstam, *Vtoraya kniga*, Paris: YMCA Press, 1983, p. 106.

77 Miturich's diary, in: Yevgeny F. Kovtun, *Russische avant-garde: Chlebnikov en zijn tijdgenoten Malevitsj, Filonov, Tatlin, Mitoeritsj*, Naarden: V+K Publishing/Inmerc, 1993, pp. 173–78.

78 Vakar and Mikhienko, I, p. 153.

79 Zhadova, *Tatlin*, p. 166.

80 Natasha Kurchanova (ed. and introd.), 'Anna Begicheva: How I Remember Tatlin', RES, 2013, no. 63–64, pp. 299–313, p. 307.

81 Khlebnikov to Mayakovsky, 18 February 1921. Velimir Khlebnikov, *Sobranie sochineniy, v shesti tomakh* (ed. R. V. Duganov), Moscow: IMLI–RAN 'Nasledie', 2000–2006, vol. 6, p. 204. See also: Zhadova, *Tatlin*, p. 397.

82 Kovtun, *Russische avant-garde*, p. 98.

83 Aai Prins, 'De President van de Wereldbol', introduction to Velimir Khlebnikov, *Zangezi* (transl. and introd. Aai Prins), Amsterdam: Pegasus, 2013, p. 10.

84　N. Punin, *O Tatline*, Moscow: RA, 2001, p. 62.
85　See, among others: Y. I. Strutinskaya, *Iskania khudozhnikov teatra: Peterburg – Petrograd – Leningrad, 1910–1920-e gody*, Moscow, 1998, p. 85.
86　Zhadova, *Tatlin*, p. 248.
87　Ibid.
88　O. V. Pokrovsky, 'Trevogoy i plamenem (vospominania o P. N. Filonove)', in: *Pavel Filonov: realnost i mify* (comp. Lyudmila Pravoverova), Moscow: Agraf, 2008, p. 248.
89　See also: Tatiana Lyuboslavskaya and Irina Arskaya, 'Postanovka Tatlinym sverkhpovesti Velimira Khlebnikova "Zangezi"', in: *Vladimir Tatlin: Leben, Werk, Wirkung*, pp. 348–53.
90　Zhadova, *Tatlin*, p. 249.
91　Kurdov, *Pamyatnye dni*, p. 55.
92　Pokrovsky, 'Trevogoy', p. 248.
93　See: Valentina Khodasevich, *Portrety slovami*, Moscow: Sovetsky pisatel, 1987, p. 152; and: *Vladimir Tatlin, Retrospektive* (ed. Anatoly Strigalev and Jürgen Harten), Cologne: Dumont, 1993, p. 390.
94　For information on Geyntse's murder, see: Fyodor Bogorodsky, *Vospominania khudozhnika*, Moscow: Sovetsky khudozhnik, 1959, pp. 12–13.
95　Khodasevich, *Portrety*, p. 152.
96　See, among others: Kachurin, *Making*, pp. 72–88.
97　*Muzey v muzee*, p. 12.
98　Andrey Sarabianov, *Zhizneopisanie khudozhnika Lva Bruni*, Moscow: RA, 2009, p. 96.
99　See: Vakar and Mikhienko, I, p. 165.
00　Khodasevich, *Portrety*, p. 153.
01　Ibid., p. 154.
02　Recollection by Viktor Yelkonin, 'Veliky masterovoy', *Ogonyok*, 1989, no. 29, p. 16 (second unnumbered page, after p. 16).
03　Kurdov, *Pamyatnye dni*, p. 56, and Kurdov, in: Vakar and Mikhienko, II, p. 396.
04　See: Kachurin, *Making*, p. 85.
05　See: Vakar and Mikhienko, I, p. 158.
06　See: Zhadova, *Tatlin*, pp. 249–58.
07　See: Kachurin, 'Working', pp. 34–35.
08　See: Vakar and Mikhienko, II, pp. 125–26.
09　*Pavel Mansurov, petrogradsky avangard*, St Petersburg: Palace Editions, 1995, p. 18.
10　See: G. L. Demosfenova, 'Dnevnik formalno-teoreticheskogo otdela GINKHUKA', *Sovetskoe iskusstvoznanie*, 1991, no. 27, pp. 485–86, n. 14.
11　Ibid., p. 481.
12　Punin, *Mir*, p. 231.
13　See: Kachurin, 'Working', p. 35, and Kachurin, *Making*, p. 87.
14　Demosfenova, 'Dnevnik', p. 483.
15　Vakar and Mikhienko, II, p. 612.
16　See: Vakar and Mikhienko, I, p. 488. Kachurin erroneously notes that Tatlin was dismissed, see: Kachurin, 'Working', p. 35. See also: Vakar and Mikhienko, I, p. 487 and p. 497.

117　Punin, *Mir*, p. 234.
118　Ibid., p. 241.
119　Khodasevich, *Portrety*, p. 154.
120　Punin, *Mir*, p. 241.
121　Nadezhda Mandelstam, *Ob Akhmatovoy (izdanie vtoroe, ispravlennoe)*, Moscow: Tri kvadrata, 2008, pp. 36–37.
122　Vakar and Mikhienko, I, pp. 163–64.
123　Khodasevich, *Portrety*, p. 154. And: V. Shklovsky, *Za sorok let: statji o kino*, Moscow: Iskusstvo, 1965, p. 60.
124　See: A. Parnis, 'Tatlin – khudozhnik teatra i kino (zametki o kievskom periode: 1925–1927)', in: *Teatr i russkaya kultura na rubezhe XIX–XX vekov* (ed. I. A. Vakar), Moscow: GTSTM im. Bakhrushina, 1998, pp. 78–93.
125　See: John Milner, *Vladimir Tatlin and the Russian Avant-garde*, New Haven/London: Yale University Press, 1983, p. 208. See also: G. Klimov and L. Yuniverg, 'SSSR na Parizhskoy vystavki', *Panorama iskusstv*, vol. 5, 1982, pp. 66–87 (specifically on the positioning of Tatlin's tower: p. 79).

Chapter 8

1　Vakar and Mikhienko, II, p. 35.
2　Ibid., I, p. 256.
3　*AKHRR, sbornik vospominaniy, statey, dokumentov* (comp. I. M. Gronsky and V. N. Perelman), Moscow: Izobrazitelnoe iskusstvo, 1973, p. 289.
4　*Borba za realizm v iskusstve 20-kh godov. Materialy, dokumenty, vospominania* (ed. P. N. Lebedev; comp. V. N. Perelman), Moscow: Sovetsky khudozhnik, 1962, p. 175.
5　See: T. V. Khvostenko, *Vechera na Maslovke bliz 'Dinamo', tom II: za fasadom proletarskogo iskusstva*, Moscow: Olympia Press, 2003, pp. 67–80. For the section on Trotsky: p. 74.
6　See: V. Komar and A. Melamid, 'The Role of the War Ministry in Soviet Art', *A-Ja*, 1980, no. 2, p. 51.
7　See: Khvostenko, *Vechera*, p. 8.
8　*AKHRR, sbornik*, p. 10.
9　Komar and Melamid, 'The Role', pp. 50–54.
10　See: *Borba za realizm*. For the number of members: p. 18; visitor numbers: p. 23; media attention: pp. 393–94.
11　See: RGALI, f. 2368, op. 2, ed. khr. 216, l. 1.
12　See: Elizabeth Kridl Valkenier, 'AKHRR, Realism and Official Style in the 1920s', *Soviet Union/Union Soviétique*, 1980, vol. 7, no. 1–2, p. 201.
13　A. Shchokin-Krotova, 'Stanovlenie khudozhnika', *Novy mir*, 1983, no. 10, p. 213.
14　*Aristarkh Lentulov. Put khudozhnika. Khudozhnik i vremya* (ed. E. B. Murina and S. G. Dzhafarova), Moscow: Sovetsky khudozhnik, 1990, p. 229.
15　*Prostranstvo kartiny* (comp. N. O. Tamruchi), Moscow: Sovetsky khudozhnik, 1989, p. 294.
16　After Jean Cocteau, *Le rappel à l'ordre*, Paris, 1926.

17 KMSob, I, p. 280.
18 See: G. A. Yankovskaya, 'Arkhivny fond K. Y. Voroshilova kak istochnik po sotsialnoy istorii sovetskogo izobrazitelnogo iskusstva', *Vestnik Permskogo universiteta*, 2011, no. 17, pp. 108–13.
19 RGASPI, f. 74, op. 1, d. 294, l. 2-2 ob.; ibid., l. 26.; ibid., l. 8.
20 See: O. N. Shikhireva, 'K istorii obshchestva "Krug khudozhnikov"', *Sovetskoe iskusstvoznanie*, 1982, no. 1, p. 319; A. Y. Nikich, *Osmerkin. Razmyshlenia ob iskusstve. Pisma. Kritika. Vospominania sovremennikov*, Moscow: Sovetsky khudozhnik, 1981, p. 146.
21 *Felix Dzerzhinsky, s predisloviem I. S. Unshlikhta*, Moscow: AKHRR, 1927 (3rd, supplemented edition; 1st edition, 1926), pp. 67–69.
22 Amshey Nurenberg, *Odessa – Parizh – Moskva. Vospominania khudozhnika*, Düsseldorf, 2009, p. 303.
23 *Avangard, ostanovlenny na begu* (comp. S. M. Turutina et al.; introd. Y. F. Kovtun), Leningrad: Avrora, 1989 (unnumbered pages: pp. 16–17).
24 Lunacharsky, II, pp. 169–70.
25 KMSob, V, pp. 206–41. This quote: p. 215.
26 See: ibid., p. 526.
27 Konstantin Akinsha, 'Malevich and Lenin: Image, Ritual, and the Cube', in: *Rethinking Malevich: Proceedings of a Conference in Celebration of the 125th Anniversary of Kazimir Malevich's Birth* (ed. Charlotte Douglas and Christina Lodder), London: Pindar Press, 2007, p. 156.
28 Khvostenko, *Vechera*, p. 71.
29 RGALI, f. 2368, op. 1, ed. khr. 3, 1. 77.
30 See: *Borba za realizm*, pp. 146, 184.
31 See: S. V. Kudryavtsev and N. A. Bogomolov, 'Sledstvennoe delo Igorya Terentyeva (1931)', in: *Minuvshee: istorichesky almanakh*, 1995, vol. 18, pp. 533–608.
32 Alexander Vvedensky, *Polnoe sobranie sochineniy* (2 vols), Moscow: Gilea, 1993, vol. 2, p. 130.
33 D. Kharms, *Polnoe sobranie sochineniy* (ed. V. N. Sazhin) (4 vols), St Petersburg: Gumanitarnoe agenstvo 'Akademichesky proekt', 1997, vol. 2, pp. 46–47.
34 *Pavel Mansurov, petrogradsky avangard*, St Petersburg: Palace Editions, 1995, pp. 44–45.
35 Vakar and Mikhienko, II, pp. 536–37.
36 *Pavel Mansurov*, p. 36, n. 33.
37 GINKHUK meeting report in: Vakar and Mikhienko, I, p. 514.
38 *Borba za realizm*, p. 314.
39 Vakar and Mikhienko, I, p. 145.
40 Alexander Rodchenko, *Opyty dlya budushchego. Dnevniki, statji, pisma, zapiski*, Moscow: Grant, 1996, pp. 235–36.41 Mansurov, cited by Mikhail Kuzmin in: 'Dnevnik 1929 goda', *Nashe nasledie*, 2010, no. 95, p. 97.

42 Alexei Gan, 'Spravka o Kazimire Maleviche', *Sovremennaya arkhitektura*, 1927, no. 3, p. 106.
43 Vakar and Mikhienko, I, p. 194.
44 Vakar and Mikhienko, II, p. 157. Also in: Rakitin, 'The Artisan' in: *The Great Utopia, The Russian and Soviet Avant-garde, 1915–1932*, New York: Solomon R. Guggenheim Museum, 1992, p. 32.
45 See: Vakar and Mikhienko, I, p. 524. For contemporary prices, see: *Moskva i moskovskaya gubernia. Statistiko-ekonomichesky spravochnik. 1923/24–1927/29*, Moscow: Izd. Moskovskogo statisticheskogo otdela, 1929, pp. 494–95.
46 See: Vitali Manin, *Iskusstvo i vlast: borba techeniy v sovetskom izobrazitelnom iskusstve 1917–1941 godov*, St Petersburg: Avrora, 2008, p. 90.
47 See: *AKHRR, sbornik*, p. 146.
48 Sheila Fitzpatrick, *The Russian Revolution*, 3rd revised edition, Oxford: Oxford University Press, 2007, p. 122.
49 The precise figures are: 1927: 76,983; 1928: 111,879; 1929: 207,212; 1930: 378,539. See: O. B. Mozokhin, *Pravo na repressii, vnesudebnye polnomochia organov gosudarstvennoy bezopasnosti*, Moscow: Kuchkovo pole, 2011, pp. 381–401.
50 N. A. Volodina, 'Kultura i iskusstvo v sovetskoy sisteme politicheskogo kontrolya', *Izvestia Rossiskogo gosudarstvennogo pedagogicheskogo universiteta im. A. I. Gertsena*, 2009, no. 111, pp. 9–16.
51 Kliment Redko, *Parizhsky dnevnik*, Moscow: Sovetsky khudozhnik, 1992, p. 82.
52 Vakar and Mikhienko, I, p. 258.
53 See: ibid., II, pp. 606–608 (Shutko), pp. 609–11 (Kristi).
54 See: Larissa Alekseevna Zhadova (ed. and comp.), *Tatlin*, London: Thames & Hudson, 1988, pp. 260–61, p. 448. See also: Alexander Labas, *Vospominania*, St Petersburg: Palace Editions, 2004, p. 47.
55 See: Y. V. Gladysheva, 'M. Kristi – direktor Tretyakovskoy galerey', in: *Tretyakovskie chtenia 2013* (ed. L. I. Iovleva and T. V. Yudenkova), Moscow: GTG, 2014, pp. 277–92.
56 See: G. I. Veselovskaya, *Ukrainsky teatralny avangard*, Kyiv: Feniks, 2010, pp. 155–59.
57 See: Zinovy Fogel, *Vasyl Yermylov*, Moscow: Sovetsky khudozhnik, 1975, pp. 50–51, n. 9 and n. 11.
58 Natasha Kurchanova (ed. and introd.), 'Anna Begicheva: How I Remember Tatlin', *RES*, 2013, no. 63–64, pp. 299–313.
59 See: A. Parnis, 'Tatlin – khudozhnik teatra i kino (zametki o kievskom periode: 1925–1927)', in: *Teatr i russkaya Kultura na rubezhe XIX–XX vekov* (ed. I. A. Vakar), Moscow: GTSTM im. Bakhrushina, 1998, p. 87.
60 Parnis, 'Tatlin', p. 83.

61 Anna Begitseva, RGALI, f. 2089, op. 2, ed. khr. 40, l. 9.

62 Parnis, 'Tatlin', p. 87.

63 See also: Varlam Shalamov, *Voskreshenie listvennitsy*, Paris: YMCA Press, 1985, p. 314. Or: Varlam Shalamov, *Sobranie sochineniy* (6 vols), Moscow: Terra-Knizhny klub, 2003–13, vol. 2, 2004, p. 271.

64 N. Punin, *Mir svetel lyubovyu. Dnevniki, pisma* (ed. L. A. Zykova), Moscow: Artist, Rezhisser, Teatr, 2000, p. 135.

65 See: Zhadova, *Tatlin*, p. 448. And: *Formalny metod. Antologia russkogo modernizma* (ed. Sergey Ushakin) (3 vols), Moscow: Kabinetny ucheny, 2016, vol. 1, pp. 884–86. And: Maria Kokkori and Alexander Bouras, 'Charting Modernism: Malevich's Research Tables', in: *Malevich* (ed. A. Borchardt-Hume), London: Tate Publishing, 2014, p. 169.

66 See: Parnis, 'Tatlin', p. 82.

67 *A Legacy Regained: Nikolai Khardzhiev and the Russian Avant-garde* (ed. and comp. John Bowlt and Mark Konecky), St Petersburg: Palace Editions, 2002, p. 221.

68 Vakar and Mikhienko, II, p. 43. See also: ibid., pp. 27–36.

69 See: RGALI, f. 2368, op. 1, ed. khr. 112, l. 4, 5.

70 Khvostenko, *Vechera*, p. 154.

71 See: Vakar and Mikhienko, II, p. 579, n. 9.

72 Vakar and Mikhienko, I, p. 253.

73 Ibid., p. 587.

74 N. I. Khardzhiev, *Statji ob avangarde, v dvukh tomakh*, Moscow: RA, 1997, vol. 1, p. 369.

75 Vakar and Mikhienko, I, pp. 501–2.

76 Ibid., p. 184.

77 Ibid., II, p. 254.

78 See: ibid., p. 185, and: ibid., pp. 255–56.

79 Ibid., I, p. 546. This letter was intercepted by the security service.

80 Nakov, III, p. 210, n. 146.

81 See: Timothy Benson and Alexandra Shatskikh, 'Malevich and Richter: An Indeterminate Encounter', *October*, 2013, no. 143, pp. 52–68.

82 Vakar and Mikhienko, I, p. 184.

83 See: ibid., II, pp. 365–69. And the commentary: p. 365, n. 2.

84 Ibid., I, p. 185.

85 Tadeusz Peiper, 'Malewicz w Polsce', *Zwrotnica*, 1927, no. 11, p. 239; see also: Nakov, III, p. 194, n. 88 and n. 89.

86 Vakar and Mikhienko, I, p. 258.

87 *Segodnya* (Riga), 5 April 1927, p. 3.

88 Cited in: Nakov, III, p. 205, n. 115.

89 Hans von Riesen, 'Malewitsch in Berlin', in: *Avantgarde in Osteuropa* (ed. Eberhard Roters), Berlin: Deutsche Gesellschaft für bildende Kunst, 1967 (cat.), p. 23.

90 See: *Grosse Berliner Kunstausstellung, 1927*, Berlin: G. E. Diehl Verlag, 1927. And: *Malevich, Catalogue Raisonné of the Berlin Exhibition 1927*, Amsterdam: Stedelijk Museum, 1970 (cat.). See also: Larissa A. Zhadova, *Malevich, Suprematism and Revolution in Russian Art 1910–1930* (transl. Alexander Lieven), New York: Thames & Hudson, 1982, p. 126, n. 81, n. 82.

91 *Grosse Berliner Kunstausstellung*, p. 107.

92 See: Nakov, III, p. 210, n. 149.

93 Vakar and Mikhienko, I, pp. 185–89.

94 Ibid., p. 188.

95 Vakar and Mikhienko, II, p. 378.

96 Tadeusz Peiper, 'W Bauhausie', *Zwrotnica*, 1927, no. 12, pp. 255–56.

97 Ibid.

98 Ibid. See also: *Kandinsky: russische Zeit und Bauhausjahre 1915–1933*, Berlin: Bauhaus Archiv, 1984, p. 40.

99 Ise Gropius, in: Heiner Stachelhaus, *Kasimir Malewitsch: ein tragischer Konflikt*, Düsseldorf: Claassen, 1989, p. 257.

100 See: G. Chugunov, *Mstislav Valerianovich Dobuzhinsky*, Leningrad: Khudozhnik RSFSR, 1984, p. 202 and p. 228, n. 31.

101 Von Riesen, 'Malewitsch in Berlin', p. 25.

102 Facsimile in: *Kazimir Malevich, 1878–1935* (ed. W. A. L. Beeren, J. M. Joosten and L. Veneman-Boersma), Amsterdam: Stedelijk Museum, 1989, p. 52.

103 Vakar and Mikhienko, II, p. 367.

104 See: Lien Heyting, *De verdwaalde collectie: De schilder Kazimir Malevitsj en de strijd om zijn erfenis*, Amsterdam: Prometheus, 2006.

Chapter 9

1 See: Vakar and Mikhienko, II, p. 35 (commentary: n. 8). See also: A. Shatskikh, *Kazimir Malevich*, Moscow: Slovo, 1996, p. 65.

2 Vakar and Mikhienko, II, p. 384.

3 V. B. Yelkonin, 'Poslednie dni "chetyrekh iskusstv"', *Panorama iskusstv*, 1990, vol. 13, p. 231.

4 Vakar and Mikhienko, II, p. 18 (commentary: n. 21, n. 22).

5 KMSob, V, p. 411.

6 Vakar and Mikhienko, I, p. 188.

7 Ibid., p. 185.

8 Cited in: *In Malevich's Circle. Confederates, Students, Followers in Russia, 1920s–1950s* (comp. Irina Karasik), St Petersburg: Palace Editions, 2000, p. 243.

9 Ibid., p. 243.

10 Maria Ender to Boris Ender, 13 February 1928, in: *Organika, bespredmetny mir prirody v russkom avangarde XX veka* (comp. Alla Povelikhina), Moscow/Cologne: RA-Gmurzynska, 2000 (cat.), pp. 69–70.

11 Vakar and Mikhienko, II, pp. 80–81. See also: ibid., p. 45.

12 Ibid., I, p. 231.

13 Charlotte Douglas, 'Beyond Suprematism – Malevich: 1927–33', *Soviet Union/Union Soviétique*, 1980, vol. 7, no. 1–2, p. 215.

14 I retain (in translation) the titles used by the museums (in this case, GRM). For alternate designations, see: Nakov, III, pp. 250–51.

15 See: Charlotte Douglas, 'Malevich and De Chirico', in: *Rethinking Malevich: Proceedings of a Conference in Celebration of the 125th Anniversary of Kazimir Malevich's Birth* (ed. Charlotte Douglas and Christina Lodder), London: Pindar Press, 2007, pp. 254–93. For Baumeister, see: Nakov, III, p. 221.

16 See: Vakar and Mikhienko, I, p. 265. See also Vakar in: *Russky avangard, problemy reprezentatsii i interpretatsii* (ed. Irina Karasik and Yevgenia Petrova), St Petersburg: Palace Editions, 2001, p. 124.

17 See: Irina Vakar, 'Vystavka K. S. Malevicha 1929 goda v Tretyakovskoy galeree', in: *Russky avangard, problemy reprezentatsii*, p. 135.

18 Vakar and Mikhienko, I, p. 212.

19 Ibid., p. 207.

20 See: Nicoletta Misler, 'Twice Removed: Pavel Filonov and Nikolai Glebov-Putilovskii', in: *Utopian Reality, Reconstructing Culture in Revolutionary Russia and Beyond* (ed. Christina Lodder, Maria Kokkori and Maria Mileeva), Leiden: Brill, 2013, p. 116.

21 Vakar and Mikhienko, I, p. 210.

22 See: A. G. Sotnikov, 'Zapiski iz moey zhizni', *Panorama iskusstv*, 1982, vol. 5, p. 17.

23 See: Vakar and Mikhienko, I, pp. 542–58. Also ibid., p. 553 (no. 14); on the raising of suspicions and the penalties, p. 543 (no. 3 and n. 1).

24 Vakar and Mikhienko, I, p. 266.

25 See for example: Hiroaki Kuromiya, *The Voices of the Dead: Stalin's Great Terror in the 1930s*, New Haven: Yale University Press, 2007, pp. 6–7.

26 Oleksander Naiden and Dmitro Gorbachov, 'Malevich Myzhitsky', *Khronika 2000*, 1993, no. 3–4, p. 237. Viktoria Zaitseva's comment is given in a note.

27 Vakar and Mikhienko, II, p. 35, n. 10.

28 Ibid.

29 See: ibid., p. 307.

30 See: Roy Medvedev, *Let History Judge* (revised and extended edition), New York: Columbia University Press, 1989, p. 486.

31 See: Vakar and Mikhienko, I, p. 543, document no. 3, n. 1.

32 Vakar and Mikhienko, II, p. 44.

33 Pavel Filonov, *Dnevniki*, St Petersburg: Azbuka, 2000, p. 165.

34 See: Vakar and Mikhienko, II, p. 18.

35 Ibid., p. 306.

36 Ibid.

37 See: Vakar and Mikhienko, I, p. 557.

38 See, among others: RGALI, f. 2089, op. 2, ed. khr. 40, l. 44.

39 See: *El Lissitzky*, Cologne: Gmurzynska, 1976 (cat.), p. 89.

40 *Formalny metod. Antologia russkogo modernizma* (ed. Sergey Ushakin) (3 vols), Moscow: Kabinetny ucheny, 2016, vol. 3, p. 881.

41 *Formalny metod*, vol. 3, pp. 882–83.

42 *Formalny metod*, vol. 3, p. 880.

43 Abram Efros, *Profili: ocherki o russkikh khudozhnikakh*, St Petersburg: Azbuka-Klassika, 2007, p. 286.

43 See: Anatoly Strigalev, 'Krylya khudozhnika', in: *Mir iskusstv 5* (ed. B. I. Zingerman), St Petersburg: Aletea, 2004, p. 376, n. 2.

44 See: A. G. Sotnikov, 'Zapiski iz moey zhizni', *Panorama iskusstv*, 1982, vol. 5, p. 16.

45 See: GTG, f. 159, ed. khr. 319, l. 105.

46 Sotnikov, 'Zapiski', pp. 15–16.

47 From an interview with Georgy Tovstonogov, in: Y. I. Gorfunkel and I. N. Shimbarevich (eds), *Georg Tovstonogov: sobiratelny portret*, St Petersburg: Baltiskie sezony, 2006, p. 496.

48 Daniil Danin, 'Uletavl', *Druzhba narodov*, 1979, no. 2, p. 222.

49 See: Samuil Marshak, *Sobranie sochineniy (vol. 8): izbrannie pisma*, Moscow: Khoduzhestvennaya literatura, 1972, p. 102. And: Sotnikov, 'Zapiski', p. 17. Marshak was the link between Kharms and Tatlin. See: D. Kharms, *Polnoe sobranie sochineniy. Zapisnie knizhki. Dnevnik, kniga I*, St Petersburg: Gumanitarnoe agenstvo 'Akademichesky proekt', 2002, p. 188.

50 Boris Semenov, 'Vy nepremenno polyubite ego', *Koster*, 1976, no. 3, p. 58.

51 D. Kalma, 'Protiv khaltury v detskoy literature!', *Literaturnaya gazeta*, 16 December 1929, no. 35, p. 2.

52 Sotnikov, 'Zapiski', p. 18.

53 For example, in the *Münchner Illustrierte Presse* (1932, no. 16), the *Haagsche Courant* (4 April 1933), and the *Algemeen Handelsblad* (17 May 1932).

54 *Formalny metod*, vol. 3, p. 889. See also: Alexander Kovalev, '"Letatlin". Poisk novogo mira', *Iskusstvo*, 1990, no. 6, p. 29.

55 *Formalny metod*, vol. 3, p. 886.

56 See: Begitseva, RGALI, f. 2089, op. 2, ed. khr. 40, l. 34.

57 See: Smirnov, GTG, f. 159, ed. khr. 319, p. 105. Also Strigalev, 'Krylya khudozhnika', p. 366.

58 See: K. A. Makarov, *Alexey Sotnikov: zhizn i tvorchestvo*, Moscow: Sovetsky khudozhnik, 1986, p. 26.

59 See: Anatoly Strigalev, 'Tatlin i Khlebnikov', *Iskusstvoznanie*, 2007, no. 3–4, pp. 410–11.

60 See: Smirnov, GTG, f. 159, ed. khr. 312, 1. 112.

61 See: Smirnov, GTG, f. 159, ed. khr. 312, 1. 115–27.

62 A. Strigalev, 'Retrospektivnaya vystavka Vladimira Tatlina', in: *Vladimir Tatlin, Retrospektive* (ed. Anatoly Strigalev and Jürgen Harten), Cologne: Dumont, 1993 (cat.), p. 40.

63 Kovalyov, "'Letatlin'", p. 29.
64 *Formalny metod*, vol. 3, p. 892.

Chapter 10

1 *Kazimir Malevich v Russkom muzee* (text: Yelena Basner, Jozef Kiblitsky et al.), St Petersburg: Palace Editions, 2000, pp. 26 and 358.
2 See: *The Cambridge History of Russia, III: The Twentieth Century* (ed. Ronald Grigor Suny), Cambridge: Cambridge University Press, 2015, p. 207.
3 See: Vitaly Manin, *Iskusstvo v rezervatsii, khudozhestvennaya zhizn Rossii 1917–1941*, Moscow: Editorial URSS, 1999, pp. 167–68.
4 Leonid Maximenkov, *Sumbur vmesto muzyki. Stalinskaya kulturnaya revolyutsia, 1936–1938*, Moscow: Yuridicheskaya kniga, 1997, pp. 23–24.
5 See: Maria Chegodaeva, 'Mass Culture and Socialist Realism', *Russian Studies in History*, 2003, vol. 42, no. 2, pp. 49–65.
6 See: A. Avtorkhanov, *Memuary*, Frankfurt: Posev, 1963, p. 223.
7 See: Masha Chlenova, 'Staging Soviet Art: 15 Years of Artists of the Russian Soviet Republic, 1932–1933', *October*, 2014, no. 147, p. 47.
8 See: *Khudozhniki RSFSR za 15 let, katalog yubileynoy vystavki*, Leningrad: Gosudarstvenny Russky muzey, 1932.
9 Chlenova, 'Staging Soviet Art', p. 47.
10 See: ibid., p. 48, n. 22.
11 Alexander Labas, *Vospominania*, St Petersburg: Palace Editions, 2004, p. 45.
12 A. Chegodaev, 'Pisma iz Leningrada', *Panorama iskusstv*, 1978, vol. 77, p. 217.
13 Ibid., pp. 213, 207.
14 Vakar and Mikhienko, I, pp. 234–35.
15 Ibid.
16 T. V. Khvostenko, *Vechera na Maslovke bliz 'Dinamo', tom II: za fasadom proletarskogo iskusstva*, Moscow: Olympia Press, 2003, p. 125.
17 Ibid., pp. 125–26.
18 See: Chlenova, 'Staging Soviet Art', p. 51. See also: *Lenin o kulture i iskusstve, sbornik statey i otryvkov* (ed. M. Lifshits), Moscow: Izogiz, 1938, p. 299.
19 Khvostenko, *Vechera*, p. 129.
20 See: Vakar and Mikhienko, I, p. 239 (in annotation).
21 Vakar and Mikhienko, I, p. 239.
22 See: D. V. Manukyan, 'Sovetskie khoduzhestvennie vystavki 1930-kh godov', *Tretyakovskie chtenia 2016* (ed. L. I. Iovleva and T. V. Yudenkova), Moscow: GTG, 2017, p. 314.
23 See: *Naselenie Rossii v XX veke* (ed. V. B. Ziromskaya) (3 vols), Moscow: Rosspen, 2000, vol. 1, p. 319.
24 See: *Vladimir Tatlin, Retrospektive* (ed. Anatoly Strigalev and Jürgen Harten), Cologne: Dumont, 1993 (cat.), p. 394.
25 See: O. B. Mozokhin, *Pravo na repressii, vnesudebnye polnomochia organov gosudarstvennoy bezopasnosti*, Moscow: Kuchkovo pole, 2011, pp. 414 and 428. For the number of political prisoners in 1933, calculated from the number of arrests due to 'counter-revolutionary and anti-Soviet activity': pp. 430–31.
26 See: S. V. Kudryavtsev and N. A. Bogomolov, 'Sledstvennoe delo Igorya Terentyeva (1931)', in: *Minuvshee: istorichesky almanakh*, 1995, vol. 18, pp. 533–608.
27 See: *Slovo i sudba, Osip Mandelstam, issledovania i materialy*, Moscow: Nauka, 1991, p. 151.
28 Osip Mandelstam, *Polnoe sobranie sochineniy i pisem v trekh tomakh*, Moscow: Progress-Pleada, 2009, vol. 1, p. 184.
29 *Osip i Nadezhda Mandelstamy v rasskazakh sovremennikov*, Moscow: Natalis, 2001, p. 153.
30 Zinaida Gippius, 'Chernye tetradi', in: *Zvenya, istorichesky almanakh*, 1992, vol. 2, p. 91.
31 See: Mark Etkind, *A. N. Benois i russkaya khudozhestvennaya kultura*, Leningrad: Khudozhnik RSFSR, 1989, p. 380.
32 Vakar and Mikhienko, I, p. 573.
33 See: Vakar and Mikhienko, II, p. 296, and: Vakar and Mikhienko, I, p. 573.
34 See: Vakar and Mikhienko, II, p. 318.
35 See: Yuri Krol, 'Priplyusovali menya!', *Zvezda*, 2011, no. 11, http://magazines.russ.ru/zvezda/2011/11/kr12.html (accessed 11 July 2018).
36 See: Antonina Zainchkovskaya, *Vera Ermolaeva, 1893–1937*, St Petersburg: Palace Editions, 2008, pp. 24–25, n. 97–114.
37 Vakar and Mikhienko, II, p. 307.
38 Vakar and Mikhienko, II, p. 413.
39 I. V. Klyun, *Moy put v iskusstve: vospominania, statji, dnevniki*, Moscow: RA, 1999, p. 113.
40 Ibid., p. 150.
41 Ibid., p. 154.
42 See: Vakar and Mikhienko, II, p. 88, n. 23.
43 Vasily Rakitin, *Nikolay Suetin, 1897–1954*, Moscow: Palace Editions/RA, 2008, p. 261.
44 D. Kharms, *Polnoe sobranie sochineniy* (ed. V. N. Sazhin) (4 vols), St Petersburg: Gumanitarnoe agentstvo 'Akademichesky proekt', 1997, vol. 1, pp. 271–72.
45 Ibid., p. 30.
46 Nadezhda Udaltsova, *Zhizn russkoy kubistki: dnevniki, statji, vospominania*, Moscow: RA, 1994, p. 106, n. 34.
47 Irina Vrubel-Golubkina, 'Beseda s N. I. Khardzhievym', *Zerkalo*, 1995, no. 131, zerkalo-litart.com/?p=3816 (accessed 12 July 2018).
48 Interview with Ninel Bykova by Peter d'Hamecourt, *Algemeen Dagblad*, 2 November 1993.
49 Elizabeth Kridl Valkenier, 'AKHRR, Realism and Official Style in the 1920s', *Soviet Union/*

Union Soviétique, 1980, vol. 7, no. 1–2, p. 201.

50 See: *Vlast i khudozhestvennaya intelligentsia: dokumenty, 1917–1953* (comp. Andrey Artizov and Oleg Naumov), Moscow: Demokratia, 1999, pp. 272–73.

51 See: Maximenkov, *Sumbur*. See also above, n. 50.

52 See: *Protiv formalizma i naturalizma v iskusstve, sbornik statey* (ed. P. I. Lebedev), Moscow: Ogiz-Izogiz, 1937, p. 79.

53 See: Yuri Elagin, *Temny Geny (Vsevolod Meyerhold)*, London: Overseas Publications, 1982. And: Sjeng Scheijen, *Sergej Diaghilev, een leven voor de kunst*, Amsterdam: Prometheus 2009, p. 513.

54 See: Maximenkov, *Sumbur*, pp. 66–71.

55 'O khudozhnikakh-pachkunakh', *Pravda*, 1 March 1936, p. 4.

56 See: *The Culture of the Stalin Period* (ed. Hans Günther), Houndmills and New York: Palgrave Macmillan, 1990, p. 186.

57 RGALI, f. 2943, op. 1, ed. khr. 81, l. 14–18.

58 *Pravda*, 25 March 1936, p. 4.

59 See: Manin, *Iskusstvo v rezervatsii*, pp. 231–32.

60 Margarita Tupitsyn, *Gustav Klutsis and Valentina Kulagina: Photography and Montage after Constructivism*, Göttingen: Steidl, 2004, p. 221.

61 Daniil Danin, 'Dnevnik odnogo goda, ili Monolog-67', *Zvezda*, 1997, no. 4, p. 193.

62 See: A. Sofronova, *Zapiski nezavisimoy, dnevniki, pisma, vospominania*, Moscow: RA, 2001, p. 235.

63 Alexander Labas, *Vospominania*, St Petersburg: Palace Editions, 2004, p. 47.

64 See: I. Lebedeva, 'Iskusstvo avangarda v ekspozitsiakh Tretyakovskoy galerey 1920–1930-kh godov', in: *Russky avangard, problemy reprezentatsii i interpretatsii* (ed. Irina Karasik and Yevgenia Petrova), St Petersburg: Palace Editions, 2001, pp. 144–45.

65 See: *Vlast i khudozhestvennaya intelligentsia*, pp. 308–9.

66 R. Kerzhentsev, 'O Tretyakovskoy galerei', *Pravda*, 7 June 1936.

67 Klyun, *Moy put*, p. 113.

68 Vakar and Mikhienko, I, p. 218.

69 N. Y. Simonovich-Efimova, *Zapiski khudozhnika*, Moscow: Sovetsky khudozhnik, 1982, p. 165.

70 For arrests and death sentences, see: O. B. Mozokhin, *Pravo na repressii, vnesudebnye polnomochia organov gosudarstvennoy bezopasnosti*, Moscow: Kuchkovo pole, 2011, pp. 450–51, pp. 457–58. For the gulag population, see: J. Arch Getty, Gábor T. Rittersporn and Viktor N. Zemskov, 'Victims of the Soviet Penal System in the Pre-War Years: A First Approach on the Basis of Archival Evidence', *The American Historical Review*, October 1993, vol. 98, no. 4, pp. 1021–22.

71 These are general figures, based on: Terry Martin, *The Affirmative Action Empire, Nations and Nationalism in the Soviet Union, 1929–1999*, Ithaca and London: Cornell University Press, 2001, pp. 338–39.

72 Olga Roytenberg, *Neuzheli kto-to vspomnil, chto my byli...*, Moscow: Galart, 2008, p. 427, n. 5.

73 Tupitsyn, *Gustav Klutsis and Valentina Kulagina*, p. 232.

74 Maria Chegodaeva, *Zapovedny mir Miturichey-Khlebnikovykh*, Moscow: Agraf, 2004, p. 190.

75 Emma Gershteyn, *Memuary*, St Petersburg: Inapress, 1996, p. 261.

76 Daniil Danin, 'Uletavl', *Druzhba narodov*, 1979, no. 2, pp. 235–36.

77 V. F. Kolyazin (comp. and ed.), *Vernite mne svobodu! Memoralny sbornik dokumentov iz arkhivov byvshego KGB*, Moscow: Medium, 1997, pp. 229–30.

78 See: L. I. Pomytkina, 'Zhizn zamechatelnykh nizhegorodtsev: A. V. Kikin', *Nizhegorodsky muzey*, 2013, no. 26, p. 80; and www.kikin.ru (April 2018).

79 Alexander Rodchenko, *Opyty dlya budushchego. Dnevniki, statji, pisma, zapiski*, Moscow: Grant, 1996, p. 352.

80 Ibid., pp. 352–53.

81 Yuri Nagibin, *Italyanskaya tetrad*, Moscow: Podkova, 1998, p. 116.

82 Alexander Labas, *Vospominania*, St Petersburg: Palace Editions, 2004, p. 104.

83 A. M. Rodchenko, *Statji, vospominania, avtobiograficheskie zapiski, pisma*, Moscow: Sovetsky khudozhnik, 1982, p. 85.

84 Labas, *Vospominania*, p. 105.

85 E. I. Gorfunkel, and I. N. Shimbarevich (eds), *Georgy Tovstonogov: sobiratelny portret*, St Petersburg: Baltiskie sezony, 2006, p. 496.

Bibliography

Key Works (abbreviations)

Entsiklopedia russkogo avangarda (ed. V. I. Rakitin and A. D. Sarabianov), Moscow: Global Ekspert, 2013 (2 vols).

KMSob, I–V = Kazimir Malevich, *Sobranie sochineniy v pyati tomakh*, Moscow: Gilea, 1995–2004.

Krusanov, I (1), (2); II (1), (2) = Andrey Krusanov, *Russky avangard, 1907–1932, istorichesky obzor. V trekh tomakh. t.1: Boevoe desyatiletie, kniga 1,2*, Moscow: Novoe literaturnoe obozrenie, 2010.
t.2: Istorichesky obzor, kniga 1,2: futuristicheskaya revolyutsia, 1917–1921, Moscow: Novoe literaturnoe obozrenie, 2003.

Lapshin = V. P. Lapshin, *Khudozhestvennaya zhizn Moskvy i Peterburga v 1917 godu*, Moscow: Sovetsky khudozhnik, 1983.

Lunacharsky, I–II = Lunacharsky, *Ob iskusstve, v dvukh tomakh* (ed. I. A. Sats and A. F. Yermakov), Moscow: Iskusstvo, 1982 (2 vols).

Nakov, I–IV = Andrei Nakov, *Malevich: Painting the Absolute*, London: Lund Humphries, 2010 (4 vols).

Vakar and Mikhienko, I–II = I. A. Vakar and T. N. Mikhienko (eds), *Malevich o sebe. Sovremenniki o Maleviche. Pisma, dokumenty, vospominania, kritika*, Moscow: RA, 2004.

Archives

GARF = State Archive of the Russian Federation, fond R4390

GRM = State Russian Museum Manuscripts Department, fond 100

GTG = Tretyakov Gallery Manuscripts Department, fond 159, 31

RGALI = Russian State Archive of Literature and Art, fond 2943, 2089, 680

RGASPI = Russian State Archive of Socio-Political History, fond 74

RSL = Russian State Library Manuscripts Department, fond 680

Berlin State Library

Library of Stedelijk Museum/Khardzhiev Foundation Archive, Amsterdam

Websites

http://imwerden.de/
http://lunacharsky.newgod.su/
https://monoskop.org/
http://www.nasledie-rus.ru/
http://uartlib.org/

Periodicals

Anarkhia
Apollon
Iskusstvo kommuny
Izvestia
Pravda
Russkie vedomosti
Vestnik zhizni

Books

Afterimages of Life, Wladislaw Strzeminski and Rights for Arts (ed. Jaroslaw Lubiak), Lodz: Museum Sztuki, 2011.

Agitatsionno-massovoe iskusstvo. Oformlenie prazdnestv, 1917–1932 (ed. V. P. Tolstoy), Moscow: Iskusstvo, 1984.

Agitatsionno-massovoe iskusstvo pervykh let Oktyabrya: materialy i issledovania (ed. E. A. Speranskaya), Moscow: Iskusstvo, 1971.

Agitmassovoe iskusstvo Sovetskoy Rossii: materialy i dokumenty (ed. V. P. Tolstoy), Moscow: Iskusstvo, 2002 (2 vols).

AKHRR, sbornik vospominaniy, statey, dokumentov (comp. I. M. Gronsky and V. N. Perelman), Moscow: Izobrazitelnoe iskusstvo, 1973.

Aksenov, I. A. *Iz tvorcheskogo nasledia* (comp. and ed. N. L. Adaskina), Moscow: RA, 2008 (2 vols).

Alexander Labas (introd. L. Shakirova), St Petersburg: Palace Editions, 2012.

Aleksandr Rodchenko (comp. Magdalena Dabrowski, Leah Dickerman and Peter Galassi), New York: MoMA, 1998 (cat.).

Alexander Rodchenko and Varvara Stepanova: The Future Is Our Only Goal (ed. Peter Noever), Munich: Prestel Verlag, 1991.

Alexander Shevchenko (comp. V. N. Shalabaeva), Moscow: Galart, 1994.

Amazons of the Avant-garde: Alexandra Exter; Natalia Goncharova, Lyubov Popova, Olga Rozanova, Varvara Stepanova, and Nadezhda Udaltsova (ed. John E. Bowlt, Matthew Drutt, Zelfira Tregulova), New York: Solomon R. Guggenheim Foundation, 2000.

A. N. Tolstoy, materialy i issledovania (ed. A. M. Kryukova), Moscow: Nauka, 1985.

Andersen, Troels. *Malevich, Catalogue Raisonné of the Berlin Exhibition 1927*, Amsterdam: Stedelijk Museum, 1970 (cat.).

Anferova, Yevgenia. *David Shterenberg. Symbol and Metaphor in the Artist's Work*, Jerusalem: Gesharim, 2005.

Annenkov, Yury. *Dnevnik moikh vstrech: tsikl tragediy*, Moscow: Khudozhestvennaya literatura, 1991 (2 vols).

Aristarkh Lentulov. Put khudozhnika. Khudozhnik i vremya (ed. E. B. Murina and S. G. Dzhafarova), Moscow: Sovetsky khudozhnik, 1990.

Art into Life: Russian Constructivism 1914–1932 (introd. Richard Andrews and Milena Kalinovska), New York: Rizzoli, 1990 (cat.).

A. V. Shevchenko, Sbornik materialov (comp. Z. E. Kaganskaya, V. N. Shalabaeva and T. E. Lotkina-Galina), Moscow: Sovetsky khudozhnik, 1980.

Avangard, ostanovlenny na begu (comp. S. M. Turutina et al.; introd. Y. F. Kovtun), Leningrad: Avrora, 1989.

Avantgarde in Osteuropa (ed. Eberhard Roters), Berlin: Deutsche Gesellschaft für bildende Kunst, 1967 (cat.).

Avtorkhanov, A. *Memuary*, Frankfurt: Posev, 1963.

Badalyan, Viktoria. *Georgi Yakulov (1884–1928). Khudozhnik, teoretik iskusstva*, Yerevan: Natsionalnaya galerea Armenii, 2010.

Bagadamyan, Irina. *Georgi Yakulov (1884–1928)*, Yerevan: Natsionalnaya Galerea Armenii, 2010.

Ball, Hugo. *Flight Out of Time: A Dada Diary* (ed. and introd. John Elderfield; transl. Ann Raimes), Berkeley and Los Angeles: University of California Press, 1996.

Benois, A. N. *Dnevnik, 1918–1924*, Moscow: Zakharov, 2010.

Benois, A. N. *Moy dnevnik, 1916–1917–1918*, Moscow: Russky put, 2003.

Berlin, Isaiah. *The Sense of Reality: Studies in Ideas and their History* (ed. Henry Hardy), London: Pimlico, 1996.

Berlin Moskau 1900–1950 (comp. Irina Antonowa and Jörn Merkert), Munich: Prestel 1995 (cat.).

Besedy D. V. Duvakina s M. M. Bakhtinym, Moscow: Progress, 1996.

Birshtein, M. A. *Kartiny i zhizn*, Moscow: Sovetsky khudozhnik, 1990.

Blok, Alexander. *Polnoe sobranie sochineniy i pisem*, Moscow: Nauka, 1997 (20 vols).

Boersma, Linda. *0,10: The Last Futurist Exhibition of Painting*, Rotterdam: 010 Publishers, 1994.

Bogorodsky, Fedor. *Vospominania khudozhnika*, Moscow: Sovetsky khudozhnik, 1959.

Borba za realizm v iskusstve 20-kh godov. Materialy, dokumenty, vospominania

(ed. P. N. Lebedev; comp. V. N. Perelman), Moscow: Sovetsky khudozhnik, 1962.

Boris Korolev, 1885–1963, St Petersburg: Palace Editions, 2011.

Bowlt, John E. *Moscow and St. Petersburg in Russia's Silver Age*, London: Thames & Hudson, 2010.

Bowlt, John E. *Nina Lobanov-Rostovsky and Nikita Lobanov-Rostovsky. Encyclopedia of Russian Stage Design. The Catalogue Raisonné of the Collection of Nina and Nikita D. Lobanov-Rostovsky*, Woodbridge: Antique Collectors' Club, 2013 (2 vols).

Bowlt, John E. *Russian Art, 1875–1975: A Collection of Essays*, New York: MSS Information Corporations, 1976.

Bowlt, John E., and Béatrice Hernad, *Aus vollem Halse: russische Buchillustration und Typographie*, Munich: Prestel, 1993.

Burlyuk, D. D. *Pisma (iz kolektsii S. Denisova)*, Tambov, 2011.

Bykov, Dmitri. *Sovetskaya literatura*, Moscow: Prozaik, 2013.

Bykov, Dmitri. *Vremya potriaseniy, 1900–1950*, Moscow: Eksmo, 2018.

The Cambridge History of Russia, III: The Twentieth Century (ed. Ronald Grigor Suny), Cambridge: Cambridge University Press, 2015.

Chagall, Marc, *Ob iskusstve i kulture* (ed. Benjamin Harshav), Moscow: Tekst, 2009.

Chegodaeva, Maria. *Zapovedny mir Miturichey-Khlebnikovykh*, Moscow: Agraf, 2004.

Christ, Thomas. *Wladimir Lebedew und die russische Avantgarde*, Basel: Schwabe Verlag, 2004.

Chugunov, G. *Mstislav Valerianovich Dobuzhinsky*, Leningrad: Khudozhnik RSFSR, 1984.

Chukovskaya, Lidia. *Zapiski ob Anne Akhmatovoy, tom I: 1938–1941*, Moscow: Soglasie, 1997.

Chukovsky, Korney. *Sobranie sochineniy*, Moscow: Terra, 2001–2009 (15 vols).

Chylińska, Teresa. *Karol Szymanowski: His Life and Works* (transl. John Glowacki), Los Angeles: University of Southern California, 1993.

Dabrowski, Magdalena. *Lyubov Popova*, New York: MoMA, 1991.

Davydova, Natalia. *Polgoda v zaklyuchenii: dnevnik, 1920–1921*, Berlin, 1923.

Drengenberg, Hans-Jürgen. *Die sowjetische Politik auf dem Gebiet der bildenden Kunst von 1917 bis 1934*, Berlin: Osteuropa-Institut an der Freien Universität, 1972.

Efros, Abram. *Profili: ocherki o russkikh khudozhnikakh*, St Petersburg: Azbuka-Klassika, 2007.

Efros, Natan. *Zapiski chtetsa*, Moscow: Iskusstvo, 1980.

Ehrenburg, Ilya. *Lyudi, gody, zhizn: vospominania*, Moscow: Sovetsky pisatel, 1990 (3 vols).

Ehrenburg, Ilya. *Und sie bewegt sich doch* (transl. L. Amberg), Baden: LIT Verlag, 1986.

Elagin, Yuri. *Temny geny (Vsevolod Meyerhold)*, London: Overseas Publications, 1982.

El Lissitzky 1890–1941, k vystavke v zalakh GTG (ed. T. Goryacheva and N. Masalin), Moscow: GTG, 1991.

El Lissitzky, Cologne: Gmurzynska, 1976 (cat.).

Etkind, Mark. *Alexander Nikolaevich Benois, 1870–1960*, Leningrad, Moscow: Iskusstvo, 1965.

Etkind, Mark. *A. N. Benois i russkaya khudozhestvennaya kultura*, Leningrad: Khudozhnik RSFSR, 1989.

Etkind, Mark. *Nathan Altman*, Dresden: VEB Verlag, 1984.

Ettinger, P. D. *Statji. Iz Perepiski. Vospominania sovremennikov*, Moscow: Sovetsky khudozhnik, 1989.

Felix Dzerzhinsky, s predisloviem I. S. Unshlikhta, Moscow: AKHRR, 1927 (3rd, supplemented edition; 1st edition, 1926).

Filonov, Pavel. *Dnevniki*, St Petersburg: Azbuka, 2001.

Filonov, Pavel. *Khudozhnik, issledovatel, uchitel*, Moscow: Agei Tomesh, 2006 (2 vols).

The First Russian Show: A Commemoration of the Van Diemen Exhibition, Berlin 1922, London: Annely Juda Fine Art, 1983 (cat.).

Fitzpatrick, Sheila. *The Commissariat of Enlightenment. Soviet Organization of Education and the Arts under Lunacharsky, 1917–1921*, Cambridge: Cambridge University Press, 1970.

Fitzpatrick, Sheila. *The Cultural Front. Power and Culture in Revolutionary Russia*, Ithaca, NY: Cornell University Press, 1992.

Fitzpatrick, Sheila (ed.). *Cultural Revolution in Russia, 1928–1931*, Bloomington: Indiana University Press, 1978.

Fitzpatrick, Sheila. *Education and Social Mobility in the Soviet Union, 1921–1932*, Cambridge: Cambridge University Press, 1979.

Fitzpatrick, Sheila. *The Russian Revolution*, Oxford: Oxford University Press, 2007 (3rd revised ed.).

Fitzpatrick, Sheila. *A Spy in the Archives: A Memoir of Cold War Russia*, London: I. B. Tauris, 2015.

Fogel, Zinovy. *Vasyl Yermylov*, Moscow: Sovetsky khudozhnik, 1975.

Foll, Claire Le. *L'école artistique de Vitebsk (1897–1923)*, Paris: L'Harmattan, 2002.

Formalny metod. Antologia russkogo modernizma (ed. Sergey Ushakin), Moscow: Kabinetny ucheny, 2016 (3 vols).

Gabrichevsky, Alexander. *Biografia i kultura: dokumenty, pisma, vospominania*, Moscow: Rosspen, 2011.

Garnyuk, S. D. *Moskovskaya vlast. Sovetskie organy upravlenia, mart 1917–dekabr 1993*, Moscow: Izd. Glavnogo arkhivnogo upravlenia goroda Moskvy, 2011.

Gassner, Hubertus, and Eckhart Gillen, *Zwischen Revolutionskunst und Sozialistischen Realismus, Dokumente und Kommentare, Kunstdebatten in der Sowjetunion von 1917 bis 1934*, Cologne: DuMont, 1979.

Geifman, Anna. *Death Orders: The Vanguard of Modern Terrorism in Revolutionary Russia*, Santa Barbara: Praeger, 2010.

Geldern, James von. *Bolshevik Festivals*, Berkeley/Los Angeles: University of California Press, 1993.

Gershteyn, Emma. *Memuary*, St Petersburg: Inapress, 1996.

Golomstock, Igor. *Totalitarian Art, in the Soviet Union, the Third Reich, Fascist Italy and the People's Republic of China* (transl. Robert Chandler), New York/London: Overlook Duckworth, 2011.

Gorfunkel, E. I., and I. N. Shimbarevich (eds), *Georgy Tovstonogov: sobiratelny portret*, St Petersburg: Baltiskie sezony, 2006.

Gough, Maria. *The Artist as Producer: Russian Constructivism in Revolution*. Berkeley/Los Angeles: University of California Press, 2005.

Grabar, Igor. *Moya zhizn: etyudy o khudozhnikakh*, Moscow: Respublika, 2001.

Grabar, Igor. *Pisma 1917–1941*, Moscow: Nauka, 1977.

Gray, Camilla. *The Russian Experiment in Art, 1863–1922* (rev. and enlarged edition, ed. Marian Burleigh-Motley), London: Thames & Hudson, 1996.

The Great Utopia, The Russian and Soviet Avant-garde, 1915–1932, New York: Solomon R. Guggenheim Museum, 1992 (cat.).

Grosse Berliner Kunstausstellung, 1927. Veranstaltet vom Kartell der vereinigten Verbände bildender Künstler Berlins E. V., Berlin: G. E. Diehl Verlag, 1927.

Grosz, George. *Ein kleines Ja, und ein grosses Nein: sein Leben von ihm selbst erzählt*, Hamburg: Rowohlt, 1983.

Groys, Boris. *The Total Art of Stalinism: Avant-garde, Aesthetic Dictatorship and Beyond*, Princeton: Princeton University Press, 1992.

Gurianova, Nina. *The Aesthetics of Anarchy, Art and Ideology in the Early Russian Avant-garde*, Berkeley/Los Angeles/London: University of California Press, 2012.

Guryanova, Nina. *Olga Rozanova i ranny russky avangard*, Moscow: Gilea, 2002.

Harmsen, Ger. *Chris Beekman, een kunstenaarsleven, 1887–1964*, Nijmegen: SUN, 1999.

Harte, Tim. *Fast Forward: The Aesthetics and Ideology of Speed in Russian Avant-garde Culture, 1910–1930*, Madison: University of Wisconsin Press, 2009.

Heyting, Lien. *De verdwaalde collectie: De schilder Kazimir Malevitsj en de strijd om zijn erfenis*, Amsterdam: Prometheus, 2006.

In Malevich's Circle. Confederates, Students, Followers in Russia, 1920s–1950s (comp. Irina Karasik), St Petersburg: Palace Editions, 2000.

Iwan Puni, synthetischer Musiker (with contributions by Eberhard Roters and Hubertus Gassner), Berlin: Berlinische Galerie, 1992 (cat.).

Iz istorii stroitelstva sovetskoy kultury, Moskva 1917–1918, Moscow: Iskusstvo, 1964.

Jakobson, Roman. *My Futurist Years* (ed. Bengt Jangfeldt and Stephen Rudy, transl. Stephen Rudy), New York: Marsilio Publishers, 1992.

Jangfeldt, Bengt. *Majakovskij and Futurism*, Stockholm: Almqvist & Wiksell, 1976.

Kachurin, Pamela. *Making Modernism Soviet: The Russian Avant-garde in the Early Soviet Era, 1918–1928*, Evanston: Northwestern University Press, 2013.

Kamchatsky, Episkop Nestor, *Rasstrel Moskovskogo Kremlya* (comp. and commentary by N. S. Malinin), Moscow: Stolitsa, 1995.

Kamensky, Vasily. *Put entuziasta. Avtobiografitcheskaya kniga*, Perm: Permskoe knizhnoe izdatelstvo, 1968.

Kamensky, V. V. *Stepan Razin. Pushkin i Dantes. Khudozhestvennaya proza i memuary*, Moscow: Pravda, 1991.

Kandinsky, Nina. *Kandinsky und ich*, Bergisch Gladbach: Gustav Lübbe Verlag, 1978 (reprint from 1976).

Kandinsky, Vasily. *Izbrannye trudy po teorii iskusstva (izdanie vtoroe, ispravlennoe i dopolnennoe)*, Moscow: Gilea, 2008 (2 vols).

Kandinsky: russische Zeit und Bauhausjahre 1915–1933, Berlin: Bauhaus Archiv, 1984.

Karasik, Irina. *K istorii petrogradskogo avangarda 1920–1930-e gody. Sobytia, lyudi, protsessy, instituty. Avtoreferat na soiskanie uchonoy stepeni doktora iskusstvovedenia*, Moscow: Gos. institut iskusstvoznania, 2003.

Kazimir Malevich, 1878–1935 (ed. W. A. L. Beeren, J. M. Joosten and L. Veneman-Boersma), Amsterdam: Stedelijk Museum, 1989.

Kazimir Malevich, Kyiv Period 1928–1930, Articles, Documents and Letters (comp. and ed. Tetyana Filevska), Kyiv: Rodovid, 2017

Kazimir Malevich v Russkom muzee (text: Yelena Basner, Jozef Kiblitsky et al.), St Petersburg: Palace Editions, 2000.

Khan-Magomedov, Selim O. *Rodchenko, the Complete Work*, London: Thames & Hudson, 1986.

Khan-Magomedov, S. O. *Arkhitektura sovetskogo avangarda, kniga pervaya: problemy formoobrazovania. Mastera i techeniya*, Moscow: Stroyizdat, 1996.

Khan-Magomedov, S. O. *Boris Korolev*, Moscow: Fond 'Russky avangard', 2007.

Khan-Magomedov, S. O. *Kazimir Malevich*, Moscow: S.E. Gordeev, 2010.

Khan-Magomedov, S. O. *Pionery sovetskogo dizayna*, Moscow: Galart, 1995.

Khan-Magomedov, S. O. *Suprematizm i arkhitektura, problemy formoobrazovania*, Moscow: Arkhitektura-S, 2007.

Khan-Magomedov, S. O. *Vkhutemas*, Moscow: Ladya, 1995 (2 vols).

Khardzhiev, N. I. *Statji ob avangarde, v dvukh tomakh*, Moscow: RA, 1997.

Khardzhiev, N., and V. Trenin, *Poeticheskaya kultura Mayakovskogo*, Moscow: Iskusstvo, 1970.

Kharms, D. *Polnoe sobranie sochineniy* (ed. V. N. Sazhin), St Petersburg: Gumanitarnoe agenstvo 'Akademichesky proekt', 1997, 2001 (4 vols).

Kharms, D. *Polnoe sobranie sochineniy. Zapisnie knizhki. Dnevnik, kniga I*, St Petersburg: Gumanitarnoe agenstvo 'Akademichesky proekt', 2002.

Khlebnikov, Velimir. *Sobranie sochineniy, v shesti tomakh* (ed. R. V. Duganov), Moscow: IMLI–RAN 'Nasledie', 2000–2006.

Khlebnikov, Velimir. *Zangezi* (transl. and introd. Aai Prins), Amsterdam: Pegasus, 2013.

Khodasevich, Valentina. *Portrety slovami*, Moscow: Sovetsky pisatel, 1987.

Khudozhestvennaya zhizn Sovetskoy Rossii 1917–1932: sobytia, fakty, kommentarii, sbornik materialov i dokumentov (ed. V. P. Tolstoy), Moscow: Galart, 2010.

Khudozhniki RSFSR za 15 let, katalog yubileynoy vystavki, Leningrad: Gosudarstvenny Russky muzey, 1932 (cat.).

Khvostenko, T. V. *Vechera na Maslovke bliz 'Dinamo', tom II: za fasadom proletarskogo iskusstva*, Moscow: Olympia Press, 2003.

King, David. *Red Star over Russia: A Visual History of the Soviet Union from 1917 to the Death of Stalin*, London: Tate Publishing, 2010.

Klyun, I. V. *Moy put v iskusstve: vospominania, statji, dnevniki*, Moscow: RA, 1999.

Klyunkova-Soloveychik, Svetlana. *Ivan Vasilievich Klyun* (transl. and ed. Nicholas A. Ohotin), New York: Ivk Art, 1993.

Kolyazin, V. F. (comp. and ed.), *Vernite mne svobodu! Memoralny sbornik dokumentov iz arkhivov byvshevo KGB*, Moscow: Medium, 1997.

Komardenkov, V. *Dni minuvshie (iz vospominania khudozhnika)*, Moscow: Sovetsky khudozhnik, 1972.

Konstantin Korovin vospominaet (ed. I. S. Zilbershteyn and V. A. Samkov), Moscow: Izobrazitelnoe iskusstvo, 1990.

Korovin, Konstantin, *Vospominania, rasskazy, pisma, v dvukh knigakh*, vol. 1, Moscow: Russky put, 2010.

Kovalenko, Georgy. *Alexandra Ekster*, Moscow: Moskovsky muzey sovremennogo iskusstva, 2010 (2 vols).

Kovalenko, Georgy. *Teatr Very Mukhinoy*, Moscow: Maier, 2012.

Kovtun, Yevgeny F. *Russische Avant-garde: Chlebnikov en zijn tijdgenoten Malevitsj, Filonov, Tatlin, Mitoeritsj*, Naarden: V+K Publishing/Inmerc, 1993.

Kremlev, Ilya. *V literaturnom stroyu: vospominania*, Moscow: Moskovsky rabochy, 1968.

Krichevsky, Vladimir. *Dmitri Bulanov: Byl v Leningrade takoy dizainer*, Moscow: Kulturnaya revolyutsia, 2007.

Kruchyonykh, Alexei. *K istorii russkogo futurizma: vospominania i dokumenty*, Moscow: Gilea, 2006.

Krupskaya, Nadezhda. *N. K. Krupskaya, ob iskusstve i literature*, Leningrad/Moscow: Iskusstvo, 1963.

Kultura, nauka, i obrazovanie. Oktyabr 1917–1920. Protokoly i postanovlenia Narkomprosa RSFSR v trekh knigakh (ed. L. A. Rogovaya), Moscow: Rosspen, 2012, vol. 1.

Kurdov, V. I. *Pamyatnye dni i gody: zapiski khudozhnika*, St Petersburg: Arsis, 1994.

Kuromiya, Hiroaki. *The Voices of the Dead: Stalin's Great Terror in the 1930s*, New Haven: Yale University Press, 2007.

Kuzin, Boris. *Vospominania, proizvedenia, perepiska*, St Petersburg: Inapress, 1999.

Labas, Alexander. *Vospominania*, St Petersburg: Palace Editions, 2004.

The Landscape of Stalinism: The Art and Ideology of Soviet Space (ed. Evgeny Dobrenko, Eric Naiman), Seattle and London: University of Washington Press, 2003.

Lapshin, V. P. *Soyuz russkikh khudozhnikov*, Leningrad: Khudozhnik RSFSR, 1974.

Lavrentyev, Alexander N. *Alexander Rodchenko* (transl. Alexey Voronin), Moscow: Sergey E. Gordeev, 2011.

Lazarev, M. P. *David Shterenberg: khudozhnik i vremya. Put khudozhnika*, Moscow: Galaktika, 1992.

A Legacy Regained: Nikolai Khardzhiev and the Russian Avant-garde (ed. and comp. John Bowlt and Mark Konecky), St Petersburg: Palace Editions, 2002.

Lenin, V. I. *Polnoe sobranie sochineniy*, vol. 50, Moscow: Gos. izd. politicheskoy literatury, 1967.

Lenin o kulture i iskusstve, sbornik statey i otryvkov (ed. M. Lifshits), Moscow: Izogiz, 1938.

Lentulova, Marianna. *Khudozhnik Aristarkh Lentulov*, Moscow: Sovetsky khudozhnik, 1969.

Leslie, R. F. *The History of Poland since 1863*, Cambridge: Cambridge University Press, 1983.

Levchenko, N. I., and E. M. Bibikova, *Agitatsionno-massovie iskusstvo: Oformlenie prazdnestv: Sovetskoe dekorativnoe iskusstvo, materialy i dokumenty 1917–1932*, Moscow: Iskusstvo, 1984.

Licht und Farbe in der russischen Avantgarde: die Sammlung Costakis, Cologne: Dumont, 2004 (cat.).

Lissitzky-Küppers, Sophie. *El Lissitzky. Maler, Architekt, Typograf, Fotograf. Erinnerungen, Briefe, Schriften*, Dresden: Verlag der Kunst, 1967.

Luchishkin, S. A. *Ya ochen lyublyu zhizn: stranitsy vospominaniy*, Moscow: Sovetsky khudozhnik, 1988.

Lugovskaya, Tatiana. *Kak znayu, kak pomnyu, kak umeyu: vospominania, pisma, dnevniki*, Moscow: Agraf, 2001.

Lunacharsky, A. V. *Neizdannye materialy*, Moscow: Nauka, 1970.

Lunacharsky, A. V. *Sobranie sochineniy*, Moscow: Khoduzhestvennaya literatura, 1963–67 (8 vols).

Makarov, K. A. *Alexey Sotnikov: zhizn i tvorchestvo*, Moscow: Sovetsky khudozhnik, 1986.

Malevich (ed. A. Borchardt-Hume), London: Tate Publishing, 2014 (cat.).

Mandelstam, Nadezhda. *Ob Akhmatovoy (izdanie vtoroe, ispravlennoe)*, Moscow: Tri kvadrata, 2008.

Mandelstam, Nadezhda. *Vtoraya kniga*, Paris: YMCA Press, 1983.

Manin, Vitaly. *Iskusstvo i vlast: borba techeniy v sovetskom izobrazitelnom iskusstve 1917–1941 godov*, St Petersburg: Avrora, 2008.

Manin, Vitaly. *Iskusstvo v rezervatsii, khudozhestvennaya zhizn Rossii 1917–1941*, Moscow: Editorial URSS, 1999.

Marc Chagall, The Russian Years (ed. Christoph Vitali), Frankfurt: Schirn Kunsthalle, 1991 (cat.).

Marc Chagall en het Joods theater (ed. E. van Voolen and E. Wouthuysen), Zwolle: Waanders, 2002 (cat.).

Marshak, Samuil. *Sobranie sochineniy (vol. 8): izbrannie pisma*, Moscow: Khoduzhestvennaya literatura, 1972.

Matjuschin und die Leningrader Avant-garde (ed. Heinrich Klotz), Karlsruhe: Zentrum für Kunst und Medientechnologie-Oktogon, 1991 (cat.).

Maximenkov, Leonid. *Sumbur vmesto muzyki. Stalinskaya kulturnaya revolyutsia, 1936–1938*, Moscow: Yuridicheskaya kniga, 1997.

Mayakovsky, V. V. *Polnoe sobranie sochineniy v trinadtsati tomakh*, Moscow: Khoduzhestvennaya literatura, 1955–61.

Mayakovsky, V. V. *Polnoe sobranie sochineniy v dvadtsati tomakh*, Moscow: Nauka, 2013.

Medvedev, Roj. *Let History Judge* (revised and extended edition), New York: Columbia University Press, 1989.

Merridale, Catherine. *Red Fortress: History and Illusion in the Kremlin*, London: Allen Lane, 2013.

Meyerhold, V. E. *Perepiska, 1896–1939* (comp. V. P. Korshunova and M. M. Sitkovetskaya), Moscow: Iskusstvo, 1976.

Miklashevsky, Konstantin. *Gipertrofia iskusstva*, Petrograd: Akademia, 1924.

Milashevsky, V. *Vchera, pozavchera: vospominania khudozhnika*, Leningrad: Khudozhnik RSFSR, 1972.

Milner, John. *Vladimir Tatlin and the Russian Avant-garde*, New Haven/London: Yale University Press, 1983.

Misler, Nicoletta, and John E. Bowlt, *Filonov, analiticheskoe iskusstvo*, Moscow: Sovetskoe iskusstvo, 1990.

Miturich, P. *Zapiski surovogo realista epokha avangarda. Dnevniki, pisma, vospominania, statji*, Moscow: RA, 1997.

Mnemozina: dokumenty i fakty iz russkogo teatra XX veka (comp. and introd. V. V. Ivanov), Moscow: Gitis, 1996.

Morozov, A. I. *Konets utopii: iz istorii iskusstva v SSSR 1990-kh godov*, Moscow: Galart, 1995.

Morozov, Alexey. *Constructivism: Annotated Bibliographical Index*, Moscow: Kontakt-kultura, 2006 (bilingual edition).

Moskovsky voenno-revolyutsionny komitet, oktyabr–noyabr 1917 goda (ed. V. A. Kondratiev), Moscow: Moskovsky rabochy, 1968.

Mozokhin, O. B. *Pravo na repressii, vnesudebnye polnomochia organov gosudarstvennoy bezopasnosti*, Moscow: Kuchkovo pole, 2011.

Murray, Natalia. *The Unsung Hero of the Russian Avant-garde: The Life and Times of Nikolay Punin*, Leiden/Boston: Brill, 2012.

Muzey v muzee, russky avangard iz kollektsii Muzea khudnozhestvennoy kultury (comp. Irina Karasik), St Petersburg: Palace Editions, 1998.

Nagibin, Yuri. *Italyanskaya tetrad*, Moscow: Podkova, 1998.

Naum Gabo, Sechzig Jahre Konstruktivismus (ed. and comp. Steven A. Nash and Jörn Merkert), Munich: Prestel-Verlag, 1986.

Neizvestny Konchalovsky. Zhivopis iz sobrania semji khudozhnika, chastnykh kollektsiy i GMII im. A. S. Pushkina: k 125-letiyu so dnya rozhdenia khudozhnika (comp. N. B. Avtonomova and A. G. Lukanova), Moscow: GMII im. A. S. Pushkina, 2002 (cat.).

Neizvestny russky avangard, v muzeakh i chastnykh sobraniakh (comp. A. Sarabianov), Moscow: Sovetsky khudozhnik, 1992.

Nekto 1917 (ed. I. Vakar), Moscow: Gos. Tretyakovskaya galerea, 2017 (cat.).

Nesterov, M. V. *Pisma. Izbrannoe*, Leningrad: Iskusstvo, 1988.

Nikich, A. Y. *Osmerkin. Razmyshlenia ob iskusstve. Pisma. Kritika. Vospominania sovremennikov*, Moscow: Sovetsky khudozhnik, 1981.

Nove, Alec. *An Economic History of the USSR. New and Final Edition*, London: Penguin, 1992.

Nurenberg, Amshey. *Odessa – Parizh – Moskva. Vospominania khudozhnika*, Düsseldorf, 2009.

Nurenberg, Amshey. *Vospominania, vstrechi, mysli ob iskusstve*, Moscow: Sovetsky khudozhnik, 1969.

O'Connor, Timothy Edward. *The Politics of Soviet Culture: Anatolii Lunarcharsky*, Ann Arbor: UMI Research Press, 1983.

Okorokov, A. Z. *Oktyabr i krakh russkoy burzhuaznoy pressy*, Moscow: Mysl, 1970.

Olga Rozanova (introd. and ed. Vera Terekhina), Moscow: RA, 2002.

Organika, bespredmetny mir prirody v russkom avangarde XX veka (comp. Alla Povelikhina), Moscow/Cologne: RA-Gmurzynska, 2000 (cat.).

Osip i Nadezhda Mandelstamy v rasskazakh sovremennikov, Moscow: Natalis, 2001.

Osorgin, Mikhail. *Vremena, proisshestvia zelenogo mira*, Moscow: Intelvak, 2005.

Paris-Moscou 1900–1930, Paris: Centre Georges Pompidou, 1979 (cat.).

Pavel Filonov: realnost i mify (comp. Lyudmila Pravoverova), Moscow: Agraf, 2008.

Pavel Mansurov, petrogradsky avangard, St Petersburg: Palace Editions, 1995 (cat.).

Perelman, V. N., and A. M. Lesyuk, *Yevgeny Alexandrovich Katsman*, Moscow: Vsekokhudozhnik, 1935.

Petrov-Vodkin, K. S. *Pisma. Statji. Vystuplenia. Dokumenty* (comp. E. N. Selizarovaya), Moscow: Sovetsky khudozhnik, 1991.

Podkopaeva, Y. N., and A. N. Sveshnikova (eds), *Konstantin Andreevich Somov. Pisma. Dnevniki. Suzhdenia sovremennikov*, Moscow: Iskusstvo, 1979.

Poezia i zhivopis, sbornik trudov pamyati Khardzhieva (ed. M. B. Meilakh and D. V. Sarabianov), Moscow: Yazyki russkoy kultury, 2000.

Povelikhina, Alla, and Yevgeny Kovtun, *Russian Painted Shop Signs and Avant-garde Artists*, Leningrad: Aurora 1991.

Prokofiev, Sergei. *Dnevnik, 1907–1933*, Paris: Sergei Prokofiev Estate, 2002 (2 vols).

Protiv burzhuaznogo iskusstva i iskusstvoznania, sbornik statey (ed. I. E. Grabar and V. S. Kemenov), Moscow: Izd. Akad. Nauk, 1951.

Protiv formalizma i naturalizma v iskusstve, sbornik statey (ed. P. I. Lebedev), Moscow: Ogiz-Izogiz, 1937.

Punin, N. *Mir svetel lyubovyu. Dnevniki, pisma* (ed. L. A. Zykova), Moscow: Artist, Rezhisser, Teatr, 2000.

Punin, N. *O Tatline*, Moscow: RA, 2001.

Raev, Ada. *Russische Künstlerinnen der Moderne 1870–1930; historische Studien, Kunstkonzepte, Weiblichkeitsentwürfe*, Munich: Wilhelm Fink Verlag, 2002.

Rakitin, Vasily. *Ilya Chashnik, khudozhnik novogo vremeni*, Moscow: RA, 2000.

Rakitin, Vasily. *Nikolay Suetin, 1897–1934*, Moscow: Palace Editions/RA, 2008.

Ratkovsky, L. S. *Krasny terror i deatelnost VTSK v 1918 godu*, St Petersburg: Izdatelstvo Sankt-Peterburgskogo universiteta, 2006.

Redko, Kliment. *Dnevniki, vospominania, statji*, Moscow: Sovetsky khudozhnik, 1974.

Redko, Kliment. *Parizhsky dnevnik*, Moscow: Sovetsky khudozhnik, 1992.

Rethinking Malevich: Proceedings of a Conference in Celebration of the 125th Anniversary of Kazimir Malevich's Birth (ed. Charlotte Douglas and Christina Lodder), London: Pindar Press, 2007.

Revolution: Russian Art 1917–1932 (ed. Natalia Murray, John Milner et al.), London: Royal Academy of Arts, 2017 (cat.).

Roberts, Graham. *The Last Soviet Avant-garde: Oberiu – Fact, Fiction, Metafiction*, Cambridge: Cambridge University Press, 1997.

Rodchenko and Popova: Defining Constructivism (ed. Margarita Tupitsyn), London: Tate, 2009 (cat.).

Rodchenko, Alexander. *Opyty dlya budushchego. Dnevniki, statji, pisma, zapiski*, Moscow: Grant, 1996.

Rodchenko, A. M. *Statji, vospominania, avtobiograficheskie zapiski, pisma*, Moscow: Sovetsky khudozhnik, 1982.

Rodtschenko, Eine neue Zeit (ed. Michael Philip and Ortrud Westheider), Hamburg: Hirmer-Bucerius Kunstforum, 2013.

Romanovich, S. M. *Oprekrasneishem iz iskusstv: literaturnoe nasledie, vyderzhki iz perepiski, vospominania sovremennikov o khudozhnike* (comp. N. S. Romanovich), Moscow: Galart, 2011.

Roth, Joseph. *Joden op drift* (transl. Els Snick), Amsterdam: Bas Lubberhuizen, 2016.

Rowell, Margit, and Deborah Wye, *The Russian Avant-garde Book, 1910–1934*, New York: The Museum of Modern Art, 2002.

Roytenberg, Olga. *Neuzheli kto-to vspomnil, chto my byli...*, Moscow: Galart, 2008.

Royzman, Matvey. *Vse, chto pomnyu o Yesenine*, Moscow: Sovetskaya Rossia, 1973.

Rukodelie (ed. Marina Losyak), Moscow: Proun, 2009.

Russell, Robert. *Russian Drama of the Revolutionary Period*, Totowa, NJ: Barnes & Noble Books, 1988.

Russian Art of the Avant-garde, Theory and Criticism 1902–1934 (ed. and transl. John Bowlt), New York: Viking Press, 1976 (2nd/3rd ed., London: Thames & Hudson, 1988/2017).

Russian Avant-garde. The Khardzhiev Collection. Stedelijk Museum Amsterdam (ed. Geurt Imanse and Frank van Lamoen), Rotterdam: nai, 2013.

Russkoe iskusstvo, XX vek: issledovania i publikatsii (ed. G. F. Kovalenko), Moscow: Nauka, 2007–9 (3 vols).

Russky avangard, problemy reprezentatsii i interpretatsii (ed. Irina Karasik and Yevgenia Petrova), St Petersburg: Palace Editions, 2001.

Russky avangard, lichnost i shkola (ed. Irina Karasik), St Petersburg: Palace Editions, 2003.

Russky avangard, nedopisannie stranitsy, pamyati. Y. F. Kovtuna, St Petersburg: Palace Editions, 1999.

Russky avangard 1910–1920-kh godov v yevropeyskom kontekste (ed. G. F. Kovalenko), Moscow: Nauka, 2000.

Russky futurizm: stikhi, statji, vospominania (comp. V. N. Terekhina and A. P. Zimenkov), St Petersburg: Poligraf, 2009.

Rylov, A. A. *Vospominania*, Leningrad: Khudozhnik RSFSR 1977.

Sachs, Harvey. *Rubinstein: A Life*, London: Phoenix, 1997.

Samarsky khudozhestvenny muzey: ot moderna do avangarda (comp. A. Y. Bart), Moscow: Galart, 1995.

Samokhvalov, Alexander. *V gody bespokoynogo solntsa*, St Petersburg: Vsemirnoe slovo, 1996.

Sarabianov, Andrey. *Zhizneopisanie khudozhnika Lva Bruni*, Moscow: RA, 2009.

Sarabianov, Dmitri, and Natalia Avtonomova, *Vasili Kandinsky, put khudozhnika, khudozhnik i vremya*, Moscow: Galart, 1994.

Sarabianov, Dmitri V. and Natalia L. Adaskina, *Popova* (transl. Marian Schwartz), New York: Harry N. Abrams Inc., 1990.

Saryan, M. S. *Iz moey zhizni*, Moscow: Izobrazitelnoe iskusstvo, 1985.

Scheijen, Sjeng. *Sergej Diaghilev, een leven voor de kunst*, Amsterdam: Prometheus, 2009.

Service, Robert (ed.). *Society and Politics in the Russian Revolution*, New York: St Martin's Press, 1992.

Shalamov, Varlam. *Sobranie sochineniy*, Moscow: Terra-Knizhny klub, 2003–13 (6 vols).

Shatskikh, Alexandra. *Black Square: Malevich and the Origin of Suprematism*, New Haven/London: Yale University Press, 2012.

Shatskikh, Alexandra. *Kazimir Malevich*, Moscow: Slovo, 1996.

Shatskikh, Alexandra, *Kazimir Malevich i obshchestvo Supremus*, Moscow: Tri kvadrata, 2009.

Shatskikh, Alexandra. *Vitebsk: zhizn iskusstva, 1917–1922*, Moscow: Yazyki russkoy kultury, 2001.

Shklovsky, V., *Za sorok let: statji o kino*, Moscow: Iskusstvo, 1965.

Sidlina, N. Z. *Naum Gabo, russky avangard*, Moscow: S. E. Gordeev, 2011.

Simonovich-Efimova, N. Y. *Zapiski khudozhnika*, Moscow: Sovetsky khudozhnik, 1982.

Sirotkina, Irina. *Shestoe chuvstvo avangarda, tanets, dvizhenie, kinestezia v zhizni poetov i khudozhnikov (izdanie vtoroe)*, St Petersburg: Izd. Yevr. universiteta, 2016.

Situating El Lissitzky: Vitebsk, Berlin, Moscow (ed. Nancy Perloff and Brian Reed), Los Angeles: Getty Publications, 2003.

Slovo i sudba, Osip Mandelstam, issledovania i materialy, Moscow: Nauka, 1991.

Sluzhenie russkomu avangardu, pamyati Y. F. Kovtun, St Petersburg: Palace Editions, 1998.

Sofronova, A. *Zapiski nezavisimoy, dnevniki, pisma, vospominania*, Moscow: RA, 2001.

Spassky, Sergey. *Mayakovsky i ego sputniki, vospominania*, Leningrad: Sovetsky pisatel, 1940.

Stachelhaus, Heiner. *Kasimir Malewitsch: ein tragischer Konflikt*, Düsseldorf: Claassen, 1989.

Stationen der Moderne: die bedeutendsten Kunstausstellungen des 20. Jahrhunderts in Deutschland, Berlin: Berlinische Galerie, 1988 (cat.).

Stepanova, Varvara. *Chelovek ne mozhet zhit bez chuda. Pisma, poeticheskie opyty, zapiski khudozhnika*, Moscow: Sfera, 1994.

Straaten, Evert van. *Theo van Doesburg: Constructeur van het nieuwe leven*, Otterlo: Kröller-Müller, 1994.

Strutinskaya, Y. I. *Iskania khudozhnikov teatra: Peterburg – Petrograd – Leningrad, 1910–1920-e gody*, Moscow, 1998.

Stupples, Peter. *Pavel Kuznetsov: His Life and Art*, Cambridge: Cambridge University Press, 1989.

Tafuri, Manfredo, *The Sphere and the Labyrinth. Avant-gardes and Architecture from Piranesi to the 1970s* (transl. Pellegrino d'Acierno and Robert Connolly), Cambridge, MA: MIT Press, 1987.

Tatlin, neue Kunst fur eine neue Welt. Internationales Symposium, Ostfildern: Hatje Cantz Verlag, 2013 (cat.).

Teplyakov, A. G. *Protsedura, ispolnenie smertnykh prigovorov v 1920–1930-kh godakh*, Moscow: Vozvrashchenie, 2007.

Tibbe, Lieske. *Een revolutie gaat aan gekijf ten onder: De Stijl en de 'Russische kwestie', najaar 1919. Een briefwisseling tussen Theo van Doesburg, Chris Beekman, Robert van 't Hoff, J-J-P Oud en Antony Kok*, publ. Radboud Univ. Nijmegen 2006 [jpg.-document, 99 pp.], http://hdl.handle.net/2066/27565 (12 April 2014).

Tolstaya, Yelena. *'Degot ili med': Alexey N. Tolstoy kak neizvestny pisatel (1917–1922)*, Moscow: RGGU, 2005.

Tugendhold, Y. *Iskusstvo Oktyabrskoy epokhi*, Leningrad: Academia, 1930.

Tupitsyn, Margarita. *Gustav Klutsis and Valentina Kulagina: Photography and Montage after Constructivism*, Göttingen: Steidl, 2004.

Udaltsova, Nadezhda. *Zhizn russkoy kubistki: dnevniki, statji, vospominania*, Moscow: RA, 1994.

Ufimtsev, Viktor. *Govorya o sebe, vospominania*, Moscow: Sovetsky khudozhnik, 1973.

Umansky, Konstantin. *Neue Kunst in Russland, 1914–1919*, Potsdam: Gustav Kiepenheuer Verlag; Munich: Hans Goltz Verlag, 1920.

Uspensky, Anton. *Mezhdu avangardom i sotsrealizm, iz istorii sovetskoy zhivopisi 1920–1930-kh godov*, Moscow: Iskusstvo-XXI vek, 2011.

Utopian Reality: Reconstructing Culture in Revolutionary Russia and Beyond (ed. Christina Lodder, Maria Kokkori and Maria Mileeva), Leiden: Brill, 2013.

Vaingurt, Julia. *Wonderlands of the Avant-garde*, Evanston: Northwestern University Press, 2013.

Valkenier, Elizabeth Kridl. *Ilya Repin and the World of Russian Art*, New York: Columbia University Press, 1990.

Vassily Kandinsky, Teaching at the Bauhaus (ed. Magdalena Droste), Berlin: Bauhaus-Archive, Museum für Gestaltung, 2014.

Veselovskaya, G. I. *Ukrainsky teatralny avangard*, Kyiv: Feniks, 2010.

Vkhutemas. Mysl Materialna (comp. I. V. Chepkunova), Moscow: Gos. MUAR, 2011.

Vladimir Tatlin: Leben, Werk, Wirkung. Ein internationales Symposium (ed. Jürgen Harten), Cologne: Dumont, 1993.

Vladimir Tatlin, Retrospektive (ed. Anatoly Strigalev and Jürgen Harten), Cologne: Dumont, 1993 (cat.).

Vlast i khudozhestvennaya intelligentsia: dokumenty, 1917–1953 (comp. Andrey Artizov and Oleg Naumov), Moscow: Demokratia, 1999.

Vvedensky, Alexander. *Polnoe sobranie sochineniy*, Moscow: Gilea, 1993 (2 vols).

Words in Revolution: Russian Futurist Manifestoes, 1912–1928 (ed. Anna M. Lawton and Herbert Eagle), Washington, DC: New Academia Publishing, 2005.

Yablonskaya, Tatyana. *Women Artists of Russia's New Age, 1900–1935* (ed. Anthony Parton), New York: Rizzoli, 1990.

Yershov, Gleb. *Khudozhnik mirovogo rastsveta: Filonov*, St Petersburg: Yevropeisky universitet, 2015.

Zainchkovskaya, Antonina. *Vera Ermolaeva, 1893–1937*, St Petersburg: Palace Editions, 2008.

Zamyatin, E. *Sobranie sochineniy*, Moscow: Ruskaya kniga, 2004 (5 vols).

Zernova, E. S. *Vospominania monumentalista*, Moscow: Sovetsky khudozhnik, 1985.

Zhadova, Larissa A. *Malevich, Suprematism and Revolution in Russian Art 1910–1930* (transl. Alexander Lieven), New York: Thames & Hudson, 1982.
Zhadova, Larissa Alekseevna (ed. and comp.), *Tatlin*, London: Thames & Hudson, 1988.

Articles and Chapters

Adaskina, Natalia. 'Zakat avangarda v Rossii', *Voprosy iskusstvoznania*, 1997, vol. 11, no. 2, pp. 264–73.
Ananyeva, Y. S. 'Problemy obespechenia sokhrannosti muzeinykh kollektsii v Ermitazhe v gody Pervoy mirovoy voiny i revolyutsii 1917 g.', *Noveyshaya istoria Rossii*, 2012, no. 1, pp. 51–58.
Apchinskaya, N. V. 'Khudozhnik Alexander Volkov', in: *Russkoe iskusstvo, XX vek: issledovania i publikatsii*, vol. 2 (ed. G. F. Kovalenko), Moscow: Nauka, 2008, pp. 330–74.
Avtonomova, Natalia. 'Pervaya khudozhestvennaya vystavka russkogo iskusstva. Berlin 1922 god', *Iskusstvoznanie*, 2003, no. 2, pp. 636–46.
Babin, Alexander. 'Pikasso i Brak glazami Malevicha', in: *Russky avangard 1910–1920-kh godov v yevropeyskom kontekste* (ed. G. F. Kovalenko), Moscow: Nauka, 2000, pp. 102–23.
Barr, Alfred H. 'Russian Diary 1927–28', *October*, 1978, vol. 7, pp. 10–51.
Basner, E. V. '"My i zapad": idea missionerstva v russkom avangarde', in: *Russky avangard 1910–1920-kh godov v yevropeyskom kontekste* (ed. G. F. Kovalenko), Moscow: Nauka, 2000, pp. 27–34.
Benson, Timothy, and Alexandra Shatskikh, 'Malevich and Richter: An Indeterminate Encounter', *October*, 2013, vol. 143, pp. 52–68.
Bogdan, Veronika. 'Akademia khudozhestv 1920-e nachalo 1930-kh', *Zhurnal 'Tretyakovskaya Galereia'*, 2013, no. 2, pp. 62–76.
Boult, Dzh. E. [= John E. Bowlt] 'Begsto form: Ivan Puni v Berline (1920–1923)', in: *Russky avangard 1910–1920-kh godov v yevropeyskom kontekste* (ed. G. F. Kovalenko), Moscow: Nauka, 2000, pp. 228–33.
Bowlt, John E. 'The Ideology of the Furniture. The Soviet Chair in the 1920s', *Soviet Union/Union Soviétique*, 1980, vol. 7, no. 1–2, pp. 138–56.
Bowlt, John E. 'One Engineer is Worth More than a Thousand Esthetes: Some Thoughts on the Origin of Soviet Constructivism', *The Structurist*, 1981, no. 21–22, pp. 57–65.
Bowlt, John E., and Nicoletta Misler, 'Uncharted Territory: Vasily Kandinsky and the Soviet Union', *Experiment*, 2002, no. 8, pp. 15–22.
Burenina, Olga. 'Anarkhia i vlast v iskusstve', *Syuzhetologia i syuzhetografia*, 2016, no. 2, pp. 120–37.

Burleigh-Motley, Marian. 'Tatlin's "Sailor": A New Reading', *Notes in the History of Art*, 1992, vol. 11, no. 3–4, pp. 47–52.
Chegodaev, A. 'Pisma iz Leningrada', *Panorama iskusstv*, 1978, vol. 77, pp. 204–20.
Chlenova, Mascha. 'Staging Soviet Art: 15 Years of Artists of the Russian Soviet Republic, 1932–33', *October*, 2014, no. 147, pp. 38–55.
Danin, Daniil. 'Dnevnik odnogo goda, ili Monolog-67', *Zvezda*, 1997, no. 4, pp. 185–212.
Danin, Daniil. 'Uletavl', *Druzhba narodov*, 1979, no. 2, pp. 220–36.
Demidenko, Yulia. 'Novaya odezhda dlya novogo mira, kostyumy V. Y. Tatlina na fone epokhi', *Teoria mody*, 2016, no. 39, pp. 241–47.
Demosfenova, G. L. 'Dnevnik formalno-teoreticheskogo otdela GINKHUKA', *Sovetskoe iskusstvoznanie*, 1991, no. 27, pp. 472–87.
Douglas, Charlotte. 'Beyond Suprematism – Malevich 1927–33', *Soviet Union/Union Soviétique*, 1980, vol. 7, no. 1–2, pp. 214–27.
Douglas, Charlotte. 'Malevich's Painting: Some Problems of Chronology', *Soviet Union/Union Soviétique*, 1978, vol. 5, no. 2, pp. 301–26.
Dymshits-Tolstaya, S. 'Chetyre mesyatsa raboty', *Vestnik zhizni*, 1918, no. 1, pp. 71–74.
Finkel, Stuart. 'Purging the Public Intellectual: The 1922 Expulsions from Soviet Russia', *The Russian Review*, 2003, no. 62, pp. 589–613.
Fokht-Larionova, T. 'Vospominania', in: *Rossisky arkhiv: istoria otechestva v svidetelstvakh i dokumentakh XVIII–XX vv.: almanakh*, Moscow: Studia TRITE, 2001, vol. 2, pp. 643–61.
Frederickson, Laurel. 'Vision and Material Practice: Vladimir Tatlin and the Design of Everyday Objects', *Design Issues*, 1999, vol. 15, no. 1, pp. 49–74.
Gan, Alexei. 'Spravka o Kazimire Maleviche', *Sovremennaya arkhitektura*, 1927, no. 3, pp. 104–106.
Gasper-Hulvat, Marie. 'Material Reenactment: The Missing and Replaced Paintings of Malevich's 1929 Retrospective', *Il capitale culturale*, 2016, no. 14, pp. 347–68.
Gerchuk, Y. 'Tatlin i Favorsky zashchishchayut svoi tvorcheskie printsipy', *Dekorativnoe iskusstvo SSSR*, 1989, no. 12, pp. 11–13.
Gerchuk, Yuri. 'Kuznetsky, dom 11', *Nashe nasledie*, 1997, no. 43–44, pp. 179–91.
Gerchuk, Yuri. 'RGALI. Fond 2943, opis 1', *Iskusstvoznanie*, 2009, no. 3–4, pp. 586–608.
Gershov, Solomon. 'Vospominania', *Byulleten Muzea Marka Shagala*, 2006, no. 14, pp. 26–38.
Gippius, Zinaida. 'Chernye tetradi', *Zvenya, istorichesky almanakh*, 1992, vol. 2, pp. 11–173.

Gladysheva, Y. V. 'M. Kristi – direktor Tretyakovskoy galerey', in: *Tretyakovskie chtenia 2013* (ed. L. I. Iovleva and T. V. Yudenkova), Moscow: GTG, 2014, pp. 277–92.

Goryacheva, Tatiana. 'Posylka Malevichu iz Gollandii', *Pinakoteka*, 2007, no. 24–25.

Goryacheva, Tatiana. '"Tsarstvo dukha" i "Tsarstvo kesarya". Sudba futuristicheskoy utopii v 1920–1930-kh godakh', *Voprosy iskusstvoznanie*, 1999, no. 1, pp. 286–99.

Gough, Maria. 'Model exhibition', *October*, 2014, no. 150, pp. 9–26.

Gough, Maria. 'Tarabukin, Spengler, and the Art of Production', *October*, 2000, no. 93, pp. 79–108.

Harmsen, Ger. 'Nederlandse en Russische kunstenaars tijdens de revolutiejaren, kanttekeningen bij een brief van Kazimir Malewitsj', *De Nieuwe Stem*, 1967, vol. 22, pp. 309–21.

Ioffe, Dennis. 'The Futurist Pragmatics of Life-creation and the Performative Ideology of the Avant-garde. Looking at Aleksej Kručenych through the Prism of Life-writing', *Russian Literature*, 2012, vol. 71, no. 3/4, pp. 371–92.

Johnson, Oliver. 'Alternative Histories of Soviet Visual Culture', *Kritika: Explorations in Russian and Eurasian History*, 2010, vol. 11, no. 3, pp. 581–608.

Junghanns, Kurt. 'Die Beziehungen zwischen deutschen und sowjetischen Architekten in den Jahren 1917 bis 1923', *Wissenschaftliche Zeitschrift der Humboldt-Universität*, 1967, no. 3, pp. 369–82.

Kachurin, Pamela. 'Working (for) the State: Vladimir Tatlin's Career in Early Soviet Russia and the Origins of the Monument to the Third International', *Modernism/Modernity*, 2012, vol. 19, no. 1, pp. 19–41.

Kalma, D. 'Protiv khaltury v detskoy literature!', *Literaturnaya gazeta*, 16 December 1929, no. 35, p. 2.

Karasik, Irina. 'K istorii petrogradskogo avangarda: 1920–1930-e gody. Sobytia, lyudi, protsessy, instituty', *Iskusstvoznanie*, 2004, no. 1, pp. 289–331.

Kazarinova, N. V. 'Provintsialny avangard. Khudozhnik Petr Ivanovich Subbotin-Permyak: sudba i vremya', in: *Russkoe iskusstvo, XX vek: issledovania i publikatsii*, vol. 1 (ed. G. F. Kovalenko), Moscow: Nauka, 2007, pp. 79–104.

Khan-Magomedov, S. O. 'Klassiki rannego konstruktivizma – bratya Stenbergi. V poiskakh rabot pervykh dizainerov i pervykh konstruktivistov', in: *Russkoe iskusstvo, XX vek: issledovania i publikatsii*, vol. 3 (ed. G. F. Kovalenko), Moscow: Nauka, 2009, pp. 397–493.3

Kiaer, Christina. 'The Russian Constructivist Flapper Dress', *Critical Inquiry*, 2001, vol. 28, no. 1, pp. 185–243.

Kiaer, Christina. 'Was Socialist Realism Forced Labor? The Case of Aleksandr Deineka in the 1930s', *Oxford Art Journal*, 2005, vol. 28, no. 3, pp. 323–45.

Klimov, G., and L. Yuniverg, 'SSSR na Parizhskoy vystavki', *Panorama iskusstv*, vol. 5, 1982, pp. 66–87.

Kochneva, Yelena. 'Chelovek Yevropy', *Nashe nasledie*, Moscow, 2016, no. 119, pp. 94–111.

Komar, V., and A. Melamid, 'The Role of the War Ministry in Soviet Art', *A-Ja*, 1980, no. 2, pp. 50–54.

Korovin, Konstantin. 'Vospominania', *Nashe nasledie*, 1990, no. 14, pp. 101–17.

Kostin V. I. 'Kto tam shagaet pravoy? Vospominania', *Panorama iskusstv*, 1980, vol. 3, pp. 94–120; 1989, vol. 9, pp. 116–48; 1989, vol. 12, pp. 199–225.

Kovalenko, G. F. 'Koshka Antuana Pevznera [Antoine Pevsner] i Nauma Gabo [Naum Gabo]', in: *Russkoe iskusstvo, XX vek: issledovania i publikatsii*, vol. 2 (ed. G. F. Kovalenko), Moscow: Nauka, 2008, pp. 225–46.

Kovalenko, Georgy. 'Alexandra Ekster v Odesse, 1919–1920', *Iskusstvoznanie*, 1999, no. 2, Moscow, pp. 402–29.

Kovalev, Alexander. '"Letatlin". Poisk novogo mira', *Iskusstvo*, 1990, no. 6, pp. 28–34.

Krol, Yuri. 'Priplyusovali menya!', *Zvezda*, 2011, no. 11. http://magazines.russ.ru/zvezda/2011/il/kr12.html (accessed 11 July 2018).

Krylova, K. K. 'Istoria spetskhrana nauchnoy biblioteki Tretyakovskoy galerei', in: *Tretyakovskie chtenia 2016* (ed. L. I. Iovleva and T. V. Yudenkova), Moscow: GTG, 2017, pp. 361–73.

Kudryavtsev, S. V., and N. A. Bogomolov, 'Sledstvennoe delo Igorya Terentyeva (1931)', in: *Minuvshee: istorichesky almanakh*, vol. 18, pp. 533–608.

Kurchanova, Natasha (ed. and introd.). 'Anna Begicheva: How I Remember Tatlin', *RES*, 2013, no. 63–64, pp. 299–313.

Lapshin, V. 'Iz tvorcheskogo nasledia G.B. Yakulova', in: *Voprosy sovetskogo izobrazitelnogo iskusstva i arkhitektury* (ed. I. M. Shmidt), Moscow: Sovetsky khudozhnik, 1975, pp. 275–303.

Lapshin, V. P. 'Pervaya vystavka russkogo iskusstva. Berlin. 1922', *Sovetskoe iskusstvoznanie*, 1982, no. 1, pp. 327–62.

Law, Alma H. 'A Conversation with Vladimir Stenberg', *Art Journal*, 1981, vol. 41, no. 3, pp. 222–33.

Lebedeva, T. A. 'Kartiny i khudozhniki. Nabroski vospominania', *Panorama iskusstv*, 1982, vol. 5, pp. 179–211.

Lodder, Christina. 'Art of the Commune: Politics and Art in Soviet Journals, 1917–1920', *Art Journal*, 1993, vol. 52, no. 1, pp. 24–33.

Lodder, Christina. 'Colour in Vladimir Tatlin's Counter-Reliefs', *The Burlington Magazine*, 2008, vol. 150, no. 1258, pp. 28–34.

Lodder, Christina. 'Naum Gabo as a Soviet Emigré in Berlin', *Tate Papers*, 2010, no. 14, www.tate.org.uk/research/tate-papers/14/naum-gabo-as-a-soviet-emigre-in-berlin (accessed 8 January 2023).

Malova, T. V. 'Obyedinenie trekh', in: *Russkoe iskusstvo, XX vek: issledovania i publikatsii*, vol. 1 (ed. G. F. Kovalenko), Moscow: Nauka, 2007, pp. 281–94.

Manukyan, D. V. 'Sovetskie khudozhestvennie vystavki 1930-kh godov', in: *Tretyakovskie chtenia 2016* (ed. L. I. Iovleva and T. V. Yudenkova), Moscow: GTG, 2017, pp. 310–20.

Matyushin, Mikhail. 'Vospominania futurista', *Volga*, 1994, no. 9–10, pp. 72–123.

Naiden, Oleksander, and Dmitro Gorbachov, 'Malevich Myzhitsky', *Khronika 2000*, 1993, no. 3–4, pp. 210–31.

Nisbet, James. 'Material Propositions on the Individual/Collective: The Work of Vladimir Tatlin', *Modernism/Modernity*, January 2010, vol. 17, no. 1, pp. 109–34.

Obatnina, Yelena. 'Khudozhnik i istoria, ili kak sdelan pamyatnik pogibshim anarkhistam', *Novoe literaturnoe obozrenie*, 2013, vol. 122, no. 4, https://www.nlobooks.ru/magazines/novoe-literaturnoe-obozrenie/122-По-4-2013/article/10545 (accessed March 2018).

Parnis, A. 'Tatlin – khudozhnik teatra i kino (zametki o kievskom periode: 1925–1927)', in: *Teatr i russkaya kultura na rubezhe XIX–XX vekov* (ed. I. A. Vakar), Moscow: GTSTM im. Bakhrushina, 1998, pp. 78–93.

Pchelkina, Lyubov. 'The Biomechanics of Voice and Movement in the Solomon Nikritin's Projection Theatre (1920s)', in: *Electrified Voices, Medial, Socio-Historical and Cultural Aspects of Voice Transfer* (ed. D. Zakharine and N. Meise), Göttingen: V&R Unipress, 2013, pp. 149–61.

Punin, N. 'Iskusstvo i revolyutsia (glava iz knigi)' (introd. Irina Punina), *Iskusstvo Leningrada*, 1989, no. 5, pp. 8–22.

Punin, N. 'Kvartira No. 5', *Panorama iskusstv*, 1989, vol. 12, pp. 162–98.

Rakitin, Vasily. 'Malevich posle anarkhizma', in: *Russky avangard, lichnost i shkola* (ed. Irina Karasik), St Petersburg: Palace Editions, 2003, pp. 26–28.

Reid, Susan E. 'Socialist Realism in the Stalinist Terror: The Industry of Socialism Art Exhibition, 1935–1941', *The Russian Review*, 2001, vol. 60, no. 2, pp. 153–84.

Roytenberg, O. 'Na rubezhe 1920–1930-kh godov: poiski i nakhodki', in: *Panorama iskusstv*, 1981, vol. 4, pp. 307–40.

Rybchenkov, B. F. 'Rasskazy Rybchenkova', in: *Prostranstvo kartiny* (comp. N. O. Tamruchi), Moscow: Sovetsky khudozhnik, 1989, pp. 283–304.

Sarabianov, Dmitri, 'Malevich mezhdu frantsuzskim kubizmom i italianskim futurizmom', in: *Russky avangard 1910–1920-kh godov v yevropeyskom kontekste* (ed. G. F. Kovalenko), Moscow: Nauka, 2000, pp. 62–71.

Sarabianov, Dmitri, 'Mikhail Larionov i khudozhestvennoe obyedinenie "Makovets"', *Voprosy iskusstvoznania*, 1996, vol. 8, no. 1, pp. 490–500.

Sedelnikov, V. 'Posle obstrela Kremlya', *Zvenya, istorichesky almanakh*, 1991, no. 1, pp. 439–50.

Semenov, Boris. 'Vy nepremenno polyubite ego', *Koster*, 1976, no. 3, pp. 56–58.

Serpinskaya, Nina. 'Flirt s zhiznyu. Glavy iz "Memuarov intelligentki dvukh epokh"', *Nashe nasledie*, 2003, no. 65, pp. 54–71.

Shatskikh, Alexandra. 'Suprematizm na yevropeyskoy stsene 1920-kh godov', in: *Russky avangard 1910–1920-kh godov v yevropeyskom kontekste* (ed. G. F. Kovalenko), Moscow: Nauka, 2000, pp. 125–32.

Shchokin-Krotova, A. 'Stanovlenie khudozhnika', *Novy mir*, 1983, no. 10, pp. 207–27.

Shchokin-Krotova, A. V. 'Lyudi i obrazy. Biografii i legendy. Iz tsikla "Modeli Falka"', *Panorama iskusstv*, 1985, vol. 8, pp. 195–227.

Shikhireva, O. N. 'K istorii obshchestva "Krug khudozhnikov"', *Sovetskoe iskusstvoznanie*, 1982, no. 1, pp. 297–326.

Shklovsky, Viktor. 'Khudozhestvennaya zhizn bolshevistskoy Rossii' (original, 11 December 1918), *Russian Studies*, 2001, vol. 3, no. 4, pp. 173–78.

Shkolnik, Yeremey. 'Vitebsk moey yunosti', *Nashe nasledie*, 2005, no. 75–76, pp. 183–85.

Sotnikov, A. G. 'Zapiski iz moey zhizni', *Panorama iskusstv*, 1982, vol. 5, pp. 8–28.

Speranskaya, Y. 'K istorii proektirovania pamyatnika III Internatsionala v Samare (1921)', in: *Voprosy sovetskogo izobrazitelnogo iskusstva i arkhitektury* (ed. V. E. Khazanova), Moscow: Sovetsky khudozhnik, 1973, pp. 453–65.

Starr, Frederick. 'Le Corbusier and the USRR [New documentation]', *Cahiers du monde russe et soviétique*, April–June 1980, vol. 21, no. 2, pp. 209–21.

Stites, Richard. 'Iconoclastic Currents in the Russian Revolution: Destroying and Preserving the Past', in: *Bolshevik Culture: Experiment and Order in the Russian Revolution* (ed. Abbott Gleason, Peter Kenez and Richard Stites), Bloomington: Indiana University Press, 1985, pp. 1–24.

Strigalev, Anatoly. 'Iskusstvo konstruktivistov: ot vystavki k vystavke (1914–1932)', *Sovetskoe iskusstvoznanie*, 1991, vol. 27, pp. 121–55.

Strigalev, Anatoly. 'Komu proletariat stavit pamyatniki', *Dekorativnoe iskusstvo SSSR*, 1969, no. 1–2, pp. 27, 52.

Strigalev, Anatoly. 'Krylya khudozhnika', in: *Mir Iskusstv 5* (ed. B. I. Zingerman), St Petersburg: Aletea, 2004, pp. 360–82.

Strigalev, Anatoly. 'Mikhail Larionov – avtor i praktik plyuralisticheskoy kontseptsii russkogo avangarda', *Voprosy iskusstvoznania*, 1996, vol. 8, no. 1, pp. 466–89.

Strigalev, Anatoly. 'O poezdke Tatlina v Berlin i Parizh', *Iskusstvo*, 1989, no. 2, pp. 39–43; no. 3, pp. 26–31.

Strigalev, Anatoly. 'O proekte "Pamyatnika III Internatsionala"', in: *Voprosy sovetskogo izobrazitelnogo iskusstva i arkhitektura* (ed. V. E. Khazanova), Moscow: Sovetsky khudozhnik, 1973, pp. 408–52.

Strigalev, Anatoly. 'Pamyatnik Geroyam Revolyutsii na Marsovom pole', in: *Voprosy sovetskogo izobrazitelnogo iskusstva i arkhitektury* (ed. I. M. Shmidt), Moscow: Sovetsky khudozhnik, 1975, pp. 105–78.

Strigalev, Anatoly. 'Tatlin i Khlebnikov', *Iskusstvoznanie*, 2007, no. 3–4, pp. 385–424.

Strigalev, Anatoly. 'Tatlin i Pikasso', in: *Pikasso i okrestnosti: sbornik statey* (ed. M. A. Busev), Moscow: Progress-Traditsia, 2006, pp. 111–43.

Strigalev, Anatoly. 'Uchastie V. Y. Tatlina v organizatsii i provedenii monumentalnoy propagandy', *Problemy istorii sovetskoy architektury*, 1975, no. 1, pp. 51–67.

Strigalev, Anatoly. '"Universitety" khudozhnika Tatlina', *Voprosy iskusstvoznania*, 1996, vol. 9, no. 2, pp. 405–38.

Strigalev, Anatoly. 'Vo pervykh Kharms, vo vtorykh Tatlin', *Teatr*, 1991, no. 11, pp. 68–75.

Strigalev, Anatoly. 'Zhurnal "Zolotoe Runo" v khudozhestvennoy zhizni 1900-kh godov', in: *Yevropeysky simvolizm* (ed. I. E. Svetlov), St Petersburg: Aletea, 2006, pp. 269–80.

Vakar, Irina, Tatiana Goryacheva, Alexander Lisov, and Vasily Rakitin, 'Malevich v Vitebske. 1919–1922. Dokumenty', *Malevich, Klassichesky Avangard*, 2008, vol. 10, pp. 28–88.

Valkenier, Elizabeth Kridl. 'AKHRR, Realism and Official Style in the 1920s', *Soviet Union/Union Soviétique*, 1980, vol. 7, no. 1–2, pp. 197–213.

V. I. Lenin i A. V. Lunacharsky: perepiska, doklady, dokumenty, Moscow: Nauka, 1971.

'V. I. Lenin i izobrazitelnoe iskusstvo' (comp. A. Pavlyuchenkov), *Iskusstvo*, 1977, no. 1, pp. 9–19.

Voronina, Y. A., and I. T. Salakhov, 'K istorii izuchenia kartini "Cherny suprematichesky kvadrat" 1915 goda K. Malevicha iz sobrania Tretyakovskoy galerei', in: *Tretyakovskie chtenia 2016* (ed. L. I. Iovleva and T. V. Yudenkova), Moscow: GTG, 2017, pp. 264–73.

'Vospominania o V. V. Mayakovskom' (ed. N. I. Abroskina), *Vstrechi s proshlym*, 1990, no. 7, pp. 323–65.

Vrubel-Golubkina, Irina. 'Beseda s N. I. Khardzhievym', *Zerkalo*, 1995, no. 131, http://zerkalo-litart.com/Pp-3816 (accessed 12 July 2018).

Walker, Barbara. 'On Reading Soviet Memoirs: A History of the "Contemporaries" Genre as an Institution of Russian Intelligentsia Culture from the 1790s to the 1970s', *The Russian Review*, July 2000, vol. 59, no. 3, pp. 327–52.

Yakovleva, E. R. 'Khudozhnik N. R. Sadovnikov (k istorii leningradskogo iskusstva 1920–1930-kh godov)', in: *Russkoe iskusstvo, XX vek: issledovania i publikatsii*, vol. 1 (ed. G. F. Kovalenko), Moscow: Nauka, 2007, pp. 295–317.

Yelkonin, V. B. 'Poslednie dni "chetyrekh iskusstv"', *Panorama iskusstv*, 1990, vol. 13, pp. 224–34.

Russian Names
and Spelling Conventions

In the text and captions, Russian names have been transliterated in ways that English-speaking readers are likely to find easiest or most recognizable. Where history has given rise to a particular (Anglicized or Europeanized) spelling during the artist's own lifetime, as in the case of Benois (instead of Benua) or Chagall (instead of Shagal), the more familiar forms are used. Terminology has been transcribed in the same manner, except in the case of a fixed international variant, such as 'soviet' (instead of 'sovyet' or 'sovet'). This rule is sometimes broken in certain collocations, especially in the bibliography, in instances such as 'sovetski khudozhnik'. Some terms have also evolved their own Western variants over the years, such as 'suprematism' (instead of 'suprematizm') and 'futurism' (instead of 'futurizm'). Soft signs and diacritics are not marked.

For the various incarnations of St Petersburg (called Petrograd from 1914 to 1924, and Leningrad from 1924 to 1991), the name used corresponds to the relevant period in history. Very occasionally, where the city is described in more generic terms, 'St Petersburg' is used after 1924.

The various historic names and descriptors used for the post-revolutionary state are less precise, mostly to avoid confusion. From 1922 onwards, for example, I use the customary term 'Soviet Union' (as opposed to the Union of Socialist Soviet Republics). Prior to 1922, shortly after the revolution, I use the terms 'revolutionary state' or 'Soviet Republic.' Place names in Ukraine are given as transliteration of their Ukrainian spelling, e.g. Kharkiv, not Charkov and Dnipro, not Dnieper.

Names of institutions (and their abbreviations/acronyms) changed with great regularity in the initial years of the Soviet Union, and faithful observation of every name-change can be confusing even to the knowledgeable reader – in official documents and publications, these names were often not used consistently, and name-changes were implemented slowly (or sometimes not at all). I therefore refer to institutions using a single name (or abbreviation) as much as possible, and only use a new name once it has been fully established. When denoting the security service, for example, I consistently use Cheka and GPU, not OGPU or GUGP. To refer to the Vkhutemas school of art in Moscow, I do not use its later name, Vkhutein. Navigating terminological conventions such as these is not an exact science, and any issues that arise are dealt with as comprehensively as possible in the notes.

Acknowledgments

I am indebted to many people who contributed to the making of this book. First of all, to Tatiana Sukhman who skilfully and patiently assisted me during the long days at the State Archives of Literature and Art in Moscow. Gijs Bakker, who offered me the most beautiful workplace in Amsterdam. Otto Boele, Jos Schaeken, and Frank Ankersmit, who helped me with the very first steps of this research.

Thank you to Irina Vakar and Alexandra Shatskikh who patiently answered my then so uninteresting questions. My co-readers Pieter van Os and Willem van Maanen, and also Nick van Staalduinen, Katerina Trubina, Alexandra Sankova, Linda Boersma, Léonie van Oudijck, Marsha Holman, and Ruben Eijkelenberg; my editors, the imperturbable and dedicated Marieke van Oostrum, and Job Lisman, the best editor-in-chief in the Netherlands. The knowledgeable, dedicated staff of the Lenin Library in Moscow and the Staatsbibliothek Berlin – the most wonderful library in the world; Tatiana Goryaeva and her dedicated staff of the State Archives of Art and Literature in Moscow; Andrew Nurnberg for his unwavering optimism and knowledge of excellent lunch spots.

I also want to pay tribute to the scientific work of the first generation of avant-garde researchers, who performed crucial work in the 1960s and 1970s under sometimes very difficult circumstances. Quite apart from the undeniable quality of their scientific work, the enthusiasm for the wonderful world of the avant-garde they have revealed is still palpable.

I will also mention John E. Bowlt, Charlotte Douglas, Nicoletta Misler, Yevgeny Kovtun, Dmitry Sarabjanov, Christina Lodder, and Selim Chan-Magomedov. Nothing has touched me more than the articles by Anatoly Strigalev, the architectural historian who is almost single-handedly responsible for the revelation of Vladimir Tatlin's work. Strigalev's trademark method of extreme historical precision, and the dramatic, almost thriller-like structure of his articles (a method that probably would no longer be accepted by any scientific journal) were a revelation. Even claiming that his articles were an example sounds presumptuous.

For this edition I am enormously grateful for the wonderful work of my translator Brent Annable, the copy-editor Carolyn Jones, Russian consultant Angus Russell and Ukrainian specialist Katia Denysova; and to Roger Thorp and everyone at Thames & Hudson, in particular Mohara Gill and Rosalind Horne. I am equally thankful to Michael Dean, who brought me to Thames & Hudson and supported and guided the initial process.

The research on which this book is based was made possible thanks to a generous Veni grant from NOW (Dutch Research Council); and a grant from the Dutch Foundation for Literature for translation into English.

Picture Credits

Index of Names

General Index